Contents

What's different in this book	XX
Acknowledgments	XXII
Photoshop Fundamentals 1	1
Photoshop installation	
The Photoshop interface	
Creating a new document	
User interface brightness	
Tabbed document windows	
Managing document windows	
Synchronized scroll and zoom	
Image document window details	
Title bar proxy icons (Mac only)	
Info panel status information	
Rulers, Guides & Grid	
'Snap to' behavior	
Pixel Grid view	
The Photoshop panels	
Panel arrangements and docking	
Panel positions remembered in workspaces	
Customizing the menu options	
Customizing the keyboard shortcuts	
Task-based workspaces	
Working with a dual display setup	
Photoshop CC Tools panel	
Options bar	
Tool Presets	
Selection tools	
Color Range	
Adjustable tone ranges	
Modifier keys	
Painting tools	
On-the-fly brush changes	
On-screen brush adjustments	
Brush panel	
Brush panel options	45
Pressure sensitive control	
Brush tool presets	
Mixer brush	46
Bristle tip brush shapes	
Load/Replace Swatches from HTML	49
Hex Field	
Tools for filling	51
Tools for drawing	52
Image editing tools	53
Move tool	55
Layer selection using the move tool	55

Navigation and information tools	57
Zoom tool shortcuts	
Hand tool	58
Bird's-eye view	58
Flick panning	59
Windows Multi-touch support	
Eyedropper tool	
Ruler tool	
Rotate view tool	
Notes tool	
Count tool	
Screen view modes	
Working with Layers	
Automating Photoshop	
Preset Manager	
History	
The History panel	
History settings and memory usage	
History brush	
Use of history versus undo	
Snapshots	
Non-linear history	
When files won't open	
Save often	
Background Saving	
Normal saves	
Using Save As to save images	
File formats	
Photoshop native file format	
Smart PSD files	
Large Document (PSB) format	
TIFF (Tagged Image File Format)	
Pixel order	
Byte order	
Save Image Pyramid	
TIFF compression options	
Flattened TIFFs	
JPEG	
PNG	
Photoshop PDF	
Adobe Bridge CC	
The Bridge interface	
Making Bridge CS6 work with Photoshop CC	
Custom work spaces in Bridge	
Opening files from Bridge	
Slideshows	
	00

Adobe Photoshop CC for Photographers

2014 Release

A professional image editor's guide to the creative use of Photoshop for the Macintosh and PC

Martin Evening

CITY OF GLASGOW COLLEGE

North Hanov Hubrary

60 North Hanov eet

Glasc

014

First published 2015 by Focal Press 70 Blanchard Road, Suite 402, Burlington, MA 01803

and by Focal Press 2 Park Square, Milton Park, Abingdon, Oxon OX14 4RN

Focal Press is an imprint of the Taylor & Francis Group, an informa business

© 2015 Martin Evening

The right of Martin Evening to be identified as the author of this work has been asserted by him in accordance with sections 77 and 78 of the Copyright, Designs and Patents Act 1988.

All rights reserved. No part of this book may be reprinted or reproduced or utilised in any form or by any electronic, mechanical, or other means, now known or hereafter invented, including photocopying and recording, or in any information storage or retrieval system, without permission in writing from the publishers.

Notices

Knowledge and best practice in this field are constantly changing. As new research and experience broaden our understanding, changes in research methods, professional practices, or medical treatment may become necessary.

Practitioners and researchers must always rely on their own experience and knowledge in evaluating and using any information, methods, compounds, or experiments described herein. In using such information or methods they should be mindful of their own safety and the safety of others, including parties for whom they have a professional responsibility.

Product or corporate names may be trademarks or registered trademarks, and are used only for identification and explanation without intent to infringe.

Library of Congress Cataloging-in-Publication Data Evening, Martin.

Adobe Photoshop CC for photographers : a professional image editor's guide to the creative use of Photoshop for the Macintosh and PC / Martin Evening. -- 2nd edition pages cm

1. Adobe Photoshop. 2. Photography--Digital techniques. 3. Computer graphics.

I. Title.

TR267.5.A3E94 2015 006.6'96-dc23

2014025247

ISBN: 978-1-138-81247-5 (pbk) ISBN: 978-1-315-74880-1 (ebk)

Printed in Canada

DNG and transparency support	
Opening photos from Bridge via Camera Raw	
Splash screen	88
2 Camera Raw Image Processing	89
Camera Raw advantages	90
The new Camera Raw workflow	90
Does the order matter?	
Raw capture	
JPEG capture	
Editing JPEGs and TIFFs in Camera Raw	
Alternative Raw processors	94
A basic Camera Raw/Photoshop workflow	
Camera Raw support	
DNG compatibility	
Getting raw images into Photoshop	
Image ingestion	99
Importing images via Photo Downloader	100
Tethered shoot imports	105
Tethered shooting via Canon EOS Utility	106
Importing images via other programs	109
Import Images from Device (Mac only)	110
Working with Bridge and Camera Raw	110
General controls for single file opening	
Full size window view	
General controls for multiple file opening	
New preview controls	
Checkpoints	
Preview preferences	
Workflow options	122
CMYK proofing	
Output proofing and the computer display	124
Saving soft proofed raw files as smart objects	124
Summary of the proposed soft proofing workflow	127
Opening raw files as Smart Objects	128
Saving photos from Camera Raw	
Saving a JPEG as DNG	133
Resolving naming conflicts	133
New Save dialog	134
Altering the background color	135
The histogram display	137
Digital camera histograms	
Interactive histogram	137
Image browsing via Camera Raw	
Camera Raw preferences	140
Default Image Settings	
Camera Raw cache	141

DNG file handling	. 141
JPEG and TIFF handling	. 142
Camera Raw cropping and straightening	. 143
How to straighten and crop	. 144
Basic panel controls	. 146
White balance	. 146
Using the white balance tool	. 147
White balance tool refinements	
Basic panel auto white balance adjustments	. 150
Process Versions	
The Process 2012 tone adjustment controls	. 154
Exposure	. 154
Contrast	
Highlights and Shadows	. 156
Whites and Blacks	
Suggested order for the Basic panel adjustments	
Preserving the highlight detail	
When to clip the highlights	
How to clip the shadows	
Shadow levels after a conversion	
Digital exposure	
How Camera Raw interprets the raw data	
Basic panel image adjustment procedure	166
Auto tone corrections	
Auto Whites and Blacks sliders	
Camera-specific default settings	
Clarity	
Negative clarity	
Vibrance and Saturation	
Tone Curve panel	
Point Curve editor mode	
RGB Curves	180
Correcting a high contrast image	
HSL/Grayscale panel	
Recovering out-of-gamut colors	
Adjusting the hue and saturation	
Lens Corrections panel	
Accessing and creating custom lens profiles	
Lens Corrections: Color tab	
Chromatic aberration	191
Defringe sliders	193
The Defringe controls in use	
Eyedropper tool mode	
Localized adjustments: Defringe slider	
Lens Corrections: Manual tab	
Upright corrections	
Synchronizing Upright settings	202
Transform controls	
Lone Vianotting controls	206

Effects panel	208
Post Crop Vignetting control	208
Post Crop Vignette style options	210
Highlights slider	212
Adding Grain effects	214
Camera Calibration panel	216
New Camera Raw profiles	216
Camera look settings profiles	
Custom camera profile calibrations	
DNG Profile Editor	
Camera Raw as a Photoshop filter	
Spot removal tool	
Creating circle spots	229
Synchronized spotting with Camera Raw	
Spot removal tool feathering	
Spot removal tool fine-tuning	231
Visualize spots	232
Creating brush spots	234
Deleting spots	235
Red eye removal	238
Red eye: pet eye removal	239
Localized adjustments	240
Adjustment brush	240
Initial Adjustment brush options	241
Brush settings	241
Adding a new brush effect	242
Resetting adjustments	243
Adjustment brush duplication	243
Editing brush adjustments	245
Previewing the brush stroke areas	245
Auto masking	247
Darkening the shadows	
Hand-coloring in Color mode	
Graduated filter tool	
Graduated color temperature adjustment	
Radial filter adjustments	
Fill to document bounds	
Modifying graduated and radial filter masks	
Correcting edge sharpness with the Radial filter	
Camera Raw settings menu	
Export settings to XMP	
Update DNG previews	
Load Settings Save Settings	
Camera Raw defaults	
Presets panel	
Saving and applying presets	
Copying and synchronizing settings	
Synchronizing different process versions	
Legacy presets	270

Synchronize Process 2010 from a Process 2012 master	271
Synchronize Process 2012 from a Process 2010 master	
Working with Snapshots	272
DNG file format	274
The DNG solution	274
DNG compatibility	275
Saving images as DNG	276
Lossy DNG	276
DNG Converter	278
3 Sharpening and noise reduction	279
When to sharpen	
Why one-step sharpening is ineffective	280
Capture sharpening	
Capture sharpening for scanned images	
Process versions	
Improvements to Camera Raw sharpening	
Sample sharpening image	285
Detail panel	285
Sharpening defaults	
The sharpening effect sliders	
Amount slider	
Radius slider	
The suppression controls	
Detail slider	
Interpreting the grayscale previews	
Radius and Detail grayscale preview	
Masking slider	
Masking slider example	
Some real world sharpening examples	
Sharpening portrait images	
Sharpening landscape images	
Sharpening a fine-detailed image	
How to save sharpening settings as presets	
Capture sharpening roundup	
Selective sharpening in Camera Raw	
Negative sharpening	
Extending the sharpening limits	
How to apply localized sharpening	
Negative sharpening to blur an image	
Noise removal in Camera Raw Process Versions and noise reduction	
Detail panel Noise Reduction sliders	
Color noise	
Non-raw image noise reduction	
Color Smoothness slider	
Adding grain to improve appearance of sharpness	

Localized noise reduction in Camera Raw	
Localized moiré removal in Camera Raw	
Localized sharpening in Photoshop	
Smart Sharpen filter	318
Basic Smart Sharpen mode	318
Advanced Smart Sharpen mode	320
Removing Motion Blur	321
Shake Reduction filter	322
The Shake Reduction controls	323
Repeat filtering	324
Smart object support	
Blur direction tool	
How to get the best results	325
Creating a depth of field brush	
Pixels versus vectors	332
Photoshop as a vector program	
Image resolution terminology	
ppi: pixels per inch	
lpi: lines per inch	
dpi: dots per inch	
Desktop printer resolution	
Altering the image size	
Image interpolation	
Nearest Neighbor (hard edges)	
Bilinear	
Bicubic (smooth gradients)	
Bicubic Smoother (enlargement)	
Bicubic Shroother (enlargement)	
Bicubic Automatic	
Preserve Details (enlargement)	
Photoshop image adjustments	
The listogram	
The Histogram panel	
Basic Levels editing and the histogram	
Bit depth	
8-bit versus 16-bit image editing	
16-bit and color space selection	
Comparing 8-bit with 16-bit editing	
The RGB edit space and color gamut	
Direct image adjustments	
Adjustment layers approach	
Adjustments panel controls	
Properties panel controls	
Maintaining focus in the Properties panel	353

	Levels adjustments	354
	Analyzing the histogram	354
	Curves adjustment layers	356
	On-image Curves editing	
	Removing curve points	
	Using Curves in place of Levels	360
	Output levels adjustments	360
	Luminosity and Color blending modes	362
	Locking down portions of a curve	364
	Creating a dual contrast curve	365
	Correcting shadow and highlight detail	366
	Amount	
	Tonal Width	
	Radius	
	Color Correction	
	Midtone Contrast	
	Auto image adjustments	
	Match Color corrections	
	Enhanced Brightness and Contrast	
	Color corrections using Curves	271
	Hue/Saturation	
	Vibrance	
	Color Lookup adjustments	
	Color Lookup Table Export	
	Photo Filter	
	Multiple adjustment layers	
	Adjustment layer masks	
	Properties panel mask controls	. 386
	Editing a mask using the masks controls	
0	Live shape properties	390
Cro	pping	
	Entering measurement units	394
	Delete cropped pixels	395
	Crop ratio modes	395
	Landscape and portrait mode crops	396
	Crop tool presets	
	Crop overlay display	397
	Crop tool options	398
	Front Image cropping	398
	Disable edge snapping	398
	Selection-based cropping	
	Canvas size	
	Big data	402
	Perspective crop tool	403
	Content-aware scaling	404
	How to protect skin tones	406
	How to remove objects from a scene	407
	Image rotation	408

Converting color to black and white	410
Dumb black and white conversions	
Smarter black and white conversions	
Black & White adjustment presets	
Split color toning using Color Balance	
Split color toning using Curves adjustments	416
Split color toning using a Gradient Map	
Camera Raw black and white conversions	420
Pros and cons of the Camera Raw approach	420
HSL grayscale conversions	422
Camera Calibration panel tweaks	
Camera Raw Split Toning panel	
Saturation shortcut	
Camera Raw color image split toning	
Black and white output	
Advanced B&W Photo tips	427
6 Extending the dynamic range	429
High dynamic range imaging HDR essentials	
Alternative approaches	
Bracketed exposures	
Photomatix Pro	
Displaying deep-bit color	
Capturing a complete scenic tonal range	
HDR shooting tips	
HDR File formats	
How to fool Merge to HDR	
Basic tonal compression techniques	
Blending multiple exposures	
Camera Raw adjustments using Process 2012	
Processing HDR files in Camera Raw	
The Camera Raw options	
Merge to HDR Pro	
Response curve	
Tone mapping HDR images	
Local Adaptation	
Removing ghosts	
How to avoid the 'HDR' look	452
Smooth Edges option	454
HDR toning examples	454
How to smooth HDR toned images	
7 Image retouching	461
Basic cloning methods	462
Clone stamp tool.	

Clone stamp brush settings	462
Healing brush	
Choosing an appropriate alignment mode	466
Clone Source panel and clone overlays	
Clone and healing sample options	468
Better healing edges	469
Spot healing brush	
Healing blend modes	
Spot healing in Content-Aware mode	
Patch tool	
The patch tool and content-aware filling	476
Adaptation Structure control	
Content-aware move tool	
Content-aware move tool in Extend mode	481
Enhanced content-aware color adaptation	
Working with the Clone Source panel	486
Perspective retouching	488
Alternative history brush spotting technique	400
Portrait retouching	
Beauty retouching	101
Liquify	
Advanced Liquify tool controls	
Reconstructions	
Mask options	
View ontions	
View options	
Saving the mesh	500
Saving the meshPhotoshop CC Liquify performance	500 501
Saving the mesh	500 501 501
Saving the mesh	500 501 501 502
Saving the mesh	500 501 501 502
Saving the mesh	500 501 501 502
Saving the mesh	500 501 501 502 503
Saving the mesh	500 501 501 502 503 505
Saving the mesh Photoshop CC Liquify performance Smart Object support for Liquify On-screen cursor adjustments Targeted distortions using Liquify 8 Layers, Selections and Masking Selections and channels Selections	500 501 501 502 503 505 506
Saving the mesh Photoshop CC Liquify performance Smart Object support for Liquify On-screen cursor adjustments Targeted distortions using Liquify 8 Layers, Selections and Masking Selections and channels Selections Quick Mask mode	500 501 501 502 503 505 506 506 508
Saving the mesh Photoshop CC Liquify performance Smart Object support for Liquify On-screen cursor adjustments Targeted distortions using Liquify 8 Layers, Selections and Masking Selections and channels Selections Quick Mask mode Creating an image selection	500 501 501 502 503 505 506 506 508 509
Saving the mesh Photoshop CC Liquify performance Smart Object support for Liquify On-screen cursor adjustments Targeted distortions using Liquify 8 Layers, Selections and Masking Selections and channels. Selections Quick Mask mode Creating an image selection Modifying selections.	500 501 501 502 503 505 506 506 508 509
Saving the mesh Photoshop CC Liquify performance Smart Object support for Liquify On-screen cursor adjustments Targeted distortions using Liquify 8 Layers, Selections and Masking Selections and channels Selections Quick Mask mode Creating an image selection Modifying selections. Alpha channels	500 501 501 502 503 505 506 506 508 509
Saving the mesh Photoshop CC Liquify performance Smart Object support for Liquify On-screen cursor adjustments Targeted distortions using Liquify 8 Layers, Selections and Masking Selections and channels Selections Quick Mask mode Creating an image selection Modifying selections Alpha channels. Modifying an image selection	500 501 501 502 503 505 506 508 509 510 511
Saving the mesh Photoshop CC Liquify performance Smart Object support for Liquify On-screen cursor adjustments Targeted distortions using Liquify 8 Layers, Selections and Masking Selections and channels Selections Quick Mask mode Creating an image selection Modifying selections Alpha channels Modifying an image selection Selections, alpha channels and masks	500 501 501 502 503 505 506 508 509 510 511 513
Saving the mesh Photoshop CC Liquify performance Smart Object support for Liquify On-screen cursor adjustments Targeted distortions using Liquify 8 Layers, Selections and Masking Selections and channels Selections Quick Mask mode Creating an image selection Modifying selections Alpha channels Modifying an image selection Selections, alpha channels and masks Anti-aliasing	500 501 501 502 503 505 506 506 508 510 510 511 513 514
Saving the mesh Photoshop CC Liquify performance Smart Object support for Liquify On-screen cursor adjustments Targeted distortions using Liquify. 8 Layers, Selections and Masking Selections and channels Quick Mask mode Creating an image selection Modifying selections Alpha channels Modifying an image selection Selections, alpha channels and masks Anti-aliasing Feathering	500 501 501 502 503 505 506 506 508 510 511 513 514 514
Saving the mesh Photoshop CC Liquify performance Smart Object support for Liquify On-screen cursor adjustments Targeted distortions using Liquify 8 Layers, Selections and Masking Selections and channels. Selections Quick Mask mode Creating an image selection Modifying selections. Alpha channels. Modifying an image selection Selections, alpha channels and masks Anti-aliasing Feathering. Layers.	500 501 501 502 503 505 506 506 508 510 511 513 514 514
Saving the mesh Photoshop CC Liquify performance Smart Object support for Liquify On-screen cursor adjustments Targeted distortions using Liquify 8 Layers, Selections and Masking Selections and channels Selections Quick Mask mode Creating an image selection Modifying selections. Alpha channels. Modifying an image selection Selections, alpha channels and masks Anti-aliasing Feathering Layers Layer basics.	500 501 501 502 503 505 506 506 508 510 511 513 514 514 515
Saving the mesh Photoshop CC Liquify performance Smart Object support for Liquify On-screen cursor adjustments Targeted distortions using Liquify 8 Layers, Selections and Masking Selections and channels. Selections Quick Mask mode Creating an image selection Modifying selections. Alpha channels. Modifying an image selection Selections, alpha channels and masks Anti-aliasing Feathering Layers Layer basics. Image layers.	500 501 501 502 503 505 506 506 508 509 510 511 513 514 515 515
Saving the mesh Photoshop CC Liquify performance Smart Object support for Liquify On-screen cursor adjustments Targeted distortions using Liquify 8 Layers, Selections and Masking Selections and channels Selections Quick Mask mode Creating an image selection Modifying selections Alpha channels Modifying an image selection Selections, alpha channels and masks Anti-aliasing Feathering Layers Layer basics Image layers Vector layers	500 501 501 502 503 505 506 506 508 509 510 511 513 514 515 515 515
Saving the mesh Photoshop CC Liquify performance Smart Object support for Liquify On-screen cursor adjustments Targeted distortions using Liquify 8 Layers, Selections and Masking Selections and channels. Selections Quick Mask mode Creating an image selection Modifying selections. Alpha channels. Modifying an image selection Selections, alpha channels and masks Anti-aliasing Feathering Layers Layer basics. Image layers.	500 501 501 502 503 505 506 508 508 510 511 513 514 515 515 515 516

Layers panel controls	516
Layer styles	519
Adding layer masks	519
Viewing in Mask or Rubylith mode	520
Removing a layer mask	520
Adding an empty layer mask	
Thumbnail preview clipping	520
Properties Panel in Masks mode	
Refine Edge command	523
View modes	525
Edge detection	525
Smart Radius	526
Adjust Edge section	526
Refine Edge output	527
Working with the quick selection tool	
Combining a quick selection with Refine Edge	
Focus area	
Ragged borders with the Refine Edge adjustment	
Color Range masking	
Layer blending modes	
Creating panoramas with Photomerge	
Depth of field blending	
Working with multiple layers	
Color coding layers	
Layer group management	
Nested group layer compatibility	
Managing layers in a group	
Clipping masks	
Ways to create a clipping mask	
Masking layers within a group	
Clipping layers and adjustment layers	
Layer Comps panel	
Layer linking	
Selecting all layers	
Layer selection using the move tool	
Layer selection with the path selection tools	
Layer mask linking	
Layer locking	
Lock Transparent Pixels	
Lock Image Pixels	
Lock Layer Position	
Lock All	
Generator: generate assets from layers	
Extended tagging	
Summary of how Generator works	
Generator uses	
Smarter naming when merging layers	
Layer filtering	
Lajor mornig	

Isolation mode layer filtering	576
Transform commands	577
Repeat Transforms	579
Interpolation options	
Numeric Transforms	
Transforming paths and selections	
Transforms and alignment	
Warp transforms	
Perspective Warp	
Puppet Warp	
Pin rotation	
Pin depth	
Multiple pin selection	
Smart Objects	
Drag and drop a document to a layer	
Smart Objects	
Linked Smart Objects	
Creating linked Smart Objects	
Packaging linked embedded assets	
Resolving bad links	
Layers panel Smart Object searches	
Photoshop paths	
Pen path modes	
Drawing paths with the pen tool	
Pen path drawing example	
Pen tool shortcuts summary	
Rubber Band mode	
Multi selection path options	
Selecting path anchor points	
Vector masks	
Isolating an object from the background	613
9 Blur, optical and lighting effects filters	615
Filter essentials	
Blur filters	
Average Blur	
Gaussian Blur	
Adding a Radial Blur to a photo	
Surface Blur	
Box Blur	
Shape Blur	
Lens Blur	
Depth of field effects	
Blur Gallery filters	622
Iris Blur	622
Radius field controls	623
Blur Tools options	624
Tilt-Shift blur	

Blur ring adjustments	
Field Blur	
Spin blur	630
Path blur	633
Motion Blur Effects panel	635
Smart Object support	638
Blur Gallery filters on video layers	638
Smart objects and selections	638
Applying a Blur Gallery filter to a video clip	639
Blur Gallery filter with a smart object plus mask	640
Smart Filters	642
Applying Smart Filters to pixel layers	
Lens Corrections	
Custom lens corrections	
Selecting the most appropriate profiles	652
Adobe Lens Profile Creator	653
Interpolating between lens profiles	653
Lens Correction profiles and Auto-Align	653
Adaptive Wide Angle filter	
How the Adaptive Wide Angle filter works	
Applying constraints	
Rotating a constraint	
Saving constraints	
Constraint line colors	
Polygon constraints	
Calibrating with the Adaptive Wide Angle filter	
Editing panorama images	
Lighting Effects filter	
Properties panel adjustments	
Filter Gallery	
The curvey minimum and the curvey many many many many many many many man	
10 Print output	671
Print sharpening	. 672
Judge the print, not the display	
High Pass filter edge sharpening technique	
Soft proof before printing	
Managing print expectations	
Making a print	
Photoshop Print dialog	
Printer selection	
Color Management	
Rendering intent selection	. 684
Hard Proofing	
Position and Size	
Print selected area	
Ensuring your prints are centered (Mac)	
Printing Marks	
Functions	
i unitions	. 550

Saving operating system print presets	. 691 . 692 . 693
11 Automating Photoshop	695
Working with Actions	. 696
Playing an action	. 696
Recording actions	. 697
Troubleshooting actions	. 699
Limitations when recording actions	. 700
Actions only record changed settings	. 700
Background layers and bit depth	
Layer naming	. 701
Inserting menu items	
Batch processing actions	. 702
Exporting and importing presets	. 704
Creating a droplet	. 705
Conditional Actions	. 706
Conditional action droplets	. 707
Image Processor	
Scripting	.711
Script Events Manager	.711
Automated plug-ins	
Crop and Straighten Photos	.712
Fit Image	.712
Index	713
Remote profiling for RGB printers	.727
Rod Wynne-Powell	.728
SOLUTIONS Photographic	
Pixel Genius PhotoKit plug-in	729

Please read first

The recent introduction of the Adobe Creative Cloud has brought with it a number of changes to the way Photoshop and other programs within the Creative Cloud are delivered to Adobe customers. You can choose to subscribe to the Cloud either with a full Cloud subscription, which gives you access to all the programs in the Creative Suite, or as a single-product subscriber. For some, this 'rental' approach can be more cost effective, especially if you need to use more than one program from the suite. The main advantage is that Cloud subscribers are able to access new program features as interim program updates are released. And here is the rub for readers of Photoshop books: as soon as a new version of Photoshop is released there will be these interim updates where new features are added, making all the current books out of date.

This doesn't just affect print books, but associated ebooks as well. My response has been to provide bulletin updates of all the latest changes in Photoshop that are relevant to photographers and post these to the book website: www.photoshopforphotographers. com. You will notice that I have done this since the announcement of Photoshop CS6.1 and will continue to do so as new updates are released. This particular book is an updated edition of the original Adobe Photoshop CC for Photographers, which was first published in 2013. In this version I have updated all the pages where the user interface has changed and included all the latest Photoshop and Camera Raw features that have been added to the program since then.

In revising this book I have had to cut some of the content that was in the previous edition. The Configuring Photoshop and Image Management chapters have been removed and are now provided as PDF chapters on the www.photoshopforphotographers.com website. The main reason for this was to make way for new content. The content in these two chapters has mostly remained unchanged in the last few versions of the program, especially with Bridge. You will also find lots of other content available from the book website, and you can also be kept fully updated via my Facebook page: www. facebook.com/MartinEveningPhotoshopAndPhotography.

Macintosh and PC keys

Throughout this book I refer to the keyboard modifier keys used on the Macintosh and PC computers. Some keys are the same on both platforms, such as the Shift key. And also the all key (although Macintosh users may still refer to it as the 'Option key' []). Where the keys used are different on each system. I show the Macintosh keys first and the PC equivalents after. For example the shortcut for opening the Levels dialog is Command + L on the Mac and Control + L on the PC. I will write this in the book as: (Mac), ctrl (PC).

Introduction

When I first started using Photoshop, it was a much simpler program to get to grips with compared with what we see today. Since then Adobe Photoshop CC has evolved to give photographers all the tools they need. My aim is to provide you with a working photographer's perspective of what Photoshop CC can do and how to make the most effective use of the program.

One of the biggest problems writing a book about Photoshop is that while new features are always being added Adobe rarely removes anything from the program. Hence, Photoshop has got bigger and more complex over the 18 years or so I have been writing this series of books. When it has come to updating each edition this has left the question, "What should I add and what should I take out?" This edition is completely focused on the essential information you need to know when working with Photoshop, Camera Raw and Bridge. plus all that's new in Photoshop CC for photographers.

One of the reasons why this series of Photoshop books has become so successful is because I have come from a professional photography background. Although I have had the benefit of a close involvement with the people who make the Adobe Photoshop program, I make no grandiose claims to have written the best book ever on the subject. Like you, I too have had to learn all this stuff from scratch. I simply write from personal experience and aim to offer a detailed book on the subject of digital photography and Photoshop. It is not a complete guide to everything that's in Photoshop, but it is one of the most thorough and established books out there; one that's especially designed for photographers.

This title was initially aimed at intermediate to advanced users, but it soon became apparent that all sorts of people were enjoying the book. As a result of this, I have over the years adapted the content to satisfy the requirements of a broad readership. I still provide good, solid, professional-level advice, but at the same time I try not to assume too much prior knowledge, and make sure everything is explained as clearly and simply as possible. The techniques shown here are based on the knowledge I have gained from working alongside the Photoshop engineering team at various stages of the program's development as well as some of the greatest Photoshop experts in the industry - people such as Katrin Eismann, the

late Bruce Fraser, Mac Holbert, Ian Lyons, Andrew Rodney, Seth Resnick, Jeff Schewe and Rod Wynne-Powell, who I regard as true Photoshop masters. I have drawn on this information to provide you with the latest thinking on how to use Photoshop to its full advantage. So rather than me just tell you "this is what you should do, because that's the way I do it", you will find frequent references to how the program works and reasons why certain approaches or methods are better than others. These discussions are often accompanied by diagrams and step-by-step tutorials that will help improve your understanding of the Photoshop CC program. The techniques I describe here have therefore evolved over a long period of time and the methods taught in this book reflect the most current expert thinking about Photoshop. What you will read here is a condensed version of that accumulated knowledge. I recognize that readers don't want to become bogged down with too much technical jargon, so I have aimed to keep the explanations simple and relevant to the kind of work most photographers do.

We have recently seen some of the greatest changes ever in the history of photography, and for many photographers it has been a real challenge to keep up with all these latest developments. Photoshop has changed a lot over the years, as has digital camera technology. As a result of this, as each new version of Photoshop comes out I have often found it necessary to revise many of the techniques and workflow steps that are described here. This is in many ways a personal guide and one that highlights the areas of Photoshop that I find most interesting, or at least those which I feel should be of most interest. My philosophy is to find out which tools in Photoshop allow you to work as efficiently and as nondestructively as possible and preserve all of the information that was captured in the original, plus to take into account any recent changes in the program that require you to use Photoshop differently. Although there are lots of ways to approach using Photoshop, you'll generally find with Photoshop that the best tools for the job are often the simplest. I have therefore structured the chapters in the book so that they follow a typical Photoshop workflow. Hopefully, the key points you will learn from this book are that Camera Raw is the ideal, initial editing environment for all raw images (and sometimes non-raw images too). Then, once an image has been optimized in Camera Raw, you can use Photoshop to carry out the finetuned corrections, or more complex retouching.

The Ultimate Workshop

Adobe Photoshop CC for Photographers can be considered an 'essentials' guide to working with this latest version of Photoshop. But if you want to take your Photoshop skills to the next level I suggest you might like to take a look at Adobe Photoshop CS5 for Photographers:

The Ultimate Workshop. This is a book that I co-authored with Jeff Schewe. It mainly concentrates on various advanced Photoshop tricks and techniques and is like attending the ultimate training workshop on Photoshop.

What's different in this book

This version has been re-edited to put most of its emphasis on the Photoshop tools that are most essential to photographers as well as all that's new in Photoshop CC. There are a number of significant changes I would like to point out here. First, the book does not come with a DVD. All additional content is now available online via the www.photoshopforphotographers.com website. Go to the main page shown below in Figure 1 and click on the 'Access online content' button. Here, you will be able to access movie tutorials to accompany some of the techniques shown in the book and download many of the images to try out on your own.

Since the CS6 edition came out I have removed the Color Management and Web Output sections. The content in these had barely changed over the years. In order to make way for new content I decided it was time to remove these and provided them as PDFs on the book website. For example, there is a 32-page printable guide to all the keyboard shortcuts for Photoshop, Camera Raw and Bridge.

Figure 1 To access the online content, go to www.photoshopforphotographers.com and click on the 'Access online content' button, which will take you to the Adobe Photoshop for Photographers Help Guide page shown in Figure 2. There is no log-in required, though you will be given the opportunity to sign up for new updates about the book.

Lastly, there is a Tools & Panels section in the Help Guide (Figure 2) with illustrated descriptions of all the tools and panels found in Photoshop.

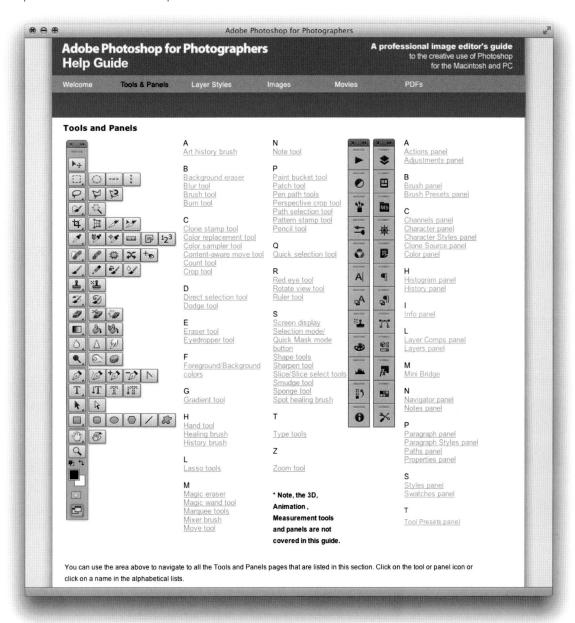

Figure 2 This shows the Tools and Panels section of the *Adobe Photoshop for Photographers Help Guide*, where you can access extra content such as movie tutorials, PDF documents and download some of the images used in this book.

Contacting the publisher/author

For problems to do with the book or to contact the publisher, please email: focalpressmarketing@ taylorandfrancis.com. If you would like to contact the author, please email: martin@martinevening.com.

To keep updated via Facebook, go to: www.facebook.com/
MartinEveningPhotoshopandphotography.

Acknowledgments

I must first thank Andrea Bruno of Adobe Europe for initially suggesting to me that I write a book about Photoshop aimed at photographers. Also, none of this would have got started without the founding work of Adam Woolfitt and Mike Lave who helped establish the Digital Imaging Group (DIG) forum for UK digital photographers. Thank you to everyone at Focal Press: Kimberly Duncan-Mooney, Kate lannotti and Lisa Jones. The production of this book was done with the help of Rod Wynne-Powell, who tech edited the final manuscript and provided me with technical advice, and Soo Hamilton, who did the proofreading. I must give a special mention to fellow Photoshop alpha tester Jeff Schewe for all his guidance and help over the years (and wife Becky), not to mention the other members of the 'pixel mafia': Katrin Eismann, Seth Resnick, Andrew Rodney, and Bruce Fraser, who sadly passed away in December of 2006.

Thank you also to the following clients, companies and individuals: Adobe Systems Inc., Peter Andreas, Amateur Photographer, Neil Barstow, Russell Brown, Steve Caplin. Jeff Chien, Kevin Connor, Harriet Cotterill, Eric Chan, Chris Cox, DPReview, Eylure, Claire Garner, Greg Gorman, Mark Hamburg, Peter Hince, Thomas Holm, Ed Horwich, David Howe, Bryan O'Neil Hughes, Carol Johnson, Julieanne Kost, Peter Krogh, Tai Luxon, Ian Lyons, John Nack, Thomas Knoll, Bob Marchant, Marc Pawliger, Pixl, Herb Paynter, Eric Richmond, Addy Roff, Gwyn Weisberg, Russell Williams, What Digital Camera and X-Rite. Thank you to the models, Courtney Hooper, Egle, Jasmin, Alex Kordek, Sabina and Sundal who featured in this book, plus my assistants Harry Dutton and Rob Cadman. Thank you to reader Richard Crack who provided some useful design tips for the book redesign. And thank you too to everyone who has bought my book. I am always happy to respond to readers' emails and hear comments good or bad (see sidebar).

Lastly, thanks to all my friends and family, my wife, Camilla, who has been so supportive over the last year, and especially my late mother for all her love and encouragement.

Martin Evening, June 2014

Chapter 1

Photoshop Fundamentals

Let's begin by looking at some of the essentials of working with Photoshop, such as how to install the program, the Photoshop interface, what all the different tools and panels do, as well as introducing the Camera Raw and Bridge programs. You can also use this chapter as a reference, as you work through the remainder of the book.

This latest version of Photoshop is the successor to Photoshop CS6 and is formally known as 'Photoshop CC', which requires taking out a subscription to the Creative Cloud. Since the first release of Photoshop CC, several updates have been released for Photoshop CC and Camera Raw. This edition of the book incorporates all the latest updates up until the 2014 release of Photoshop CC.

Adobe Photoshop activation limits

You can install Photoshop on any number of computers, but only a maximum of two installations can be active at any one time. To run Photoshop on more computers than this, you only need to sign out from your Creative Cloud account, rather than do a complete uninstall and reinstall.

Figure 1.1 This shows the Migrate
Settings dialog that allows you to import
custom preset settings created in older
versions of Photoshop. Note that the overall
sync settings behavior for Photoshop CC has
been revised, details of which can be found
in the Configuring Photoshop PDF on the
book website.

Photoshop installation

Installing Photoshop (Figure 1.2) is as easy as installing any other application on your computer, but do make sure any other Adobe programs or web browsers are closed prior to running the installation setup. You will be asked to enter your Adobe ID, or create a new Adobe ID account. This is something that has to be done in order to activate Photoshop and is to limit unauthorized distribution of the program. Basically, the standard license entitles you to run Photoshop on up to two computers, such as a desktop plus a laptop.

Figure 1.2 The Photoshop installer procedure is more or less identical on both Mac and PC systems. As you run through the installation process you will be asked to register the program by entering your Adobe ID or create a new Adobe ID account. If installing on a machine running an older version of Photoshop, you will also be asked if you wish to migrate saved user preset settings from the older program (see Figure 1.1).

The Photoshop interface

The Photoshop CC interface shares the same design features as all the other CC creative suite programs, which makes it easier to switch from working in one CC program to another. You can also work with the Photoshop program as a single application window on both the Mac and PC platforms (Figures 1.3 and 1.4). This arrangement is more in keeping with the interface conventions for Windows, plus you also have the ability to open and work with Photoshop image documents as tabbed windows. Note that since the Application bar was removed in CS6, the Workspace options can be accessed via the Options bar. Meanwhile, the document layout options are now solely available via the Window ➡ Arrange menu (circled).

Default workspace

The default workspace setting for PC and Macintosh uses the Application frame shown in Figures 1.3 and 1.4. If you go to the Window menu and deselect 'Application Frame', you can switch to the classic layout where the panels appear floating on the desktop.

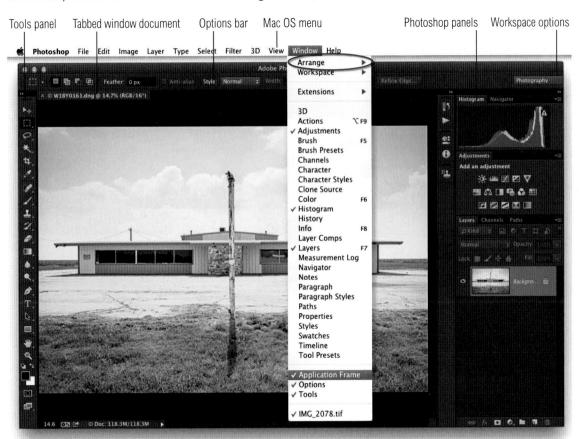

Figure 1.3 This shows the Photoshop CC Application Frame view for Mac OS X (also now known as simply 'osx'), using the default, dark UI settings. To switch between the classic mode and the Application Frame workspace, go to the Window menu and select or deselect the Application Frame menu item.

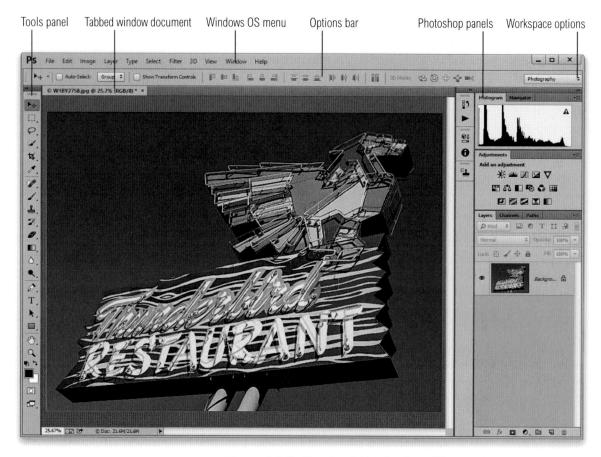

Figure 1.4 The Photoshop CC interface for the Windows OS. This has been captured using the middle light gray theme and the Photography workspace setting.

The Photoshop panels are held in placement zones with the Tools panel normally located on the left, the Options bar running across the top and the other panels arranged on the right, where they can be docked in various ways to economize on the amount of screen space that's used yet still remain easily accessible. This default arrangement presents the panels in a docked mode, but over the following few pages we shall look at ways you can customize the Photoshop interface layout. For example, you can reduce the amount of space that's taken up by the panels by collapsing them into compact panel icons (see Figures 1.28 and 1.29).

Creating a new document

To create a new document in Photoshop with a blank canvas, go to the File menu and choose New... This opens the dialog shown in Figure 1.5, where you can select a preset setting type from the Preset pop-up menu followed by a preset size option from the Size menu. When you choose a preset setting, the resolution adjusts automatically depending on whether it is a preset intended for print or one intended for computer screen type work (you can change the default resolution settings for print and screen in the Units & Rulers Photoshop preferences). Alternatively, you can manually enter dimensions and resolution for a new document in the fields below.

The Advanced section lets you do extra things like choose a specific profiled color space. After you have entered the custom settings in the New Document dialog these can be saved by clicking on the Save Preset... button. In the New Document Preset dialog shown below, you will notice that there are also some options that will allow you to select which attributes are to be included in a saved preset.

Note that if you make a selection, such as Select All and follow this with Edit Copy, when you choose New Document it will do so using the same pixel dimensions as the selection. This also retains the same color space.

Custom settings

In the New Document dialog you can set a custom color as the background color. It includes a color swatch and Other... option, allowing you to choose a color via the Color Picker. The Advanced section also allows you to select a color profile and pixel aspect ratio (see Figure 1.5).

Pixel Aspect Ratio

The Pixel Aspect Ratio is to aid multimedia designers who work with stretched screen video formats. If a 'non-square' pixel setting is selected, Photoshop creates a scaled document which previews how a normal 'square' pixel Photoshop document will display on a stretched wide screen. The title bar adds [scaled] to the end of the file name to remind you are working in this special preview mode. The scaled preview can be switched on or off by selecting the Pixel Aspect Correction item from the View menu.

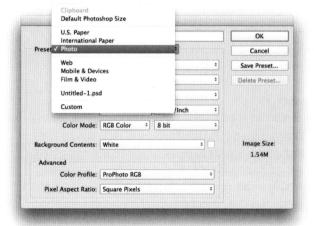

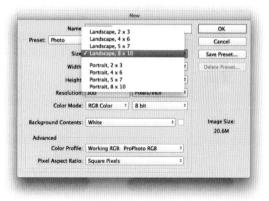

Figure 1.5 When you choose File ⇒ New, this opens the New document dialog shown here (top left). Initially, you can go to the Preset menu and choose a preset setting such as: Photo, Web or Film & Video. Depending on the choice you make here, this will affect the size options that are available in the Size menu (shown top right). If you use the New document dialog to configure a custom setting, you can click on the Save Preset… button to save this as a new Document preset (right). When you do this the new document preset will appear listed in the main preset menu (top left).

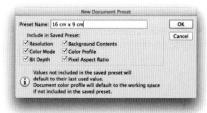

Figure 1.6 This shows an example of how the Photoshop panels look when the default UI setting is selected.

Figure 1.7 This shows an image that was curves adjusted while viewed against a black canvas color.

User interface brightness

Photoshop CS6 saw the introduction of a new interface design, which offered newly-designed panels and icons and also four color themes with different levels of brightness. You can adjust the program's appearance via the Interface preferences shown in Figure 1.8.

Having the ability to adjust the brightness of the interface has to be a good thing. But, having said that, you do need to decide carefully which setting is right for the kind of work you do. By default, Photoshop uses a dark color theme and Figure 1.6 shows an example of how the Layers and Histogram Photoshop panels look when this is selected. Now, dark themes can look quite nice when they are implemented well. For example, in my view the Lightroom interface is a good example of user interface design. But the thing to be aware of here is that the dark default setting in Photoshop isn't particularly easy to read, especially if you are working on a large display where the panel lettering can appear quite small (more of which later). More importantly, the default canvas color is linked to the interface brightness setting. In the case of the dark default, it's almost completely black and this can certainly lead to problems when editing photographic images because how we perceive tone and color is very much dependent on what surrounds the image.

To show you what I mean, take a look at the photograph in Figure 1.7. Do you think it looks OK? Now compare this with the Figure 1.10 version on page 9. Does it still look the same when viewed against white? Actually, I adjusted these two versions of the photograph separately using a Curves adjustment to obtain what I thought looked like the best-looking result, first against the black background and then against white. You can see a comparison of these two versions, both displayed against a neutral gray background (Figure 1.11). This highlights the fact that the canvas color can greatly affect the edit decisions we make.

What you have to understand here is that Photoshop is a program that's used by a wide variety of customers. For example, those who work with video will probably find a dark interface works well for them. This is because the work they produce is intended to be viewed in dark surroundings. Photographers on the other hand will primarily be interested in the way their photographs will look when printed, which is most likely to be against a paper white background.

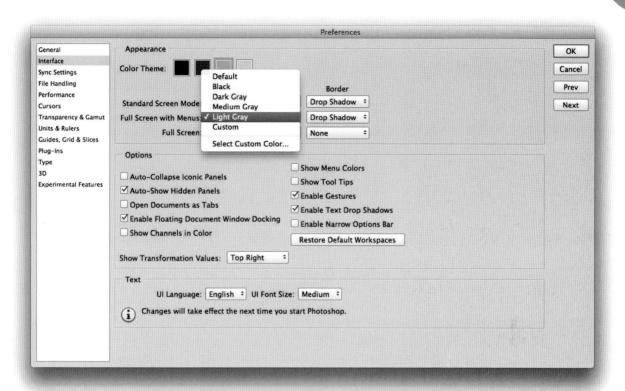

Figure 1.8 This shows the Photoshop Interface preferences, where you will want to edit the canvas color and set this to 'Light Gray'.

Regardless of whichever interface theme you think looks nicest, I strongly recommend you customize the Photoshop canvas color to make it suitable for photo editing work. To do this, choose Photoshop ⇒ Preferences ⇒ Interface... (Mac), or Edit ⇒ Preferences ⇒ Interface... (PC). This opens the dialog shown in Figure 1.8, where, if you go to the Standard Screen, Full Screen with Menus and Full Screen options you can click on the pop-up menu and choose an appropriate canvas color. If you would like to match the previous Photoshop canvas color, I suggest you choose the Light Gray option. Do this for each menu and click OK.

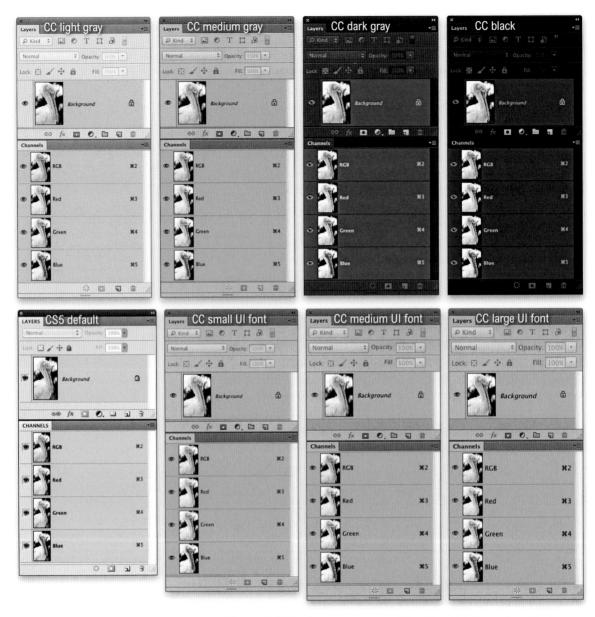

Figure 1.9 This shows a comparison of the different interface options. The top row shows examples of the four main brightness themes in Photoshop CS6 and CC ranging from the lightest to the darkest. In the bottom row, the bottom left example shows how these same panels looked when viewed in Photoshop CS5. Next to this I selected the second darkest theme from the top row and captured this using the default small UI font size, next to it the medium UI font size and lastly, the large UI font size.

The other thing to consider is the legibility of the interface. Figure 1.9 shows a quick comparison of the different interface brightness settings. If you compare the CS6/CC panel design with that used in CS5, you'll notice that the separation between the panels is less distinct and the panel lettering doesn't stand out so well. This isn't helped by the 'dark wash' effect as you select darker themes. It seems to me that the lack of tone contrast in the overall interface tends to make the panels blend together. However, there are things you can do to further tweak the interface. If you refer back to Figure 1.8 there is an option marked 'Enable Text Drop Shadows'. This allows you to add a drop shadow edge to the lettering (actually it's a white edge). With the two dark themes it's really effective at making the lettering stand out more, but with the two lighter themes it can make the lettering harder to read. Another thing you can do is to adjust the UI font size (see Figure 1.8), although any changes you make here won't take place until you relaunch Photoshop. As you can see in Figure 1.9, increasing the font size marginally increases the overall size of the panels, but certainly makes the lettering stand out more clearly. Throughout this book I mainly captured the screen shots using the medium light gray theme with a medium UI font size and the Enable Text Drop Shadows disabled. I chose this combination to ensure the screen shots remained legible. I know from experience that dark UI screen shots can be notoriously difficult to reproduce well in print.

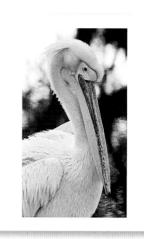

Figure 1.10 This shows the same image as in Figure 1.7, but curves adjusted while viewed against a white canvas.

Figure 1.11 Here, you see how the image views shown in Figure 1.7 and 1.10 looked when compared alongside each other using the 'Light Gray' canvas color. The white background edited version is on the left and the black background edited version is on the right. Do they still look the same to you? As you can see, although these image views each looked fine when viewed against a black or white background, when you compare them side by side, you can see that the canvas color choice has quite an impact on how the image is perceived when making those all-important tone adjustments.

OpenGL display performance

If the video card in your computer has OpenGL and you have 'Enable OpenGL Drawing' selected in the Photoshop Performance preferences, you can take advantage of the OpenGL features that are supported in Photoshop. For example, when OpenGL is enabled you will see smoother-looking images at all zoom display levels, plus you can temporarily zoom back out to fit to screen using the Bird's-eye view (page 58), or use the Rotate view tool to rotate the on-screen image display (see page 60).

Dual display setup

Those users who are working with a dual display setup will notice that new documents are opened on whichever display the current target document is on.

Reveal in Finder

Mac OS X users will also see a 'Reveal in Finder' option in the document tab contextual menu for pre-existing (saved) images (see Figure 1.14).

Tabbed document windows

Let's now look at the way document windows can be managed in Photoshop. The default preference setting forces all new documents to open as tabbed windows, where new image document windows appear nested in the tabbed document zone, just below the Options bar. In Figure 1.12 I have highlighted the tabbed document zone in yellow, where I had four image documents open. This approach to managing image documents can make it easier to locate a specific image when you have several image documents open at once. To select an open image, you simply click on the relevant tab to make it come to the front. When documents aren't tabbed in this way, you'll often have to click and drag on the document title bars to move the various image windows out of the way until you have located the image document you were after.

Of course, not everyone likes the idea of tabbed document opening and if you find this annoying you can always deselect the 'Open Documents as Tabs' option in the Interface preferences (circled in Figure 1.13). This allows you to revert to the old behavior where new documents are opened as floating windows. On the other hand you can have the best of both worlds by clicking on a tab and dragging it out from the docked zone. This action lets you easily convert a tabbed document to a floating window (as shown in Figure 1.14). Alternatively, you can right mouse-click on a tab to access the contextual menu from where you can choose from various window command options such as 'Move to a New Window', or 'Consolidate All to Here'. The latter gathers all floating windows and converts them into tabbed documents. You can also use the N-up display options (see Figure 1.16) to manage the document windows.

With Mac OS X, you can mix having tabbed document windows with a classic panel layout. If you disable the Application Frame mode (Figure 1.3) and use the Open Documents as Tabs preference or the 'Consolidate All to Here' contextual menu command, you can still have the open windows arranged as tabbed documents.

Figure 1.12 The default Photoshop behavior is for image documents to open as tabbed windows (highlighted here in yellow), docked to the area just below the Options bar. Click on a tab to make a window active and click on the 'X' to close a document window.

Figure 1.13 The Photoshop Interface preferences.

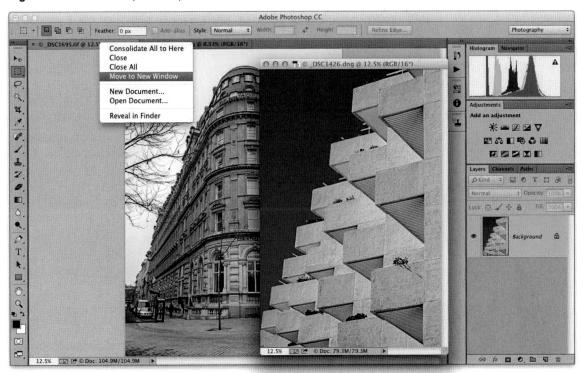

Figure 1.14 This screen shot shows the two ways you can convert a tabbed document to a floating window, either by dragging a tab out from the tabbed windows zone, or by using the contextual menu.

Switching between windows

The # (Mac), etr) (PC) shortcut can be used to toggle between open window documents and use # Shift (Mac), etr/ Shift (PC) to reverse the order.

Dragging layers between tabs

To drag layers between tabbed documents you need to use the move tool and drag from the document to the target tab. Wait a few seconds and then (very importantly) you have to drag down from the tab to the actual image area to complete the move.

Managing document windows

Documents can also be tabbed into grouped document windows by dragging one window document across to another (see Figure 1.15). You can also manage the way multiple document windows are displayed on the screen. For example, multiple window views are useful if you wish to compare different soft proof views before making a print (see Chapter 10 for more about soft proofing in Photoshop). With floating windows you can Choose Window

⇒ Arrange

⇒ Cascade to have all the document windows cascade down from the upper left corner of the screen, or choose Window ⇒ Arrange ⇒ Tile to have them appear tiled edge to edge. With document windows (tabbed or otherwise) you can use the Document Layout menu to choose any of the 'N-up' options that are shown in Figure 1.16. This document layout method offers a much greater degree of control and lets you choose from one of the many different layout options shown here.

Figure 1.15 Floating windows can be grouped as tabbed document windows by dragging the title bar of a document across to another until you see a blue border (as shown above). You can also click on the title bar (circled in red) to drag a group of tabbed document windows to the tabbed windows zone.

Figure 1.16 This shows the 'N-up' display options for tabbed document windows.

Synchronized scroll and zoom

In the Window \Rightarrow Arrange submenu (Figure 1.16), there are menu controls that allow you to match the zoom, location (and rotation) for all document windows, based on the current foreground image window. The Match Zoom command matches the zoom percentage based on the current selected image, while the Match Location command matches the scroll position. You can also synchronize the scrolling or magnification by depressing the *Shift* key as you scroll or zoom in and out of any window view.

It is also possible to create a second window view of the image you are working on, where the open image is duplicated in a second window. For example, you can have one window with an image at a Fit to Screen view and the other zoomed in on a specific area. Any changes you make to the image can be viewed simultaneously in both windows (see Figure 1.17).

Figure 1.17 To open a second window view of a Photoshop document, choose Window ⇒ Arrange ⇒ New Window for (document name). Any edits that are applied to one document window are automatically updated in the second window preview.

Image document window details

The boxes in the bottom left corner of the image window display extra information about the image (see Figure 1.18). The left-most box displays the current zoom scale percentage for the document view. Here, you can type in a new percentage for any value you like from 0.2% to 1600% up to two decimal places and set this as the new viewing resolution. The Zoom status box also has a scrubby slider option. If you hold down the <code>#</code> (Mac), <code>cirl</code> (PC) key as you click inside the Zoom status box you can dynamically zoom in and out as you drag left or right, and at double the speed with the <code>Shift</code> key held down as well. The zoom tool Options bar also offers a scrubby zoom option, which I describe later on page 57. In the middle is a Work Group Server button that can be used to check in or check out a document that is being shared over a WebDAV server.

Figure 1.18 The document status is shown in the bottom left corner of the document window. **#** (Mac), *ctrl* (PC)-clicking inside the Zoom status box allows you to access the scrubby slider feature.

To the right of this is the status information box, which can be used to display information about the image. If you mouse down on the arrow to the right of this box, you will see a list of all the items you can choose to display here (see Figure 1.19).

If you mouse down in the status information box, this displays the width and height dimensions of the image along with the number of channels and image resolution. If you hold down the (Mac), (CII) (PC) key as you mouse down on the status information box, this will show the image tiling information.

(Mac only)

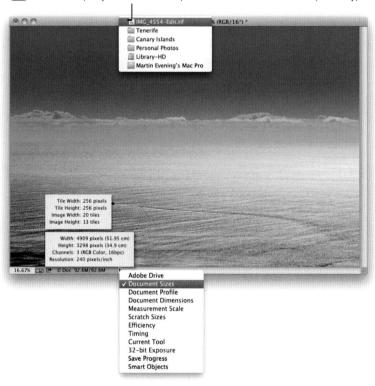

Figure 1.19 This shows the window layout of a Photoshop document as it appears on the Macintosh. If you mouse down in the status information box, this displays the file size and resolution information. If you hold down (#) (Mac), ctrl (PC) key as you mouse down in the status information box, this displays the image tiling information. Lastly, if you mouse down on the arrow icon next to the status information box, you can select the type of information you wish to see displayed there (the Status items are described on the right).

Adobe Drive (formerly Version Cue)

Current Adobe Drive status.

Document Sizes

The first figure represents the file size of a flattened version of the image. The second shows the size if saved including all layers.

Document Profile

The color profile assigned to the document.

Document Dimensions

This displays the physical image dimensions, as would be shown in the Image Size dialog box.

Measurement Scale

Shows measurement scale units.

Scratch Sizes

First figure shows amount of RAM memory used. Second figure shows total RAM memory available to Photoshop after taking into account the system and application overhead.

Efficiency

This summarizes how efficiently Photoshop is working. Basically it provides a simplified report on the amount of scratch disk usage.

Timing

Displays the time taken to accomplish a Photoshop step or the accumulated timing of a series of steps. Every time you change tools or execute a new operation, the timer resets itself.

Current Tool

This displays the name of the tool you currently have selected. This is a useful aide-mémoire for users who like to work with most of the panels hidden.

32-bit Exposure

This Exposure slider control is only available when viewing 32-bit mode images.

Save Progress

Shows the current background save status.

Smart Objects

Shows the current Smart Objects status.

Mac proxy shortcuts

You can also create a duplicate elsewhere by alt -clicking and dragging the proxy from a Finder window to another location. Also just clicking and dragging elsewhere you can create an alias for the file somewhere else. This is very handy when something comes in via Mail, you open the file then decide you need it in a specific place, it can be dealt with straight away.

Up to ten color samplers

You can now have up to ten color samplers in the Info panel, instead of just four. You can change the color mode of each of these by clicking on the eyedropper icon next to each. Also, if you hold down the all key as you do so, you can change the color mode for all the color sample readouts.

Title bar proxy icons (Mac only)

Macintosh users will see a proxy image icon in the title bar of any floating windows. The proxy icon appears dimmed when the document is in an unsaved state and is reliant on there being a preview icon saved with the image. For example, many JPEGs will not have an icon until they have been resaved as something else. If you hold down the key and mouse down on the proxy icon in the title bar you will see a directory path list like the one shown in Figure 1.19. You can then use this to navigate and select a folder location from the directory path and open it in the Finder.

Info panel status information

The status information box can only show a single item at a time. However, if you open the Info panel options shown below in Figure 1.20, you can check any or all of the Status Information items shown here so that the items that are ticked appear in the middle section of the Info panel. In addition to this, you can choose to enable 'Show Tool Hints'. These appear at the bottom of the Info panel and will change according to any modifier keys you have held down at the time, to indicate any extra available options.

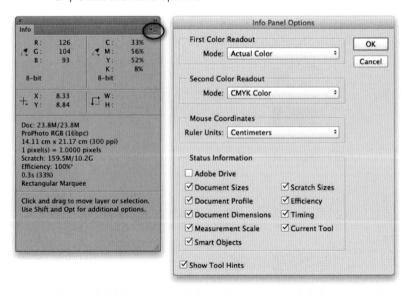

Figure 1.20 If you go to the Info panel options menu (circled) and choose Panel Options... this opens the Info Panel Options dialog. Here, you can choose which Status items you would like to see displayed in the Status Information section of the Info panel. The above Info panel screen shot shows all the Status Information items along with the 'Show Tool Hints' info display.

Rulers, Guides & Grid

Guides can be added at any time to an image document and flexibly positioned anywhere in the image area (see Figure 1.22). To add a new guide, the rulers will need to be displayed and you just need to mouse down on the ruler bar and drag a new guide out and then release the mouse to drop the guide in place. Once positioned, guides can be used for the precise positioning and alignment of image elements. If you are not happy with the placement of a guide, you can select the move tool and drag the guide to the exact required position. But once positioned, it is sometimes a good idea to lock all guides (View ⇒ Lock Guides) to avoid accidentally moving them again. You can also place a guide using View ⇒ New Guide... and in the New Guide dialog (Figure 1.21) enter an exact position for either the horizontal or vertical axis. The Grid (which is shown on the next page in Figure 1.23) provides a means for aligning image elements to a horizontal and vertical axis (to alter the grid spacing, open the Photoshop preferences and select Guides & Grid). If the ruler units need altering, just right mouse-click on one of the rulers and select a new unit of measurement. If the rulers are visible but the guides are hidden, dragging out a new guide will make all the other hidden quides reappear again.

View menu options

Figure 1.21 The New Guide dialog.

Figure 1.22 This shows an image displaying the rulers and guides. To place a new guide first choose View ⇒ Rulers. You can then drag from either the horizontal or vertical ruler to place a new guide. If you hold down the Shift key as you drag, this makes the guide snap to a ruler tick mark (providing View ⇒ Snap is checked). If you hold down the all key as you drag this allows you to switch dragging a horizontal guide to dragging it as a vertical (and vice versa). Lastly, you can use **H** (Mac), ctr/ H (PC) to toggle hiding/showing all extras items, like Guides (assuming you haven't assigned this shortcut to Hide Photoshop [see Figure 1.43]).

Figure 1.23 The Grid view can be enabled by choosing View ⇒ Show ⇒ Grid. When the Grid view is switched on it can be used to help align objects to the horizontal and vertical axis.

'Snap to' override

If you are placing a Guide close to an edge and the 'Snap to' function proves to be a problem, temporarily hold down the ctrl key (Mac), right mouse (PC). This will allow a Guide to be placed close to an edge, but not snap to it.

Figure 1.24 The Pixel Grid view can be enabled by going to the View ⇒ Show menu and selecting 'Pixel Grid'. When checked, Photoshop displays the pixels in a grid whenever an image is inspected at a 500% magnification or greater.

'Snap to' behavior

The Snap option in the View menu allows you to toggle the 'snap to' behavior for the Guides, Grid, Slices, Document bounds and Layer bounds. The shortcut for toggling the 'snap to' behavior is # Shift; (Mac), ctrl Shift; (PC). When the 'snap to' behavior is active and you reposition an image, type or shape layer, or use a crop or marquee selection tool, these will snap to one or more of the above. It is also the case that when 'snap to' is active, and new guides are added with the Shift key held down, a guide will snap to the nearest tick mark on the ruler, or if the Grid is active, to the closest grid line. Objects on layers will snap to position when placed within close proximity of a guide edge. The reverse is also true: when dragging a guide, it will snap to the edge of an object on a layer at the point where the opacity is greater than 50%. Also note that when Smart Guides are switched on in the View ⇒ Show menu, these can help you align layers as you drag them with the move tool.

Pixel Grid view

The Pixel Grid view described in Figure 1.24 can only be seen if you have OpenGL enabled and the Pixel Grid option selected in the View menu. It is useful when editing things like screen shots and can, for example, aid the precise placement of the crop tool.

The Photoshop panels

The default workspace layout settings place the panels in a docked layout where they are grouped into column zone areas on the right. However, the panels can also be placed anywhere on the desktop and repositioned by mousing down on the panel title bar (or panel icon) and dragging them to a new location. A double-click on the panel tab (circled red in Figure 1.25) compacts the panel upwards and double-clicking on the panel tab area unfurls the panel again. A double-click on the panel header bar (circled blue in Figure 1.25) collapses the panel into the compact icon view mode and double-clicking on the same panel header expands the panel again. Some panels, such as the Layers panel, can be resized horizontally and vertically by dragging the bottom right corner tab, or by hovering the cursor over the left, right or bottom edge and dragging. Others, such as the Info panel, are of a fixed height, where you can only adjust the width of the panel by dragging the side edges or the corner tab.

Panels can be organized into groups by mousing down on a panel tab and dragging it across to another panel (see Figure 1.26). When panels are grouped in this way they'll look a bit like folders in a filing cabinet. Just click on a tab to bring that panel to the front of the group and to separate a panel from a group, mouse down on the panel tab and drag it outside the panel group again.

Figure 1.25 Photoshop panels can be collapsed with a double-click in the panel tab area (circled in red), while a double-click on the panel header (circled in blue) shrinks the panel to the compact panel size shown here. Or even smaller, if you drag the panel sides inward.

Figure 1.26 To group panels together, mouse down anywhere on the panel header and with the mouse held down, drag the tab across to another panel, or group of panels (a blue surround appears when you are within the dropping zone) and release the mouse once it is inside the other panels. To remove a panel from a group, mouse down on the panel tab and drag it outside the panel group.

Figure 1.27 As you reposition a panel and prepare to dock it inside or to the edges of the other panels, a thick blue line indicates that, when you release the mouse, this is where the panel will attach itself.

Figure 1.28 When panels are docked you can adjust the width of the panels by dragging anywhere along the side edge of the panels.

Panel arrangements and docking

The default 'Essentials' workspace arranges the panels using the panel layout shown in Figure 1.3 (shown at the beginning of this chapter), but there are quite a few other different workspace settings you can choose from. It is also easy to create custom workspace settings by arranging the panels to suit your own preferred way of working and save these as a new setting. Panels can be docked together by dragging a panel to the bottom or side edge of another panel. In Figure 1.27 you can see how a thick blue line appears as a panel is made to hover close to the edge of another panel. Release the mouse at this point and the panel will become docked to the side or to the bottom of the other panels.

When panels are compacted (as shown in the bottom example in Figure 1.25), you can drag on either side of the panel to adjust the panel's width. At the most compact size, only the panel's icon is displayed, but as you increase the width of a panel (or column of panels), the panel contents expand and you'll get to see the names of the panels appear alongside their icons (see Figure 1.28).

Just remember if you can't find a particular panel, then it may well be hidden. If this happens, go to the Window menu, select the panel name from the menu and it will reappear again on the screen. It is worth remembering that the Tab key shortcut (also indicated as N on some keyboards) can be used to toggle hiding and showing all the panels, while Tab Shift toggles hiding/showing all the currently visible panels except for the Tools panel and Options bar. These are useful shortcuts to bear in mind. So, if you are working in Photoshop and all your panels seem to have disappeared, just try pressing Tab and they'll be made visible again.

In the Figure 1.29 example, the tabbed image document fills the horizontal space between the Tools panel on the left and the three panel columns on the right. I have also shown here how you can mouse down on the column edge to adjust the column width (see the double arrow icon that's circled in red). Photoshop panels can be grouped into as many columns as you like within the application window, or positioned separately outside the application window, such as on a separate display (see 'Working with a dual display setup' on page 26).

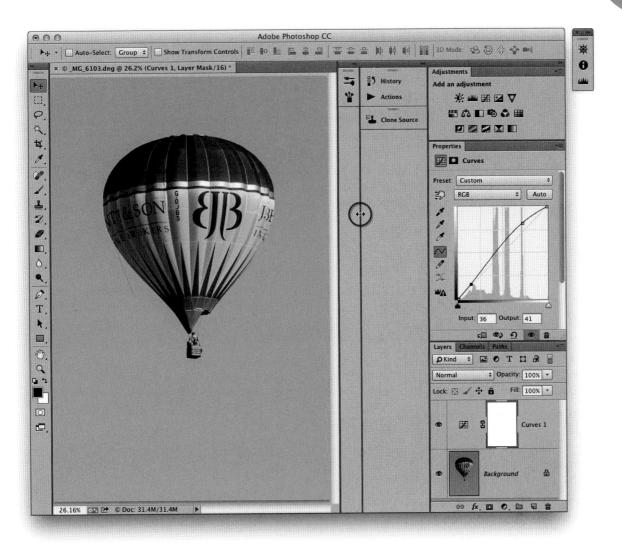

Figure 1.29 This shows a multi-column workspace layout with some of the panels grouped in a docked, compact icon layout, outside the main application window.

Panel positions remembered in workspaces

Photoshop is able to remember panel positions after switching workspaces. When you select a workspace and modify the layout of the panels, the new layout position is remembered when you next choose to use that particular workspace.

CITY OF GLASGOW COLLEGE
North Hanover Street Library
60 North Hanover Street
Glasgow G1 2BP
0141 566 4132

Closing panels

To close a panel, click on the close button in the top left corner (or choose 'Close' from the panel options fly-out menu).

Help menu searches

Here is an interesting tip for Mac users who are running Mac OS X. If you go to the Photoshop Help menu and start typing the first few letters for a particular menu command, the Help menu lists all the available menu options. Now roll the mouse over a search result: Photoshop locates the menu item for you and points to it with an arrow.

Figure 1.30 This shows a custom menu setting in use that color codes in blue some of the menu items that are new to this version of Photoshop.

Customizing the menu options

As the number of features in Photoshop has grown over the years, the menu choices have become quite overwhelming and this is especially true if you are new to Photoshop. However, if you go to the Edit menu and choose Menus.... this opens the Keyboard Shortcuts and Menus dialog shown in Figure 1.31, where you can customize the menu options and decide which menu items should remain visible. This Customize menu feature is like a 'make simpler' command. You can hide those menu options you never use and apply color codings to the menu items you do use most (so they appear more prominent). The philosophy behind this feature is: 'everything you do want with nothing you don't'. For example, in Figure 1.30 I applied a custom menu setting in which some new Photoshop CC menu items were color coded blue. You can easily create your own menu settings, but note that if you set up the Menu options so that specific items are hidden from view, a 'Show All Menu Items' command will appear at the bottom of the menu list. You can select this menu item to restore the menu so that it shows the full list of menu options again.

Figure 1.31 The Keyboard Shortcuts and Menus dialog.

Customizing the keyboard shortcuts

While you are in the Keyboard Shortcuts and Menus dialog, you can click on the Keyboard Shortcuts tab to reveal the keyboard shortcut options shown below in Figure 1.32 (or you can go to the Edit menu and choose Keyboard Shortcuts...). In this dialog you first select which kinds of shortcuts you want to create, i.e. Application Menus, Panel Menus or Tools. You can then navigate the menu list, click in the Shortcut column next to a particular menu item and hold down the combination of keys you wish to assign as a shortcut for that particular tool or menu item. Now the thing to be aware of here is that Photoshop has already used up nearly every key combination there is, so you are likely to be faced with the choice of reassigning an existing shortcut, or using multiple modifier keys such as: ***Shift** (Mac), or **otrological Shift** (PC) plus a letter or Function key, when creating new shortcuts.

Creating workspace shortcuts

If you scroll down to the Window section in the Keyboard Shortcuts for Application Menus, you will see a list of all the currently saved Workspace presets. You can then assign keyboard shortcuts for your favorite workspaces. This will allow you to jump quickly from one workspace setting to another by using an assigned keyboard shortcut.

Figure 1.32 The Keyboard Shortcuts and Menus dialog showing the keyboard shortcut options for the Photoshop Application Menus commands.

Task-based workspaces

You can use workspaces to access alternative panel layouts, tailored for different types of Photoshop work, such as the Photography workspace example shown in Figure 1.35. You can also save a current panel arrangement as a new custom workspace via the Options bar Workspace list menu or by going to the Window menu and choosing Workspace ⇒ New Workspace... This opens the dialog box shown in Figure 1.34, which asks you to select the items you would like to have included as part of the workspace (the workspace settings can also include specific keyboard shortcuts and menu settings). The saved workspace will then appear added to the Options bar Workspace list (see Figure 1.33). Here, you will also be

Figure 1.33 The Workspace list settings can be accessed via the Application bar menu (shown here), or via the Window ⇒ Workspace submenu. Workspace settings are automatically updated as you modify them. However, to reset a workspace back to the default setting, you can do so via the Workspace list menu (circled above).

able to choose 'Reset Workspace', to restore the workspace settings (this can be particularly useful after altering the computer screen resolution).

Another improvement has been to force all workspace settings to include panel locations and have them update as you modify the layout you are working in. This means if you select a workspace and fine-tune the panel layout or other settings, these tweaks are updated automatically. When you switch to another workspace and back to the original, the updated settings are remembered (although you do have the option of reverting to the original saved setting). As you can see in Figure 1.34, saving keyboard shortcuts and menus is optional and the way things stand now, if you choose not to include these settings as part of the workspace, the menu and keyboard shortcuts used in the last selected workspace remain sticky. Let's say you save a custom workspace that excludes saving menus and shortcuts. If you switch to a workspace setting that makes use of specific menus or keyboard shortcuts and switch back again you can add these menu and shortcuts settings to the current workspace setting (until you reset).

Figure 1.34 The Save Workspace menu can be used to save custom panel workspace setups. These can be recalled by revisiting the menu and highlighting the workspace name. To remove a workspace, choose Delete Workspace... from the menu.

Saved workspaces location

Custom and modified workspaces are saved to the following locations:
User folder/Library/Preferences/Adobe
Photoshop CC 2014 Settings/ (Mac),
userfolder/AppData\Roaming\Adobe\Adobe
Photoshop CC 2014 Settings\ (Windows).

Figure 1.35 Here is an example of the Photography workspace in use.

Working with a dual display setup

If you have a second computer display, you can arrange things so that all panels are placed on the second display, leaving the main screen clear to display the image document you are working on. Figure 1.36 shows a screen shot of a Dual display panel layout workspace that I use with my computer setup. In this example I have ensured that only the panels I use regularly are visible. The important thing to remember here is to save a custom panel layout like this as a workspace setting so that you can easily revert to it when switching between other workspace settings.

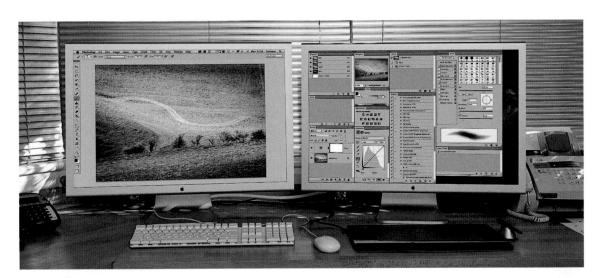

Figure 1.36 This shows an example of how you might like to arrange the Photoshop panels on a second display, positioned alongside the primary display.

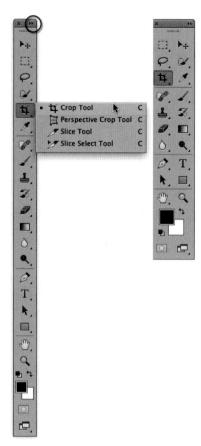

Figure 1.37 On the left you can see the default single column panel view. However, you can click on the double arrow (circled) to toggle between this and the double column view shown on the right. Where tools are marked with a triangle in the bottom right corner, you can mouse down on the tool to see the other tools that are nested in that particular group.

Photoshop CC Tools panel

The Tools panel, shown in Figure 1.38, contains 65 separate tools. Clicking any tool automatically displays the tool Options bar (if it is currently hidden) from where you can manage the individual tool settings (see page 30). Many of the tools in the Tools panel have a triangle in the bottom right corner of the tool icon, indicating there are extra tools nested in this tool group. You can mouse down on a featured tool, select any of the other tools in this list and make that the selected tool for the group (see Figure 1.37).

You will notice that most of the tools (or sets of tools) have single-letter keystrokes associated with them. These are displayed whenever you mouse down to reveal the nested tools or hover with the cursor to reveal the tool tip info (providing the 'Show Tool Tips' option is switched on in the Photoshop Interface preferences). You can therefore use these key shortcuts to quickly select a tool without having to go via the Tools panel. For example, pressing on the keyboard selects the move tool and pressing will select one of the healing brush group of tools (whichever is currently selected in the Tools panel). Photoshop also features spring-loaded tool selection behavior. If instead of clicking, you hold down the key and keep it held down, you can temporarily switch to using the tool that's associated with that particular keystroke. Release the key and Photoshop reverts to working with the previously selected tool again.

Where more than one tool shares the same keyboard shortcut, you can cycle through the other tools by holding down the *shift* key as you press the keyboard shortcut. If on the other hand you prefer to restore the old behavior whereby repeated pressing of the key would cycle through the tool selection options, go to the Photoshop menu, select Preferences \Rightarrow General and deselect the 'Use Shift Key for Tool Switch' option. Personally, I prefer using the Shift key method. You can also *alt* -click a tool icon in the Tools panel to cycle through the grouped tools.

There are specific situations when Photoshop will not allow you to use certain tools and displays a prohibit sign (S). For example, you might be editing an image in 32-bit mode where only certain tools can be used when editing 32-bit images. Clicking once in the image document window will call up a dialog explaining the exact reason why you cannot access or use a particular tool.

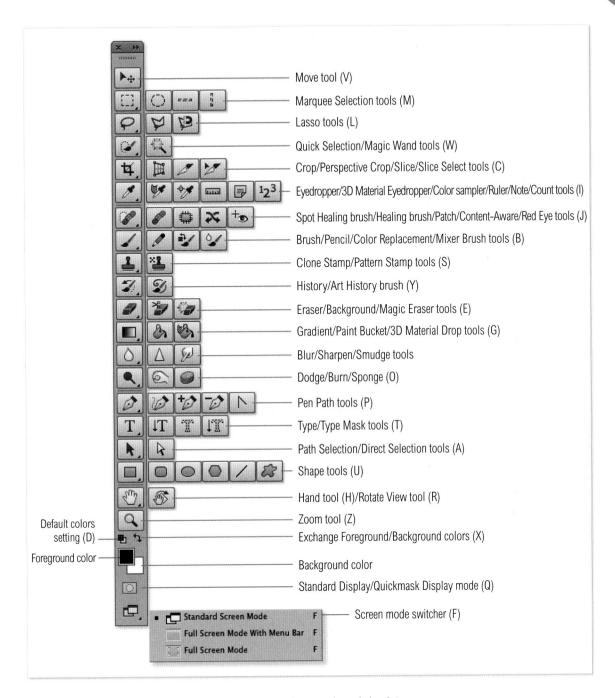

Figure 1.38 This shows the Tools panel with the keystroke shortcuts shown in brackets.

Hovering tool tips

In order to help familiarize yourself with the Photoshop tools and panel functions, a Help dialog box normally appears after a few seconds whenever you leave a cursor hovering over any one of the Photoshop buttons or tool icons. Note that this is dependent on having the 'Show Tool Tips' option checked in the Interface preferences.

Options bar

The Options bar (Figure 1.39) normally appears at the top of the screen, just below the Photoshop menu, and you will soon appreciate the ease with which you can use it to make changes to any of the tool options. However, it can be removed from its standard location and placed anywhere on the screen by dragging the gripper bar on the left edge (circled in Figure 1.39).

The Options bar contents will vary according to which tool you have currently selected and you'll see plenty of examples of the different Options bar layouts in the rest of this chapter (a complete list of the Options bar views can be seen in the Help Guide for Photoshop tools on the book website). Quite often you will see tick () and cancel () buttons on the right-hand side of the Options bar and these are there so that you can OK or cancel a tool that is in a modal state. For example, if you are using the crop tool to define a crop boundary, you can use these buttons to accept or cancel the crop, although you may find it easier to use the **Enter** key to OK and the **esc** key to cancel such tool operations. Also, as I mentioned earlier on page 20, you can use the **Shift Tab** shortcut to toggle hiding the panels only and keeping just the Tools panel and Options bar visible.

Tool Presets

Many of the Photoshop tools offer a wide range of tool options. In order to manage the tool settings effectively, the Tool Presets panel can be used to store multiple saved tool settings, which can then also be accessed via the Options bar (Figure 1.40), or the Tool Presets panel (Figure 1.41).

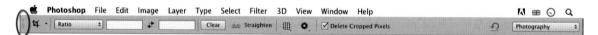

Figure 1.39 The Options bar, which is shown here docked to the main menu.

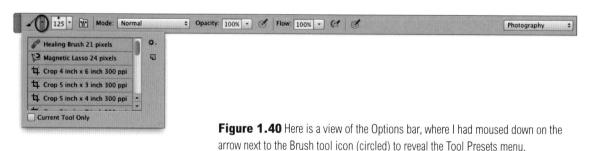

With Tool Presets you can access any number of tool options very quickly and this can save you the bother of having to reconfigure the Options bar settings each time you choose a new tool. For example, you might find it useful to save crop tool presets for all the different image dimensions and pixel resolutions you typically use. Likewise, you might like to store pre-configured brush preset settings, rather than have to keep adjusting the brush shape and attributes. To save a new tool preset, click on the New Preset button at the bottom of the Tool Presets panel and to remove a preset, click on the Delete button next to it.

If you mouse down on the Tool Presets options button (circled in Figure 1.41), you can use the menu shown in Figure 1.42 to manage the various tools presets. In Figure 1.41 the Current Tool Only option (at the bottom) was deselected which meant that all the tool presets could be accessed at once. This can be useful, because clicking on a preset simultaneously selects the tool and the preset at the same time. Most people though will find the Tool Presets panel is easier to manage when the 'Current Tool Only' option is checked.

You can use the Tool Presets panel to save or load presaved tool preset settings. For example, if you create a set of custom presets, you can share these with other Photoshop users by choosing Save Tool Presets... This creates a saved set of settings for a particular tool. Another thing that may not be immediately apparent is the fact that you can also use tool presets to save type tool settings. This again can be useful, because you can save the font type, font size, type attributes and font color settings all within a single preset. This feature can be really handy if you are working on a Web or book design project.

One important thing to bear in mind here is that since there has been a recent major update to the Photoshop painting engine, any painting tool presets that have been created in Photoshop CS5 or later will not be backward compatible with earlier versions of the program. Similarly, you won't be able to import and use any painting tool presets that were created in earlier versions of Photoshop either.

Lastly, you can ctri-click (Mac), or right mouse down on the tool icon in the Options bar and choose 'Reset Tool' or 'Reset All Tools' from the contextual menu. This will reset the Options bar to the default settings.

Figure 1.41 The Tool Presets panel.

Figure 1.42 The Tool Presets options.

The Paste Special menu commands

The standard Paste command pastes the copied pixels as a new layer centered in the image. The Paste Special submenu offers three options. The Paste In ctrl Shift V [PC]) pastes the pixels that have been copied from a layer to create a new layer with the pixels in the exact same location. If the pixels have been copied from a separate document. it pastes the pixels into the same relative location as they occupied in the source image. Paste Into (策区Shift V) [Mac], ctrl alt Shift V [PC]) pastes the clipboard contents inside a selection, while Paste Outside pastes the clipboard contents outside a selection.

Figure 1.43 The first time you use the Macintosh # H keyboard shortcut, this pops a dialog asking you to select the desired default behavior: Hide Photoshop, or Hide Extras.

Selection tools

The Photoshop selection tools are mainly used to define a specific area of the image that you wish to modify, or copy. The use of the selection tools in Photoshop is therefore just like highlighting text in a word processor program in preparation to do something with the selected content. In the case of Photoshop, you might want to make a selection to define a specific area of the image, so that when you apply an image adjustment or a fill, only the selected area is modified. Alternatively, you might use a selection to define an area you wish to copy and paste, or define an area of an image that you want to copy across to another image document as a new layer. The usual editing conventions apply and mistakes can [PC]), or by selecting a previous history state via the History panel. The # (Mac), ctrl H (PC) keyboard shortcut can be used to hide an active selection, but note that on a Macintosh, the first time you use the Rh keyboard shortcut, this opens the dialog shown in Figure 1.43, where you will be asked to select the desired default behavior: do you want this shortcut to hide the Photoshop application, or hide all extras?

The marquee selection tool options include the rectangular, elliptical and single row/single column selection tools. In Figure 1.44 I have shown the elliptical marquee tool in use and below that in Figure 1.45, an example of how you can work with the rectangular marquee tool. The lasso tool can be used to draw freehand selection outlines and has two other modes: the polygon lasso tool, which can draw both straight line *and* freehand selections, plus the magnetic lasso tool, which is like an automatic freehand lasso tool that is able to auto-detect the edge you are trying to trace.

The quick selection tool is a bit like the magic wand tool as it can be used to make selections based on pixel color values; however, the quick selection tool is a little more sophisticated than that and hence it has been made the default tool in this particular tool group. As you read through the book you'll see a couple of examples where the quick selection tool can be used to make quite accurate selections based on color and how these can then be modified more precisely using the Refine Edge command. For full descriptions of these and other tools mentioned here don't forget to check out the *Photoshop for Photographers Help Guide* on the website.

Figure 1.44 A selection can be used to define a specific area of an image that you wish to work on. In this example, I made an elliptical marquee selection of the cup and saucer and followed this with an image adjustment to make the color warmer.

Figure 1.45 In this example I used the rectangular marquee tool to make a marquee selection of the door. I then applied a Hue/Saturation adjustment to modify the colors within the selection area.

Color Range tip

A Color Range selection tool can only be used to make discontiguous selections. However, it is possible to make a selection first of the area you wish to focus on and then choose Color Range to make a color range selection within the selection area.

Out-of-gamut selections

Among other things, you can use the Color Range command to make a selection based on out-of-gamut colors. This means you can use Color Range to make a selection of all the 'illegal' RGB colors that fall outside the CMYK gamut and apply corrections to these pixels only. To be honest, while Color Range allows you to do this, I don't recommend using Photoshop's out-of-gamut indicators to modify colors in this way. Instead, I suggest you follow the instructions on soft proofing in Chapter 10.

Skin tone and faces selections

There is a Skin Tones option available in the Select menu. You can use this to specifically select skin tone colors in an image. There is also a separate 'Detect Faces' checkbox (which is available when the Localized Color Clusters checkbox is activated). When Detect Faces is enabled it uses a face detection algorithm to automatically look for and select faces in a photo. It appears to be effective with all different types of skin colors. Checking the Detect Faces option in conjunction with a Skin Tones selection can often really help narrow down a selection to select faces only.

Color Range

Color Range is a color-based selection tool (Figure 1.46). While the quick selection and magic wand tools create selections based on luminosity, Color Range can be used to create selections based on similar color values.

To create a Color Range selection, go to the Select menu, choose Color Range... and click on the target color anywhere in the image window (or Color Range preview area) to define the initial selection (note, if you press the Spacebar when launching the Color Range dialog the current foreground color is loaded as the sampled color). To add colors to a Color Range selection, click with the 'Add to Sample' eyedropper and keep clicking to expand the selection area. To subtract from a selection, click on the 'Subtract from Sample' eyedropper and click to select the colors you want to remove from the selection. You can then adjust the Fuzziness slider to adjust the tolerance of the selection, which increases or decreases the number of pixels that are selected based on how similar the pixels are in color to the already sampled pixels.

If the Localized Color Clusters box is checked, Color Range can process and merge data from multiple clusters of color samples. As you switch between 'sampling colors to add to a selection' and 'selecting colors to remove', Photoshop calculates these clusters of color samples within a three-dimensional color space. As you add and subtract colors Photoshop can produce a much more accurate color range selection mask based on the color sampled data. When Localized Color Clusters is checked the Range slider lets you determine which pixels are to be included based on how far or near a color is from the sample points that are included in the selection.

The selection preview options for the document window can be set to None (the default), Grayscale, a Matte color such as the White Matte example shown in Figure 1.47, or as a Quick Mask. The skin tones selection has been improved to help reduce the number of false positives, though in most instances the difference between this and the original Photoshop CS6 behavior is quite slight. It is also possible to save Color Range settings such as sub selections (i.e. Reds, Yellows, Greens etc.) as presets and this also includes the ability to save skin tones settings, detect faces and fuzziness settings. By default Color Range presets are now saved to a Color Range folder in the Adobe Photoshop application Presets folder. The Color Range dialog also remembers the previously applied settings and applies these the next time the dialog is opened.

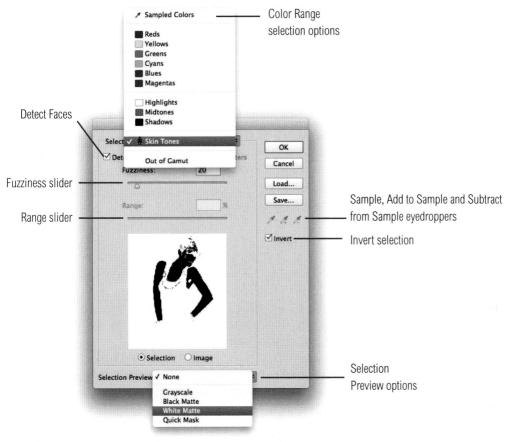

Figure 1.46 This shows the Color Range dialog with expanded menus that show the full range of options for the Color Range selection dialog.

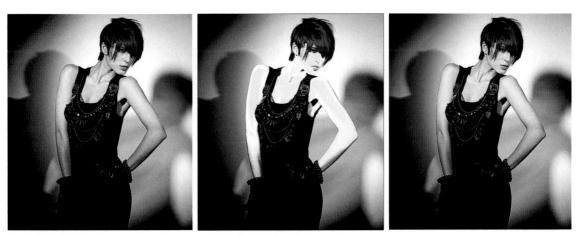

Figure 1.47 This shows a before image (left), Color Range White Matte preview (middle) and a color adjusted image (right) made using a Color Range selection.

Adjustable tone ranges

Color Range improvements in Photoshop CC offer greater control of Highlights, Midtones, and Shadows selections. Now, instead of being restricted to the use of 'hard-coded' value ranges, the exact range of tones and the partial selection of surrounding tones can be customized. In the case of the Highlights and Shadows selections there is a single slider with which to adjust the extent of a highlights or shadows selection. In the case of the Midtones you have two sliders with which to fine-tune the midtone range.

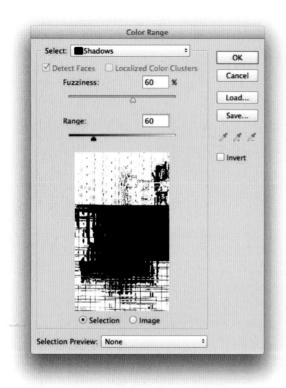

1 I opened the image shown here in Photoshop, went to the Select menu and chose Color Range... To start with I selected the Shadows option from the Select menu. Shown here is the default setting, which is the same as the previous, hard-coded range value used in Color Range. To reset the sliders here to the defaults, hold down key and the Cancel button will change to say 'Reset'.

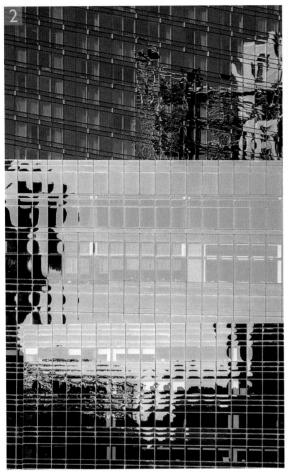

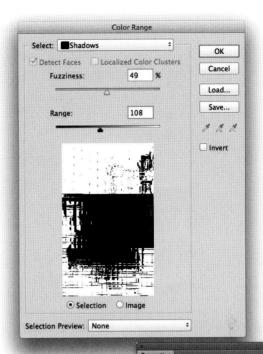

2 In Photoshop CC it is now possible to edit the Fuzziness and Range values for a Shadows, Midtones or Highlights selection. In this instance I adjusted both sliders to fine-tune the shadows selection. With the selection active, I added a Curves adjustment layer and applied the lightening curve shown here to lighten the shadows.

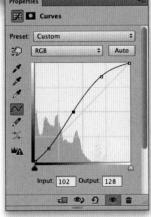

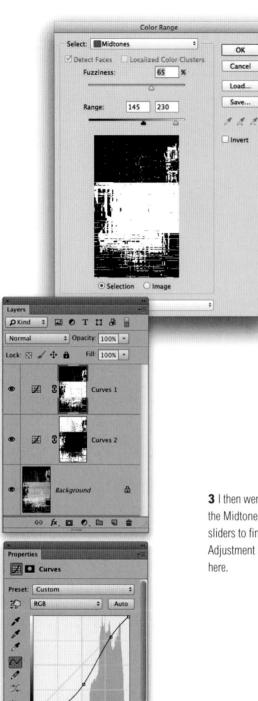

3 I then went to the Select menu again, chose Color Range... and this time selected the Midtones option from the Select menu. I then adjusted the Fuzziness and Range sliders to fine-tune the Midtones selection. After that I added another new Curves Adjustment layer, this time applying a darkening curve to create the final version seen here.

和 ® 5 @ m

Modifier keys

Macintosh and Windows keyboards have slightly different key arrangements, hence the reason for me including double sets of instructions throughout the book, where the # key on the Macintosh is equivalent to the # key on a Windows keyboard (see Figure 1.49). You can use the right mouse button to access the contextual menus (Mac users can also use the # key to access these menus) and, finally, the # key which is the same on both Mac and PC computers.

These keys are commonly referred to as 'modifier' keys, because they can modify tool behaviors. In Figure 1.48 you can see how if you hold down at when drawing a marquee selection it centers the selection around the point where you first clicked on the image. If you hold down the the selection to a circle. If you hold down this constrains the selection to a circle. If you hold down the constrains the selection to a circle and enters the selection, this constrains the selection to a circle and centers the selection around the point where you first clicked. The Spacebar is a modifier key too in that it allows you to reposition a selection midstream. This can prove really useful. If you make a mistake when selecting an area, rather than deselect and try again, you can simply depress the spacebar key as you drag to realign the position of the selection.

Figure 1.48 These screen shots show Quick Mask plus marching ant selections created by dragging out from the center with *Shift* held down (top), with *alt* held down (middle) and *Shift* (Mac), *Shift alt* (PC) (bottom).

Figure 1.49 This shows the modifier keys (shaded in orange), showing both the Macintosh and Windows equivalent key names. The other keys commonly used in Photoshop are the Tab and Tilde keys, shown here shaded in blue.

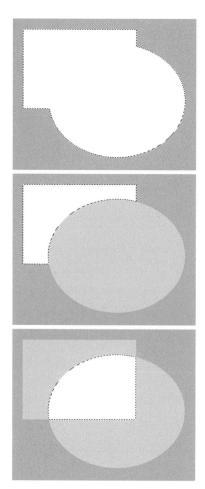

Figure 1.50 These screen shots show examples of Quick Mask plus marching ant selections that have been modified after the initial selection stage. The top view shows an elliptical selection combined with a rectangular selection with **Shift** held down, adding to a selection. The middle view shows an elliptical selection combined with a rectangular selection with **alt** held down, which subtracts from the original selection. The bottom view shows an elliptical selection combined with a rectangular selection with **Shift alt** held down, which results in an intersected selection.

After you have created an initial selection the modifier keys will behave differently. In Figure 1.50 you can see how if you hold down the *Shift* key as you drag with the marquee or lasso tool, this adds to the selection (holding down the *Shift* key and clicking with the magic wand tool also adds to an existing selection). If you hold down the *all* key as you drag with the marquee or lasso tool, this subtracts from an existing selection (as does holding down the *all* key and clicking with the magic wand tool). And the combination of holding down the *Shift all* keys together while dragging with a selection tool (or clicking with the magic wand) creates an intersection of the two selections. As well as using the above shortcuts, you will find there are also equivalent selection mode options in the Options bar for the marquee and lasso selection tools (see Figure 1.51).

Modifier keys can also be used to modify the options that are available elsewhere in Photoshop. For example, if you hold down the all key as you click on, say, the marquee tool in the Tools panel you will notice how this allows you to cycle through all the tools that are available in this group. Whenever you have a Photoshop dialog box open it is worth exploring what happens to the dialog buttons when you hold down the all key. You will often see the button names change to reveal more options (typically, the Cancel button will change to say 'Reset' when you hold down the all key).

Figure 1.51 The Options bar has four modes of operation for each of the selection tools: Normal; Add to Selection; Subtract from Selection; and Intersect Selection. These are equivalent to the use of the modifier modes described in the main text when the tool is in Normal mode.

Painting tools

The next set of tools we'll focus on are the painting tools, which include: the brush, pencil, mixer brush, blur, sharpen, smudge, burn, dodge and sponge tools. These can be used to paint, or used to edit the existing pixel information in an image. If you want to keep your options open you will usually find it is preferable to carry out your paint work on a separate new layer. This allows you to preserve all of the original image on a base layer and you can easily undo all your paint work by turning off the visibility of the paint layer.

When you select any of the painting tools, the first thing you will want to do is to choose a brush, which you can do by going to the Brush Preset Picker (the second item from the left in the Options bar) and select a brush from the drop-down list shown in Figure 1.52. Here, you can choose from the many different types of brushes, including the bristle shape brushes. The Size slider can be used to adjust the brush size from a single pixel to a 5000 pixel-wide brush. If a standard round brush is selected you can also use the Hardness slider to set varying degrees of hardness for the brush shape.

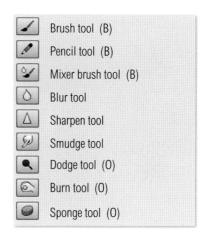

Round brush presets

There are now just six round brush presets. These allow you to select hard or soft brushes with either no pressure-linked controls, the brush size linked to the amount of pressure applied, or brush opacity linked to the amount of pressure applied.

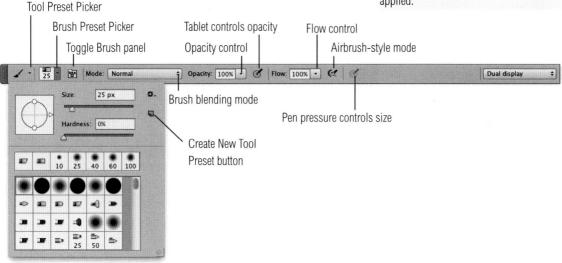

Figure 1.52 This screen shot shows you the Options bar for the brush tool. To display the brush preset list shown here, mouse down on the arrow next to the brush shape icon. You can then use the Size and Hardness sliders to modify one of the round brush settings and save as a new setting by clicking on the Create New Tool Preset button. Most of the painting tools offer a fairly similar range of settings and here you can see the pen tablet options, which allow you to set the pen pressure to control the opacity and/or the size of a selected painting tool.

Figure 1.53 There is no need to visit the Brush or Tool presets each time you want to change the size of a brush. You can use the right square bracket key to make a brush bigger and the left square bracket key to make it smaller.

Figure 1.54 You can combine the square bracket keys with the Shift key on the keyboard. You can use Shift 1 to make a round brush edge harder and use Shift 1 to make a round brush edge softer. Note that this only applies when editing one of the round brush presets.

On-the-fly brush changes

Instead of visiting the Brush Picker every time you want to adjust the size or hardness of a brush, you will often find it is quicker to use the square bracket keys (as described in Figures 1.53 and 1.54) to make such on-the-fly changes. Also, if you ctrl right mouse-click on the image you are working on this opens the Brush Preset menu directly next to the cursor. Click on the brush preset you wish to select and once you start painting, the Brush Preset menu closes (or alternatively, use the esc key). Note that if you are painting with a Wacom™ stylus you can close this pop-up dialog by lifting the stylus off the tablet and squeezing the double-click button. If you ctrl Shift-click or right mouse + Shift-click on the image while using a brush tool, this opens the blending mode list shown in Figure 1.55. These blend modes are like rules which govern how the painted pixels are applied to the pixels in the image below. For example, if you paint using the Color mode, you'll only alter the color values in the pixels you are painting.

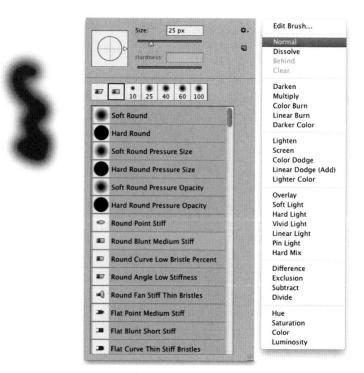

Figure 1.55 When using any of the paint tools in Photoshop, a *ctrl*-click or right mouse-click opens the Brush Preset menu (middle), while a *ctrl Shift*-click or right mouse + *Shift*-click reveals the brush blending modes list shown on the right.

On-screen brush adjustments

Providing you have the OpenGL option enabled in the Performance preferences. Photoshop offers you on-screen brush adjustments. If you hold down the ctri se keys (Mac), or the [all] key and right-click, dragging to the left makes the brush size smaller and dragging to the right, larger. Also, if you drag upwards this makes a round brush shape softer, while dragging downwards makes a round brush shape harder. Note here how the brush hardness is represented with a quick mask type overlay. If you hold down the # ctrl keys (Mac), or the alt Shift keys and right-click (PC), this opens the Heads Up Display (HUD) Color Picker where for as long as you have the mouse held down you can move the cursor over the outer hue wheel or hue strip to select a desired hue color and then inside the brightness/saturation square to select the desired saturation and luminosity. The point where you release the mouse selects the new foreground color. When you use the key combination described here to access the HUD Color Picker, you can hold down the Spacebar to freeze the cursor position. You can then select a hue color from the hue wheel/ strip, freeze the hue color selection and switch to select a brightness/saturation value. Figure 1.56 shows examples of how the paint tool cursor looks for both the on-screen brush size/hardness adjustments and the Hue Wheel HUD Color Picker displays.

Non-rotating brushes

If you use the rotate tool to rotate the canvas, Photoshop prevents the brushes from rotating too. You can continue to paint with the same brush orientation at all canvas rotation angles.

Brush preview overlay color

If you go to the Photoshop Cursors preferences you can customize the overlay color that's used for the brush preview.

Brush panel selection

In the Brushes panel the last selected brush is now highlighted plus you can now access the most recently used brush presets in brush contextual menu and Brush Preset panel (providing you have Show Recent Brushes checked – see Figure 1.58).

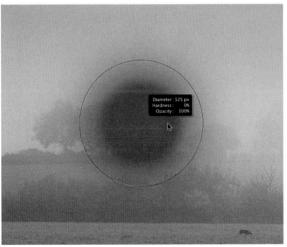

Figure 1.56 You can dynamically adjust the brush size and hardness of the painting tool cursors on screen, or open the Heads Up Display Color Picker using the modifier keys described in the main text (providing OpenGL drawing is enabled in the Performance preferences).

Figure 1.57 In this example, I selected the round point stiff brush and adjusted the Angle Jitter in the Shape Dynamics settings and the foreground/background jitter in the Color Dynamics, linking both to the angle of the pen. I then set blue as the foreground color, orange for the background and used a combination of pen pressure and pen tilt to create the doodle shown here, twisting the pen angle as I applied the brush strokes.

Brush panel

Over in the Brush panel if you click on the Brush Presets button (circled in Figure 1.58), this opens the Brush Presets panel listing a brush presets list. You can then append or replace these brush presets by going to the panel fly-out menu shown below and selecting a new brush settings group from the list.

So far we have looked at the Brush options that are used to determine the brush shape and size, but if you click on any of the brush attribute settings shown in Figure 1.58, the brush presets list changes to reveal the individual brush attribute options (see Figure 1.59). The brush attributes include things like how the opacity of the brush is applied when painting, or the smoothness of the brush. You can therefore start by selecting an existing brush preset, modify it, as in the Figure 1.58 example, and then click on the Create new brush button at the bottom to define this as a new custom brush preset setting.

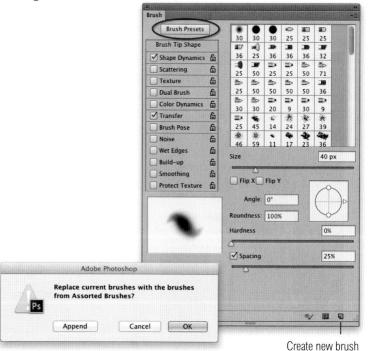

Figure 1.58 If you open the Brush panel, the default panel setting shows an Expanded View and lists the various brush presets in the right-hand section of the panel. If you click on any of the brush attributes in the list on the left, the right-hand section changes to reveal the various options settings (see Figure 1.59). If you open, or go to the Brush Presets panel menu, you can select any of the brush settings listed here, which will then ask if you want to Append or Replace the current list of presets.

Brush panel options

The following notes and tips on working with the Brush panel will apply to most, but not all, of the painting tools.

To create your own custom brush preset settings click on any of the brush attribute items that are listed on the lefthand side of the panel. The Jitter controls introduce some randomness into the brush dynamics behavior. For example, increasing the Opacity Jitter means that the opacity will respond according to how much pen pressure is applied and there is a built-in random fluctuation to the opacity that varies more and more as the litter value is increased. Meanwhile, the Flow Jitter setting governs the speed at which the paint is applied. To understand how the brush flow dynamics work, try selecting a brush and quickly paint a series of brush strokes at a low and then a high flow rate. When the flow rate is low, less paint is applied, but as you increase the flow setting more paint is applied. Other tools like the dodge and burn toning tools use the terms Exposure and Strength, but these essentially have the same meaning as the opacity control. The Shape Dynamics can be adjusted to introduce iitter into the size angle and roundness of the brush and the scattering controls allow you to produce broad, sweeping brush strokes with a random scatter, while the Color Dynamics let you introduce random color variation to the paint color. The Foreground/Background color control lets you vary the paint color between the foreground and background color, according to how much pressure is applied (see Figure 1.57). The Dual Brush and Texture Dynamics can introduce texture and more interactive complexity to the brush texture (it is worth experimenting with the Scale control in the Dual Brush options) and the Texture Dynamics can utilize different blending modes to produce different paint effects. The Transfer Dynamics allow you to adjust the dynamics for the build-up of the brush strokes – this relates particularly to the ability to paint using wet brush settings.

Pressure sensitive control

If you are using a pressure sensitive pen stylus, you will see additional options in the Brush panel that enable you to link the pen pressure of the stylus to how the effects are applied. You can therefore use these options to determine things like how the paint opacity and flow are controlled by the pen pressure or by the angle of tilt or rotation of the pen stylus. But note here

Figure 1.59 If you click on a brush attribute setting in the list on the left, the right-hand side of the panel displays the options that are associated with each attribute. Specific brush panel settings can be locked by clicking on the Lock buttons. If using a bristle tip brush shape, clicking the live brush tip preview button (circled above) enables the preview shown here.

Brush Pose

The Brush Pose options allow mouse users to set a stylus pose that is applied while painting. If painting with, say, a Wacom device, enabling the checkboxes (like those shown checked in Figure 1.59) overrides any tablet data to set a fixed pose. To see how this works, try selecting a dynamic tip brush and enable the live brush tip preview (circled above). Brush Pose settings can be saved with Brush and Tool presets.

Wacom™ tablets

Photoshop is able to exploit all of the pressure responsive built-in Wacom™ features. You will notice that as you alter the brush dynamics settings in the Brush panel, the brush stroke preview below changes to reflect what the expected outcome would be if you had drawn a squiggly line that faded from zero to full pen pressure (likewise with the tilt and thumb wheel). This visual feedback is extremely useful as it allows you to experiment with the brush dynamics settings in the Brushes panel and learn how these affect the brush dynamics behavior.

Figure 1.60 The Tool Presets panel. When you click on the New Preset button (circled) this opens the New Tool Preset dialog, where you can save and name the current tool settings as a new tool preset.

that the tablet pressure controls can also be controlled via the buttons in the Options bar for the various painting tools (I've highlighted these tablet button controls in Figure 1.52).

Brush tool presets

When you have finished adjusting the Brush panel dynamics and other settings, you can save combinations of the brush preset shape/size, Brush panel attribute settings, and the brush blending mode (and brush color even) as a new Brush tool preset. To do this, go to the Tool Presets panel and click on the New Preset button at the bottom (see Figure 1.60). Or, you can mouse down on the Tool Preset Picker in the Options bar and click on the New Brush setting button. Give the brush tool preset a name and click OK to append this to the current list. Once you have saved a brush tool preset, you can access it at any time via the Tool Presets panel or via the Tool Preset menu in the Options bar.

Mixer brush

The mixer brush allows you to paint more realistically in Photoshop. With the mixer brush you can mix colors together as you paint, picking up color samples from the image you are painting on and set the rate at which the brush picks up paint from the canvas and the rate at which the paint dries out. The mixer brush can be used with either the bristle tips or with the traditional Photoshop brush tips (now referred to as static tips) to produce natural-looking paint strokes. The combination of the mixer brush and bristle tip brushes provides a whole new level of sophistication to the Photoshop paint engine. The only downside is that the user interface has become even more complicated. The brush controls and feedback are split between the Brush panel, the Brush Presets panel, the Options bar and the live brush tip preview. It's not particularly easy to pick up a brush and play with it unless you have studied all the brush options in detail and you understand how the user interface is meant to work. Fortunately, the Tool Presets panel can help here and the easiest way to get started is to select one or two of the new brush presets and experiment painting with these brush settings to gain a better understanding of what the new brush settings can do. In the meantime, let's take a look at the Options bar settings for the mixer brush that's shown in Figure 1.61.

The mixer brush tool has two wells: a reservoir and a pickup. The reservoir well color is defined by the current foreground color swatch in the Tools panel or by [a/t]-clicking

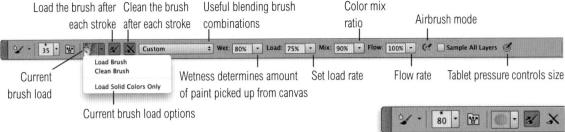

Figure 1.61 The mixer brush options.

in the image canvas area. This is the color you see displayed in the Load swatch preview. The pickup well is one that has paint flowing into it and continuously mixes the colors of where you paint with the color that's contained in the reservoir well. Selecting 'Clean Brush' from the 'Current brush load' options immediately cleans the brush and clears the current color, while selecting 'Load Brush' fills with the current foreground color again. The 'Load brush after each stroke' button does what it says, it tells the mixer brush to keep refilling the pickup well with color and therefore the pickup well becomes progressively contaminated with the colors that are sampled as you paint. The 'Clean brush after each stroke' button empties the reservoir well after each stroke and effectively allows you to paint from the pickup well only (Figure 1.62 shows an example of how the well colors are displayed in the Options bar).

The Paint wetness controls how much paint gets picked up from the image canvas. Basically, when the wetness is set to zero the mixer brush behaves more like a normal brush and deposits opaque color. As the wetness is increased so is the streaking of the brush strokes. The 'Set load rate' is a dry-out control. This determines how much paint gets loaded into the main reservoir well. With low load rate settings you'll get shorter brush strokes where the paint dries out quickly and as the load rate setting is increased you get longer brush strokes.

The Mix slider determines how much of the color picked up from the canvas that goes into the pickup well is mixed with the color stored in the main reservoir well. A high Mix ratio means more ink flows from the pickup to the reservoir well, while the Flow rate control determines how fast the paint flows as you paint. With a high Flow setting, more paint is applied as you paint. If you combine this with a low Load rate setting you'll notice how at a high Flow setting the paint flows out quickly and results in shorter paint strokes. At a lower Flow rate you'll notice longer (but less opaque) brush strokes.

Figure 1.62 The Load swatch displays the main reservoir well color in the outer area and the pickup well color in the center. Clicking on the mixer brush Current brush load swatch launches the Photoshop Color

Picker.

Typing in a number changes the Wetness value. Holding down the alt Shift keys while entering a number changes the Mix value. Lastly, holding down just the Shift key as you enter a number changes the Flow value. Note, you should type '00' to set any of the above values to zero.

Wet/Mix/Flow numeric shortcuts

Mixer brush presets

Sampled fill colors are retained whenever you switch brush tips or adjust the brush tip parameters. You can also include saving the main reservoir well and pickup well colors with a mixer brush tool preset.

Windows stylus and mouse tracking

Stylus support on Windows OS for non-Wacom devices has been updated and in particular, targeting new tabletbased computers that use n-trig tablet technology. The mouse tracking code has also been updated to take advantage of modern operating system Application Program Interfaces (APIs). These changes include performance tweaks, which should speed up painting and other input device interactions.

Figure 1.63 This shows the live brush preview, which can be enabled by clicking on the button circled in Figure 1.64. It can be toggled in size, moved around the screen, or closed. The Brush preview can also be turned on or off via the View/Show menu (or use **\$3 (H)** [Mac], **ctrl (H)** [PC]).

Dodge and burn tools

The dodge and burn tools have been much improved since Photoshop CS4. However, you are still limited to working directly on the pixel data. If you do want to use the dodge and burn tools, I suggest you work on a copied pixel layer. Overall, I reckon you are better off using the Camera Raw adjustment tools to dodge and burn your images, or use adjustment layers and edit the associated layer mask.

Bristle tip brush shapes

If you select one of the bristle tip brush shapes you can click on the Brush Tip Shape option in the Brush panel (Figure 1.64) to reveal the Bristle Qualities options. These brush tips can be used in conjunction with any of the Photoshop painting tools. When a bristle tip (as opposed to a traditional 'static' Photoshop brush tip) is selected you can also click the Bristle preview button (circled in Figure 1.64) to display the floating Bristle preview panel shown in Figure 1.63. As you adjust the slider controls in the Brush panel the Bristle preview provides visual feedback as to how this will affect the current bristle tip behavior.

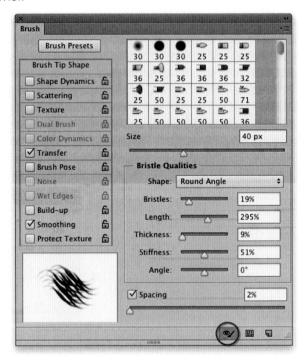

Figure 1.64 The Bristle tip Brush panel options. The Bristles slider determines the density of the number of bristles within the current brush size. The Length determines the length of the bristles relative to the shape and size of the selected brush. The Thickness determines the thickness of each bristle. The Stiffness controls the stiffness or resistance of the bristles. The Angle slider determines the angle of the brush position — this isn't so relevant for pen tablet users, but more so if you are using a mouse. Lastly, the Spacing slider sets the spacing between each stamp of the brush stroke.

Load/Replace Swatches from HTML

From the Swatches panel it is now possible to load swatches from an HTML page you are working on. As shown here, you use the Swatches panel menu to select the Load Swatches... or Replace Swatches... menu item and then select an HTML document to read from (this option is also available via other swatch pickers). This option will read color swatches from HTML, CSS and SVG files. It only loads colors that are unique to a document as opposed to every instance a color appears in a document.

The main benefit of this feature is that when working on a web page design you can now efficiently import precise HTML colors into Photoshop.

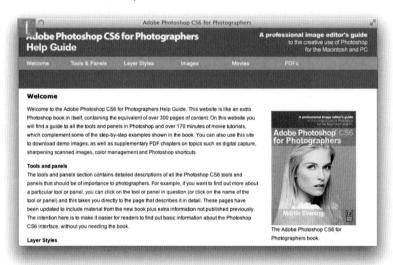

1 Here is a web page that I created in Adobe Dreamweaver and saved as an HTML file.

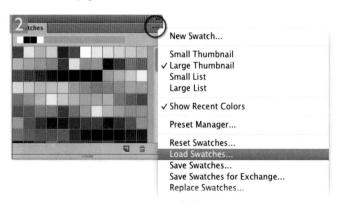

2 In Photoshop, I went to the Swatches panel, moused down to reveal the panel options menu (circled) and chose Load Swatches...

HTML color support

This feature recognizes HTML/CSS color syntax: #112233 #123 rgb(1,2,3) rgba(1,2,3,4) hsb(1,2,3) and hsba(1,2,3,4).

Adding colors to Swatches panel

As was mentioned earlier, in the New Document dialog you can set a custom color as the background color. The Background Content menu now features an Other... option. When this is selected it opens the Color picker, which allows you to select a custom color. This can be useful because it means you can make a series of color samples by clicking with the eyedropper tool and these will automatically be added to the Swatches panel ready for use in the same or another document. You don't have to explicitly save the swatches, it semi-permanently adds them to a swatch collection. Overall, this is a tidier solution.

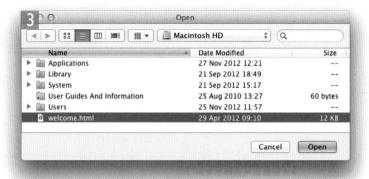

3 I then navigated to select the HTML document that was shown open in step 1.

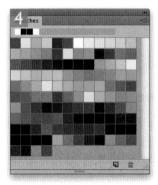

4 This then added two colors from the web page design to the Swatches panel.

Hex Field

When working in RGB mode, the Hex Field is now selected by default in the Color picker (see Figure 1.65).

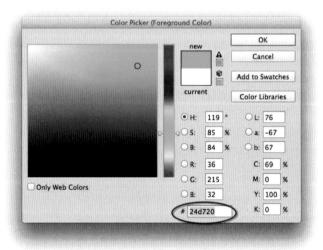

Figure 1.65 The Color Picker dialog with the Hex field auto-selected.

Tools for filling

The various shape tools, including the line tool, are mostly useful to graphic designers who wish to create things like buttons or who need to add vector shapes to a design layout. In Figure 1.66, you can see an example of how a filled, custom shape vector layer was placed above a pixel layer that had been filled with a radial gradient. The gradient tool may certainly be of interest to photographers. For example, you can use the Adjustment layer menu to add gradient fill layers to an image. Gradient fill layers can be applied in this way to create gradient filter type effects. You will also find that the gradient tool comes in use when you want to edit the contents of a layer mask. For example, you can add a black to white gradient to a layer mask to apply a graduated fade to the opacity of a layer.

The paint bucket tool is another type of fill tool and is a bit like a combination of a magic wand selection combined with an Edit \Rightarrow Fill using the foreground color.

Figure 1.66 In this example I added a radial gradient using a transparency to blue gradient. Above this I added a 35 mm filmstrip custom shape layer filled with black.

51

0	Pen tool (P)	
0	Freeform pen tool (P)	
+0	Add anchor point tool	
0	Delete anchor point tool	
	Convert point tool	
A	Path selection tool (A)	
4	Direct selection tool (A)	
120020455335536999	<u> </u>	

Tools for drawing

If you want to become a good retoucher, then at some stage you are going to have to bite the bullet and learn how to use the pen tools. The selection tools are fine for making approximate selections, but as I show below in Figure 1.67, whenever you need to create precision selections or masks, the pen tool and associated path editing tools are essential.

The pen tool group includes the main pen tool, a freeform pen tool (which in essence is not much better than the lasso or magnetic lasso tools) plus modifier tools to add, delete or modify the path points. There are several examples coming up in Chapter 8 where I will show how to use the pen tools to draw a path.

Figure 1.67 If you need to isolate an object and create a cut-out like the one shown here, the only way to do this is by using the pen and pen modifier tools to first draw a path outline. You see, with a photograph like this, there is very little color differentiation between the object and the background and it would be very difficult for an auto masking tool to accurately predict the edges in this image. With experience it shouldn't take you too long to create a cut-out like this.

Image editing tools

The move tool can be used to move objects, while the crop tool can be used to trim pictures or enlarge the canvas area. This tool has undergone some major changes along with the addition of a perspective crop tool. You can read more about these in the Image editing essentials chapter.

The clone stamp tool has been around since the early days of Photoshop and is definitely an essential tool for all kinds of retouching work. You can use the clone stamp to sample pixels from one part of the image and paint with them in another (as shown in Figure 1.68). The spot healing and healing brush tools can be used in almost exactly the same way as the clone stamp, except they cleverly blend the pixels around the edges of where the healing brush retouching is applied to produce almost flawless results. The spot healing brush is particularly clever because you don't even need to set a sample point: you simply click and paint over the blemishes you wish to see removed. This tool has been enhanced with a content-aware healing mode that allows you to tackle what were once really tricky subjects to retouch. The patch tool is similar to the healing brush except you first use a selection to define the area to be healed and this is now also joined by a content-aware move tool that allows you to either extend a selected area or move it and at the same time fill the initial selected area.

Providing you use the right flash settings on your camera it should be possible to avoid red eye from ever occurring in your flash portrait photographs. But for those times when the camera flash leaves your subjects looking like beasts of the night, the red eye tool provides a fairly basic and easy way to auto-correct such photos. Meanwhile, the color replacement brush is like a semi-smart color blend mode painting tool that analyzes the area you are painting over and replaces it with the current foreground color, using either a Hue, Color, Saturation or Luminosity blend mode. It is perhaps useful for making quick and easy color changes without needing to create a Color Range selection mask first.

The eraser tools will let you erase pixels directly, although these days it is more common to use layer masks to selectively hide or show the contents of a layer. The background eraser and magic eraser tools do offer some degree of automated erasing capabilities, but I would be more inclined to use the quick selection tool combined with a layer mask for this kind of masking.

1	Move tool (V)
4	Crop tool (C)
	Perspective Crop tool (C)
1	Clone Stamp (S)
×1	Pattern Stamp (S)
60	Spot Healing brush (J)
600	Healing brush (J)
	Patch tool (J)
*	Content-Aware Move tool (J)
+•	Red Eye tool (J)
1	Color Replacement tool (B)
a)	Eraser (E)
*/	Background Eraser (E)
7	Magic Eraser (E)

Figure 1.68 I mostly use the healing brush and clone stamp tools to retouch small blemishes or remove sensor dust marks from my photographs. In this example I show how the clone stamp tool was used to paint detail from one part of an image onto another. Note how the retouching work was applied to an empty new layer and the Sample: 'Current & Below' option selected in the clone stamp tool Options bar.

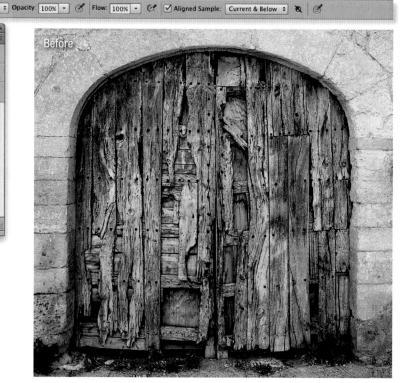

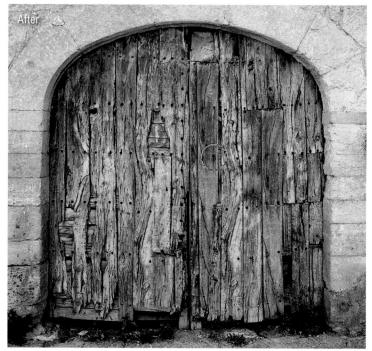

Move tool

The move tool can perform many functions such as move the contents of a layer, directly move layers from one document to another, copy layers, apply transforms, plus select and align multiple layers. In this respect the move tool might be more accurately described as a move/transform/alignment tool and you'll also see a heads up display that indicates how much you are moving something. The move tool can also be activated any time another tool is selected simply by holding down the (Mac), ctrl (PC) key (except when the slice tools, hand tool, pen or path selection tools are selected). If you hold down the late key while the move tool is selected, this lets you copy a layer or selection contents. It is also useful to know that using at + # ctrl (the move tool shortcut) lets you make a copy of a layer or selection contents when any other tool is selected (apart from the ones I just listed). If the Show Transform Controls box is checked in the move tool Options bar (Figure 1.69), a bounding box will appear around the bounds of the selected layer. When you mouse down on the bounding box handles to transform the layer, the Options bar switches modes to display the numeric transform controls.

Nudging layers and selections

Figure 1.69 The move tool Options bar with the Auto-Select layer option checked. Note you can select Group or Layer from the pop-up menu here.

Layer selection using the move tool

When the move tool is selected, dragging with the move tool moves the layer or image selection contents (the cursor does not have to be centered on the object or selection, it can be anywhere in the image window). However, when the Auto-Select option is switched on (circled in Figure 1.69), the move tool can auto-select the uppermost layer (or layer group) containing the most opaque image data below the cursor. This can be useful when you have a large number of layers in an image. Multiple layer selection is also possible with the move tool, because when the move tool is in Auto-Select mode you can marquee drag with the move tool from outside the canvas area to select multiple layers, the same way as you can make a marquee selection using the mouse cursor to select multiple folders or documents in the Finder/Explorer (see Figure 1.70).

Auto layer/layer group selection

The move tool Options panel has a menu that allows you to choose between 'Group' or 'Layer' auto-selection. When 'Layer' is selected, Photoshop only auto-selects individual layers. When 'Group' is selected, Photoshop can auto-select whole layer groups. If the move, marquee, lasso or crop tool are selected, a ** Ctrl [Mac], ctrl all + right mouse-click [PC] selects a target layer based on the pixels where you click. When the move tool only is selected, ** [Mac], ctrl all [PC] + click selects a layer group based on the pixels where you click.

Align/Distribute layers

When several layers are linked together, you can click on the Align and Distribute buttons in the Options bar as an alternative to navigating the Layer ⇒ Align Linked and Distribute Linked menus.

Layer selection shortcuts

You can at any time use the **A (Mac), **A (PC) shortcut to select all layers. But note that the move tool layer selection method will not select any layers that are locked. For example, if you use the Auto-Select layer mode to marquee drag across the image to make a layer selection, the background layer will not be included in the selection.

Where you have many layers that overlap, remember there is a contextual mode for the move tool that can help you target specific layers (use *cm* right mouse-click to access the contextual layer menu). Any layer with an opacity greater than 50% will show up in the contextual menu. This then allows you to select a specific layer from below the cursor.

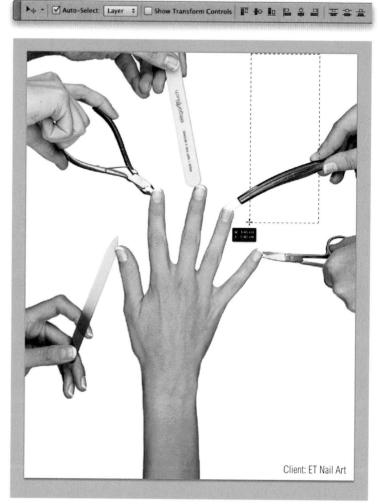

Figure 1.70 When the move tool is selected and the Auto-Select box is checked, you can marquee drag with the move tool from outside of the canvas area inwards to select specific multiple layers or layer groups. If the Auto-Select Layer option is deselected, you can instead hold down the [H] [Mac], [PC] key to temporarily switch the move tool to the 'Auto-Select' mode.

Navigation and information tools

To zoom in on an image, you can either click with the zoom tool to magnify, or drag with the zoom tool, marqueeing the area you wish to inspect in close-up. This combines a zoom and scroll function in one (a plus icon appears inside the magnifying glass icon). To zoom out, just hold down the all key and click (the plus sign is replaced with a minus sign). You can also zoom in by holding down the Spacebar + the key (Mac) or the all key (PC). You can then click to zoom in and you can also zoom out by holding down the Spacebar + the all key. This keyboard shortcut calls up the zoom tool in zoom out mode and you can then click to zoom out.

Zoom tool (Z) Hand tool (H) Eyedropper tool (I) Color Sampler tool (I) Ruler tool (I) Rotate View tool (R) Notes tool (I) Count tool (I)

Zoom tool shortcuts

Photoshop uses the #11 (Mac), ctrl 1 (PC) shortcut to zoom to 100% and \(\max_0 \) (Mac), \(\begin{aligned} \text{ctrl} \(0 \) (PC) to zoom out to a fit to view zoom view (the 🕱 🔼 0 (Mac), ctrl alt 0 (PC) zoom to 100% shortcut is gone now). This was first implemented in CS4 in order to unify the window document zoom controls across all of the Creative Suite applications. As a consequence of this, the channel selection shortcuts have been shifted along two numbers. # 2 (Mac), ctrl 2 (PC) selects the composite channel, #3 (Mac), ctrl 3 (PC) selects the red channel, # 4 (Mac), ctrl 4 (PC) the green channel and so on. The Tilde key has also changed use. Prior to CS4 (#) ~ (Mac), ctrl ~ (PC) selected the composite color channels (after selecting a red, green or blue channel). It now allows you to toggle between open window documents. Another handy zoom shortcut is 第十 (Mac), ctrl+ (PC) to zoom in and 第一 (Mac), ctrl-(PC) to zoom out (note the 🛨 key is really the 🚍 key). If your mouse has a wheel and 'Zoom with mouse wheel' is selected in the preferences, you can use it with the all key held down to zoom in or out. If OpenGL is enabled you can carry out a continuous zoom by simply holding down the zoom tool (and use all to zoom out). Photoshop also supports two-fingered zoom gestures such as drawing two fingers together to zoom out and spreading two fingers apart to zoom in.

Figure 1.71 You can use the Zoom tool Options bar buttons to adjust the zoom view. If OpenGL is enabled 'Scrubby Zoom' will be checked. This overrides the marquee zoom behavior — dragging to the right zooms in and dragging to the left zooms out.

Hand tool

When you view an image close-up, you can select the hand tool from the Tools panel (H) and drag to scroll the image, and you can also hold down the Spacebar at any time to temporarily access the hand tool (except when the type tool is selected). The hand and zoom tools also have another navigational function. You can double-click the hand tool icon in the Tools panel to make an image fit to screen and double-click the zoom tool icon to magnify an image to 100%. There are also further zoom control buttons in the zoom tool Options bar, such as 100%, Fit Screen and Fill Screen (Figure 1.71).

Bird's-eye view

Another OpenGL option is the Bird's-eye view feature. If you are viewing an image in a close-up view, you can hold down the \mathbf{H} key and, as you do this, if you click with the mouse, the image view swiftly zooms out to fit to the screen and at the same time shows an outline of the close-up view screen area (a bit like the preview in the Navigator panel). With the \mathbf{H} key and mouse key still held down, you can drag to reposition the close-up view outline, release the mouse and the close-up view will re-center to the newly selected area in the image (see Figure 1.72).

Figure 1.72 If a window document is in OpenGL mode and in a close-up view, you can hold down the key and click with the mouse to access a bird's eye view of the whole image. You can then drag the rectangle outline shown here to scroll the image and release to return to a close-up of the image centered around this new view.

Flick panning

With OpenGL enabled in the Photoshop Performance preferences, you can also check the Enable Flick Panning option in the General preferences. When this option is activated, Photoshop will respond to a flick of the mouse pan gesture by continuing to scroll the image in the direction you first scrolled, taking into account the acceleration of the flick movement. When you have located the area of interest just click again with the mouse to stop the image from scrolling any further.

Windows Multi-touch support

If you are using the Windows 7 or 8 operating system and have multi-touch aware hardware, Photoshop supports touch zoom in and out, touch pan/flicking as well as touch canvas rotation.

Eyedropper tool

The eyedropper tool can be used to measure pixel values directly from a Photoshop document, which are displayed in the Info panel shown in Figure 1.73. Photoshop also features a heads up display, which I describe in Figure 1.74. The color sampler tool can be used to place up to four color samplers in an image to provide persistent readouts of the pixel values, which is useful for those times when you need to closely monitor the pixel values as you make image adjustments. In Photoshop you can now sample the current layer and below as well as with no adjustments (see Figure 1.75).

Ruler tool

The ruler tool can be used to measure distance and angles in an image and again, this data is displayed in the Info panel, such as in the example shown in Figure 1.73.

Figure 1.73 The Info panel showing an eyedropper color reading, a measurement readout, and two color sampler readouts below. Note, you can now have up to ten color samplers in the Info panel.

Figure 1.74 This shows the OpenGL eyedropper wheel. The outer gray circle is included to help you judge the inner circle colors more effectively. The top half shows the current selected color and the bottom half, the previous selected color. The sample ring display can be disabled in the eyedropper options.

Figure 1.75 The eyedropper tool has sample options in the Options bar. You can sample 'Current & Below', 'All Layers no Adjustments', and 'Current & Below no Adjustments'. The sample size pop-up menu also appears when using the various eyedropper tools, such as black point and white point eyedroppers in Levels and Curves.

The rotate view tool uses the R keyboard shortcut, which (before CS4) was previously assigned to the blur/sharpen/sponge tool set. This has been generally accepted as a positive move, but you can, if desired, use the Keyboard Shortcuts menu described on page 22 to reassign the keyboard shortcuts as you prefer.

Rotate view tool

If OpenGL is enabled in the Performance preferences, you can use the rotate view tool to rotate the Photoshop image canvas (as shown below in Figure 1.76). Being able to quickly rotate the image view can sometimes make it easier to carry out certain types of retouching work, rather than be forced to draw or paint at an uncomfortable angle. To use the rotate view tool, first select it from the Tools panel (or use the Reystroke) and click and drag in the window to rotate the image around the center axis. As you do this, you will see a compass overlay that indicates the image position relative to the default view angle (indicated in red). This can be useful when you are zoomed in close on an image. To reset the view angle to normal again, just hit the esc key or click on the Reset View button in the Options bar.

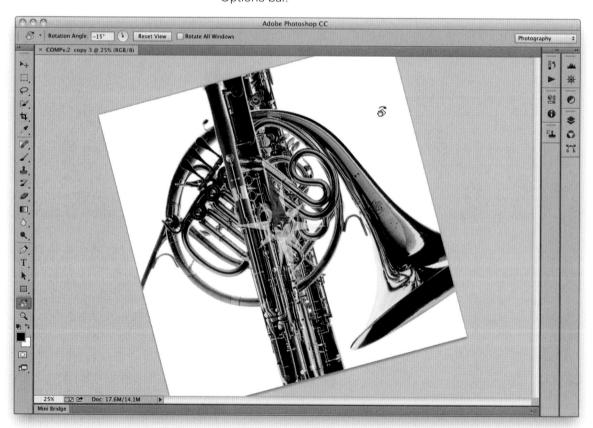

Photograph: Eric Richmond

Figure 1.76 This shows the rotate view tool in action.

Notes tool

The notes tool is handy for adding sticky notes to open images. You can use the Notes panel (Figure 1.77) to store the recorded note messages. This method makes the notes display and management easy to control. I use this tool quite a lot at work, because when a client calls me to discuss a retouching job, I can open the image, click on the area that needs to be worked on and use the Notes panel to type in the instructions for whatever further retouching needs to be done to the image. If the client you are working with is also using Photoshop, they can use the notes feature to mark up images directly, which when opened in Photoshop can be inspected as shown in Figure 1.78 below.

Figure 1.77 The Notes panel.

Count tool

The count tool is more useful to those working in areas like medical research where, for example, you can use the count tool to count the number of cells in a microscope image.

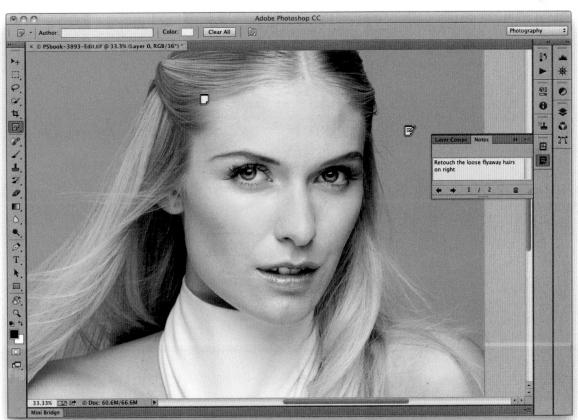

Figure 1.78 An example of the notes tool being used to annotate an image.

Full view screen mode

The Full Screen Mode with Menu Bar and Full Screen modes are usually the best view modes for concentrated retouching work. These allow full movement of the image, not limited by the edges of the document bounds. In other words, you can scroll the image to have a corner centered in the screen and edit things like path points outside the bounds of the document. Also note that the key can be used to cycle between screen modes and Shift F to cycle backwards.

Figure 1.79 This shows examples of two of the three screen view modes for the Photoshop interface. Here you can see the Standard Screen Mode view (top) and Full Screen Mode with Menu Bar (bottom). The absolute Full Screen mode, which isn't shown here, displays the image against a black canvas and with the menus and panels hidden

Screen view modes

In Figure 1.79 I have highlighted the Application bar screen view mode options which allow you to switch between the three main screen view modes. The standard screen view displays the application window the way it has been shown in all the previous screen shots and lets you view the document windows as floating windows or tabbed to the dock area. In Full Screen Mode with Menu Bar, the frontmost document fills the screen, while allowing you to see the menus and panels. Lastly, the Full Screen view mode displays a full screen view with the menus and panels hidden.

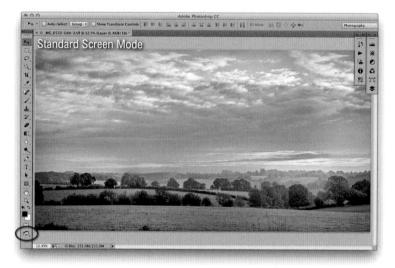

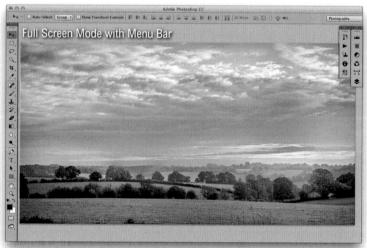

Working with Layers

Photoshop layers allow you to edit a photograph by building up the image in multiple layered sections, such as in the Figure 1.80 example below. A layer can be an image element, such as a duplicated background layer, a copied selection that's been made into a layer, or content that has been copied from another image. Or, you can have text or vector shape layers. You can also add adjustment layers, which are like image adjustment instructions applied in a layered form.

Layers can be organized into layer group folders, which will make the layer organization easier to manage, and you can also apply a mask to the layer content using either a pixel or vector layer mask. You will find there are plenty of examples throughout this book in which I show you how to work with layers and layer masks.

Blending modes

Layers can be made to blend with the layers below them using any of the 27 different blending modes that are in Photoshop. Layer effects/styles can be used to add effects such as drop shadows, gradient/pattern fills or glows to any layer, plus custom layer styles can be loaded from and saved to the Styles panel.

Drag and drop layers

You can drag and drop a file to a Photoshop document and place it as a new layer.

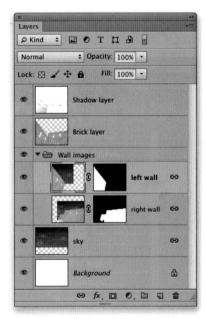

Figure 1.80 The above Layers panel view shows the layer contents of a typical layered Photoshop image and the diagram on the left shows a composite image broken down into its constituent layers.

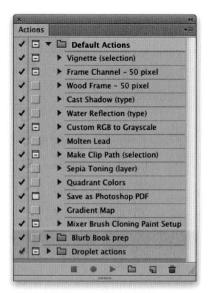

Figure 1.81 The Actions panel.

Allow tool recording

In the Actions panel fly-out menu there is an item called: Allow Tool Recording. When this is checked Photoshop allows you to record things like brush strokes as part of an action. There are some limitations to this feature, but providing the images you record and play back the action on have the same pixel dimensions, it will work as expected.

Automating Photoshop

Why waste your time performing repetitive tasks when Photoshop is able to automate these processes for you? By using the Actions panel you can record steps in Photoshop as an action and use this to replay on other images. Figure 1.81 shows a screen shot of the Actions panel, where it currently displays an expanded view of the Default Actions set. As you can see from the descriptions, these actions can perform automated tasks such as adding a vignette to a photo or creating a wood frame edge effect. OK, these are not exactly the sort of actions you would use every day, but if you go to the panel fly-out menu you will see listed in the fly-out menu a number of action sets that are worth installing.

To run an action, you will usually need to have a document already open in Photoshop and press the Play button. It is also quite easy to record your own custom actions, and once you get the hang of how to do this you can use the File \Rightarrow Automate \Rightarrow Batch... command to apply recorded actions to several images at once. You can also go to the File \Rightarrow Automate menu and choose 'Create Droplet..'. Droplets are like self-contained batch action operations located in the Finder/ Explorer. All you have to do is drag an image file to a droplet to initiate a Photoshop action process (see Figure 1.82). I explain later in Chapter 11 how to automate Photoshop and make efficient use of actions.

By saving and loading actions it is easy to share your favorite Photoshop actions with other users – all you have to do is to double-click an action icon to automatically install it in the Actions panel, and if Photoshop is not running at the time, this will also launch the program.

Figure 1.82 With Photoshop droplets you can apply a batch action operation by simply dragging and dropping an image file or a folder of images onto a droplet that has been saved to the Finder/Explorer.

Preset Manager

The Preset Manager (Edit ⇒ Presets ⇒ Preset Manager) lets you manage all your presets from within the one dialog. This allows you to keep track of: Brushes, Swatches, Gradients, Styles, Patterns, Layer effect contours, Custom shapes and Tools (Figure 1.83 shows the Preset Manager used to manage the Tool presets). You can append or replace an existing set of presets via the Preset Manager options and the Preset Manager can also be customized to display the preset information in different ways, such as in the Figure 1.84 example, where I used a Large List to display large thumbnails of all the currently loaded Gradient presets.

Figure 1.83 As well as loading and replacing presets, you can choose how presets are displayed. In the case of Gradients, it's nice to see a preview alongside each gradient.

Figure 1.84 You can use the Photoshop Preset Manager to load custom settings that can be used to append or replace the pre-supplied defaults.

Saving presets as Sets

As you create and add your own custom preset settings, you can manage these via the Preset Manager. For example, this means that you can select a group of presets and click on the Save Set... button to save these as a new group of presets. Note that if you rearrange the order of the tool presets, the edited order will remain sticky when you next relaunch Photoshop.

Loading presets

If you double-click any Photoshop setting that is outside the Photoshop folder, this automatically loads the Photoshop program and appends the preset to the relevant section in the Preset Manager.

Figure 1.85 A previous history step can be selected by clicking on the history step name in the History panel. In its default configuration, you'll notice when you go back in history, the history steps after the one that is selected will appear dimmed. If you move back in history and you then make further edits to the image, the history steps after the selected history step will be deleted. However, you can change this behavior by selecting Allow Non-linear History in the History panel options (see Figure 1.86).

Figure 1.86 The History Options can be accessed via the History panel fly-out menu. These allow you to configure things like the Snapshot and Non-linear history settings. I usually have Allow Non-Linear History option checked — this enables me to use the History feature to its full potential (see page 71).

History

The History feature was first introduced in Photoshop 5.0 and back then was considered a real breakthrough feature. This was because, for the first time, Photoshop was able to offer multiple undos during a single Photoshop editing session. History can play a really important role in the way you use Photoshop, so I thought this would be the best place to describe this feature in more detail and explain how history can help you use Photoshop more efficiently.

As you work on an image, Photoshop is able to record a history of the various image states as steps and these can be viewed in the History panel (Figure 1.85). If you want to reverse a step, you can always use the conventional Edit \Rightarrow Undo command (# Z [Mac], [PC]), but if you use the History panel, you can go back as many stages in the edit process as you have saved history steps.

The History panel

The History panel displays the sequence of Photoshop steps that have been applied during a Photoshop session and its main purpose is to let you manage and access the history steps that have been recorded in Photoshop. The history source column in the History panel will allow you to select a history state to sample from when working with the history brush (or filling from history). So, to revert to a previous step, just click on a specific history step. For example, in Figure 1.85 I carried out a simple one-step undo by clicking in the Source column for the last but one history step.

One can look at history as a multiple undo feature in which you can reverse through up to 1000 image states. However, it is actually a far more sophisticated tool than just that. For example, there is a non-linear history option for multiple history path recording (see the History Options dialog in Figure 1.86). Non-linear history allows you to shoot off in new directions and still preserve all the original history steps. Painting from history can therefore save you from tedious workarounds like having to create more layers than are really necessary in order to preserve fixed image states that you can sample from. With history you don't have to do this and by making sensible use of non-linear history, you can keep the number of layers that are needed to a minimum.

Figure 1.87 The number of recorded history states can be set via the History & Cache section of the Performance preferences dialog.

To set the options for the History panel, mouse down on the fly-out menu and select History Options... (Figure 1.86). By default, history automatically creates an 'open' state snapshot each time you open an image and you can also choose to create additional snapshots each time an image is saved. Basically, Snapshots can be used to prevent history states from slipping off the end of the list and becoming deleted as more history steps are created (see page 70). 'Make Layer Visibility Changes Undoable' makes switching layer visibility on or off a recordable step in history, although this can be annoying if turning the layer visibility on or off prevents you from using undo/redo to undo the last Photoshop step.

History settings and memory usage

When the maximum number of recordable history steps has been reached, the earliest history step at the top of the list is discarded. With this in mind, the number of recorded histories can be altered via the Photoshop Performance preferences (Figure 1.87). Note that if you reduce the number of history states (or steps) that are allowed, any subsequent action will immediately cause all earlier steps beyond this new limit to be discarded.

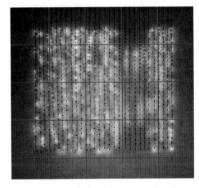

Figure 1.88 This shows the underlying tiled structure of a Photoshop image.

This is a clue as to how history works as economically as possible. The history stores the minimum amount of data necessary at each step in Photoshop's memory. So if just one or two tile areas are altered by a Photoshop action, only the data change that takes place in those tiles is actually recorded.

History stages	Scratch	
	disk	
Open file	1360 MB	
Add new layer	1360 MB	
Healing brush	1670 MB	
Healing brush	1670 MB	
Marquee selection	1610 MB	
Feather selection	1630 MB	
Inverse selection	1660 MB	
Add adjustment layer	1700 MB	
Modify adjustment layer	1700 MB	
Flatten image	1630 MB	

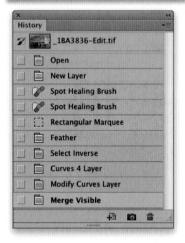

Figure 1.89 The accompanying table shows how the scratch disk usage can fluctuate during a typical Photoshop session. The image I opened here was 160 MB in size and 10 GB of memory was allocated to Photoshop. The scratch disk overhead is usually quite big at the beginning of a Photoshop session, but notice how there was little proportional increase in the scratch disk usage with each successive history step.

Conventional wisdom would suggest that a multiple undo feature is bound to tie up vast amounts of scratch disk space to store all the previous image steps. However, this is not really the case. It is true that a series of global Photoshop steps may cause the scratch disk usage to rise, but localized changes will not. This is because the history feature makes clever use of the image cache tiling structure to limit any unnecessary drain on the memory usage. Essentially, Photoshop divides an image up into tiled sections and the size of these tiles can be set in the Performance preferences (see Figure 1.87). Because of the way Photoshop images are tiled, the History feature only needs to memorize the changes that take place in each tile. Therefore, if a brush stroke takes place across two image tiles, only the changes taking place in those tiles needs to be updated (see Figure 1.88). If a global change such as a filter effect takes place, the whole of the image area is updated and the scratch disk usage rises accordingly. A savvy Photoshop user will want to customize the History feature to record a reasonable number of histories, while at the same time be aware of the need to change this setting if the history usage is likely to place too heavy a burden on the scratch disk. The history steps example discussed in Figure 1.89 demonstrates that successive histories need not consume an escalating amount of memory. In this example, the healing brush work only affected the tiled sections. After the first adjustment layer had been added, successive adjustment layers had little impact on the scratch disk usage (because only the screen preview was being changed). By the time I got to the 'flatten image' stage the scratch disk/memory usage had begun to bottom out.

If the picture you are working with is exceptionally large, then having more than, say, ten undos can be both wasteful and unnecessary, so you should perhaps consider restricting the number of recordable history states. On the other hand, if multiple history undos are well within the scratch disk memory limits of your system, then why not make the most of them? If excessive scratch disk usage does prove to be a problem, the Purge History command in the Edit \Rightarrow Purge menu provides a useful way to keep the scratch disk memory usage under control. Above all, remember that the History feature is not just there as a mistake-correcting tool, it has great potential for mixing composites from previous image states.

History brush

The history brush can be used to paint from any previous history state and allows you to selectively restore image data as desired. To do this you need to leave the current history state as it is and select a source history state for the history brush by clicking in the box next to the history step you wish to sample from. In Figure 1.90 you can see how I had set the 'New Layer' history step as the history source (notice the small history brush icon where the box next to this is currently checked). I was then able to paint with the history brush from this previous history state, painting over the areas that had been worked on with the spot healing brush and use the history brush to restore those parts of the picture back to its previous, 'New Layer' history state.

Use of history versus undo

As you will have seen so far, the History feature is capable of being a lot more than a repeat Edit ⇒ Undo command. Although the History feature is sometimes described as a multiple undo, it is important not to confuse Photoshop history with the role of the undo command. For example, there are a number of Photoshop procedures that are only undoable through using the Edit

□ Undo command, like intermediate changes made when setting the shadows and highlights in the Levels dialog. There are also things which can be undone using Edit ⇒ Undo that have nothing to do with Photoshop's history record for an image. For example, if you delete a swatch color or delete a history state, these actions are only recoverable by using Edit ⇒ Undo. The undo command is also a toggled action and this is because the majority of Photoshop users like having the ability to switch quickly back and forth to see a before and after version of the image. The current combination of having undo commands and a separate History feature has been carefully planned to provide the most flexible and logical approach. History is not just an "oh I messed up. Let's go back a few stages" feature, the way some other programs work; it is a tool designed to ease the workflow and provide you with extra creative options in Photoshop. A key example of this is the Globe Hands image that was created by Jeff Schewe. The story behind this image and its influence on the History feature is told in Figure 1.92.

Art history brush

The art history brush is something of an oddity. It is a history brush that allows you to paint from history but does so via a brush which distorts the sampled data and can be used to create impressionist type painting effects. You can learn more about this tool from the *Photoshop for Photographers Help Guide* that's on the book website.

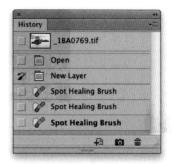

Figure 1.90 A previous history state can be selected as the source for the history brush by going to the History panel and clicking in the box to the left of the history step you want to paint from using the history brush.

Filling from history

When you select the Fill... from the Edit menu there is an option in the Contents Use menu to choose 'History'.

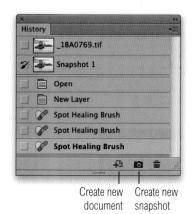

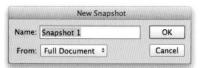

Figure 1.91 To record a new snapshot, click on the Create New Snapshot button at the bottom of the History panel. This records a snapshot of the history at this stage. If you alt -click the button, there are three options: Full Document, which stores all layers intact; Merged Layers, which stores a composite; and Current Layer, which stores just the currently active layer. Note if you have the Show New Snapshot dialog by Default turned on in the History panel options, the New Snapshot dialog appears directly, without you having to alt -click the New Snapshot button. The adjacent Create New Document button can create a duplicate image of the active image in its current history state.

Snapshots

Snapshots are stored above the History panel divider and used to record the image in its current state so as to prevent this version of the image from being overwritten and for as long as the document is open and being edited in Photoshop. The default settings for the History panel will store a snapshot of the image in its opened state and you can create further snapshots by clicking on the Snapshot button at the bottom of the panel (see Figure 1.91). This feature is particularly useful if you have an image state that you wish to store temporarily and don't wish to lose as you make further adjustments to the image. There is no real constraint on the number of snapshots that can be added, and in the History panel options (Figure 1.86) you can choose to automatically generate a new snapshot each time you save the image (which will also be time-stamped). The Create New Document button (next to the Snapshot button) can be used to create a duplicate image state in a new document window and saved as a separate image.

Figure 1.92 Photographer Jeff Schewe has had a long-standing connection with the Adobe Photoshop program and its development. The origins of the History feature can perhaps be traced back to a seminar where he used the Globe Hands image shown here to demonstrate his use of the Snapshot feature in Photoshop 2.5. Jeff was able to save multiple snapshots of different image states in Photoshop and selectively paint back from them. This was all way before layers and history were introduced in Photoshop. Chief Photoshop Engineer Mark Hamburg was suitably impressed by Jeff's technique and the ability to paint from snapshots became an important part of the History feature. Everyone had been crying out for a multiple undo in Photoshop, but when history was first introduced in Photoshop 5.0 it came as quite a surprise to discover just how much the History feature would allow you to do.

Non-linear history

The non-linear history option lets you branch off in several directions and experiment with different effects without needing to add lots of new layers. Non-linear history is not an easy concept to grasp, so the best way to approach this is to imagine a series of history steps as having more than one 'linear' progression, allowing the user to branch off in different directions in Photoshop instead of in a single chain of events (see Figure 1.93). Therefore, while you are working on an image in Photoshop, you have the opportunity to take an image down several different routes and a history step from one branch can then be blended with a history step from another branch without having to save duplicate files.

Non-linear history requires a little more thinking on your part in order to monitor and recall image states, but ultimately makes for a more efficient use of the available scratch disk space. Overall, I find it useful to have non-linear history switched on all the time, regardless of whether I need to push this feature to its limits or not

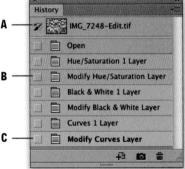

Non-linear history in use

On page 490 in Chapter 7 you can see

a practical example of how the history

feature might be used in a typical

Photoshop retouching session.

Figure 1.93 The non-linear history option allows you to branch off in different directions and simultaneously maintain a record of each history path up to the maximum number of history states that can be allowed. Shown here are three history states selected from the History panel: (A) the initial opened image state. (B) with a Curves layer adjustment added and (C) an alternative version where I added a Black and White layer adjustment layer followed by a Curves adjustment layer to add a sepia tone color effect.

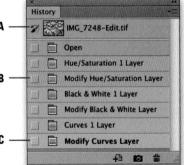

Corrupt files

There are various reasons why a file may be corrupt and refuses to open, but it often happens when images have been sent as attachments. Here, it is most likely due to a break during transmission somewhere, resulting in missing data.

Figure 1.94 The header information in some files may contain information that tells the operating system to open the image in a program other than Photoshop. On a Macintosh go to the File menu and choose File ⇒ Get Info and under the 'Open with' item, change the default application to Photoshop. On a PC you can do the same thing via the File Registry.

Figure 1.95 When files won't open up directly in Photoshop the way you expect them to, then it may be because the header is telling the computer to open them up in some other program instead. To force open an image in Photoshop, drag the file icon on top of the Photoshop application icon or an alias or shortcut thereof, such as an icon placed in the dock or on the desktop.

When files won't open

You can open an image file in Photoshop in a number of ways. You can open an image via Bridge, or you can simply double-click a file to open it. As long as the file you are about to open is in a file format that Photoshop recognizes, it will open in Photoshop and if the program is not running at the time this action should also launch Photoshop.

Every document file contains a header section, which among other things tells the computer which application should be used to open it. For example, Microsoft Word documents will, naturally enough, default to opening in Microsoft Word. Photoshop can recognize nearly all types of image documents regardless of the application they may have originated from, but sometimes you will see an image file with an icon for another specific program, like Macintosh Preview, or Internet Explorer. If you double-click these particular files, they will open in their respective programs. To get around this, you can follow the instructions described in Figure 1.94. Alternatively, you can use the File ⇒ Open command from within Photoshop, or you can drag a selected file (or files) to the Photoshop program icon, or a shortcut/alias of the program icon (Figure 1.95). In each of these cases this allows you to override the computer operating system which normally reads the file header to determine which program the file should be opened in. If you use Bridge as the main interface for opening image files in Photoshop, then you might also want to open the File Type Association preferences (see Bridge chapter PDF on website) to check that the file format for the files you are opening are all set to open in Photoshop by default.

Yet, there are times when even these methods may fail and this points to one of two things. Either you have a corrupt file, in which case the damage is most likely permanent. Or, the file extension has been wrongly changed. It says .psd, but is it really a PSD? Is it possible that someone has accidentally renamed the file with an incorrect extension? In these situations, the only way to open it will be to rename the file using the *correct* file extension, or use the Photoshop File \Rightarrow Open command and navigate to locate the mis-saved image (which once successfully opened should then be resaved to register it in the correct file format).

Graphic Converter

1

Save often

It goes without saying that you should always remember to save often while working in Photoshop. Hopefully, you won't come across many crashes when working with the latest Macintosh and PC operating systems and the fact Photoshop can now carry out automatic background saves is a real bonus, but there are still some pitfalls you need to be aware of.

Choosing File ⇒ Save always creates a safe backup of your image, but as with everything else you do on a computer, do make sure you are not overwriting the original with an inferior modified version. There is always the danger that you might make permanent changes such as a drastic reduction in image size, accidentally hit 'Save' and lose the original in the process. If this happens, there is no need to worry so long as you don't close the image. You can always go back a step or two in the History panel and resave the image in the state it was in before it was modified. Note that with Photoshop CC it is now possible to save multiple documents at once, placing them in a queue.

When you save an image in Photoshop, you are either resaving the file (which overwrites the original) or are forced to save a new version using the Photoshop file format. The determining factor here will be the file format the image was in when you opened it and how it has been modified in Photoshop. Over the next few pages I'll be discussing some of the different file formats you can use, but the main thing to be aware of is that some file formats do restrict you from being able to save things like layers, pen paths or extra channels. For example, if you open a JPEG format file in Photoshop and modify it by adding a pen path, you can choose File ⇒ Save and overwrite the original without any problem. However, if you open the same file and add a layer or an extra alpha channel, you won't be able to save it as a JPEG any more. This is because although a JPEG file can contain pen paths, it doesn't support layers or additional channels, so it has to be saved using a file format that is capable of containing these extra items.

I won't go into lengthy detail about what can and can't be saved using each format, but basically, if you modify a file and the modifications can be saved using the same file format that the original started out in, then Photoshop will have no problem saving and overwriting the original. If the modifications applied to an image mean that it can't be saved using the original file format it will default to using the PSD (Photoshop document) format and save the image as a new

If you are still having trouble trying to open a corrupted file, the Graphic Converter program can sometimes be quite effective at opening mildly corrupted image files.

Closing unchanged files (Mac)

On the Mac Salcicking the Close button on one open image will close all the others that have remained unchanged. Where images have had changes it will stop to ask whether you want to save these or not.

History saves

While there is an Auto-Save feature in Photoshop, it is still not possible to save a history of everything you did to an image. However, if you go to the Photoshop preferences you can choose to save a history log information of everything that was done to the image. This can record a log of everything that was done during a Photoshop session and can be saved to a central log file or saved to the file's metadata.

The other thing you can do is go to the Actions panel and click to record an action. If you have the tool recording option enabled, such an action will record things like brush strokes and you may be able to fully record everything that was done to the image while it was edited in Photoshop.

document via the Save As dialog (Figure 1.96). You can also choose to save such documents using the TIFF or PDF format. In my view, the TIFF format is a good choice for saving master images since this file format can contain anything that's been added in Photoshop.

Essentially, there are four main file formats that can be used to save everything you might add to an image such as image layers, type layers, channels and also support 16-bits per channel. These are: TIFF, Photoshop PDF, the large document format, PSB and lastly the native Photoshop file format, PSD. As I say, I now mostly favor using the TIFF format when saving master RGB images. When you choose File \Rightarrow Close All, if any of the photos have been modified, a warning dialog alerts you and allows you to close all open images with or without saving them first. For example, if you make a series of adjustments to a bunch of images and then change your mind, with this option you can quickly close all open images if you don't really need them to be saved.

Background Saving

The Background Save or Auto-Save is a recovery feature. In case of a crash it will allow you to recover data from any open files that you were working on which had been modified since opening. Note that this feature does not auto-save by overwriting the original file (which could lead to all sorts of problems). What Photoshop does is to auto-save copies of whatever you are working on in the background using the PSD format. In the event of a crash, the next time you launch Photoshop it will automatically open the most recent auto-saved copies of whatever you were working on. If you refer to the configuring Photoshop PDF on the website you can read about how to configure the File Handling preferences to switch this option on and determine how frequently you wish to update the background save file.

Normal saves

As with all other programs, the keyboard shortcut for saving a file is: #\$\square\$ (Mac), crr/\$ (PC). If you are editing an image that has never been saved before or the image state has changed (so that what started out as a flattened JPEG, now has layers added), this action will pop the Save As...dialog. Subsequent saves may not show the Save dialog. But if you do wish to force the Save dialog to appear and save a copy version, use:

Using Save As... to save images

If the image you are about to save has started out as, say, a flattened JPEG, but now has layers, this will force the Save As dialog shown in Figure 1.96 to appear as you save. However, you can also choose 'File \Rightarrow Save As...' (\Rightarrow Simple Simpl

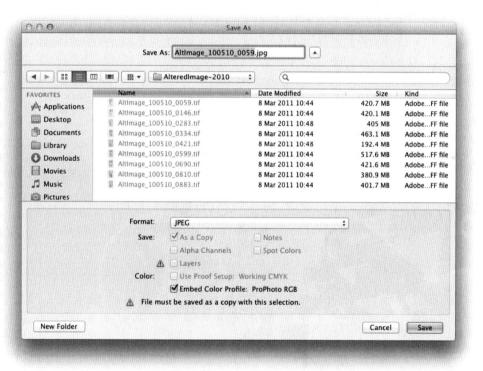

Figure 1.96 If the file format you choose to save in won't support all the components in the image such as layers, then a warning triangle alerts you to this when you attempt to save the document, reminding you that the layers will not be included. Note that the Mac OS dialog shown here can be collapsed or expanded by clicking on the downward pointing disclosure triangle to toggle the expanded folder view.

Maximum compatibility

Only the Photoshop PSD, PDF, PSB and TIFF formats are capable of supporting all the Photoshop features such as vector masks and image adjustment lavers. The PSD format has been supported in Photoshop for as long as I have been using the program, but, as I say, remains poorly documented and poorly implemented outside of Photoshop. This is the main reason why, for Photoshop (PSD) format documents to be completely compatible with other programs (such as Lightroom). you must ensure you have the 'Maximize PSD and PSB Compatibility' checked in Photoshop's File Handling preferences. The reason for this is because Lightroom is unable to read layered PSD files that don't include a saved composite within the file. If PSD images fail to be imported into Lightroom, it is most likely because they were saved with this preference switched off, Looking ahead to the future, it is difficult to say if PSD will be supported forever. What we do know though is that the TIFF file format has been around longer than PSD and is certainly a welldocumented format and integrates well with all types of image editing programs. TIFF is currently at version 6.0 and it is rumored it's going to be updated to v 7.0 at some point in the near future. Meanwhile, even the Adobe engineers are suggesting that PSD is close to its end, and are now recommending the use of TIFF.

File formats

Photoshop supports nearly all the current, well-known image file formats. And for those that are not supported, you will find that certain specialized file format plug-ins are supplied as free extras for Photoshop. When these plug-ins are installed in the Plug-ins folder they allow you to extend the range of file formats that can be chosen when saving. Your choice of file format when saving images should be mainly determined by what you want to do with a particular file and how important it is to preserve all the features (such as layers and channels) that may have been added while editing the image in Photoshop. Some formats such as PSD and PSB are mainly intended for archiving master image files, while others, such as TIFF, are ideally suited for many types of uses and, in particular, prepress work. Here is a brief summary of the main file formats in common use today.

Photoshop native file format

The Photoshop file format is a universal format and seemingly a logical choice when saving and archiving your master files since the Photoshop (PSD) format will recognize and contain all known Photoshop features. There are a number of advantages to using PSD. Firstly, it can help you easily distinguish the master, layered RGB files from the flattened output files (which I usually save as TIFFs). Secondly, when saving layered images. the native Photoshop format is generally a very efficient format because it uses a run length encoding type of compression that can make the file size more compact, but without degrading the image quality in any way. LZW compression does this by compressing large areas of contiguous color such as a white background into short lengths of data instead of doggedly recording every single pixel in the image. The downside is that PSD is a poorly documented format. It arose at an early stage in Photoshop's development and remains, essentially, a proprietary file format to Adobe and Photoshop. The TIFF format is now generally considered a better format for archive work.

Smart PSD files

Adobe InDesign and Adobe Dreamweaver will let you share Photoshop format files between these separate applications so that any changes made to a Photoshop file will automatically be updated in the other program. This modular approach means that most Adobe graphics programs can integrate with each other seamlessly.

Large Document (PSB) format

The PSD and TIFF file formats have a $30,000 \times 30,000$ pixel dimensions limit, while the PSD file format has a 2 GB file size limit and the TIFF format specification has a 4 GB file size limit. You need to bear in mind here that most applications and printer RIPs can't handle files that are greater than 2 GB anyway and it is mainly for this reason that the above limits have been retained for all the main file formats used in Photoshop (although there are some exceptions, such as ColorByte's ImagePrint and Onyx's PosterShop, which can handle more than 2 GB of data).

The Large Document (PSB) file format is provided as a special format that can be used when saving master layered files that exceed the above limits. The PSB format has an upper limit of 300,000 × 300,000 pixels, plus a file size limit of 4 exabytes (that's 4 million terrabytes). This format is therefore mainly useful for saving extra long panoramic images that exceed 30,000 pixels in length, or when saving extra large files that exceed the TIFF 4 GB limit. You do have to bear in mind that only Photoshop CS or later is capable of reading the PSB format, and, just like TIFF and PSD, only recent versions of Photoshop will offer full file format compatibility.

TIFF (Tagged Image File Format)

The main formats used for publishing are TIFF and EPS. Of the two, TIFF is the most universally recognized image format. TIFF files can readily be placed in QuarkXpress, InDesign and any other type of desktop publishing (DTP) program. The TIFF format is more open and unlike the EPS format, you can make adjustments within the DTP program as to the way a TIFF image will appear in print. It is also a well-documented format and set to remain as the industry standard format for archive work and publishing, plus Camera Raw recognizes TIFF, but not PSD. Labs and output bureaux generally request that you save your output images as TIFFs, as this is the file format that can be read by most other imaging computer systems. Therefore, if you are distributing a file for output as a print or transparency, or for someone else to continue editing your master file, it is usually safest to supply the image using TIFF.

TIFFs saved using Photoshop 7.0 or later support alpha channels, paths, image transparency and all the extras that can normally be saved using the native PSD and PDF formats. Labs or service bureaux that receive TIFF files for direct output will normally request that a TIFF file is flattened and saved with the

PSDX format

PSDX is a special file format that has been developed for Photoshop Touch with tablet devices in mind and to provide better performance. Only a subset of PSD capabilities are available on tablet devices. so Photoshop Touch doesn't support things like Smart Objects, layer groups. layer styles, etc. Photoshop Touch can export your file as a PSDX. However, if you store your files in Creative Cloud. the PSDX to PSD conversion happens in the Cloud so that what you end up downloading will in fact be a PSD. You can also download the Touch Apps Plug-in for Photoshop, which then allows Photoshop to read the PSDX format.

TIFF and bit depth

Photoshop does allow for more bit depths when saving TIFF files. For example, BIGTIFF files can now also be read in Photoshop. The BIGTIFF format is a variant of the standard TIFF format that allows you to extend beyond the 4 GB data limit. The BIGTIFF file format is designed to be backward compatible with older TIFF readers in as much as it allows such programs to read the first 4 GB of data as normal. In order to read file data that exceeds this limit, TIFF readers need to be able to read the BIGTIFF format, which Photoshop can now do. Also, prior to Photoshop CS6, Photoshop could only read TIFF files that contained an even number bit depth, such as 2, 4, 6, 8, 10, etc., but could not read TIFF files that had odd number bit depths, such as 3, 5, 7, 9. It is only really files that come from certain scientific cameras and medical systems that create such files. Anyway, Photoshop now allows these files to be read.

alpha channels and other extra items removed. For example, earlier versions of Quark Xpress had a nasty habit of interpreting any path that was present in the image file as a clipping path.

Pixel order

The Photoshop TIFF format has traditionally saved the pixel values in an interleaved order. So if you were saving an RGB image, the pixel values would be saved as clusters of RGB values using the following sequence: RGBRGBRGB. All TIFF readers are able to interpret this pixel order. The Per Channel pixel order option saves the pixel values in channel order, where all the red pixel values are saved first, followed by the green, then the blue. So the sequence used is: RRRGGGBBB. Using the Per Channel order can therefore provide faster read/write speeds and better compression. Most third-party TIFF readers should support Per Channel pixel ordering, but there is just a very slim chance that some TIFF readers won't.

Byte order

The byte order can be made to match the computer system platform the file is being read on, but there is usually no need to worry about this and it shouldn't cause any compatibility problems.

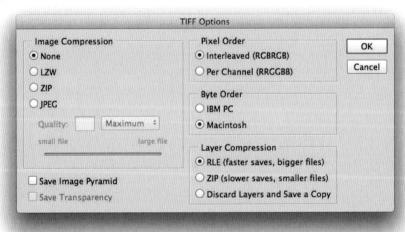

Figure 1.97 This dialog shows the save options that are available when you save an image as a TIFF.

Save Image Pyramid

The Save Image Pyramid option saves a pyramid structure of scaled-down versions of the full resolution image. TIFF pyramid-savvy DTP applications (and there are none I know of yet) will then be able to display a good quality TIFF preview, but without having to load the whole file.

TIFF compression options

An uncompressed TIFF will usually be about the same megabyte size as the figure you see displayed in the Image Size dialog box, but Photoshop offers several compression options when saving a TIFF. LZW uses lossless compression, where image data is compacted and the file size reduced, but without image detail being lost. Saving and opening takes longer when LZW is utilized so some clients will request you don't use it. ZIP is another lossless compression encoding, which like LZW is most effective where images contain large areas of a single color. JPEG image compression uses a lossy method that offers even greater levels of file compression, but again be warned that this option can cause problems downstream with the printer RIP if it is used when saving output files for print. If there are layers present in an image, separate compression options are available for the layers. RLE stands for Run Length Encoding and provides the same type of lossless compression as LZW, and ZIP compression is as described above. Alternatively, choose Discard Layers and Save a Copy, which saves a copy version of the master image as a flattened TIFF.

Flattened TIFFs

If an open image contains alpha channels or layers, the Save dialog (Figure 1.97) indicates this and you can keep these items checked when saving as a TIFF. If 'Ask Before Saving Layered TIFF Files' is switched on in the File Saving preferences, a further alert dialog will warn you that 'including layers will increase the file size' the first time you save an image as a layered TIFF.

JPEG

The JPEG (Joint Photographic Experts Group) format is the most effective way to compress continuous tone image files. JPEG uses what is known as a lossy compression method. For more about working with JPEG and other file formats for the Web, check out the Web Output PDF on the book website. Previously, the maximum number of pixels you could save as a JPEG was 30,000. However, Photoshop can now open and save JPEG documents up to 65,535 pixels in width or height.

Redundant formats

The Filmstrip file format is no longer supported in Photoshop. The same applies to the PICT format as well. Photoshop is still able to read raster PICT files (though not QuickDraw PICTs), it just won't allow you to write to the PICT file format.

Saving 16-bit files as JPEGs

For those who prefer to edit their images in 16-bit, it always used to be frustrating when you would go to save an image as a JPEG copy, only to find that the JPEG option wasn't available in the Save dialog File Format menu. The reason for this is because 16-bit isn't supported by the JPEG format. When you choose Save As... for a 16-bit image, the JPEG file format is actually available as a save option, whereby Photoshop carries out the necessary 16-bit to 8-bit conversion as part of the JPEG save process. This allows you to quickly create JPEG copies without having to temporarily convert the image back to 8-bit. Note, however, that only the JPEG file format is supported in this way.

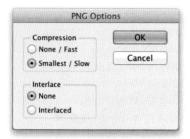

Figure 1.98 The PNG Save dialog. One of the advantages of PNG is that it is capable of storing transparency, which avoids the fudging that has to occur when using formats such as JPEG and GIF. It is useful for creating overlays and watermarks for Lightroom, because of its added compactness.

PDF versatility

The PDF format in Photoshop is particularly useful for sending Photoshop images to people who don't have Photoshop, but do have the Adobe Reader™ or Macintosh Preview programs on their computer. If they have a full version of Adobe Acrobat™ they will even be able to conduct a limited amount of editing, such as the ability to edit the contents of a text layer. Photoshop is also able to import or append any annotations that have been added via Adobe Acrobat.

PNG

The PNG file format is one that is very popular for Web design and sometimes a useful substitute for the JPEG format. The PNG Save dialog is shown in Figure 1.98, where the file save options allow you to choose between 'None' or 'Smallest' compression. In Photoshop CC you can now save metadata and ICC profiles when saving as a PNG, plus there is now support for PNG files up to 2 GB in size.

Photoshop PDF

The PDF (Portable Document Format) is a cross-platform file format that was initially designed to provide an electronic publishing medium for distributing documents without requiring the recipient to have a copy of the program that originated the document. PDF files can be read in Adobe Acrobat or the Adobe Reader TM program, which will let others view documents the way they are meant to be seen, even though they may not have the exact same fonts that were used to compile the document.

Adobe PDF has now gained far wider acceptance as a reliable and compact method of supplying page layouts to printers, due to its color management features, and its ability to embed fonts and compress images. It is now becoming the native format for Illustrator and other desktop publishing programs and is also gaining popularity for saving Photoshop files, because it can preserve everything that a Photoshop (PSD) file can. Adobe ReaderTM is free, and can easily be downloaded from the Adobe website. But the full Adobe AcrobatTM program may be required if you want to distill page documents into the PDF format and edit them on your computer.

Best of all, Acrobat documents are small in size and can be printed at high resolution. I can create a document in InDesign and export it as an Acrobat PDF using the Export command. Anyone who has installed the Adobe Reader program can then open a PDF document I have created and see the layout just as I intended it to be seen, with the text displayed using the correct fonts. The Photoshop PDF file format can be used to save all Photoshop features such as Layers, with either JPEG or lossless ZIP compression and is backward compatible in as much as it saves a flattened composite for viewing within programs that are unable to fully interpret the Photoshop layer information.

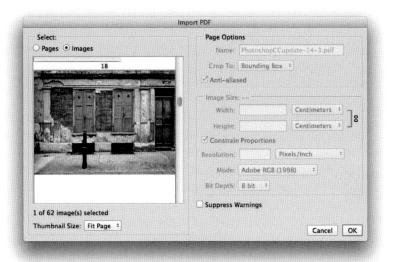

Figure 1.99 If you open a generic Acrobat PDF from within Photoshop choosing File ⇒ Open, you will see the Import PDF dialog shown here. This allows you to select individual or multiple pages or selected images only and open these in Photoshop or place them within a new Photoshop document.

Placing PDF files

The Photoshop Parser plug-in allows
Photoshop to import any Adobe Illustrator,
EPS or generic single/multi-page PDF file.
Using File ⇒ Place (Embedded or Linked),
you can select individual pages or ranges
of pages from a generic PDF file, rasterize
them and save them to a destination folder.
You can also use File ⇒ Place (Embedded
or Linked) to extract all or individual
image/vector graphic files contained within
a PDF document as separate image files. In
these instances the dialog will be similar to
that shown in Figure 1.99.

Adobe Bridge CC

The Bridge program provides you with an integrated way to navigate through the folders on your computer and complete compatibility with all the other Creative Suite applications (see Figure 1.100). The Bridge interface lets you inspect images in a folder, make decisions about which ones you like best, rearrange them in the content panel, hide the ones you don't like, and so on.

You can use Bridge to quickly review the images in a folder and open them up in Photoshop, while at a more advanced level, you can perform batch operations, share properties between files by synchronizing the metadata information, apply Camera Raw settings to a selection of images and use the Filter panel to fine-tune your image selections. It is very easy to switch back and forth between Photoshop and Bridge and one of the key benefits of having Bridge operate as a separate program is that Photoshop isn't fighting with the processor whenever you use Bridge to perform these various tasks. Bridge started as a file browser for Photoshop and has evolved to provide advanced browser navigation for all programs in the Creative Suite. Having said that, there isn't anything new in CC and this release is again more notable for what's been taken out, such as the discontinuation of Mini Bridge.

Installing Bridge

Bridge CC is now provided as a separate download. Therefore, when you download Photoshop CC, you will need to remember to download the Bridge package separately and install afterwards. But do also see the notes on page 83 about getting Bridge CS6 to work with Photoshop CC.

Figure 1.100 The Bridge interface consists of three column zones used to contain the Bridge panel components. This allows you to customize the Bridge layout in any number of ways.

The Bridge interface

Bridge can be accessed from Photoshop by choosing File Browse in Bridge... or by using the ** alt* O (Mac), ctrl* alt* O (PC) keyboard shortcut. Once in Bridge you can use the same keyboard shortcut to return to Photoshop again, although to be more precise, this shortcut always returns you to the last used application. So if you had just gone to Bridge via Illustrator, the ** CO [Mac], ctrl* alt* O [PC] shortcut will in this instance take you from Bridge back to Illustrator again.

You can also set the Bridge preferences so that Bridge launches automatically during the system login so that it is always open and ready for use. Bridge initially opens a new window pointing to the last visited folder location. You can have multiple Bridge windows open at once and this is useful if you want to manage files better by being able to drag them from one folder to another. Having multiple windows open also saves having to navigate back and forth between different folders. If you have a dual display setup you can always have the Photoshop application window on the main display and the Bridge window (or windows) on the other.

Image folders can be selected via the Folders or Favorites panels and the folder contents viewed in the content panel area as thumbnail images. When you click on a thumbnail, an enlarged view of the individually selected images can be seen in the Preview panel and images can be opened by double-clicking on the thumbnail. The main thing to be aware of is that you can have Bridge running alongside Photoshop without compromising Photoshop's performance and it is considered good practice to use Bridge in place of the Finder/ Explorer as your main tool for navigating the folders on your computer system and opening documents. This can include opening photos directly into Photoshop, but of course, you can use Bridge as a browser to open up any kind of document: not just those linked to the Adobe Creative Suite programs. For example, Word documents can be made to open directly in Microsoft Word via Bridge.

Making Bridge CS6 work with Photoshop CC

The removal of the Output module and Export panel will annoy some I am sure. But do bear in mind, if you happen to have an older version of Bridge installed, you can still use this in conjunction with Photoshop CC. If you want to do this, then first of all make sure you don't uninstall that earlier version!

From there, make sure you copy the latest Camera Raw plug-in from the CC Camera Raw plug-in folder to the CS6 one. You will also want to open the File Association preferences for Bridge CS6 and update these to open all the main Photoshop supported file formats (such as PSD, TIFF, JPEG, DNG and native raw formats) via Photoshop CC. However, be aware that as Photoshop CC evolves it is less likely to maintain this backward compatibility.

Custom work spaces in Bridge

The Bridge panels can be grouped in different ways and the panel dividers dragged, so for example, the Preview panel can be made to fill the Bridge interface more fully and there are already a number of workspace presets which are available to use from the top bar. In the Figure 1.101 example you can see Bridge being used with the Filmstrip workspace setting.

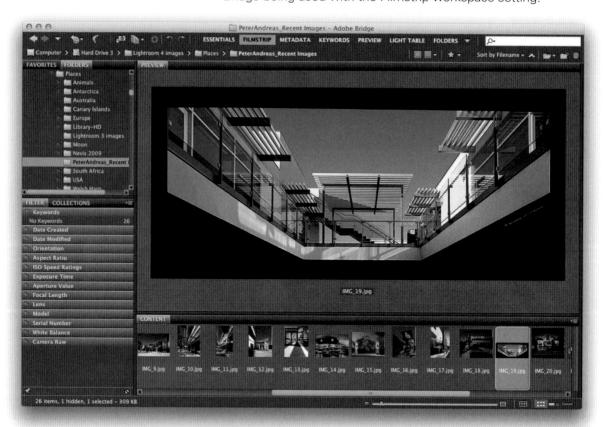

Photograph: © Peter Andreas.

Figure 1.101 You can use the different workspaces to quickly switch Bridge layouts. This example shows the Filmstrip workspace in use, which is a good workspace to start with when you are new to Bridge.

Opening files from Bridge

There are a lot of things you can do in Bridge by way of managing and filtering images and other files on your computer. For now, all that you really need to familiarize yourself with are the Favorites and Folders panels and how you can use these to navigate the folder hierarchy. The Content panel is then used to inspect the folder contents and you can use the Preview panel to see an enlarged preview of the image (or images) you are about to open. Once photos have been selected, just double-click the images within the Content panel (not the Preview panel) to open them directly into Photoshop.

Slideshows

You can also use Bridge to generate slideshows. Just go to the View menu and choose Slideshow, or use the # (Mac), etr) (PC) keyboard shortcut. Figure 1.102 shows an example of a slideshow and instructions on how to access the Help menu.

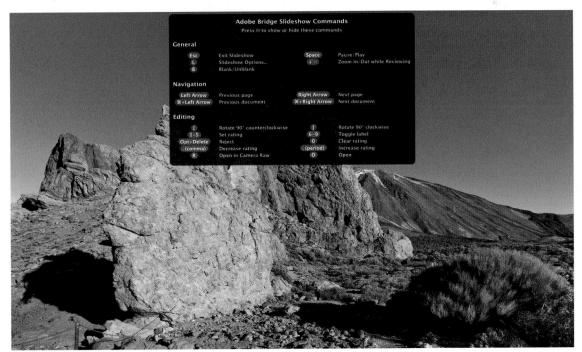

Figure 1.102 You can use the Bridge application View ⇒ Slideshow mode to display selected images in a slideshow presentation, where you can make all your essential review and edit decisions with this easy-to-use interface (press the key to call up the Slideshow shortcuts shown here).

Camera Raw

Camera Raw (which at the time of writing is at version 8.5) offers a number of new features since the original Photoshop CC release. The Workflow options and Save dialogs have been much enhanced. New preview controls allow you to compare before and after versions more flexibly. With localized adjustments there is now a feather control for the spot removal tool and brush edit adjustments when using the graduated and radial filters. There are interactive adjustments on the Histogram and auto Whites and Blacks adjustments in the Basic panel. There is a Pet Eye removal option, auto straightening and lastly, a new Color Smoothness slider in the Detail panel controls.

DNG and transparency support

Camera Raw is able to read transparency in files and represent transparency as a checkerboard pattern (just like in Photoshop). Camera Raw can read simple, single layer files that are saved in the TIFF and PSD file formats as well as read transparency contained in HDRTIFF files and extract the transparency from multi-layered PSD files (providing the maximize compatibility option has been checked).

Opening photos from Bridge via Camera Raw

If you double-click to open a raw or DNG image via Bridge, these will automatically open via the Camera Raw dialog shown in Figure 1.103, where Photoshop will host Camera Raw. Alternatively, if you choose File ⇒ Open in Camera Raw... via the Bridge menu, this will open the file in Camera Raw hosted by Bridge. The advantage of doing this is that it allows you to free up Photoshop to carry on working on other images. If you choose to open multiple raw images you will see a filmstrip of thumbnails appear down the left-hand side of the Camera Raw dialog, where you can edit one image and then sync the settings across all the other selected photos. There is also a preference setting in Bridge that allows you to open up JPEG and TIFF images via Camera Raw too.

The whole of Chapter 2 is devoted to looking at the Camera Raw controls and I would say that the main benefits of using Camera Raw is that any edits you apply in Camera Raw are non-permanent and Photoshop CC offers yet further major advances in raw image processing. If you are still a little intimidated by the Camera Raw dialog interface, you can for

now just click on the Auto button (circled in red in Figure 1.103). When the default settings in Camera Raw are set to Auto, Camera Raw usually does a pretty good job of optimizing the image settings for you. You can then click on the 'Done' or 'Open Image' button without concerning yourself too much just yet with what all the Camera Raw controls do. This should give you a good image to start working with in Photoshop and the beauty of working with Camera Raw is that you never risk overwriting the original master raw file. If you don't like the auto settings Camera Raw gives you, then it is relatively easy to adjust the tone and color sliders and make your own improvements upon the auto adjustment settings.

Full Screen mode

If you click on the Full Screen mode button in Camera Raw (circled below in blue), you can quickly switch the Camera Raw view to Full Screen mode.

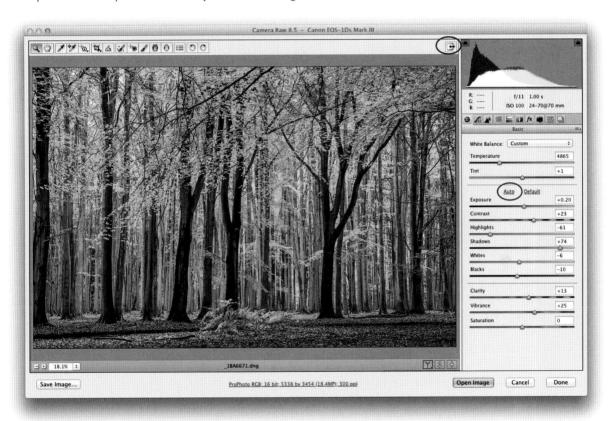

Figure 1.103 When you select a single raw image in Bridge, and double-click to open, you will see the Camera Raw dialog shown here. The Basic panel controls are a good place to get started, but as was mentioned in the text, the Auto button can often apply an adjustment that is ideally suited for most types of images. Once you are happy, click on the Open Image button at the bottom to open it in Photoshop.

Photoshop Online

Photoshop Online... is available from the Help menu and lets you access any late-breaking information along with online help and professional Photoshop tips.

Splash screen

If you drag down from the system or Apple menu to select About Photoshop..., the splash screen reopens and after about 5 seconds the text starts to scroll telling you lots of stuff about the Adobe team who wrote the program, etc. Hold down all and the text scrolls faster. Last, but not least, you'll see a special mention of the most important Photoshop user of all... Now hold down (Mac), ctrl all (PC) and choose About Photoshop... Here, you will see the Single Malt Whiskey Cat beta test version of the splash screen (Figure 1.104).

Figure 1.104 The Single Malt Whiskey Cat beta splash screen.

Chapter 2

Camera Raw Image Processing

In the 18 or so years that I have been writing this series of books, the photography industry has changed out of all recognition. When I first began writing about Photoshop, most photographers were shooting with film cameras, getting their pictures scanned, and only a few professionals were shooting with high-end digital cameras. In the last decade the number of photographers who shoot digitally has grown to the point where it is the photographers who shoot film who are now in the minority. The vast majority of photographers reading this book will therefore be working with pictures that have been shot using a digital SLR or high-end digital camera that is capable of capturing files in a raw format that can be read by Adobe Camera Raw in Photoshop. This is why I have devoted a whole chapter (and more) to discussing Camera Raw image processing.

From light to digital

The CCD or CMOS chip in your camera converts the light hitting the sensor into a digital image. In order to digitize the information, the signal must be processed through an analog-to-digital converter (ADC). The ADC measures the amount of light hitting the sensor at each photosite and converts the analog signal into a binary form. At this point, the raw data simply consists of image brightness information coming from the camera sensor. The raw data must somehow be converted and it is here that the raw conversion method used can make a huge difference to the quality of the final image output. Digital cameras have an on-board microprocessor that is able to convert the raw data into a readable image file. which in most cases will be in a JPEG file format. The choice here normally boils down to raw or JPEG output. The quality of a digital image is therefore primarily dependent on the lens optics used to take the photograph, the recording capabilities of the CCD or CMOS chip and the analog-to-digital converter, but it is the raw conversion process that matters most. If you choose to process the raw data on your computer, you have much greater control than is the case if you had let your camera automatically guess the best raw conversion settings to use.

Camera Raw advantages

Although Camera Raw started out as an image processor exclusively for raw files, it has, since version 4.0, also been capable of processing any RGB image that is in a JPEG or TIFF file format. This means you can use Camera Raw to process any image that has been captured by a digital camera, including raw photos up to 65,000 pixels in any dimension or up to 512 megapixels in size, or a photograph that has been scanned by a film scanner and saved as an RGB TIFF or JPEG. Camera Raw allows you to work non-destructively and anything you do to process an image in Camera Raw is saved as an instruction edit and the pixels in the original file are never altered. In this respect, Camera Raw treats your master files like they were your negatives and you can use Camera Raw to process an image any way that you like without ever altering the original.

The new Camera Raw workflow

When Camera Raw first came out it was regarded as a convenient tool for processing raw format images, without having to leave Photoshop. The early versions of Camera Raw had controls for applying basic tone and color adjustments, but Camera Raw could never, on its own, match the sophistication of Photoshop. Because of this, photographers would typically follow the Camera Raw workflow steps described in Figure 2.1. They would use Camera Raw to do all the 'heavy lifting' work such as adjusting the white point, exposure and contrast and from there output the picture to Photoshop, where they would carry out the remaining image editing.

Camera Raw 8 in Photoshop CC offers far more extensive image editing capabilities and it is now possible to replicate in Camera Raw some of the things which previously could only have been done in Photoshop. The net result of all this is that you can (and should) use Camera Raw as your first port of call when preparing any photographic image for editing in Photoshop. Let's be clear, Camera Raw does not replace Photoshop. It simply enhances the workflow and offers a better set of tools to work with in the early stages of an image editing workflow. Add to this what I mentioned earlier about being able to work with JPEG and TIFF images, and you can see that Camera Raw is a logical place for any image to begin its journey through Photoshop.

If you look at the suggested workflow listed in Figure 2.2 you will see that Camera Raw 8 now has everything you need to optimize and enhance your photographs. It can also be

argued that if you use Camera Raw to edit your photos, this replaces the need for Photoshop adjustments such as Levels, Curves and Hue/Saturation. To some extent this is true, but as you will read later in Chapter 5, these Photoshop adjustment tools are still relevant for fine-tuning the images that have been processed in Camera Raw first, especially when you want to edit your photos directly or apply certain kinds of image effects that require the use of adjustment layers or additional image layers.

Does the order matter?

- ⇒ Set the white point
- Apply a fine-tuned camera calibration adjustment
- ⇒ Set the highlight and shadow clipping points
- Adjust the brightness and contrast
- ⇒ Adjust the color saturation
- ⇒ Compensate for chromatic aberrations and vignetting
- Apply basic sharpening and noise reduction
- ⇒ Apply a crop
- ⇒ Open images in Photoshop for further image editing

Figure 2.1 Camera Raw 1 offered a limited but useful range of image adjustments, and this remained unchanged through to version 3.0 of Camera Raw.

- ⇒ Set the white point
- Apply a Camera Profile camera calibration adjustment
- ⇒ Apply a Lens Profile calibration adjustment (correct for distortion, chromatic aberrations and vignetting)
- ⇒ Apply an Upright perspective correction
- ⇒ Set the overall Exposure brightness
- ⇒ Enhance the highlight detail using the Highlights slider
- ⇒ Enhance the shadow detail using the Shadows slider
- Fine-tune the highlight and shadow clipping points
- ⇒ Adjust the midtone contrast (Clarity)
- ⇒ Fine-tune the Tone Curve contrast
- ⇒ Fine-tune the color saturation/vibrance plus HSL color
- ⇒ Retouch spots using the clone or heal brush modes
- ⇒ Make localized adjustments (i.e. adjustment brush, radial/ graduated filter)
- Apply capture sharpening and noise reduction
- ⇒ Apply a crop and/or a rotation
- Den images in Photoshop for further image editing

Figure 2.2 Camera Raw 8 has now extended the list of things that can be done to an image at the Camera Raw editing stage.

Camera Raw support

Camera Raw has kept pace with nearly all the latest raw camera formats in the compact range and digital SLR market, but only supports a few of the higher-end cameras such as the Hasselblad, Leaf, Leica and Phase One cameras. Camera Raw currently offers support for over 490 raw camera formats, including most of the leading models, and is updated regularly every three months or so. As I mentioned here, you can also use Camera Raw to open JPEG and TIFF files. It is an RGB editor, so is designed to edit in RGB. However, CMYK files can be opened via Camera Raw, but these will be converted to RGB upon opening. For the full list, go to: www.adobe.com/products/photoshop/ extend.html. With Camera Raw 8 there is implicit support for PNG. This has been done mainly with a view to providing PNG support in Lightroom. In terms of Photoshop Camera Raw use, such PNG support remains pretty much hidden at this point.

Figure 2.3 The camera's on-board processor is used to generate the low resolution JPEG preview image that appears in the LCD screen. The histogram is also based on this JPEG preview and therefore a poor indicator of the true exposure potential of a raw capture image.

When you edit an image in Camera Raw it does not matter which order you apply the adjustments in. For example, Figure 2.2 shows just one possible Camera Raw workflow. So for example, you could start by applying a crop first and work your way through the rest of the list backwards. However, you are best advised to start with the major adjustments first, such as setting the white point and Exposure in the Basic panel before you go on to fine-tune the image using the other controls. Also, with the advent of advanced lens corrections in Camera Raw, you are now advised to apply these early on, such as after applying a lens profile correction before you apply an Upright correction.

Raw capture

If you are shooting with a professional digital back, digital SLR, or an advanced compact digital camera, you will almost certainly have the capability to shoot using the camera's raw format mode. The advantages of shooting raw as opposed to JPEG mode are not always well understood. If you shoot using JPEG, the files are compressed by varying amounts and this file compression enables you to fit more captures on to a single card. Some photographers assume that shooting in raw mode simply provides you with uncompressed images without JPEG artifacts, but there are other, more important reasons why capturing in raw mode is better than shooting JPEG. The main benefit is the flexibility raw gives you. The raw file is like a digital negative, waiting to be interpreted any way you like. It does not matter about the color space or white balance setting that was used at the time of capture, since these can all be set later in the raw processing. You can also liken capturing in raw mode to shooting with negative film, since when you shoot raw you are recording a master file that contains all the color information that was captured at the time of shooting. To carry the analogy further, shooting in JPEG mode is like taking your film to one of those old high street photo labs, throwing away the negatives and making scans from the prints. If you shoot in JPEG mode, the camera is deciding automatically at the time of shooting how to set the white balance and tonal corrections, often clipping the highlights and shadows in the process. In fact, the camera histogram you see on the camera LCD is based on the JPEG interpretation capture data regardless of whether you are shooting in raw or JPEG mode (see Figure 2.3).

When shooting raw, all you need to consider is the ISO setting and camera exposure. But this advantage can also be seen by some to be its biggest drawback; since the Camera Raw stage adds to the overall image processing, this means more time has to be spent working on the images, plus there will be an increase in the file size of the raw captures and download times. Therefore, some news photographers and others may find that JPEG capture is preferable for the kind of work they do.

JPEG capture

When you shoot in JPEG mode, your options are more limited since the camera's on-board computer makes its own automated decisions about how to optimize for tone, color, noise and sharpness. When you shoot using JPEG or TIFF, the camera is immediately discarding up to 88% of the image information that's been captured by the sensor. This is not as alarming as it sounds, because as you'll know from experience, you don't always get a bad photograph from a JPEG capture. But consider the alternative of what happens if you shoot using raw mode. The raw file is saved without being altered by the camera. This allows you to work with all 100% of the image data that was captured by the sensor. If you choose to shoot in JPEG capture mode you have to make sure that the camera settings are absolutely correct for things like the white balance and exposure. There is some room for maneuver when editing JPEGs, but not as much as you get when editing raw files. In JPEG mode, your camera will be able to fit more captures onto a card, and this will depend obviously on the capture file size and compression settings used. However, it is worth noting that at the highest quality setting, JPEG capture files are sometimes not that much smaller than those stored using the native raw format. What you will find though is that the burst capture rate is higher when shooting in JPEG mode and for some photographers, such as those who cover sports events, speed is everything.

Editing JPEGs and TIFFs in Camera Raw

Not everyone is keen on the idea of using Camera Raw to open non-raw images. However, the Camera Raw processing tools are so powerful and intuitive to use so why shouldn't they be available to work on other types of images? The idea of applying further Camera Raw processing may seem redundant in the case of JPEGs, but despite these concerns, Camera

It's 'raw' not 'RAW'

This is a pedantic point, but raw is always spelled using lower case letters and never all capitals, which would suggest that 'raw' was some sort of acronym, like JPEG or TIFF, which it isn't.

Adobe Photoshop Lightroom

The Adobe Photoshop Lightroom program is designed as a raw processor and image management program for photographers. It uses exactly the same Adobe Camera Raw color engine that is used in Photoshop, which means that raw files that have been adjusted in Lightroom can also be read and opened via Camera Raw in Photoshop or Bridge, Having said that, there are compatibility issues to be aware of whereby only the most recent version of Camera Raw will be able to fully interpret the image processing carried out in Lightroom and vice versa. Lightroom does have the advantage of offering a full range of workflow modules designed to let you edit and manage raw images all the way from the camera import stage through to Slideshow, Book, Print or Web output. There is no differentiation made between a raw or non-raw file, and with the latest Process 2012, the same default settings are applied when a photo is first imported. When you choose to open a Lightroom imported, non-raw file (a JPEG. TIFF or maximum compatibility PSD) into Photoshop, Lightroom gives you the option to apply or not apply Lightroom edited image adjustments.

Raw does happen to be a good JPEG image editor. So from one point of view, Camera Raw can be seen as offering the best of all worlds, but it can also be seen as a major source of confusion (is it a raw editor or what?)

Perhaps the biggest problem so far has been the implementation rather than the principle of non-raw Camera Raw editing. In the Configuring Photoshop PDF (available on the book website) I made the point that opening JPEGs and TIFFs via Camera Raw was made unnecessarily complex in Photoshop CS3, but following the changes made in Photoshop CS4, this issue has been mostly resolved. The Camera Raw file opening behavior for non-raw files is now much easier to configure and anticipate (see the Configuring Photoshop PDF on the book website for the full details).

On the other hand, if you look at the Lightroom program, I think you'll find that the use of Camera Raw processing on non-raw images works very well indeed (I explain the Lightroom approach to non-raw editing in a separate PDF that's also on the book website). It has to be said that editing non-raw files in Lightroom is much easier to get to grips with, since Lightroom manages to process JPEGs rather seamlessly (see sidebar).

Alternative Raw processors

While I may personally take the view that Camera Raw is a powerful raw processor, there are other alternative raw processing programs photographers can choose from. Some camera manufacturers supply their own brand of raw processing programs which either come free with the camera or you are encouraged to buy separately. Other notable programs include Capture One (www.phaseone.com/ en/software.aspx), which is favored by a lot of professional shooters, Bibble (www.bibblelabs.com), DxO Optics Pro (www.dxo.com) and Apple's Aperture which can also be seen as a rival for Adobe's own Lightroom program. If you are using some other program to process your raw images and are happy with the results you are getting then that's fine. Even so, I would say that the core message of this chapter still applies, which is to use the raw processing stage to optimize the image so that you can rely less on using Photoshop's own adjustment tools to process the photograph afterwards. Overall it makes good sense to take advantage of the non-destructive processing in Camera Raw to freely interpret the raw capture data in ways that can't be done using Photoshop alone.

A basic Camera Raw/Photoshop workflow

The standard Camera Raw workflow should be kept quite simple. Select the photo you wish to edit and double-click the thumbnail in Bridge to open it in Camera Raw. Or, you can use the R (Mac), MR (PC) shortcut to open in Camera Raw via Bridge (this is discussed later on page 112). In the example shown over the next few pages, I mainly used the Basic panel controls to adjust the white balance, and make some initial tone edits. With these basic adjustments it is possible to produce a well-balanced color master image that can then be edited in Photoshop, where layers and filters can be added as necessary. Any special effects or black and white conversions are best applied at the end in Photoshop (as shown in Step 5).

1 In this first step I opened a window in Bridge, selected a raw photo that I wished to edit and double-clicked on the highlighted thumbnail to open it via Camera Raw in Photoshop.

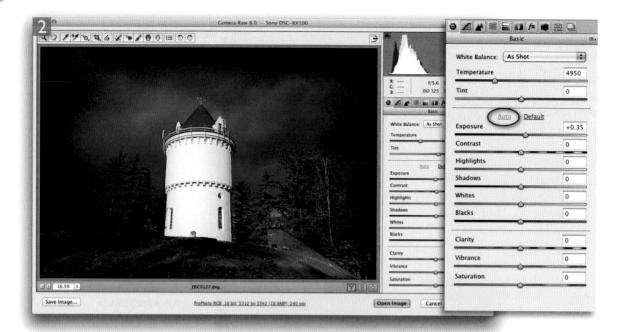

2 This shows the photograph opened via the Camera Raw dialog hosted in Photoshop, where I clicked 'Auto' (circled) to apply the Camera Raw Auto settings.

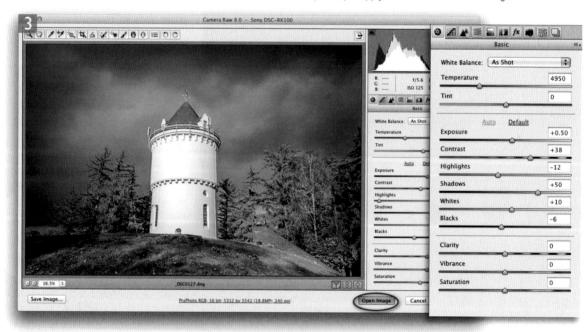

3 I was then able to use the Basic panel controls to optimize the tone, color and contrast. Once I was happy with the way the image looked I clicked the Open Image button (circled) to continue editing it in Photoshop.

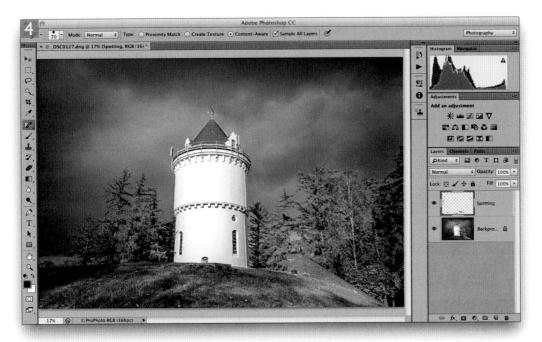

Opening the image from Camera Raw rendered a pixel image version of the raw file that could then be edited in Photoshop using all the tools that Photoshop has to offer.

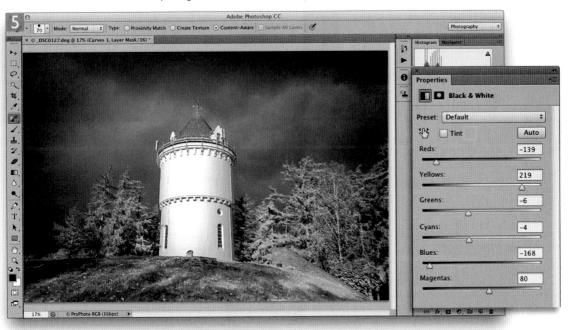

In this step I added a Black & White adjustment layer to the top of the layer stack. This allowed me to preserve the color data in the retouched image and retain the ability to switch this conversion on or off.

Forward compatibility for raw files

Adobe's policy is to provide ongoing Camera Raw support throughout the life of a particular Photoshop product. This means if you bought Photoshop CS6, you will have been provided with free Camera Raw updates up until version 7.4. Once a new Photoshop program comes out. Camera Raw support is only continued for customers who bought the latest version. Consequently, you are obliged to upgrade Photoshop if you wish to take advantage of the support that's offered for any new cameras. Now that Adobe offer a Creative Cloud subscription license, such customers will always be able to access the most current version of any Adobe product that's included in the Cloud. Even if you don't choose to upgrade Photoshop you won't be completely blocked from being able to process raw files from all the latest cameras. If you refer to the end of this chapter you can read about the free DNG Converter program that is always released at the same time as any Camera Raw updates. What you can do is use DNG Converter to convert any supported raw camera format file to DNG. When you do this, the DNG file can then be read by any previous version of Camera Raw.

Camera Raw support

Camera Raw won't 'officially' interpret the raw files from every digital camera, but over 490 different raw formats are now supported and Adobe is committed to providing intermittent free Camera Raw updates that will always include any new camera file interpreters as they become available. This generally happens about once every three months and sometimes sooner if a significant new camera is released. It used to be the case that these updates were always to add support for more cameras and fix a few bugs and/or improved integration with Lightroom. These days a Camera Raw update may well include major new features. For example, the Camera Raw 7.1 update for Photoshop CS6 included new defringe controls in the Lens Corrections panel and the ability to edit 32-bit HDRTIFF files. It is therefore always worth keeping a close check on any new Camera Raw releases to see if they contain important new features.

Now understand that while not all raw camera file formats are supported, this is in no way the fault of Adobe. Certain camera manufacturers have, in the past, done things like encrypt the white balance data, which makes it difficult for anyone but themselves to decode the raw image data. The Camera Raw team have always done their best to make Camera Raw compatible with the latest digital cameras, but sometimes there have been obstacles that aren't directly Adobe's fault.

DNG compatibility

The DNG file format is an open-standard file format for raw camera files. DNG was devised by Adobe and there are already a few cameras such as Leica, Ricoh and Hasselblad H2D cameras that can shoot directly to DNG; there are also now quite a few raw processor programs that can read DNG, including Camera Raw and Lightroom of course. Basically, DNG files can be read and edited just like any other proprietary raw file format and it is generally regarded as a safe file format to use for archiving your digital master files. For more about the DNG format I suggest you refer to page 274 at the end of this chapter.

Getting raw images into Photoshop

There was a time, not so long ago, when one would simply scan a few photographs, put them in a folder and double-click to open them up in Photoshop. These days most photographers are working with large numbers of images and it is therefore important to be able to import and manage those images efficiently. With Photoshop 7, Adobe introduced the File Browser, which was like an alternative open dialog interface that was built in to the Photoshop program. The File Browser offered a superior way to manage your images, allowing you to preview and manage multiple images at once. The File Browser was then superseded by Bridge, which was supplied as a separate program and included as part of the CS2 Creative Suite.

As image browser programs go, Bridge's main advantage is that you have ready access to Photoshop. You can open up single or multiple images and apply batch operations all directly from within Bridge. If you compare Bridge with other browser programs, it has enough basic functionality to suit most photographers' needs, although it has to be said that Bridge has yet to provide the full functionality that professional photographers have come to rely on in other programs, such as those which are dedicated to the task of managing large numbers of photographs (such as Lightroom or Aperture).

Image ingestion

The first thing we should look at is how to get the images from the camera and on to the computer, such as when shooting with a studio setup like the one shown in Figure 2.4. This process is usually referred to as 'image ingestion'.

Bridge features a Photo Downloader utility program that makes the downloading process easier to carry out than was the case in earlier versions of Bridge. Over the next few pages I have outlined all the steps that are required when working with the Photo Downloader. It so happens that I mostly use Lightroom to import my photos, so for comparison purposes I have provided a PDF on the book website where I show an example of how to use the Lightroom program to import captured images to the computer ready for Lightroom and Photoshop editing.

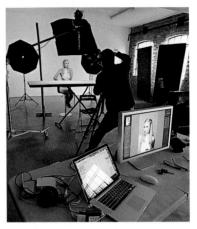

Figure 2.4 Here is a typical studio setup where I have a laptop computer (plus a separate display) stationed close to the actual shooting area, ready to process the captured images from the shoot. With the setup shown here I am able to import images either via a card reader or by shooting tethered.

Importing images via Photo Downloader

EOS_DIGITAL

1 To begin with I inserted a camera card into the computer via a card reader. The card should mount on the desktop, or appear in the My Computer window, as a newly mounted volume.

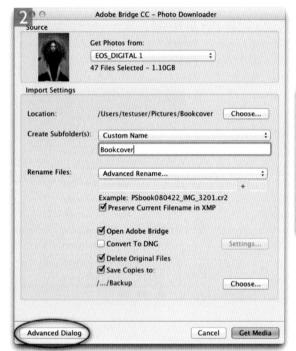

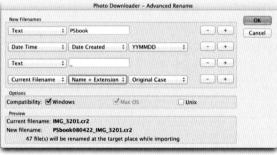

Figure 2.5 The subfolder naming options.

2 The next thing was to launch Bridge CC and choose File ⇒ Get Photos from Camera... This opened the Photo Downloader dialog shown here, where I could start by selecting where to download the files from (in this instance, the EOS Digital camera card). Next, I chose a location to download the photos to. Here, I selected the Pictures folder. I then selected 'Custom Name' from the Create Subfolder(s) menu (see Figure 2.5) and typed in a name for the shoot import (this name is appended to the Location setting to complete the file path). I then went on the Rename Files menu, selected the Advanced Rename... option and configured the rename settings as shown above. If the 'Delete Original Files' option is checked, Photo Downloader gives you the option to delete the files from the camera card once they have been successfully downloaded to the computer. I then checked the Save Copies to: option and clicked on the Choose... button to locate a backup folder to save the backup files to.

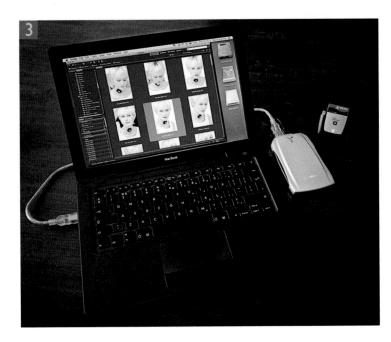

3 Let's review the Photo Downloader settings that have been applied so far. The camera card contained the images I wished to import and the Photo Downloader settings had so far been configured to copy these files to the primary disk location (which in this instance would be the computer hard drive), and at the same time made a backup copy of all the files to a secondary location (in this case, a backup hard drive). With the setup shown here, I was able to use Photo Downloader to make renamed copies of the files to the principal drive/folder location and, if desired, convert the files to DNG as I did so. With this type of configuration I would end up with two copies of each image: one on the main computer and one on the backup drive.

Backup insurance

For as long as they remain in one location only, your camera files are vulnerable to loss. This is especially true when they only exist on the camera card, which can easily get lost or the data could become corrupted. This is why it is always a good idea to get the camera files off the card and safely stored on a computer hard drive as soon as possible. Not only that, it is also a good idea to make a backup of the camera files as you do so. Note that Bridge will apply the settings setup in the Photo Downloader to the files that are copied to the main folder location. But, the files that are copied to the backup location will be plain clone copies of the original camera files. The backup copy files will not be renamed (as are the main import files). This is a good thing because should you make a mistake during the rename process you will always retain a backup version of the files just as they were named when captured by the camera. Basically, backup files are like an insurance policy against both a drive failure as well as any file renaming mix-ups.

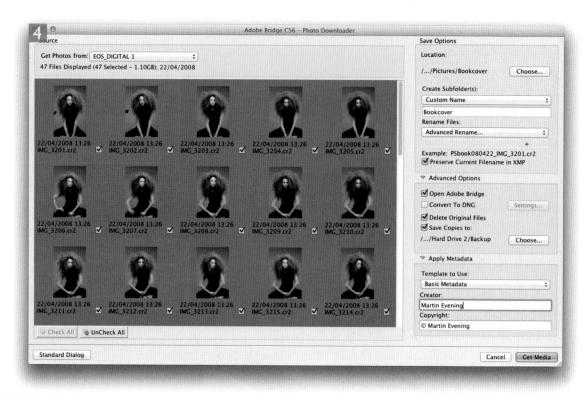

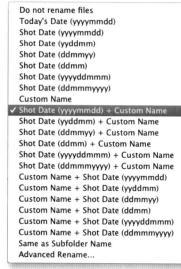

Figure 2.6 Here are the options for the Rename Files menu in the above dialog.

4 I then clicked on the Advanced dialog button in the bottom left corner (circled in Step 2). This revealed an expanded version of the Photo Downloader dialog, which allowed me to see a grid preview of all the images I was about to import from the card. I could now decide which images were to be imported by clicking on the thumbnail checkboxes to select or deselect individual photos. You can also use the Check All and Uncheck All buttons in the bottom left of the dialog to select or deselect all the thumbnails at once.

The Rename Files section allowed me to choose a renaming scheme from the options shown in Figure 2.6. Which you should choose here will depend on what works best for you. In this example I retained the custom settings that were configured in Step 2. I could see how the renaming would work by inspecting the Example filename below, where, as you can see, the imported files were automatically renumbered beginning from the start number entered here. If you check the Preserve Current Filename in XMP, this gives you the option to use the Batch Rename feature in Bridge to recover the original filename at a later date.

The Advanced Options lets you decide what happens to the imported images after they have been renamed. You will most likely want to check the Open Adobe Bridge option so that Bridge displays the image download folder contents as the images are being imported. In the Apply Metadata section you can also choose a pre-saved metadata template and enter your author name and copyright information. This is then automatically embedded in the metadata of all the files as they are imported.

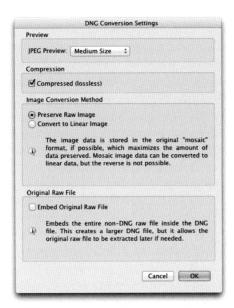

5 If the Convert to DNG option is selected, this can be used to convert raw images to the DNG file format as they are imported. If you click on the Settings... button (next to the Convert to DNG option in Photo Downloader) this opens the DNG Conversion Settings dialog shown here. If you select the Medium Size JPEG Preview option, this will generate a standard size preview for the imported pictures. There is no point in generating a full size preview just yet since you may well be changing the camera raw settings soon anyway, so to get reasonably fast imports it is better to choose 'Medium Size'. Check the Compressed option if you would like smaller file sizes (note this uses lossless compression and does not risk degrading the image quality). In the Image Conversion Method section I suggest you don't choose 'Convert to Linear Image', but choose 'Preserve Raw Image' as this keeps the raw data in the DNG in its original state. Lastly, you can choose to embed the original raw data (along with the DNG data) in the DNG file, but I would advise against this unless you really need to preserve the proprietary raw file data.

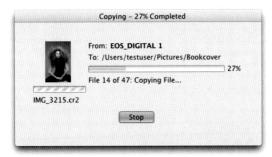

6 After I clicked on the Get Photos button in the Photo Downloader dialog, the images started to download from the card to the disk location specified in the Save Options in Step 4. The above progress dialog showed me how the download process was proceeding.

Converting to DNG

For some people it can be useful to carry out a DNG conversion straight away, but be warned that this will add to the time it takes to import all the photos. To read more about converting proprietary raw files to DNG and the conversion settings shown here, please refer to pages 274–278 at the end of this chapter.

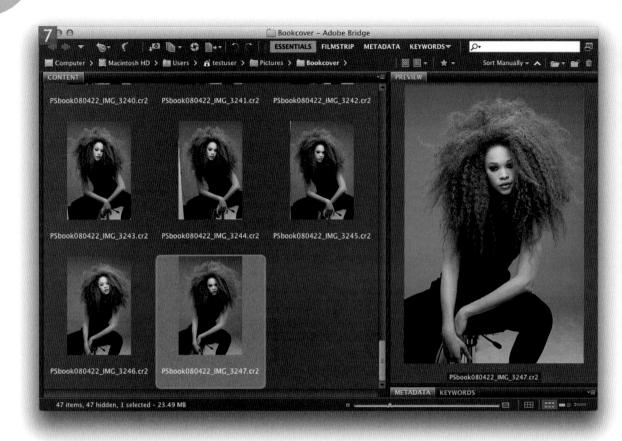

Deleting camera card files

It isn't actually necessary to delete the files from the camera card first, because formatting a card in the camera deletes everything that's on the card anyway. Formatting the card is good housekeeping practice as this helps guard against future file corruptions occurring. However, I find that if I am in the midst of a busy shoot it is preferable to get into a routine of deleting the files before you put the card back in the camera. Otherwise I am always left with the nagging doubt: 'Have I downloaded all the files on this card yet?' Is it really safe to delete everything on this card?'

7 Because the 'Open Adobe Bridge' option had been selected, once all the photos were downloaded, Bridge opened a new window to display the imported photos that were now in the selected download images folder.

8 Also, because the 'Delete Original Files' option was selected, the above warning dialog appeared once the downloads to the primary destination folder (and backup folder) were complete. This step conveniently cleared the camera card of all the images that were stored on it and prepared it for reuse in the camera. Be warned that this step bypasses any opportunity to confirm if you really want to delete these files. Once you click 'Yes', the files will be permanently removed from the card. When I put a card back in the camera I usually reformat it anyway before shooting a fresh batch of photos to that card (see sidebar: Deleting camera card files).

Tethered shoot imports

There is no direct support for tethered shooting in Bridge CC, but if Bridge were able to do so, it would have to offer tethered support for many if not all the cameras that Camera Raw already supports. Enabling full tethered shoot functionality is difficult enough to do for one camera let alone several hundred. This is why those software programs that do offer tethered shooting, such as Capture One and Bibble, only do so for a specific range of digital cameras. However, it is possible to shoot in tethered mode with Bridge, but it all depends on the capabilities of your camera and whether it has a suitable connection socket, plus if the supplied camera software allows you to download files directly to the computer. Many cameras (especially digital SLR cameras) will most likely come with some kind of software that allows you to hook your camera up to the computer via a FireWire (IEEE 1394), USB 2, USB 3 or Ethernet cable (Figure 2.7). If you are able to download files directly to the computer, then Bridge can monitor that folder and this will give you a next best solution to a dedicated software program designed to operate in tethered mode.

The only drawback to shooting tethered is that the camera must be wired up to the computer and you don't have complete freedom to wander around with it. If you have a wireless communication device it may be possible to shoot in a direct import mode to the computer, without the hassle of a cable, but at the time of writing, wireless shooting isn't particularly speedy when shooting raw files with a typical digital SLR.

Over the next few pages I have described a method for shooting in tethered mode with a Canon EOS camera, using the EOS Utility program that ships with most of the Canon cameras. This program lets you download camera files as they are captured, to a designated watched folder. Nikon owners will find that Nikon Capture NX2 includes a Camera Control component that allows you to do the same thing as the Canon software and establishes a watched folder to download the images to. The latest version of Nikon Capture supports all the latest D Series cameras. Alternatively, you might want to consider buying Bibble Pro 5 software from Bibble Labs (www.bibblelabs.com). Bibble Pro does not cost as much as Nikon Capture. It enables tethered shooting with a wide variety of digital cameras and, again, allows you to establish a watched folder for the downloaded images, which you can monitor using Bridge CC.

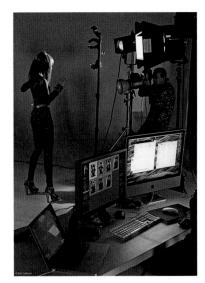

Figure 2.7 Here is a photograph taken of me at work in the studio, shooting in tethered mode.

Which utility?

One of the problems with the Canon system is the way the utility programs have been named and updated with succeeding generations of cameras. First of all there was EOS Viewer Utility and now EOS Utility, which have both interacted with a program called EOS Capture. On top of this you also have to make sure that you are using the correct version of 'utility' software for your camera. It would help if there were just one program that was updated to work with all Canon cameras.

Which transfer protocol?

Nikon and Canon systems both offer FTP and PTP transfer protocols. Make sure you select the right one, as failure to do so can result in an inability to get tethered shooting to work. This information can be found in the camera manufacturer's manual for your camera model.

Tethered shooting via Canon EOS Utility

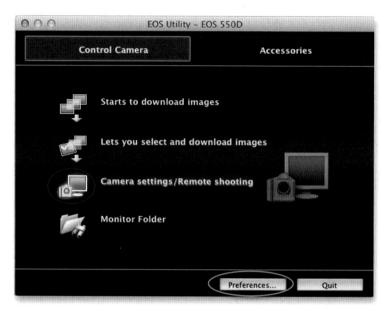

1 To begin with, I made sure the camera was tethered to the computer correctly and was switched on, I then launched EOS Utility and clicked the Preferences button (circled in blue) to open the Preferences dialog shown in Step 2 below.

2 In the Destination Folder section, I clicked on the Browse... button and selected a destination folder that the camera captures were to be downloaded to. This could be an existing folder, or a new folder, such as the 'watched folder' selected here. Meanwhile, in the Linked Software section, I set the 'Software to link' to 'None'.

3 I also needed to establish a file renaming scheme. It is possible to carry out the file renaming in Bridge afterwards, but establishing this beforehand can save time and helps reduce the risk of error if it's applied automatically as the files are captured. In this example, I selected the Shooting Date+Prefix+Number file naming scheme and set the start count number to '1'.

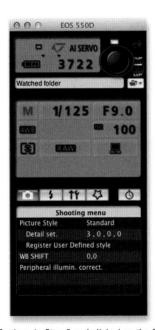

4 I then clicked OK to the Settings in Step 3 and clicked on the Camera Settings/ Remote shooting option circled in red in Step 1. This opened the Camera control window shown here, where I could configure the camera settings remotely. As soon as this window appeared I was ready to start shooting.

Lightroom conflict

If you are also running Lightroom, the one thing to watch out for here is that the watched folder you select in Step 2 does not conflict with a watched folder that is currently being monitored by the Lightroom program. If this is the case, you will need to disable the auto-import feature in Lightroom first before using it to import photos that can be viewed via Bridge.

Auto renumbering

When you select a numbering option in the File Name section, the numbering will keep on auto-updating until such time as you change the file prefix name. This is useful to know because it means that if you were to lose a camera connection or switch the camera off between shoots, the EOS Utility program knows to continue the file renaming of the import files from the last number used.

Remote shooting controls

As soon as the Camera control window appears you know that you have succeeded in establishing a tethered connection and are ready to start shooting. This can be done by pressing the shutter on the camera, or alternatively, you can use the EOS Capture utility to capture the photos remotely from the computer by clicking on the large round button (circled in red in Step 4). You can also use this window to adjust the camera settings by selecting any of the status items in the window and use the left/right keyboard arrow keys to navigate between the various mode options and use the up/down keys to increase or decrease the individual settings.

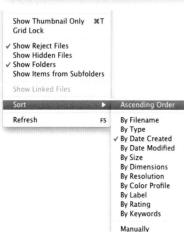

5 As I started shooting, the EOS Utility enabled the import of the camera files directly into the watched folder I had established in Step 1 and renamed them (as configured in Step 2). All I needed to do now was point Bridge at the same watched folder as was configured in the EOS Utility preferences and I would see the pictures appear in Bridge directly. Of course, if you are shooting continuously in the studio or on location with a setup like this, then you will most likely wish to see the newest pictures appear first at the top of the content area in the Bridge window. To do this, I went to the View menu and ensured the Ascending Order item in the Sort menu was deselected (as shown in the screen shot on the left). Having done this, the files would now be sorted in reverse order with the most recent image appearing at the top.

When you have finished shooting in tethered mode, you will either need to move the files from the watched folder and place them elsewhere, or rename the folder. The main thing to be aware of here is that every time you start a new shoot, you will either want to choose a new job folder to download the photos to, or move the files from this folder to a new location and make sure that the watched folder you are linking to has been emptied. Of course, you could always create an Automator workflow action (Mac), or VB script (Windows PC) that allowed you to press a button to do the transfer and clearing of the watched folder.

Importing images via other programs

Figure 2.8 highlights some of the various methods that can be used for importing images. There is no one program that can do everything perfectly, but of these, I would say Capture One is the only program capable of ticking all the essential boxes (as long as your camera is supported). Ingestamatic and ImageIngester are great utility programs that can provide a fast and robust import workflow. These are both currently available as demo versions from the link on the right. The newest versions allow you to download from up to 8 cards simultaneously. They can also provide raw file verification, apply default Camera Raw settings and incorporate GPS tagging.

Ever since Adobe Photoshop Lightroom was first released, I have been using it in the studio and on location to import images from cards as well as when shooting in tethered mode. To show you how I do this, I have included a PDF on the book website that demonstrates how I use Lightroom to import new photos into the computer. However, I do still use Bridge a lot for various browsing tasks. For example, I mainly used Bridge to manage all the files used in the production of this book.

Ingestamatic and ImageIngester

The Ingestamatic[™] and ImageIngester[™] utilities have been designed by Marc Rochkind and are aimed at photographers who shoot raw files, and who need to ingest hundreds of images from a typical shoot. You can download demos of both from the following link: http://basepath.com/new/index1.php.

	Direct integration with Bridge	File renaming	Full auto renumbering	Secondary backup of data	Convert to DNG	Import settings saved for concurrent imports	Tethered shooting	Preview and pre- selection of import files
Photo Downloader in Bridge	1	1	1	1	1	1		1
Tethered shooting via Bridge	1						/*	
DNG Converter		1	1		1	1		
Lightroom Import Photos		1	1	1	1	1	1	1
ImageIngester Standard		1	1	1	1	1		
Capture One		1	1	1	1	1	1	1

Figure 2.8 In this table I have compared the features that are available when using some of the various methods for importing camera images into the computer. As you can see, there is no one perfect solution out there that will let you do everything (although Lightroom and Capture One tick all the important boxes). Lightroom does include the ability to shoot tethered, but does not provide as extensive support or as many options as some of the other methods of tethered shooting.

^{*} In these instances, tethered shooting is only possible if done in conjunction with a camera manufacturer's import software.

TWAIN origins

On a side note here, the name TWAIN was originally arrived upon as a reference to Rudyard Kipling's 'The Ballad of East and West', in which he writes: '...and never the twain shall meet...'. An alternative explanation is that it's an acronym for 'Technology Without An Interesting Name'.

Import Images from Device (Mac only)

This isn't a raw capture feature, but while we are on the subject of importing images I do want to draw attention here to 'Import Images from Device' from the File \Rightarrow Import submenu in Photoshop. This lets you interact with scanner devices and import images from a scanner directly into Photoshop (although you do need to install the appropriate driver and configure the scanner before you can scan images in this way). The impetus for this was the fact that TWAIN 64-bit drivers are pretty scarce, and this feature does at least offer some extra features that TWAIN can't offer, such as support for networked scanners and cropping and rotation of images on import. This does at least give Macintosh users a simple interface control for importing photos from their desktop scanners.

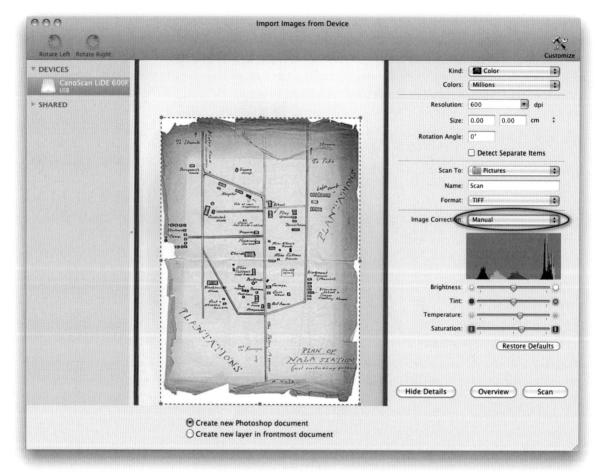

Figure 2.9 This shows Import Images from Device with a scanner device selected.

When a supported scanner device is selected from the Devices menu, you'll see options like those shown in Figure 2.9, where I selected the Manual option in the Image Correction menu (circled). This revealed the extra image adjustment controls that were available for this scanner. As you can see, what you have here is fairly basic and advanced users will most likely prefer to stick with dedicated scanner software such as Vuescan or SilverFast. There is though an option to 'Detect Separate items', which works the same way as the Crop and Straighten command from the File \Rightarrow Automate submenu. At the bottom are two buttons, which allow you to choose whether to import files as new image documents, or to place as a new layer in the frontmost document.

Import Images from Device does more though than just allow you to connect to desktop scanner devices. You can also import files from a connected digital camera, or a card reader. If you have an iSight camera connected to your computer, you can even use it to take photos. In Figure 2.10 you can see that I had a smart phone connected to the computer and could use Import Photos from Device to import the photos I had stored on it.

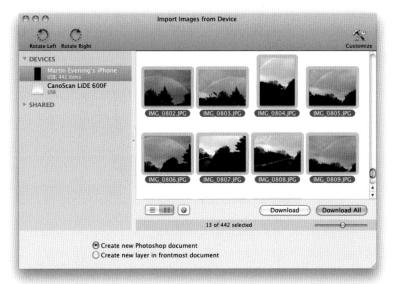

Figure 2.10 This shows Import Images from Device with a smart phone device selected. Note that the Rotate Right and Rotate Left icons are dimmed when importing images from a scanner but are enabled when importing images from a camera.

Scanning to layers

When you choose 'Create new layer in frontmost document', the scanned image will be placed as a Smart Object layer. If you have 'Detect Separate Items' checked and this means you are going to be making multiple scans, you will need to commit each layer before the following scanned layer can be placed. If not, an alert will appear: 'Cannot create new layer while current layer is active. Double-click layer to deactivate.' Click OK to get rid of the alert message. However, if you do not commit the placed layer in time, you will lose all further scanned images, though copies will be saved to the usual designated scan folder.

Closing the Import Images dialog

The 'Import Images from Device' dialog always remains open after you have made a scan. This is so that it remains on standby for making further scans. You can close it either by clicking on the Close button, or use the ** (Mac), ** (PC) shortcut.

Closing Bridge as you open

If you hold down the *III* key as you double-click to open a raw image, this closes the Bridge window as you open the Camera Raw dialog hosted by Photoshop.

Installing updates

Adobe release regular Camera Raw updates which keep Camera Raw up-to-date and compatible with the latest digital cameras. The update process is fairly straightforward, where standard installers for Mac and PC will automatically update Camera Raw for you. Note that whenever there is an update to Camera Raw there will also be an accompanying update for Lightroom and Adobe DNG Converter.

Basic Camera Raw image editing

Working with Bridge and Camera Raw

The mechanics of how Photoshop and Bridge work together are designed to be as simple as possible so that you can open single or multiple images or batch process images quickly and efficiently. Figure 2.11 summarizes how the file opening between Bridge, Photoshop and Camera Raw works. Central to everything is the Bridge window interface where you can browse, preview or make selections of the images you wish to process. To open images, select the desired thumbnail (or thumbnails) and open using one of the following three methods: use the File ⇒ Open command, use a doubleclick, or use the # O (Mac), ctrl O (PC) shortcut. All of the above methods can be used to open a selected raw image (or images) via the Camera Raw dialog hosted by Photoshop. If the image is not a raw file, it will open in Photoshop directly. Alternatively, you can use File ⇒ Open in Camera Raw... or use the #R (Mac), ctr/R (PC) shortcut to open images via the Camera Raw dialog, this time hosted by Bridge. This allows you to perform batch processing operations in the background without compromising Photoshop's performance. If the 'Double-click edits Camera Raw Settings in Bridge' option is deselected in the Bridge General preferences, Shift doubleclicking allows you to open an image or multiple selections of images in Photoshop directly, bypassing the Camera Raw dialoa.

Opening single raw images via Photoshop is quicker than opening them via Bridge, but when you do this Photoshop does become tied up managing the Camera Raw processing and this in turn will prevent you from doing any other work in Photoshop. The advantage of opening via Bridge is Bridge can be used to process large numbers of raw files in Camera Raw, while freeing up Photoshop to perform other tasks. You can then toggle between the two programs. For example, you can be processing images in Camera Raw while you switch to working on other images that have already been opened in Photoshop.

Regarding JPEG and TIFF images, Camera Raw can be made to open these as if they were raw images, but please refer to page 142 for a fuller description as to how JPEG and TIFF files can be made to open in Camera Raw.

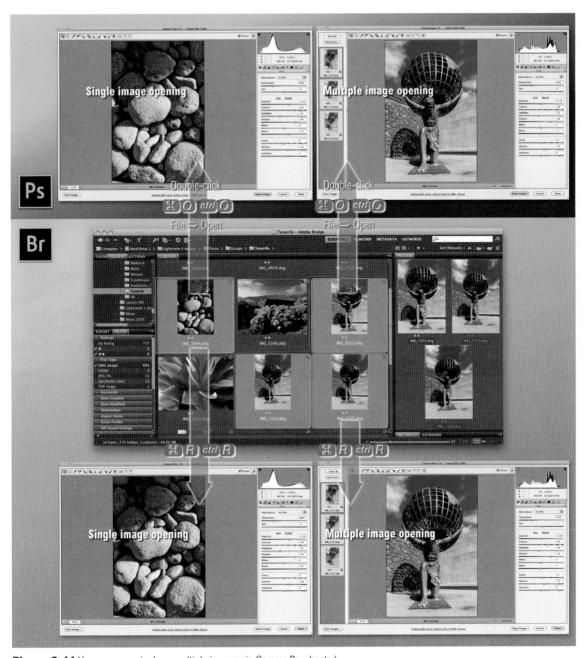

Figure 2.11 You can open single or multiple images via Camera Raw hosted by Photoshop using a double-click, File ⇒ Open or ♣ ② (Mac), ﴿ (PC). Photoshop is ideal for processing small numbers of images. If you use ♣ ♠ (Mac), ﴿ (PC), Bridge hosts the single or multiple Camera Raw dialog. Opening via Bridge is better suited for processing large batches of images in the background.

Camera Raw tools

Zoom tool (Z)

Use as you would the normal zoom tool to zoom the preview image in or out.

Hand tool (H)

Use as you would the normal hand tool to scroll a magnified preview.

White balance tool (I)

The white balance tool is used to set the White Balance in the Basic panel.

Color sampler tool (S)

Allows you to place up to 9 color sampler points in the preview window (these are temporary and are not stored in the XMP data).

். Target adjustment tool (T)

This allows you to use the cursor to mouse down on an image and apply targeted image adjustments, dragging the cursor up or down.

♥ Crop tool (C)

The crop tool can apply a crop setting to the raw image which is applied when the file is opened in Photoshop.

Straighten tool (A)

Drag along a horizontal or vertical line to apply a 'best fit', straightened crop.

Spot removal (B)

Use to remove sensor dust spots and other blemishes from a photo.

😼 Red eye removal tool (E)

For removing red eye from portraits shot using on-camera direct flash.

Adjustment brush (K)

Use to paint localized adjustments.

Graduated filter (G)

Use to apply linear graduated localized adjustments.

Radial filter (J)

Use to apply radial graduated localized adjustments.

Open the Camera Raw preferences dialog.

Rotate counterclockwise (L)

Rotates the image 90° counter clockwise.

C Rotate clockwise (R)

Rotates the image 90° clockwise.

General controls for single file opening

Whenever you open a single image, you will see the Camera Raw dialog shown in Figure 2.12 (which, in this case, shows Camera Raw hosted via Bridge). The status bar shows which version of Camera Raw you are using and the make of camera for the file you are currently editing. In the top left section you have the Camera Raw tools (which I have listed on the left) and below that is the image preview area where the zoom setting can be adjusted via the pop-up menu at the bottom. The initial Camera Raw dialog displays the Basic panel control settings and in this mode the Preview checkbox allows you to toggle global adjustments that have been made in Camera Raw on or off. Once you start selecting any of the other panels, the Preview toggles only the changes that have been made within that particular panel.

The histogram represents the output histogram of an image and is calculated based on the RGB output space that has been selected in the Workflow options. As you carry out Basic panel adjustments, the shadow and highlight triangles in the histogram display will indicate the shadow and highlight clipping. As either the shadows or highlights get clipped, the triangles will light up with the color of the channel or channels that are about to be clipped and if you click on them, will display a color overlay (blue for the shadows, red for the highlights) to indicate which areas in the image are currently clipped.

At the bottom are the Show Workflow Options, which when clicked will open the Workflow Options dialog shown in Figure 2.13. The destination color space should ideally match the RGB workspace setting established in the Photoshop color settings, and I would suggest setting the bit depth to 16-bits per channel, as this ensures a maximum number of levels are preserved when the image is opened in Photoshop. The file size setting lets you open images using smaller or larger pixel dimensions than the default capture file size (these size options are indicated by + or – signs) and the Resolution field lets you set the file resolution in pixels per inch or per centimeter, but note that the value selected has no impact on the actual pixel dimensions of the image.

The default Camera Raw dialog takes up more room than earlier versions did. So, to allow for small screen sizes you can adjust the dialog size to allow scrolling of the panels, thus allowing the dialog to still fit smaller screen displays.

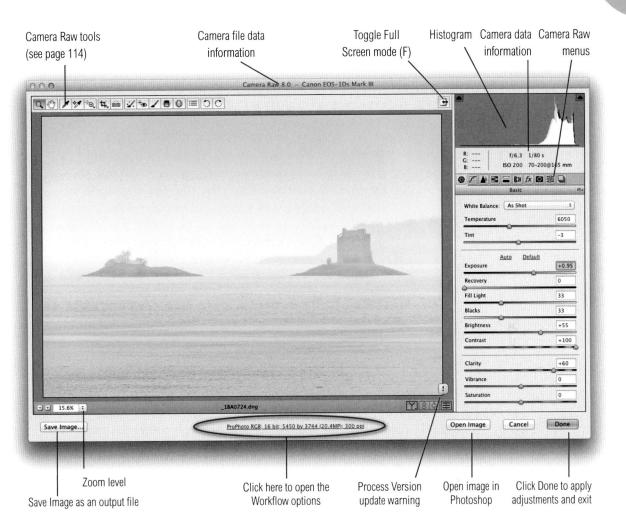

Figure 2.12 This shows the Camera Raw dialog (hosted by Bridge), showing the main controls and shortcuts for the single file open mode. You can tell if Camera Raw has been opened via Bridge, because the 'Done' button is highlighted. This is an 'update' button that you click when you are done making Camera Raw edits and wish to save these settings, but without opening the image.

If you click on the Workflow options (circled), this opens the Workflow Options dialog shown (see page 122), where you can adjust the settings that determine the color space the image will open in, the bit depth, cropped image pixel dimensions plus resolution (i.e. how many pixels per inch).

Figure 2.13 After editing an image via the Camera Raw dialog, you will see a settings badge appear in the top right corner of the image thumbnail (circled). This indicates that an image has been edited in Camera Raw.

Figure 2.14 If there is a process version conflict when selecting multiple files, there will be the option to convert all the selected files to the process version that's applied to the most selected image.

Full size window view

The Toggle Full screen mode button () can be used to expand the Camera Raw dialog to fill the whole screen, which can make Camera Raw editing easier when you have a bigger preview area to work with. Click this button again to restore the previous Camera Raw window size view.

General controls for multiple file opening

If you have more than one photo selected in Bridge, you can open these all up at once via Camera Raw. If you refer back to Figure 2.11, you can see a summary of the file opening behavior, which is basically as follows. If you double-click (or use File ⇒ Open ((Mac), (Mac), (PC)), this opens the multiple image Camera Raw dialog hosted via Photoshop (as shown in Figure 2.15) and if you choose File ⇒ Open in Camera Raw... or (Mac), (Mac), (MR) (PC), this opens the multiple image Camera Raw dialog hosted via Bridge.

The multiple image dialog contains a filmstrip of the selected images running down the left-hand side of the dialog and you can select individual images by clicking on the thumbnails in the filmstrip, or use the Select All button to select all the photos at once. You can also make custom selections of images via the filmstrip using the Shift key to make continuous selections, or use the (Mac), ctrl (PC) key to make discontinuous selections of images. Once you have made a thumbnail selection you can then navigate the selected photos by using the navigation buttons in the bottom right section of the Preview area to progress through them one by one and apply Camera Raw adjustments to individually selected images. The Synchronize... button then allows you to synchronize the Camera Raw settings adjustments across all the images that have been selected, based on the current 'most selected' image. This will be the thumbnail that's highlighted with a blue border. When you click on the Synchronize... button, the Synchronize dialog (Figure 2.16) lets you choose which of the Camera Raw settings you want to synchronize. You can learn more about this and how to synchronize Camera Raw settings on page 255, as well as how to copy and paste Camera Raw settings via Bridge.

Once a photo has been edited in Camera Raw you will notice a badge icon appears in the top right corner of the Bridge thumbnail (Figure 2.13). This indicates that a photo has had Camera Raw edit adjustments applied to it.

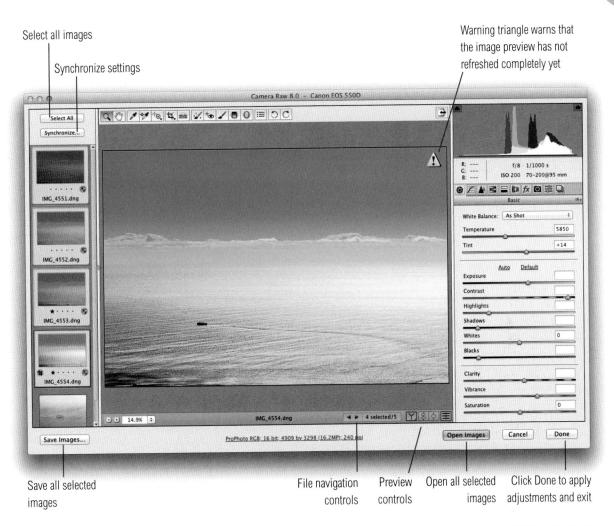

Figure 2.15 Here is a view of the Camera Raw dialog in the multiple file open mode, hosted in Photoshop (you can tell because the Open Images button is highlighted here). This screen shot shows a filmstrip of opened images on the left where all four of the opened images are currently selected and the bottom image (highlighted with the blue border) is the one that is 'most selected' and displayed in the preview area. Camera Raw adjustments can be applied to the selected photos one at a time, or synchronized with each other, by clicking on the Synchronize settings button. This opens the Synchronize dialog shown in Figure 2.16. Because images may now have different process versions, if you select multiple photos that use different process versions, the Basic panel will show a message like the one shown in Figure 2.14, requiring you to update the selected photos to the process version applied to the most selected image. Note that if you hold down the all key as you do so, this will bypass the Synchronize dialog options and synchronize everything.

Figure 2.16 The Synchronize dialog.

New preview controls

The old preview checkbox has been replaced with new controls that allow you to quickly compare the current state of the image with a before or checkpoint state. Repeat clicking the preview mode button lets you cycle through the five available modes. To see the list shown in Figure 2.17, click on the preview mode button and hold the mouse down. You can also use the Q key to advance to the next preview setting.

Note that zooming or panning in one pane view automatically zooms or pans on the other. As soon as you use the crop, or straighten tool, this will always take you back to the full 'After' preview mode.

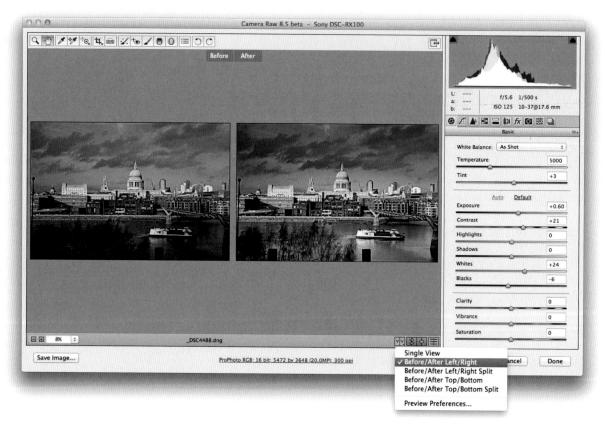

Figure 2.17 This shows the new preview controls menu for previewing the current state against a before, or checkpoint view state. The five options are: Single View; Before/After Left/Right (as shown here); Before/After Left/Right Split; Before/After Top/Bottom; Before/After Top/Bottom Split.

Checkpoints

Anyone who has worked with Lightroom will be familiar with these preview controls and also the fact that you are able to create checkpoints mid-session to create an updated before preview to compare against.

The Swap button () can be used to swap the current image settings with the before or checkpoint state settings. What happens here is when you click this the settings in the image for the before state are actually updated (like creating a new snapshot). You can then click again on the Swap button to return to the previous working state and also use the key to swap between the two states. To update the current checkpoint using the current settings, click the Checkpoint button (), or use the alt P shortcut. You can also use the Toggle between current settings button () to toggle the preview between the current settings and defaults for that panel, or use the # alt P (Mac) ctrl alt P (PC) shortcut.

Suppose you want to compare one image state against another. Once you arrive at a setting you wish to compare with, click the Swap button to make the current After state the new Before state. You can then load a pre-saved snapshot setting and load this as a new After preview to compare with the current Before checkpoint state; you can then click on the Swap button again to swap between these two states.

Preview preferences

The Preview Preferences can be accessed via the menu shown in Figure 2.17. This allows you to enable/disable the various Cycle Preview Modes (when clicking on the Preview button or using the shortcut) and choose to show or hide the Draw Items listed below. The screen shots shown here were all captured with the Divider in side-by-side views and Divider in split views checked.

Figure 2.18 The Preview Preferences dialog, which can be accessed via the Preview options list shown in Figure 2.17.

1 In this first step I selected the Before/After Left/Right Split preview.

2 Here you can see the image previewed using the Before/After Top/Bottom preview.

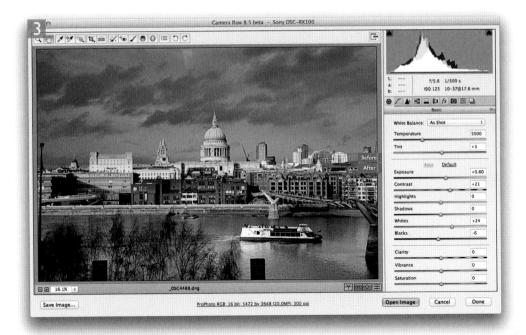

3 And this shows the Before/After Top/Bottom Split preview.

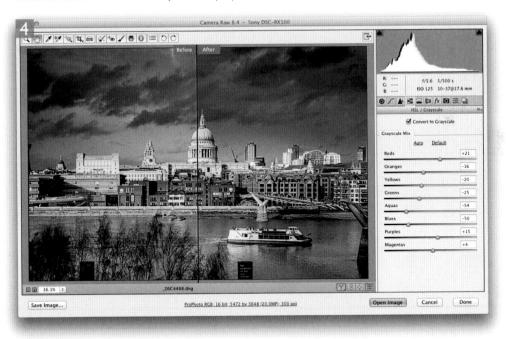

4 In this example, I returned to the Before/After Left/Right Split preview and clicked on the Checkpoint button (to update the Before preview. I then converted the image to black and white and was now able to compare this state with the full color edited checkpoint state.

Saving Workflow presets

The Workflow Options dialog allows you to save presets. For example, in Figure 2.19 you can see the Workflow Options dialog configured to use a SWOP Medium GCR profile as the preview space using a Relative Colorimetric rendering intent and saved as a preset setting. This allows you to quickly switch between different workflow options settings, which can also be accessed by right mouse-clicking the Workflow options.

Workflow options

Clicking on the blue hyperlink text (at the bottom of Figure 2.17) opens the Workflow Options dialog. This determines how files are saved, or opened in Photoshop via Camera Raw. The new Workflow Options dialog is shown in Figure 2.19. The Color Space options now allow you to choose any available profile space as the output space. This includes printer profiles, CMYK profiles, or the Lab space even.

Next, we have the Image Sizing options, where you can set the pixel dimensions and resolution for the saved/opened images. Included here is a Percentage menu option, which means you can now specify a percentage to resize an image by. Below that is the Output Sharpening section, where you can choose to sharpen the rendered image for print or screen output. These options are relevant if you are producing a file to go directly to print or for a website. If you intend carrying out any type of further retouching then leave this disabled.

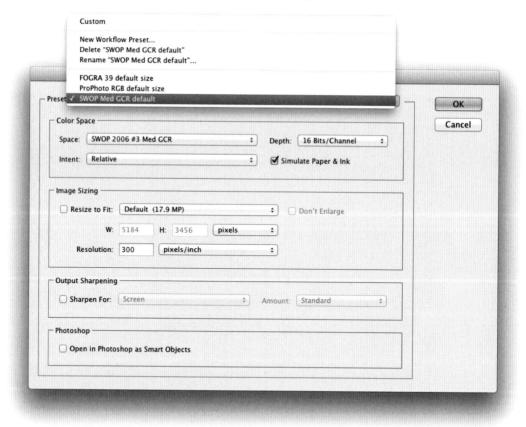

Figure 2.19 The Camera Raw Workflow Options dialog showing the Presets menu.

CMYK proofing

One of the more obvious benefits the new Workflow Options dialog brings is the ability to soft proof in Camera Raw. Some of you will be aware that soft proofing was introduced in Lightroom 4, which lets you use the Develop module to very effectively preview how an image is likely to look when printed. The new Workflow Options dialog allows you to kind of do the same thing. It does not provide a total workflow solution the way Lightroom does, but when you select a profile such as a CMYK profile this affects the way the preview image is displayed in the Camera Raw dialog, and you now also have the option to select a rendering intent and compare between the use of a Relative or Perceptual conversion. The Workflow Options dialog shown below in Figure 2.20 shows a CMYK profile selected.

Essentially, when you select a specific CMYK profile the preview adjusts to show how the image you are editing in Camera Raw will look when output or saved as a CMYK TIFF, PSD or JPEG pixel image. When the Output options are configured in this way everything you adjust in Camera Raw is

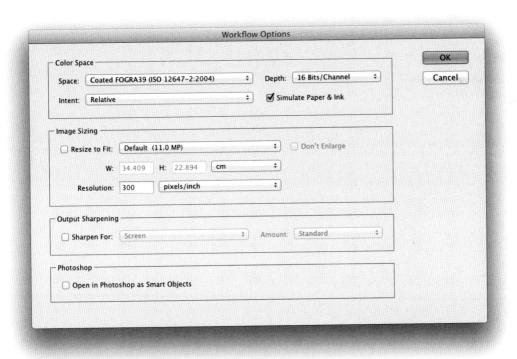

Figure 2.20 The Workflow Options dialog with CMYK profile selected.

filtered through the prism of the selected CMYK output profile. You can also check the 'Simulate Paper & Ink' box to simulate how the image will appear when printed. The underlying image will still be edited as a full raw image. It is just the preview that is modified to provide a more realistic interpretation of the final output. The same thing applies when you select an inkjet printer profile. The Camera Raw preview aims to show the outcome when printing to a specified printer profile.

Output proofing and the computer display

The one thing to point out here with soft proofing in Camera Raw is that the accuracy of the soft proof view can only be as good as the monitor display you are using to view the image on. Most standard LCD displays have a native color gamut that is not that different from the sRGB color space. Consequently, a basic display isn't going to help you much when evaluating color output if the gamut of the display is smaller than that of the output space. However, even in these situations the soft proofing can still be valid in terms of judging the tone contrast. You will at least be able to get a sense of the tone appearance of the intended print output and modify the contrast accordingly. A better answer is to use a professional quality display that is able to match closely to the Adobe RGB gamut. That way you should be able to at least gauge CMYK color output reasonably accurately.

Saving soft proofed raw files as smart objects

Prompted by my colleague, Jeff Schewe, it became clear that you can take this one stage further. If you check the 'Open in Photoshop as Smart Objects' box at the bottom of the Camera Raw Workflow Options dialog (see Step 1 opposite), this allows you to open a raw image as a Smart Object in Photoshop. Now, if you happen to select a CMYK profile that matches the intended print output you can preview how your raw images will look when printed in CMYK. When you then save the smart object image as a TIFF, it can be placed directly into an InDesign layout. The following steps summarize such a workflow.

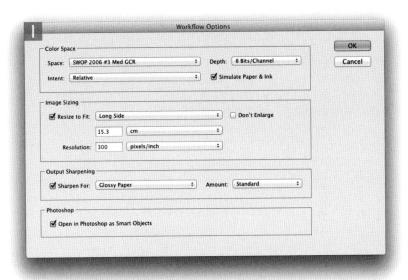

1 To begin with, I opened the Workflow Options and set the output space to the intended CMYK output space. I set the rendering intent in this case to 'Relative' and checked the Simulate Paper & Ink box. The long side image dimension was adjusted to match that of the page layout column width. In the Output Sharpening section I checked the Sharpen For box and chose 'Glossy Paper' from the menu using a 'Standard' Amount. I also checked the 'open in Photoshop as Smart Objects' box.

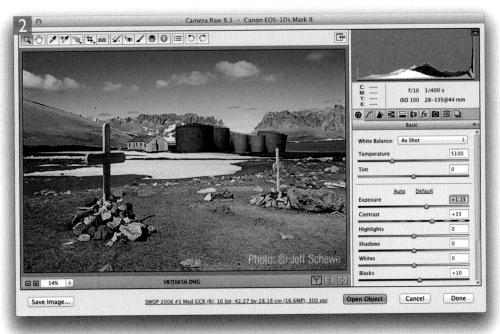

2 In Camera Raw the Open Image button now showed as 'Open Object'. I clicked this to open as a smart object in Photoshop.

3 Here you can see the Layers panel view of the image opened in Photoshop as a smart object. I then saved the smart object image as a TIFF (which could be placed directly into an InDesign layout).

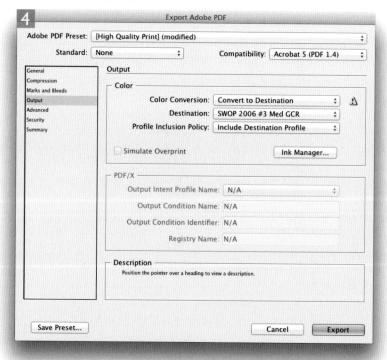

4 When exporting the layout from InDesign as a PDF, I went to the Output settings, selected the intended CMYK output space and chose 'Convert to Destination'. This meant that during the PDF export, the images such as the one shown in step 3 would be converted to CMYK directly from the original raw data.

Summary of the proposed soft proofing workflow

Let me now go back over the steps described on the previous two pages. The Workflow Options in Camera Raw were set to the CMYK profile of the intended CMYK output and the size settings were adjusted to match the column width. The rendering intent was set to Relative (because this tends to be the optimum rendering intent for most color images) and the Simulate Paper & Ink option was checked so the preview gave a reasonable indication of how the final image would look when printed.

In the Output Sharpening section I chose to apply a standard glossy paper output sharpening setting. Ideally, I would prefer to apply a custom Photoshop action that applied a more precise form of sharpening designed for CMYK printing. However, the paper sharpening settings offered here are the same ones used in the Lightroom Book module when output sharpening files for Blurb books that are printed on an Indigo press. Experience shows that this sharpening workflow, while not intended for CMYK repro, does appear to work well enough for this purpose.

The raw image was opened as a smart object in Photoshop, preserving all the raw data. The Camera Raw settings remained editable and the Camera Raw preview allowed me to make color and tone adjustments while being able to preview the CMYK outcome.

The smart object image could then be saved as a TIFF (preserving the Camera Raw data) and placed directly in an InDesign layout. It would still be possible to double-click the layout image to open it in Photoshop and double-click the smart object layer thumbnail to edit the Camera Raw settings.

At the PDF export stage the PDF settings were set so that when the PDF generation took place, the original raw data was read, the Camera Raw adjustment settings applied and the image data resized to the desired pixel dimensions. Next, the image data was sharpened for output and converted to CMYK according to the settings configured in the Export to PDF dialog, making sure the Camera Raw Output and PDF Export Output settings both matched.

Soft proofing in practice

These few simple additions to the Workflow Options dialog have some interesting implications. The ability to select various output profiles is definitely a big step forward and gives photographers the option to edit their photographs while being able to preview the expected print outcome while working in Camera Raw. That much is easy enough to implement and get to grips with. The other thing we can now do is devise a non-destructive Camera Raw to print workflow in which the raw data remains completely editable right through to the final Export to PDF stage. This is seemingly a good thing to do, but comes at a cost. I would not choose to do this with the books I produce because of the sheer number of images involved. Saving raw images as smart objects will result in image files that are very large and always much bigger than a rendered TIFF that was resized to match the required output size. This would work if the rendering intent is to be the same for all printed images. In practice I tend to use both Relative and Perceptual rendering intents when converting images to CMYK as well as different black generation profiles. Now, if it were possible to have a link between Camera Raw and InDesign whereby you could assign the rendering intent and profile in the Workflow Options and have these picked up at the Export to PDF stage, this would make such a workflow more practical. Maybe this will be on the cards for the future?

Opening raw files as Smart Objects

The Smart Objects feature in Photoshop can be used to open a raw image in Photoshop and have the Camera Raw settings remain editable. Essentially, if you open a photo from Camera Raw as a Smart object, it is placed as a Smart Object layer in a new Photoshop document. This is almost like a hidden feature, but once discovered can lead to all sorts of interesting possibilities. There are two ways you can go about this. You can click on the Workflow options link to open the Workflow Options dialog and check the 'Open in Photoshop as Smart Objects' option (see Figure 2.21). When this is done all Camera Raw processed images will open as Smart Object layers in Photoshop. The other method is to simply hold down the Smitt key to make the Camera Raw 'Open Image' button change to say: 'Open Object'.

It is also now possible to apply Camera Raw adjustments as a filter in Photoshop. This isn't the same as being able to place a raw image as a Camera Raw Smart Object, but it does give you the option to apply Camera Raw style edits to already rendered RGB images in Photoshop (see page 224).

Let's now look at a practical example in which I opened two raw images as Smart Object layers and was able to merge them as a composite image in Photoshop.

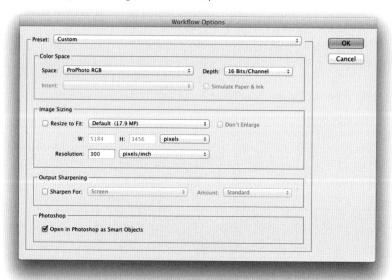

Figure 2.21 If you click on the Workflow options link this opens the Workflow Options dialog, where you can check the 'Open in Photoshop as Smart Objects' option. Alternatively, hold down the **Shift** key as you click the 'Open Image' button.

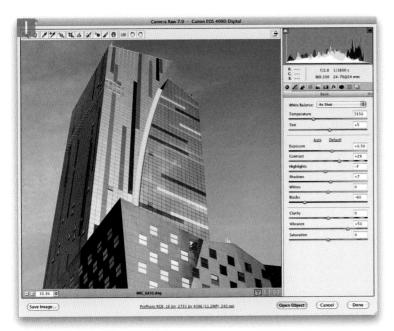

In this first step, I opened a raw image of a building and held down the *Shift* key as I clicked on the 'Open Image' button, to open it as a Smart Object layer in Photoshop.

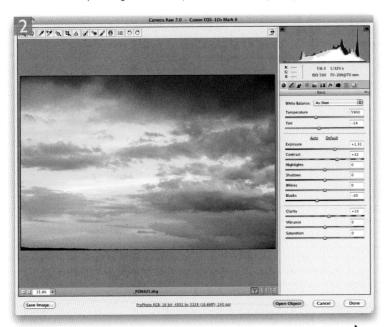

In this next step I selected a new image, this time a photo of a sky, and again, held the *Shift* key as I clicked on the 'Open Image' button, to open this too as a Smart Object layer.

3 In Photoshop I dragged the Smart Object layer of the sky across to the Smart Object layer image of the building, to add it as a new layer. I then made a selection of the outline of the building and applied it as a layer mask to create the merged photo shown here.

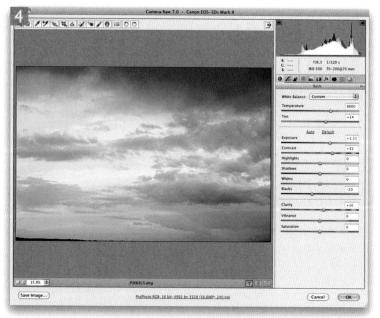

4 Because both of these layers were raw image Smart Objects, I was able to doubleclick the top layer thumbnail (circled in red in Step 3 above) to open the Camera Raw dialog and edit the settings. In this case I decided to give the sky more of a sunset color balance.

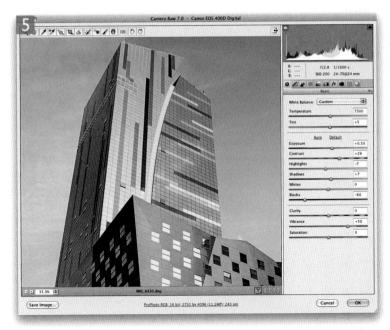

5 The same thing happened when I double-clicked the lower layer. This too opened the raw image Smart Object layer via Camera Raw and allowed me to warm the colors and add more contrast to the building.

6 This shows the Photoshop image with the revised Smart Object layers. The thing to bear in mind here is that all edits made to the Smart Object layers are completely non-destructive.

Saving photos from Camera Raw

When you click on the Save Image... button you have the option of choosing a folder destination to save the images to and a File Naming section to customize file naming. In the Format section you can choose which file format to use when rendering a pixel version from the raw master. These options include: PSD, TIFF, JPEG or DNG. If you have used the crop tool to crop an image in Camera Raw, the PSD options allow you to Preserve the cropped pixels by saving

Figure 2.22 Clicking on the Save Image... button opens the Save Options dialog. After configuring the options and clicking 'Save', you will see a status report next to the Save Image button that shows how many images remain to be processed. For more about the new DNG save options, see page 274 at the end of this chapter.

the image with a non-background layer (in Photoshop you can use Image ➡ Reveal All should you wish to revert to an uncropped state). The JPEG and TIFF format saves provide the usual compression options and if you save using DNG you can convert any raw original to DNG. The file save processing is then carried out in the background, allowing you to carry on working in Bridge or Photoshop (depending on which program is hosting Camera Raw at the time) and you'll see a progress indicator (circled in Figure 2.22) showing how many photos there are left to save.

If you hold down the [att] key as you click on the Save... button, this will bypass the Save dialog box and save the image (or images) using the last used Save Options settings. This is handy if you want to add file saves to a queue and continue making more edit changes in the Camera Raw dialog.

Saving a JPEG as DNG

Although it is possible to save a JPEG or TIFF original as a DNG via Camera Raw it is important to realize that this step does not actually allow you to convert a JPEG or TIFF file into a raw image. Once an image has been rendered as a JPEG or TIFF it cannot be converted back into a raw format. Saving to DNG does though allow you to use DNG as a container format for a JPEG or TIFF. For example, this means that you can now store a Camera Raw rendered preview alongside the JPEG or TIFF data, which will be portable when sharing such files with other (non Camera Raw aware) programs. Also, now that one can save using a lossy DNG format, on this level at least, there are some reasons for saving JPEGs using DNG.

Resolving naming conflicts

A save operation from Camera Raw will auto-resolve any naming conflicts so as to avoid overwriting any existing files in the same save destination. This is done by incrementing a number at the end of the filename when saving. This is important if you wish to save multiple versions of the same image as separate files and avoid overwriting the originals.

New Save dialog

Along with refinements to the Workflow Options, the Save dialog allows you to save a document using a profiled color space (Figure 2.23). These new options are at the bottom. Basically, you can preview a document in Camera Raw using a profiled color space and have the ability to export using that same color space. When saving as a rendered TIFF, PSD or JPEG, you can select the desired color space and choose an image sizing setting that is independent of what has been set in the Workflow Options dialog. You can also choose to apply output sharpening when saving. Once configured you can save these settings as a preset.

Figure 2.23 The new Camera Raw Save dialog.

Altering the background color

You can set the background color of the work area and toggle the visibility of the image frame. Right mouse-click outside the image in the work area to select the desired options from the contextual pop-up menu (see Figure 2.24).

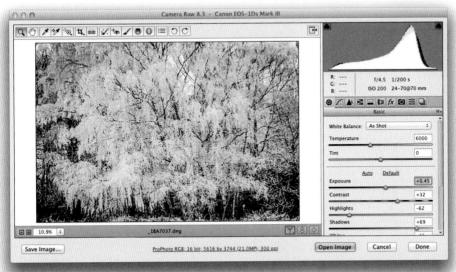

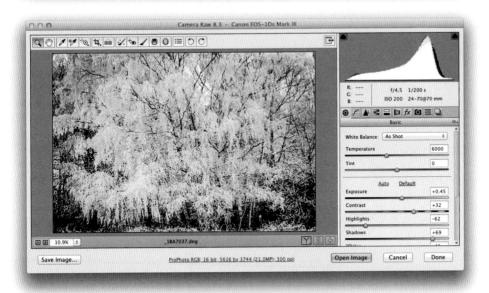

Figure 2.24 In these screen shots you can see examples of the Camera Raw interface using alternative background colors. In the top screen shot a white background was used and in the lower screen shot a medium gray color was selected.

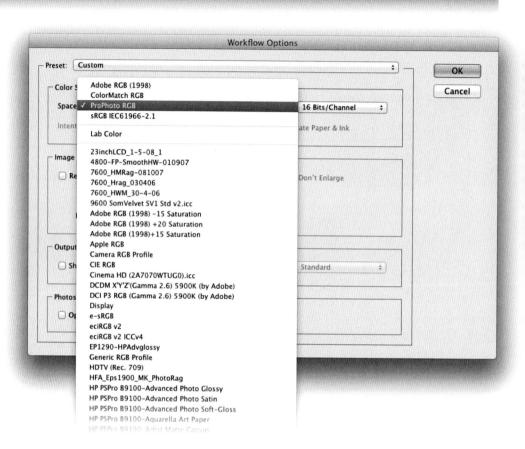

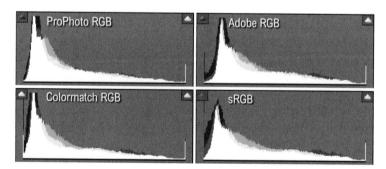

Figure 2.25 This Camera Raw histogram may vary depending on which color space is selected in the Workflow options.

The histogram display

The Camera Raw Histogram provides a preview of how the Camera Raw output image histogram will look after the image data has been processed and output as a pixel image. The histogram appearance is affected by the tone and color settings applied in Camera Raw, but more importantly, is also influenced by the RGB space selected in the Workflow options (see Figure 2.25). It can therefore be interesting to compare the effect of different output spaces when editing a raw capture image. For example, if you edit a photo in an RGB space like ProPhoto or Adobe RGB and then switch to sRGB, you will most likely see some color channel clipping in the histogram. Such clipping can then be addressed by readjusting the Camera Raw settings to suit the smaller gamut RGB space. This exercise is particularly useful in demonstrating why it is better to output your Camera Raw processed images using either the ProPhoto or Adobe RGB color spaces.

Digital camera histograms

Some digital cameras provide a histogram display that enables you to check the quality of what you have just shot. This too can be used as an indication of the levels captured in a scene. However, the histogram you see displayed is usually based on a JPEG capture image. If you prefer to shoot using raw mode, the histogram you see on the back of the camera will not provide an accurate guide to the true potential of the image you have captured (see also, Figure 2.3 on page 92).

Interactive histogram

The Histogram is now interactive, meaning that you can click on the histogram directly to apply basic tone adjustments. More specifically, it allows you to click and drag to adjust the Blacks, Shadows, Exposure, Highlights and Whites settings (Figure 2.26). If using Process 2003 or 2010, it allows you to adjust: Blacks, Fill Light, Exposure and Recovery. Now, I have to say this feature was introduced early on to Lightroom 1.0 and seemed an interesting innovation at the time. It has to be said that the zones referenced in the histogram are not actually an accurate representation of the tones that are being manipulated. I think in the end that it is just as easy to click and drag on the sliders in the Basic panel. Where this is advantageous is if you are working in one of the other panels, say the Tone Curve panel. It means you can access these Basic panel tone controls without having to switch panel views.

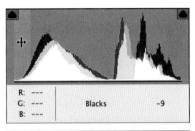

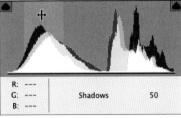

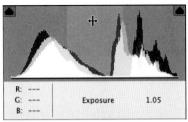

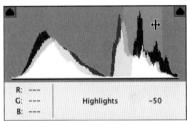

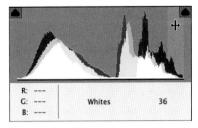

Figure 2.26 The new interactive histogram.

Deleting images

As you work with Camera Raw to edit your shots, the *Delete* key can be used to mark images that are to be sent to the trash. This places a red X in the thumbnail. To undo, select the image and hit *Delete* again.

Image browsing via Camera Raw

In a multiple view mode, the Camera Raw dialog can be used as a 'magnified view' image browser. You can match the magnification and location across all the selected images to check and compare details, inspect them in a sequence and apply ratings to the selected photos.

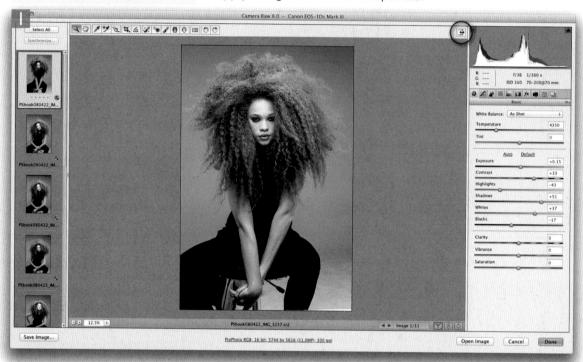

Selecting rated images only

If you an -click on the 'Select All' button, this selects the rated images only. This means that you can use star ratings to mark the images you are interested in during a 'first pass' edit and then use the above shortcut to make a quick selection of just the rated images.

- **1** If you have a large folder of images to review, the Camera Raw dialog can be used to provide a synchronized, magnified view of the selected pictures. The dialog is shown here in a normal window view, but you can click on the Full Screen mode button (circled) to expand the dialog to a Full screen view mode.
- **2** Here, I selected the first image in the sequence and clicked on the Select All button. I then used the zoom tool to magnify the preview. This action synchronized the zoom view used for all the selected images in the Camera Raw dialog; I was also able to use the hand tool to synchronize the scroll location for the selected photos.
- 3 Once this had been done I could deselect the thumbnail selection and start inspecting the photos. This could be done by clicking on the file navigation controls (circled), or by using the keyboard arrow keys to progress through the images one by one. I could then mark my favorite pictures using the usual Bridge shortcuts:

 (Mac), ctrl (PC) progressively increases the star rating for a selected image; (Mac), ctrl (PC) progressively decreases the star rating.

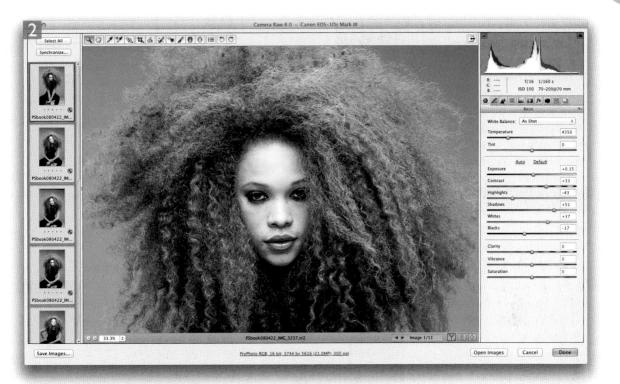

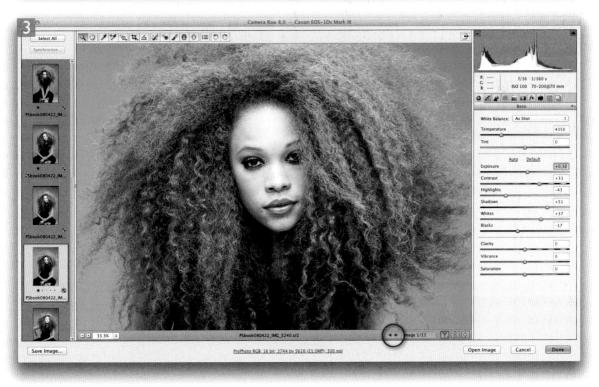

XMP sidecar files

Camera Raw edit settings are written as XMP metadata. This data is stored in the central Camera Raw database on the computer and can also be written to the files directly. In the case of JPEG, TIFF and DNG files, these file formats allow the XMP metadata to be written to the XMP space in the file header. However, in the case of proprietary raw file formats such as CR2 and NEF, it would be unsafe to write XMP metadata to incompletely documented file formats. To get around this, Camera Raw writes the XMP metadata to XMP sidecar files that accompany the image in the same folder and stay with the file when you move it from one location to another via Bridge.

Camera Raw preferences

The Camera Raw preferences (Figure 2.27) can be accessed via the Photoshop/Bridge menu (Mac), or Edit menu (PC). While the Camera Raw dialog is open you can use ****** (Mac), ****** (PC) to open the Camera Raw preferences, or click on the Camera Raw Preferences... button in Photoshop's File Handling preferences.

Let's look at the General section first. In the 'Save image settings' section I suggest you choose 'Sidecar ":xmp" files'. TIFF, JPEG and DNG files can store the XMP data in the header, but if the XMP data can't be stored internally within the file itself, this forces the image settings to be stored locally in XMP sidecar files that accompany the image files (see also page 266).

Should you wish to preview adjustments with the sharpening turned on, but without actually sharpening the output, the 'Apply sharpening to' option can be set to 'Preview images only'. This is because you might want to use a third-party sharpening program in preference to Camera Raw. However, with the advent of Camera Raw's improved

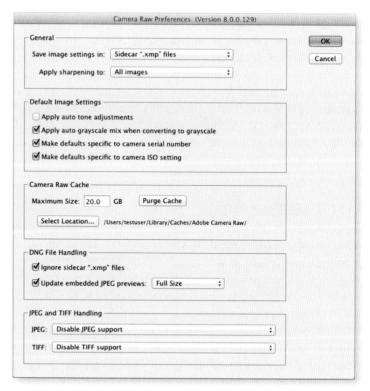

Figure 2.27 Camera Raw preferences dialog.

sharpening, you will most likely want to leave this set to 'All images' to make full use of Camera Raw sharpening.

Default Image Settings

In the Camera Raw preferences Default Image Settings section, you can select 'Apply auto tone adjustments' as a Camera Raw default. When this is switched on, Camera Raw automatically applies an auto tone adjustment to new images it encounters that have not yet been processed in Camera Raw, while any images you have edited previously via Camera Raw will remain as they are.

The 'Apply auto grayscale mix when converting to grayscale' option refers to the HSL/Grayscale controls, where Camera Raw can apply an auto slider grayscale mix adjustment when converting a color image to black and white. The next two options can be used to decide, when setting the camera default settings, if these should be camera body and/or ISO specific (see page 171).

Camera Raw cache

When photos are rendered using the Camera Raw engine, they go through an early stage initial rendering and the Camera Raw cache stores a cache of this data so that when you next reopen an image that has data stored in the cache, it renders the photo quicker in the Camera Raw dialog. The 1 GB default setting is rather conservative. If you have enough free hard disk space available, you may want to increase the size limit for the cache, or choose a new location to store the central preview cache data. If you increase the limit to, say, 20 GB or more, you should expect to see an improvement in Camera Raw's performance.

DNG file handling

Camera Raw and Lightroom both embed the XMP metadata in the XMP header space of a DNG file. There should therefore be no need to use sidecar files to read and write XMP metadata when sharing files between these two programs. However, some third-party programs may create sidecar files for DNG files. If 'Ignore sidecar "xmp" files' is checked, Camera Raw will not be sidetracked by sidecar files that might accompany a DNG file and cause a metadata conflict.

However, there are times where it may be useful to read the XMP metadata from DNG sidecar files. For example, when I work from a rental studio I'll have a computer in the

Camera Raw cache

Whenever you open an image in Camera Raw, it builds full, high quality previews direct from the master image data. In the case of raw files, the early stage processing includes the decoding and decompression of the raw data as well as the linearization and demosaic processing. All this has to take place first before getting to the stage that allows the user to adjust things like the Basic panel adjustments. The Camera Raw cache is therefore used to store the unchanging, early stage raw processing data that is used to generate the Camera Raw previews so that this step can be skipped the next time you view that image. If you increase the Camera Raw cache size, more image data can be held in the cache. This in turn results in swifter Camera Raw preview generation when you reopen these photos. Also, because the Camera Raw cache can be utilized by Lightroom, the cache data is shared between both programs. Since version 3.6. the Camera Raw cache files have been made much more compact. This means that one can now cache a lot more files. within the limit set in the Camera Raw preferences.

studio with all the captured files (kept as standard raws) and a backup/shuttle disk to take back to the office at my house from which I can copy everything to the main computer there. If I make any further ratings edits on this main machine, the XMP metadata is automatically updated as I do so. It then only takes a few seconds to copy just the updated XMP files across to the backup disk, replacing the old ones. Back at the studio I can again copy the most recently modified XMP files back to the main computer (overwriting the old XMP files). The photos in Bridge will then appear updated. So, if in the meantime the files on the studio computer happen to have been converted to DNG, it's important that the 'Ignore sidecar "xmp" files' option be now left unchecked, otherwise the imported xmp files will simply be ignored.

DNG files have embedded previews that represent how the image looks with the current applied Camera Raw settings. When 'Update embedded JPEG previews' is checked, this forces the previews in all DNG files to be continually updated based on the current Camera Raw settings, overriding previously embedded previews. It's important to point out here though that DNG previews created by Camera Raw can only be considered 100% accurate when viewed by other Adobe programs such as Lightroom or Bridge and even then, they must be using the same version of Camera Raw. While DNG is a safe format for the archiving of raw data, other DNG compatible programs that are not made by Adobe, or that use an earlier version of Camera Raw, will not always be able to read the Camera Raw settings that have been applied using the latest version of Camera Raw or Lightroom.

JPEG and TIFF handling

If 'Disable JPEG (or TIFF) support' is selected, all JPEG (or TIFF) files will always open in Photoshop directly. If 'Automatically open all supported JPEGs (or TIFFs)' is selected, this causes all supported JPEGs and TIFFs to always open via Camera Raw. However, if 'Automatically open JPEGs (or TIFFs) with settings' is selected, Photoshop will only open a JPEG or TIFF via Camera Raw if it has previously been edited via Camera Raw. When this option is selected you have the option in Bridge to use a double-click to open a JPEG directly into Photoshop, or use **B*R** (Mac), **CM*** (PC) to force JPEGs to open via Camera Raw. But note that when you edit the Camera Raw settings for that JPEG, the next time you use a double-click to open, it will default to opening via Camera Raw.

Camera Raw cropping and straightening

You can crop an image in Camera Raw before it is opened in Photoshop, but note that the cropping is limited to the bounds of the image area only. The crop you apply in Camera Raw is updated in the Bridge thumbnail and preview, and applied when the image is opened in Photoshop. However, if you save a file out of Camera Raw using the Photoshop format, there is an option in the Save dialog to preserve the cropped pixels so you can recover the hidden pixels later. Meanwhile, the Camera Raw straighten tool can also be used to measure a vertical or horizontal angle and apply a minimum crop to the image, which you can then resize accordingly.

A useful tip I learnt from Bruce Fraser was how you can use the Custom Crop menu option that's highlighted in Figure 2.29 to create a custom crop size using whatever units you like (Figure 2.28) and save this as a custom size output that matches the size required for a specific layout, or one that exceeds the standard output sizes available in the Workflow Options.

To remove a crop, open the image in the Camera Raw dialog again, select the crop tool and choose 'Clear Crop' from the Crop menu. Alternatively, you can hit <code>Delete</code> or simply click outside the crop in the gray canvas area.

Figure 2.29 The Camera Raw Crop Tool menu includes a range of preset crop proportions. You can also add your own custom presets by clicking on Custom... (see Figure 2.28).

Figure 2.28 This shows the Custom Crop settings that can be accessed via the Crop Tool menu (Figure 2.29). The crop units can be adjusted to crop according to the 'Ratio' (the default option) or by pixels, inches or centimeters. In this example I set a custom pixel size that enabled me to render files at a larger pixel size than the maximum size currently allowed.

Spacebar tip

If you press down the spacebar after dragging with the crop tool, this allows you to reposition the marquee selection. Release the spacebar to continue to modify the marquee area. Incidentally, this same shortcut applies when dragging with the zoom tool to define an area to zoom in to.

Auto straighten

You can automatically straighten a picture in the following ways. You can simply double-click on the straighten tool button icon in the Toolbar to auto-straighten an image. Or, with the straighten tool selected, you can double-click anywhere within the preview image. Alternatively, if the crop tool is selected, you can hold down the key (Mac), or crr key (PC) to temporarily switch to the straighten tool, and then double-click anywhere within the preview image. Also, when using the crop tool or Straighten tool you can press to flip the crop aspect ratio.

How to straighten and crop

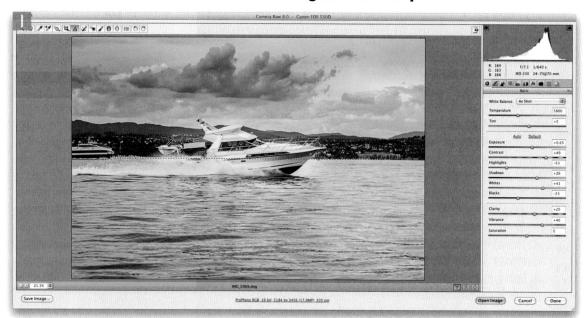

1 To straighten this photograph, I selected the straighten tool from the Camera Raw tools and dragged with the tool to follow the line that I wished to have appear straight.

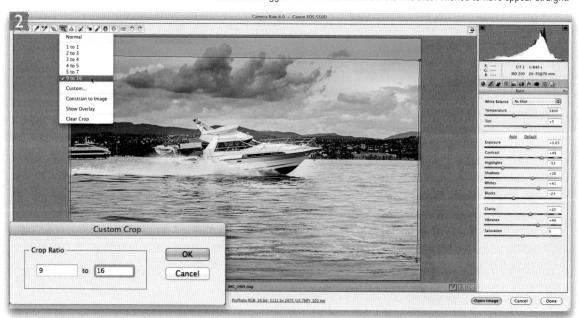

2 This action straightened the image. I could then click on the crop tool to access the Crop Tool menu and choose a crop ratio preset, or click on Custom... to create a new setting.

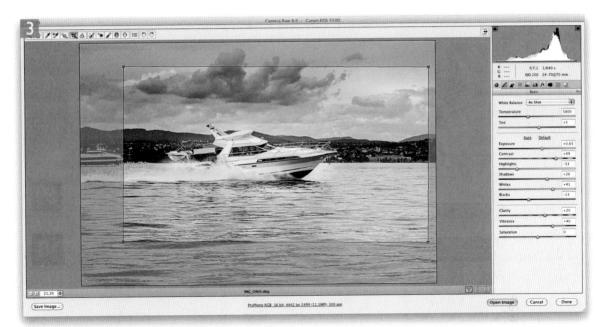

3 After creating and selecting a new custom 16:9 crop ratio setting, I dragged one of the corner handles to resize the crop bounding box as desired.

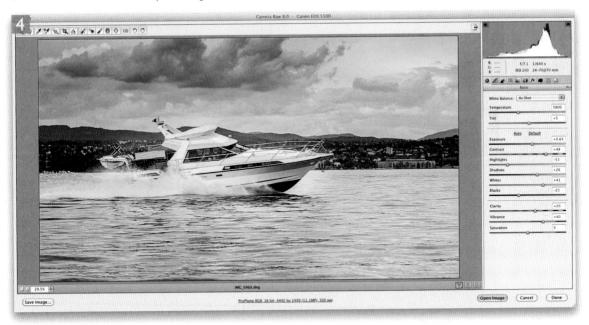

4 Finally, I deselected the crop tool by clicking on one of the other tools (such as the hand tool). This reset the preview to show a fully cropped and straightened image.

Figure 2.30 The Camera Raw Basic panel controls.

Figure 2.31 WhiBal[™] cards come in different sizes and are available from RawWorkflow.com.

Basic panel controls

The Basic panel (Figure 2.30) is where you carry out the main color and tone edits to an image. Most photos can be improved by making just a few Basic panel edits.

White balance

Let's start with the white balance controls. These refer to the color temperature of the lighting conditions at the time a photo was taken and essentially describe the warmth or coolness of the light. Quartz-halogen lighting has a warmer color and a low color temperature value of around 3,400 K, while daylight has a bluer color (and a higher color temperature value of around 6,500 K). If you choose to shoot in raw mode it does not matter how you set the white point setting on the camera because you can always decide later which is the best white balance setting to use.

Camera Raw cleverly uses two color profile measurements for each of the supported cameras, one made under tungsten lighting conditions and another made using daylight balanced lighting. From this data, Camera Raw is able to extrapolate and calculate the white balance adjustment for any color temperature value that falls between these two white balance measurements, as well as calculating the more extreme values that go beyond either side of these measured values.

The default white balance setting normally uses the 'As Shot' white balance setting that was embedded in the raw file metadata at the time the image was taken. This might be a fixed white balance setting that you had selected on your camera, or it could be an auto white balance that was calculated at the time the picture was shot. If this is not correct you can try mousing down on the White Balance popup menu and select a preset setting that correctly describes which white balance setting should be used. Alternatively, you can simply adjust the Temperature slider to make the image appear warmer or cooler and adjust the Tint slider to balance the white balance green/magenta tint bias.

Using the white balance tool

The easiest way to set the white balance manually is to select the white balance tool and click on an area that is meant to be a light gray color (Figure 2.32). Don't select an area of pure white as this may contain some channel clipping and this will produce a skewed result (which is why it is better to sample a light gray color instead). You will also notice that as you move the white balance tool across the image, the sampled RGB values are displayed just below the histogram, and after you click to set the white balance, these numbers should appear even.

There are also calibration charts such as the X-Rite ColorChecker chart, which can be used in carrying out a custom calibration, although the light gray patch on this chart is regarded as being a little on the warm side. For this reason, you may like to consider using a WhiBalTM card (Figure 2.31). These cards have been specially designed for obtaining accurate white point readings under varying lighting conditions.

Color temperature

Color temperature is a term that links the appearance of a black body object to its appearance at specific temperatures, measured in degrees Kelvin. Think of a piece of metal being heated in a furnace. At first it will glow red but as it gets hotter, it emits a red, then yellow and then a white glow. Indoor tungsten lighting has a low color temperature (a more orange color), while sunlight has a higher color temperature and emits a bluer light.

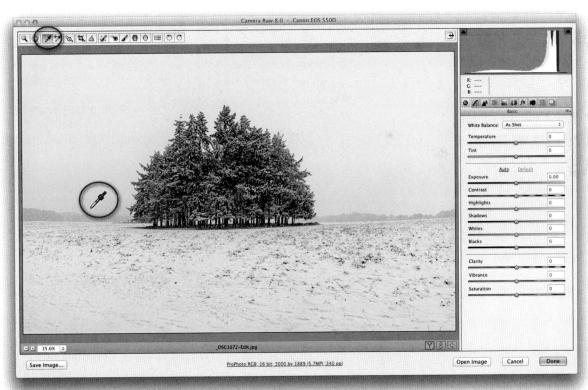

Figure 2.32 To manually set the white balance, select the white balance tool (circled), locate what should be a neutral area and click to update the white balance.

Single-clicking with behavior

The single-click behavior of the white balance tool remains unchanged.

White balance tool refinements

The white balance tool can now be applied selectively when white balancing an image. Just click-and-drag with the white balance tool to define a rectangular pixel area. As you release the mouse, Camera Raw uses all the pixels within the marked rectangle to set the global white balance. This can be particularly useful for measuring white balance from a textured surface, such as in the example shown below.

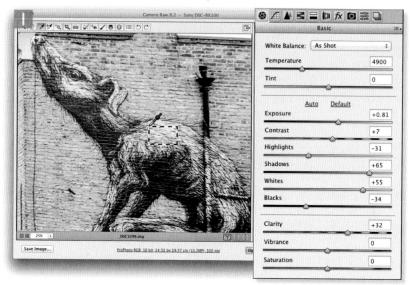

1 I opened this image in Camera Raw, which currently shows the 'As Shot' white balance setting. I selected the white balance tool and marquee dragged to sample the pixels within the area shown here to set the white balance.

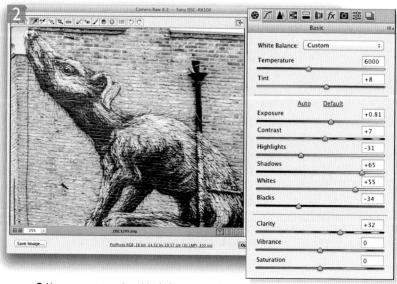

2 Here you can see the white balance corrected result.

Another improvement is the way the white balance tool is now smarter and takes into account locally applied white balance adjustments. For example, if you use the graduated filter to apply a warming white balance, when you click with the white balance tool it takes the localized Temp or Tint adjustments into account to ensure the pixels where you click are neutralized.

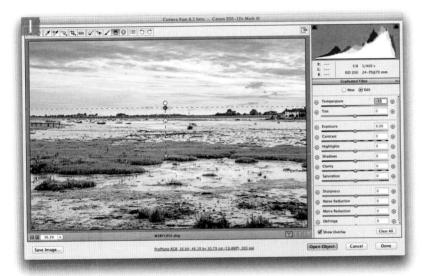

1 In this example, a cooling Temp adjusted graduated filter was applied to the lower half of the image.

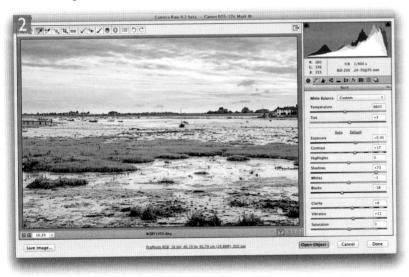

2 When I selected the white balance tool and clicked on the bottom half of the image it calculated a new white balance adjustment that took into account the locally applied white balance adjustment.

Basic panel auto white balance adjustments

You can now apply new kinds of auto adjustments when working in the Basic panel in Camera Raw. Previously, when you selected 'Auto' from the White Balance menu, this auto set both the Temperature and Tint sliders. Now, in Camera Raw, you can use **Shift** + double-click on the Temperature and Tint sliders to set these independently.

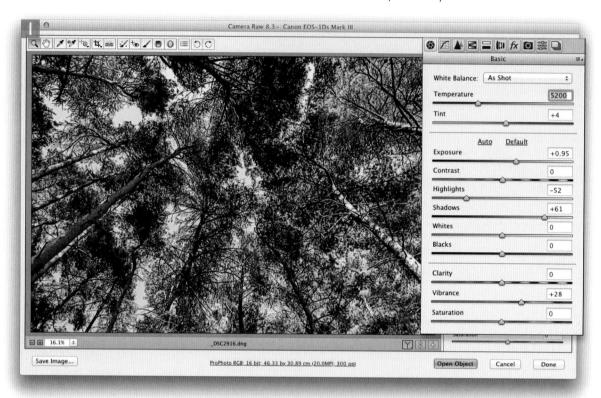

 ${\bf 1}$ I opened this image in Camera Raw, which currently shows the 'As Shot' white balance setting.

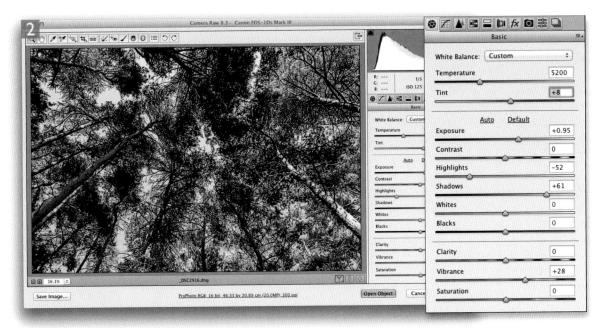

2 I held down the *Shift* key and double-clicked on the Tint slider. This auto-set the Tint slider only to the Auto calculated white balance setting.

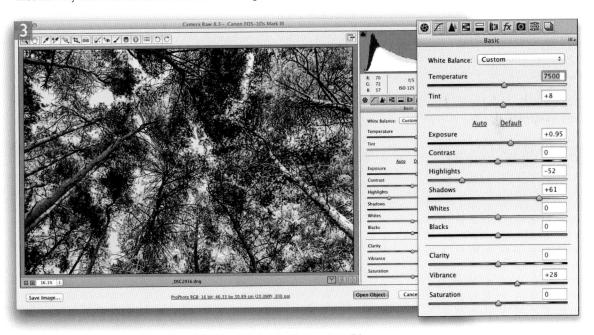

3 I then held down the *Shift* key again and double-clicked on the Temperature slider. This auto-set the Temperature slider only to the Auto calculated white balance setting. With both the Tint and Temperature sliders auto-adjusted, this now produced the same result as selecting 'Auto' from the White Balance menu.

Camera Raw 4.1 and later

In the main body text I stated that the Camera Raw processing remained more or less exactly the same from version 1.0 through to Camera Raw 5.0. There was one aspect to Camera Raw behavior though that changed slightly. When Camera Raw 4.1 was released a certain amount of noise reduction became integral to the Camera Raw demosaic process. This displeased some users who preferred things the way they were prior to this. In Camera Raw 6.0 or later the Process 2003 rendering reverted to pre-Camera Raw 4.1 behavior with the noise reduction removed again. Consequently, Process 2003 will match pre Camera Raw 4.1 processing exactly, but images that have previously been processed in Camera Raw 4.1-5.7 may appear slightly less sharp when using Process 2003 in Camera Raw 6.0 or later. You can compensate for this by adding 15-25% extra Luminance noise reduction in the Detail panel. But bear in mind that this only applies should you wish to preserve an image in the Process 2003 state. I assume that most readers will want to update such images to Process 2010 or 2012 rather than keep them in Process 2003.

Process Versions

Version 1.0 of Camera Raw was first released in late 2002 as an optional plug-in for Photoshop 7.1. Between then and October 2008, with the release of Camera Raw 5 in Photoshop CS4, Camera Raw underwent many changes. Later versions had the benefit of more tools to play with, such as Recovery, Fill Light, Clarity, Vibrance and localized adjustments, but the underlying demosaic processing remained (almost) unchanged. An image that had been processed in Camera Raw 1.0 could be opened in Camera Raw 5.0 and still look the same. With Camera Raw 6.0 in Photoshop CS5, Adobe completely revised the way raw data was demosaiced, and they also updated the noise reduction and sharpening, as well as fine-tuning the Recovery and Fill Light controls. It was therefore necessary to draw a line between the old and new-style processing and this resulted in the need for 'process versions'. In Camera Raw 6.0 you could use the Process 2003 rendering to preserve the Develop settings in all your legacy files (raw, TIFF or JPEG) more or less exactly as they were (see sidebar on Camera Raw 4.1). Or, you could use the newer Process 2010 rendering to update your older files to the new processing method and take full advantage of the much-improved image processing capabilities in Camera Raw 6.0. Process 2010 was also applied by default to all newly-imported photos.

Camera Raw 7.0 in Photoshop CS6 saw the introduction of yet another new process version: Process 2012. This time the change was just as radical. This is because Process 2012 featured a new set of Basic panel tone adjustment slider controls where the line-up now includes: Exposure, Contrast, Highlights, Shadows, Blacks and Whites. Some of the names remain the same, but the Process 2012 sliders all behave guite differently compared to Process 2003/2010. I'll be explaining how these work shortly, but there are important reasons why it was felt necessary to introduce such changes. Firstly, Camera Raw had evolved a lot since it was first introduced. Initially, the Basic panel had just four tone control sliders: Exposure, Blacks, Brightness and Contrast. To this was added the Recovery and Fill Light sliders, by which time there was quite a bit of overlap between each of these sliders and the effect they would have on an image. For example, the Exposure, Recovery and Fill Light sliders all handled the highlights and shadows somewhat differently, but they would also have an effect on the image midtones and, hence, the overall brightness. Yes, there was the

Brightness slider that could be used to adjust the midtones, but there was also confusion in some users' minds over the role of Brightness versus the Exposure slider. The other thing that could be said was wrong with the old set of tone controls was the lack of symmetry between highlight and shadow adjustments. Those of you who are familiar with Process 2003/2010 Camera Raw processing will know that small incremental adjustments to the Blacks slider had a much more pronounced effect on an image compared with an Exposure or Recovery adjustment. The Process 2012 Basic panel tone sliders address these problems. The Exposure slider is slightly different in that it is now more of a midtones brightness slider rather than a highlight clipping adjustment. The Highlights and Shadows sliders have a more symmetrical response and can be used to adjust the shadow and highlight tones while leaving the midtones more or less unchanged (to be adjusted by Exposure). The Contrast slider can be used to compress or expand the entire tonal range and the Blacks and Whites sliders allow you to fine-tune the black and white clipping at the extreme ends of the tonal range.

Another thing Process 2012 addresses is the discrepancy in the Camera Raw tone settings between raw and non-raw images. Previously, raw images would default to a Blacks setting of 5, a +50 Brightness and +25 Contrast. For non-raw files such as JPEGs and TIFFs, the equivalent default settings were all zero. With Process 2012 the default settings are identical for both raw and non-raw files alike. Apart from removing the mystery as to why these settings had to be different, it is possible to share and synchronize settings between raw and non-raw images more effectively. Lastly, the tone controls were revised with an eye to the future and provide the ability to handle high dynamic range images. For example, the Camera Raw 7.1 update showed how it is now possible to edit 32-bit HDR files just as if they were raw originals (see page 444).

Whenever you edit a photo that's previously been edited in an earlier version of Camera Raw using Process 2003 or Process 2010, an exclamation mark button will appear in the bottom right corner of the preview (Figure 2.33) to indicate this is an older Process Version image. Clicking on the button updates the file to Process 2012, which then allows you to take advantage of the latest image processing features in Camera Raw. Or, you can go to the Camera Calibration panel and select the desired Process Version from the Process menu

High contrast image processing

The redesign of the tone controls means that contrasty images of high dynamic range scenes can be processed more effectively. As camera manufacturers focus on better ways to capture high dynamic range scenes, the raw image processing tools will need to offer the flexibility to keep up with such developments.

Camera Raw rendering times

With Camera Raw 6, the Process 2010 rendering was more sophisticated than Process 2003 and, as a result of this, increased the amount of processing time that was required to render individual images. In some circumstances this could result in longer output processing times, such as when saving images or opening them in Photoshop. With Process 2012 for Camera Raw 7 and later, this too has implications that will affect the image processing. Also, the addition of non-circular spot removal and Upright corrections may further affect processing times. Certainly there were comments about slowness in Camera Raw 7 and steps have been taken to improve the processing in Camera Raw 8, but it will very much depend on which types of adjustments you choose to apply to an image that will affect overall speed.

Figure 2.33 This shows the Process Version update warning triangle. Note that you can *alt* -click to bypass the subsequent warning dialog.

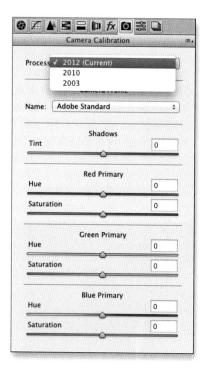

Figure 2.34 The Process Version setting can be accessed via the Camera Calibration panel.

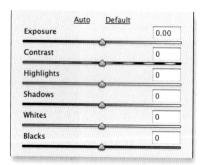

Figure 2.35 The Process 2012 tone adjustment controls.

shown in Figure 2.34. Here you can update to Process 2012 by choosing 2012 (Current). Should you wish to do so you can use this menu to revert to a previous Process 2010 or Process 2003 setting. Note that Camera Raw will attempt to match the legacy settings as closely as possible when updating to Process 2012.

The Process 2012 tone adjustment controls

Now that I have outlined the new changes in Process 2012, let's look at the Basic panel tone adjustment controls in more detail (Figure 2.35). You can adjust the sliders described here manually, and you can click on the Auto button to auto-set the slider settings. Note that in this edition of the book I only discuss the new Process 2012 controls. If you want to know how to master the Process 2003/2010 controls there is a 24-page PDF guide on Process 2010 image processing that you can download from the book website.

Exposure

With Process 2003 and 2010, as you adjusted the Exposure, Fill Light or Brightness sliders these would have an overlapping effect on an image's appearance and could all affect the midtones in different ways. Consequently an adjustment made to any one of these sliders could affect the overall image brightness. With Process 2012, there is only one control for adjusting the overall brightness and that is the Exposure slider, which is essentially a blend of the old, 2003/2010 Exposure and Brightness sliders.

The adjustment units remain the same, ranging from –4.00 to +4.00, but apart from that everything about this slider is different. Previously you would think of adjusting Exposure to set the highlight clipping point and perhaps adjust the Exposure in conjunction with the Fill Light slider to find an ideal combination that applied an appropriate Exposure level of brightness while retaining sufficient detail in the extreme highlights. You can still hold down the well key as you drag the Exposure slider to see a threshold preview that indicates any highlight clipping, but I would urge you to rethink the way you work with the Exposure slider. Consider it primarily as an 'Exposure brightness' adjustment. If you now try to preserve clipping using the Exposure slider you'll quite possibly end up with an overdark image that you can't fully lighten with the Basic panel sliders alone. What you want to do is to

concentrate on the midtones rather than the highlights as you adjust the Exposure slider and use the Contrast, Highlights and Whites sliders to adjust the highlight clipping.

The Exposure slider's behavior is also dependent on the image content. Previously, with Process 2003/2010, as you increased the Exposure the highlights would at some point 'hard clip'. Also, as you increased the Exposure slider further, there was a tendency for color shifts to occur in the highlights as one or more color channels began to clip. With Process 2012, as you increase Exposure there is more of a 'soft clipping' of the highlights as the highlight clipping threshold point is reached. Additional increases in Exposure behave more like a Process 2010 Brightness adjustment in that the highlights roll off smoothly instead of being clipped. As you further increase Exposure you will of course see more and more pixels mapping to pure white, but overall, such Exposure adjustments should result in smoother highlights and reduced color shifts.

Contrast

The Process 2012 Contrast slider also behaves slightly differently. With any contrast type adjustment there is a midpoint and as you increase the contrast the tones on one side get darker and the other lighter. As you reduce contrast the opposite happens. With Process 2003/2010 the midpoint was always fixed (see Figure 2.36). With Process 2012 the midpoint varies slightly according to the content of the image. So with low key images the midpoint shifts slightly more to the left and with high key images, it shifts more to the right. Consequently, the Contrast slider behavior adapts slightly according to the image content and should allow you to better differentiate the tones in the tone areas that predominate.

Basically, you need to think of the Exposure slider as the control for establishing the midtone brightness and the Contrast slider as the control for setting the amount of contrast around that midpoint. By working with just these two sliders you can fairly quickly get to a point where you have an image with more or less the right brightness and contrast. Everything you do from there on with the remaining sliders is about fine-tuning this initial outcome. Highlights and Shadows help you reveal more tone detail either side of the Exposure midpoint and Whites and Blacks allow you (where required) to fine-tune the white and black clipping points.

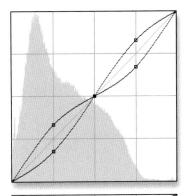

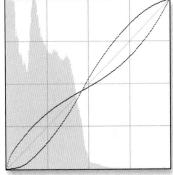

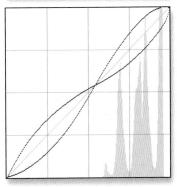

Figure 2.36 The Contrast slider in Process 2012 works slightly differently to its Process 2010 counterpart. With Process 2012 it automatically varies the midpoint setting depending on the image content. In the top Curve diagram the Process 2010 midpoint is locked in the center. With Process 2012 the midpoint can shift left or right depending on whether you are processing a low key or high key image.

Extreme Highlights/Shadows

As you play around with the Process 2012 controls you'll notice that the Highlights and Shadows adjustments have the potential to apply quite strong corrections when bringing out detail in the shadow and highlight areas. If you prefer a more natural look then you are advised to keep your adjustments within the ± 50 range. As you go beyond this, Camera Raw uses a soft edge tone mapping method to compress the tonal range. This technique is similar to that used when converting high dynamic range images to low dynamic range versions, such as when using the HDR Toning adjustment in Photoshop or the Photomatix program. As you increase the amounts applied in the Highlights or Shadows sliders you will start to get more of an 'HDR effect' look, though this will be nothing like as noticeable as the obvious halo effects associated with a typical HDR processed image.

Going in the other direction it is now possible to apply negative Shadows adjustments to darken the shadows—this can be useful where you wish to darken just the shadows to add more contrast. Similarly, you can apply positive Highlights adjustments in order to lighten the whites in images where the highlight tones need extra lifting.

The Highlights and Shadows controls also inform the Whites and Blacks how much tonal compression or expansion has been applied and the Whites and Blacks controls adjust their ranges automatically taking this into account.

One of the things that tends to confuse some people is the fact that as well as the Contrast adjustment in the Basic panel there is also a separate Tone Curve panel that can be used to adjust contrast. Basically, The Tone Curve panel sliders are useful for fine-tuning the image contrast *after* you have adjusted the main Contrast slider. Note that increasing the contrast does not produce the same kind of unusual color shifts that you sometimes see in Photoshop when you use Curves. This is because the Camera Raw processing manages to prevent such hue shifts when you pump up the contrast.

Highlights and Shadows

The Highlights and Shadows sliders should be regarded as the 'second-level' tone adjustment controls that you apply after you have adjusted the Exposure and Contrast. Highlights and Shadows are essentially improved versions of Recovery and Fill Light. The important things to note here is that they work exactly the same, but from opposite ends of the tonal scale. They are also symmetrical in behavior and their range extends just slightly beyond the midtone region. A Highlights adjustment won't affect the darkest areas and similarly, a Shadows adjustment won't affect the lighter areas. So, by using these two sliders it is easier to work on the shadow and highlight regions independently without affecting the overall image brightness. This is because the midtones will mostly remain unchanged, where they can be better governed by an Exposure slider adjustment. Overall, this is a better way of working because it is now clearer which control it is you need to grab when adjusting the highlights or shadows and the results are better too. For example, with Process 2003/2010, a Recovery adjustment to restore more detail in the highlights would quickly flatten out and soften the highlight tones. Meanwhile, a Fill Light adjustment would have a much bolder effect on the shadows, but would also be influenced by the Blacks setting, which in turn would affect how far into the midtones a Fill Light adjustment would lighten. The new process 2012 setup with the Highlights and Shadows sliders is more consistent and easier to use.

You can also hold down the all key as you drag a slider to see a threshold preview, which indicates any highlight or shadow clipping. I would say that a threshold preview analysis at this stage is more 'helpful' rather than essential.

Whites and Blacks

The Whites and Blacks sliders can be used to fine-tune the extremes of the tonal range. In most instances it should be possible to achieve the look you are after using just the first four sliders, namely: Exposure, Contrast, Highlights and Shadows. Should you find it necessary to further tweak the highlight and shadows, you can use the Whites and Blacks sliders to precisely determine how much the shadows and highlights should be clipped, while preserving the overall tonal relationships in the image. These controls do offer less range. This is because they are primarily intended for fine-tuning the endpoints after the overall tonal relationships in the image have been established. As with the Highlights and Shadows sliders, you can hold down the all key as you drag a slider to see a threshold preview and this will indicate any highlight or shadow clipping. At this stage a threshold preview analysis can be particularly useful. You can also rely on the highlight clipping indicator (discussed on page 160) to tell you which highlights are about to be clipped. It should be noted here that the direction of the Blacks slider adjustment is reversed in Process 2012 and the old zero value for the Blacks slider is now equivalent to a +25 adjustment. Previously, where you might have used a range of 0-5, you can now work with a range of +25-0, and it is now easier to fine-tune a blacks clipping adjustment. Also, the Blacks range is automatically calculated on an image-by-image basis (see sidebar).

Suggested order for the Basic panel adjustments

It isn't mandatory that you adjust the Basic panel sliders in a set order, but it is generally best to work on the sliders in the order they are presented from top to bottom. The first step should be to set the Exposure to get the overall image brightness looking right. After that you may want to use the Contrast slider to set the contrast. You can judge this visually on the display and maybe also reference the Histogram to see what type of Contrast adjustment would be appropriate. After that, use the Highlights and Shadows sliders to fine-tune the highlight and shadow regions. By this stage you should be almost there. Only if you feel it is necessary to improve the image further should it be necessary to adjust the Whites and Blacks sliders as well.

Extreme Whites/Blacks

Working with the Whites and Blacks sliders you can correct for extreme highlights and shadows by adjusting them to reveal more detail. But you can also push them the other way in order to decrease shadow or highlight detail. For example, you might want to apply a positive Whites adjustment to deliberately blow out certain highlights. And you might also want to use a negative Blacks adjustment in order to make a dark background go completely black. See also the section on localized adjustments and how it is useful to apply such corrections via the adjustment brush. Note that images where the Blacks slider has been run up the scale using Process 2003/2010 will most likely appear somewhat different after a conversion. The Process 2012 Blacks slider tends to back off quite a bit.

Auto-calculated Blacks range

Previously, in Process 2003/2010, it was not always possible to crush the Blacks completely when editing a low contrast image. This was because the Blacks range was fixed. In Process 2012, the Blacks range is auto-calculated based on the image content. This means that when editing a low contrast image, such as a hazy landscape, the Blacks range adapts so that you should always be able to crush the darkest tones in the image. Also, the Blacks adjustment will become increasingly aggressive as you get closer to a -100 value. This means that you gain more range when processing such images, but at the expense of some loss in precision.

Highlight recovery technology

Camera Raw features an internal technology called 'highlight recovery'. This is designed to help recover luminance and color data in the highlight regions whenever the highlight pixels are partially clipped: in other words, when one or more of the red, green and blue channels are partially clipped, but not all three channels are affected. Initially, the highlight recovery process looks for luminance detail in the non-missing channel or channels and uses this to build luminance detail in the clipped channel or channels. This may be enough to recover the missing detail in the highlights. After that Camera Raw also applies a darkening curve to the highlight region only, and in doing so brings out more detail in the highlight areas. Note that this technology is designed to work for raw files only, although JPEG images can sometimes benefit too (but not so much).

Process 2012 notably provides improved highlight color rendering, which preserves the partial color relationships as well as the luminance texture in the highlights. You should find that highlight detail is rendered better. There is also less tendency for color detail to quickly fade to neutral gray.

Preserving the highlight detail

The Exposure slider's response correlates quite well with the way film behaves and you should also find that using Process 2012 provides you with about an extra stop of exposure latitude compared to editing with the Process 2003/2010 Exposure slider. As you apply Basic adjustments in Camera Raw, you will want to make the brightest parts of the photo go to white so the highlights are not too dull. At the same time though, you will want to ensure that important highlight detail is always preserved. This means taking care not to clip the highlights too much, since this might otherwise result in important highlight detail being lost when you come to make a print. You therefore need to bear in mind the following guidelines when deciding how the highlights should be clipped.

Where you should set the highlight clipping point is really dependent on the nature of the image. In most cases you can adjust the Highlights, followed by the Whites slider so that the highlights just begin to clip and not worry too much about losing important highlight detail. If the picture you are editing contains a lot of delicate highlight information then you will want to be careful when setting the highlight point so that the brightest whites in the photo are not too close to the point where the highlights start to be clipped. The reason for this is all down to what happens when you ultimately send a photo to a desktop printer or convert an image to CMYK and send it to the press to be printed. Most photo inkjet printers are quite good at reproducing highlight detail at the top end of the print scale, but at some point you will find that the highest pixel values do not equate to a printable tone on paper. Basically, the printer may not be able to produce a dot that is light enough to print successfully. Some inkjet printers use light colored inks such as a light gray, light magenta and light cyan to complement the regular black, gray, cyan, magenta, yellow ink set and these printers are better at reproducing faint highlight detail. CMYK press printing is a whole other matter. Printing presses will vary of course, but there is a similar problem where a halftone dot may be too small for any ink to adhere to the paper. In all the above cases there is an upper threshold limit where the highlight values won't print. So, when you are adjusting the Highlights and Whites sliders, it is important to examine the image and ask yourself if the highlight detail matters or not.

Some pictures may contain subtle highlight detail (such as in Figure 2.37), where it is essential to make sure the important highlight tones don't get clipped. Other images may look like the example on the next page in Figure 2.38. Here, the light reflecting off a shiny metal surface creates bright, specular highlights and the last thing you need to concern yourself with is preserving the highlight detail. I would say that most images contain at least a few specular highlights and it is only where you have a photo like the one shown below, in Figure 2.37, where you have to pay particular attention to ensure the brightest highlights aren't totally clipped.

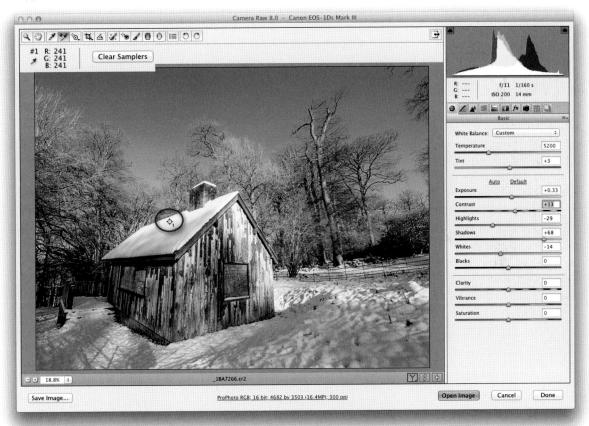

Figure 2.37 In this example it was important to preserve the delicate highlight tones To be absolutely sure that I didn't risk making the highlight detail areas too bright, I placed a color sampler (circled) over an area that contained important highlight detail. This allowed me to check that the RGB highlight value did not go too high. In this case I knew that with a pixel reading of 241,241,241, the highlight tones in this part of the picture would print fine using almost any print device.

White backdrops

For studio shots with a white background, you usually want the backdrop to reproduce as pure white. If you do this with the lighting you need to ensure the lighting ratios are balanced so that important detail in the subject highlights isn't clipped. It is best not to overexpose the white background exposure too much at the capture stage. One can always force the background tones to white when editing in Camera Raw by applying a positive Highlights and/or Whites adjustment (or edit the image in Photoshop).

When to clip the highlights

As I say, you have to be careful when judging where to set the highlight point. If you clip too much then you risk losing important highlight detail. However, what if the image contains bright specular highlights, such as highlight reflections on shiny metal objects? The Figure 2.38 image has specular highlights that contain no detail. It is therefore safe to clip these highlights, because if you were to clip them too conservatively you would end up with dull highlights in your print. In this case the aim is for the shiny reflections to print to paper white. So when adjusting the Highlights and Whites slider for a subject like this, you would use the Exposure slider to visually decide how bright to make the photo and not be afraid to let the specular highlights blow out to white when adjusting the Highlights and Whites sliders.

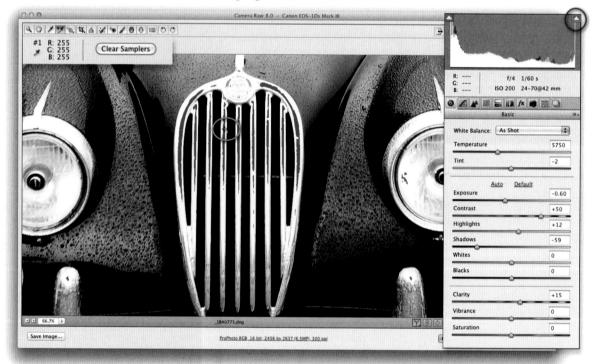

Figure 2.38 The highlights in this photograph contain no detail, so there is no point in trying to preserve detail in the shiny areas as this would needlessly limit the contrast. One can safely afford to clip the highlights in this image without losing important image detail and as you can see here, the color sampler over the shiny reflection (circled in blue) measures a highlight value of 255,255,255. With images like this it is OK to let the highlights burn out. Note that the highlight clipping warning is checked (circled in red) and the colored overlay in the preview image indicates where there is highlight clipping.

How to clip the shadows

Setting the black clipping point is, by comparison, a much easier thing to do. Put aside any concerns you might have about matching the black clipping point to a printing device, I'll explain how that works over the next two pages. Blacks slider adjustments are simply about deciding where you want the shadows to clip. The default setting is now 0 and this will usually be about right for most images. With some images, where the initial clipping appears too severe, you may want to ease the clipping off by dragging the Blacks slider more to the right, but it is inadvisable to lighten the Blacks too much. Some photos, such as the one shown below in Figure 2.39, can actually benefit from a heavy black clipping so that the dark areas print to a solid black.

Hiding shadow noise

Raising the threshold point to where the shadows start to clip is one way to add depth and contrast to your photos. It can also help improve the appearance of an image that has very noisy shadows.

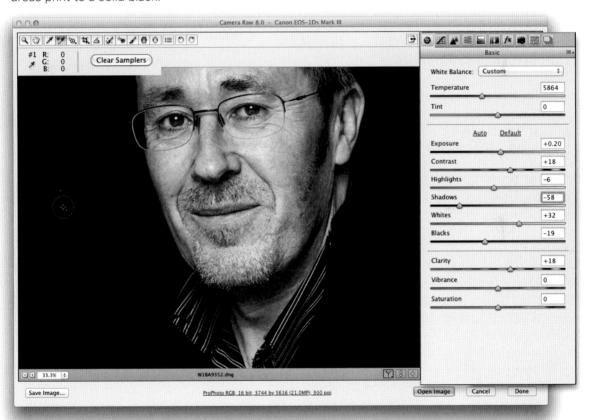

Figure 2.39 In this picture you can see that the Blacks in this photo are well and truly clipped. This is because I deliberately wanted to force any shadow detail in the backdrop to a solid black. As you can see, the color sampler over the backdrop in this picture (circled) showed an RGB reading of 0,0,0.

Is it wrong to set levels manually?

All I am suggesting here is that it is an unnecessary extra step to use Photoshop to set the black output levels to anything higher than the zero black after you have already set the black clipping at the Camera Raw editing stage (or have done so in Photoshop). If you do set the black output levels manually to a setting that is higher than zero you won't necessarily get inferior print outputs, providing, that is, you set the black levels accurately and don't set them any higher than is needed. And there's the rub: how do you know how much to set the output levels, and what if you want to output a photo to more than one type of print paper? You see, it's easier to let Photoshop work this out for you automatically. Some picture libraries are quite specific about how you set the output levels, but their suggested settings are usually very conservative and unlikely to result in weak shadows when printed to most devices. It is therefore probably better to oblige the libraries and just give them what they ask for. The only time when you may need to give special consideration to setting the shadows to anything other than zero is when you are required to edit an already converted CMYK or grayscale file that is destined to go to a printing press, where the black output levels have been set incorrectly. However, if you use Photoshop color management properly you are unlikely to encounter such scenarios.

Shadow levels after a conversion

You will sometimes come across advice saying that the output levels for the black point in an RGB image should be set to something like 20,20,20 (for the Red, Green, Blue RGB values). The usual reason given for this is because anything darker than, say, a 20,20,20 shadow value will reproduce in print as a solid black. Just to add to the confusion, different numbers are suggested for the output levels: one person suggests using 10,10,10, while another advises you use 25,25,25. In all this you are probably left wondering how to set the Blacks slider in Camera Raw, since you can only use it to clip the black input levels and there is no control for setting the black output levels so that they match these suggested output settings.

This is one of those areas where the advice given is more complex than it needs to be. It is well known that because of factors such as dot gain, it has always been necessary to make the blacks in a digital image slightly lighter than the blackest black (0,0,0,) before outputting it to print. As a result of this, in the early days of digital imaging, the only way to get a digital image to print correctly was to manually adjust the output levels so that the black clipping point matched the print device. Back then, if you set the levels to 0,0,0, RGB, the blacks would print too dark and you would lose detail in the shadows. Therefore the solution was to set the output levels point to a value higher than this (such as 20,20,20 RGB), so that the blacks in the image matched the blackest black for the print device. These are the historical reasons for such advice. because the black levels had to be adjusted differently for each type of print output including CMYK prepress files.

For the last 18 years or so, Photoshop has had a built-in automated color management system that's designed to take care of the black clipping at the output stage. The advice these days is therefore quite simple: you decide where you want the blackest blacks to be in the picture and clip them to 0,0,0, RGB (as discussed on the previous page). When you save the image out to Photoshop as a pixel image and send the image data to the printer, the Photoshop or print driver software automatically calculates the precise amount of black clipping adjustment that is required for each and every print/paper combination. In the Figure 2.40 example you can see how the black clipping point for different print papers is automatically compensated when converting the data from the edited image to the profile space for the printing paper. Don't just take my word, it is easy

to prove this for yourself. Open an image (any will do), set the Channel display in the Histogram panel to Luminosity and refresh the histogram to show the most up-to-date histogram view (you do this by clicking on the yellow warning triangle in the top right corner). Once you have done this go to the Edit menu, choose Convert to Profile and select a CMYK or RGB print space. You'll need to refresh the histogram display again, but once you have done so you can compare the before and after histograms and check what happens to the black clipping point.

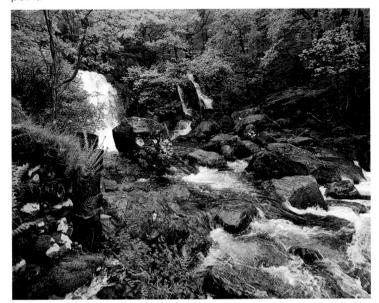

Figure 2.40 The Histogram panel views on the right show (top) the original histogram for this ProPhoto RGB image. The middle histogram shows a comparison of the image histogram after converting the ProPhoto RGB data to a print profile space for Innova Fibraprint glossy paper printed to an Epson 4800 printer. The print output histogram is overlaid here in green and you can see how the black levels clipping point has been automatically indented. The bottom example shows a standard CMYK conversion to the US Web coated SWOP profile, colored green so that you can compare it more easily with the before histogram. Again, the black clipping point is moved inwards to avoid clogging up the shadow detail. Please note that the histograms shown here were all captured using the Luminosity mode since this mode accurately portrays the composite luminance levels in each version of the image.

Original histogram - ProPhoto RGB

Innova Fibraprint glossy paper

US Web coated SWOP CMYK

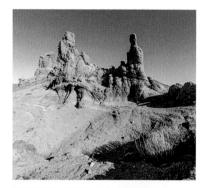

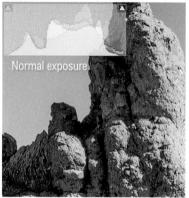

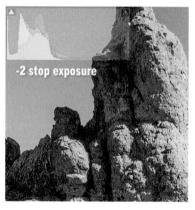

Figure 2.41 This shows the difference the exposure can make in retaining shadow information. The darker the exposure, the fewer discrete levels that can be captured via the camera sensor. This will result in poorly recorded shadow detail.

Digital exposure

Compared to film, shooting with a digital camera requires a whole new approach to determining what the optimum exposure should be. With film you tended to underexpose slightly for chrome emulsions (because you didn't want to risk blowing out the highlights). With negative emulsion film it was considered safer to overexpose as this would ensure you captured more shadow detail and thereby recorded a greater subject tonal range.

When capturing raw images on a digital camera it is best to overexpose as much as it is safe to do so before you start to clip the highlights. Most digital cameras are capable of capturing 12 bits of data, which is equivalent to 4096 recordable levels per color channel. As you halve the amount of light that falls on the chip sensor, you potentially halve the number of levels that are available to record an exposure. Let us suppose that the optimum exposure for a particular photograph at a given shutter speed is f16. This exposure makes full use of the chip sensor's dynamic range and consequently there is the potential to record up to 4096 levels of information. If one were then to halve the exposure to f22, you would only have the ability to record up to 2048 levels per channel. It would still be possible to lighten the image in Camera Raw or Photoshop to create an image that appeared to have similar contrast and brightness. But (and it's a big but), that one stop exposure difference has immediately lost you half the number of levels that could potentially be captured using a one stop brighter exposure. The image is now effectively using only 11 bits of data per channel instead of 12. This is true of digital scanners too. Perhaps you may have already observed how difficult it can be to rescue detail from the very darkest shadows, and how these can end up looking posterized. Also, have you ever noticed how much easier it is to rescue highlight detail compared with shadow detail when using the Shadows/Highlights adjustment? This is because far fewer levels are available to define the information recorded in the darkest areas of the picture and these levels are easily stretched further apart as you try to lighten them. This is why posterization is always much more noticeable in the shadows (see Figure 2.41). It also explains why it is important to target your digital exposures as carefully as possible so that you capture the brightest exposures possible, but without the risk of blowing out the highlight detail.

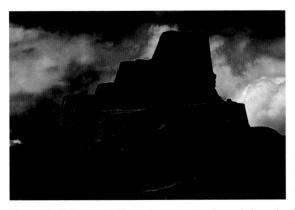

Figure 2.42 If you could inspect a raw capture image in its native, linear gamma state, it would look something like the image shown top left. Notice that the picture is very dark and is lacking in contrast. During the raw conversion process, a gamma curve correction is applied when converting the linear data so that the processed image matches the way we are used to viewing the relative brightness in a scene. The picture top right shows the same image after a basic raw conversion. As a consequence of this, the more brightly exposed areas will preserve the most tonal information and the shadow areas will end up with fewer levels. A typical CCD sensor can capture up to 4096 levels of tonal information. Half these levels are recorded in the brightest stop exposure range and the recorded levels are effectively halved with every stop decrease in exposure. The digital camera exposure is therefore quite critical. Ideally, you want the exposure to be as bright as possible so that you make full use of the Levels histogram, but at the same time be careful to make sure the highlights don't get clipped.

How Camera Raw interprets the raw data

Camera sensors have a linear response to light and unprocessed raw files therefore exist in a 'linear gamma space' (see Figure 2.42). Human vision on the other hand interprets light in a non-linear fashion, so one of the main things a raw conversion has to do is apply a gamma correction to the original image data to make the correctly exposed, raw image look the way our eyes would expect such a scene to look. The preview image you see in the Camera Raw dialog presents a gamma corrected preview of the raw data, while the adjustments you apply in Camera Raw are in fact applied directly to the raw linear data. This illustrates one aspect of the subtle but important differences between the tonal edits that can be made in Camera Raw to raw files and those that are applied in Photoshop where the images have already been 'gamma corrected'. Note that in the case of non-raw files, Camera Raw has to temporarily convert the image to a linear RGB space to carry out the image processing calculations.

Camera histograms

As I have mentioned already in this book, the histogram that appears on a compact camera or digital SLR screen is unreliable for anything other than JPEG capture. This is because the histogram you see there is usually based on the camera-processed JPEG and is not representative of the true raw capture. The only way to check the histogram for a raw capture file is to open the image via a raw processing program such as Camera Raw or Lightroom.

Basic panel image adjustment procedure

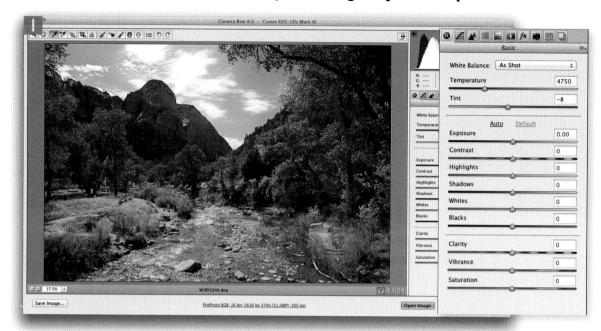

1 Here you can see the starting point for this image where the Basic panel settings were all set to their default values.

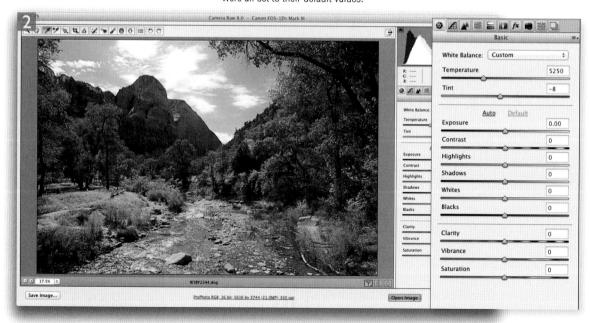

2 To begin with I manually adjusted the Temperature slider in order to make the image appear slightly warmer in color.

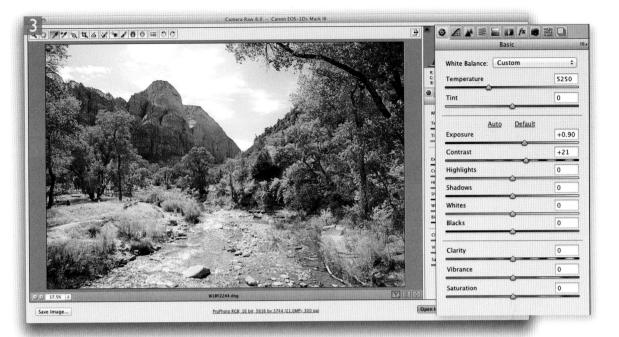

3 Next, I adjusted the Exposure and Contrast sliders to lighten the image and also to increase the contrast slightly.

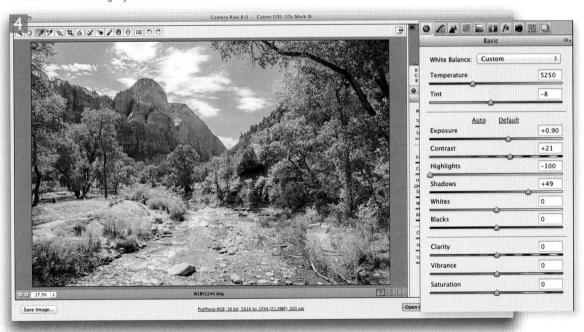

4 I then reduced the Highlights to restore more detail in the highlight areas and at the same time increased the Shadows to lift the darker areas.

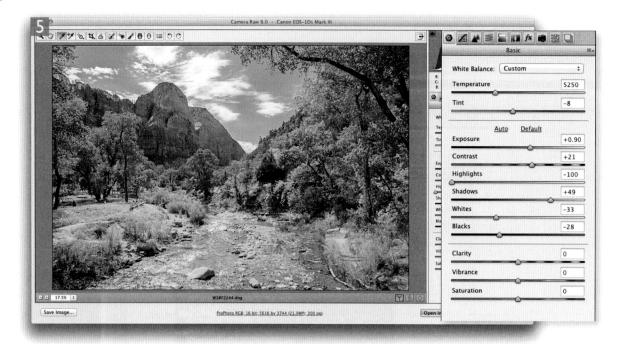

5 In this step I reduced both the Whites and Blacks sliders to fine-tune the white and black clipping points.

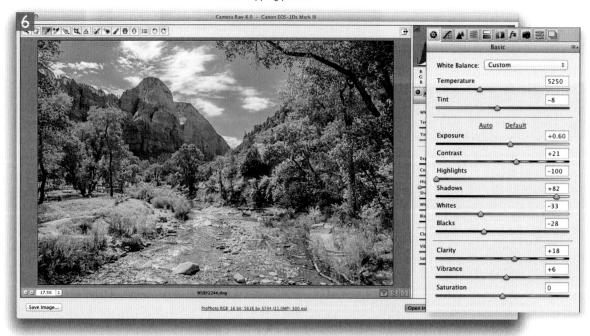

6 Finally, I readjusted the Exposure and Shadows sliders to rebalance the overall brightness of the photo, and I added some positive Clarity and Vibrance.

Auto tone corrections

Camera Raw has the useful ability to apply auto tone corrections. To do this, just click on 'Auto' (#U [Mac], ctr/U [PC]) in the Camera Raw dialog (circled in Figure 2.43). An auto tone adjustment will affect the Exposure, Contrast, Highlights, Shadows, Whites and Blacks and is to some extent affected by the white balance setting. This is also noticeable when making auto grayscale adjustments. Here too, the white balance settings have an impact. If you adjust the Temp and Tint white balance controls in the Basic panel and then select the Convert to Grayscale box in the HSL/Grayscale panel, as shown in Step 2 on page 421 (with Auto enabled), you will see the Grayscale sliders readjust according to the white balance settings. Auto tone adjustments work really well on most images, such as outdoor scenes and naturally-lit portraits, but work less well on photographs that have been shot in the studio under controlled lighting conditions. In these instances it is best not to use Auto.

Auto Exposure has also been improved recently, making it more consistent from image to image, as well as being more consistent across different image sizes that have been set in the Workflow options. For the most part the Auto Exposure results will appear to produce the same result, but with overbright images the auto setting result will be noticeably tamer.

Auto Whites and Blacks sliders

The Whites and Blacks sliders also now support functionality akin to auto levels. You can the double-click on either of these sliders to independently auto-set the Whites and Blacks adjustments. More specifically, when using this method, Camera Raw analyzes the image and computes the Whites or Blacks value needed to just begin to clip. This isn't quite the same as applying a standard auto tone adjustment, as the auto adjustment is recalculated based on all other adjustment settings that have been applied and also takes into account things like cropping and Lens Corrections to exclude from the auto calculation pixels that are not currently visible. Therefore, if there are some bright highlights in your image, but these have been cropped, then when you double-click the Whites slider, these highlight areas will be ignored when making the calculation (see the example shown on the following page).

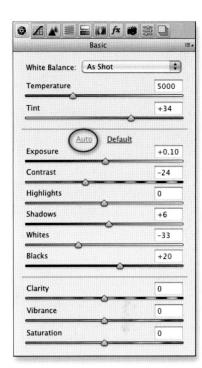

Figure 2.43 Clicking on the Auto button applies an auto adjustment to the Basic panel settings in Camera Raw. This auto-adjusts the Exposure, Contrast, Highlights, Shadows, Whites and Blacks settings. You can also use **Shift** +double-click to apply an auto setting to individual sliders.

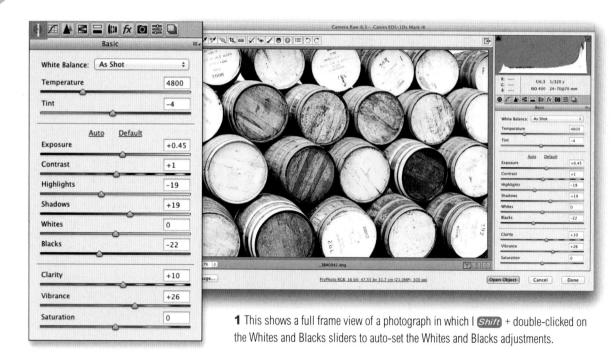

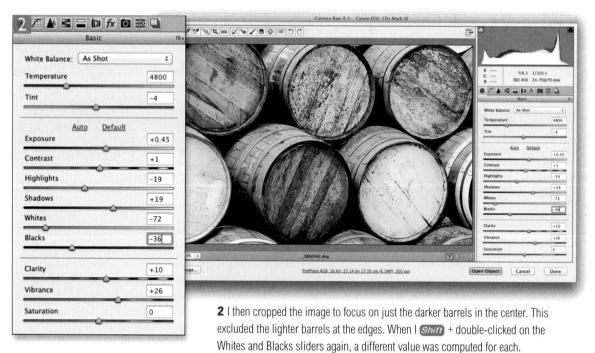

Camera-specific default settings

The Default Image Settings section of the Camera Raw preferences allows you to make any default settings cameraspecific. If you go to the Camera Raw fly-out menu options shown in Figure 2.44, there is an option that allows you to 'Save New Camera Raw Defaults' as the new default setting to be used every time Bridge or Camera Raw encounters a new image. On its own, this menu item allows you to create a default setting based on the current Camera Raw settings and apply this to all subsequent photos (except where you have already overridden the default settings). However, if the 'Make defaults specific to the camera serial number' option is selected in the Camera Raw preferences, selecting 'Save New Camera Raw Defaults' only applies this setting as a default to files that match the same camera serial number. Similarly, if the 'Make defaults specific to camera ISO setting' option is checked, this allows you to save default settings for specific ISO values. When both this and the previous option

Figure 2.44 You can use the Camera Raw menu option circled here to choose the 'Save New Camera Raw Defaults'. This saves all the current Camera Raw settings as a default setting according to how the preferences are set in Figure 2.27. The important thing to bear in mind here is to ensure the Basic panel settings have all been set to their defaults first.

are checked, you can effectively have multiple default settings in Camera Raw that take into account the combination of the camera model and ISO setting.

You do have to be careful how you go about using the 'Save New Camera Defaults' option. When used correctly you can cleverly set up Camera Raw to apply appropriate default settings for any camera and ISO setting. However, it is all too easy to make a mistake, or worse still, select the 'Reset Camera Defaults' option and undo all your hard work.

The main thing to watch out for is that you don't include too many Camera Raw adjustments (such as the HSL/Grayscale panel settings) as part of a default setting. The best thing is to open a previously untouched image, apply a Camera Calibration panel adjustment plus, say, enabling the Camera Profile and Lens Profile correction settings and save this as a camera-specific default. You might find it useful to adjust the Detail panel noise reduction settings for an image shot at a specific ISO setting and save this as a 'Make defaults specific to camera ISO setting'. Or, you might like to check using both Camera Raw preference options and setup defaults for different ISO settings with specific cameras.

Clarity

The Clarity slider is the first of three 'Presence' controls in Camera Raw. Adding Clarity to a photo can be thought of as adding sharpness, but it is more accurate to say that Clarity adds localized, midtone contrast. In other words, the Clarity slider can be used to build up the contrast in the midtone areas by effectively applying a soft, wide radius unsharp mask type of filter. Consequently, when you add a positive Clarity adjustment, you will notice improved tonal separation and better texture definition in the midtone and highlight areas. By applying a small positive Clarity adjustment you can therefore increase the local contrast across narrow areas of detail and a bigger positive Clarity adjustment increases the localized contrast over broader regions of the photo. Positive Clarity adjustments now utilize the new tone mapping logic that is employed for the Highlights and Shadows sliders. As a result of this, halos either side of a high contrast boundary edge should appear reduced.

All photos can benefit from adding a small amount of Clarity. I would say, a +10 value works well for most pictures. However, you can safely add a maximum Clarity adjustment if you think a picture needs it (such as in the Figure 2.45 example shown here). But note that in terms of strength, a maximum Clarity adjustment using Process 2012 is now roughly double what it was in Process 2010. Also in the current version of Camera Raw Clarity adjustments have been speeded up slightly.

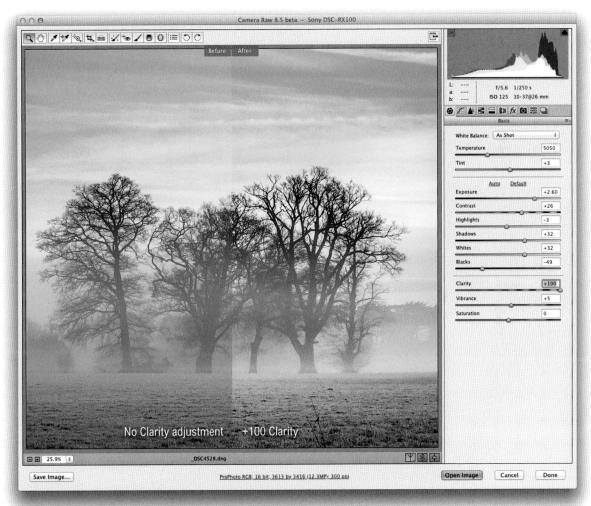

Figure 2.45 This screen shot shows an example of Clarity in action. The left half of the Camera Raw preview shows how the photo looked before Clarity was added and the right half of the preview shows Clarity being applied using a maximum +100 value.

Negative clarity

Just as you can use a positive clarity adjustment to boost the midtone contrast, you can also apply a negative clarity adjustment to soften the midtones. There are two uses that come to mind here. Clicio Barroso and Ettore Causa suggested that a negative clarity adjustment could be useful for softening skin tones in portrait and beauty shots (see Figure 2.46). This works great if you use the adjustment brush tool (discussed on page 240-page 252) to apply a negative clarity in combination with a sharpening adjustment. The other idea I had was to use negative clarity to simulate a diffusion printing technique that used to be popular with a lot of traditional darkroom printers. In Figure 2.47 you can see examples of a before and after image where I used a maximum negative clarity to soften the midtone contrast to produce a kind of soft focus look. You will also find that this technique works particularly well with photos that have been converted to black and white. Note that negative Clarity adjustments don't need to make use of the new tone mapping logic.

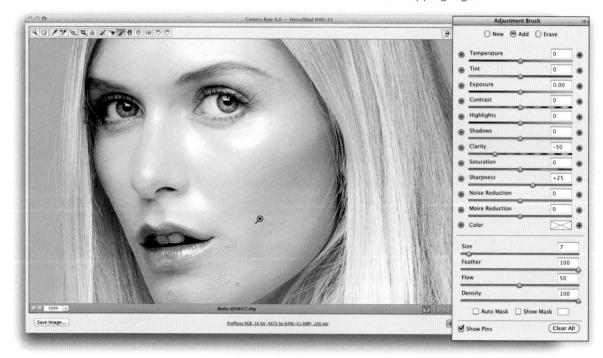

Figure 2.46 This shows the results of an adjustment brush applied using the combination of a –50 Clarity effect with a +25 Sharpness effect to produce the skin softening look achieved here. I applied this effect a little stronger than I would do normally in order to really emphasize the skin softening effect.

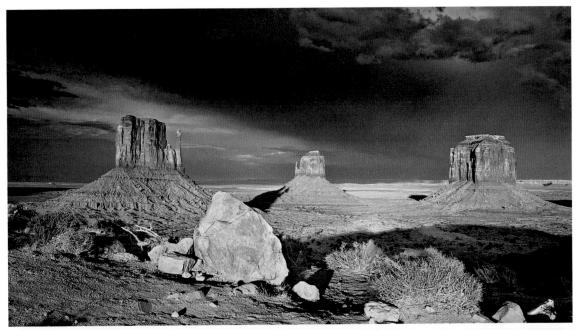

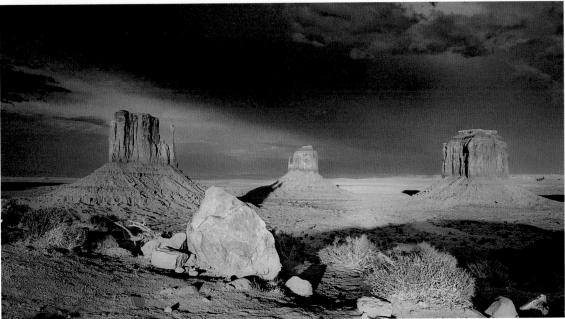

Figure 2.47 This shows a before version (top) and an after version (below), where I applied a -100 Clarity adjustment.

Negative vibrance and saturation

Not all of us want to turn our photographs into super-colored versions of reality. So it is worth remembering that you can use the Vibrance and Saturation sliders to apply negative adjustments too. If you take the Saturation down to –100, this converts an image to monochrome, but lesser negative Saturation and Vibrance adjustments can be used to produce interesting pastel-colored effects.

Vibrance and Saturation

The Saturation slider can be used to boost color saturation, but extreme saturation adjustments will soon cause the brighter colors to clip. However, the Vibrance slider can be used to apply what is described as a non-linear color saturation adjustment, which means colors that are already brightly saturated in color will remain relatively protected as you boost the vibrance, whereas the colors that are not so saturated receive a greater saturation boost. The net result is a saturation control that allows you to make an image look more colorful. but without the attendant risk of clipping those colors that are saturated enough already. Try opening a photograph of some brightly colored flowers and compare the difference between a Vibrance and a Saturation adjustment to see what I mean. The other thing that is rather neat about the Vibrance control is that it has a built-in skin tone protection filter which does rather a good job of not letting the skin tones increase in saturation as you move the slider to the right. In Figure 2.48, I set the Vibrance to +55, which boosted the colors in the dress, but without giving the model too 'vibrant' a suntan.

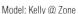

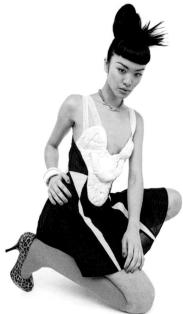

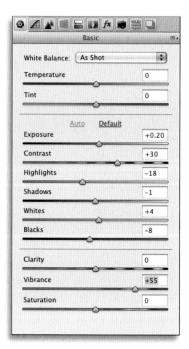

Figure 2.48 Boosting the colors using the Vibrance control in the Basic panel.

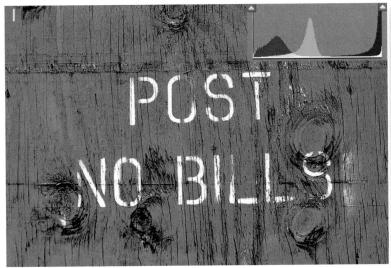

1 In this example you can see what happens if you choose to boost the saturation in a photo using the Saturation slider only to enrich the colors. If you look at the histogram you will notice how the blue channel is clipped. This is what we should expect, because the Saturation slider in Camera Raw applies a linear adjustment that pushes the already saturated blues off the histogram scale.

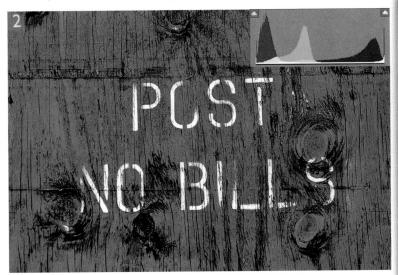

2 Compare what happens when you use the Vibrance slider instead. In this example you will notice how none of the blue channel colors are clipped. This is because the Vibrance slider boosts the saturation of the least saturated colors most, tapering off to a no saturation boost for the already saturated colors. Hence, there is no clipping in the histogram.

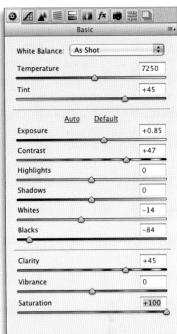

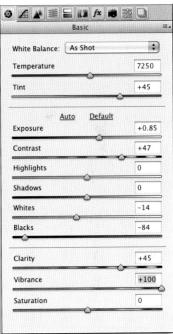

Linear contrast in Process 2012

The default Tone Curve for Process 2003/2010 applies a Medium Contrast curve, whereas the Process 2012 default is 'Linear'. However, the Linear setting in Process 2012 actually applies the same Tone Curve kick to the shadows as the old Medium Contrast setting. Adobe simply recalibrated the underlying tone curve settings in Process 2012 so that Medium Contrast is now the new 'Linear' starting point. The important thing here is that the starting point in Process 2003/2010 and Process 2012 is actually the same. It's only the names and how the Tone Curve is represented in the Point Curve editor mode that have changed.

Tone Curve panel

The Tone Curve panel offers a fine-tuning contrast control that can be applied in addition to the tone and contrast adjustments made in the Basic panel. There are two modes of operation available here: parametric and point. We'll look at the parametric controls first. The starting point is a straight curve. though in actual fact, the underlying tone curve does actually apply a small amount of contrast (see sidebar). When editing a Tone Curve in parametric mode you use the Tone Curve panel slider controls to modify the curve shape. This is essentially a more intuitive way to work, plus you can also use the target adjustment tool () in conjunction with the parametric sliders to adjust the tones in an image. Note that you can use the shortcut as a toggle action to access and use the Tone Curve target adjustment tool while editing in the Basic panel. Here is an example of how to edit the Tone Curve in the parametric editor mode.

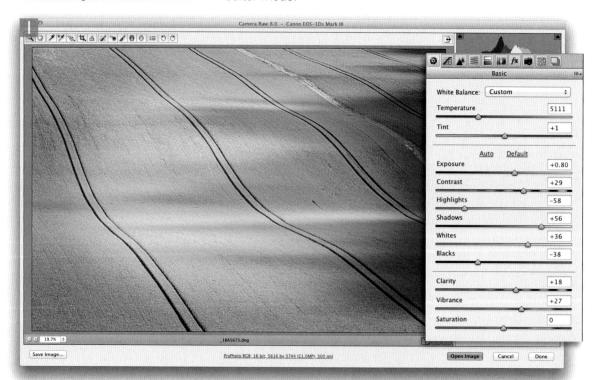

1 In this first example, the image was corrected using the Basic panel controls to produce an optimized range of tones that were ready to be enhanced further. I could have used the Contrast slider to boost the contrast more, but the Tone Curve panel provides a simple yet effective interface for manipulating the image contrast.

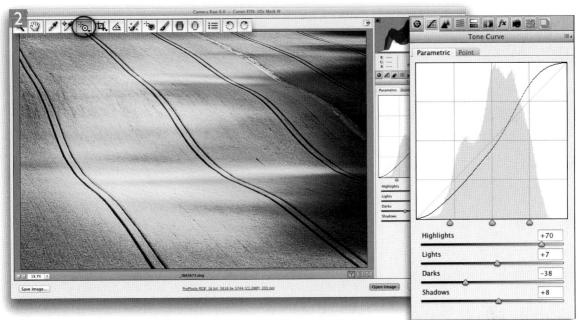

2 In the Tone Curve panel I selected the Parametric curve option. By adjusting the four main sliders I was able to apply a strong tone contrast to the photo. You can also apply these adjustments by selecting the target adjustment tool (circled) and then clicking and dragging up or down on target areas of the image.

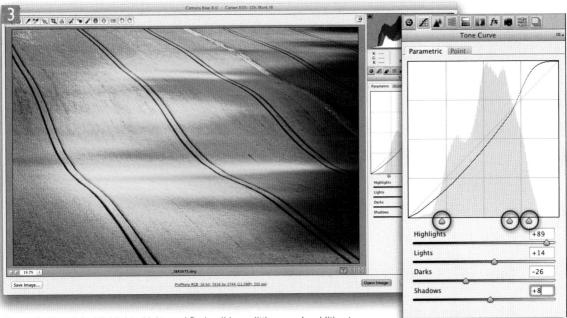

3 Here, I adjusted the Highlights, Lights and Darks sliders a little more. In addition to this, I fine-tuned the scope of adjustment for the Tone Curve sliders by adjusting the positions of the three tone range split points (circled).

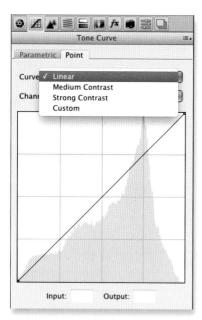

Figure 2.49 The Tone Curve panel, shown here in Point Curve editor mode with the default Linear tone curve setting.

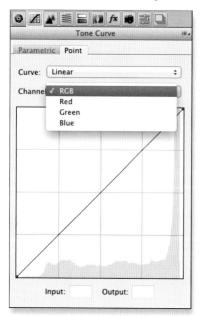

Figure 2.50 The Tone Curve panel, shown here with the RGB channel selected.

Point Curve editor mode

In the Point Curve editor mode, you can manipulate the shape of the Tone Curve as you would with the Curves adjustment in Photoshop. As I mentioned on the previous page, the default curve shape in Process 2012 is 'Linear', which is actually the same as the old Medium Contrast curve. If you want, you can use the Point Tone Curve panel mode to apply a stronger contrast base curve setting. Regardless of any adjustments you have already made in the parametric mode, the curve shape that's shown here uses the Curve setting selected from the Curve menu in Figure 2.49 as the starting point curve shape. I suppose you could say that the way the Tone Curve panel represents curves in Camera Raw is similar to having two Curves adjustment layers one on top of the other in Photoshop. In fact, if you also take into account the effect of the Contrast slider in the Basic panel, you effectively have three curves adjustments to play with. To edit the point tone curve, just click on the curve line to add points and drag to adjust the overall curve shape. You can edit curve points just like in Photoshop. When a point is selected, use the keyboard arrow keys to move the point around. Note that in Camera Raw 8 as you nudge using the arrow keys this now pins an anchor point within the allowable curve range instead of it being removed from the curve. To select a new existing point, use ctrl Tab to select the next point up and use ctrl Shift Tab to select the next point down. You can delete a selected anchor point by (Mac), ctrl (PC) + clicking it, hit the Delete key, or drag the point off to the side of the curve graph. Also, if you hold down the (Mac), ctrl (PC) key while hovering the cursor over the image preview, you can see exactly where a tone will fall on the curve, and you can (Mac), oth (PC)-click in the preview to place a point on the curve. Lastly, use the Shift key to select multiple points on the curve.

RGB Curves

When working in Process 2012, you will see a Channel menu, which allows you to edit either the RGB or individual red, green or blue channels (Figure 2.50). This allows you to apply finetuned color corrections. To some extent this does duplicate functionality available elsewhere in Camera Raw. Even so, RGB curves do let you apply unique kinds of adjustments, such as those seen in Figures 2.51 and 2.52. You can use it to apply strong color casts, you can correct images with mixed lighting and you can also achieve split tone effects that go beyond what can be achieved in the Split Toning panel alone.

Figure 2.51 This shows two different RGB point tone curve adjustments. In the middle, a correction to cool the highlights and warm the shadows, and on the right, an example where I deliberately applied a strong red/yellow cast.

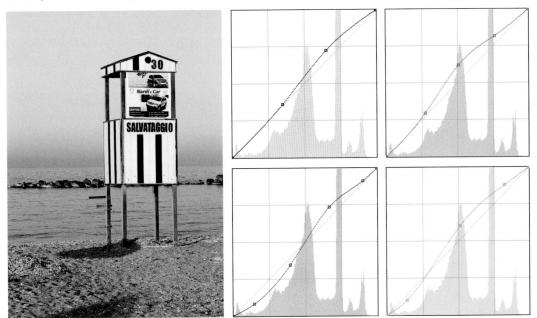

Figure 2.52 In this example I desaturated the image, taking the Saturation slider in the Basic panel to -100. I then applied the point tone curve adjustments shown here to apply a multi-color split toning effect.

Correcting a high contrast image

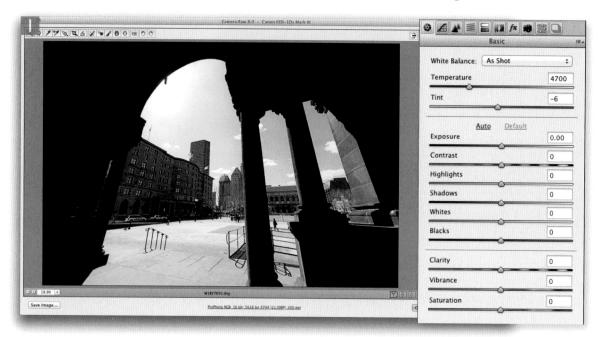

1 This photograph has a wide subject brightness range, and is shown here opened in Camera Raw using the default Process 2012 settings.

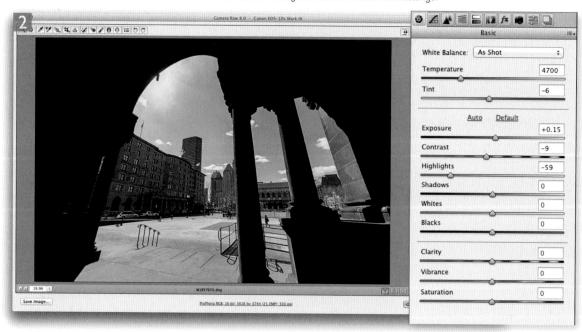

2 In this step I adjusted the Exposure, Contrast and Highlights sliders to compress the tonal range. This resulted in more detail being seen in the sky.

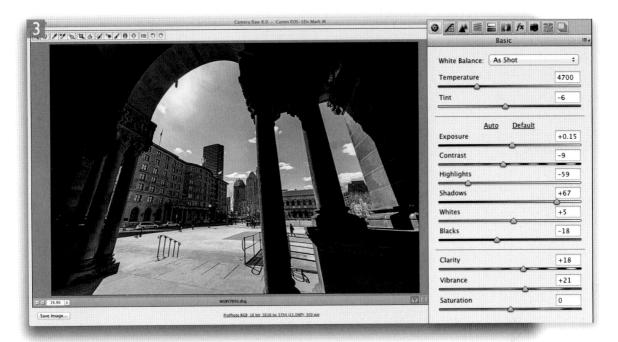

3 I then tackled the Shadow areas by raising the Shadows slider to +67. I did find it necessary to fine-tune the whites and blacks clipping points. As you can see, I set the Whites slider to +5 and the Blacks slider to -18.

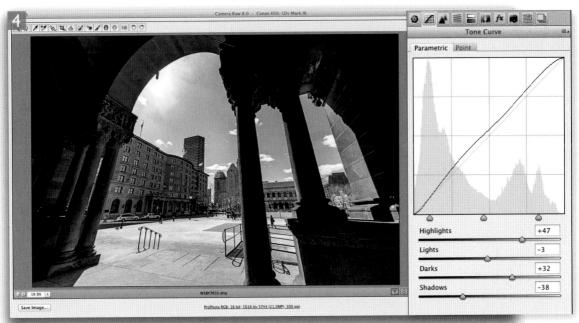

4 Lastly, I went to the Tone Curve panel and used the slider settings shown here to carefully add more contrast to the photograph where it was needed most.

Camera Raw Detail panel

In case you are wondering, the following chapter contains a major section on working with the Detail panel.

HSL color controls

The choice of color ranges for the HSL sliders is really quite logical when you think about it. We may often want to adjust skin tone colors, but skin tones aren't red or yellow, but are more of an orange color. And the sea is often not blue but more of a turquoise color. Basically, the hue ranges in the HSL controls are designed to provide a more applicable range of colors for photographers to work with.

HSL/Grayscale panel

The HSL controls provide eight color sliders with which to control the Hue, Saturation and Luminance. These work in a similar way to the Hue/Saturation adjustment in Photoshop, but are in many ways better. Based on my own experience I find these controls are more predictable in their response. In Figure 2.53 I used the Luminance controls to darken the blue sky and add more contrast in the clouds, and I lightened the rocks slightly. Try doing this using Hue/Saturation in Photoshop and you will find that the blue colors tend to lose saturation as you darken the luminosity. You will also notice that instead of using the traditional additive and subtractive primary colors of red, green, blue, plus cyan, magenta and yellow, the color slider controls in the HSL panel are based on colors that are of more actual relevance when editing photographic images. For example, the Oranges slider is useful for adjusting skin tones and Aquas allows you to target the color of the sea, but without affecting the color of the sky.

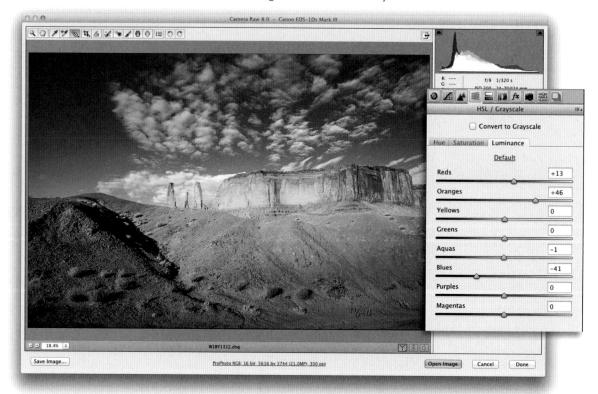

Figure 2.53 In this example, the Luminance sliders in the HSL/Grayscale panel were used to darken the sky and also to lighten the rocks.

Recovering out-of-gamut colors

Figure 2.54 highlights the problem of how the camera you are shooting with is almost certainly capable of capturing a greater range of colors than can be displayed on the monitor or seen in print. Just because you can't see them doesn't mean they're not there! Although a typical monitor can't give a true indication of how colors will print, it is all you have to rely on when assessing the colors in a photo. The HSL Luminance and Saturation sliders can therefore be used to reveal hidden color detail (see Figure 2.55).

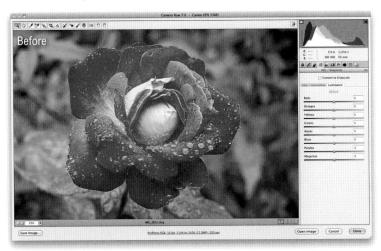

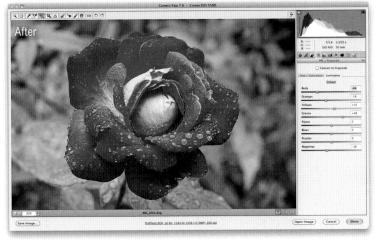

Figure 2.55 In the 'Before' screen shot view the pink rose appeared flat. In the 'After' example I applied a negative luminance adjustment to darken the red, orange and magenta colors to produce the improved 'After' version.

Figure 2.54 This diagram shows a plot of the color gamut of an LCD monitor (the solid shape in the center) compared to the actual color gamut of a digital camera (the wireframe that surrounds it). Assuming you are using a wide gamut RGB space such as Adobe RGB, or ProPhoto RGB, the colors you are able to edit will certainly extend beyond what can be seen on the display.

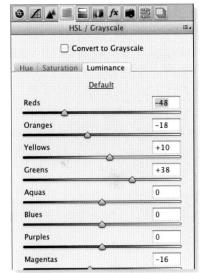

Tech note

The previews shown here are not simple screen grabs, but were mocked up using fully processed ProPhoto RGB images. You can judge the effectiveness of this adjustment by how well the lower one reproduces in print.

Grayscale conversions

To find out about how to apply grayscale conversions in Camera Raw, please refer to page 420 in the Black and White chapter.

Emulating Hue/Saturation behavior

In Photoshop's Hue/Saturation dialog, there is a Hue slider that can be used to apply global hue shifts. This can be useful if you are interested in shifting all of the hue values in one go. With Camera Raw you can create preset HSL settings where all the Hue sliders are shifted equally in each direction. Using such presets you can quickly shift all the hues in positive or negative steps, without having to drag each slider in turn.

Adjusting the hue and saturation

The Hue sliders in the HSL/Grayscale panel can be used to fine-tune the hue color bias using each of the eight color sliders. In the Figure 2.56 example, I adjusted the Reds hue slider to make the reds look less magenta and more orange. Photographs shot using a basic digital camera can often benefit from hue tweaks such as this to make the skin tones appear more natural.

The Saturation sliders allow you to decrease or increase the saturation of specific colors. In the Figure 2.57 example you can see how I used these to knock back specific colors so that everything in the photograph ended up looking monochrome, except for the grass and red wheel. Of course, I could have used the adjustment brush to do this, but adjusting the Saturation sliders offers a quick method for selectively editing the colors in this way. As with the Tone Curve, you can also use the target adjustment tool to pinpoint the colors and tones you wish to target and adjust.

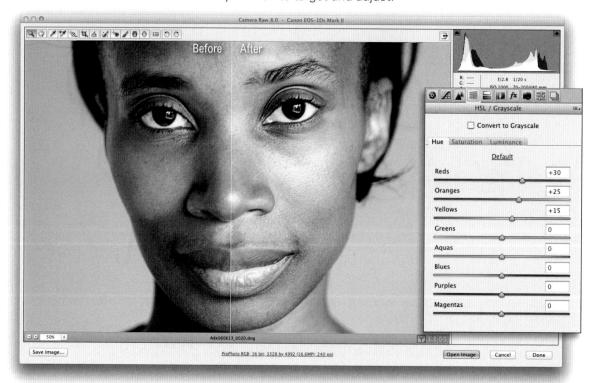

Figure 2.56 Here, I used a combination of positive Reds, Oranges and Yellows Hue adjustments to make the skin tones look less reddish.

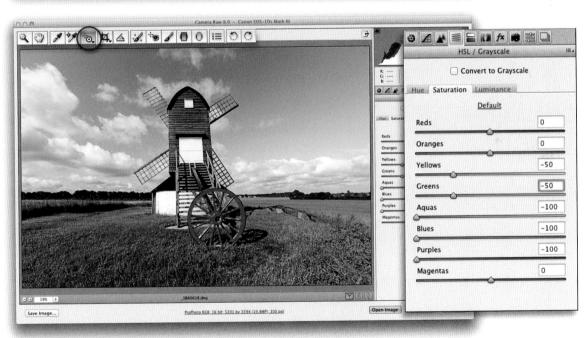

Figure 2.57 In this example, I have shown the before version (top) and a modified version (below), where I used the HSL/Grayscale panel Saturation sliders to selectively desaturate some of the colors in this scene. This can be done manually, or by using the target adjustment tool (circled) to target specific colors and drag downwards to desaturate.

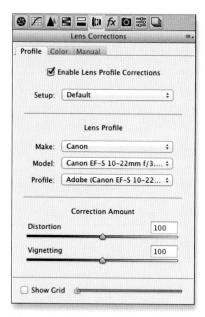

Figure 2.58 This shows the Lens Corrections panel Profile tab controls.

Lens Corrections panel

The Lens Corrections panel controls (Figure 2.58) can be used to help correct some of the optical problems that are associated with digital capture.

With Camera Raw 6.1 or later the Lens Corrections panel defaults to showing you the Profile tab mode shown in Figure 2.58, which allows you to 'Enable lens Profile Corrections' for instant auto lens correction adjustments. This can be done for any image, providing there is a matching lens profile in the lens profile database installed with Photoshop and Camera Raw. If the lens you are using is not included in the camera lens profile database, you will need to use a custom lens profile. I'll come on to this shortly, but if we assume there are lens profiles available for the lenses you are shooting with, it should be a simple matter of clicking the 'Enable Lens Profile Corrections' box to apply auto lens corrections to any selected photo. When you do this you should see the 'Make' of the lens manufacturer, the specific lens 'Model' and lens 'Profile' (which will most likely be the installed 'Adobe' profile) appear in the boxes below. If these don't show up, then you may need to first select the lens manufacturer brand from the 'Make' menu, then the specific lens 'Model' and lastly, the desired lens profile from the 'Profile' menu. It is important to appreciate here that some camera systems capture a full-frame image, while compact SLR range cameras have smaller-sized sensors which make use of a smaller area of the lens's total coverage area. The Adobe lens profiles have mostly been built using cameras that have full-frame sensors. Therefore, from a single lens profile it is possible to calculate the appropriate lens correction adjustments to make for all other types of cameras in that manufacturer's range where the sensor size is smaller than a full-frame. Also note that when processing raw images, Camera Raw will prefer to use lens profiles that have also been generated from raw capture files. This is because the vignette estimation and removal has to be measured directly from the raw linear sensor data rather than from a gamma-corrected JPEG or TIFF image.

An auto lens correction consists of two main components: a 'Distortion' correction to correct for barrel or pincushion geometric distortion and a 'Vignetting' correction. The Amount sliders you see here allow you to fine-tune an auto lens correction. So, for example, if you wanted to have a lens profile correction correct for the lens vignetting, but not correct for,

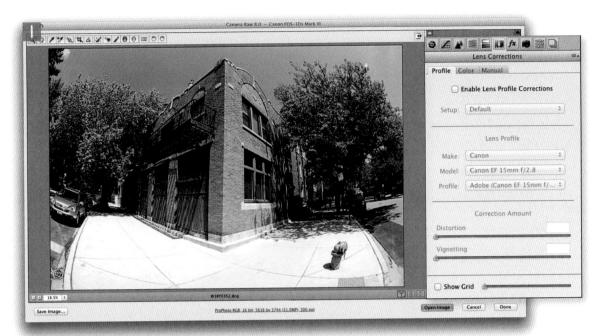

1 In this initial step you can see an example of a photograph that was shot using a 15 mm fisheye lens, where there is a noticeable curvature in the image.

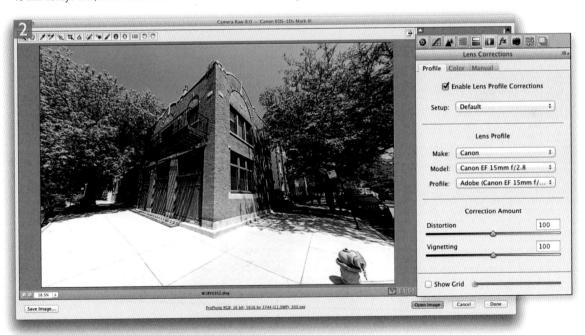

2 In the Lens Corrections panel I simply checked the Enable Lens Profile Corrections box to apply an auto lens correction to the photograph. In this instance I left the two Correction Amount sliders at their default 100% settings.

Where lens profiles are kept

Custom lens profiles created via Adobe Lens Profile Creator 1.0 should be saved to the following locations:

Library/Application Support/Adobe/Camera Profiles/Lens Correction/1.0 (Mac), C: \Program Data\Adobe\CameraRaw\ LensProfiles\1.0 (PC).

Setup:	Default	*
	Lens Profile	
Make:	None	.
Model:	None	1100 (100 (100 (100 (100 (100 (100 (100
Profile:	None	
Distortion	Correction Amou	unt
/ignetting	9	

Figure 2.59 If the lens used is one that applies a profile correction automatically, you will see an alert message like the one shown here. Some compact cameras rely on software to correct for geometric distortion and chromatic aberration. In fact, it has always been conditional that Adobe read and apply these behind the scenes when reading the raw data. If you could see the raw image without the correction you would see quite a difference. But because these are applied automatically there is no need to apply a profile correction, hence the message.

say, a fisheye lens distortion, you could drag the Distortion slider all the way to the left. On the other hand, if you believe an auto lens correction to be too strong or not strong enough, you can compensate the correction amount by dragging either of these sliders left or right.

The default option in the Setup menu will say 'Default'. This instructs Camera Raw to automatically work out what is the correct lens profile to use based on the available EXIF metadata contained in the image file, or use whatever might have been assigned as a 'default' Lens Corrections to use with a particular lens (see below). The 'Custom' option will only appear if you choose to override the auto-selected default setting, or you have to manually apply the appropriate lens profile. As you work with the automatic lens profile corrections feature on specific images you will also have the option to customize the Lens Corrections settings and use the Setup menu to select the 'Save new Defaults...' option. This allows you to set new Lens Correction settings as the default to use when an image with identical camera EXIF lens data settings is selected. After you do this the Setup menu will in future show 'Default' as the selected option in the Setup menu.

Accessing and creating custom lens profiles

If you don't see any lens profiles listed for a particular lens, you have two choices. You can either make one yourself using the Adobe Lens Profile Creator program, or locate a custom profile that someone else has made. The Adobe Lens Profile Creator program is available free from the labs.adobe.com website, along with full documentation that explains how you should go about photographing one of the supplied Adobe Lens Calibration charts and generate custom lens profiles. It really isn't too difficult to do yourself once you have mastered the basic principles. If you are familiar with the Lens Correction filter in Photoshop (see page 648) you will know how easy it is to access shared custom lens profiles that have been created by other Photoshop customers (using the Adobe Lens Profile Creator program). Unfortunately, the Lens Corrections panel in Camera Raw doesn't provide a shared user lens profile option, so whether you are creating lens profiles for yourself or wishing to install supplied lens profiles, you will need to reference the directory path lists shown in the 'Where lens profiles are kept' sidebar. Once you have added a new lens profile to the Lens Correction or Lens Profiles folder, you will need to quit

Photoshop and restart before any newly added lens profiles appear listed in the Automatic Lens Corrections panel profile list.

Note that images missing their EXIF metadata cannot be processed directly using the lens profile corrections feature. However, if you save a lens profile correction setting as a Camera Raw preset, it is kind of possible to apply such adjustments to any images that are missing the EXIF metadata by applying this preset via Camera Raw.

Some cameras that have built-in lenses, apply lens profile corrections automatically behind the scenes and Adobe are obliged to respect these. Camera Raw reads the camera manufacturer's own embedded lens correction metadata and applies a lens profile correction by default. In these instances, checking the Enable Lens Profile Corrections box will make no difference and a message at the bottom explains why (see Figure 2.59).

Lens Corrections: Color tab

The Lens Corrections panel contains a Color tab, which can be used specifically for making color lens corrections to do with chromatic aberration and color fringing (Figure 2.60).

Chromatic aberration

Sensors in the latest digital cameras can resolve a much finer level of detail than was possible with film. As a consequence of this any deficiencies in the lens optics can be made even more apparent. If you inspect an image closely towards the edge of the frame area, you may notice some color fringing where the different color wavelengths are not all focused at the same point. This is known as latitudinal chromatic aberration. It will be most apparent around areas of high contrast and is particularly noticeable when shooting with wide angle lenses at a wide aperture. It's mainly a problem that's associated with cheaper lens optics, but can still be seen with the best lenses sometimes. To correct for latitudinal chromatic aberration check the 'Remove Chromatic Aberration' box. Note that the method by which chromatic aberration is corrected has changed since Process 2010. When using Process 2012, the chromatic aberration data contained in a lens profile is ignored and Camera Raw carries out an auto correction based on an analysis of the image. As you can see in the Figure 2.61 example, this approach to removing chromatic aberration appears to work really well. One of the added advantages of

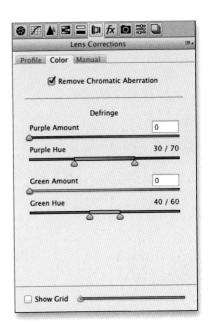

Figure 2.60 The Lens Corrections dialog showing the Color tab controls.

Chromatic Aberration

Lens profiles actually describe three aspects of a lens correction: Distortion, Vignetting and Chromatic Aberration. However, you will now see just the Distortion and Vignetting sliders. The chromatic aberration data is ignored and the chromatic aberration distortion is handled separately by checking the 'Remove Chromatic Aberration' option. This carries out an 'analysis' method of correction, rather than using the data in the profile. Essentially, this correction kind of scales the size of the individual color channels that make up the composite color image so that what apparent 'color misregistration' towards the edges of the frame is corrected.

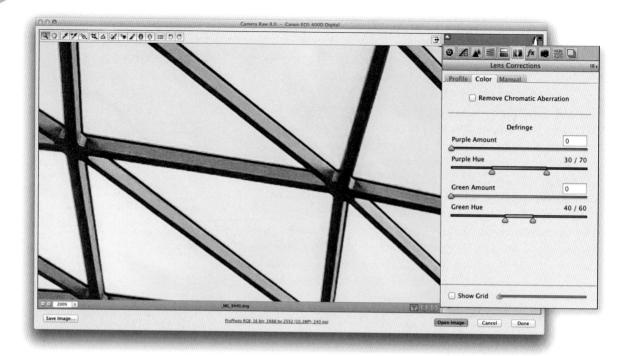

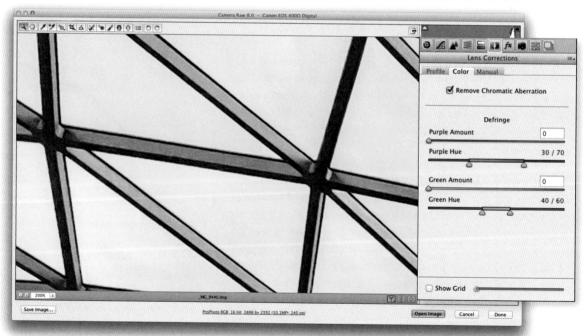

Figure 2.61 The top screen shot shows a 200% close-up view of an image where you can see strong color fringing around the high contrast edges. In the lower version I used an automatic Remove Chromatic Aberration correction to remove the color fringes.

this is that one can process images where a non-centrallyaligned lens has been used. For example, a photograph that's been shot using a tilt/shift lens where the central axis has been tilted can now be corrected more effectively.

Defringe sliders

The Defringe controls are designed to fix axial (longitudinal) chromatic aberrations. These can also be caused due to ghosting, lens flare, charge leakage (which affects some CCD sensors).

Unlike lateral chromatic aberration, which occurs towards the edges of the frame, these types of aberrations can appear anywhere in an image. It is something that can particularly affect fast, wide aperture lenses and is typically most noticeable when shooting at the widest lens apertures, where fringes will usually be at their most visible just in front of and just behind the plane of focus. These will typically appear purple/magenta when they're in front of the plane of focus, and green when they're behind the plane of focus. But even at the exact point of focus you may sometimes see purple fringes (especially along high contrast or backlit edges), which can be caused be flare. As you stop down a lens these types of aberrations usually become less noticeable.

The Defringe section consists of four sliders. There are now Purple Amount and Green Amount sliders for controlling the degree of correction and below each of these are Purple Hue and Green Hue sliders, which have split slider controls.

So, if we look at the two Purple sliders, the Purple Amount slider has a range of 0-20 and is used to determine the strength of the purple fringing removal. The Purple Hue slider can then be used to fine-tune the range of purple colors that are to be affected. What you need to be aware of here is that a higher Purple Amount setting will apply a stronger correction, but the downside is that at higher settings this may cause purple colors in the image that are not the result of fringing to also become affected by the Purple Amount adjustment. So, to moderate this undesired effect you can tweak the Purple Hue slider split points to narrow or realign the purple range of colors to be targeted. You can drag on either of the knobs one at a time, or you can click and drag on the central bar to align the Hue selection to a different purple portion of the color spectrum. If you need to reset these sliders then just doubleclick on each individual knob. Likewise, double-click the central

The old Defringe menu

The Defringe controls found in Camera Raw 7.1 or later provide a new and more effective way to deal with all kinds of fringing artifacts. You will notice in the Manual tab section that the old Defringe menu has now been removed. It was probably not used that much anyway and rarely proved to be that effective. The new controls in the Color tab are a better substitute.

Where an image has had a Highlight Edges or All Edges adjustment applied previously in Camera Raw, Camera Raw 7.1 or later will apply a Purple Amount value of 1, leaving all the other sliders at their default settings.

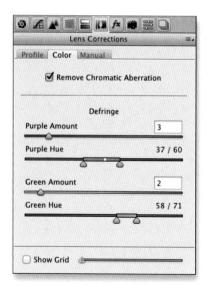

Figure 2.62 This shows the Lens
Corrections panel where the <code>#</code> (Mac),
<code>ftr</code> (PC) key was held down. Here, you
can see a white bar on the Purple Hue color
ramp indicating where on the color ramp the
sampled color lies.

bar to reset this to its default position. The minimum distance that may be set between the two sliders is 10 units.

The Green Amount and Green Hue sliders work in exactly the same fashion as the Purple sliders, except these two sliders allow you to control the green fringes. However, the default range for the Green Hue slider is set at 40 to 60 instead of 30 to 70. This is to help protect common green and yellow colors such as foliage colors.

The Defringe controls in use

The recommended approach is to carry out all your major tone and color edits first. Then make sure that you have turned on the profile-based lens corrections to correct for geometric distortion and vignetting. Once these steps have been taken, ao to the Color tab of the Lens Corrections panel and check the 'Remove Chromatic Aberration' check box. You can then start using the global Defringe sliders to remove any remaining signs of fringing. Also, be aware that where the global controls are having an adverse effect on the rest of the image, you can always turn down the Purple/Green Amount sliders and use a localized adjustment with the Defringe slider set to a positive value to apply a stronger, localized adjustment. If carrying out a localized adjustment it is important to apply the geometric and any manual distortion controls first. As with the Detail panel controls, the Lens Correction defringe controls are best used when viewing an image at 100% or higher.

You can also use the [all] key as a visualization aid. These can greatly help the user see an emphasized overlay that gives a clearer indication of what effect the sliders are having and making the most suitable slider adjustments.

Use the [at] key to drag on the Purple Amount slider to visualize purple fringe removal. This will cause the preview to reveal only the affected areas of the image. All other areas will be shown as white. This lets you concentrate on the affected areas and help verify that the purple fringe color is being removed.

Use the all key to drag on either of the Purple Hue slider knobs to visualize the range of hues that are to be defringed. As you do this, the preview will show the affected hue range as being blacked out. As you drag on a slider you need to pay close attention to the borders of the blacked out area to check if there are any residual purple colors showing still. Obviously, the same principles apply when adjusting the Green Amount and Green Hue sliders with the all key held down.

Eyedropper tool mode

When working with the Defringe sliders you can hold down the (Mac), (PC) key as you roll the cursor over the preview window to reveal an eyedropper tool. This tool can be used to help set the Purple/Green Hue slider knobs. If the Caps Lock key is enabled, the eyedropper cursor will be shown as a cross hair. This can help you to pick the fringe pixels more accurately.

To use this tool it helps to be zoomed in extra close, such as at 200%, or even 400%. This will make the color picking more accurate and you will notice a little white bar appear on one or other color ramp as you hover the cursor over different parts of the image (see Figure 2.62). As you click in the preview this allows Camera Raw to analyze the pixels in the local area around where you click, which can result in one of four outcomes. Camera Raw detects that you clicked on a purple fringe and adjusts the Purple Amount and Purple Hue sliders to suit. Alternatively, Camera Raw detects that you clicked on a green fringe and will adjust the Green Amount and Green Hue sliders. Or, Camera Raw determines that the area you clicked on was too neutral, or was a color that falls outside the supported color range. In which case you will see one of the alert dialogs shown in Figure 2.63.

Figure 2.63 This shows the two possible error messages you might see when working with the eyedropper tool. The top one shows an alert pointing out that the sampled color is too neutral. The bottom alert dialog indicates that the sampled color falls outside the supported color range.

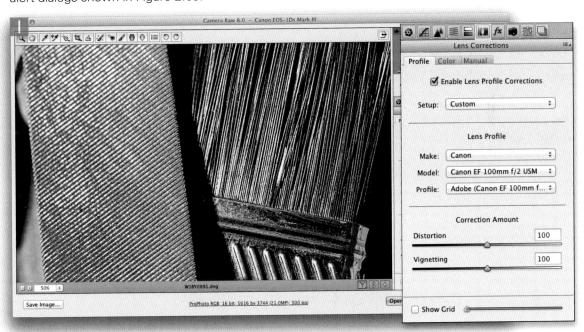

1 The first step is to apply all the main color and tone adjustments as well as enable the lens profile corrections in the Lens Corrections Profile tab section.

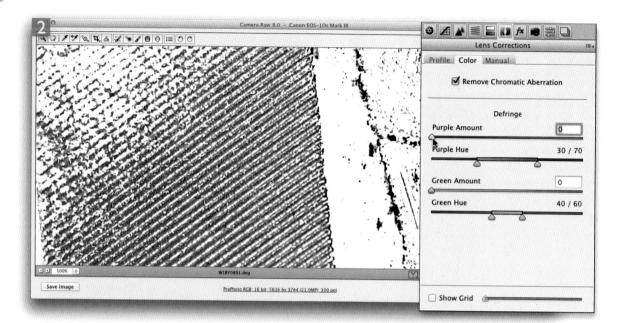

2 I clicked on the Color tab to view the color controls. It is usually best to simply check the Remove Chromatic Aberration option to auto correct the image. I then held down the all key and moused down on the Purple Amount slide to get a visualization of the extent of the purple fringed area, with everything else displayed white.

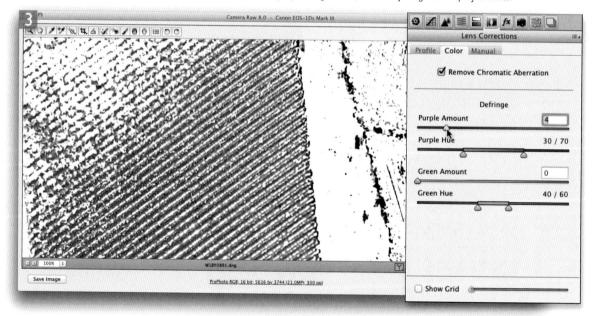

3 With the *all* key held down still I dragged the Purple Amount slider till all of the purple fringing seemed to have been removed. Note that it may often help to use a close-up view beyond 100% when judging the effectiveness of such an adjustment.

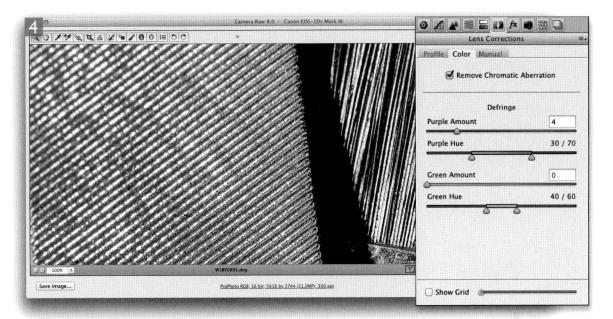

4 Next, I wanted to concentrate on the Green fringing. Here, you can see the extent of the green fringes in the areas that were behind the plane of focus.

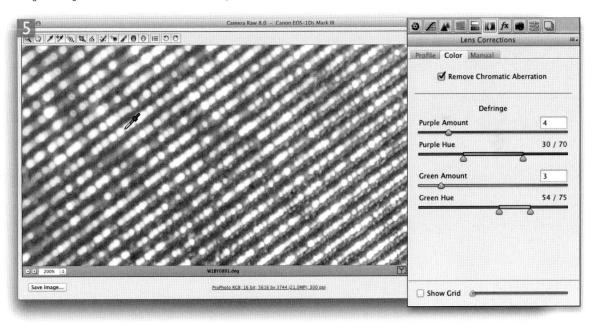

5 In this instance I used the eyedropper mode to determine both the Green Amount and Green Hue slider settings. I held down the (Mac), (PC) key to change the cursor to an eyedropper and clicked on the green fringe area. This single step auto-set the Green Amount and Green Hue sliders.

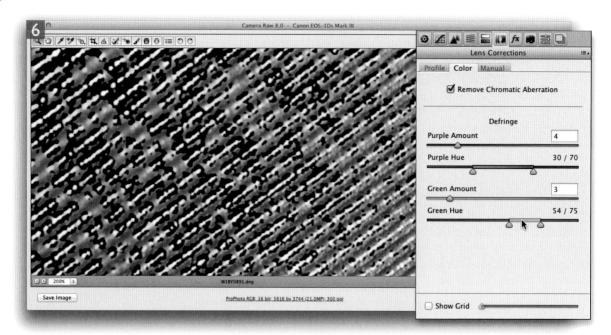

6 I held down the **a**/**!** key and moused down on the Green Hue ramp to obtain a visualization of the green hues and the extent they were being adjusted. However, there was no need to tweak the hue ramp sliders — the auto correction worked fine as it was.

Localized adjustments: Defringe slider

The global Defringe controls should be all that you need to remove troublesome fringing. However, there may be times where it won't be possible to remove all visible fringing using the global Defringe sliders on their own. Or, it may be the case that when applying a strong global correction the adjustment you apply has an adverse effect on other areas. In situations like this it may be useful to apply a global adjustment combined with a localized defringe correction using either the adjustment brush or graduated filter. Note that localized Defringe adjustments will remove fringes for all colors (not just purple and green) and therefore works independently from the global Purple Hue and Green Hue settings set in the lens Corrections panel.

The global lens corrections are available for all process versions, but in order to apply a localized adjustment the image you are processing must be updated to the latest Process 2012. The standard range goes from -100 to +100. A positive Defringe adjustment can be used to apply extra defringing where required, such as when working on specific problem areas in a picture. It may even be the case that with some

images a localized defringe adjustment is all that you need to apply. A negative Defringe adjustment can be used where you don't want to apply a defringe and wish to protect this area. One example of how you might want to use this would be to imagine a picture where say, a strong purple defringe had been applied globally, which resulted in the edges of purple areas becoming desaturated. In a situation like this you could paint over the affected areas with the Defringe slider set to-100. This would allow you to restore some of the original color to these areas.

It should be noted that the localized defringe control is not as powerful as the global defringe controls. This is why it is often best to use the global Lens Corrections panel controls first and then use a localized adjustment to fine-tune as necessary. A negative, –100 defringe adjustment will of course completely remove any global defringing. Just be aware that there is no benefit to be gained in applying multiple localized defringe adjustments to improve upon what a single application can achieve.

Defringe and Process Versions

The Defringe slider is only available as a localized adjustment when an image has been updated to Process 2012. You do need to watch out though that once an image has been updated to Process 2012 and a defringe adjustment has been made you don't attempt to convert the image back to Process 2010 or Process 2003. If you do so this will cause the defringe effect to be zeroed. The pin you added will still be present, but there will be no defringe adjustment. If you then convert the image back to Process 2012 the adjustment mask will be preserved and you can restore the defringe effect by adjusting the Defringe slider setting.

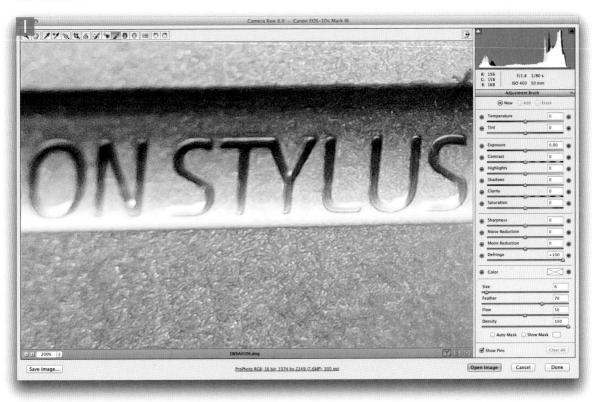

1 This shows a close-up view of an image with noticeable fringes.

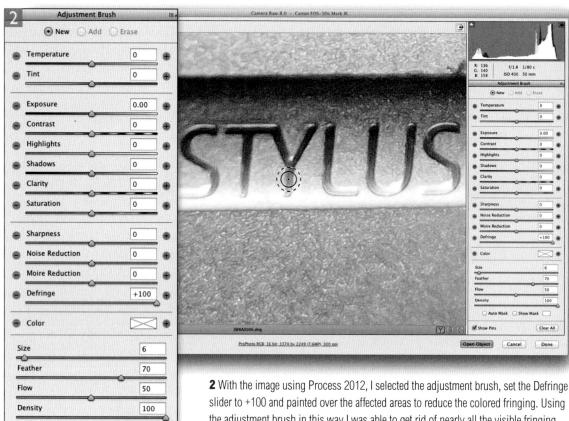

the adjustment brush in this way I was able to get rid of nearly all the visible fringing and target the Defringe adjustment precisely, where it was needed most.

Lens Corrections: Manual tab

In the Manual tab section (Figure 2.64) you can apply automated Upright corrections (new to Photoshop CC) and manual Transform and Lens Vignetting adjustments.

Upright corrections

Upright corrections are auto-calculated in Camera Raw based on an analysis of the image. By selecting one of the four options described below you can apply an instant auto transform correction in place of using the Vertical, Horizontal or Rotate sliders found in the Transform section below. The best way to use this tool is to check the 'Enable Lens Profile Corrections' option in the Profile tab section first before you apply an Upright adjustment and make sure you don't have a rotate crop applied or manual transform adjustments already applied to the image. The impact of a geometric correction is not always as major, but this should help you achieve the

Auto Mask Show Mask

best results since letting Upright work with a geometricallycorrected image can make the line detection work better.

The Auto setting applies a balanced correction to the image. which rather than auto-selecting an Upright setting, uses a balanced combination of the options listed below. Essentially, it aims to level the image and, at the same time, fixes converging vertical and horizontal lines in an image. The ultimate goal here is to apply a suitable transform adjustment that avoids applying too strong a perspective correction. When selecting an Auto setting it mostly crops the image to hide the outside areas. However, if the Auto adjustment ends up being quite strong some outside areas may become visible as transparent pixels. It is worth pointing out here that Camera Raw now includes transparency support. This means such outer areas are displayed using the same default checker board pattern as in Photoshop and preserved as such whenever you export from Camera Raw using the PSD and TIFF formats (Camera Raw is also able to read transparency in DNG and TIFF files). If, on the other hand, you export as a JPEG, the transparent areas will be rendered solid white.

A Level adjustment applies a levelling adjustment only—this behaves like an auto straighten tool. The Vertical setting applies a level plus converging vertical lines adjustment. Lastly, there is a Full setting which applies a full level plus converging vertical and horizontal lines adjustment, and will allow strong perspective corrections to occur.

It may be that an Upright correction can end up looking too perfect. With architectural shots it is generally a good idea to allow the verticals to converge just a little. You might therefore want to combine an Upright correction with a manual transform, such as a positive Vertical adjustment. You might even consider saving an Upright auto correction plus a Vertical adjustment as a preset. And, if you find an Upright setting that you like, but an important part of the image ends up being cropped, you can also adjust the Scale slider to reduce the scale.

The Off setting can be used to turn off an Upright correction, while preserving the initial, pre-computed analysis of the image. You can use <code>ctrl Tab</code> to cycle through the correction options and <code>ctrl Shift Tab</code> to reverse cycle. If you click on 'Reanalyze' this switches off the adjustment and clears the memory so to speak. The Reanalyze option is there in case you wish to enable or disable a Lens Profile correction, which would otherwise affect the way an Upright pre-calculation is made. Or, if you forgot you needed to undo a rotated crop, you would want to click

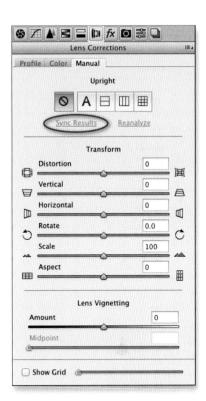

Figure 2.64 This shows the Manual Lens Corrections controls. Note that if a crop is currently applied to the image, you'll see a message informing you that an Upright correction will reset any crop that's active. If the image you intend to process cannot be corrected after clicking one of the Upright buttons, you'll see here a warning message saying 'No upright correction found'

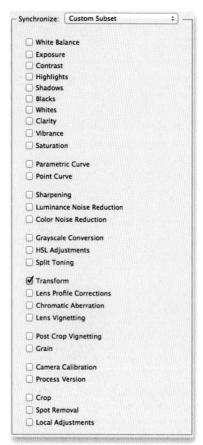

Figure 2.65 This shows the Synchronize Settings menu options for synchronizing Camera Raw settings. When the Transform option is selected this allows auto synchronization of Upright settings. One thing to note here is that whenever an Upright adjustment is enabled on the primary, most-selected photo, synchronizing the Transform setting will also force synchronize the crop as well.

on Reanalyze and then try running through the Upright options again (use all-click to reset the Reanalyze button). As you click on any of the Upright options (except for Off) this automatically resets the Horizontal, Vertical, Rotate, Scale and Aspect Transform sliders, as well as resetting any crop that's active.

It is important to understand here that the underlying math behind Upright adjustments is doing more than just auto-set the Vertical, Horizontal and Rotate sliders in the Transform section. Behind the scenes there are angle of view and center of projection adjustments taking place and the vertical and horizontal adjustments involved in the Upright process are actually rather sophisticated. It's all to do with how the interaction of one rotation movement can affect another. Think what it's like when you adjust the tilt and yaw on a camera tripod head and you may get some idea of the problem.

Upright adjustments may also cause the image to appear stretched vertically or horizontally. An Aspect slider is provided so that you can compensate for such distortions and thereby keep the adjusted image looking more natural. At the bottom of the panel is a Show Grid option (use V to toggle), which can help you evaluate the effectiveness of an Upright correction. Next to this is a slider that allows you to adjust the fineness/coarseness of the grid scale. You can also use the V keys to adjust the grid size and use V (Mac), V (PC) for bigger steps. Note that the Grid on/off setting and grid slider settings always remain sticky.

Synchronizing Upright settings

There are two ways to synchronize Upright adjustments. If you apply an Upright adjustment and use the Synchronize Settings menu to sync the settings and the Transform option is checked (Figure 2.65), this will apply an auto type of synchronization, similar to that which occurs when synchronizing an auto white balance setting. So, if you synchronize the settings in this way, each image will be synchronized in terms of having an Upright adjustment applied to it. But the way that adjustment is applied is auto-determined for each image.

If, on the other hand, you wish to synchronize the exact transform settings you will need to open a selection of images via Camera Raw, apply the desired Upright transform to the first image and then click on 'Sync Results' (circled in Figure 2.64). For example, if you wanted to prepare a group of bracketed exposure images to create an HDR master you would want to use 'Sync Results' rather than 'Synchronize Settings'.

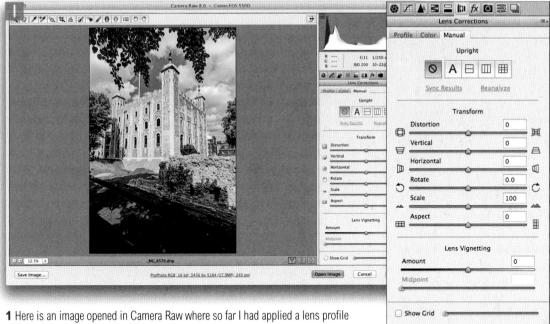

1 Here is an image opened in Camera Raw where so far I had applied a lens profile correction via the Profile tab section of the Lens Corrections panel. No Upright correction had been applied to this image yet.

2 On the left you can see the outcome of a 'Full' Upright adjustment where Camera Raw carried out a full perspective plus levelling correction regardless of how strong the perspective adjustment would be. As you can see, this produced a very strong correction with outside areas visible (the transparent boundary). On the right is a Vertical adjustment, which aimed to level the horizon and correct the converging verticals. Where you do end up with transparency in an image you can select the 'Constrain to image' option from the crop tool menu (see Figure 2.66).

Figure 2.66 This shows the 'Constrain to Image' item in the Crop menu.

Upright adjustment order

It is always best to apply Upright adjustments early on before you apply localized adjustments, a rotate crop. or manual transform. If you use the Lens Corrections panel to apply an Upright adjustment after applying a local adjustment, such as the adjustment brush, gradient or radial filter, these can't always be preserved exactly and there may be some shift in the positioning of the adjustments depending on how extreme the Upright adjustment is. With adjustment brush edits, small brush strokes will be preserved quite accurately if you apply an Upright adjustment afterwards, but with larger, individual brush strokes you are more likely to see a misalignment when applying an Upright adjustment after. The same is also true with applying lens profile adjustments – these too should ideally be applied early on. With spot removal adjustments these take place early on in the Camera Raw imaging chain and are not affected by Lens Profile or Upright adjustments that are applied after. Basically, you are always advised to apply Upright adjustments early on and before you add any kind of localized adjustments.

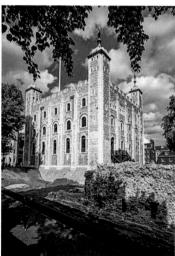

3 Here on the left is an Auto adjustment in which Camera Raw applied an adjustment that combined a level, horizontal and vertical adjustment in a more balanced way and On the right is a 'Level' adjustment, which aimed to straighten the horizon only. Of the five different outcomes the Vertical option from step 2 was the most natural-looking.

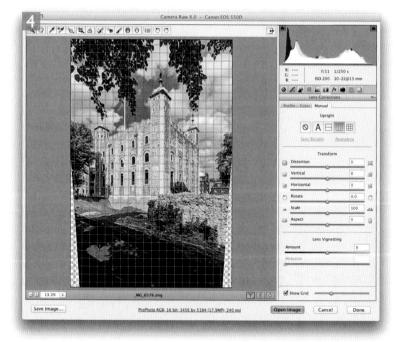

4 I checked the Show Grid box at the bottom of the Lens Corrections panel to enable the grid overlay. I could also adjust the slider to fine-tune the grid overlay scale.

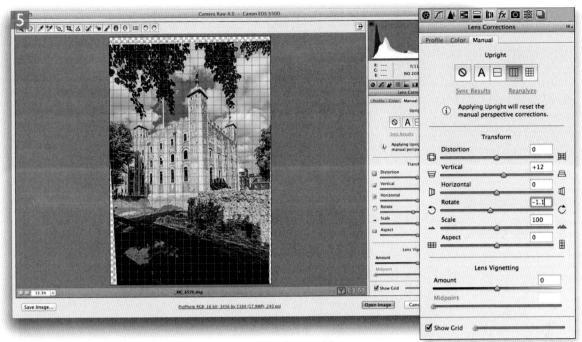

5 In the Transform section I adjusted the Vertical slider to dial back some of the keystone effect and also manually rotated the transform slightly.

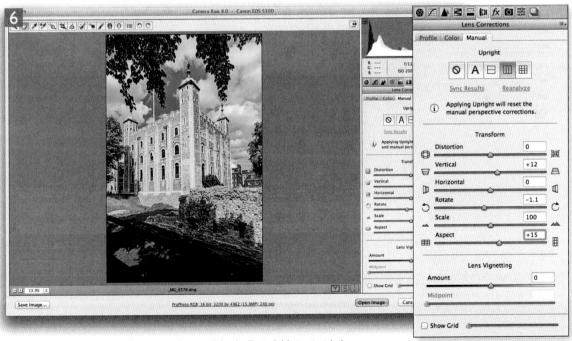

6 The Transform section also features an Aspect slider. I adjusted this to stretch the image more vertically. The end result is shown here with the image cropped.

Another use for Lens Vignetting

Vignetting is not always a result of the lens used. In the studio I am fond of shooting with extreme wide angle lenses and the problem here is that it's often difficult to get the backdrop evenly lit in all four corners. In these kinds of situations I find it sometimes helps to use the Lens Vignetting slider to compensate for the fall-off in light towards the corners of the frame by lightening the edges.

Transform controls

The Transform controls can be used to fine-tune an Upright correction, or used in place of applying a manual transform adjustment. As I explained earlier, the way the Upright feature calculates its corrections cannot be replicated using the Transform sliders alone. However, there may be times when Upright can't make an appreciable improvement to the perspective and you will be better off using the manual Transform sliders. Sometimes you may find it helps to combine the two.

The Distortion slider can be used to apply a geometric distortion adjustment, which will be independent of a distortion correction applied using a lens profile correction. The Vertical slider can be used to make keystone corrections and the Horizontal slider can similarly be used to correct for horizontal shifts in perspective, such as when a photo has been captured from a viewpoint that is not completely 'front on' to the camera. Note that you can click the Show Grid box (V) to toggle showing/hiding a grid overlay. The Rotate slider allows you to adjust the rotation of the transform adjustment. This is not exactly the same as rotating the image. So, while it is possible to use the Rotate slider to straighten a photo, I suggest that you should primarily use the straighten tool to make this type of correction first. The Scale slider allows you to adjust the image scale and, as I explained earlier, the Aspect slider can be used to adjust the aspect ratio of an image. As you adjust any of the above sliders you may end up with transparent areas around the edges of a transformed image. You have the option of using the 'Constrain to image' option from the crop tool menu (see Figure 2.59), or you can use Photoshop to fill these in for you (see page 552).

Lens Vignetting controls

If you wish to correct for the lens vignetting inherent in an image, it is always best to enable a lens profile correction and fine-tune the correction using the Vignetting slider. This assumes a lens profile is available though. Where there is none, or you are processing a scanned image, you can use the Manual tab Lens Vignetting controls. The Amount slider can be used to compensate for the corner edge darkening relative to the center of the photograph and the Midpoint slider can be used to offset the rate of fall-off. As you increase the Midpoint value, the exposure compensation will be accentuated more towards the outer edges.

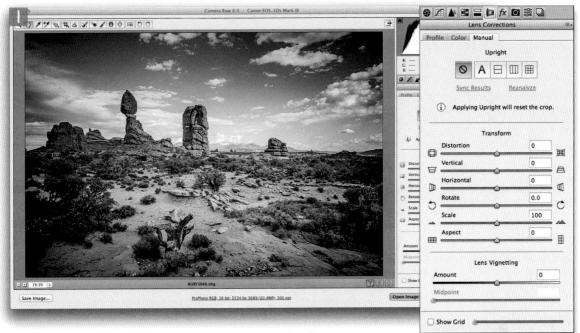

1 Here is an example of a photograph shot with a wide angle lens, where lens vignetting can be seen in the corners of the frame.

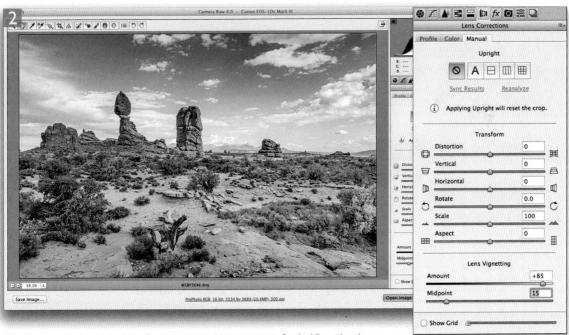

2 In this example, I used the Lens Corrections panel to compensate for the Vignetting. I set the Amount slider to +85 and adjusted the Midpoint to fine-tune the correction. The aim here was to obtain an even exposure at the corners of the photograph.

Combined effects

Now that we have Post Crop Vignetting controls as well as the standard Lens correction vignette sliders, you can achieve even more varied results by combining different combinations of slider settings, whether a photo is cropped or not.

Effects panel

Post Crop Vignetting control

A lot of photographers have got into using the Lens Vignetting controls as a creative tool for darkening or lightening the corners of their pictures. The only problem here is that the lens vignetting can only be applied to the whole of the image frame area. However, you can also use the Post Crop. Vignetting sliders to apply a vignette relative to the cropped image area. This means you can use the Lens Vignetting controls for the purpose they were intended (to counter any fall-off that occurs towards the edges of the frame) and use the Post Crop Vignette sliders in the Effects panel as a creative tool for those times when you deliberately wish to lighten or darken the edges of a photo. The Post Crop Vignetting Amount and Midpoint sliders work identically to the Lens Corrections lens Vignetting controls, except you also have the option to adjust the Roundness and the Feathering of the vignette adjustment.

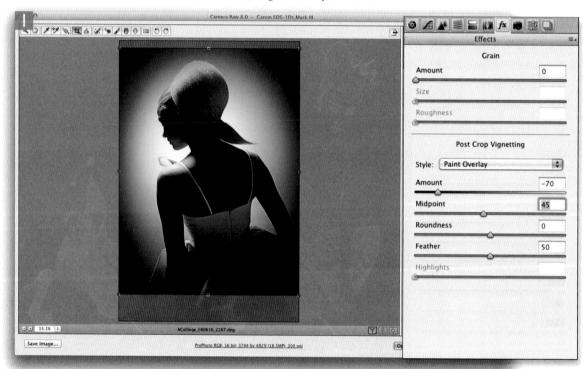

Client: Andrew Collinge Hair & Beauty. Hair by Andrew Collinge artistic team, Make-up: Liz Collinge. 1 In this first example I applied a –70, darkening vignette offset with a +45 Midpoint setting. This adjustment was not too different from a normal Lens Vignetting adjustment, except it was applied to the cropped area of an image.

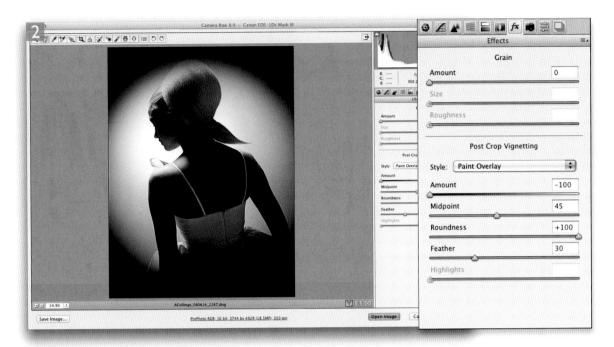

2 In this next version, I adjusted the Roundness slider to make the vignette shape less elliptical and adjusted the Feather slider to make the vignette edge harder.

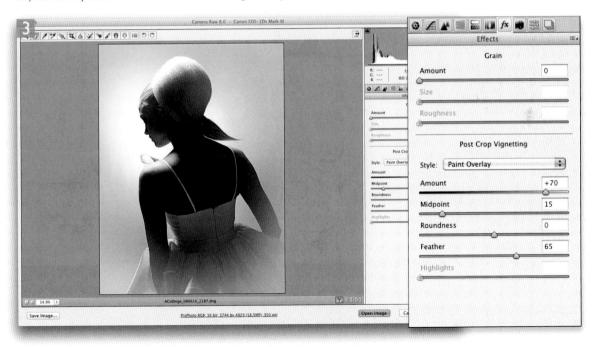

3 For this final version, I applied a +100 vignette Amount to lighten the corners of the cropped image, combined with a low Midpoint and a soft Feather setting.

Post Crop Vignette style options

So far I have just shown you the options for the Paint Overlay vignette style option. It wasn't named as such before, since this was the only Post Crop Vignette mode available in previous versions (Camera Raw 5 or earlier). When first introduced, some people were quick to point out that the Post Crop Vignetting wasn't exactly the same as a Lens Correction

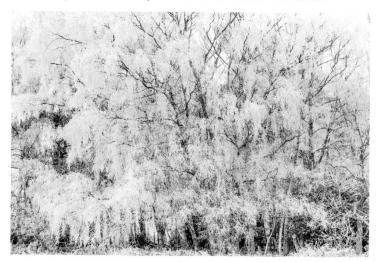

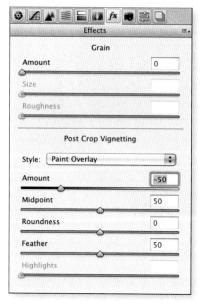

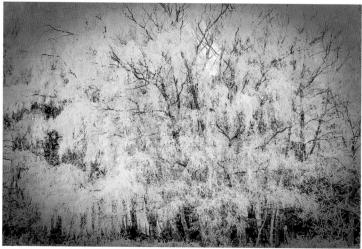

Figure 2.67 In this example I took a photograph of some snow-covered tree branches. Shown here is the before version (top) and one where I had applied a standard Paint Overlay style Post Crop Vignette using the settings shown here.

Vignette effect. You can see for yourself in the Figure 2.67 example how the Paint Overlay vignette applies a soft contrast, hazy kind of effect. This wasn't to everyone's taste (although I didn't always particularly mind it) and so Camera Raw 6 or later now offers you two alternative post crop editing modes which more closely match the normal Lens Correction edit mode, yet offer extra scope for adjustment. Where people were once inclined to use the Lens Correction sliders as a creative tool (because the Paint Overlay Post Crop effect was a bit wishywashy), they should now think of using the Lens Correction panel for lens corrections only and use the Post Crop Vignetting sliders in the Effects panel to add different kinds of vignette effects. So let's now look at the post-crop options.

In the Paint Overlay mode example (Figure 2.67), the Post Crop effect blends either a black or white color into the edges of the frame depending on which direction you drag the Amount slider. The two new 'Priority' modes produce an effect that is now more similar to the Lens Correction effect since the darkening or lightening is created by varying the exposure at the edges. Of the two, the Color Priority (Figure 2.68) is usually gentler as this applies the Post Crop Vignette *after* the Basic panel Exposure adjustments, but *before* the Tone Curve stage. This minimizes color shifts in the darkened areas, but it can't perform any highlight recovery when you darken the edges.

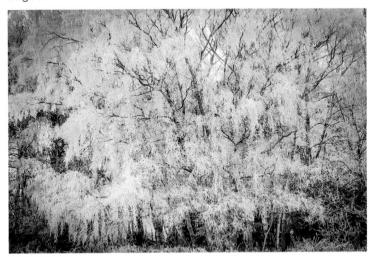

Figure 2.68 This shows an example of a darkening post-crop vignette adjustment in which the Color Priority style was used.

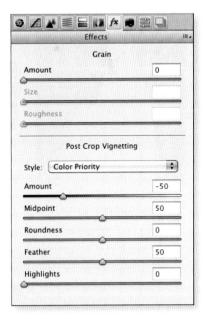

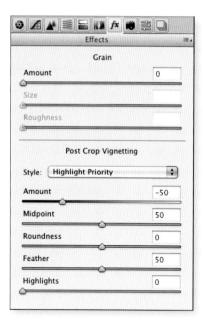

The Highlight Priority style (see Figure 2.69) tends to produce more dramatic results. This is because it applies the Post Crop Vignette *prior* to the Exposure adjustment. It has the benefit of allowing better highlight recovery, but this can lead to color shifts in the darkened areas

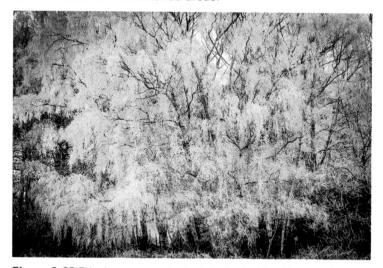

Figure 2.69 This shows an example of a darkening Post Crop Vignette adjustment in which the Highlight Priority style was used.

Highlights slider

You will notice there is also a 'Highlights' slider, which can be used to further modify the effect. In Paint Overlay mode, the Highlights slider has no effect on the image. In the two new priority modes the Highlights slider is only active when applying a negative Amount setting. As soon as you increase the Amount to apply a lightening vignette, the Highlights slider will be disabled. As you can see in the Figure 2.70 and 2.71 examples, increasing the Highlights amount allows you to boost the highlight contrast in the vignetted areas, but the effect is only really noticeable in subjects that feature bright highlights. Here it had the effect of lightening the snowcovered branches in the corners of the image, taking them back more to their original exposure value. In these examples the difference is quite subtle, but I find that the Highlights slider usually has the greatest impact when editing a Color Priority Post Crop Vignette.

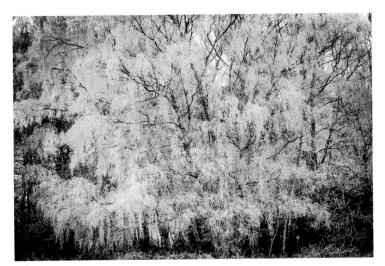

Figure 2.70 In this example I applied a Highlight Priority Post Crop Vignette style and added a 100% Highlights adjustment to the Highlight Priority vignette. In this instance, the Highlights slider adjustment made a fairly subtle change to the appearance of this Post Crop Vignette effect.

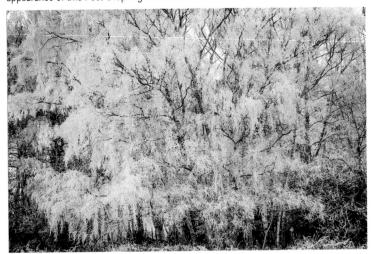

Figure 2.71 In this example I applied a Color Priority Post Crop Vignette style and added a 100% Highlights adjustment to the Color Priority vignette. If you compare this with the above example in Figure 2.70, you can see how a Highlights slider adjustment can have a more substantial effect on the Post Crop Vignette adjustment when used in the Color Priority mode.

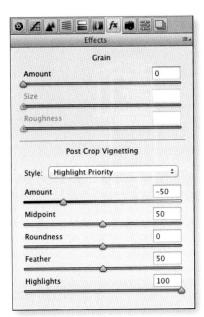

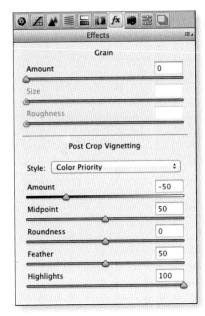

Figure 2.72 The Effects panel showing the Grain sliders.

Adding Grain effects

The Effects panel also contains Grain controls (Figure 2.72). The Amount slider determines how much grain is added, while the Size slider controls the size of the grain particles. The default setting is 25 and dragging to the left or right allows you to decrease or increase the grain particle size. Note here that if the Size slider is set any higher than 25, then a small amount of blur is applied to the underlying image. This is done to help make the image blend better with the grain effect. The exact amount of blur is also linked to the Amount setting; the higher the Amount, the more blur you'll see applied. The Roughness slider controls the regularity of the grain. The Default value is 50. Dragging to the left will make the grain pattern more uniform, while dragging to the right can make the grain appear more irregular. Basically, the Size and Roughness sliders are intended to be used in conjunction with the Amount slider to determine the overall grain effect. In Figure 2.73 you can see a before and after example of a grain effect being applied to a photo in Camera Raw.

The most obvious reason for including these new sliders is so that you can deliberately add a grain effect and give your photos a film-like look. However, if this is your aim you will probably need to apply quite a strong setting in order for the grain effect to be noticeable in print. Even then, this will only work effectively if you are producing a large-sized print output. The thing is, if you apply a grain effect while looking at the image at a 1:1 view and then make, say, a 10 x 8 print, the grain effect will mostly be lost due to the down sampling of the image data. With images that are going to be downsized even further to appear on the Web, it is unlikely a grain effect will be noticed at all.

It is also possible to use the Grain sliders to add subtle amounts of noise which can be used to disguise ugly image artifacts that can't otherwise be eradicated from the image. Having said this, it is possible to end up needlessly fretting about what you can see on screen at a 1:1 or a 200% view, especially when the detail you are analyzing will be diffused by the print process. Therefore tiny artifacts you see at a 100% view or higher shouldn't really be worth getting all that concerned about. A low Amount setting will allow you to add a fine amount of noise to a photo and this might well look even more pleasing as you add extra micro detail to a photo. In all honesty though, adding some extra fine grain is still

only creating the illusion of an improved image. What you see close-up on the screen won't have much bearing on the actual amount of detail in the final print. This is really something that should mainly be reserved for problem photos that can't be fixed with the new noise reduction sliders in the Detail panel (see page 312). In other words, where you have an image that contains really noticeable artifacts, you can try using the Grain sliders to cover these up, but I wouldn't recommend overdoing this too much. As you might have gathered, I'm not that enamored with this new feature. One of the main reasons I prefer shooting with digital cameras is because of the lack of grain you get in a digital capture.

The micro detail effect

It has been suggested that some raw converter programs have already been adding small amounts of grain by default in order to add micro detail to the image processing, which, as I say in the main text, is only creating the illusion of better image quality. Camera Raw doesn't do this by default, but gives you the opportunity to do so selectively.

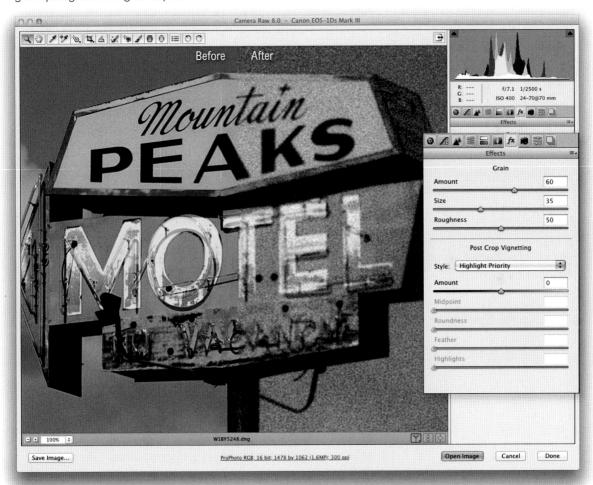

Figure 2.73 This shows a before and after example of a grain effect applied to a photo.

Figure 2.74 The Camera Calibration panel controls can be used to set the desired Process Version and fine-tune the Camera Raw color interpretation. The Camera Profile setting at the top can offer a choice of camera profile settings. These may include legacy settings such as ACR 4.3, etc. The recommended default setting to use now is 'Adobe Standard'.

ACR compatible cameras

The list of cameras that are compatible with the latest version of Camera Raw can be found at the Adobe website by following this link: www.adobe.com/products/photoshop/cameraraw.html.

Camera Calibration panel

The Camera Calibration panel (Figure 2.74) lets you do two things. It allows you to choose which Process Version to use when rendering a raw file and also lets you select an appropriate camera profile. As I explained earlier, if you click on the warning triangle that appears in the bottom right corner of the preview section you can update an image from Process 2003 or 2010 to the latest Process 2012. You can therefore use the Camera Calibration panel to update the Process Version used or reverse this process and select an older Process Version should you need to.

Everyone wants or expects their camera to be capable of capturing perfect colors whether they really need to or not. What is perfect color though? Some photographers may look at a JPEG version of an image and judge everything according to that, while others, who shoot raw, may prefer the default look they get from a particular raw processing program. Apart from anything else, is the display you are using actually capable of showing all the colors your camera can capture?

Camera Raw is the product of much camera testing and raw file analysis, which has been carried out by the Camera Raw team. By selecting the most appropriate camera profile in the Camera Calibration panel you can ensure you get the most accurate (or most suitable) color from your camera. Test cameras will have been used to build a two-part profile of each camera sensor's spectral response under standardized tungsten and daylight balanced lighting conditions. From this, Camera Raw is able to calculate a pretty good color interpretation under these specific lighting conditions, and also extrapolate beyond these across a full range of color temperatures. This method may not be as accurate as having a proper profile built for your camera, but realistically, profiling a camera is something that can only be done where the light source conditions are always going to be the same.

New Camera Raw profiles

You have to bear in mind that many of the initial default Camera Raw profiles were achieved through testing a limited number of cameras. It was later discovered that there could be a discernible variation in color response between individual cameras. As a result of this a wider pool of cameras were evaluated and the default profile settings were updated for certain makes of camera and in some cases newer versions of

the default camera profiles were provided. This is why you will sometimes see extra profiles listed that refer to earlier builds of Camera Raw, such as ACR 2.4 or ACR 3.6, etc. (see sidebar on 'New camera profile availability'). More recently, Eric Chan (who works on the Camera Raw engineering team) managed to improve many of the standard ACR profiles as well as extend the range of profiles that can be applied via Camera Raw. In Camera Raw 5 or later, the 'Adobe Standard' profile is now the new default and this and the other profiles you see listed in the Profile menu options are the result of improved analysis as well as an effort to match some of the individual camera vendor 'look settings' associated with JPEG captured images.

Although 'Adobe Standard' is now the recommended default camera profile, it has been necessary to preserve the older profiles such as ACR 3.6 and ACR 4.4, since these need to be kept in order to satisfy customers who have, in the past, relied on these previous profile settings. After all, it wouldn't do to find that all your existing Camera Raw processed images suddenly looked different because the profile had been updated. Therefore, in order to maintain backward compatibility, Adobe give you the choice to decide which profile is best to use. If you are happy to trust the new 'Adobe Standard' profile, then I suggest you leave this as the default starting point for all your raw conversions. The difference you'll see with this profile may only be slight, but I think you will find this still represents an improvement and should be left as the new default.

Camera look settings profiles

The other profiles you may see listed are designed to let you match some of the camera vendor 'look settings'. The profile names will vary according to which camera files you are editing, so for Canon cameras Camera Raw offers the following camera profile options: Camera Faithful, Camera Landscape, Camera Neutral, Camera Portrait as well as a Camera Standard option. Nikon users may see Mode 1, Mode 2, Mode 3, Camera Landscape, Camera Neutral, Camera Portrait and Camera Vivid profile options. In Figure 2.76 you can see an example of how these can compare with the older ACR and Adobe Standard profiles.

The 'Camera Standard' profile is rather clever because Eric has managed here to match the default camera vendor settings for some of the main cameras that are supported

New camera profile availability

Not all the Camera Raw supported cameras have the new profiles. These are mainly done for Canon, Nikon and a few Pentax and Leica models. So, you may not see a full list of profile options for every Camera Raw compatible camera, just the newer and most popular camera models.

Figure 2.75 X-Rite ColorChecker charts can be bought as a mini chart or the full-size chart you see here.

Embedding custom profiles

If you create a custom camera profile for your camera and apply this to any of the images you process through Camera Raw, you need to be aware that the custom profile component can only be read if that camera profile exists on the computer that's reading it. If you transfer a raw file that's been processed in Camera Raw to another computer it will look to see if the same camera profile is in the 'CameraProfiles' folder. If it isn't, it will default to using the Adobe Standard profile. Which leads me to point out an important solution to this problem, which is to convert your raw files to DNG. The current DNG spec allows for camera profiles to be embedded within the file and thereby removes the dependency on the host computer having a copy of the custom camera profile used.

by Camera Raw. By choosing the Camera Standard profile you can get the Camera Raw interpretation to pretty much match exactly the default color renderings that are applied by the camera manufacturer software. This means that if you apply the Camera Standard profile as the default setting in the Camera Calibration panel, Camera Raw applies the same kind of default color rendering as the camera vendor's software and will also match the default camera JPEG renderings. For years, photographers have complained that Camera Raw in Bridge and Lightroom changed the look of their photos soon after downloading. The initial JPEG previews they saw that they liked would quickly be replaced by a different Camera Raw interpretation. When Camera Standard profile is selected you won't see any jumps in color as the Camera Raw processing kicks in. This is because, as I say, Camera Raw is now able to match the JPEG rendering for certain supported cameras.

Custom camera profile calibrations

While the Adobe Standard profiles are much improved, they have still been achieved through testing a limited number of cameras. You can, however, create custom standard camera profiles for individual camera bodies. Creating a custom camera calibration profile does require a little extra effort to set up, but it is worth doing if you want to fine-tune the color calibration for each individual camera you shoot with. This used to be done by adjusting the Camera Calibration panel sliders, but should now be done through the use of camera profiles. However, the sliders do have their uses still, as I'll explain shortly.

In the early days of Camera Raw I used to shoot an X-Rite ColorChecker chart and visually compared the shot results with a synthetic ColorChecker chart and adjusted the Camera Calibration panel sliders to achieve a best match. It was all very complex. Fortunately there is now an easier way to calibrate your camera equipment. You will still need to capture an X-Rite ColorChecker chart (Figure 2.75). These can easily be ordered online and will probably cost you around \$100. You then need to photograph the chart with your camera in raw mode. It is important that the chart is evenly lit and exposed correctly. The best way to do this is to use two studio lights in a copy light setup, or failing that, use a diffuse light source. Apart from that it does not matter what other camera settings are used, although I would recommend you shoot at a low ISO rating.

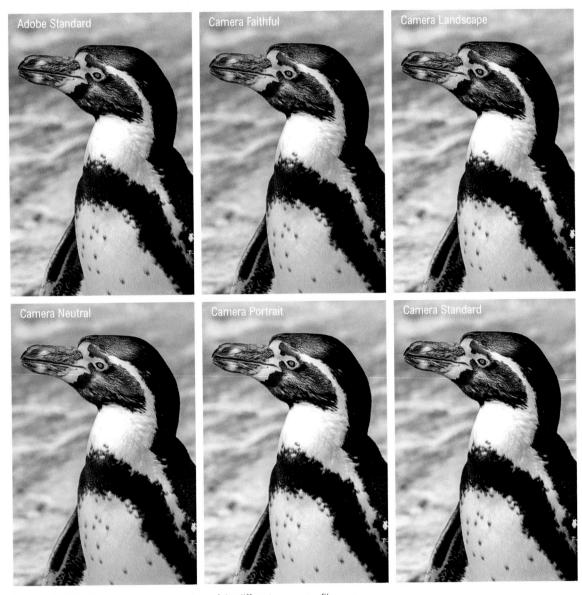

Figure 2.76 This page shows a comparison of the different camera profiles one can now choose from and the effect these will have on the appearance of an image, which in this case was shot using a Canon EOS 1Ds MkIII camera.

Camera profiles and white balance

In the step-by-step example shown here I recommend creating a camera profile using a standard strobe flash lighting setup. This lets you calibrate the camera sensor for the studio lights you normally shoot with. The camera profile measurements can vary slightly for pictures that are shot using different white balance lighting setups. It is for this reason the DNG Profile Editor allows you to measure and generate camera profiles in the same way as the Camera Raw team do. For example, if you shoot the ColorChecker chart once with a lighting setup at a measured white balance of 6500 K and again at a white balance of 3400 K, you can measure these two charts using the DNG Profile Editor to create a more accurate custom camera profile.

DNG Profile Editor

In the quest to produce improved camera profiles, a special utility program called DNG Profile Editor was used to help re-evaluate the camera profiles supplied with Camera Raw and produce the revised camera profiles. You can get hold of a copy of this program by going to tinyurl.com/pq9d33j (Mac)/tinyurl.com/q7c8h3p (PC). At the time of writing it is currently a version 1.04 product and available as a free download. There are a number of things you can do with this utility, but its main strength is that it allows you to create custom calibration profiles for individual cameras. You see, while the default camera profiles can be quite accurate, there may still be a slight difference in color response between your particular camera and the one Adobe used to test with. For this reason you may like to run through the following steps to create a custom calibration for your camera sensor.

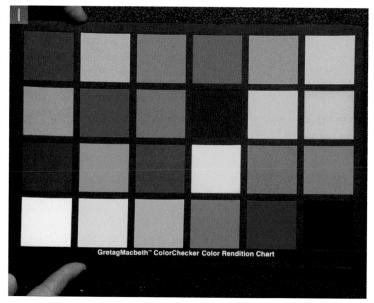

1 As I showed in Figure 2.75, you'll first need to photograph an X-Rite ColorChecker chart. I suggest you shoot this against a plain, dark backdrop and make sure it is evenly lit from both sides, and, for the utmost accuracy, is illuminated with the same strobe lights that you normally work with. It is also a good idea to take several photos and bracket the exposures slightly. If the raw original isn't exposed correctly you'll see an error message when trying to run the DNG Profile Editor. The other thing you'll need to do is to convert the raw capture image to the DNG format, which you can do using Adobe DNG Converter (see page 278).

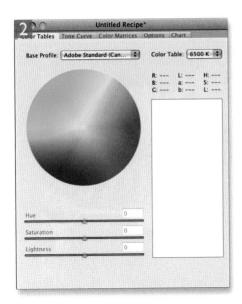

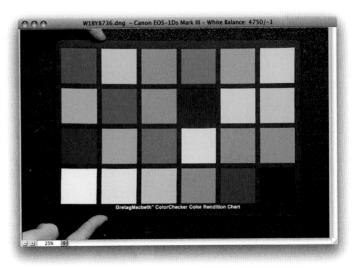

2 The next step is to launch DNG Profile Editor. Go to the File menu and choose File
⇒ Open DNG Image... Now browse to locate the DNG image you just edited and click
Open. The selected image appears in a separate window. Go to the Base Profile menu
and select the Adobe Standard profile for whichever camera was used to capture the
ColorChecker chart.

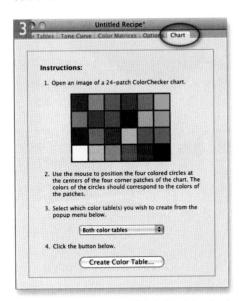

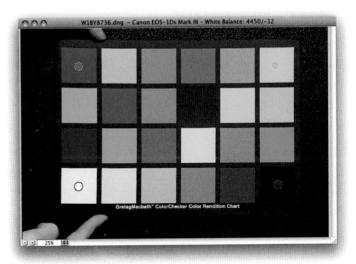

3 Now click on the Chart tab (circled) and drag the four colored circles to the four corner swatches of the chart. If you are just measuring the one chart, select the Both color tables option and click on the Create Color Table... button. If you are recording two separately shot targets at different white balance settings, use this menu to select the appropriate color table.

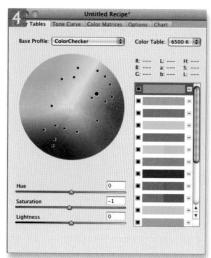

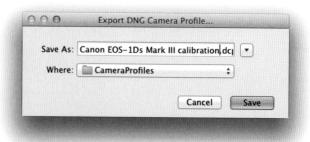

4 The camera profile generation process will be pretty much instantaneous. Once this has been done you can then go to the Edit menu and choose File ⇒ Export (name of camera) Profile, or use the **★ E** (Mac), **ctrl E** (PC) shortcut and rename the profile as desired.

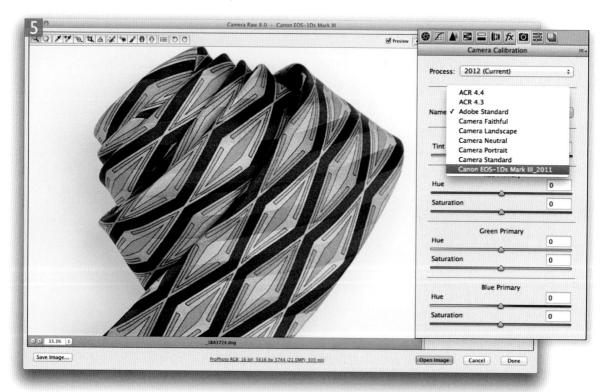

5 Custom camera profiles are saved to a default user folder but won't appear visible in the Camera Calibration panel profile list until you next launch Photoshop or Bridge and open a raw image via Camera Raw. Once you have done this you can select the newly created camera profile and apply it to any photos that have been shot using this camera.

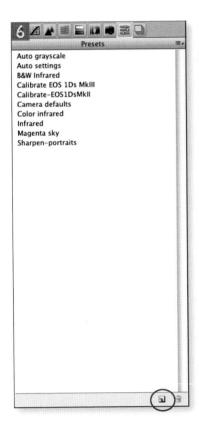

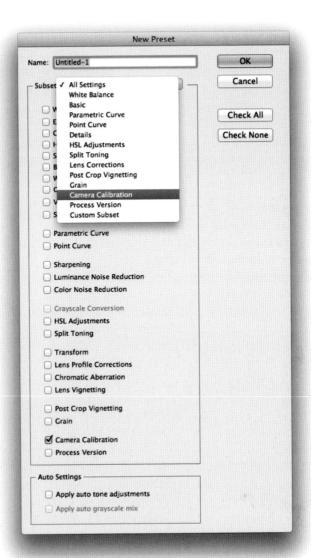

6 Here is an extra tip that is worth carrying out. You can save the camera profile selected in the Camera Calibration panel as a custom Camera Raw preset. In the example shown here I went to the Camera Raw Presets panel, clicked on the New preset button (circled) and in the New Preset dialog shown here, selected the Camera Calibration subset setting, so that only the Camera Calibration option was checked. Once I had done this I now had a camera profile preset setting that could easily be applied to any other photographs that had been shot with the same camera. One can also easily apply a setting like this via the Bridge Edit ⇒ Develop settings submenu.

Workflow options

You will notice that the workflow options (the hyperlink underneath the preview) is missing when using Camera Raw as a filter. This is because the workflow output settings are not needed when processing an image directly in Photoshop—it will already have been rendered to a specific RGB space and bit-depth.

Camera Raw filter tips

When using the Camera Raw filter you are limited to working with files no bigger than 65,000 pixels in either dimension. If the image you are editing happens to exceed this you will see a warning message. You can also apply the Camera Raw filter to targeted channels (as opposed to the entire composite channel). This means you can apply the Camera Raw filter to individual channels, such as the luminosity channel while working in Lab mode. However, when used this way certain features such as per-channel curves and split tone controls will be disabled.

Camera Raw as a Photoshop filter

You can now apply Camera Raw adjustments as a filter effect. You can do this directly in a destructive fashion, or ideally non-destructively by first converting to a Smart Object (Smart Filter) layer. This will allow you to re-edit the Camera Raw settings just as you would when editing a raw image. In the case of layered images you must distinguish whether you intend to filter a specific layer or all current visible layers. So, before creating a smart object do make sure you have the layer or layers you wish to process correctly selected. Some might argue that Camera Raw editing is already available for non-raw images, but it's important to point out that this was previously limited to flattened files saved in the TIFF or JPEG format.

Using Camera Raw as a Photoshop filter now gives you the opportunity to make full use of Camera Raw edits when working on any RGB or grayscale image. This may well benefit certain workflows. For example, when working with scanned images you can use Camera Raw to apply the capture sharpening. Or, maybe you'll feel more comfortable using the Camera Raw Basic panel tone controls instead of Levels or Curves to tone edit an image? There's also the benefit of being able to apply other Camera Raw specific adjustments such as Clarity to adjust the midtone contrast, or Camera Raw style black and white conversions.

There are limitations. For example, you can't expect to achieve the same range of adjustment control on a non-raw image when adjusting say the Highlights slider to rescue extreme highlight detail. Not all Camera Raw tools are made available when using Camera Raw as a filter. It didn't make sense to allow the saving of snapshots, because there is nowhere to save them when used as a filter in this way. The lens profile correction options are not available because you already have the Lens Corrections filter in Photoshop. There is also the overhead that comes from having to create a Smart Object, which inevitably leads to bigger saved file sizes. Above all, if you care about optimum image quality, you shouldn't skip carrying out the Camera Raw processing at the raw image stage. Camera Raw is most effective when it's used to edit raw images. The Camera Raw filter is basically a convenience when working in Photoshop as it can save you having to export an image or layer to apply the Camera Raw processing separately.

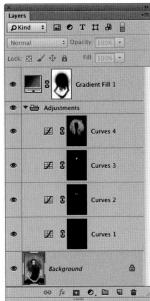

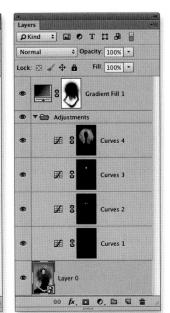

1 Here is a photograph that had been edited in Photoshop. In this first step the Background layer only was selected. I then went to the Filter menu and chose 'Convert for Smart Filters'. This converted the Background layer to a smart object.

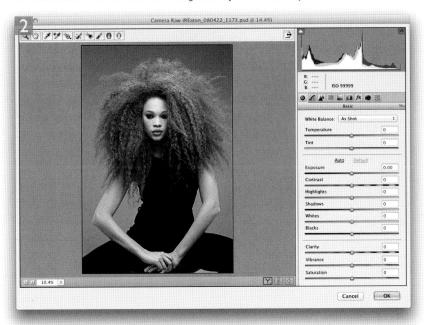

2 I went to the Filter menu and chose the Camera Raw Filter. As you can see, the filter was applied to the Background layer contents only as that was what had been selected in step 1.

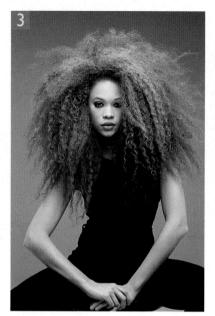

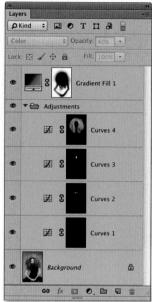

3 I clicked the Cancel button to return to the original, layered image in Photoshop. This time I ensured all the visible layers were selected and chose 'Convert for Smart Filters' again. This created a smart object that contained all the layers.

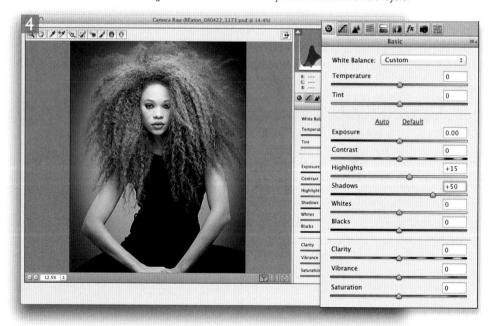

4 I renamed the smart object layer 'Merged composite' and chose the Camera Raw Filter, which would now be applied to a composite of all the layers contained within the smart object. In the Effects panel I added a post-crop vignette adjustment to darken the corners and in the Basic panel I adjusted the Highlights and Shadows.

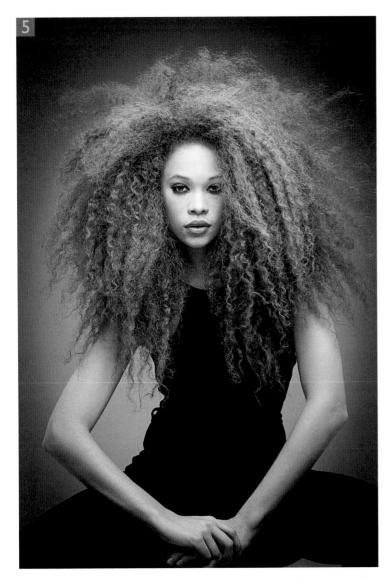

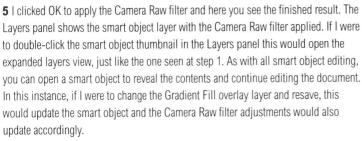

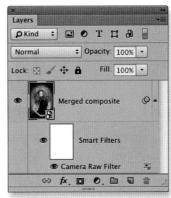

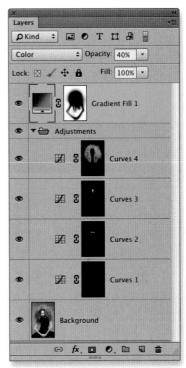

Spot removal tool

You can use the spot removal tool (B) to retouch spots and blemishes. Whenever the spot removal tool is active you will see the Spot Removal options appear in the panel section on the right (Figure 2.77). From here you can choose between Heal and Clone type retouching. In Clone mode, the tool behaves like the clone stamp tool in Photoshop. It allows you to sample from a source area that will replace the destination area, without blending. In Heal mode, the tool behaves like the healing or spot healing brush in Photoshop, blending the sampled pixels with the surrounding pixels outside the destination area. This latest version of Camera Raw uses a new healing algorithm, which provides speedier healing performance. However, adding multiple spots (and especially brush spots) will soon slow down the overall Camera Raw performance.

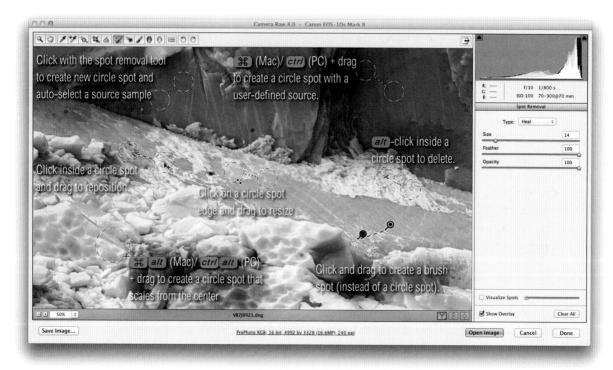

Figure 2.77 This screen shot shows the spot removal tool in action, with explanations of how to apply and modify the retouch circle spots. Brush spots are covered later on page 234.

Creating circle spots

Ideally you should carry out the spotting work at a 100% zoom setting. Whenever you click with the spot removal tool. this creates a new spot circle and auto-selects the most suitable area to clone from. This is a little like using the spot healing brush in Photoshop, except it works using either the Clone or Heal modes. If you don't like the auto-selection made you can use the 🥼 key to recalculate. You see, when you 'click only' with the spot removal tool it always auto selects the area to sample from. Now, when you press 🍘 Camera Raw recomputes a new source area to sample from. This is useful where the initial auto-sample selection wasn't successful. Rather than manually override the source selection you can ask Camera Raw to take another guess, which may just work out better. The auto find source aspect of the spot removal tool is now able to cope better with textured areas such as rocks, tree bark and foliage. It now also takes into account the applied crop. This means that if a crop is active the spot removal tool gives preference to sourcing areas within the cropped area rather than outside it. Basically, if an image is cropped, Camera Raw carries out two searches for a most suitable area to clone from: one within the cropped area and one outside. Preference is given to the search inside the cropped area when computing the auto find area. If somewhere outside the cropped area vields a significantly better result, then that will be used instead.

If you hold down the # alt (Mac), or ctrl alt (PC) key + click and drag, this allows you to create a circle spot that scales from the center. To manually set the source area to sample from you now need to hold down the (Mac), (Mac), (PC) key + click and drag to define the source area. If you click to select an existing spot circle you can adjust both the destination or source point circles, repositioning them and changing the type from Clone to Heal or vice versa. You also have the option to adjust the radius of the spot removal tool as well as the opacity (the Opacity slider allows you to edit the opacity of your spotting work on a spot by spot basis). You can always use the left left left with the Radius, but it is usually simpler to follow the instructions in Figure 2.77 and drag with the cursor instead. You can click on the 'Show Overlay' box or use the M key to toggle showing and hiding the circles so that you can view the retouched image without seeing the retouch circles and use the Toggle Preview button (# all P [Mac], or ctri att P [PC]) to toggle showing/hiding the spot removal retouching.

Synchronized spotting with Camera Raw

You can synchronize the spot removal tool across multiple photos. Make a selection of images in Bridge and open them up via Camera Raw (as shown in Figure 2.78). Now click on the Select All button. This selects all the photos and if you now use the spot removal tool, you can retouch the most selected photo (the one shown in the main preview), and the spotting work will be automatically updated to all the other selected images.

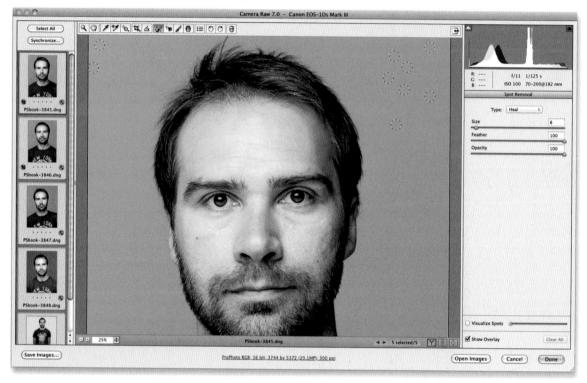

Figure 2.78 Here is an example of the Camera Raw dialog being used to carry out synchronized spotting.

Spot removal tool feathering

The spot removal tool now features a Feather slider (Figure 2.79). This allows you to modify the brush hardness when working with the spot removal tool in the clone or heal modes, applying either a circle spot or brush spot. This is interesting because while it has always been possible to adjust the brush hardness in Photoshop when working with the clone stamp tool, there has never been a similar hardness

control option for the healing brush. This is because the healing brush and spot healing brush have always had an internal feathering mechanism built-in, so additional feathering has never been needed. Looking at what has been done here in Camera Raw the Feather slider control works well and is useful for both modes of operation. There is also another reason. With Lightroom 5 and Camera Raw 8, Adobe switched to using a faster healing algorithm in order to make brush spots retouching work speedier. However, as a result of this the blending isn't always as smooth as the previous algorithm. This was one motivation for adding a Feather slider. At the same time, the Feather slider does appear to offer more control over the spot removal blending and can help overcome the edge contamination sometimes evident when using the spot removal tool in heal mode, but with a fixed feather edge. The feathering is applied to the destination circle spot or brush spot and the Feather amount is proportional to the size of the spot, so bigger spots will use a bigger feather. Also, the Feather setting applied remains sticky across Camera Raw sessions.

You can hold down the *Shift* key as you use the square bracket keys to control the feather setting. Use *Shift* + 1 to increase the feathering and *Shift* + 1 to decrease. You can also hold down the *Shift* key as you right-mouse click and drag left or right to dynamically adjust the Feather amount.

Spot removal tool fine-tuning

You can nudge both the destination and source circle/brush spots using the keyboard arrow keys. Use the # key (Mac), or ctrl key (PC) + arrow to nudge a destination circle or brush spot more coarsely and use # alt (Mac), or ctrl alt (PC) + arrow to nudge more finely. Use the # Shift keys (Mac), or ctrl Shift keys (PC) + arrow to nudge a source circle or brush spot more coarsely and use # Shift alt (Mac), or ctrl Shift alt (PC) + arrow to nudge more finely.

Finally, when you hold down the **#** all (Mac), or ctrl all keys (PC) and click in the preview and drag to adjust the cursor size, the size value is now reflected by the Size slider.

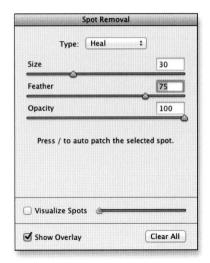

Figure 2.79 The panel controls for the spot removal tool.

Preview auto-dismiss

Note that the spot tool visualization will only be active for as long as the spot removal tool is selected. As soon as you select another tool the preview will revert to normal.

Visualize spots

The Visualize spots feature can be used to help detect dust spots and other anomalies. This consists of a Visualize Spots checkbox and a slider. When enabled, you drag the slider to adjust the threshold for the preview and this can sometimes make it easier for you to highlight the spots in an image that need to be removed. You can also use the comma and period keys (or think of them as the and keys) to make the slider value increase or decrease, and use the shift key to jump more. Obviously, it helps to view the image close-up as you do this and when adjusting the slider the slider value remains sticky until you turn on Visualize spots to treat another image.

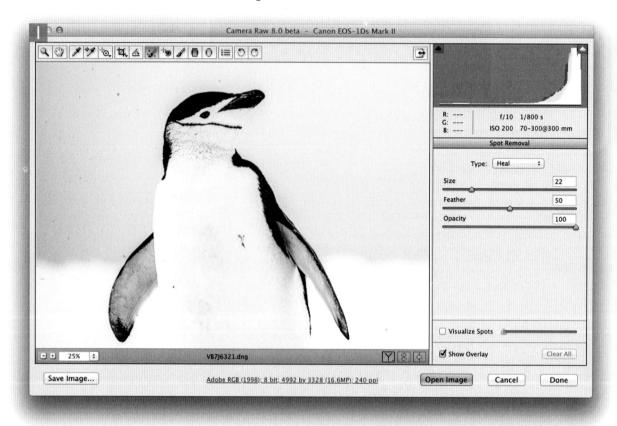

1 This shows an image that was shot with dirty camera sensor marks and wasn't helped much by shooting a high key subject.

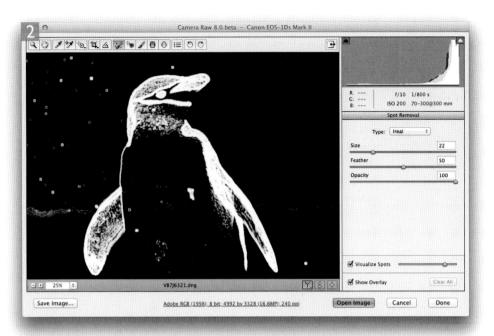

2 I checked the Visualize Spots box at the bottom of the Spot Removal panel options and adjusted the slider to obtain a suitable preview, one that picked out the spots more clearly.

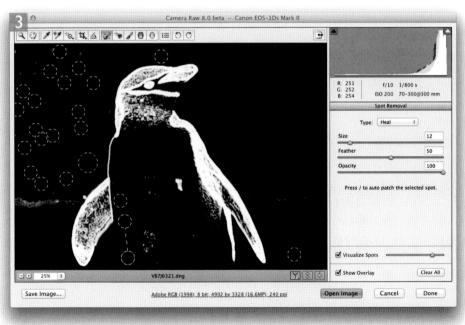

 $\bf 3$ I then clicked with the spot removal tool to remove the spots that had been identified using this method.

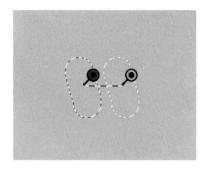

Figure 2.80 When you click and drag with the spot removal tool this allows you to more precisely define the area you wish to remove.

Creating brush spots

The tool behavior when you click and drag has changed in Photoshop CC. Previously, a click and drag allowed you to manually determine the position of the sample area circle. Now in Camera Raw, clicking and dragging allows you to precisely define the area you wish to remove (see Figure 2.81). As you drag with the spot removal tool a red dotted outline will define the area you are removing and a green dotted outline define the area you are sampling from (see Figure 2.80). As with a basic click operation, the new click and drag method autoselects the best area to sample from and you can use the key to force Camera Raw to recalculate a new sample area.

If you click and drag with the **Shift** key held down this constrains the line to a horizontal or vertical direction. But if you click and click again with the **Shift** key held down this allows you to create a 'connect the dots' selection. Also, using a regular right-mouse click you can drag left or right to reduce or increase the cursor size.

With brush spots (where you click and drag), these are indicated by a pin marker. As you hover over the pin you will see a white outline of the brush spot shape. When you click to make a pin active the outline of the destination brush spot will appear red and the corresponding source outline green.

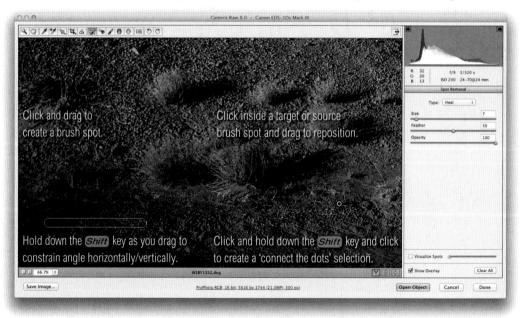

Figure 2.81 This screen shot shows the spot removal tool in action, with explanations of how to apply and modify brush spots.

With brush spots it is not possible to manually resize the brush outline, but you can click on either pin marker or drag anywhere inside either brush stroke outline to reposition a destination or source brush spot.

Deleting spots

To delete a circle or brush spot, you simply select it and press the *Delete* key to delete the adjustment. Alternatively, you can hold down the *all* key and click on an individual spot (as you do so the cursor changes to a scissor). Or, you can hold down the *all* key and marquee drag within the preview area to select any spots you wish to delete. This will delete the spots as soon as the mouse is released. If you press down the spacebar after doing so, this allows you to reposition the marquee selection. Release the spacebar to continue to modify the marquee area.

Substitute zoom shortcut

You can use **#** *alt Shift* (Mac)

ctrl alt Shift (PC) as a substitute zoom tool in Camera Raw when working with spot tool.

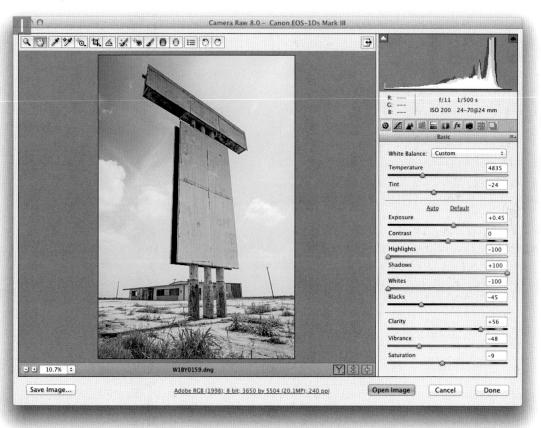

1 With this image I was interested in using the spot removal tool to remove a pole from the bottom right corner.

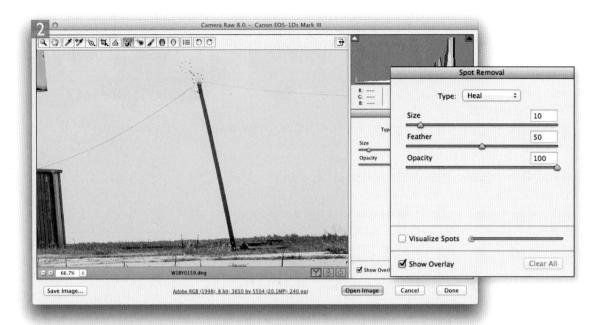

2 In this screen shot you can see that I had zoomed in on the image, selected the spot removal tool and clicked at the top of the pole. As with previous versions of Camera Raw, this applied a standard circle spot that auto-selected a source circle area.

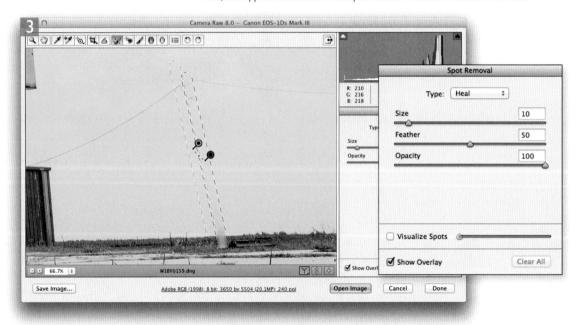

3 I then held down the *Shift* key and clicked at the bottom of the pole to apply a non-circular spot removal. In this screen shot the destination area is outlined in red and the auto-selected source area is outlined in green.

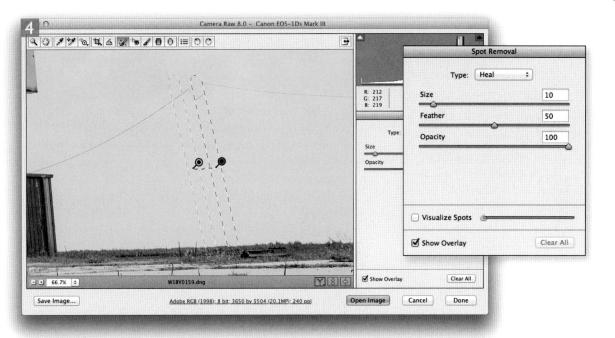

4 I obviously needed to adjust the source selection area, so I clicked on the green pin and moved this until I had found a nice match inside the red selected destination area.

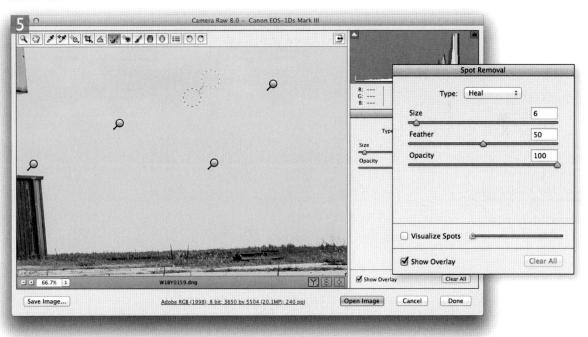

5 I carried on using the spot removal tool in this way to remove the cables and last of all, applied a standard spot circle to tidy up the last remaining bit of cable.

Hiding the red eye rectangles

As with the spot removal tool, you can click on the 'Show Overlay' box to toggle showing and hiding the rectangle overlays (or use the W key).

Spacebar tip

When dragging with the red eye removal tool you can press down the spacebar to reposition the marquee selection. Release the spacebar to continue to modify the marquee area.

Red eye removal

The remove red eye tool is useful for correcting photos that have been taken of people where the direct camera flash has caused the pupils to appear bright red. To apply a red eye correction, select the red eye removal tool and drag the cursor over the eyes that need to be adjusted. In the Figure 2.82 example I dragged with the mouse to roughly select one of the eyes. As I did this, Camera Raw was able to detect the area that needed to be corrected and automatically adjusted the marquee size to fit. The Pupil Size and Darken sliders can then be used to fine-tune the Pupil Size area that you want to correct as well as the amount you want to darken the pupil by. You can also revise the red eye removal settings by clicking on a rectangle to reactivate it, or use the Delete key to remove individual red eye corrections. If you don't like the results you are getting, you can always click on the 'Clear All' button to delete the red eye retouching and start over again.

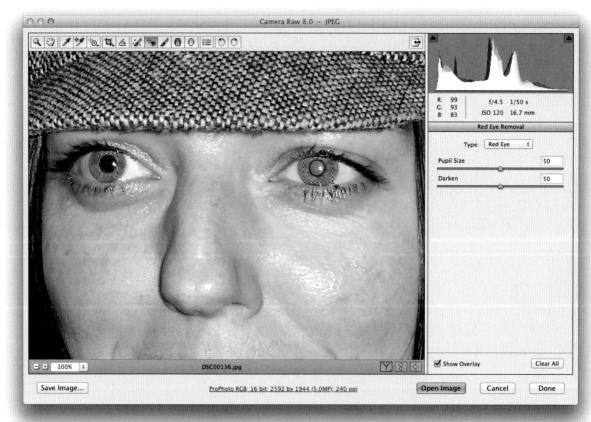

Figure 2.82 Here is an example of the red eye removal tool in action.

Red eye: pet eye removal

There is now a Pet Eye mode for the red eye tool (Figure 2.83), which is available as a menu option. This has been added because the red eye effect you get when using flash to photograph animals isn't always so easy to remove using the standard red eye tool. Corrected pupils can now be made darker to give you a more natural look. The Pet Eye controls allow you to adjust each pupil independently by adjusting the Pupil Size slider. You can also check the Add Catchlight box to enable adding a catchlight highlight, which you can then click and drag into position over each eye.

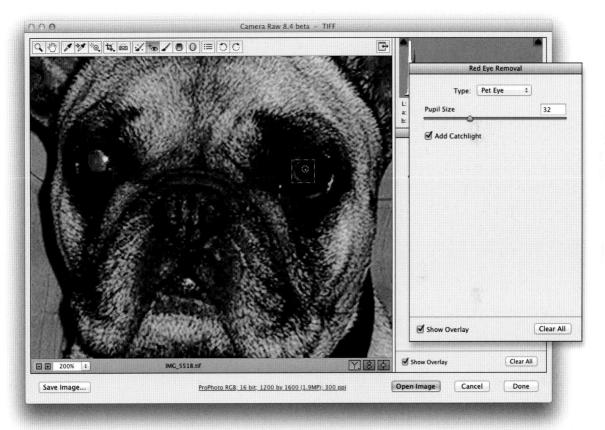

Figure 2.83 Here you can see I had selected the new Pet Eye option before using the red eye tool to marquee drag over the right eye of the dog in this photograph. Having selected the eye I adjusted the sliders for the Pupil Size and Darken setting.

Localized adjustments

The adjustment brush and graduated filter tools can be used to apply localized edits in Camera Raw. As with the spot removal and red eye removal tools, you can revise these edits as often as you like. But these are more than just dodge and burn tools—there's a total of 13 effects to choose from, as well as an Auto Mask option.

Adjustment brush

When you select the adjustment brush tool (K) the tool options shown in Figure 2.84 will appear in the panel section on the right with the 'New' button selected (you can also use the K key to toggle between the Adjustment Brush panel and the main Camera Raw panel controls). Below this are the sliders you use to configure the adjustment brush settings before you apply a new set of brush strokes.

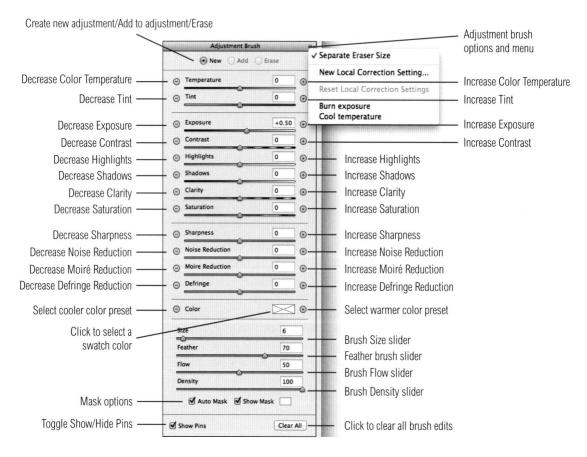

Figure 2.84 The Adjustment brush options.

Initial Adjustment brush options

To apply a brush adjustment, click on the New brush button at the top of the panel and select the effect options you wish to apply by using either the plus or minus buttons or the sliders. For example, clicking on the Exposure plus button increases the exposure setting to +0.50 and clicking on the negative button sets it to -0.50 (these are your basic dodge and burn settings). The effect buttons therefore make it fairly easy for you to quickly create the kind of effect you are after. However, using these buttons you can only select one effect setting at a time and all the other settings are zeroed. If you use the slider controls you can fine-tune the adjustment brush effect settings and combine multiple effects in a single setting.

Brush settings

Below this are the brush settings. The Size slider adjusts the brush radius, and you can use the live keys to make the brush smaller or larger. It is also possible to resize a brush on screen. If you hold down the ctrl key (Mac), or use a rightmouse click (Mac and PC), you can drag to resize the cursor before you start using it to retouch the image. The Feather slider adjusts the softness of the brush and you can also use the Shift 1 keys to make the brush edge softer and Shift 1 to make the brush harder (you can also hold down the Shift key combined with a right mouse drag to adjust the feathering). Note that these settings are reflected in the cursor shape shown in Figure 2.85. The Flow slider is a bit like an airbrush control. If you select a low Flow setting, you can apply a series of brush strokes that successively build to create a stronger effect. As you brush back and forth with the brush, you will notice how the paint effect gains opacity, and if you are using a pressure-sensitive tablet such as a Wacom™, the Flow of the brush strokes is automatically linked to the pen pressure that you apply. The Density slider determines the maximum opacity for the brush. This means that if you have the brush set to 100% Density, the flow of the brush strokes can build to a maximum density of 100%. If on the other hand you reduce the Density, this limits the maximum brush opacity to a lower opacity value. For example, if you lower the Density and paint over an area that was previously painted at a Density of 100%, you can paint with the adjustment brush to reduce the opacity in these areas. If you reduce the Density to 0%, the adjustment brush acts like an eraser tool.

Hiding and showing brush edits

Note there is now a new mechanism in Camera Raw for comparing the current image state with a previous checkpoint state (see page 118 for more details). When carrying out localized adjustments it is useful to click on the Toggle between current settings and the defaults for the visible panel only button, or use the ## all P (Mac) ctrl all P (PC) shortcut.

Figure 2.85 The outer edge of the adjustment brush cursor represents the overall size of the brush, while the inner circle represents the softness (feathering) of the brush relative to the overall brush size.

Localized adjustment strength

Localized adjustments have the same effective strength as their global adjustment counterparts. But note that all the effects have linear incremental, cumulative behavior except for the Temp, Tint, Highlights, Shadows and Clarity adjustments. These have non-linear incremental behavior, which means that they only increase in strength by 75% relative to the previous localized adjustment each time you add a new pin group.

Adding a new brush effect

Now let's look at how to apply a brush effect. When you click on the image preview, a pin marker is added and the Adjustment Brush panel shows that it is now in 'Add' mode (Figure 2.86). As you start adding successive brush strokes, these are collectively associated with this marker and will continue to be so until you click on the 'New' button and click to create a new pin marker with a new set of brush strokes. The pin markers therefore provide a tag for identifying groups of brush strokes. You just click on a pin marker whenever you want to add or remove brush strokes, or need to re-edit the brush settings that were applied previously. If you want to hide the markers you can do so by clicking on the Show Pins box to toggle showing/hiding the pins, or use the W key shortcut.

that is currently active was used to lighten the park sign with a positive Exposure value. Double-clicking a slider arrow pointer resets it to zero, or to its default value.

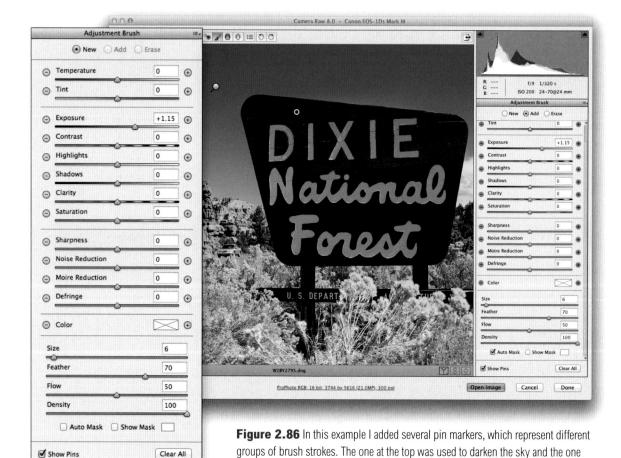

Resetting adjustments

There are two easy ways you can reset localized adjustment settings in Camera Raw. One method is to right-click on an adjustment pin and choose 'Reset Local Correction Settings' from the context menu. The other method is to click to select a localized adjustment pin and choose 'Reset Local Correction Settings' from the fly-out menu.

Adjustment brush duplication

Refinements have been made to the adjustment brush tool, bringing it more in line with the behavior of other localized adjustment tools in Camera Raw. When you add a brush adjustment you can click on the pin and drag to relocate the applied adjustment. There is a contextual menu for the brush pins (right-click on a pin to reveal), which allows you to duplicate a selected adjustment or delete (see Figure 2.87). There is also a new shortcut (*** alt**) + drag [Mac], ciri alt**) + drag [PC]), which you can use to clone an adjustment brush pin. Click on a brush pin with the above key combo held down and drag.

1 In this example, I applied an adjustment brush effect to the flower head in this picture to make it slightly bluer in color and also to lighten the Exposure and boost the Contrast and Clarity settings.

Figure 2.87 The adjustment brush contextual menu.

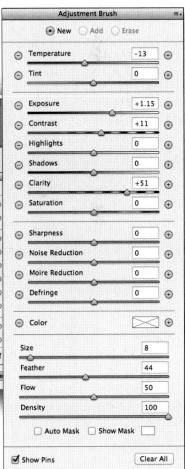

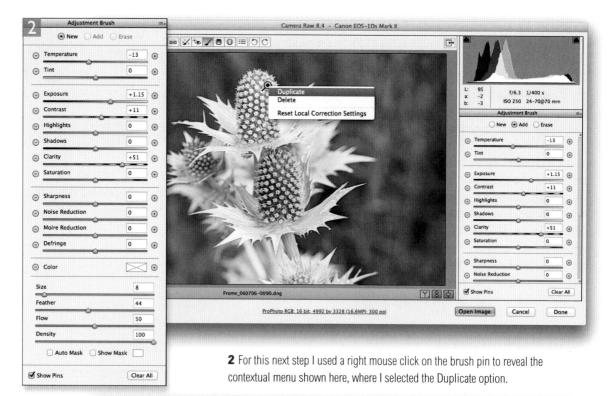

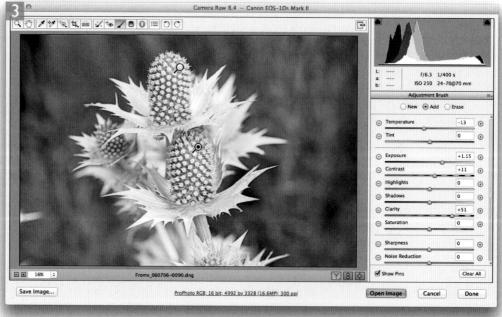

I was then able to click and drag on the duplicated pin to reposition it in the image. In this case I dragged to place it over the second flower head below.

Editing brush adjustments

To edit a series of brush strokes, just click on an existing pin marker to select it (a black dot appears in the center of the pin). This takes you into the 'Add' mode, where you can add more brush strokes or edit the current brush settings. For example, in Step 2 (over the page), I might have wanted to drag the Exposure slider to darken the selected brush group more. You might also want to erase portions of a brush group, which you can do by clicking on the Erase button at the top of the Adjustment Brush panel, where you can independently edit the brush settings for the eraser mode (except for the Density slider which is locked at zero). Alternatively, you can hold down the all key to temporarily access the adjustment brush in eraser mode. When you are done editing, click on the New button to return to the New adjustment mode, where you can now click on the image to add a new pin marker and a new set of brush strokes.

Undoing and erasing brush strokes

As you work with the adjustment brush, you can undo a brush stroke or series of strokes using the undo command (# Z [Mac], ctrl Z [PC]).

Previewing the mask more clearly

Sometimes it is useful to initially adjust the settings to apply a stronger effect than is desired. This lets you judge the effectiveness of your masking more clearly. You can then reduce the effect settings to reach the desired strength for the brush strokes.

Previewing the brush stroke areas

If you click on the 'Show Mask' option, you'll see a temporary overlay view of the painted regions (Figure 2.88). The color overlay represents the areas that have been painted and can also be seen as you roll the cursor over a pin marker.

Figure 2.88 In this screen view, the 'Show Mask' option is checked and you can see an overlay mask for the selected brush group. Click on the swatch next to it if you wish to choose a different color for the overlay display.

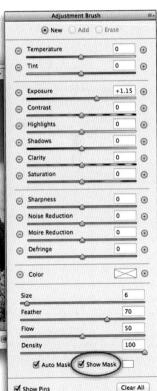

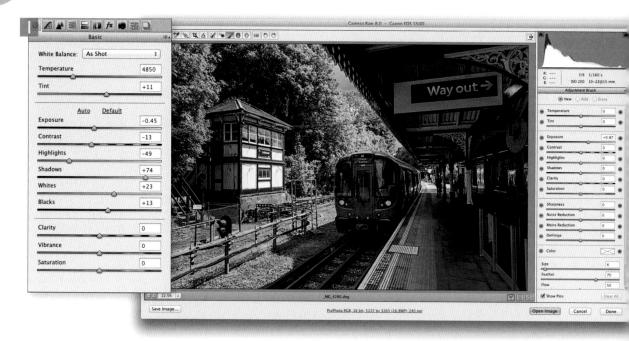

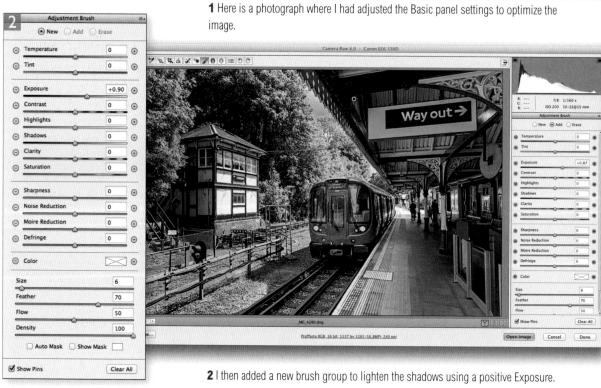

Auto masking

At the bottom of the Adjustment Brush panel is the Auto Mask option. When this is switched on it cleverly masks the image at the same time as you paint. It does this by analyzing the colors in the image where you first click and then proceeds to apply the effect only to those areas with the same matching tone and color (Figure 2.89). It does this on a contiguous selection basis. For example, in the steps shown here, I dragged with the adjustment brush in auto mask mode on the egg in the middle to desaturate the color. While the Auto Mask can do a great job at auto selecting the areas you want to paint, at extremes it can lead to ugly 'dissolved pixel' edges. This doesn't happen with every photo, but it's something to be aware of. The other thing to watch out for is a slow-down in brush performance. As you add extra brush stroke groups, the Camera Raw processing takes a big knock, but it gets worse when you apply a lot of auto mask brushing. It is therefore a good idea to restrict the number of adjustment groups to a minimum.

Figure 2.89 Quite often, you only need to click on an area of a picture with the color you wish to target and drag the adjustment brush in auto mask mode to quickly adjust areas of the picture that share the same tone and color.

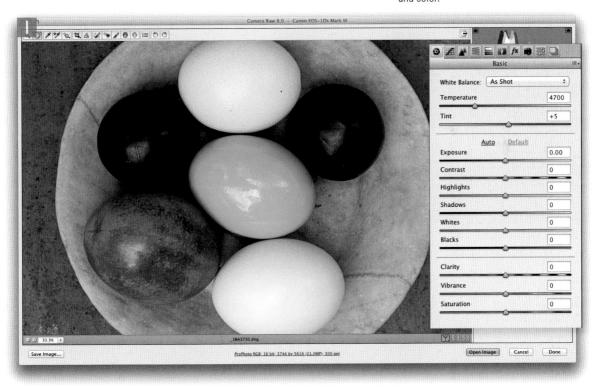

1 This shows a still life subject with just the Basic panel corrections applied.

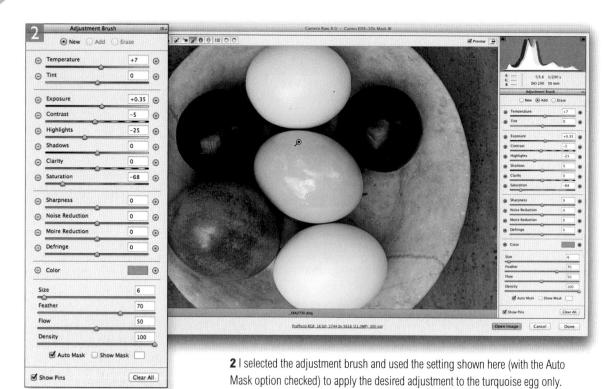

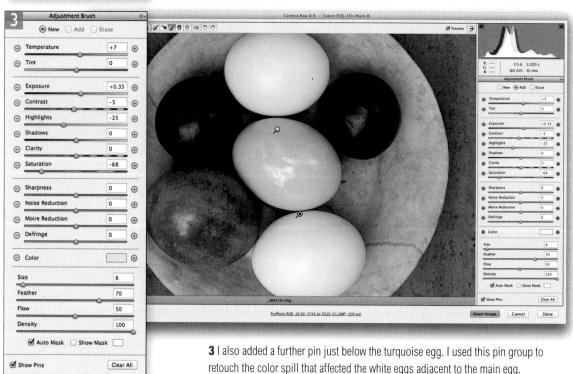

Darkening the shadows

With Process 2012 you now have a lot more tools at your disposal when making localized adjustments. I wanted to focus here though on the Shadows slider. In many ways the Shadows adjustment is a bit like the Fill Light control in Process 2010. As you raise the Shadows amount you can selectively lighten the shadow to midtone areas. However, with Shadows you can apply a negative amount in order to darken the shadows more. I see this as being particularly useful in situations like the one shown here, where you can use this type of regional adjustment to make a dark backdrop darker and clip to black.

Also, with the Highlights slider you can use negative amounts to apply localized adjustments to selectively darken the highlight areas and you can also use positive amounts to deliberately force highlight areas to clip to white. Therefore, you can use a positive Highlights adjustments to deliberately blow out the highlights in an image.

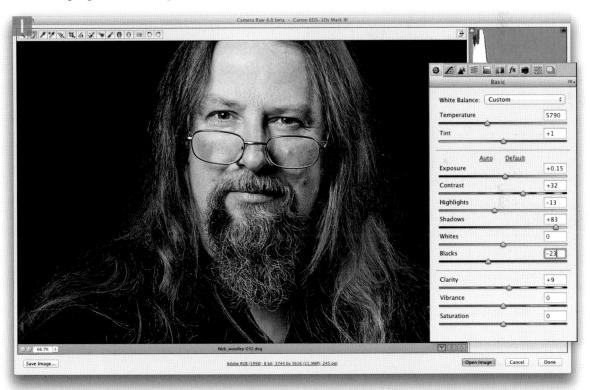

1 For this portrait I photographed my subject against a dark backdrop, which I wished to have appear black in the final image. As you can see, after carrying out preliminary Basic panel adjustments, there was still some detail showing in the backdrop.

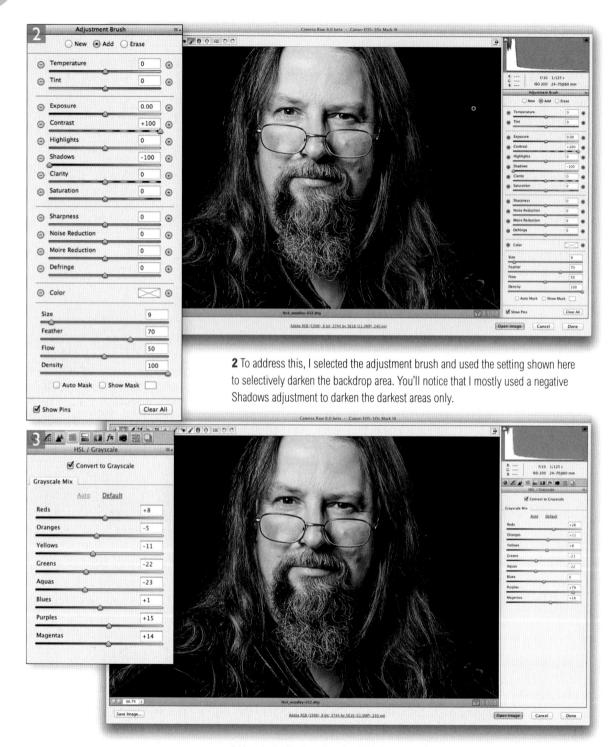

Here is the final version, in which I converted the photo to black and white and added a split tone effect.

Hand-coloring in Color mode

The adjustment brush tool can also be used to tint black and white images and this is a technique that will work well with any raw, JPEG or TIFF image that is in color. This is because the auto mask feature can be used to help guide the adjustment brush to colorize regional areas that share the same tone and color. In other words, if the underlying image is in color, the auto mask has more information to work with. To convert the image to black and white, you can do what I did here and take the Saturation slider in the Basic panel all the way to the left. Alternatively, you can go to the HSL panel and set all the Saturation sliders to -100. The advantage of doing this is that you then have the option of using the HSL panel Luminance sliders to vary the black and white mix (see Chapter 5). After desaturating the image you simply select the adjustment brush and click on the color swatch to open the Color Picker dialog and choose a color to paint with.

Adjustment brush speed

The fact that you can apply non-destructive localized adjustments to a raw image is a clever innovation, but this type of editing can never be as fast as editing a pixel image in Photoshop. This example demonstrates how it is possible to get quite creative with the adjustment brush tool. In reality though it can be extremely slow to carry out such complex retouching with the adjustment brush, even on a fast computer.

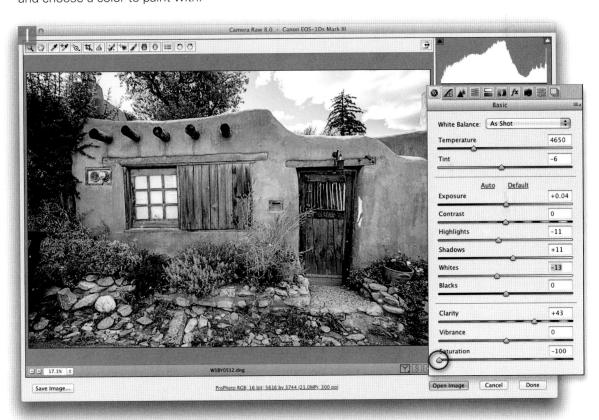

1 The first step was to go to the Basic panel and desaturate the colors in the image by dragging the Saturation slider all the way to the left.

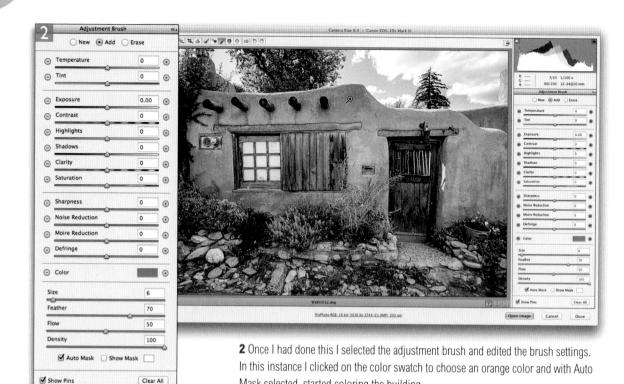

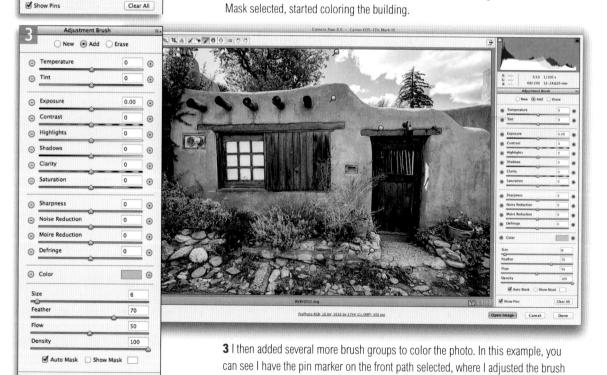

settings to apply a green color to the bushes.

Show Pins

Clear All

Graduated filter tool

Everything that has been described so far with regards to working with the adjustment brush more or less applies to working with the graduated filter (Figure 2.90), which allows you to add linear graduated adjustments. To use the graduated filter tool, click in the photo to set the start point (the point with the maximum effect strength), drag the mouse to define the spread of the graduated filter, and release to set the minimum effect strength point. There is no midtone control with which you can offset a graduated filter effect, but you can use the key to invert a graduated filter selection.

Graduated filter effects are indicated by green and red pin markers. The green dashed line represents the point of maximum effect strength and the red dashed line represents the point of minimum effect strength. The dashed line between the two points indicates the spread of the filter and you can change the width by dragging the outer pins further apart and move the position of the gradient by clicking and dragging the central line.

Toggle the main panel controls

You can use the key to toggle between the Graduated Filter panel and the main Camera Raw panel controls.

Resetting the sliders

As with the Adjustment brush options, double-clicking a slider arrow pointer resets it to zero, or to its default value.

Angled gradients

As you drag with the graduated filter you can do so at any angle you like and edit the angle afterwards. Just hover the cursor over the red or green line and click and drag. If you hold down the *Shift* key you can constrain the angle of rotation to 45° increments.

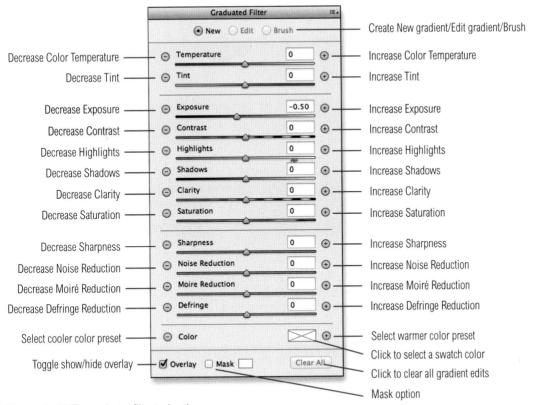

Figure 2.90 The graduated filter tool options.

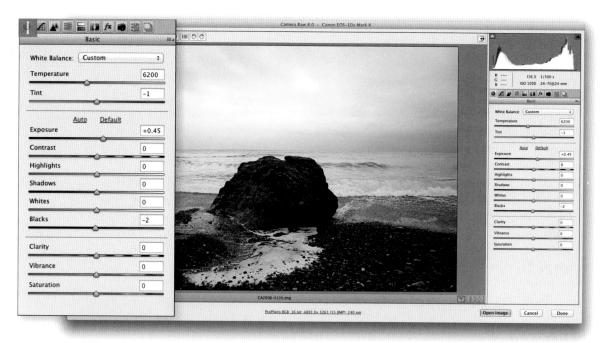

1 In this screen shot you see an image where all I had done initially was to optimize the Exposure.

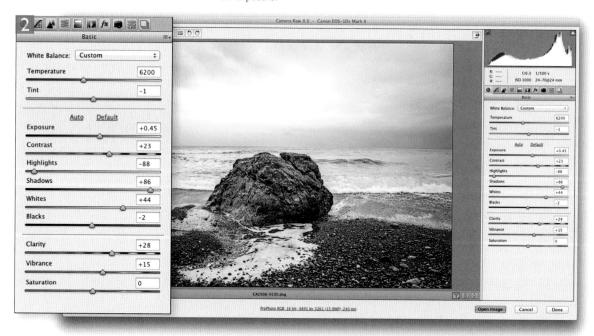

2 With the Process 2012 controls there is a lot that you can do to a photo like this just by adjusting the Highlights and Shadows sliders to reveal more detail in the sky and the rock in the foreground.

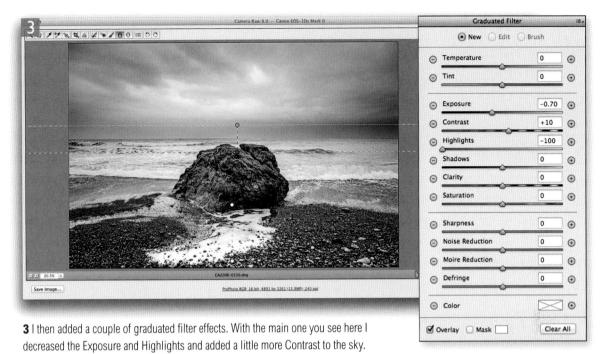

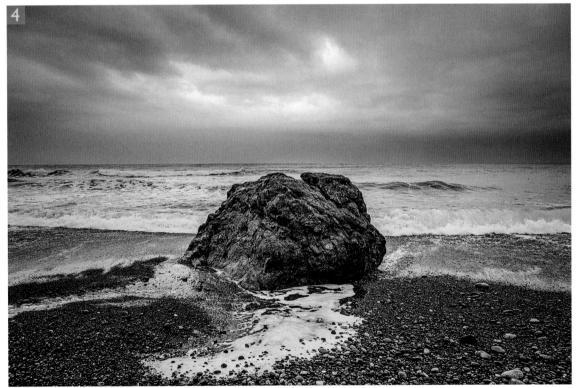

4 Here is the final Camera Raw processed version.

Graduated color temperature adjustment

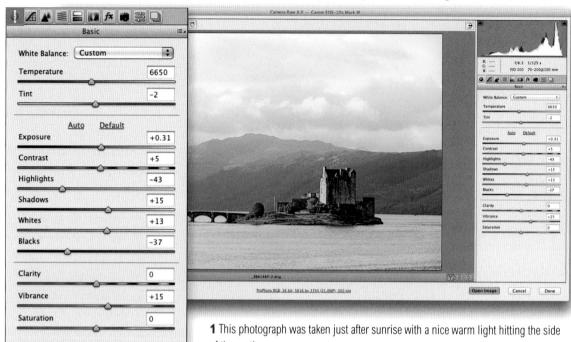

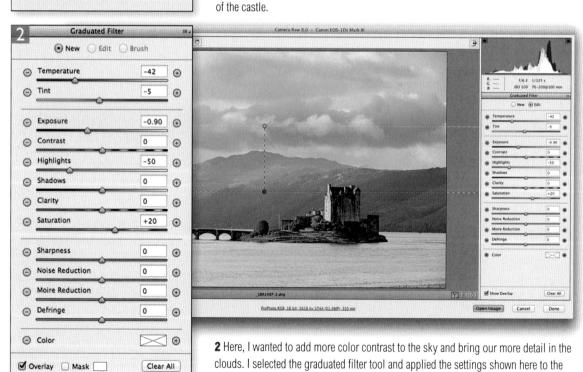

sky.

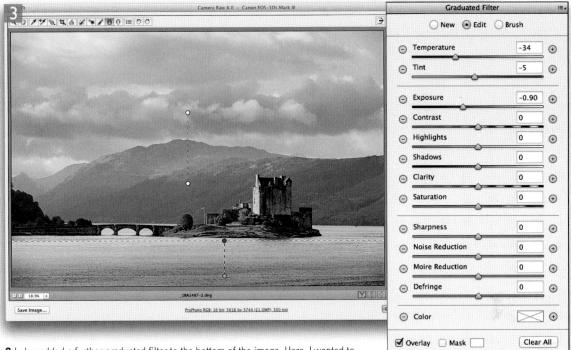

3 I also added a further graduated filter to the bottom of the image. Here, I wanted to darken the bottom and add more contrast.

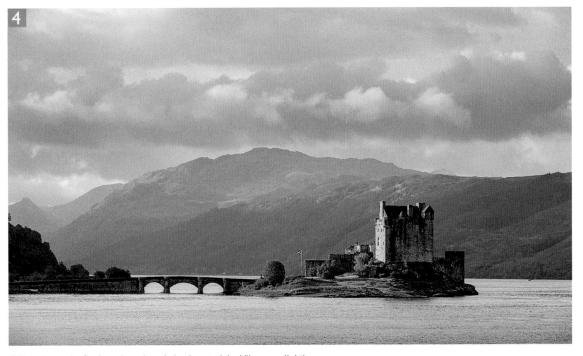

4 This shows the final version where I also boosted the Vibrance slightly.

Figure 2.91 The Radial filter options.

Radial filter adjustments

The latest version of Camera Raw now includes a radial filter to complement the 'linear' graduated filter. Essentially, the radial filter adjustment options (Figure 2.91) are exactly the same and you can use this new tool to apply selective adjustments to the inner or outer area of a pre-defined ellipse shape. By default, the full effect adjustment is applied using the 'Inside' option where the effect starts at the center of the ellipse, and the zero effect is at the boundary and outside the ellipse. The strength of the effect tapers off smoothly between the center and the boundary edge. You can invert the adjustment effect by clicking the 'Outside' button, or use the X key shortcut to quickly toggle between the two. The radial filter also has a Feather slider control, which allows you to adjust the hardness of the edge and the Caps Lock key allows you to visualize the extent of feathering applied to the radial filter adjustment.

To apply a Radial filter adjustment you click and drag to define the initial ellipse area (you can press spacebar as you do so to reposition). Once you have done this, use the handles to adjust the ellipse shape and drag the central pin to reposition the filter and narrow or widen the ellipse shape. To center a new radial adjustment hold down the all key as you click and drag. If you want to preserve the roundness of the radial ellipse shape hold down the shift key as you drag.

Use the <code>#</code> (Mac), or <code>ctrl</code> (PC) key + a double-click to autocenter the ellipse shape within the current (cropped) image frame area and use <code>#</code> (Mac), or <code>ctrl</code> (PC) + double-click to expand an existing radial filter to fill the cropped image area. To clone an existing radial filter hold down the <code>#</code> <code>att</code> (Mac), or <code>ctrl</code> (PC) keys as you click and drag on a radial filter pin. Lastly, double-click on a pin to dismiss the Radial filter edit mode and select the crop tool.

There are lots of potential uses for this tool. You can use it to apply more controllable vignette adjustments to darken or lighten the corners. For example, instead of simply lightening or darkening using the Exposure slider, you can use instead, the Highlights or Shadows sliders to achieve more subtle types of adjustments. As I see it there are many creative uses for this new tool.

As with the gradient filter, you can add multiple radial filter adjustments to an image. Once added, a radial filter adjustment is represented by a pin marker. As you roll over unselected pins the adjustment area will be revealed as a dashed outline.

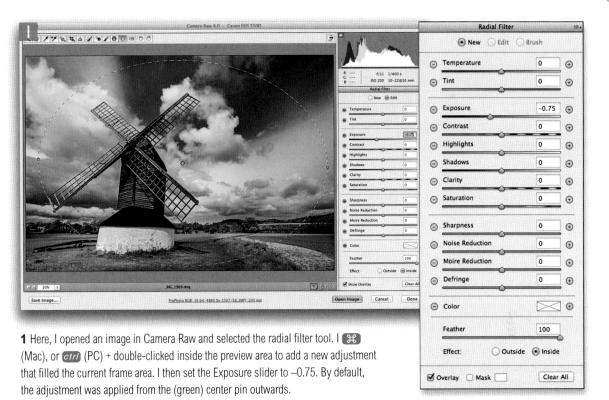

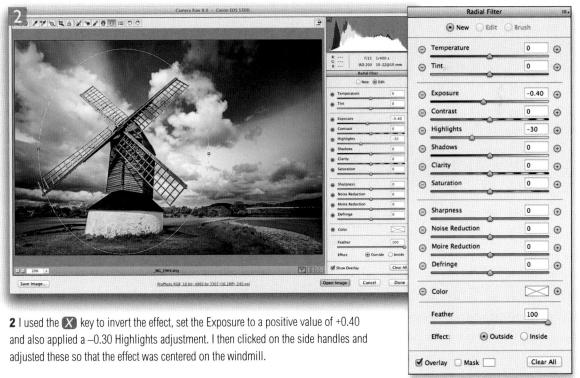

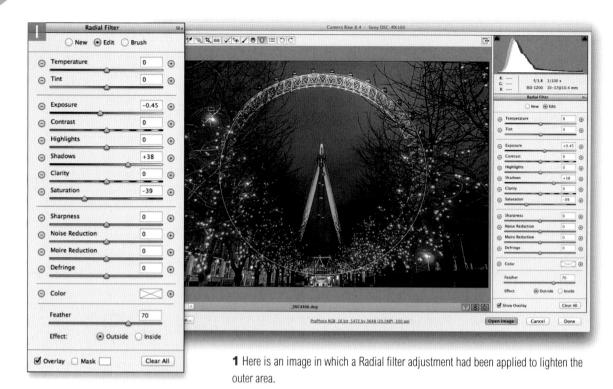

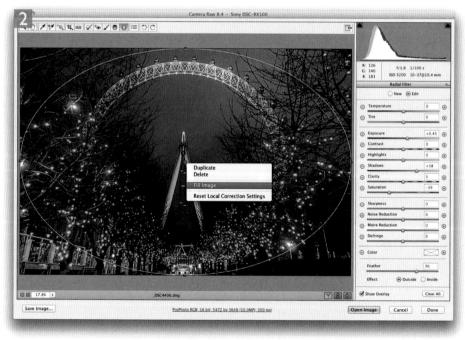

I then used a right mouse-click to access the contextual menu and selected Fill Image to expand the radial filter size to fit the bounds of the image.

Fill to document bounds

There is now a new contextual menu option that allows you to expand a Radial filter adjustment to fill the image bounds (see opposite). Just right mouse-click on a Radial filter pin and select 'Fill Image'. Note that double-clicking inside the ellipse overlay for a Radial filter adjustment achieves the same result.

Modifying graduated and radial filter masks

New to Photoshop CC is the ability to edit the graduated filter and radial filter masks. To start with you will notice that there is now a Mask option at the bottom of the Graduated filter and Radial filter panels (see Figure 2.92). When this is enabled you can click on the color swatch to choose any mask color you want.

After applying a Graduated filter, or Radial filter adjustment you can click on the Brush button to reveal the brush editing options, or use Snift + K to enter and leave brush modification mode. This allows you to modify the mask for the filter adjustment. You can then click on the Brush + and Brush - buttons to add to or erase from the selected mask. If you want to undo the mask editing you can click on the Clear button to undo your edits. There is also an Auto Mask option to help limit the brush editing based on the pixel color where you first clicked.

1 This photograph has been processed using the Basic panel controls to optimize for tone and color.

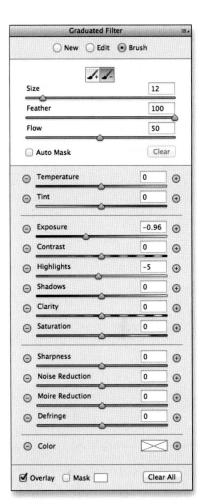

Figure 2.92 This shows the Brush edit controls for the Graduated filter options.

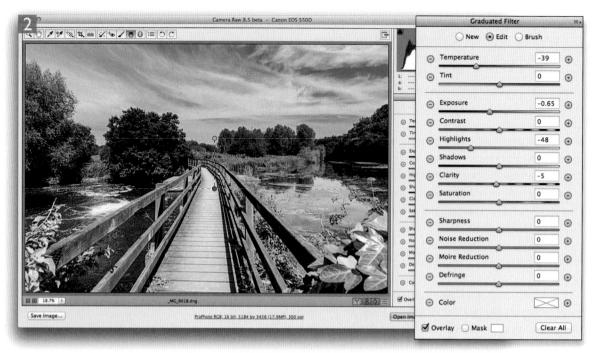

2 In this step I added a graduated filter effect to darken the sky and add more blue.

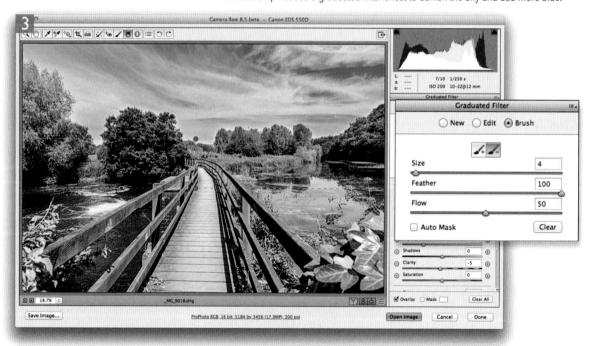

3 I then clicked on the Brush button to edit the Graduated filter mask. By switching between the subtract and add brush options I was able to edit the Graduated filter effect so that it had less impact on the trees.

Correcting edge sharpness with the Radial filter

Another thing the radial filter might be useful for is adding sharpness to the edges of a picture. If you own good quality lenses then this should not always be a problem as you would expect these to provide good overall sharpness. However, I do have a couple of lenses where the quality isn't always so great. In particular, I recently bought a little Sony RX-100 compact camera, which I shoot with a lot. I like the fact that this camera has a nice wide lens aperture and you can shoot in raw mode, but the edge sharpness is an issue compared to when shooting with prime lenses on a digital SLR camera. To address this I have found that you can use the radial filter to apply a Sharpness adjustment that gains strength from the center outwards. Now it has to be said that the fall off in sharpness towards the edges is more tangential in nature and a standard/ radial sharpening boost isn't the optimum way to sharpen the corner edges. For example, DxO Optics Pro features a special edge sharpness correction that is built in to its auto lens corrections. Even so, the following example shows how you can make some improvements using this new feature in Camera Raw.

Edge sharpening presets

If you find this technique appealing you might want to save a radial filter adjustment as a preset and then simply apply the preset setting to other images shot using the same lens and at the same aperture range.

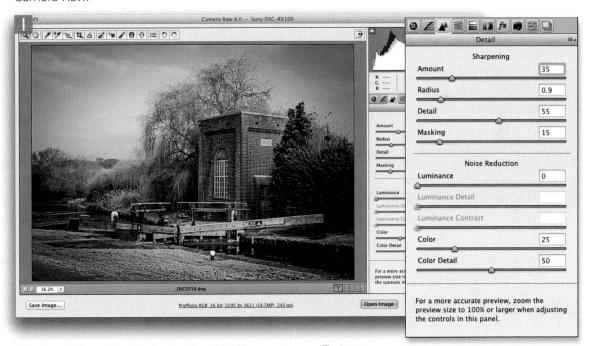

1 Here is a photograph that I shot using a Sony RX-100 compact camera. The image quality is good, though there is a noticeable fall-off in sharpness towards the edges of the frame. I went to the Detail panel and applied the sharpening settings shown here.

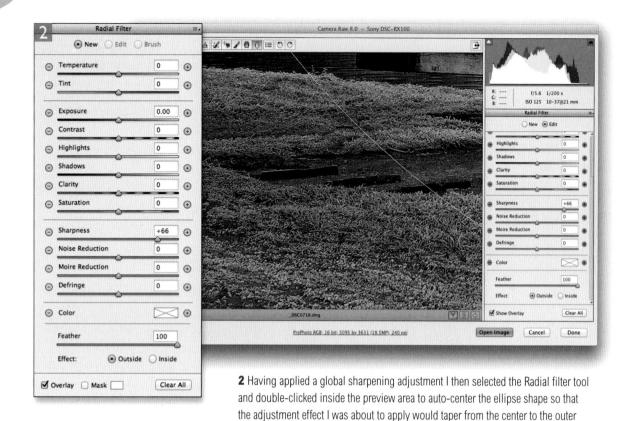

3 Here you can see a comparison of one of the corners of the image where the version on the left shows how the image looked before with the global sharpening only and on the right, how it looked with additional edge sharpening using the Radial filter adjustment.

edges. I also needed to press the key to toggle the adjustment so that the effect was strongest at the outer edges. I then adjusted the Sharpness slider, to apply a +66

Camera Raw settings menu

If you mouse down on the Camera Raw menu (circled in Figure 2.93) this reveals a number of Camera Raw settings options. 'Image Settings' is whatever the Camera Raw settings are for the current image you are viewing. This might be a default setting or it might be a custom setting you created when you last edited the image in Camera Raw. 'Camera Raw Defaults' resets the default settings in all the panels and applies whatever the white balance setting was at the time the picture was captured. 'Previous Conversion' applies the Camera Raw settings that were applied to the previously saved image.

If you proceed to make any custom changes while the Camera Raw dialog is open, you'll also see a 'Custom Settings' option. Whichever setting is currently in use will be shown with a check mark next to it and below that is the 'Apply Preset' submenu that lets you quickly access any pre-saved presets (which you can also do via the Presets panel that is discussed on page 267 onwards).

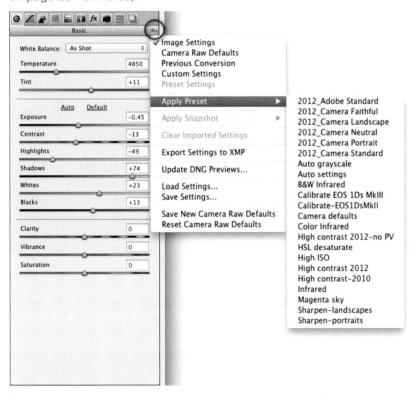

Figure 2.93 The Camera Raw menu options can be accessed via any of the main panels by clicking on the small menu icon that's circled here.

The Camera Raw database

The Camera Raw preferences gives you the option to save the XMP metadata to the Camera Raw database or to the XMP sidecar files (or the XMP space in the file header). If you choose to save to the Camera Raw database, all the Camera Raw adjustments you make will be saved to this central location only. An advantage of this approach is that it makes it easier to back up the image settings. All you have to do is ensure that the database file is backed up, rather than the entire image collection.

On a Mac, the Adobe Camera Raw Database file is stored in: username/Library/ Preferences. On Windows it is stored in: Username\AppData\Roaming\Adobe\ CameraRaw. However, if you are working with Bridge and Lightroom, Lightroom will not be able to pick up any changes made to an image using Camera Raw via Photoshop or Bridge. You then have two options. You either have to remember to select the photos first in Camera Raw and choose 'Export Settings to XMP', or forget about saving image settings to the Camera Raw database and ensure that the 'Save image settings to XMP sidecar files' option is selected in the Camera Raw preferences.

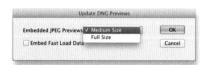

Figure 2.94 When 'Update DNG Previews' is selected you can force update the JPEG previews in a DNG file, choosing either a Medium Size or Full Size preview. You can also chose to 'Embed Fast Load Data'.

Export settings to XMP

If you refer to the Camera Raw preferences shown in Figure 2.27 on page 140, there is an option to save the image settings either as sidecar "xmp" files, or save them to the 'Camera Raw database'. If the 'sidecar "xmp" files' option is selected, the image settings information is automatically written to the XMP space in the file header. This is what happens for most file formats, including DNG. In the case of proprietary raw files such as CR2s or NEFs, it would be unsafe for Camera Raw to edit the header information of an incompletely documented file format. To get around this the settings information is stored using XMP sidecar files, which share the same base file name and accompany the image whenever you use Bridge or Lightroom to move a raw file from one location to another. Storing the image settings in the XMP space is a convenient way of keeping the image settings data stored locally to the individual files instead of it being stored only in the central Camera Raw database. If 'Save image settings in Camera Raw database' is selected in the Camera Raw preferences you can always use the 'Export Settings to XMP' option from the Camera Raw options menu (Figure 2.93) to manually export the XMP data to the selected images. For example, if you are editing a filmstrip selection of images and want to save out the XMP data for some images, but not all. you could use the 'Export Settings to XMP' menu command to do this (see also the sidebar).

Update DNG previews

DNG files can store a JPEG preview of how the processed image should look based on the last saved Camera Raw settings. If you refer again to the Camera Raw preferences (Figure 2.27), there is an option to 'Update embedded JPEG previews'. When this is checked, the DNG JPEG previews are automatically updated, but if this option is disabled in the Camera Raw preferences you can manually update the JPEG previews by selecting 'Update DNG Previews...' from the Camera Raw options menu (Figure 2.93). This opens the Update DNG Previews dialog shown in Figure 2.94.

Load Settings... Save Settings...

These Camera Raw menu options allow you to load and save pre-created XMP settings. Overall, I find it preferable to click on the New Preset button in the Preset panel (discussed opposite) when you wish to save a new Camera Raw preset.

Camera Raw defaults

The 'Save New Camera Raw Defaults' Camera Raw menu option creates a new default setting based on the current selected image. Note that these defaults are also affected by the 'Default Image Settings' that have been selected in the Camera Raw preferences (see 'Camera-specific default setting' on page 171).

Presets panel

The Presets panel is used to manage saved custom Camera Raw preset settings.

Saving and applying presets

To save a preset, you can go to the Camera Raw fly-out menu and choose Save Settings... Or, you can click on the Add Preset button in the Presets panel (circled in Figure 2.95) to create a new Camera Raw preset. A preset can be one that is defined by selecting all the Camera Raw settings, or it can be one that

New Camera Raw defaults

The Save New Camera Raw Defaults option will make the current Camera Raw settings sticky every time from now on when Camera Raw encounters a new file. This includes images processed by Bridge. So, for example, if you were working in the studio and had achieved a perfect Camera Raw setting for the day's shoot, you could make this the new Camera Raw default setting. All subsequent imported images will use this setting by default. At the end of the day you can always select 'Reset Camera Raw defaults' from the Camera Raw options menu to restore the default Camera Raw camera default settings.

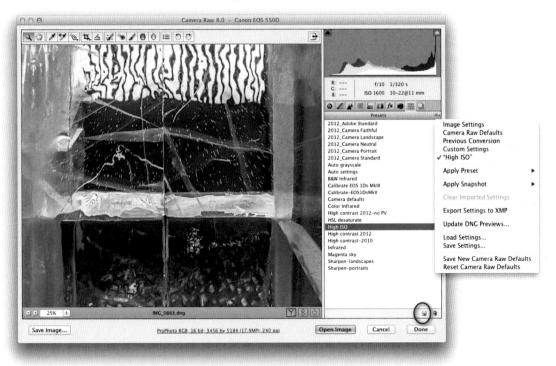

Figure 2.95 When the Presets panel is selected, you can click on the button at the bottom (circled) to add Camera Raw settings as a new preset. In this example I saved a High ISO preset using the New Preset settings shown in Figure 2.96. You can also use the Load Settings... and Save Settings... menu options to load and save new presets.

Camera Raw preset wisdom

Before you save a Camera Raw preset, it is important to think carefully about which items you need to include in a preset. When saving presets it is best to save just the bare minimum number of options. In other words, if you are saving a grayscale conversion preset, you should save the Grayscale Conversion option only. If you are saving a camera body and ISO-specific camera default, you might want to save just the Camera Calibration and Enable lens profile correction settings. The problem with saving too many attributes is that although the global settings may have worked well for one image, there is no knowing if they will work as effectively on other images. It is therefore a good idea to break your saved presets down into smaller chunks.

Camera Raw dialogs

An all-click shortcut has been added to the Synchronize, New Preset, Save Settings, and Copy/Paste (Bridge) dialogs. What happens now is when you all-click a checkbox item in one of these dialogs, it checks that box exclusively. Just all-click again to toggle back to the previous checkbox state.

is made up of a subset of settings (as shown in Figure 2.96). Either way, a saved preset will next appear listed in the Presets panel as well as in the Apply Preset menu (Figure 2.93). Just click on a setting to apply it to an image. To remove a preset setting, go to the Presets panel, select it and click the Delete button at the bottom, next to the Add new preset button (see Figure 2.95).

Figure 2.96 The New Preset dialog can be accessed by clicking on the New Preset button (circled in Figure 2.95). You can choose to save All Settings to record all the current Camera Raw settings as a preset. You can select a sub setting selection such as: Basic, or HSL Adjustments, or you can manually check the items that you want to include in the subset selection that will make up a saved Camera Raw preset.

Copying and synchronizing settings

If you have a multiple selection of photos in the Camera Raw dialog you can apply synchronized Camera Raw adjustments to all the selected images at once. For example, you can [#] (Mac), ctrl (PC)-click or Shift-click to make an image selection via the Filmstrip, or click on the Select All button to select all images. Once you have done this any adjustments you make to the most selected photo are simultaneously updated to all the other photos too. Alternatively, if you make adjustments to a single image, then include other images in the Filmstrip selection and click on the Synchronize... button, this pops the Synchronize dialog shown in Figure 2.97. Here you can select the specific settings you wish to synchronize and click OK. The Camera Raw settings will now synchronize to the currently selected image. You can also copy and paste the Camera Raw settings via Bridge. Select an image and choose Edit ⇒ Develop Settings

Copy Camera Raw Settings (

Copy Camera Raw Settings [Mac], ctrl alt C [PC]). Then select the image or images you wish to paste the settings to and choose Edit

Develop Settings ⇒ Paste Camera Raw Settings (# Nac), ctrl alt V [PC]).

Figure 2.97 When the Synchronize options dialog box appears you can select a preset range of settings to synchronize with or make your own custom selection of settings to synchronize the currently selected images.

Figure 2.98 In this example, I made a selection of images via the Filmstrip and clicked the Synchronize... button, which opened the dialog shown in Figure 2.97.

Figure 2.99 If there is a process version conflict when selecting multiple files, there will be the option to convert all the selected files to the process version that's applied to the most selected image.

Copying and pasting settings

Whenever you copy Camera Raw settings, Camera Raw utilizes the Basic panel settings associated with the process version of the selected image, and automatically includes the process version of the image in the copy settings. You can override this by disabling the Process Version box. But as you will gather from what's written here, it is not a good idea to not include the process version when synchronizing or copying settings.

Synchronizing different process versions

The Synchronize command will work as described, providing the photos you are synchronizing all share the same process version. If you have a mixture of process version images selected, the Basic panel will appear as shown in Figure 2.99. highlighting the fact that the selected images have differing, incompatible process versions. What happens next when you synchronize depends on whether you have the Process Versions box checked or not. If checked, it synchronizes the selected photos converting them to the process version of the most selected photo and updates them accordingly. If unchecked, it synchronizes just those settings that are common to the process versions that are applied to the selected images and ignores all the others (see Figure 2.100). Be aware that such synchronizations can produce unexpectedlooking results. In any case, converting Process 2012 images to Process 2010 with the Process Version box checked can also produce unpredictable results.

Legacy presets

If the Process Version box is checked when saving a preset (see Figure 2.96), the process version is included when applying the preset to other images. If the photos you apply this preset to share the same process version, no conversion takes place, but if they don't share the same process version they'll have to be converted. If the Process Version box isn't checked when you create a preset, things again become more unpredictable. In this situation no process version is referenced when applying the preset. Therefore, if you apply a Process 2010 preset (without including the process version) to a Process 2012 image, settings such as Recovery or Fill Light won't be translated. Similarly, if you apply a Process 2012 preset (without including the process version) to a Process 2010 photo, settings like Highlights and Shadows won't be recognized either. Older presets that don't contain Basic or Tone Curve panel adjustments (other than White Balance, Vibrance and Saturation) will still work OK when applied to Process 2012 images. Where legacy presets do contain Basic or Tone Curve panel settings, they'll only continue to work effectively on images that share the same process version. Therefore, when creating new presets it is important to check the Process Version box. When you do this, if the image you apply the preset to has the same process version, nothing happens—the preset is applied as normal. If it has a different process version a conversion is carried out.

Synchronize Process 2010 from a Process 2012 master

Synchronize Process 2012 from a Process 2010 master

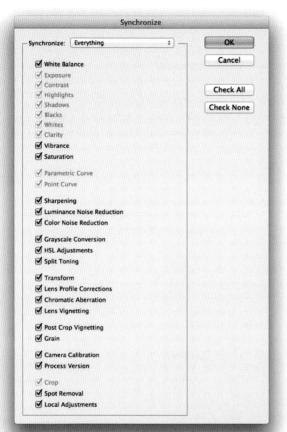

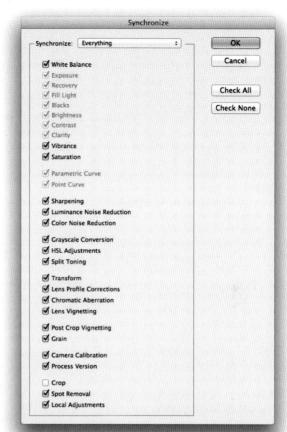

Figure 2.100 If there is a process version mismatch when synchronizing settings, the Process Version box determines what will happen. If checked, those photos with differing process versions will be updated to match the process version of the most selected image. If you attempt to synchronize Process 2010 images from a Process 2012 master, the adjustments that are new in Process 2012: Exposure, Contrast, Highlights, Shadows, Blacks, Whites, Clarity and Tone Curve will be applied by default, which is why the boxes next to the above settings are all checked and dimmed (meaning you can't edit them). Similarly, if you attempt to synchronize Process 2012 images from a Process 2010 master, the Exposure, Recovery, Fill Light, Blacks, Brightness, Contrast, Clarity and Tone Curve adjustments will be checked by default. If you deselect the Process Version box the above process version-specific settings will be disabled completely. When this is done only those settings that can be synchronized (without applying a process version conversion) will be synchronized, which in turn can lead to unpredictable results.

Lightroom snapshots

Snapshots can also be created in Lightroom and as long as you save and update the metadata to the file (in Lightroom), these can be read in Camera Raw. Similarly, snapshots applied in Camera Raw can also be read in Lightroom. The only limiting factor is whether the Develop settings are compatible between your current version of Camera Raw and Lightroom.

Working with Snapshots

As you work in Camera Raw you can save favorite Camera Raw settings as snapshots via the Snapshots panel. The ability to save snapshots means you are not limited to applying only one type of Camera Raw rendering to an image. By using snapshots you can easily store multiple renderings within the image file's metadata and with minimal overhead, since Camera Raw snapshots will only occupy a small amount of file space. I find snapshots are extremely useful and I use them a lot whenever I wish to experiment with different types of processed looks on individual images, or save in-between states.

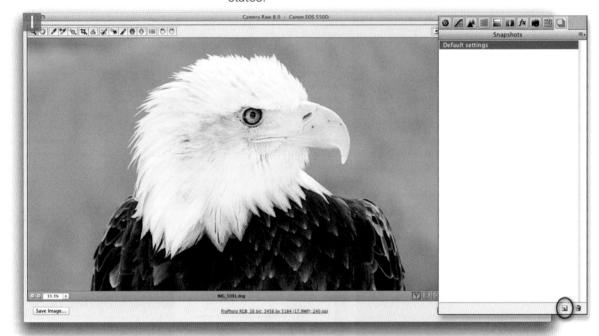

1 The Snapshots panel can be used to store multiple versions of Camera Raw settings. When you visit this panel you may sometimes see a snapshot called 'Import', which will be the setting that was first applied to the photo at the time it was imported. What you can do here is make adjustments to the photo using the Camera Raw controls and use this panel to create new saved snapshots. To begin with I clicked on the Add New Snapshot button (circled) to save this setting as a snapshot called 'Default settings'.

I then adjusted the Camera Raw settings to create an optimized adjustment and saved this as an 'Optimized edit' snapshot.

After that, I created a black and white version and saved this too as a snapshot.

Raw compatibility and DNG adoption

Seventeen years ago, Adam Woolfitt and myself conducted a test report on a range of professional and semi-professional digital cameras. Wherever possible, we shot using raw mode. I still have a CD that contains the master files and if I want to access those images today I am, in some cases, going to have to track down a computer capable of running Mac OS 8.6, in order to load the camera manufacturer software that will be required to read the data! If that is a problem now, what will the situation be like in another 15 years' time? Over the last few years DNG has been adopted by many of the mainstream software programs such as Phase One Media Pro 1, Capture One, Portfolio and Photo Mechanic. At this time of writing. there are Hasselblad, Leica, Pentax, Ricoh, Casio and Samsung cameras that support DNG as a raw capture format option.

DNG file format

In the slipstream of every new technology there follows the inevitable chaos of lots of different new standards competing for supremacy. Nowhere is this more evident than in the world of digital imaging. In the last 20 years or so, we have seen many hundreds of digital cameras come and go along with other computer technologies such as Syquest disks and SCSI cables. In that time I have probably encountered well over a hundred different raw format specifications. It would not be so bad if each camera manufacturer were to adopt a raw format specification that could be applied to all the cameras they produced. Instead we've seen raw formats evolve and change with each new camera model that has been released and those changes have not always been for the better.

The biggest problem is that with so many types of raw formats being developed, how reliable can any one raw format be for archiving your images? It is the proprietary nature of these formats that is the central issue here. At the moment, all the camera manufacturers appear to want to devise their own brand of raw format. As a result of this if you need to access the data from a raw file, you are forced to use *their* brand of software in order to do so. Now, while the camera manufacturers may have excelled in designing great hardware, the proprietary raw processing software they have supplied with those cameras has mostly been quite basic. Just because a company builds great digital cameras, it does not follow they are going to be good at designing the software that's needed to read and process the raw image data.

The DNG solution

Fortunately there are third-party companies who have devised ways to process some of these raw formats, which means you are not always limited to using the software that comes with the camera. Adobe is the most obvious example here of a company able to offer a superior alternative, and at this time of writing, Camera Raw can recognize the raw formats from over 490 different cameras.

The DNG (digital negative) file format specification came about partly as a way to make Adobe's life easier for the future development of Camera Raw and make Adobe Photoshop compatible with as many cameras as possible. DNG is a well thought out file format that is designed to accommodate the many different requirements of the proprietary raw data files

in use today. DNG is also flexible enough to adapt to future technologies and has recently been updated to work with cameras that store proprietary lens correction data in the raw file. Because DNG is an open standard, the specification is freely available for anyone to develop and to incorporate it into their software or camera system. It is therefore hoped that the camera manufacturers will continue to adopt the DNG file format and that DNG will at some point be offered at least as an alternative file format choice on the camera.

DNG brings several advantages. Since it is a well-documented open-standard file format, there is less risk of your raw image files becoming obsolete. There is the potential for ongoing support for DNG despite whatever computer program, computer operating system or platform changes may take place in the future. This is less likely to be the case with proprietary raw files. Can you imagine in, say, 25 years' time there will be guaranteed support for the CR2 or NEF files shot with today's cameras?

DNG compatibility

When raw files are converted to DNG the conversion process aims to take all the proprietary MakerNote information that is sitting alongside the raw image data in the raw original and place it into the DNG. Any external DNG-compatible software should have no problem reading the raw data that is rewritten as a DNG. However, there are known instances where manufacturers have placed some of the MakerNote data in odd places, such as alongside the embedded JPEG preview. At one point this was discarded during the conversion process (but has now been addressed in Camera Raw 5.6 or later). Basically, the DNG format is designed to allow full compatibility, but is in turn dependent on proper implementation of the DNG spec by third parties.

Note that converting JPEGs to DNG won't allow you to magically turn them into raw files, but with the advent of lossy DNG, there are better reasons to now consider doing so. Where a JPEG has been edited using Camera Raw or Lightroom, when you save using the DNG format a Camera Raw generated preview is saved with the file. The advantage of this is that Camera Raw/Lightroom adjustments can now be seen when previewing such images in other (non-Camera Raw aware) programs.

Should you keep the original raws?

It all depends if you feel comfortable discarding the originals and keeping just the DNGs. Some proprietary software such as Canon DPP is able to recognize and process dust spots from the sensor using a proprietary method that relies on reading private XMP metadata information. Since DPP is a program that does not support DNG, if you delete the original CR2 files you won't be able to process the DNG versions in DPP. The only solution here is to either not convert to DNG or choose to embed the original raw file data when you convert to DNG. This means you retain the option to extract the CR2 raw originals any time you need to process them through the DPP software. The downside is you end up with bloated DNG files that will be about double in size.

Saving images as DNG

To convert images to DNG, you can either do so at the time you import photos from the camera (see page 103), or when you click on the Save Image button in the Camera Raw dialog. This will open the dialog shown in Figure 2.101, where you can see the options available when saving an image using the DNG format.

Lossy DNG

With Camera Raw 7 or later it is possible to save DNG files using lossy compression while preserving most of the raw DNG aspects of the image, such as the tone and color controls. To do this you need to check the 'Use Lossy Compression' option. When this option is enabled you can also reduce the pixel dimensions of a raw image by selecting one of the resize options shown in Figure 2.101. Whenever you resize a DNG in this way the image data has to be demosaiced, but is still kept in a linear RGB space. This means that while the demosaic processing becomes baked into the image, most of the other Develop controls such as those for tone and color remain active and function in the same way as for a normal raw/DNG image. Things like Lens Correction adjustments for vignetting and geometric distortion will be scaled down to the DNG output size. The same is true for sharpening, where the slider adjustments for things like Radius are scaled down to the new downsampled size.

You do want to be careful about where and when you use lossy compression for DNG. On the one hand, 'baking' the demosaic processing is a one-way street. Once done, you'll never be able to demosaic the raw data differently. Will Adobe (or someone else) one day come up with an even better way to demosaic a raw image? Overall, I would say if you don't need to compress your DNG files, then don't—aim to preserve your raw files in as flexible a state as possible. On the other hand, I do foresee some uses. A lot of photographers are into timelapse video created using digital SLR cameras. Here I reckon it might be a good idea to archive the raw stills for such projects as lossy DNGs. Another benefit of lossy DNG is that I am now able to provide more images from this chapter as downsized DNGs for readers to experiment with.

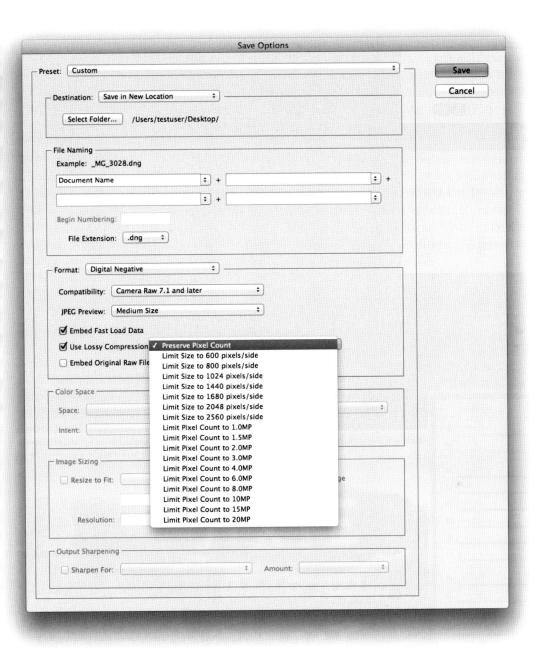

Figure 2.101 The Camera Raw Save Options dialog, showing the Lossy Compression DNG options, including the pixel size menu choices.

Maintaining ACR compatibility

If you refer back to page 98, you can read how it is possible to use the DNG Converter program to convert new camera files to DNG and thereby maintain Camera Raw support with older versions of Photoshop and Camera Raw.

DNG Converter

Adobe have made the DNG Converter program (Figure 2.102) available as a free download from their website: www.adobe. com/products/dng/main.html. The DNG Converter is able to convert raw files from any camera that is currently supported by Camera Raw. The advantage of doing this is that you can make backups of your raw files in a file format that allows you to preserve all the data in your raw captures and archive them in a format that has a greater likelihood of being supported in the future. I personally feel quite comfortable converting my raw files to DNG and deleting the original raw files. I don't see the need to embed the original raw file data in the DNG file since this will unnecessarily increase the file size. However, if you do feel it is essential to preserve complete compatibility, embedding the original raw file data will allow you to extract the original native raw file from the DNG at some later date. The advantage of this is it provides complete compatibility with the camera manufacturer's software. The downside is that you may more than double the size of your DNG files.

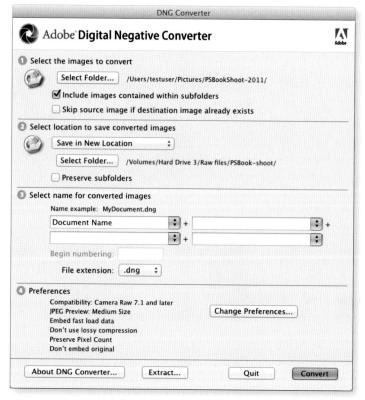

Figure 2.102 The DNG Converter program.

Chapter 3

Sharpening and noise reduction

This chapter is all about how to pre-sharpen your photographs in Photoshop and reduce image noise. Here, I will be discussing which types of images need pre-sharpening, which don't and what are the best methods to use for camera captured or scanned image files.

In previous editions of this book I found it necessary to go into a lot of detail about how to use the Unsharp Mask filter and the Photoshop refinement techniques that could be used to improve the effectiveness of this filter. Now that the sharpening and noise reduction controls in Camera Raw have been much improved, I strongly believe that it is best to carry out the capture sharpening and noise reduction for both raw and scanned TIFF images in Camera Raw first, before you take them into Photoshop. Therefore, the first part of this chapter is devoted entirely to Camera Raw sharpening and noise reduction.

Real World Image sharpening

If you want to learn more about image sharpening in Camera Raw, Lightroom and Photoshop then I can recommend: Real World Image Sharpening with Adobe Photoshop, Camera Raw, and Lightroom (2nd Edition) which is available from Peachpit Press. ISBN: 0321637550. The first edition was authored by Bruce Fraser. This new version is an update of Bruce's original book, now co-authored by Jeff Schewe.

Print sharpening

I should also mention here that this chapter focuses solely on the capture and creative sharpening techniques for raw and non-raw images. I placed this chapter near the beginning of the book quite deliberately, since capture sharpening should ideally be done first (at the Camera Raw stage) before going on to retouch an image. The output sharpening, such as the print sharpening, should be done last. For more about print output sharpening, please refer to Chapter 10.

When to sharpen

All digital images will require sharpening at one or more stages in the digital capture and image editing process. Even if you use the finest resolution camera and lens, it is inevitable that some image sharpness will get lost along the way from capture through to print. At the capture end, image sharpness can be lost due to the quality of the optics and the image resolving ability of the camera sensor, which in turn can also be affected by the anti-aliasing filter that covers the sensor (and blurs the camera focused image very slightly). With scanned images you have a similar problem, where the resolving power of the scanner sensor and the scanner lens optics can lead to scans slightly lacking in sharpness. These main factors can all lead to capture images that are less sharp than they should be.

When it comes to making a print, this too results in a loss of sharpness, which is why it is always necessary to add some extra sharpening, just before you send the photograph to the printer. Also, between the capture and print stages you may find that some photographs can do with a little localized sharpening to make certain areas of the picture appear that extra bit sharper. This briefly summarizes what we call a multipass sharpening workflow: capture sharpening followed by an optional creative sharpen, followed by a final sharpening for print.

Why one-step sharpening is ineffective

It may seem like a neat idea to use a single step sharpening that takes care of the capture sharpening and print sharpening in one go, but it's just not possible to arrive at a formula that will work for all source images and all output devices. There are too many variables that have to be taken into account and it actually makes things a lot simpler to split the sharpening into two stages. A capture image sharpening should be applied at the beginning, dependent on the source image characteristics and an appropriate amount of output sharpening should be applied at the end, dependent on the type of print you are making and the print output size.

Capture sharpening

The majority of this chapter focuses on the capture sharpening stage, which is also referred to as pre-sharpening. It is critical that you get this part right because capture sharpening is one of the first things you do to an image before you start any

retouching work. The question then is, which images need sharpening and of those that do need sharpening, how much sharpening should you apply?

Let's deal with JPEG capture images first. If you shoot using the JPEG mode, your camera will already have sharpened and attempted to reduce the noise in the capture data, so no further pre-sharpening or noise reduction should be necessary. Since JPEG captures are created already pre-sharpened there is no way to undo what has already been fixed in the image. I suppose you could argue that there are some cameras that allow you to disable the sharpening in JPEG mode and you could do this separately in Camera Raw, but I think this runs counter to the very reason why some photographers prefer to shoot JPEG in the first place. They do so because they want their pictures to be fully processed and ready to proceed to the retouching stage. So, if you are shooting exclusively in JPEG mode, capture sharpening isn't something you really need to worry about and you can skip the first section of this chapter.

If you shoot in raw mode it won't matter what sharpen settings you have set on your camera; these will have no effect on the raw file. Any capture sharpening must be done either at the raw processing stage or done afterwards in Photoshop. It now makes sense to carry out the capture sharpening at the Camera Raw image processing stage *before* you open your images in Photoshop.

Capture sharpening for scanned images

Scanned images may have already been pre-sharpened by the scanning software and some scanners will do this automatically without you even realizing it. If you prefer to take control of the capture sharpening yourself you should be able to do so by disabling the scanner sharpening and use whatever other method you prefer. For example, you could use a third-party plug-in like PhotoKit SharpenerTM, or follow the Unsharp Mask filter techniques I describe in the Image Sharpening PDF on the website. So long as you export your scanned images using the TIFF or JPEG format, you can also use the Detail panel controls in Camera Raw to sharpen them.

So what about all those techniques that rely on Lab mode sharpening or luminosity fades? Well, if you analyze the way Camera Raw applies its sharpening, these controls have almost completely replaced the need for the Unsharp Mask filter. In fact, I would say that the Unsharp Mask filter has for

PhotoKit™ Sharpener

Bruce Fraser devised the Pixel Genius PhotoKit Sharpener plug-in, which can be used to apply capture, creative and output sharpening via Photoshop. The work Bruce did on PhotoKit capture sharpening inspired the improvements made to the Sharpening controls in Camera Raw. It can therefore be argued that if you use Camera Raw you won't need to use PhotoKit Sharpener capture sharpening routines. Adobe also worked closely with Pixel Genius to bring the PhotoKit Sharpener output routines to the Lightroom Print module. If you are using Lightroom 2.0 or later, you can take advantage of this. However, if you have Photoshop and Lightroom, PhotoKit Sharpener can still be useful for the creative sharpening and halftone sharpening routines it provides.

How to use the Unsharp Mask filter

The main book no longer covers the manual pre-sharpening techniques that use the Unsharp Mask filter. However, you will find a 20-page PDF document on the website that fully describes how to work with the Unsharp Mask filter sliders and outlines some of the advanced ways you can use the Unsharp Mask filter to achieve better capture sharpening results.

some time now been a fairly blunt instrument for sharpening images, plus I don't think it is advisable to convert from RGB to Lab mode and back again if it's unnecessary to do so. Compare the old ways of sharpening (including the techniques I described in my earlier books) with the Camera Raw method and I think you'll find that this is now the most effective, if not the only way to capture sharpen your photos.

Process versions

As I mentioned in Chapter 2, Process Versions updates for Camera Raw have seen new changes to the way raw images are handled. Since Camera Raw 6 and the introduction of Process 2010, there have been refinements to capture sharpening in Camera Raw. As a result of this, legacy photos processed via Camera Raw 5 or earlier and photos processed via Lightroom 2 or earlier are classified as using Process 2003. All photos that have been edited subsequently in Camera Raw 6 or later can now be edited using Process 2010 or Process 2012.

Improvements to Camera Raw sharpening

The latest versions of Camera Raw using Process 2010 or 2012, offer better demosaic processing, sharpening and noise reduction. The combination of these three factors has led to better overall image processing. Having said that, it should be noted that it is mainly only those cameras that use the three-color Bayer pattern sensors that are affected by this change. The demosaic processing for other types of sensor patterns such as the four-color shot cameras and the Fuji SuperCCD have not been modified. However, improvements have been made in the demosaic processing for specific camera models. For example, an improved green balance algorithm addresses the problem of maze pattern artifacts, which were seen with the Panasonic G1 camera and this may also improve the image resolution for some other camera models too.

Let me try and explain what exactly has changed and how Camera Raw is now different. We can start by looking at the two image examples shown in Figure 3.1, where the top image shows a photograph edited using Process 2003 and the bottom one shows the same image processed via Camera Raw using Process 2010 (the underlying demosaic processing is effectively the same in Process 2012). What you see here is a section of an image that's been enlarged to 400% so that you can see the difference more clearly. The first thing to point

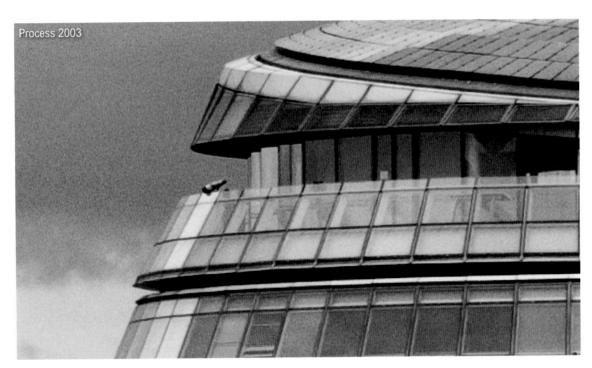

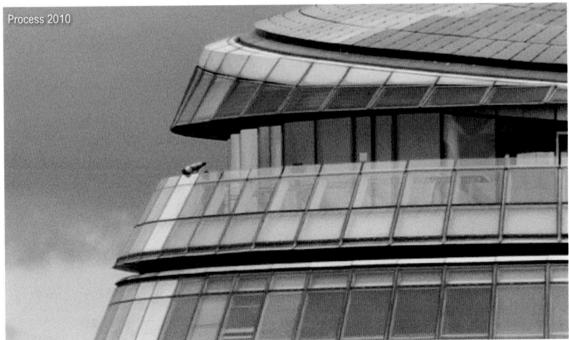

Figure 3.1 This shows a comparison between a raw image processed in Process 2003 (top) and Process 2010 (bottom). Shown here is a magnified 4:1 comparison view.

Ideal noise reduction

The thing to understand here is that the ideal noise reduction in the demosaic process isn't where every trace of noise gets removed from the image. OK, so you might think this would be a good thing to achieve, but you would in fact end up with a photograph where the image detail in close-up would look rather plastic and over-smooth in appearance. What the Camera Raw engineers determined was this: it is better to concentrate on eradicating the noise we generally find obtrusive such as color and luminance pattern noise (which is usually a problem with high ISO capture), but preserve the residual luminance noise that is random in nature. The result of this precise filtering are images that are as free as possible of ugly artifacts, yet retain a fine-grain-like structure that photographers might be tempted to describe as being 'film-like'.

out is that the Process 2010/2012 demosaic process is more 'noise resistant', which means it does a better job of removing the types of noise we find unpleasant such as color artifacts and structured (or pattern) noise. At the same time, the aim has been to preserve some of the residual, non-pattern noise which we do find appealing. The underlying principle at work here is that colored blotches or regular patterns tend to be more noticeable and obtrusive, whereas irregular patterns such as fine, random noise are considered more pleasing to the eye. The new demosaic process therefore does a better job of handling color artifacts and filters the luminance noise to remove any pattern noise, yet retains some of the fine, grainlike structure. The net result is that Camera Raw is able to do a better job of preserving fine detail and texture and this will be particularly noticeable when analyzing higher ISO raw captures.

The next component is the revised sharpening. Sharpening is achieved by adding halos to the edges in an image. Generally speaking, halos add a light halo on one side of an edge and a dark halo on the other. To quote Camera Raw engineer Eric Chan (who worked on the new Camera Raw sharpening), "good sharpening consists of halos that everybody sees, but nobody notices." To this end, the halo edges in Camera Raw have been made more subtle and rebalanced such that the darker edges are a little less dark and the brighter edges are brighter. They are still there of course but you are less likely to actually 'see' them as visible halos in an image. You should only notice them in the way they create the illusion of sharpness. The Radius sharpening was also improved. When you select a Sharpen Radius that's within the 0.5-1.0 range the halos are now made narrower. Previously the halos were still quite thick at these low radius settings and it should now be possible to sharpen fine-detailed subjects more effectively. You'll also read later how the Detail panel Sharpen settings are linked to the Sharpen mode of the Adjustment tools. This means you can use the adjustment brush, graduated filter or radial filter as creative sharpening tools to 'dial in' more (or less) sharpness. Lastly, we have the improved noise reduction controls which, compared to Process 2003, offer more options than before for removing the luminance and color noise from a photograph.

Sample sharpening image

To help explain how the Camera Raw sharpening tools work, I have prepared a sample test image that you can access from the book website. The Figure 3.2 image has been especially designed to highlight the way the various slider controls work when viewed at 100%. Although this is a TIFF image, it's one where the image has been left unsharpened and the lessons you learn here can equally be applied to sharpening raw photos.

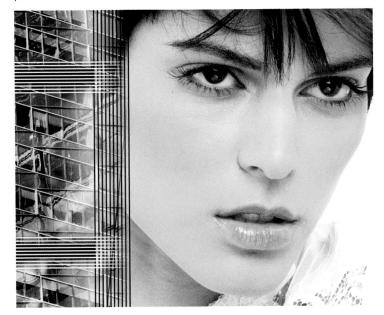

Figure 3.2 The sample image that's used on the following pages can be found on the website. To open this photo via Camera Raw, use Bridge to locate the test image and use File ⇒ Open in Camera Raw, or use the ﷺ (Mac) (PC) keyboard shortcut.

Detail panel

To sharpen an image in Camera Raw, I suggest you start off by going to Bridge, browse to select a photo and choose File
⇒ Open in Camera Raw, or use the ℜ (Mac) ctr ℜ (PC) keyboard shortcut. The Sharpening controls are all located in the Detail panel in the Camera Raw dialog (Figure 3.3). If the photo won't open via Camera Raw, check you have enabled TIFF images to open via Camera Raw in the Camera Raw preferences (see page 140).

Figure 3.3 This shows the Detail panel in the Camera Raw dialog. Note that the Luminance Detail, Luminance Contrast, Color Detail and Color Smoothness sliders will only appear active if the image has been updated to Process 2010 or Process 2012.

Figure 3.4 This shows the default settings for the Detail panel in Camera Raw when processing a raw image.

Sharpening defaults

The Detail panel controls consist of four slider controls: Amount, Radius, Detail and Masking. When you open a raw image via Camera Raw, you will see the default settings shown in Figure 3.4. But if you open a non-raw image up via Camera Raw, such as a JPEG or TIFF, the Amount setting defaults to 0%. This is because if you open a JPEG or TIFF image via Camera Raw it is usually correct to assume the image has already been pre-sharpened, so the default Amount sharpening for non-raw files is always set to zero. You should only apply sharpening to JPEGs or TIFF images if you know for sure that the image has not already been sharpened. Note that the TIFF image used in the following steps should normally open with zero sharpening and noise reduction settings.

The Noise Reduction sliders can be used to remove image noise and we'll come onto these later, but for now I just want to guide you through what the sharpening sliders do.

The sharpening effect sliders

Let's start by looking at the two main sharpening effect controls: Amount and Radius. These two sliders control how much sharpening is applied and how the sharpening gets distributed.

If you want to follow the steps shown over the next few pages, I suggest you download a copy of the Figure 3.2 image from the website and use Bridge to open it via the Camera Raw dialog. To do this use File ⇒ Open in Camera Raw, or use the R (Mac) ctrl R (PC) keyboard shortcut. Then go to the Detail panel section (Figure 3.4). If you are viewing a photo at a fit to view preview size you will see a warning message that says: 'For a more accurate preview, zoom the preview size to 100% or larger when adjusting the controls in this panel', which means you should follow the advice given here and set the image view magnification in the Camera Raw dialog to a 100% view or higher. The test image I created is actually quite small and will probably display at a 100% preview size anyway. The main thing to remember is that when you are sharpening images, the preview display should always be set to a 100% view or higher for you to judge the sharpening accurately. In addition to this I should also point out that the screen shots over the next few pages were all captured as gravscale sharpening previews, where I held down the all key as I dragged the sliders. Note that if using Process Version 2003 you will only get to see these grayscale previews if you are viewing the image at a 100% view or bigger.

Amount slider

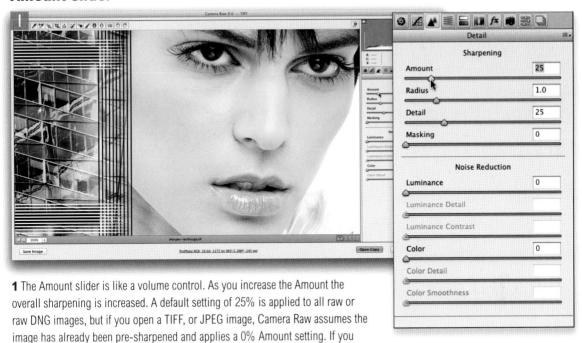

are editing the downloaded image you will need to set this to 25% to simulate the

necessary when you start dampening the sharpening effect using the Detail and

Masking sliders.

default shown here. □ (1) fx (1) (2) □ Sharpening 100 Amount 1.0 Radius 25 Detail 0 Masking Noise Reduction 0 Luminance Luminance Detail Luminance Contrast Open Copy Color Color Detail 2 As you increase the Amount setting to 100% you will notice how the image Color Smoothness becomes sharper. 100% is plenty strong enough, but you can take the Amount even higher. Camera Raw allows this extra headroom because it can sometimes be

Radius slider

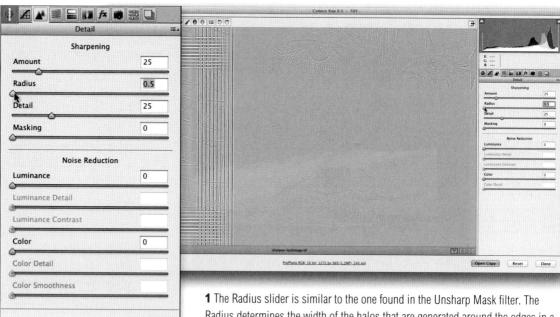

1 The Radius slider is similar to the one found in the Unsharp Mask filter. The Radius determines the width of the halos that are generated around the edges in a photo. A small radius setting can be used to pick out fine detail in a picture, but will have a minimal effect on the soft, wider edges in a picture.

extremes that can be used, but for most sharpening adjustments you will want to stick close to a 1.0 Radius and make small adjustments around this setting.

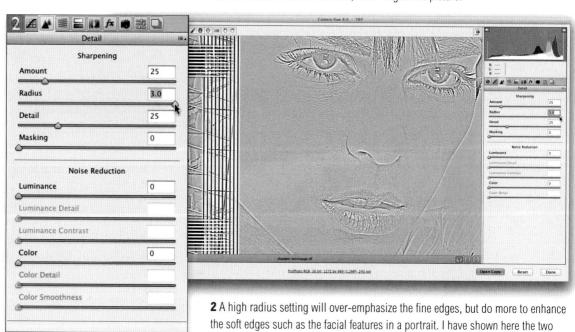

The suppression controls

The Amount and Radius sliders control the sharpening effect. The next two sliders act as 'suppression' controls. These constrain the sharpening and target the effect where it is most needed.

Detail slider

The Detail slider suppresses the halo effects in the image. It allows you to increase the Amount sharpening but without generating too noticeable halo edges in the image. There has always been a certain amount of halo suppression built into the Camera Raw sharpening, but you can now use the Detail slider to fine-tune the Amount and Radius effects. One of the recent minor changes to Camera Raw sharpening means that Detail slider settings above 50 are more likely to exaggerate any areas that contain fine-textured detail (such as noise). As a result you may want to avoid setting the Detail too high when processing high ISO images. One way to cure this is to increase the Masking setting. With low ISO images it is certainly safer to use a high Detail setting. In fact, Eric Chan, who worked on the Camera Raw sharpening, points out he often uses a +100 Detail setting on his low ISO landscape images.

Detail slider settings

As you take the Detail slider below the default 25 value it acts as a halo suppressor that suppresses the amount of contrast in the halos. As you set the Detail slider above 25 it acts as a 'high frequency concentrator', which is to say it biases the amount of sharpening, applying more to areas of high frequency and less to areas of low frequency.

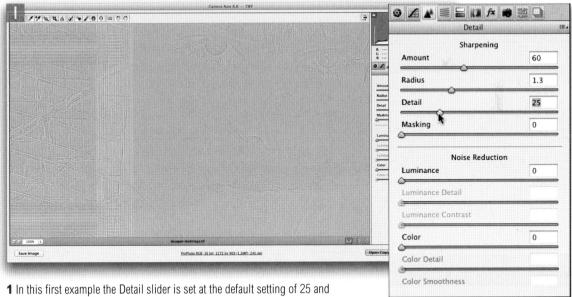

1 In this first example the Detail slider is set at the default setting of 25 and captured here with the all key held down. This displays an isolated grayscale preview of the sharpening effect. At this setting the Detail slider gently suppresses the halo effects to produce a strong image sharpening effect but without overemphasizing the fine detail or noisy areas of the image.

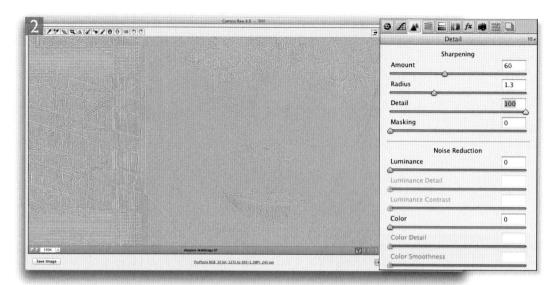

2 If you take the Detail slider all the way up to 100, the capture sharpening will be similar to a standard unsharp mask filter effect applied in Photoshop at a zero Threshold setting.

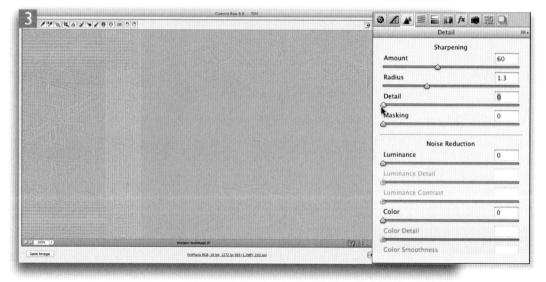

3 If, on the other hand, you take the Detail slider down to zero you can see how the image looks with maximum halo suppression. What we learn from this is how to set the Detail slider between these two extremes. For portraits and other subjects that have soft edges, I would recommend a lowish Detail setting of around 20–30 so that you prevent the flat tone areas from becoming too noisy. For images that have lots of fine detail I would mostly suggest using a higher value of 30–50, because you don't want to suppress the halo edges quite so much. With these types of photos you probably will want to add more emphasis to the fine edges.

Interpreting the grayscale previews

In the screen shots you have seen so far, I captured all these with the all key held down as I dragged on the sliders. In the case of the Amount and Radius adjustments, holding down the all key allows you to preview the effect these two adjustments have on the full color image by displaying a grayscale image which shows the sharpening effect as applied to the luminance information only.

One of the things that has long been known about the conventional Photoshop unsharp masking method is that a 'normal mode' unsharp mask filter effect sharpens all the color channels equally. It is mainly for this reason that people have in the past strived to sharpen the image luminance detail only, without actually sharpening the color information. This is what the 'convert to Lab mode, sharpen the Lightness channel and convert back to RGB mode' technique is doing. The same principle applies when using an Edit ⇒ Fade Unsharp Mask Luminosity mode fade. With Camera Raw the sharpening is always applied to the luminance of the image, which is why you shouldn't see any unwanted color artifacts generated whenever you apply a sharpening effect. This explains the purpose of the grayscale preview for the Amount slider. It is designed to show you exactly how the sharpening is applied to the luminance of the photo, hiding the color information so that you can judge the sharpening effect more easily.

Radius and Detail grayscale preview

With the Radius and Detail sliders you are seeing a slightly different kind of preview when you hold down the all key as you adjust these sliders. The grayscale preview you see here displays the sharpening effect in isolation as if it were a sharpening effect applied on a separate layer. For those of you who are well-acquainted with Photoshop layering techniques, imagine a layer in Photoshop that is filled with 50% gray and where the blend mode is set to 'Overlay'. Such a layer will have no effect on the layers beneath it until you start darkening or lightening parts of that layer. In Figure 3.5 you can see a mock up of what the Detail grayscale preview is actually showing you. It effectively displays the sharpening effect in isolation as light and dark areas against a neutral, midtone gray.

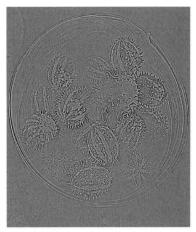

Figure 3.5 This is a Photoshop simulation of what the grayscale Radius and Detail previews in Camera Raw are showing you. Imagine the sharpening effect being carried out on a separate layer above the background layer with the blend mode set to Overlay. When using the Overlay blend mode, a 50% gray has no effect on the layer below. Any gray tone that's darker than 50% darkens the layer below and any gray that's lighter than 50% lightens. If you consider a Camera Raw Detail panel grayscale preview in this context you will understand better that the low contrast preview image represents an isolated preview of the sharpening effect.

Figure 3.6 Here is another simulation of what the Camera Raw Masking slider grayscale preview is showing you. As you hold down the alt key and drag the Masking slider you are effectively previewing a layer mask that masks the sharpening layer effect. In other words, the Masking slider preview shown opposite is kind of showing you a pixel layer mask preview of the masking effect.

Masking slider

The Masking slider can be used to add a filter mask based on the edge details of an image. Essentially, this allows you to target the Camera Raw sharpening so that the sharpening adjustments are more targeted to the edges in the image rather than sharpening everything globally. As you adjust the Masking slider a mask is generated based on the image content, so that areas of the image where there are high contrast edges remain white (the sharpening effect is unmasked) and in the flatter areas of the image where there is smoother tone detail the mask is made black (the sharpening effect is masked). If you take the Masking slider all the way down to zero, no mask is generated and the sharpening effect is applied without any masking. As you increase the Masking, more areas become protected.

I like to think of the effect the Masking slider has on the Camera Raw sharpening as being like a layer mask that masks the layer that's applying the sharpening effect (see the Photoshop example shown in Figure 3.6). The calculations required to generate the mask are quite intensive, but on a modern, fast computer you should hardly notice any slow-down.

I should also mention here how the Masking slider was inspired by a Photoshop edge masking technique that was originally devised by Bruce Fraser. You can read all about Bruce's Photoshop techniques for Input and Output sharpening in an updated version of his book, which is now co-authored with Jeff Schewe: Real World Image Sharpening with Adobe Photoshop, Camera Raw and Lightroom (2nd Edition). This book includes instructions on how to apply the edge masking technique that's referred to here. As I said earlier, because of how the sharpening controls have been updated in Camera Raw, the Detail panel slider controls now provide a much better capture sharpening workflow solution. For example, the original Photoshop edge masking technique (on which this is based) could only ever produce a fixed width mask edge. While you could vary some of the settings to refine the look of the final mask, it was still rather tricky and cumbersome to do so. With Camera Raw it is now much easier to vary the mask width because we now have a single slider control that does everything.

Masking slider example

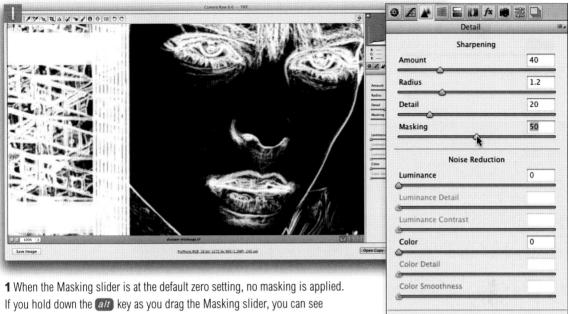

a grayscale preview of the mask that is being generated. At the 50% setting shown here, the mask is just starting to protect the areas of flat tone from being sharpened.

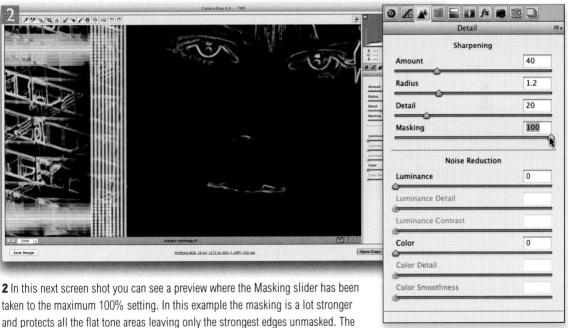

sharpening effect is now only applied to the remaining white areas.

Some real world sharpening examples

Now that I have given you a rundown on what the individual Sharpening sliders do, let's look at how you would use them in practice to sharpen an image.

Sharpening portrait images

Figure 3.7 shows a 1:1 close-up view of a portrait shot where I used the following settings: *Amount: 35, Radius: 1.2, Detail: 20, Masking 70.* This combination of Sharpening slider settings is most appropriate for use with portrait photographs, where you wish to sharpen the important areas of detail such as the eyes and lips, but protect the smooth areas (like the skin) from being sharpened.

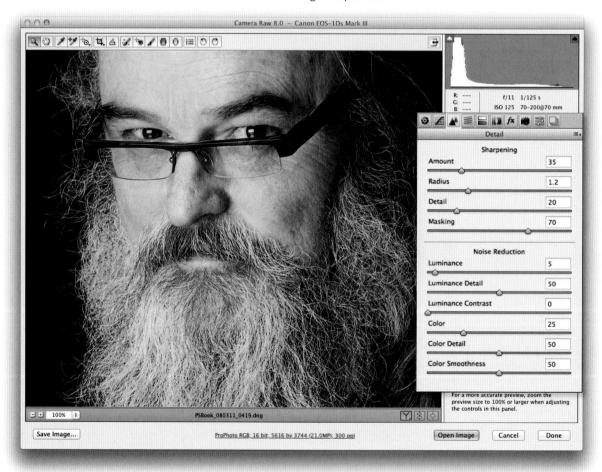

Figure 3.7 Here is an example of the sharpening settings used to pre-sharpen a portrait.

Sharpening landscape images

Figure 3.8 shows the settings that would be used to sharpen a landscape image. The settings used here were: *Amount:* 40, *Radius:* 0.8, *Detail:* 50, *Masking:* 10. This combination of Sharpening slider settings is most appropriate for subjects like the example shown below. You can include quite a wide range of subject types in this category and basically you want to use this particular combination of slider settings whenever you needed to sharpen photographs that contain a lot of narrow edge detail. Process 2010/2012 generates narrower halo edges whenever the Radius slider is applied in the 0.5–1.0 range. This has resulted in the ability to apply lower Radius settings to fine-detailed images that need a low radius, but without generating such noticeable halos.

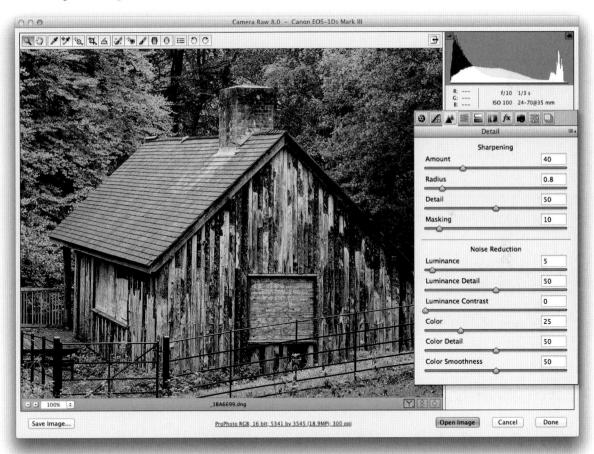

Figure 3.8 Here is an example of the sharpening settings used to pre-sharpen a landscape photo.

Sharpening a fine-detailed image

Figure 3.9 shows an example of a photograph that contains a lot of fine-edge detail. In order to sharpen the fine edges in this picture I took the Radius down to a setting of 0.7. I also wanted to emphasize the detail here and therefore ended up setting the Detail slider to +90. This is a lot higher than one would choose to use normally, but I have included this particular image in order to show an example of a photograph that required a unique treatment. As with the previous example, I only needed to apply a very small amount of Masking since there were few areas in the photograph where I needed to hide the sharpening.

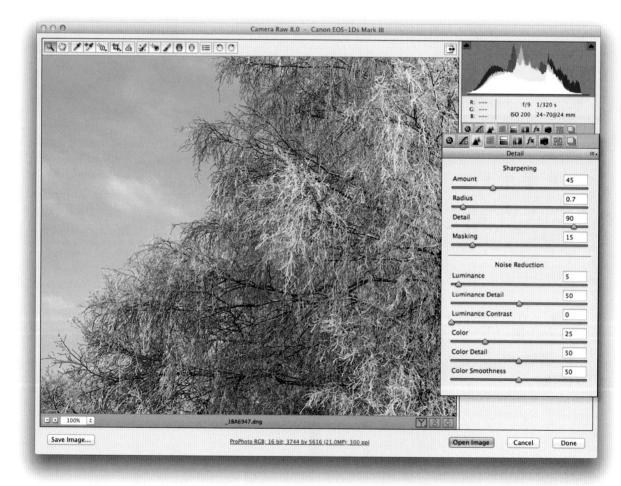

Figure 3.9 This shows an example of the Detail panel sharpening settings that were used to pre-sharpen a fine-detailed subject.

How to save sharpening settings as presets

You can save the sharpening settings as ACR presets and then, depending on what type of photo you are editing, load them as required. You could try using the settings in Figure 3.7, 3.8 or 3.9 to create sharpening presets that can be applied to other photos.

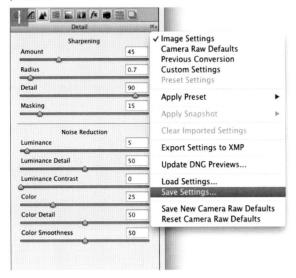

1 After configuring the Detail panel settings, go to the fly-out menu and choose 'Save Settings...'

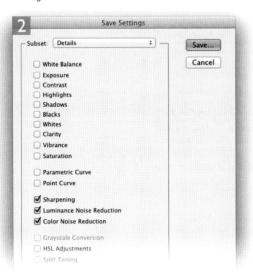

2 This opens the Save Settings dialog shown here. Choose the Details setting from the Subset menu and click the Save... button.

Default sharpening settings

The standard default sharpening setting for raw images uses the settings shown earlier in Figure 3.4. This isn't a bad starting point, but based on what you have learned in the last few examples, you might like to modify this and set a new default. For example, if most of the work you shoot is portraiture, you might like to use the settings shown in Figure 3.7 and set these as a default and make this setting specific to your camera (see page 171).

Settings folder location

On a Mac, the Camera Raw Settings folder location is: username/Library/Application Support/Adobe/Camera Raw/Settings. On a PC, look for: C:\Documents and Settings\ username\Application Data\Adobe\ CameraRaw\Settings.

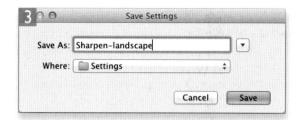

3 Now name the setting and save to the default Settings folder. Don't change the directory location you are saving the setting to here.

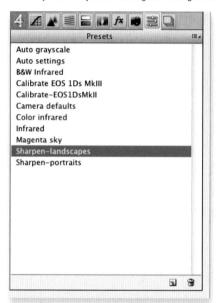

4 When you need to access a saved setting, go to the Settings panel in Camera Raw and click on a saved setting to apply it to the image. Since the setting selected here saved the Sharpening adjustments only, when selected this preset only adjusts the Sharpening sliders when it's applied to another image.

Capture sharpening roundup

Hopefully this section has given you the confidence to now carry out all your capture sharpening in Camera Raw. Remember, the only images that should need pre-sharpening are camera shot raws or scanned TIFFs, although you can process any image in Camera Raw providing it is in a JPEG, TIFF, raw or DNG format and in an RGB, Lab or CMYK mode color space. Although in the case of CMYK images these will (behind the scenes) get converted to RGB internally before being processed in Camera Raw.

As I explained in the previous section, you should use the Camera Raw Sharpening controls to tailor the capture sharpening adjustment to suit the image content. Soft edged subjects such as portraits will suit a higher than 1.0 Radius setting combined with a low Detail and high Masking setting, Fine-detailed subjects such as the Figure 3.8 and 3.9 examples will suit using a low Radius, high Detail and low Masking setting. The aim always is to apply enough sharpening to make the subject look visually sharp on the screen, but without oversharpening to the point where you see any edge artifacts or halos appear in the image. If you overdo the capture sharpening you are storing up trouble for later when you come to retouch the photograph.

Selective sharpening in Camera Raw

With some images it can be tricky to find the optimum settings that will work best across the whole of the image. This is where it can be useful to use the localized adjustment tools to selectively modify the sharpness of an image. Basically, whenever you are using the adjustment brush, gradient filter, or radial filter tools in Camera Raw you can use the Sharpness slider to add more or less sharpness. In particular, with Camera Raw 6 or later, as you increase the Sharpness, the sharpness applied using a brush or gradient increases the sharpness 'Amount' setting based on the other settings already established in the Detail panel Sharpening section.

Negative sharpening

You can also apply negative local sharpening in the zero to -50 range to fade out existing sharpening. Therefore, if you apply -50 sharpness as a localized adjustment this means you can use the adjustment tools to disable the capture sharpening. As you apply a negative sharpness in the -50 to -100 range, you start to apply anti-sharpening, which is effectively like a gentle lens blur effect.

Extending the sharpening limits

You can also go beyond the +100/-100 limit set by the Sharpness slider by applying multiple sharpness adjustments. To do this you need to create a new brush group using a new Sharpness setting and paint on top of an existing brush group.

Two Smart Object sharpening layers

An alternative approach is to use the 'Open raw files as Smart Objects' technique described on page 128 to open an image twice. You can then apply one set of Detail panel settings to one Camera Raw Smart Object layer and a different type of sharpening effect to the other Camera Raw Smart Object layer. You can then use a layer mask to blend these two layers so that you are able to combine two different methods of sharpening in the one image.

How to apply localized sharpening

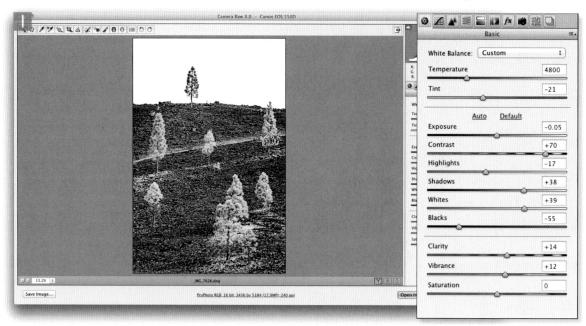

1 In this photograph I had the camera switched to auto focus mode. Although the trees at the top were fairly sharp, some of those at the bottom weren't.

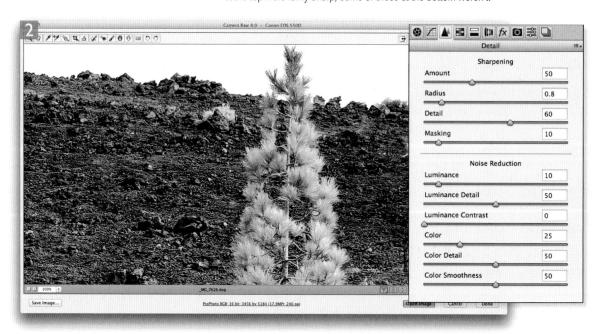

2 To start with I clicked to select the Detail panel and adjusted the Sharpening sliders to obtain the optimum sharpness for a tree near the top of the picture.

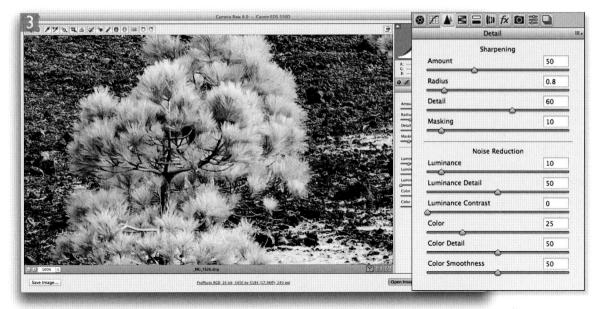

3 Here you can see a close-up view of a tree at the bottom, which even with the benefit of capture sharpening is clearly not as sharp as the one at the top.

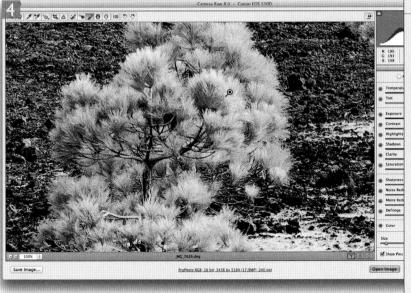

4 In this next step I selected the adjustment brush, set the Sharpness to +100, and painted with the brush on top of the tree that wasn't so sharp. The objective here was to use the adjustment brush to add more sharpness to this area of the image only. The Amount setting for the Sharpness slider effectively added an extra Sharpness amount using the same Radius, Detail and Masking settings as had already been applied via the Detail panel in Step 2.

Negative sharpening to blur an image

Here is an example of how to use a negative Sharpness amount to deliberately blur an image. Again, it is possible to apply multiple passes of negative sharpening, but the effect will eventually max out and, beyond a certain point, won't add any extra blurring. You can't yet apply what you might call a true lens blur effect in Camera Raw. Having said that it's still possible to be used effectively as a creative tool and there is one use where I think this technique would be particularly useful and that is when shooting a sequence of images to be incorporated into a time-lapse video. Rather than having to render every frame as a TIFF or JPEG and process each of these in Photoshop using the Lens Blur filter, doing this in Camera Raw can still be quite effective and offers the ultimate in flexibility.

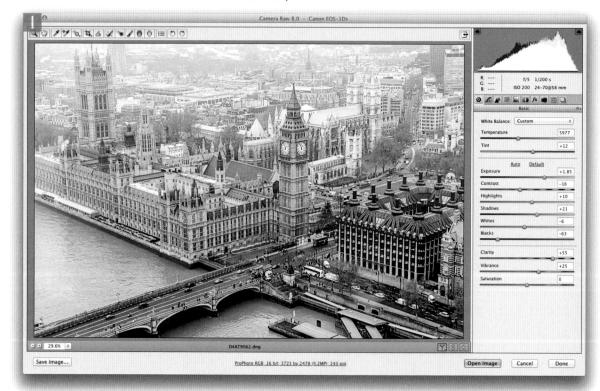

1 Here you can see a photograph opened in Camera Raw, where the aim was to apply a combination of negative sharpening effects and eventually synchronize the settings applied here to every frame in a sequence of photographs. You'll note that I also preapplied a 16:9 ratio crop, to format the image for video output.

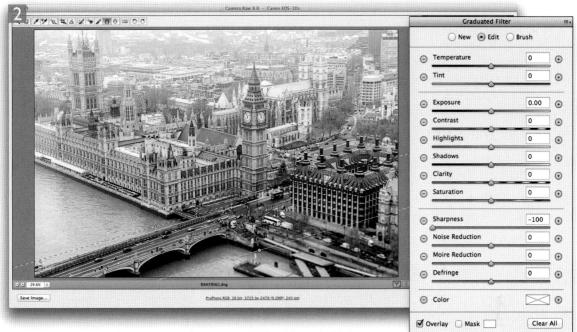

2 I selected the graduated filter tool, set the Sharpness to -100 and dragged with the tool to apply a negative sharpness, blurring adjustment. By repeating this process two or three times I was able to build a blurring effect in the bottom right corner.

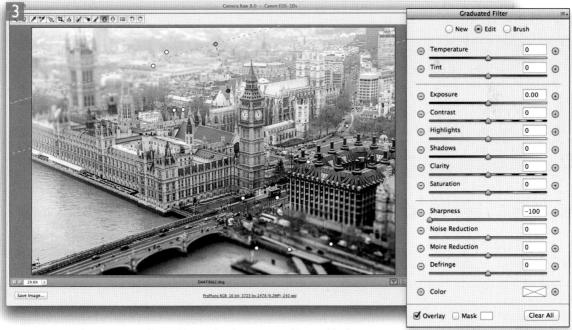

3 Finally, I added further gradient filters with negative sharpness to add more blurring to the top left corner.

Is the noise really visible?

Some of the latest digital cameras such as Nikon and Canon digital SLRs are capable of capturing images at extremely high ISO settings and although reviewers talk about seeing noise in these captures, I've yet to see much in the way of noticeable noise appear in print, unless you were to print an enlarged detail of what can be seen on the screen at say 2:1. In other words, one shouldn't always over-obsess when analyzing your images in close-up.

Noise removal in Camera Raw

All images are likely to suffer from some degree of noise, but the amount of noise present will vary according to a number of factors. With digital images the noise seen will depend mainly on the quality of the camera sensor and what ISO setting the photograph was shot at. All camera sensors have a base level of noise even at the optimum, lowest ISO setting, and it is as the ISO is increased that the underlying noise becomes amplified and therefore more noticeable. Some sensors definitely perform better than others when used at higher ISO speeds and with the most recent digital SLR cameras we have seen a remarkable improvement in image capture quality at high ISO settings.

Another factor is exposure. On page 164 I showed how deliberately underexposing a digital photo can lead to shadow noise problems as you compensate by increasing the Exposure slider amount. In fact, the shadow areas are always the biggest problem. To determine how successful your camera is as at handling image noise, you should check how the shadows look. The Noise Reduction sliders in Camera Raw should be able to meet all your noise reduction requirements and there should be less need to rely on Photoshop or thirdparty products to carry out the noise reduction. Bear in mind that JPEG capture images will have already been processed in-camera to remove any noise. So, to take full advantage of Camera Raw noise reduction, you'll need to work with raw capture images. The other thing to bear in mind here is that the noise reduction and sharpening processes are essentially counteractive. As you attempt to reduce the noise in an image you'll inevitably end up softening some detail. The Camera Raw Process 2010 and 2012 controls have therefore been designed to make the noise reduction as targeted as possible to curing the problems of noise and with minimal softening of the image. Even so, in some instances you will still need to consider revising the sharpening settings.

Process Versions and noise reduction

Key to all this is understanding the effect the Process Version has on a raw image and the Detail panel controls. All images processed in Camera Raw prior to Camera Raw 6 will have used what is now referred to as Process 2003 rendering, which in turn limits the Noise Reduction slider controls so you can only adjust the Luminance and Color sliders. The improved noise reduction discussed here only applies to images

processed in Camera Raw 6 or later using the latest Process 2010 or 2012 rendering. Process 2003 images will need to be updated to Process 2010 or 2012 in order to take advantage of the new sharpening and noise reduction processing. But it should also be noted here that with Process 2003 for Camera Raw 4.1 onwards, a certain amount of Luminance noise reduction was always integral to the image demosaic process. With the advent of Camera Raw 6 in Photoshop CS5, the default luminance poise reduction was removed for both Process 2003 and Process 2010. This was because some users complained they didn't like the added noise reduction in the demosaic processing. This means with a Camera Raw image that has been processed in Camera Raw 4.1 or later using a Process 2003 rendering, you may find it now necessary to boost the Luminance noise reduction by around 15-25 in order to match the previous Camera Raw Process 2003 rendering. Let me explain exactly what impact this has if you are new to Photoshop CS5, CS6 or CC and hence Camera Raw 6 or later. Images processed in Camera Raw prior to version 4.1 will show no difference in the Process 2003 rendering. Images processed in Camera Raw 4.1 or later may appear a little more noisy when opened through Camera Raw 6 or later, but this will really only be noticeable in those cases where it was necessary to apply Luminance noise reduction to remove noise. So in other words, it is only going to be an issue with high ISO images. In all likelihood you will want to update such photos to Process 2012 anyway in order to specifically take advantage of the improved noise reduction.

So let's look at what is special about the Process 2010 and 2012 rendering. The new demosaic process aims to filter the noise so as to reduce the luminance pattern noise and color noise component which we generally find obtrusive, but retain the random grain-like noise that we don't find distracting. The aim here is to filter out the good noise from the bad and provide, as a starting point, an image where the Camera Raw demosaic process preserves as much detail as possible. As the ISO setting is increased beyond whatever is the optimal ISO setting you then have the means to remove noise by adjusting the Noise Reduction sliders from their default settings. Extra help will still be required to further suppress the unwanted image noise which can be characterized in two ways: as luminance and color noise. This is where the Noise Reduction sliders in the Detail panel come in.

Removing random pixels

Camera Raw noise reduction is also able to remove outlying pixels, those additional, random light or dark pixels that are generated when an image is captured at a high ISO setting. Camera Raw can also detect any dead pixels and smooth these out too. You won't normally notice the effect of dead pixels, but they do tend to show up more when carrying out long time exposures. Even then you may only see them appear very briefly on the screen as Camera Raw quickly generates a new preview image.

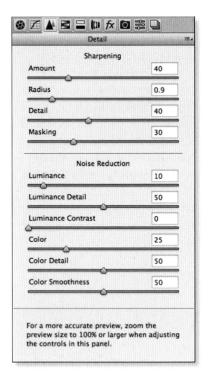

Figure 3.10 The Detail panel showing the Noise Reduction sliders.

Adaptive noise reduction

Noise reduction in Camera Raw is adaptive to different camera models and their respective ISO settings. The effective amount of noise reduction for the Luminance noise and Color noise amount settings therefore varies when processing files from different cameras as the noise reduction is based on a noise profile for each individual camera. The end result is that the noise reduction behavior feels roughly the same each time you adjust the noise reduction controls although the under the hood the values applied are actually different.

Detail panel Noise Reduction sliders

The Noise Reduction controls are shown in Figure 3.10. The Luminance slider is used to smooth out the speckled noise that is always present to some degree, but is more noticeable in high ISO captures. The default setting is zero, but even with low ISO captures I think you'll find it beneficial to apply just a little Luminance noise reduction; in fact my colleague Jeff Schewe likes to describe this as the fifth sharpening slider and suggests you always include adding at least a little Luminance noise reduction as part of a normal sharpening process. Since Luminance noise reduction inevitably smooths the image, it is all about finding the right balance between how much you set the Luminance slider to suppress the inherent noise and how much you sharpen to emphasize the edges (but without enhancing the noise). Improvements made since Camera Raw 4.1 mean Camera Raw now does a much better job of reducing any white speckles in the shadows and the Luminance noise reduction was further improved in Camera Raw 6 to provide the smoothest luminance noise reduction possible.

Excessive Luminance slider adjustments can lead to a softening of edge detail. To help counter this, the Luminance Detail slider acts like a threshold control for the main Luminance slider. The default setting is 50 and the Luminance Detail slider sets the noise threshold of what the noise reduction algorithm determines to be noise. When this slider dragged to the left you will see increased noise smoothing. However, be warned that some detail areas may be inappropriately detected as noise and important image detail may also become smoothed. Dragging the slider to the right reduces the amount of smoothing used and preserves more detail. This allows you to dial back in any missing edge sharpness, but it may also cause noisy areas of the image to be inappropriately detected as detail and therefore not get smoothed.

Luminance noise tends to have a flattening effect at the macro level where the underlying texture of the noise grain appears so smoothed out that in close-up the image has something of a plastic look to it. The Luminance Contrast slider therefore allows you to restore more contrast, but does so at the expense of making preserved noise blobs more noticeable. The smoothest results are achieved by leaving the Luminance Contrast slider at the default zero setting. However, doing so can sometimes leave the noise reduction looking unnatural

and the details may appear too smoothed out. Dragging the slider to the right allows you to preserve more of the contrast and texture in the image, but at the same time this can lead to increased mottling in some high ISO images. It is also worth pointing out here that the Luminance Contrast slider has the greatest effect when the Luminance Detail slider is set to a low value. As you increase the Luminance Detail the Luminance Contrast slider has less effect on the overall Luminance noise reduction.

Color noise

Color noise occurs due to the inability of the sensor in low light levels to differentiate color because the luminance is so low. As a result of this we see errors in the way color is recorded and hence the appearance of color artifacts in the demosaiced image. The Color slider smooths out the color noise artifacts such as the magenta/green speckles you commonly see in noisy high ISO captures. For the most part you can now safely crank the Color noise reduction slider up towards the maximum setting. However, increasing the Color noise slider can also result in color bleeding, which results in the fine color details in an image becoming desaturated. This kind of problem is one that you are only likely to see with really noisy images that contain fine color edge detail, so it's not something you need to worry about most of the time. Where this does appear to be an issue, the Color Detail slider allows you to help preserve color detail in such images and as you increase the Color Detail slider beyond the default 50 setting you'll notice how it preserves more detail in the color edges. Take care when you use this slider, because as you increase the amount that is applied this can lead to some color speckles reappearing along the preserved edges. And in areas that have a strong color contrast you can see an over-sharpening of the color boundary edges. To understand more clearly the effect all of these sliders are having, you may want to zoom in to look at a 400% view.

Non-raw image noise reduction

In previous editions of the book I provided at the end of this chapter coverage of how to use the Reduce Noise filter. In light of how effective the controls are now in Camera Raw and the fact you can use Camera Raw to process JPEG and TIFF images, I suggest you use Camera Raw as a primary means to reduce noise. There is though a PDF on the book website that shows how to use Photoshop's Reduce Noise filter.

CMOS and **CCD** sensors

In recent years we have seen advances in sensor technology for digital SLR cameras, where the latest sensors are now able to capture images at incredibly high ISO settings without producing too much obtrusive noise once processed using a raw processor such as Camera Raw. At the highest ISO settings it is mostly only luminance noise that you have to remove. The reason why this has become possible is because these digital SLRs are using CMOS type sensors. However, the sensors designed for use with medium format cameras are mostly of the CCD type, which, while being very good in terms of color performance and sharpness, do not tend to respond well when the signal is amplified at higher ISO settings. To be honest, the sensors designed for use in medium format backs are best used when used at the lowest ISO settings. However, Sony have recently created a 50 megapixel CMOS sensor for medium format cameras. I have tested this with the Hasselblad H5D-50C camera system and the sensor performance is exceptionally good, even at the highest ISO 6,400 setting.

Improved color noise reduction

Since Camera Raw 7, the quality of the color noise reduction has been improved at extreme color temperatures such as 3200°K or lower in order to reduce the effects of color splotchiness.

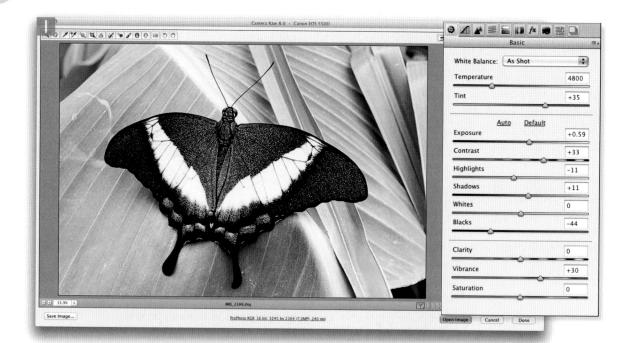

1 Here is a photograph that was shot at 3200 ISO and is a good example with which to demo the Process 2010/2012 color noise reduction.

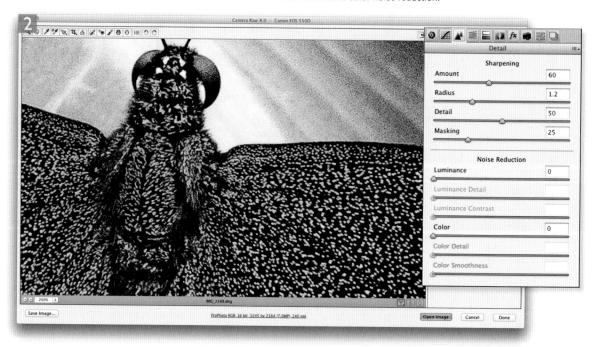

2 Here, I enlarged the image preview to 200% and set the Color slider to zero. As you can see, there were a lot of visible color noise artifacts in this image.

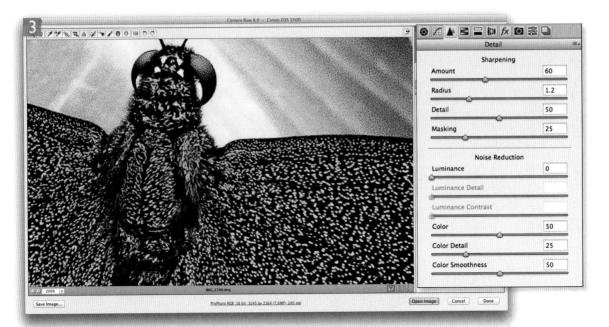

3 In this step, I applied a color noise reduction of 50. The Color Detail slider can do a good job resolving the problem of color edge bleed, commonly associated with color noise reductions. However, an excessive amount can cause edges with color contrast to appear unnaturally over-sharpened. Here, I applied a Color Detail setting of 25.

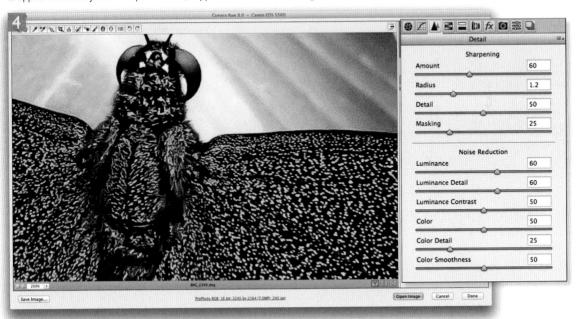

4 I then applied a Luminance noise reduction of 60 with a Luminance Detail setting of 60 and a Luminance Contrast setting of 50. This 'noise reduced' version is much smoother.

Color Smoothness slider

The Detail panel now offers a Color Smoothness slider in the Noise Reduction section. This can be used to help deal with color mottling artifacts (or large colorful noise blobs). These are usually caused by low frequency color noise and can be present in low as well as high ISO images, especially in the shadow regions. The default setting is 50. Dragging to the right can help make these disappear, though this will, at the same time, cause the image to appear smoother.

The example shown here was shot using a Canon EOS 1Ds MkIII camera at 100 ISO. I deliberately lightened the shadows to reveal the problem highlighted here. Canon cameras will benefit most from this feature, whereas the latest Nikon sensors have much better sensor noise characteristics at high ISO settings.

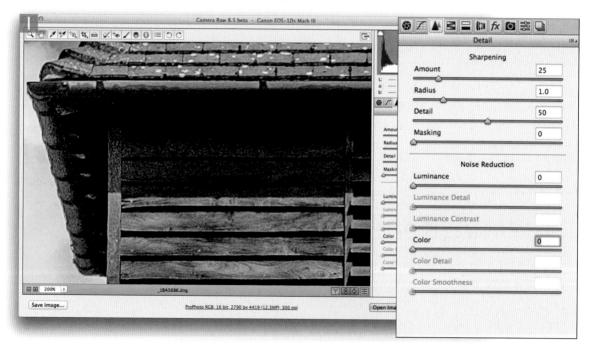

1 This shows a 200% close-up view of an image that was shot at ISO 100, but where there were clearly signs of color mottling in the shadow areas.

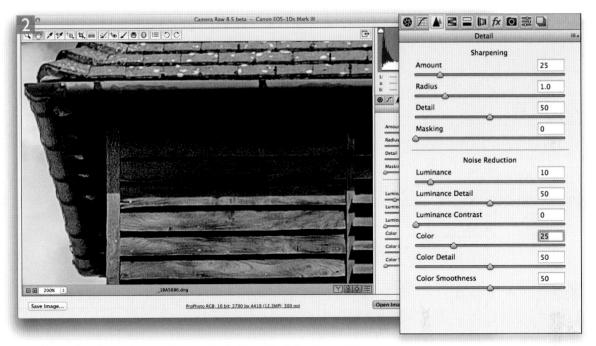

In this step I set the Luminance noise reduction to 10 and the Color slider to 25. This got rid of some of the color noise, but not all.

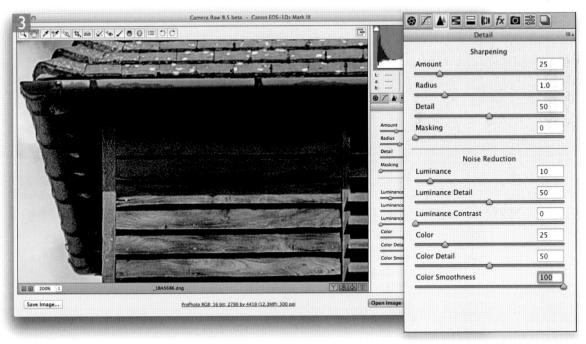

Setting the Color Smoothness slider to 100 smoothed out the mottling effect. This avoided me having to otherwise further increase the Color amount setting.

Adding grain to improve appearance of sharpness

Earlier, in the Camera Raw chapter, you may have got the impression that I'm not particularly keen about adding grain to images. Well, at least not when it's applied as a special effect. But the Grain slider can sometimes actually be useful when you are editing high ISO images and need to get rid of obtrusive noise artifacts. In the example shown here you can see how adding a small amount of noise can be used to compensate for some of the over-smoothing produced by the noise reduction process.

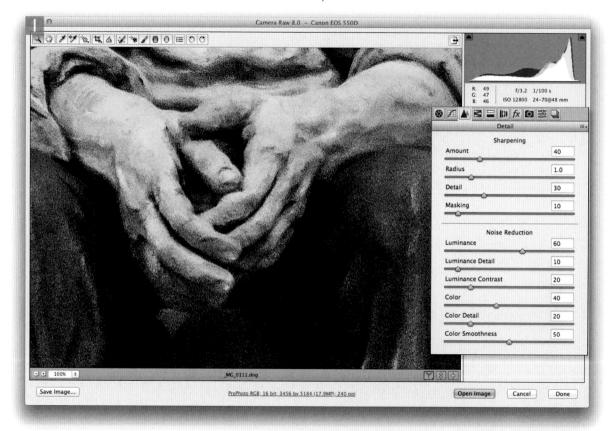

1 When editing this image it was necessary to apply the settings shown here in the Detail panel to help remove the luminance and color noise from the picture. Note the image is shown here at a 100% view.

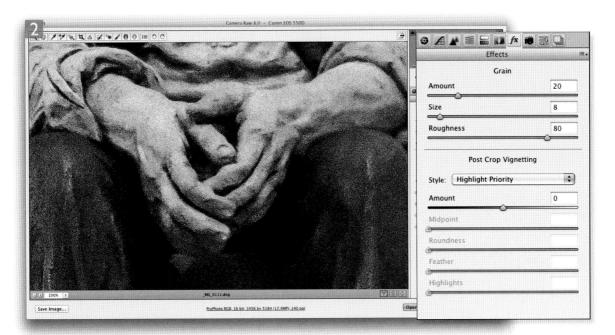

2 As a result of the noise reduction adjustment applied in Step 1, some of the image detail ended up becoming over-smooth. To counteract this I added a small amount of grain using the Grain slider in the Effects panel.

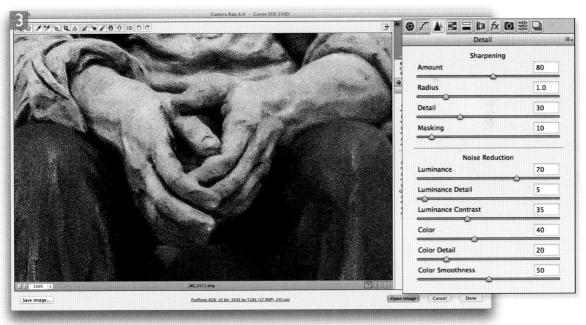

3 Finally, I returned to the Detail panel and readjusted the Sharpening sliders, in order to restore more sharpness in the final processed image (and also added more Clarity).

Localized noise reduction in Camera Raw

Camera Raw 7 and later features a Noise slider in the adjustment brush and graduated filter settings. As you increase the slider setting you can apply a localized adjustment that strengthens the noise reduction that's applied to the selected area. As with localized sharpening adjustments, this strengthening of the noise reduction effectively increases the amount setting for the Luminance and Color sliders, proportionally. Basically, you can use this slider adjustment to apply additional noise reduction where it is needed most, such as the shadow areas. I see this tool being useful where you have used a Camera Raw localized adjustment to deliberately lighten the shadows in a scene. Instead of bumping up the overall noise reduction it makes sense now to do so locally by increasing the Noise slider amount. Note that you can also apply negative amounts of noise reduction with the adjustment brush. For example, you might have an image where it is easier to apply a global adjustment that is heavy on the noise reduction and use a negative localized noise reduction adjustment to remove the noise reduction effect locally.

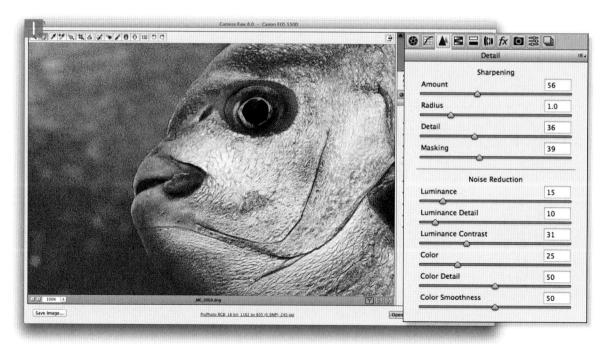

1 Here is a photograph that required localized lightening in the shadow areas. As you can see, I had already adjusted the Detail panel sliders to remove most of the image noise.

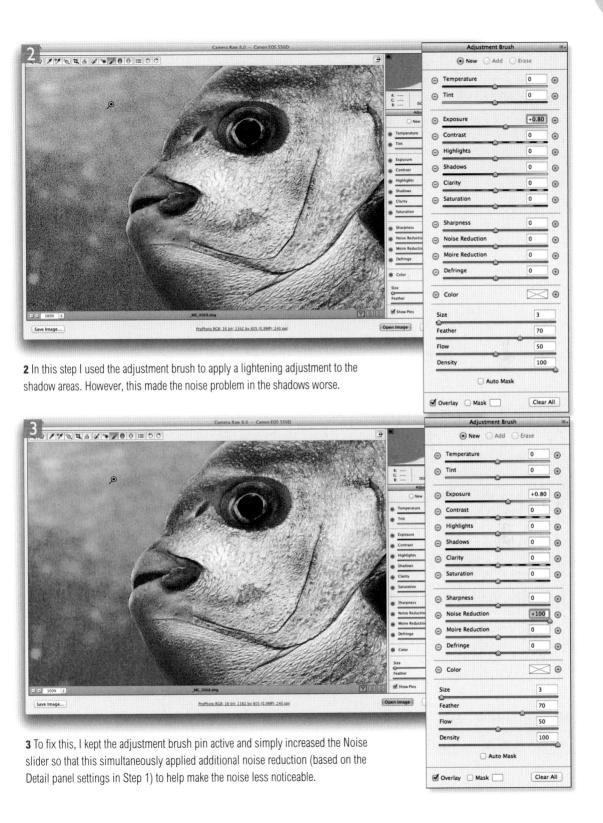

Removing moiré at the shoot stage

One way to avoid the effects of moiré is to reshoot the subject from a slightly further distance and crop the image accordingly. Usually a small change in shooting distance is all that is required. The effects of moiré are much less of a problem now compared with the early days of digital camera technology.

Negative moiré

You'll notice that you also have the ability to apply negative amounts of moiré. This is there so that you can apply multiple passes of moiré reduction in which subsequent applications of negative moiré can be used to reduce the moiré reduction effect.

Raw and JPEG moiré removal

Moiré removal is more effective removing luminance artifacts on raw images than JPEGs. This is because Camera Raw can take advantage of the higher resolution green channel (before color processing) to perform a fix. This is not possible with JPEGs as the green channel has already been fixed (color processed) and therefore 'polluted' the other three channels.

Localized moiré removal in Camera Raw

The term 'moiré' is used to describe image detail problems that are related to artifacts generated as a result of light interference. This can be due to the way light reflected from a fine pattern subject, such as a shiny fabric, causes interference patterns to appear in the final capture. What actually happens here is the frequency of the fabric pattern and the frequency of the photosites on the sensor clash and this causes an amplified moiré pattern to appear in the captured image. Our eyes don't see this, it is just a limitation of the sensor. These days digital SLR cameras mostly all have a high pass, anti-aliasing filter attached to the surface of the sensor, which is designed to mitigate some of the effects of moiré. That plus the increased capture resolution of today's cameras have made this problem largely go away. However, there are some cameras where the sensors don't have high pass filters (such as the Nikon D800E) and as a result of this you can end up seeing moiré-type effects when viewing an image close-up. Basically, if the camera lens is imaging fine-detail lines which correspond to less than one pixel width, this can cause a problem in the demosaic process. Therefore, it is really only certain types of subject matter photographed on the larger, medium format backs where the need to reduce moiré becomes necessary.

In the Camera Raw localized adjustments menus is a Moiré slider. As with the Noise slider, increasing the amount is designed to help reduce the effects of moiré (as seen in the example opposite). Here are some things to watch out for. Increasing the Moiré Reduction setting will allow you to apply a stronger effect and you can, if necessary, consider applying a double dose of moiré reduction to a local area. However, as you increase the effect you are likely to see color bleeding occur. In the accompanying example a moiré pattern could be seen in the brickwork. When I used a moiré reduction adjustment brush to remove the moiré, the brush referenced a broad area of pixels near where I was brushing in order to calculate what the true color should be. When retouching an image such as this it was important to use a hard edged brush to constrain the brush work and avoid the green colors of the foliage spilling over. Selecting the Auto Mask option can certainly help here. Also, when fixing different areas (such as the moiré on the air conditioning grills in this picture) you should consider creating a new brush pin to work on these areas separately.

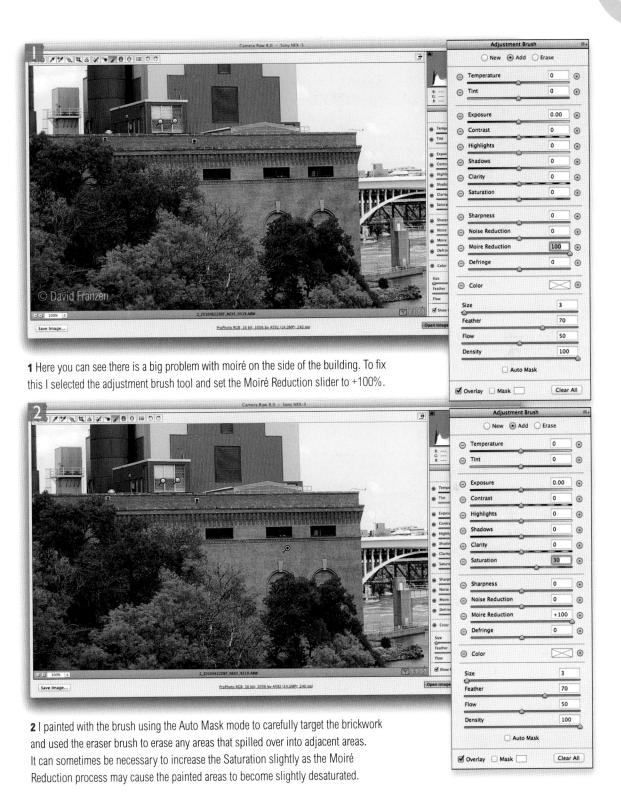

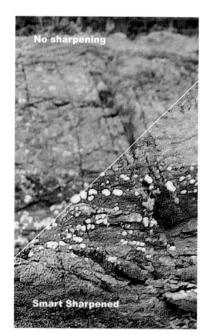

Figure 3.11 Take care when using the Smart Sharpen filter. An excessive amount of Smart Sharpen can lead to more noticeable artifacts like those seen in the bottom half of this screen grab. Though I have to say, the Smart Sharpen quality is a lot smoother now in Photoshop CC

Improved sharpen tool

The sharpen tool in Photoshop has been improved since CS5. The Protect Detail mode utilizes an algorithm that minimizes any pixelation when the sharpen tool is used to emphasize image details. The Protect Detail mode can therefore faithfully enhance high frequency image details without introducing noticeable artifacts, though I recommend using this tool set to the Luminosity mode in order to help reduce the risk of generating color artifacts (see Figure 3.12).

Localized sharpening in Photoshop

Smart Sharpen filter

So far we have seen how to apply localized sharpening in Camera Raw. Let me now show you a few ways this can be done directly in Photoshop. One method is to use the Smart Sharpen filter. Don't be too taken in by the fact that it's called a 'smart' filter. Some people figure this is a kind of 'super Unsharp Mask' filter to be used for general sharpening. If applied correctly, it can be used to sharpen areas where there is a distinct lack of sharpness, but if used badly may introduce noticeable artifacts (see Figure 3.11). The Smart Sharpen filter also runs very slowly compared with the Unsharp Mask filter. and Camera Raw sharpening. Therefore, I generally consider Smart Sharpen to be more useful as a tool for 'corrective' rather than general sharpening. However, the Smart Sharpen filter image processing has been much improved in Photoshop CC and now also includes a Reduce Noise slider in the Advanced options, which can play a key role in suppressing artifacts

Basic Smart Sharpen mode

The Smart Sharpen filter has three blur removal modes: Gaussian Blur is more or less the same as the Unsharp Mask filter, but the Lens Blur method is the more useful as it enables you to counteract optical lens blurring. Lastly, there is Motion Blur removal, which can sometimes be effective at removing small amounts of motion blur from an image. After you have selected a blur removal method, you can use the Amount and Radius slider controls to adjust the sharpening effect.

In the example shown on the page opposite I first went to the Filter menu and chose 'Convert for Smart Filters', which converted the Background layer to a Smart Object layer. This allowed me to apply the Smart Sharpen filter as a 'smart filter', where I could edit the filter effect coverage by painting on the layer mask. An alternative option would be to duplicate the Background layer and apply the Smart Sharpen filter to that layer, but the advantage of the Smart Object/Smart filter layer approach is that the Smart Sharpen filter settings remain editable.

Figure 3.12 This shows the sharpen tool options, including the 'Protect Detail' mode.

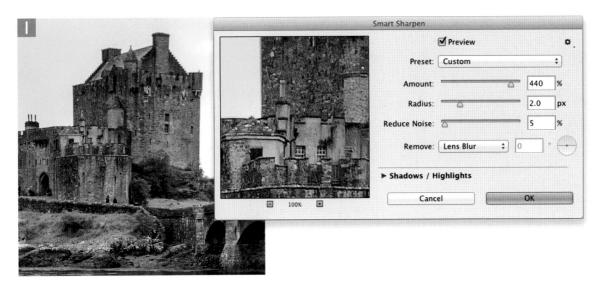

1 This shows a close-up view of a photograph where the main subject was slightly out of focus. I didn't want to apply any further global sharpening as this would have created artifacts in the background. I converted the Background image layer to a Smart Object and applied the Smart Sharpen filter in 'Lens Blur' mode using the settings shown here. Note the use of the Reduce Noise slider can help hide unwanted artifacts.

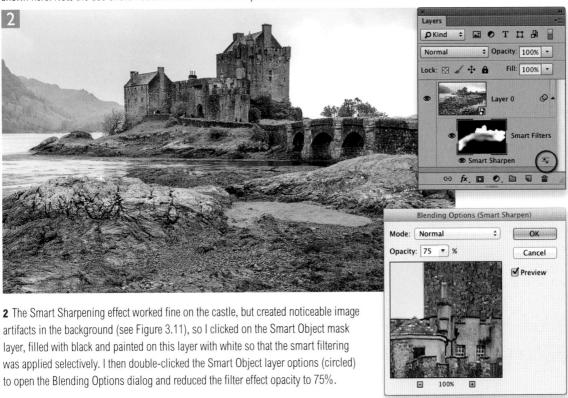

Saving the Smart Sharpen settings

You can save Smart Sharpen settings as you work by clicking on Presets menu circled below in Figure 3.13, and choose 'Save Preset...'

Legacy mode

If you click on the cog wheel in the Smart Sharpen dialog, there is 'Use Legacy' option. Checking this allows you to work with the Smart Sharpen filter using the old style Smart Sharpen processing should you wish (there is also a 'More Accurate' check box you can check here as well).

Advanced Smart Sharpen mode

Just below the Advanced mode section are two additional expandable sections marked Shadows and Highlights. The controls in these sections act like dampeners on the main smart sharpening effect. The Fade Amount slider selectively reduces the amount of sharpening in either the shadow or highlight areas. This is the main control to play with as it will have the most initial impact in reducing the amount of artifacting that may occur in the shadow or highlight areas. Below that is the Tonal Width slider and this operates in the same way as the one you find in the Shadows/Highlights image adiustment: vou can use this to determine the tonal range width that the fade is applied to. These two main sliders allow you to subtly control the smart sharpening effect. The Radius also works in a similar way to the Radius slider found in the Shadows/Highlights adjustment and is used to control the area width of the smart sharpening.

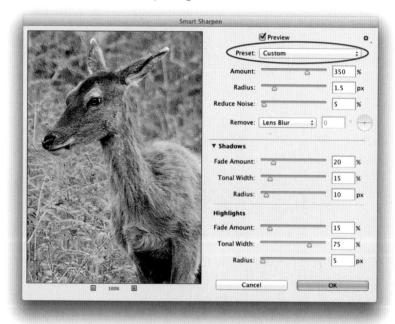

Figure 3.13 In this photograph I set the Smart Sharpen filter to Advanced mode and applied an Amount of 150% at a Radius of 1.5 using the 'Lens Blur' mode. Once I had selected suitable settings for the main Smart Sharpen, I clicked on the Shadow and Highlight tabs and used the sliders in these sections to decide how to limit the main sharpening effect. A high Fade Amount setting faded the sharpening more, while the Tonal Width determined the range of tones that were to be faded. Lastly, there was the Radius slider, where I could enter a Radius value to determine the scale size for the corrections.

Removing Motion Blur

The Motion Blur mode can be used to correct for mild camera shake or small amounts of subject movement in a photograph (see Figure 3.14). If you select the Remove Motion Blur mode, the trick here is to get the angle in the dialog to match the angle of the Motion Blur in the picture and adjust the Radius and Amount settings to optimize the Motion Blur correction.

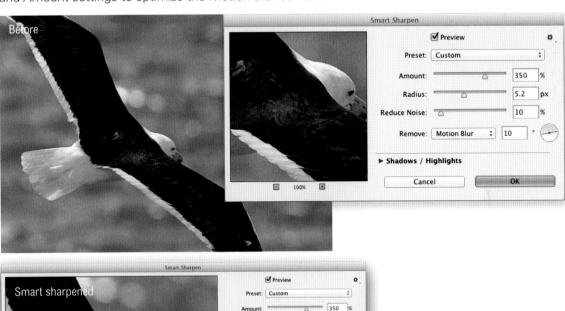

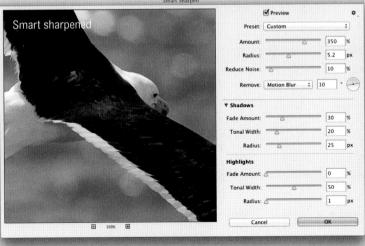

Figure 3.14 The Motion Blur method of smart sharpening is reasonably good at improving sharpness where there is just a slight amount of camera shake or subject movement. In this example I initially set the Amount, Radius and Angle to achieve the most effective sharpening and in Advanced mode I went to the Shadow tab to adjust the Fade Amount and Tonal Width settings so as to dampen the sharpening effect in the shadows. This helped achieve a slightly smoother-looking result.

Figure 3.15 The Shake Reduction filter tools

Shake Reduction filter

At the Adobe Max show in 2011, there was a sneak preview of a new 'de-blurring' plug-in that generated a lot of excitement. Well, that filter has now arrived in Photoshop. What it does is correct the camera shake in a captured photo rather than work out how to refocus an out-of-focus image. The way it does this is to interpret the image and look for signs of camera shake, and in particular, clues to the path that a camera moved during an exposure. For example, this will be most apparent in sharp pin-point areas such as catch lights in the eyes. From this the Stabilize plug-in is able to calculate a camera shake signature for the image and use this to work out how to reconstruct the scene without camera shake. It's kind of like a software version of the image stabilizing control found on some lenses and cameras.

This can't be expected to work perfectly in every case as there is a lot of guess work going on here that is being

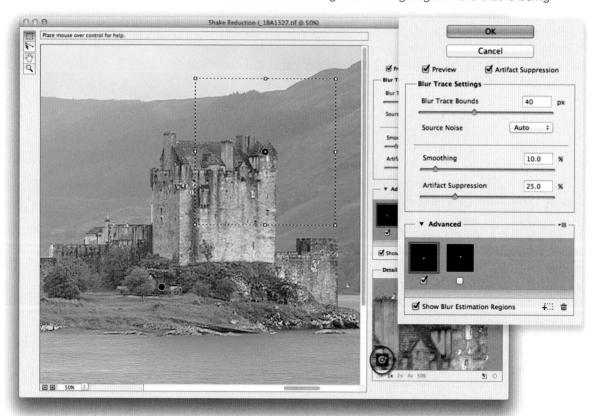

Figure 3.16 The Shake Reduction filter dialog. In this example, there is one blur trace active with an active blur trace region plus filled pin and one that's inactive (with a hollow pin).

computed by the plug-in. It works best where the source image is essentially in focus, but was shot at a slow shutter speed and where camera shake is the only issue. In other words, without additional subject movement. This means the filter works best when processing static subjects, because if you shoot anything that's moving at a slow shutter speed you'll have the combined issue of camera shake plus subject movement to contend with. It will also work best if the source image is captured with a decent lens and camera sensor.

The Shake Reduction controls

The Shake Reduction filter controls are quite complex. Fortunately, when you open the filter it goes through an automatic routine of analyzing the image and applies autocalculated settings for you, including the auto-placement of a blur estimation region, represented by a marquee area with a central pin. If you like the result this gives, then click OK to apply. If not, then you can override this auto-calculated starting point and refine the settings. These are shown in Figure 3.16. The loupe view window at the bottom shows you a close-up view of the current blur estimation region and as you adjust the controls you'll see the results of that adjustment in the loupe view. If you want to relocate the blur estimation region, then simply click in the main preview window. This re-centers the loupe. As you do this though, you will see a refresh icon appear in the bottom left corner of the loupe view (circled in Figure 3.16). Click on this to recenter the blur estimation region based around this new location.

In the Blur Trace Settings section there is a Blur Trace Bounds slider. This is initially set automatically, but you can adjust the amount here to increase or decrease the size of the blur trace area. The Source Noise menu is used to specify the noise content of the original image and defaults to Auto, but you can override this to choose Low, Medium or High. It is usually best to leave it set to 'Auto' though. The Smoothing slider can be used to control the sharpening-induced noise. In Figure 3.17 you can see the result of applying no Smoothing and with smoothing. Below this is the Artifact Suppression slider, which can be used to suppress large artifacts. There is also a checkbox at the top of the panel controls that allows you to disable the Artifact Suppression and hides the Artifact Suppression slider. In Figure 3.18 'ringing' artifacts can clearly be seen in the 'Without' version. When the Artifact Suppression is applied using the correct amount, these can mostly be removed.

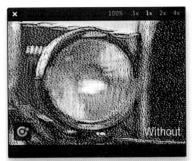

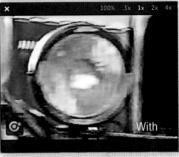

Figure 3.17 This shows the before and after effects of controlling the Smoothing

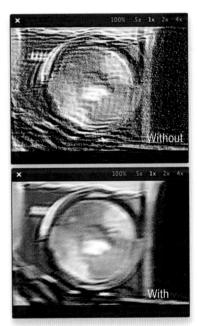

Figure 3.18 This shows the before and after effects of controlling the Artifact Suppression.

Figure 3.19 This shows the 'Region Too Small' warning.

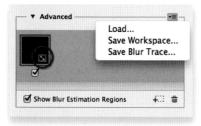

Figure 3.20 This shows the Advanced controls, showing the Advanced menu options and enlarge blur trace icon (circled).

Figure 3.21 This shows an enlarged blur trace view.

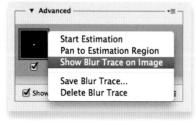

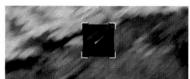

Figure 3.22 This shows the contextual blur trace menu with 'Show Blur Trace on Image' and a blur trace overlaying the preview.

In the Advanced section there is an option to show or hide the Blur Estimation Regions in the preview area. This simply allows you to see the blur region outlines or not. Below that are the trace blur previews and here you can choose to turn individual blur regions on or off. Figure 3.20 shows a normal blur trace produced as a result of using the blur estimation tool (see the tools in Figure 3.15). Figure 3.23 shows a manual blur trace, produced by using the blur direction tool to manually define the camera shake blur. Note that in the Figure 3.16 example only one blur estimation blur trace is currently active and Blur Trace settings can be applied individually to each blur trace. If the blur estimation made is too small, then you will see the warning shown in Figure 3.19, which points out the blur estimation region is not big enough to calculate a blur trace from.

In Figure 3.20 you can see the Advanced section menu options. Here, you can save and load workspaces or blur traces. A workspace is the combination of the blur estimation regions plus their associated blur reduction settings. To save a blur trace, select one from the Advanced panel section and choose 'Save Blur Trace...' This will save the selected blur trace as a 16-bits per channel PNG format grayscale image (which you can then edit in Photoshop if you wish). Also, if you hover the mouse over a blur trace you can click on the enlarge blur trace icon (circled in Figure 3.20) to see a magnified blur trace view (see Figure 3.21). If you make a right mouse-click on a blur trace icon, you'll see a pop-up menu, from where you can choose 'Show Blur Trace on Image' (Figure 3.22). This overlays the Blur Trace on the image and allows you to adjust the Blur Trace Bounds slider to see how it grows or shrinks.

Repeat filtering

If you apply the Shake Reduction filter using an automatic settings adjustment, a repeat filter (using ****E** [Mac], attle [PC]) will also apply an automatic adjustment. If custom settings were used to override the auto-calculated settings, a repeat use of the filter will use these same user-defined settings. However, if a repeat run is done on an image with different dimensions, the image will be reanalyzed and autocorrected.

Smart object support

You can also apply Shake Reduction as a Smart Filter and make use of the masking to apply the filter effect selectively.

Blur direction tool

The blur direction tool allows you to manually specify the direction and length of a straight blur trace, but is only available when the Advanced options are expanded. It is purposely designed to let you apply a more aggressive style shake reduction to a specified area or areas. Its a tool you should therefore use in moderation and in conjunction with blur estimation region calculations to treat particularly tricky sections of an image (although you can use it on its own should you wish). A blur direction blur trace is represented using a lock icon (see Figure 3.23).

You can edit a manual blur trace in a number of ways. You can click inside the bounds of the blur trace that overlays the preview and drag to reposition it. If you click on either of the two handles you can manually drag to change the length or angle of the blur trace (see Figure 3.24). But note here that small changes made to the blur trace can have a significant impact on the result of the Shake Reduction adjustment. If you want to apply small, incremental adjustments you can use the bracket keys. Use to reduce the blur trace length and use to increase it. Also, you can use the (Mac), ctrl (PC) shortcut to twist the angle anti-clockwise and use the (Mac), ctrl (PC) shortcut to twist the angle clockwise.

How to get the best results

To help improve the success of the filter, it is best to apply noise reduction first in Camera Raw (especially for the Color noise), avoid use of Clarity and Contrast and disable capture sharpening. I imagine the majority of candidate images for this filter will have been shot using a camera phone or cheap compact camera, as it is these types of cameras that will suffer most from camera shake. At the same time, the camera settings in low light conditions will mean the camera is capturing an image at a high ISO setting and at full aperture. Therefore, the plug-in is having to contend with processing an image that's not optimally in sharp focus and there will also be issues to do with sensor noise. That said, every bit helps of course. If you are aware of these limitations you should be pleased with its ability to at least make most pictures appear to look somewhat sharper than they did before, even if the results you get won't always be as dramatic as those shown in the demos.

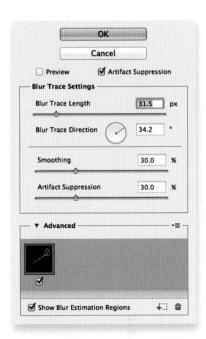

Figure 3.23 Here you can see the Blur Trace Settings for when a Manual blur direction is in force.

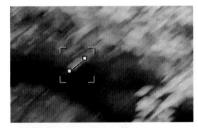

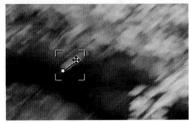

Figure 3.24 In the top view you can see the blur direction tool being applied to an image, where I dragged with the tool to follow the direction and length of the blur. The bottom view shows how you can edit a manually-defined blur trace.

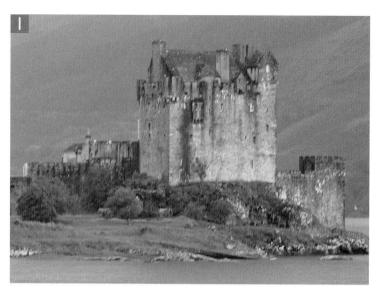

1 Here you can see the image I wished to improve. This was shot using a long focal length lens and there is noticeable camera shake in this picture.

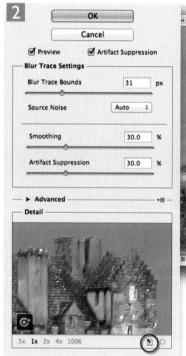

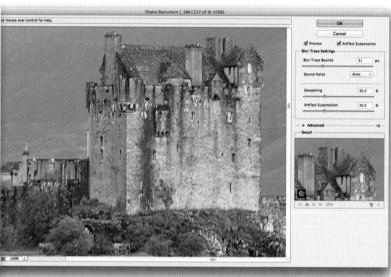

2 I went to the Filter menu and chose Sharpen ⇒ Shake Reduction. When this filter is opened it first auto-estimates the required blur size. It follows this by auto-estimating the required noise reduction (using the Auto setting). The Auto noise is a value calculated by the Shake Reduction algorithm. When set to 'None' it means it won't take noise into consideration. It then auto-chooses a blur trace estimate for the blur trace. The default Blur Trace size is determined by the image size and some image analysis, so it can be different from one image to another. After that, it renders a coarse preview, followed by a fine preview. In many cases the result you see here should not need any further alteration to achieve a sharper result.

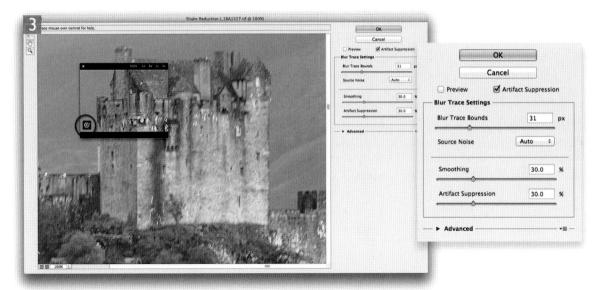

3 In the Detail section you can click on the Unlock Detail button circled in Step 2 (or use the 10 toggle shortcut) to undock the detail loupe. This will snap to the preview area and allow you to drag and reposition on an area of interest. As you adjust the Blur Trace Bounds you will see a fast update within the loupe view. When repositioning the loupe view, click the refresh button (circled) to recalculate.

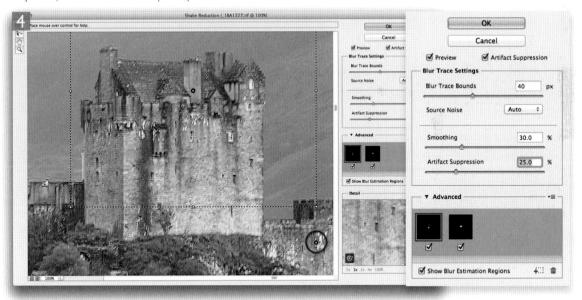

4 When the Advanced options are expanded, you can use the blur estimation tool (**(E)**) to define additional blur trace regions, which will then be added to the Blur Estimation Regions gallery. When two or more of these are defined (and made active), the overall blur estimations are blended together between these points. In this step I had two regions defined. In the first I modified the settings to increase the shake reduction effect.

Smart Filter layer limitations

On page 319 I mentioned how it was advantageous to use Smart Filter layers when applying a localized filter effect, mainly because with a Smart Object layer you can go back and revise the filter settings later. Unfortunately you can't apply the technique described here using Smart Object layers, because there are no options to set the layer blending (as shown in Step 2). There is also no way to get the two filter effects applied in Step 3 to merge as one when setting the blend mode to Overlay. Basically, Smart Filter layers are a great idea, but still somewhat limited in their application.

Creating a depth of field brush

On page 318 I described how you could use the Smart Sharpen filter to remove the blurriness from parts of an image and selectively apply the filter effect through a layer mask. There is also another way you can reduce blur in a photograph and this technique is closely based on a technique first described by Bruce Fraser, in the *Real World Image Sharpening with Adobe Photoshop, Camera Raw and Lightroom* (2nd Edition) book. The only thing I have done here is to change some of the suggested settings, in order to produce a narrower edge sharpening brush. Basically, you can adapt these settings to produce a sharpness layer that is suitable for different types of focus correction.

This technique can be used to help make the blurred image detail *appear* to look sharper by adding a blended mixture of sharp and soft halos, which create the illusion of apparent sharpness. The method described here requires you to first create a duplicate of the Background layer and adjust the Layer Style options so that the filter effects you are about to apply are limited to the midtone areas only and the extreme shadows and highlights are protected.

You will notice that the first step involves changing the blend mode of the duplicate background layer to Overlay. This will initially make the image appear more contrasty, but you will find that once you have applied the Unsharp Mask followed by the High Pass filter, it is only the image edges that are enhanced by the use of this technique. In Step 3 you will notice I applied the Unsharp Mask filter at a maximum strength of 500%, with a Radius of 1.0 pixel and the Threshold set to zero. The purpose of this step is to aggressively build narrow halos around all the edge detail areas, and in particular the soft edges, while the High Pass filter step is designed to add wider, overlapping, soft edged halos that increase the midtone contrast. When these two filters are combined you end up with a layer that improves the apparent sharpness in the areas that were out of focus, but the downside is that the previously sharp areas will now be degraded. By adding a layer mask filled with black, you can use the brush tool to paint with white to selectively apply the adjustment to those areas where the sharpening effect is needed most.

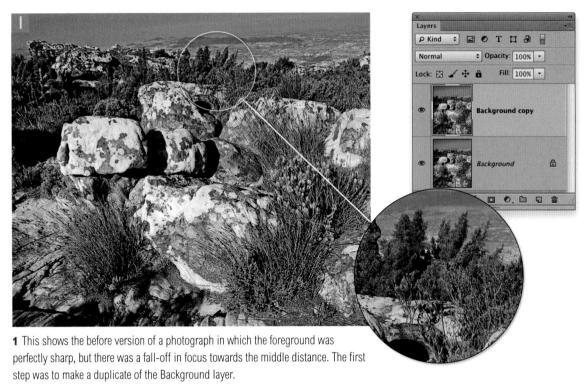

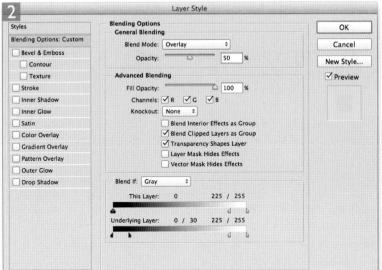

2 I then double-clicked the Background layer to open the Layer Style options and adjusted the settings as follows. The blend mode was set to Overlay and the layer Opacity reduced to 50%. The layer 'Blend If' sliders were adjusted as shown here to provide more protection for the extreme shadows and highlights.

Split slider adjustments

Blend If slider adjustments are covered later, but to achieve the split slider adjustment shown here, you need to hold down the att key and click on one half of the slider arrow and drag to split it into two.

Adjusting the Depth of field settings

The Unsharp Mask and High Pass filter settings used here were designed to add sharpness to areas that contained a lot of narrow edge detail (such as the edges in a landscape). You will want to vary these settings when treating other types of photographs where you perhaps have wider edges that need sharpening. For example, Bruce's original formula suggests using an Unsharp Mask filter Radius of 4 pixels combined with a 40 pixel Radius in the High Pass filter.

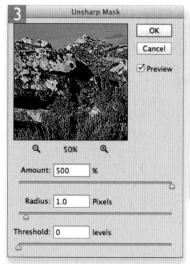

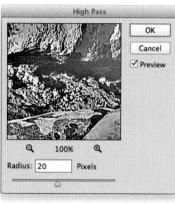

3 I clicked OK to the Layer Style changes and applied an Unsharp Mask filter to the Background copy layer, using an amount of 500% and a Radius of 1.0 pixel. This was followed by a High Pass filter (Filter ⇒ Other ⇒ High Pass) using a Radius of 20 pixels.

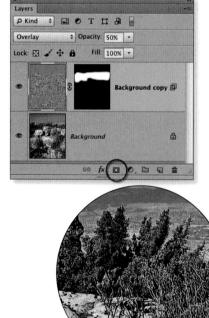

4 Finally, I <u>alt</u> clicked the Add Layer Mask button in the Layers panel (circled). This added a layer mask filled with black, which hid the layer contents. I was then able to select a normal brush and paint on the layer mask with white to reveal the depth of field sharpening layer and in doing so, add more apparent sharpness to the middle distance.

Chapter 4

Image Editing Essentials

So far I have shown just how much can be done to improve an image's appearance when editing it in Camera Raw, before you bring it into Photoshop. Some of the techniques described in this chapter may appear to overlap with Camera Raw editing, but image adjustments such as Levels and Curves still play an important role in everyday Photoshop work. This chapter also explains how to work with photos that have never been near Camera Raw, such as images that have originated as TIFFs or JPEGs. I'll start off by outlining a few of the fundamental principles of pixel image editing such as bit depth and the relationship between image resolution and image size. After that we'll look at the main image editing adjustments and how they can be used to fine-tune the tones and colors in a photograph.

Pixels versus vectors

Digital photographic images are constructed of pixels and as such are resolution-dependent. You can therefore only scale the finite pixel image information so far, before the underlying pixel structure becomes apparent. By contrast, vector objects, created in programs like Adobe Illustrator, are defined mathematically. So, if you draw a rectangle, the proportions of the rectangle edges, the relative placement on the page and fill color can all be described using a mathematical description. An object that's defined using vectors can therefore be output at any resolution and it does not matter if the image is shown on a computer display, a postage stamp or as a huge poster, it will always be rendered with the same amount of detail (see Figure 4.1).

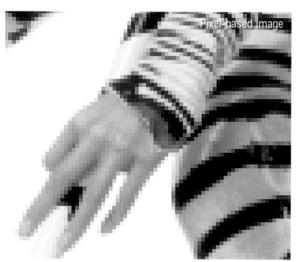

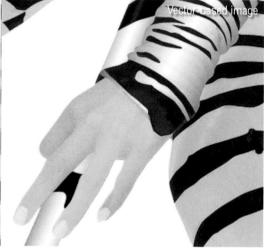

'Stalkers' by The Wrong Size. Photograph: © Eric Richmond.

Figure 4.1 Digital images are made up of a mosaic of pixels. This means that a pixel-based digital image will always have a fixed resolution and is said to be 'resolution-dependent'. If you enlarge such an image beyond the size at which it is meant to be printed, the pixel structure will soon become apparent, as can be seen here in the left-hand close-up view. Suppose though the above picture originated not as a photograph, but was drawn as an illustration using a program like Adobe Illustrator. If a picture is constructed using vector paths, it will be resolution-independent. The mathematical numbers used to describe the path outlines shown in the example on the right can then be scaled to reproduce at any size: from a postage stamp to a billboard poster. As you can see in the comparison shown here, the pixel image starts to break up as soon as it is magnified, whereas the outlines in the vector-drawn image will reproduce perfectly smoothly at any size.

Photoshop as a vector program

Photoshop is mainly regarded as a pixel-based graphics program, but is in fact both a pixel and vector editing program. This is because Photoshop contains a number of vector-based features that can be used to generate things such as custom shapes and layer clipping paths. This raises some interesting possibilities, because you can create various graphical elements like type, shape layers and layer clipping paths in Photoshop, which are all resolution-independent. These vector elements can be scaled up in size in Photoshop without any loss of detail, just as they can with an Illustrator graphic.

Image resolution terminology

Before I proceed any further let me help explain a few of the terms that are used when describing image resolution and clarify their correct usage.

ppi: pixels per inch

The term 'pixels per inch' (ppi) should be used to describe the pixel resolution of an image. However, the term 'dpi' is also often used (inappropriately) to describe the digital resolution of an image, which is wrong because input devices like scanners and cameras produce pixels and it's only printers that produce dots. Even so, it's become commonplace for scanner manufacturers and other software programs to use the term 'dpi' when what they really mean is 'ppi'. Unfortunately this has only added to the confusion, because you often hear people describing the resolution of an image as having so many 'dpi', but if you look carefully, Photoshop and the accompanying user guide always refer to the input resolution as being in 'pixels per inch'. So if you have an image that has been captured on a digital camera, scanned from a photograph, or displayed in Photoshop, it is always made up of pixels and the pixel resolution (ppi) is the number of pixels per inch in the input digital image. Obviously, those using metric measurements can refer to the number of 'pixels per centimeter'.

lpi: lines per inch

This is the number of halftone lines or 'cells' in an inch (also described as the screen ruling). The origins of this term go back way before the days of digital desktop publishing. To produce a halftone plate, the film exposure was made through a finely etched criss-cross screen of evenly spaced lines on a glass plate. When a continuous tone photographic image was

Confusing terminology

You can see from this description where the term 'lines per inch' originated. In today's digital world of imagesetters. the definition is somewhat archaic, but is nonetheless commonly used. You may hear people refer to the halftone output as 'dpi' instead of 'lpi', as in the number of 'halftone' dots per inch, and the imagesetter resolution referred to as having so many 'spi', or 'spots per inch'. Whatever the terminology I think we can all logically agree on the correct use of the term 'pixels per inch', but I am afraid there is no clear definitive answer to the mixed use of the terms 'dpi', 'lpi' and 'spi'. It is an example of how the two separate disciplines of traditional repro and those who developed the digital technology chose to apply different meanings to these same terms.

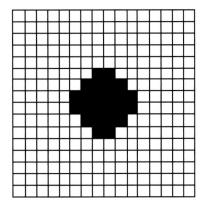

Figure 4.2 Each halftone dot is rendered by a PostScript RIP from the pixel data and output to a device called an 'imagesetter'. The halftone dot illustrated here is plotted using a 16×16 dot matrix. This matrix can therefore reproduce a total of 256 shades of gray. The dpi resolution of the imagesetter, divided by 16, will equal the line screen resolution. 2400 dpi divided by 16 = 150 lpi screen resolution.

exposed this way, dark areas formed heavy halftone dots and the light areas formed smaller dots, which when viewed from a normal distance gave the impression of a continuous tone image on the page. The line screen resolution (lpi) is therefore the frequency of halftone dots or cells per inch.

dpi: dots per inch

This refers to the resolution of an output device. For example, let's say we have an imagesetter device that is capable of printing small, solid black dots at a resolution of 2450 dots per inch and the printer wishes to use a screen ruling of 150 lines per inch. If you divide the dpi of 2400 by the lpi of 150, you get a figure of 16. Therefore, within a matrix of 16×16 printer dots, an imagesetter can generate individual halftone dots that vary in size on a scale from zero (no dot) to 255. It is this variation in halftone cell size (constructed of smaller dots) which gives the impression of tonal shading when viewed from a distance (see Figure 4.2).

Desktop printer resolution

In the case of desktop inkjet printers the term 'dpi' is used to describe the resolution of the printer head. The dpi output of a typical inkjet can range from 360 to 2880 dpi. Most inkjet printers lay down a scattered pattern of tiny dots of ink that accumulate to give the impression of different shades of tone. depending on either the number of dots, the varied size of the dots, or both. While a correlation can be made between the pixel size of an image and the 'dpi' setting for the printer, it is important to realize that the number of pixels per inch is not the same as the number of dots per inch created by the printer. When you send a Photoshop image to an inkjet printer, the pixel image data is processed by the print driver and converted into data that the printer uses to map the individual ink dots that make the printed image. The 'dpi' used by the printer simply refers to the fineness of the dots. Therefore a print resolution of 360 dpi can be used for speedy, low quality printing, while a dpi resolution of 2880 can be used to produce high quality print outputs.

Altering the image size

The image size dimensions and resolution can be adjusted using the Image Size dialog (Figure 4.3). In Photoshop CC this has been updated to provide a new revised user interface, where it should be easier to understand what you are doing when modifying the Width, Height and Resolution settings. Performance has also been improved in the 2014 release. The image preview window shows you what the resized image will look like and can be made larger by resizing the dialog box. You can also click inside the preview and drag to pan the preview image; the Image Size dialog settings are now also sticky.

The Resample menu contains a new Preserve Details option, which can offer improved image quality when enlarging an image. This, along with the other resample methods has been allocated a keyboard shortcut (see sidebar) to make it easy to toggle and compare different interpolation methods.

Resample method shortcuts

While the Image Size dialog is active you can use the following keyboard shortcuts to quickly access a desired resample method.

1: Automatic

2: Preserve Details

3: Bicubic Smoother

3: Bicubic Sharper

5: Bicubic

(6): Nearest Neighbor

7: Bilinear

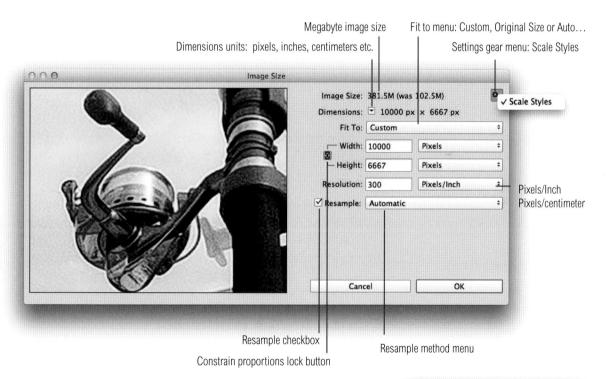

Figure 4.3 The new Image Size dialog. You now need to go to the 'Fit To' menu and select Auto... to open the Auto Resolution dialog shown here. This can help you pick the ideal pixel resolution for repro work based on the line screen resolution.

Resolution and viewing distance

In theory the larger a picture is printed, the further away it is meant to be viewed. Because of this you can easily get away with a lower pixel resolution such as 180 or 200 pixels per inch when making a poster print output. There are limits, though, below which the quality will never be sharp enough at normal viewing distance (except at the smallest of print sizes). As my late colleague Bruce Fraser used to say, 'in the case of photographers, the ideal viewing distance is limited only by the length of the photographer's nose'.

When the Resample box is checked (as shown in Figure 4.3) you can resize an image by adjusting the values for the Width/Height fields, or by adjusting the Resolution. If you uncheck the Resample checkbox the Resolution field becomes linked to the Width and Height fields and you can resize an image to make it print bigger or smaller by altering the Width/ Height dimensions, or the file resolution (but not the actual image document size). Therefore, any adjustment made to the Width. Height or resolution settings will not alter the total pixel dimensions and only affect the relationship between the measurement units and the resolution. Remember: the number of pixels = physical dimension \times (ppi) resolution. You can put that to test here and use the Image Size dialog as a training tool to better understand the relationship between the number of pixels, the physical image dimensions and resolution. The constrain proportions lock button links the horizontal and vertical dimensions, so that any adjustment is automatically scaled to both axes. Only uncheck this if you wish to squash or stretch the image when altering the image size.

Image interpolation

Image resampling is also referred to as interpolation and Photoshop can use one of seven methods when calculating how to resize an image. These interpolation options are all located in the Resample menu (see Figure 4.3) as well as appearing in the Options bar when transforming a layer (except for the new Edge-Preserving Upscale option).

I generally consider it better to 'interpolate up' an image in Photoshop rather than rely on the interpolation methods offered by other programs. Digital camera files are extremely clean and because there is no grain present, it is usually easier to magnify a digitally captured image than a scanned image of equivalent size. Here is a guide to how each of the interpolation methods works and which are the best ones to use and when.

Nearest Neighbor (hard edges)

This is the simplest interpolation method of all, in which the pixels are interpolated exactly using the nearest neighbor information. I actually use this method a lot to enlarge dialog box screen grabs by 200% for use in the book. This is because I don't want the interpolation to cause the sharp edges of the dialog boxes to appear fuzzy.

Bilinear

This calculates new pixels by reading the horizontal and vertical neighboring pixels. It is a fast method of interpolation, which was perhaps an important consideration in the early days of Photoshop, but there is not much reason to use it now.

Bicubic (smooth gradients)

This provides better image quality when resampling continuous tone images. Photoshop reads the values of neighboring pixels vertically, horizontally and diagonally, to calculate a weighted approximation of each new pixel value. Photoshop intelligently guesses new pixel values, by referencing the surrounding pixels.

Bicubic Smoother (enlargement)

This is the ideal choice when making pictures bigger, as it will result in smoother, interpolated enlargements. It has been suggested that you can also get good results using Bicubic Sharper when interpolating up before going directly to print. However, this ignores the fact that print sharpening should really be applied as a separate step *after* interpolating the image and the sharpening should ideally be tailored to the final output size (see Chapter 10). It is therefore always better to use Bicubic Smoother followed by a separate print sharpening step. This is because the smooth interpolation prevents any artifacts in the image from being over-emphasized and the sharpening can be applied at the correct amount for whatever size of print you are making.

Bicubic Sharper (reduction)

This method should be used whenever you need to reduce the image size more accurately. If you use Bicubic Sharper to dramatically reduce a master image in size, this can help avoid the stair-step aliasing that could sometimes occur when using other interpolation methods.

Bicubic Automatic

In the Photoshop preferences you'll notice how Bicubic Automatic is the default option. This automatically chooses the most suitable interpolation method to use when resizing an image. If you make a small size increase/decrease, it applies the Bicubic interpolation method. If upsampling to a greater degree, it uses Bicubic Smoother and if downsampling to a greater degree, it selects the Bicubic Sharper option. The same logic is also applied if you select the Bicubic Automatic option when transforming a layer.

Planning ahead

Once an image has been scanned at a particular resolution and manipulated. there is no going back. A digital file prepared for advertising usage may never be used to produce anything bigger than a 35 MB CMYK separation, but you never know. It is therefore safer to err on the side of caution and better to sample down than have to interpolate up. It also depends on how much manipulation you intend doing. Some styles of retouching work are best done at a magnified size and then reduced afterwards. Suppose you wanted to blend a small element into a detailed scene. To do such work convincingly, you need to have enough pixels to work with to be able to see what you are doing. Another advantage of working with large file sizes is that you can always guarantee being able to meet clients' constantly changing demands, even though the actual resolution required to illustrate a glossy magazine double-page full-bleed spread is probably only around 40-60 MB RGB or 55-80 MB CMYK. Some advertising posters may even require smaller files than this, because the print screen on a billboard poster is that much coarser. When you are trying to calculate the optimum resolution you cannot rely on being provided with the right advice from every printer.

Step interpolation

Some people might be familiar with the step interpolation technique, where you can gradually increase or decrease the image size by small percentages. This is not really necessary now because you can use Bicubic Sharper or Bicubic Smoother to increase or decrease an image size in a single step. Some people argue that for really extreme image size changes they still prefer to use the 10% step interpolation method, but I think the new Preserve Details algorithm and slider controls now beats that as the best way to interpolate an image upwards.

Preserve Details (enlargement)

These days most digital cameras are capable of shooting large enough files suited for most output requirements. However, if an image ends up being heavily cropped, or you are perhaps working with older images shot with a camera that had a low pixel count, you may find yourself needing to enlarge an image in order to meet some output requirements. The Preserve Details option works by upscaling the image in multiple steps of x1.5 magnification. At each step the image is divided into 7x7 pixel segments and the output step segments compared with the source. The new algorithm makes use of the high frequency information in the source to make the patches in the output appear as sharp as the source and so on at each stage. The calculation is also carried out in a color space similar to Lab in order to reduce color contamination and gain speed.

When this option is selected a Noise slider becomes visible. Since the Preserve Details upscaling process has a tendency to generate noise artifacts you can use this slider along with the Image Size preview to judge how much noise reduction should be dialled in to produce a smooth-looking result. As with all noise reduction, there will be a trade-off between edge sharpness and noise removal, so if you set the Noise slider too high you may end up with an over-soft result.

1 This shows a close-up section of a photograph that was shot using an 11 megapixel camera, where I used the Image Size dialog to enlarge by 300%. Here, the Bicubic Automatic option was selected, which in this instance would have auto-selected the Bicubic Smoother option to interpolate the image data.

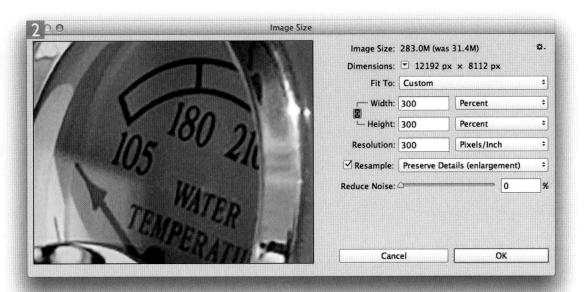

2 In Photoshop CC you can select the Preserve Details option when enlarging an image. If you compare the preview in this dialog with that shown is Step 1 you can see that the detail in the lettering is now crisper.

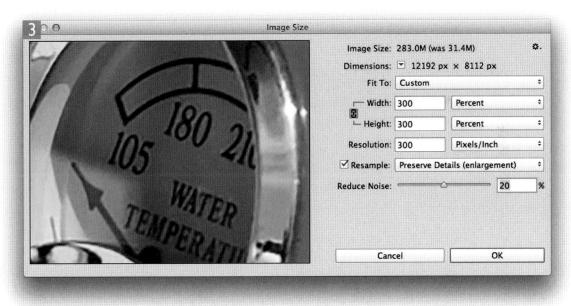

3 Although the Preserve Details option helped keep the details looking sharp, it did so at the expense of adding more noise to the image. To help combat this a Reduce Noise slider will appear when this option is selected. By increasing the Reduce Noise setting it is possible to reduce the noise that may result from detail enhancement.

Raw to pixel image conversions

Once a raw image has been rendered as a pixel image you cannot revert to the raw data version because the raw to pixel image conversion is a one-way process. Once you have done this, the only way you can undo something in the raw processing is to revert to the original raw image and generate a new pixel image copy. Although the goal of this book is to show you how to work as non-destructively as possible, this is the one step in the process where there is no going back. You therefore need to be sure that the photograph you start editing in Photoshop is as fully optimized as possible.

WYSIWYG image editing

If you want true WYSIWYG editing (what you see is what you get), it is important to calibrate the display and configure the color settings. Do this and you will now be ready to start editing your photographs with confidence. For more information about calibration see the Configuring Photoshop PDF on the book website.

Photoshop image adjustments

In Chapter 2 we explored the use of Basic panel adjustments in Camera Raw to optimize a photo before it is opened in Photoshop as a rendered pixel image. The following section is all about the main image adjustment controls in Photoshop and how you can use these to fine-tune your images, or use them as an alternative to working in Camera Raw, such as when editing camera shot JPEGs or scanned TIFFs directly in Photoshop.

If you intend bringing your images in via Camera Raw, it can be argued that Photoshop image adjustments are unnecessary, since Camera Raw provides you with everything you need to produce perfectly optimized photos. Even so, you will still find the information in this chapter important, as these are the techniques every Photoshop user needs to be aware of and use when applying things like localized corrections. The techniques discussed here should be regarded as essential foundation skills for Photoshop image editing. However you bring your images into Photoshop, you will at some point need to know how to work with the basic image editing tools such as Levels and Curves. So, for now, let's look at some basic pixel image editing principles and techniques.

The image histogram

The histogram graphically represents the relative distribution of the various tones (referred to as Levels) that make up a digital photograph. For example, an 8-bit per channel grayscale image has a single channel and uses 256 shades of gray to describe all the levels of tone from black to white. Black has a levels value of 0 (zero), while white has a levels value of 255 and all the numbers in between represent the different shades of gray going from black to white. The histogram is therefore like a bar graph with 256 increments, each representing how frequently a particular levels number (a specific gray value) occurs in the image. Figure 4.4 shows a typical histogram such as you'll see in the Histogram, Levels and Curves panels. This diagram also shows how the appearance of the graph relates to the tonal structure of a photographic image.

Now let's look at what that information can actually tell us. The histogram graphically shows the distribution of tones in a digital image. A low-key photograph (such as the one shown in Figure 4.4) will have most of the peaks on the left. Most importantly, it shows the positioning of the shadow and highlight points. When you apply a tonal correction using Levels

Slaxid Jo Jaquini 0 32 64 96 128 160 192 224 255 Black White

Figure 4.4 Here is an image histogram that represents the distribution of tones from the shadows to the highlights. Because this photograph mostly contains dark tones you will notice that the levels are predominantly located to the left end of the histogram. The height of each bar in the histogram indicates how frequently each levels value is represented in the image based on a 0–255 scale.

or Curves, the histogram provides visual clues that help you judge where the brightest highlights and deepest shadows should be. The histogram also tells you something about the condition of the image you are editing. If there are peaks jammed up at one or other end of the histogram, this suggests that either the highlights or the shadows have become clipped and when the original photograph was captured or scanned it was effectively under or overexposed. Unfortunately, once the levels are clipped you can't restore the detail that's been lost here. Also, if there are gaps in the histogram at this stage, it most likely indicates a poor quality original capture or scan, or that the image had previously been heavily manipulated.

Interpreting an image

A digital image is nothing more than a bunch of numbers and it is how those numbers are interpreted in Photoshop that creates the image you see on the display. We can use our eyes to make subjective judgments about how the picture looks, but we can also use the number information to provide useful and usable feedback. Plus we have the Histogram panel, which is also an excellent teaching tool and makes everything that follows much easier to understand.

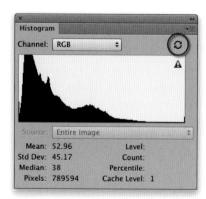

Figure 4.5 The warning triangle in the Histogram panel indicates that you need to click on the Refresh button (circled) to update it.

The Histogram panel

You'll see a histogram whenever you work in Levels and Curves and there is also a separate Histogram panel (Figure 4.5), to provide feedback when working in Photoshop. With the Histogram panel, you can continuously observe the effect your image editing has on the image levels and you can check the histogram while making any type of image adjustment. The Histogram panel only provides an approximate representation of the image levels. To see a more accurate representation of the image levels, it is advisable to force Photoshop to update the histogram view, by clicking on the Refresh button in the top right corner (see Figure 4.5).

Throughout this book I like to guide readers to work as non-destructively as possible. Even so, anything you do to adjust the levels to make the image look better results in some data loss. This is normal and an inevitable consequence of the image editing process. The steps on the page opposite illustrate what happens when you edit a photograph. You will notice that as you adjust the input levels and adjust the gamma (middle) input slider, you end up stretching some of the levels further apart and gaps may start to appear in the histogram. More importantly, stretching the levels further apart can result in less well-defined tonal separation and therefore less detail in these regions. This can particularly be a problem with shadow detail because there are always fewer levels of usable tone information in the shadows compared with the highlights (see Digital exposure on page 164). While moving the gamma slider causes the tones on one side to stretch, it causes the tones on the other side to compress more and these can appear as spikes in the histogram. This too can cause data loss. sometimes resulting in flatter tone separation.

The histogram can therefore be used to provide visual feedback on the levels information in an image and indicate whether there is clipping at either end of the scale. However, does it really matter whether we obtain a perfectly smooth histogram or not? If you are preparing a photograph to go to a print press, you would be lucky to detect more than 50 levels of tonal separation from any single ink plate. Therefore, the loss of a few levels at the completed edit stage does not necessarily imply that you have too little digital tonal information from which to reproduce a full-tonal range image in print. Having said that if you begin with a bad-looking histogram, the image is only going to be in a worse state after it has been retouched. For this reason it is best to start out with the best quality scan or capture you can get.

Basic Levels editing and the histogram

This image editing example was carried out on an 8-bit RGB image, so it should come as no surprise that the histogram broke down as soon as I applied a simple Levels adjustment (in the following section we are going to look at the advantages of editing in 16-bits per channel mode).

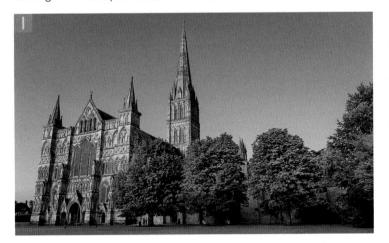

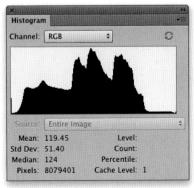

1 Here is an image that displayed an evenly distributed range of tones in the accompanying Histogram panel view.

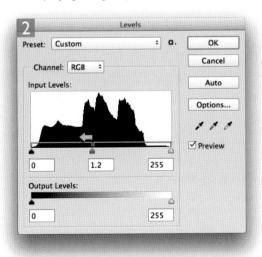

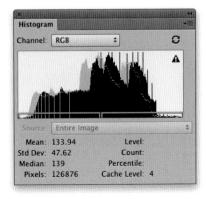

2 When I applied a Levels image adjustment and dragged the middle (gamma) input slider to the left, this lightened the image and the Histogram panel on the right shows the histogram display after the adjustment had been applied. To understand what has happened here, this histogram represents the newly mapped levels. The levels in the section to the left of the gamma slider have been stretched and the levels to the right of the gamma slider have been compressed.

Bit depth status

You can check the bit depth of an image quite easily by looking at the document window title bar, where it will indicate the bit depth as being 8, 16 or 32-bit.

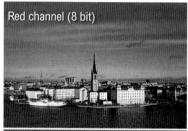

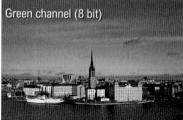

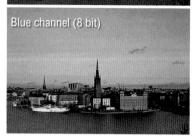

Bit depth

The bit depth refers to the maximum number of levels per channel that can be contained in a photograph. For example, a 24-bit RGB color image is made up of three 8-bit image channels, where each 8-bit channel can contain up to 256 levels of tone (see Figure 4.6), while a 16-bit per channel image can contain up to 32,768 data points per color channel, because in truth, Photoshop's 16-bit depth is actually 15-bit +1 (see the sidebar on page 345).

JPEG images are always limited to 8-bits, but TIFF and PSD files can be in 8-bits or 16-bits per channel. Note though that Photoshop only offers 8-bits or 16-bits per channel modes for standard integer channel images, while 32-bit support in Photoshop uses floating point math to calculate the levels values. Therefore, any source image with more than 8-bits per channel has to be processed as a 16-bits per channel mode

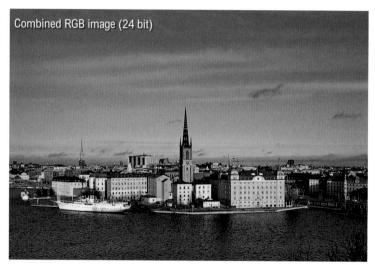

Figure 4.6 The bit depth of an image is a mathematical description of the maximum levels of tone that are possible, expressed as a power of 2. A bitmap image contains 2 to the power of 1 (2 levels of tone), in other words, black or white tones only. A normal Photoshop 8-bit grayscale image or an individual color channel in a composite color image contains 2 to the power of 8 (2^8) and up to 256 levels of tonal information. When three RGB 8-bit color channels are combined together to form a composite color image, the result is a 24-bit color image that can contain up to 16.7 million shades of color ($2^8 \times 3$).

image. Since most scanners are capable of capturing at least 12-bits per channel data, this means that scanned images should ideally be saved as 16-bits per channel images in order to preserve all of the 12-bits per channel data.

In the case of raw files, a raw image contains all the original levels of capture image data, which will usually have been captured at a bit depth of 12-bits, or 14-bits per channel. Camera Raw image adjustments are mostly calculated using 16-bits per channel, so once again, all the levels information that is in the original can only be preserved when you save a Camera Raw processed raw image using 16-bits per channel mode.

8-bit versus 16-bit image editing

A higher bit depth doesn't add more pixels to an image. Instead, it offers a greater level of precision to the way tone information is recorded by the camera or scanner sensor. One way to think about bit depth is to consider the difference between having the ability to make measurements with a ruler that is accurate to the nearest millimeter, compared with one that can only measure to the nearest centimeter.

There are those who have suggested that 16-bit editing is a futile exercise because no one can tell the difference between an image that has been edited in 16-bit and one that has been edited in 8-bit. Personally I believe this to be a foolish argument. If a scanner or camera is capable of capturing more than 8-bits per channel, then why not make full use of the extra tonal information? In the case of film scans, you might as well save the freshly scanned images using the 16-bits per channel mode and apply the initial Photoshop edits using Levels or Curves in 16-bits mode. If you preserve all the levels in the original through these early stages of the edit process, you'll have more headroom to work with and avoid dropping useful image data. It may only take a second or two longer to edit an image in 16-bits per channel compared with when it is in 8-bit, but even if you only carry out the initial edits in 16-bit and then convert to 8-bit, you'll retain significantly more image detail.

My second point is that you never know what the future holds in store for us. On pages 366–369 we shall be looking at Shadows/Highlights adjustments. This feature can be used to emphasize image detail that might otherwise have remained hidden in the shadows or highlight areas. It exploits the fact that a deep-bit image can contain lots of hidden levels of data

Why is 16-bits really 15-bits?

If you have a keen knowledge of math, you will notice that Photoshop's 16-bits per channel mode is actually 15-bit as it uses only 32,768 levels out of a possible 65,536 levels when describing a 16-bit mode image. This is because having a tonal range that goes from 0 to 32,767 is more than adequate to describe the data coming off any digital device. Also, from an engineering point of view, 15-bit math calculations give you an exact midpoint value, which can be important for precise layer blending operations.

Camera Raw output and bit depth

If you use Camera Raw to process a raw camera file or a 16-bit TIFF, the Camera Raw edits will all be carried out in 16-bits. If you are satisfied with the results obtained in Camera Raw and you have managed to produce a perfectly optimized image, it can be argued there is less harm in converting such a file to an 8-bits per channel mode image in Photoshop. However, as I mentioned in the main text, you never know when you might be required to adjust an image further. Keeping a photo in 16-bits gives you the peace of mind, knowing that you've preserved as many levels as possible that were in the original capture or scan.

that can be further manipulated to reveal more detail in the shadows or highlights. A Shadows/Highlights adjustment can still work just fine with 8-bit images, but you'll get better results if you open your raw processed images as 16-bit photos or scan in 16-bit per channel mode first.

Photoshop also offers extensive support for 16-bit editing. When a 16-bit grayscale, RGB, CMYK or Lab color mode image is opened in Photoshop you can crop, rotate, apply all the usual image adjustments, use any of the Photoshop tools and work with layered files. The main restriction is that not all filters can work in 16-bits per channel mode. You may not feel the need to use 16-bits per channel all the time, but I would say for critical jobs where you don't want to lose an ounce of detail, it is essential to make at least all your preliminary edits in 16-bits per channel mode. It should go without saying of course, but there is no point editing an image in 16-bit unless it started out as a deep-bit image to begin with. There is nothing to be gained by converting an image that is already in 8-bit to 16-bit.

In the steps shown opposite, I started with an image that was in 16-bits mode and created a duplicate version that was converted to 8-bits. I then proceeded to compress the levels and expand them again in order to demonstrate how keeping an image in 16-bits per channel mode provides a more robust image mode for making major tone and color edits. Admittedly, this is an extreme example, but preserving an image in 16-bits offers a significant extra margin of safety when making everyday image adjustments.

16-bit and color space selection

Ever since the advent of Photoshop CS, it has been possible to edit extensively in 16-bits per channel mode. One of the advantages this brings is that you are not limited to editing in relatively small gamut RGB workspaces. If you edit using 16-bit, it is perfectly safe to use a large gamut space such as ProPhoto RGB when you are editing in 16-bits per channel mode because you'll have that many more data points in each color channel to work with (see the following section on RGB edit spaces).

Comparing 8-bit with 16-bit editing

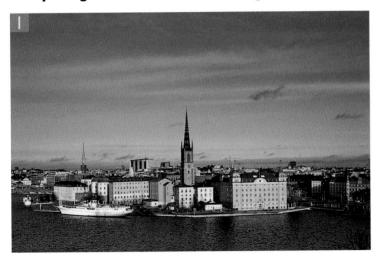

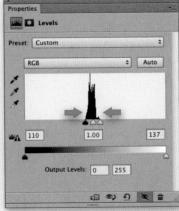

- **1** Here, I started out with a full color image that was in 16-bits per channel mode and created a duplicate that was converted to 8-bits per channel mode.
- **2** With each version I applied two sequential Levels adjustment layers. The first (shown here on the left) compressed the output levels to an output range of 110–136. I then applied a second Levels adjustment layer in which I expanded these levels to 0–255 again.
- **3** The outcome of these two sequential Levels adjustments can clearly be seen when examining the individual color channels. On the left you can see the image histogram for the 8-bit file green channel after these two adjustments had been applied and on the right you can see the histogram of the 16-bit file green channel after making the same adjustments. As you can see, with the 8-bit version there is noticeable banding in the sky and lots of gaps in the histogram. Meanwhile, the 16-bit version exhibits no banding and retains a smooth histogram appearance.

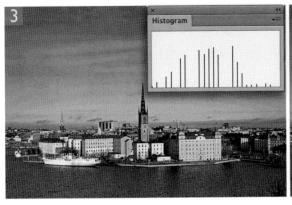

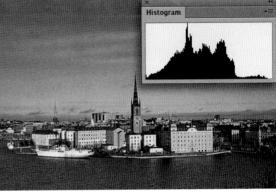

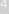

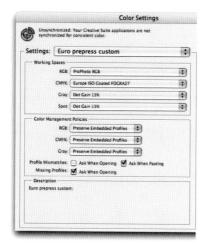

Figure 4.7 The Color Settings dialog.

The RGB edit space and color gamut

One of the first things you need to do when you configure Photoshop is to choose an appropriate RGB edit space from the RGB Working Spaces menu in the Edit ⇒ Color Settings dialog (Figure 4.7).

For photo editing work, the choice really boils down to Adobe RGB or ProPhoto RGB. The best way to illustrate the differences between these two RGB color spaces is to consider how colors captured by a camera or scanner are best preserved when they are converted to print. Figure 4.8 shows (on the left) top and side views of a 3D plot for the color gamut of a digital camera, seen relative to a wire frame of the Adobe RGB working space. Next to this you can see top and side views of a glossy inkjet print space relative to Adobe RGB. You will notice here how the Adobe RGB edit space clips

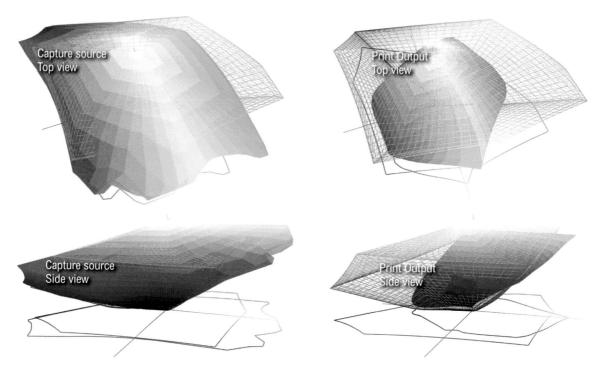

Figure 4.8 This diagram shows on the left, a top and side view of the gamut of a digital camera source space plotted as a solid shape within a wire frame shape representing the color gamut of the Adobe RGB edit space. On the right is a top and side view of the gamut of a glossy inkjet printer color space plotted as a solid shape within a wire frame of the same Adobe RGB space.

both the input and output color spaces. This can be considered disadvantageous because all these potential colors are clipped as soon as you convert the capture data to Adobe RGB. Meanwhile, Figure 4.9 offers a direct comparison showing you what happens when you select the ProPhoto RGB space. The ProPhoto RGB color gamut is so large it barely clips the input color space at all and is certainly big enough to preserve all the other colors through to the print output stage. In my view, ProPhoto RGB is the best space to use if you really want to preserve all the color detail that was captured in the original photo and see those colors preserved through to print.

The other choice offered in the Color Settings is the sRGB color space, but this is only really suited for Web output work (or when sending pictures to clients via email).

Is ProPhoto RGB too big a space?

There have been concerns that the ProPhoto RGB space is so huge that the large gaps between one level's data point and the next could lead to posterization. This might be a valid argument where images are mainly edited in 8-bits per channel throughout. In practice, you can edit a ProPhoto RGB image in 16-bits or 8-bits per channel mode, but 16-bits is safer. Also, these days you can use Camera Raw to optimize an image prior to outputting as a ProPhoto RGB pixel image.

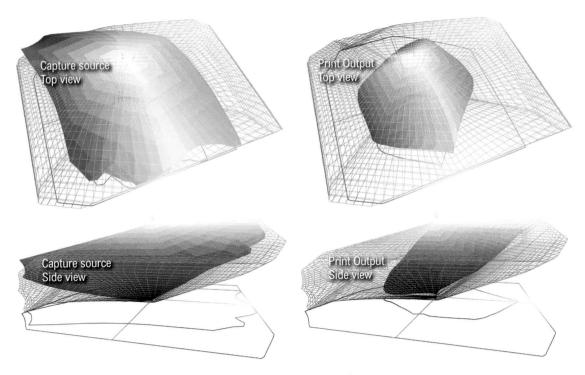

Figure 4.9 This diagram shows on the left, a top and side view of the gamut of a digital camera source space plotted as a solid shape within a wire frame shape representing the color gamut of the ProPhoto RGB edit space. On the right is a top and side view of the gamut of a glossy inkjet printer color space plotted as a solid shape within a wire frame of the same ProPhoto RGB space.

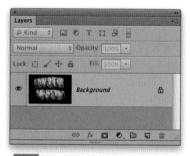

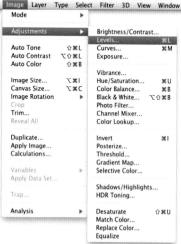

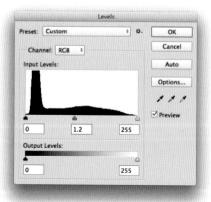

Figure 4.10 This shows the basic workflow for applying a normal image adjustment. Go to the Image ⇒ Adjustments menu and choose an adjustment type. In this example I selected Levels..., adjusted the settings and clicked OK to permanently apply this adjustment to the image.

Direct image adjustments

Most Photoshop image adjustments can be applied in one of two ways. There is the traditional, direct adjustment method where image adjustments can be accessed via the Image \Rightarrow Adjustments menu and applied to the whole image (or an image layer) directly. Figure 4.10 shows an example of how one might apply a basic Levels adjustment. Here, I had an image open with a Background layer, I went to the Image Adjustments menu and selected 'Levels…' (***) [Mac], and [PC]). This opened the Levels dialog where I was able to apply a permanent tone adjustment to the photograph.

Direct image adjustments are appropriate for those times where you don't need the editability that adjustment layers can offer. They are also the only way to edit an alpha channel or layer mask, since you can't use adjustment layers when editing Photoshop channels.

Adjustment layers approach

With adjustment layers, an image adjustment can be applied in the form of an editable layer adjustment. These can be added to an image in several ways. You can go to the Layer \Rightarrow New Adjustment layer submenu, or click on the Add new adjustment layer button in the Layers panel to select an adjustment type. Or, you can also use the Adjustments panel to select and add an adjustment layer.

The Properties panel, in the adjustment controls mode, displays the adjustment controls. In the Figure 4.11 example you'll see I again started out with an image with a Background layer. I went to the Adjustments panel and clicked on the Levels adjustment button (circled in red). This added a new Levels adjustment layer above the Background layer and the Properties panel showed the Levels adjustment controls for this new adjustment layer.

There are several advantages to the Adjustment layer approach, especially with the way the options are now presented in Photoshop. First of all, adjustment layers are not permanent. If you decide to undo an adjustment or readjust the settings, you can do so at any time. Adjustment layers offer the ability to apply multiple image adjustments and/or fills to an image and for the adjustments to remain 'dynamic'. In other words, an adjustment layer is an image adjustment that can be revised at any time and allows the image adjustment processing to be deferred until the time when an image is

flattened. The adjustments you apply can also be masked when you edit the associated layer mask and this mask can also be refined using the Masks mode in the Properties panel. Best of all, adjustment layers are no longer restricted to a modal state where you have to double-click the layer first in order to access the adjustment controls. With the Properties panel you have the ability to quickly access the adjustment layer settings any time you need to. This also means you can easily switch between tasks. So, if you click on an adjustment layer to select it, you can paint on the layer mask, adjust the layer opacity and blending options and have full access to the adjustment layer controls via the Properties panel.

The beauty of adjustment layers is that they add very little to the overall file size and are much more efficient than applying an adjustment to a duplicate layer. Images that contain adjustment layers are savable in the native Photoshop (PSD), TIFF and PDF formats.

Adjustments panel controls

Figure 4.12 shows the default Adjustments panel view, where you can click on any of the buttons to add a new image adjustment. The button icons may take a little getting used to at first, but you can refer to the summary list on the page opposite to help identify them and read a brief summary of what each one does. If you have the 'Show Tool Tips' option selected in the Photoshop Interface preferences, the tool tips feature displays the names of the adjustments as you roll the cursor over the button icons.

Properties panel controls

Once you are in the Properties panel there are two modes of operation. There is the Mask controls mode, which I describe later on page 386, and also an 'adjustment controls' mode. The Properties panel will by default display the 'adjustment controls' mode when an adjustment layer is first created (Figure 4.13).

As you click on any other adjustment layers in the Layers panel to select them, the Properties panel will update to show the controls and settings for that particular layer. Note that double-clicking an adjustment layer opens up the Properties panel if it is currently hidden.

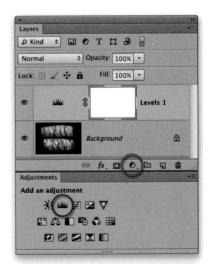

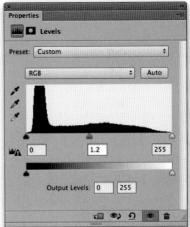

Figure 4.11 This shows the adjustment layer workflow. Go to the Adjustments panel and choose an adjustment type (in this example Levels, which is circled in red) and make the adjustment. This will then be added as a new adjustment layer. The adjustment controls are now displayed in the Properties panel. You can also mouse down on the Add Adjustment layer button in the Layers panel (circled in blue) to add a new adjustment layer.

Adjustment panel options

Brightness/Contrast

A basic brightness and contrast tone adjustment.

Levels

To set clipping points and adjust gamma.

Curves

Used for more accurate tone adjustments.

Exposure

Primarily for adjusting the brightness of 32-bit images.

▼ Vibrance

A tamer saturation adjustment control.

Hue/Saturation

A color adjustment for editing hue color, saturation and lightness.

△ Color Balance

Basic color adjustments.

Black & White

For simple black and white conversions.

Photo Filter

Adds a coloring filter adjustment.

Channel Mixer

For adjusting the balance of the individual color channels that make up a color image.

■ Color Lookup

Adds a color lookup adjustment.

Invert

Converts an image to a negative.

Posterize

Used to reduce the number of levels in an image.

Threshold

Reduces the number of levels to 2 and allows you to set the midpoint threshold.

Gradient Map

Lets you use gradients to map the output colors.

Selective Color

Apply CMYK selective color adjustments based on RGB or CMYK colors.

Figure 4.12 The Adjustments panel showing the adjustment buttons.

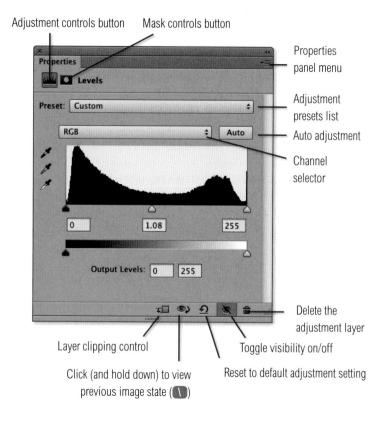

Figure 4.13 This shows the Properties panel with a Levels adjustment selected.

You can click on the Presets pop-up menu to quickly access one of the pre-supplied adjustment settings. Here, you might want to select each in turn, to see what each effect does, but without adding a new adjustment layer. Once you have configured a particular adjustment you can go to the Properties panel menu and choose Save Preset... to save as a custom adjustment setting. This will then appear appended to the Preset list as a custom setting.

The middle section contains the main adjustment controls for whatever adjustment you are currently working on.

At the bottom you have, on the far left, the adjustment layer clipping control button, which lets you determine whether a new adjustment is applied to all the layers that appear below the current adjustment layer, or are clipped just to the layer immediately below it. Next to this is a button for changing the preview image between the current edited state and the previous state. If you click on the button and hold the mouse down (or hold down the M key), you can see what the image looked like before the last series of image adjustments had been applied to it. Next to this is a Reset button for canceling the most recent adjustments, but you can also use the undo command # Z (Mac), ctrl Z (PC) to toggle undoing and redoing the last adjustment and use the # alt Z (Mac), ctrl alt Z (PC) shortcut to progressively undo a series of adjustment panel edits. Next to this is an eyeball icon for turning the adjustment layer visibility on or off and lastly a Delete button. When you click on this it will delete the current adjustment layer. The Properties panel will remain open though and simply say 'No Properties' at the top.

Maintaining focus in the Properties panel

The Photoshop adjustment layers behavior has evolved over the last three versions such that adjustment layer editing is now no longer modal. This is mostly a good thing, but losing the modality means that you must first use the *Shift Return* keyboard command in order to enter a 'Properties panel edit mode' where, for example, pressing the *Tab* key allows you to jump from one field to the next. Simply press the *esc* key to exit the Properties panel edit mode.

Auto image adjustments

The Auto button sets the clipping points automatically. Use att-click to open the Auto Options dialog (the Auto settings are covered later in this chapter).

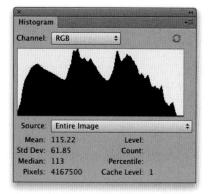

Figure 4.14 This histogram shows an image that contains a full range of tones, without any shadow or highlight clipping and no gaps between the levels.

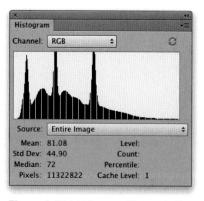

Figure 4.15 A histogram with a comb-like appearance indicates that either the image has already been heavily manipulated or an insufficient number of levels were captured in the original scan.

Levels adjustments

There was a time when every Photoshop edit session would begin with a Levels adjustment to optimize the image. These days, if you use Camera Raw to process your raw or JPEG photos, there shouldn't be so much need to use Levels for this purpose – you should already have optimized the shadows and highlights during the Camera Raw editing. However, it is important and useful to understand the basic principles of how to apply Levels adjustments since there are still times when it is more convenient to apply a quick Levels adjustment to an image, rather than use Camera Raw. The main Levels controls are shown below in Figure 4.16.

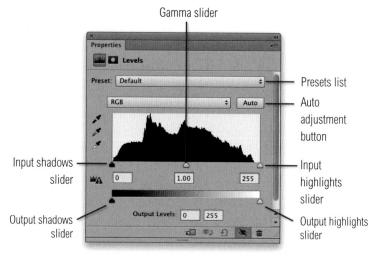

Figure 4.16 This shows a view of the Properties panel when adding a Levels adjustment. The Input sliders are just below the histogram display and you can use these to adjust the input shadows, highlights and gamma (the relative image brightness between the shadows and highlights). Below this are the Output sliders and you use these to set the output shadows and highlights. It is best not to adjust the Output sliders unless you are retouching a prepress file in grayscale or CMYK, or you deliberately wish to reduce the output contrast.

Analyzing the histogram

Levels adjustments can have a big effect on the appearance of the histogram and so it is important to keep a close eye on the histogram shown in the Levels dialog/Properties panel as well as the one in the Histogram panel itself. Figure 4.14 shows a nice, smooth histogram where the image was first optimized in Camera Raw before being opened in Photoshop, while Figure 4.15 shows the histogram for an image that's obviously been heavily manipulated in Photoshop. In Figure 4.17 you can see a low-key image where the blacks are quite heavily clipped and most of the levels are bunched up to the left, while in Figure 4.18 the highlights are clearly clipped in this high-key image. As I explain below, it isn't necessarily a bad thing to sometimes clip the shadows or highlights in this way.

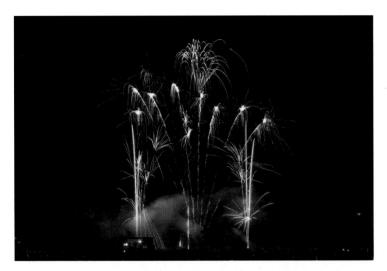

Figure 4.17 If the levels are bunched up towards the left, this is a sign of shadow clipping. With this image it was probably a good thing to let the darkest shadows clip.

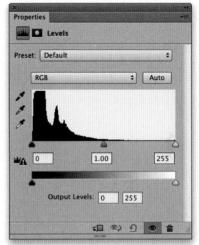

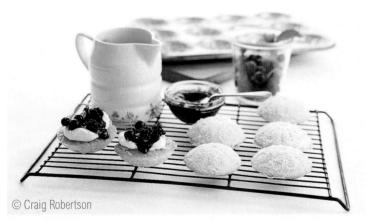

Figure 4.18 If the levels are bunched up towards the right, the highlights may be clipped. However, in this example it was desirable to let some of the highlights burn out to white.

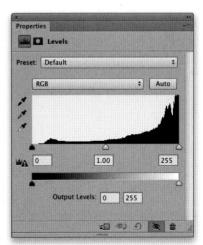

Are Curves all you need?

I have become a firm believer in trying to make Photoshop as simple as possible. There are 22 different items listed in the Image Adjustments menu and of these I reckon that you can achieve almost all the image adjustments you need by using just Curves and Hue/Saturation. While Curves can replace the need for Levels. I do still like to use the Levels dialog, because it is nice and simple to work with, plus there are also a lot of tutorials out there that rely on the use of Levels. You are still likely to come across lots of suggestions on ways to tonally adjust images by various means. And you know what? In most cases these techniques can often be summarized with a single Curves adjustment. It's just that it can sometimes actually work out quicker (and feel more intuitive) to use a slightly more convoluted route. In Photoshop there is often more than one way to achieve a particular effect. To quote Fred Bunting: there are always those techniques that are 'more interesting than relevant.'

Better negative number support

When applying a Curves adjustment and editing an image in Lab color mode, it is now possible to enter triple digit negative numbers directly into the fields in the Curves dialog. Previously, you could only type in two digit negative numbers, or three digit positive number values.

Curves adjustment layers

Any image adjustment that can be done using Levels can also be done using Curves, except Curves allows you to accurately control the tonal balance and contrast of the master composite image as well as the individual color channels. You can also target specific points on the Tone Curve and remap the pixel values to make them lighter or darker and adjust the contrast in specific tonal areas.

As with all the other image adjustments, there are two ways you can work with Curves. There is the direct route (using the Image \Rightarrow Adjustments menu) and the adjustments layer method described here. I have chosen to concentrate on the adjustments layer Properties panel here first because I believe this method is more useful for general image editing.

Figure 4.19 shows the Properties panel displaying the Curves controls, where the default RGB units are measured in brightness levels from 0 to 255 and the curve line represents the output tonal range plotted against the input tonal range. The vertical axis represents the output and the horizontal axis the input values (and the numbers correspond to the levels scale for an 8-bit per channel image). When you edit a CMYK image, the input and output axis is reversed and the units are measured in ink percentages instead of levels. The Curves grid normally uses 25% increments for RGB images and 10% increments for CMYK images, but you can toggle the Curves grid display mode by [all]-clicking anywhere in the grid.

Let's now look at the Curves control options. In the controls section you have a channel selection menu. This defaults to the composite RGB or CMYK mode, where all channels are affected equally by the adjustments you make. You can however use this menu to select specific color channels, which can be useful for carrying out color corrections (see Figure 4.20). The Auto button in Curves is the same as the one found in Levels. When you click on this, it applies an auto adjustment based on how the auto settings are configured (see Auto image adjustments on page 370).

If you double-click the eyedroppers, you can edit the desired black point, gray point and white point colors and then use these eyedroppers to click in the image to set the appropriate black, gray and white point values. There was a time in the early days of Photoshop where the eyedropper controls were important, but there are two reasons why this is less the case

Figure 4.19 The Curves dialog represents the relationship between the input and output levels plotted as a graph. In this example, the shadow end of the curve has been dragged inwards (just as you would in Levels) to set the optimum shadow clipping point. You can control both the lightness and the contrast of the image by clicking on the curve line to add curve points and adjust the shape of the curve.

now. Firstly, you can accurately set the black and white clipping points in Camera Raw (as described on pages 158–161) and secondly, the color management system in Photoshop automatically maps the black point for you when you convert an image to CMYK, or uses the Photoshop Print dialog to make a color managed print output. However, the gray eyedropper can still prove useful for auto color balancing a photo.

The Input levels sliders work the same way as those in Levels and you can drag these with the **M** key held down to access a threshold view mode (RGB and Grayscale Curves adjustments only). The Input and Output boxes provide numeric feedback for the current selected curve point so that you can adjust the curve points more precisely. You may sometimes see a histogram warning appear. This tells you that the histogram displayed in the grid area is not an accurate reflection of what the true histogram should be and if you click on this, it forces an update of the histogram view. The Curves dialog uses the Point curve editor mode by default, but there

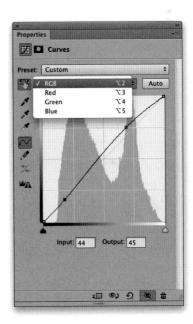

Figure 4.20 The default setting for Levels or Curves applies the corrections to the composite of the color channels. If you mouse down on the Channel menu, you can choose to edit individual color channels. This is how you use Curves to apply color adjustments.

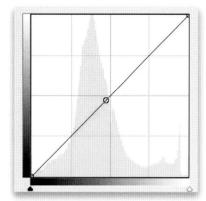

Figure 4.21 When the cursor is dragged over the image, a hollow circle indicates where the tone value is on the curve.

is also a pencil button for switching to a draw curve mode, which allows you to draw a curve shape directly. While in 'draw curve' mode the 'Smooth curve shape' button is made active and clicking on this allows you to smooth a drawn curve shape. Overall, you are unlikely to need to use the draw curve mode when editing photographic images.

On-image Curves editing

If you click on the target adjustment tool button to activate it and move the cursor over the document window, you will notice a hollow circle that hovers along the curve line. This shows you where the tones in any part of the image appear on the curve. If you then click on the image a new curve point is added to the curve (Figure 4.21). However, if you click to add a curve point and at the same time drag the mouse up or down, this also moves the curve up and down where you just added the curve point. This means when the target adjustment tool mode is active, you can click and drag directly on the image to make specific tone areas lighter or darker (see the step-by-step example shown opposite). For added convenience, there is also an 'Auto-Select Targeted Adjustment Tool' Properties panel menu option that automatically selects the target adjustment tool whenever a Curves adjustment layer is made active.

With both the eyedropper and the target adjustment tool methods, the pixel sampling behavior is determined by the sample options set in the Options bar. Figure 4.22 shows a view of the Options bar while the target adjustment tool is active. If a small sample size is used, the curve point placement can be quite tricky, because the hollow circle will dance up and down the curve as you move the cursor over the image. If you select a large sample size this averages out the readings and makes the cursor placement and on-image editing a much smoother experience.

Removing curve points

To remove a curve point select it and drag from the grid. Or, as you hover the cursor over an existing curve point on the curve line you can (Mac) (Mac) (PC)-click to delete it

Figure 4.22 The target adjustment tool options bar showing the Sample Size options. For on-image selections it can be useful to choose a large sample size.

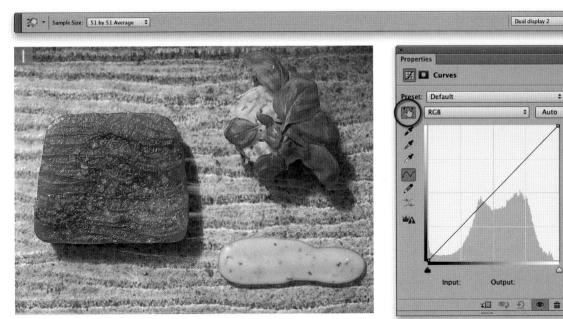

I deliberately chose a photograph that lacked contrast in order to demonstrate how the on-image curves editing works. To begin with I added a new Curves adjustment layer. I clicked on the target adjustment tool button (circled) and made sure that I had set a large sample size in the target adjustment tool options.

As I moved the cursor over the image I was able to click with the mouse to add new points to the curve. As I dragged the cursor upwards, this raised the curve upward and lightened the tones beneath where I had clicked. Likewise, as I dragged downwards I was able to darken those areas of the image.

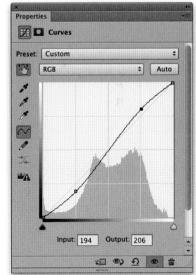

Threshold mode preview

The Curves input sliders work exactly like the ones found in Levels. You can preview the shadow and highlight clipping by holding down the [a/] key as you drag on the shadow and highlight sliders circled in the Properties panel views shown in Figures 4.23 and 4.24.

Using Curves in place of Levels

You can adjust the shadow and highlight levels in Curves in exactly the same way as you would using Levels. For example, you have the Input shadows and Input highlights sliders and you can drag these inwards to clip the shadow and highlight levels (Figure 4.23). In Levels you alter the relative brightness of the image by adjusting the gamma slider, while in the Curves adjustment you can add a single curves point and move it left to lighten or right to darken.

Output levels adjustments

If you select a shadow or highlight curves point and move it up or down, you can adjust the output levels for the shadows or highlights. Figure 4.24 shows how to apply equivalent tone adjustments to the output levels in Levels and Curves, while Figure 4.25 shows some further examples of where the output levels have been adjusted.

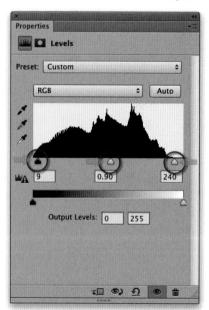

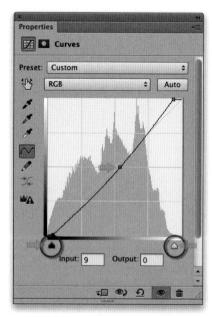

Figure 4.23 The Levels and Curves panel settings shown here can both be used to apply identical adjustments to an image. In the Levels adjustment example I moved the shadows and highlight Input levels sliders inwards. You will notice that the Curves adjustment has an identical pair of sliders with which you can map the shadow and highlight input levels. In the Levels adjustment you will notice how I moved the gamma slider to the right, to darken the midtones. In the Curves adjustment one can add a point midway along the curve and drag this to the right to achieve an identical kind of 'Gamma' midtone adjustment.

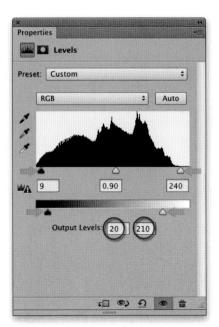

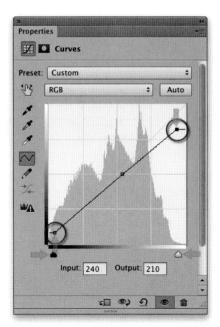

Figure 4.24 The Levels and Curves settings shown here will also apply identical adjustments. In the Levels adjustment I kept the input levels the same and adjusted the output levels to produce an image where the optimized levels were mapped to a levels range of 20–210. In the Curves dialog you can see the highlight point is selected and the curve point has been moved downwards to show a corresponding output value of 210 (the same value as the one entered in the Levels output levels).

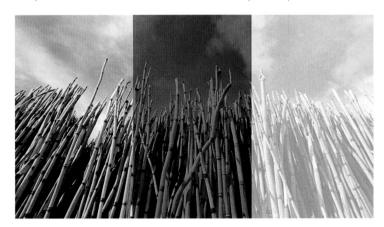

Figure 4.25 Setting the output levels to something other than zero isn't something you would normally want to do, except for those times where you specifically want to dull down the tonal range of an image. In the example shown here, the left section shows standard optimized levels, the middle section shows the same image with reduced highlight output levels and the right section shows the image with reduced shadow output levels.

Easier blend mode access

One of the main benefits of the adjustment layers approach is that you can switch easily between editing the adjustment controls in the Properties panel and adjusting the layer opacity and blend mode settings.

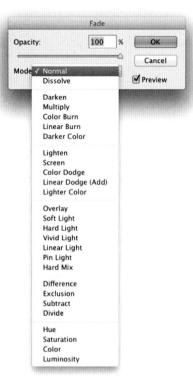

Figure 4.26 The Edit ⇒ Fade dialog.

Luminosity and Color blending modes

One of the problems you may encounter when applying Normal blend mode tone adjustments is that as you use Levels or Curves to adjust the tonal balance of a picture, the adjustments you make will also affect the color saturation. In some instances this might be a desirable outcome. For example, whenever you start off with a flat image that requires a major Levels or Curves adjustment, the process of optimizing the shadows and highlights will produce a picture with increased contrast and more saturated color. This can be considered a good thing, but if you are carrying out a careful tone adjustment and wish to manipulate the contrast or brightness, but without affecting the saturation, changing the blend mode to Luminosity can isolate the adjustment so that it targets the luminosity values only.

This is where working with adjustment layers can be useful, because you can easily switch the blend modes for any adjustment layer. In the example that's shown opposite, a Curves adjustment was used to add more contrast to the photograph. When this adjustment was applied in the Normal mode (as shown in Step 1), the color saturation was increased. However, when the same Curves adjustment was applied using a Luminosity blend mode, there was an increase in the contrast but without an increase in color saturation. Incidentally, I guite often use the Luminosity blend mode whenever I add a Levels or Curves adjustment laver to an image, especially if it has already been optimized for color. This is because whenever I add localized corrections I usually don't want these adjustments to further affect the saturation of the image. Similarly, if you are applying an image adjustment (such as Curves) to alter the colors in a photo, you may want the adjustment to target the colors only and leave the luminance values as they are. So whenever you make a color correction using, say, Levels, Curves, Hue/Saturation, or any other method, it is often a good idea to change the adjustment layer blend mode to Color.

If you happen to prefer the direct adjustment method, you can always go to the Edit menu after applying a Curves and choose Fade Curves... (**Shift** [Mac], ctri/Shift** [PC]). This opens the Fade dialog shown in Figure 4.26, where you can change the blend mode of any adjustment as well as fade the opacity.

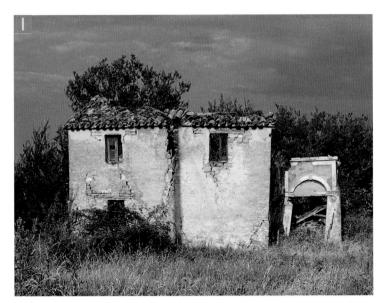

1 When you increase the contrast in an image using a Curves adjustment, you will also end up increasing the color saturation. Sometimes this will produce a desirable result because often photographs will look better when you boost the saturation.

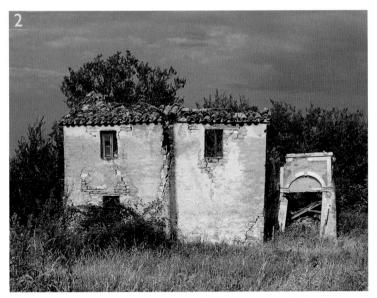

2 In this example I applied the same Curves adjustment as was applied in Step 1, but I changed the layer blend mode to Luminosity. This effectively allowed me to increase the contrast in the original scene, but without increasing the color saturation.

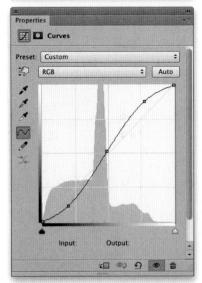

Locking down portions of a curve

As you go beyond adding one or two points to a curve, you need to be careful to keep the curve shape under control. Once you start adding further points to a curve, adjusting a point on one part of the curve may cause the curve shape to move, pivoting around the adjacent points. One solution is to sometimes lay down 'locking' points on the curve, as shown below in Figure 4.27.

Figure 4.27 In this example I wanted to make the dark tones darker, but without affecting the mid to highlight tones so much. Here is what I did. I placed one curve point on the middle intersection point of the curve and another on the 75% intersection point. I then added a third curve point towards the toe of the curve and dragged downwards to darken the shadows and steepen the curve in the shadow to midtone areas. You will notice that because I had added the other two curve points first, adjusting the third curve point had little effect on the upper portion of the curve.

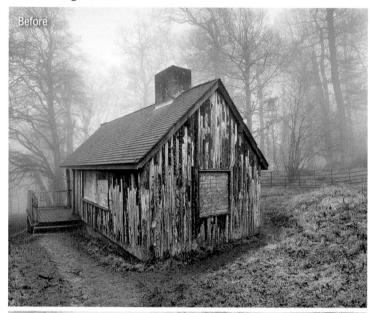

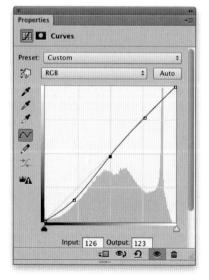

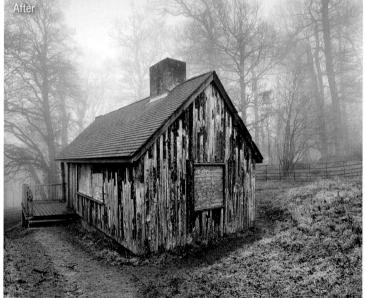

Creating a dual contrast curve

Now let's look at adding even more curve points. There are times where you may want to manipulate the contrast in two sections of the curve at once. For this you may need to place three or more points on the curve such as in the Figure 4.28 example shown below. This is where you need to be really careful, because it is all too easy to make some of the tones look solarized, or you may end up flattening them. Either way you risk losing tonal detail.

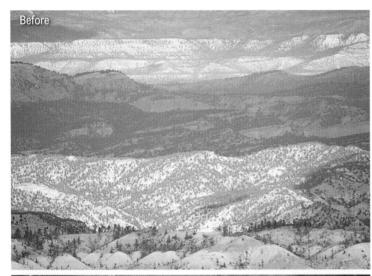

Figure 4.28 In this example I wanted to boost the contrast in the shadows and the highlights separately. To do this, I applied the curve shape shown here where you will see that by using six curve points I was able to independently steepen the shadow/midtone and highlight portions of the curve.

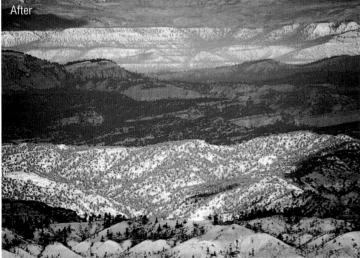

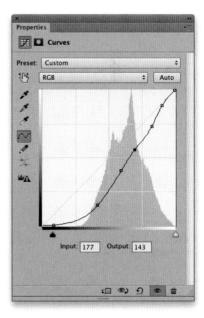

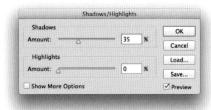

Figure 4.29 The Shadows/Highlights adjustment dialog is shown here in basic mode. Checking the Show More Options box will reveal the Advanced mode dialog shown in Figure 4.30.

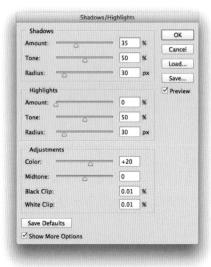

Figure 4.30 In the Advanced mode, the Shadows/Highlights dialog contains a comprehensive range of controls. I would advise you to always leave the 'Show More Options' box checked so that you have this as the default mode for making Shadows/ Highlights adjustments.

Correcting shadow and highlight detail

The Shadows/Highlights image adjustment (Figure 4.29) can be used to reveal more detail in either the shadow or highlight areas of a picture. It is a great image adjustment tool to use whenever you need to expand compressed image tones in an image, but it can be used to perform wonders on most photos and not just those where you desperately need to recover shadow or highlight detail.

The Shadows/Highlights image adjustment tool makes adaptive adjustments to an image, and works in much the same way as our eyes do when they automatically compensate and adjust to the amount of light illuminating a subject. Essentially, the Shadows/Highlights adjustment works by looking at the neighboring pixels in an image and makes a compensating adjustment based on the average pixel values within a given radius. In the Advanced mode, the Shadows/ Highlights dialog has additional controls that allow you to make the following fine-tuning adjustments (Figure 4.30).

Amount

This is an easy one to get to get to grips with. The default Amount setting applies a 35% amount to the Shadows. You can increase or decrease this to achieve the desired amount of highlight or shadow correction. I find the default setting does tend to be rather annoying, so I usually try setting the slider to a lower amount (or zero even) and click on the 'Save As Defaults' button to set this as the new default setting each time I open Shadows/Highlights.

Tonal Width

The Tonal Width determines the tonal range of pixel values that will be affected by the Amount setting. A low Tonal Width setting narrows the adjustment to the darkest or lightest pixels only. As the Tonal Width is increased, the adjustment spreads to affect more of the midtone pixels as well (see the example shown in Figure 4.31).

Radius

The Radius setting governs the pixel width of the area that is analyzed when making an adaptive correction. To explain this, let's analyze what happens when making a shadow correction. If the Shadow Radius is set to zero, the result will be a very flat-looking image. You can increase the Amount to lighten the

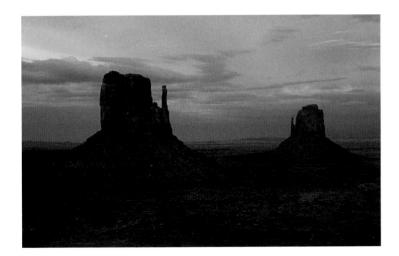

shadows and restrict the Tonal Width, but if the Radius is low or set to zero, Photoshop has very little neighbor pixel information to work with when trying to calculate the average luminance of the neighboring pixels. So if the Radius is set too small, the midtones will also become lightened. If the Radius setting is set too high this has the effect of averaging a larger selection of pixels in the image and likewise the lightening effect will be distributed such that most of the pixels get the lightening treatment and not just the dark pixels. The optimum setting is always dependent on the image content and the pixel area size of the dark or light regions in the image. The optimum pixel Radius width should therefore be about half that amount or less. In practice you don't have to measure the pixel width of the light and dark areas in an image to work this out. Just be aware that after you have established the Amount and Tonal Width settings you should adjust the Radius setting and make it larger or smaller according to how large the dark or light areas are. There will be a 'sweet spot' where the Shadows/ Highlights Radius correction is just right.

As you make an adjustment to the Radius setting you will sometimes notice a soft halo appearing around sharp areas of contrast between the dark and light areas. This is a natural consequence of the Radius function and is most noticeable when you apply large Amount corrections. Aim for a Radius setting where the halo is least noticeable or apply a Fade... adjustment after applying the Shadows/Highlights adjustment. If I am really concerned about halos, I sometimes use the history brush to selectively paint in a Shadows/Highlights adjustment.

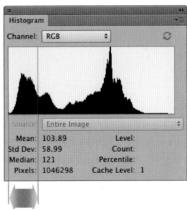

Figure 4.31 The Tonal Width slider determines the range of levels the Shadows/ Highlights adjustment is applied to. For example, if the Shadow adjustment Tonal Range is set to 40, then only the pixels which fall within the darkest range from level 0 to level 40 will be adjusted (such as the deep shadows in this photograph).

HDR Toning adjustment

There is also an HDR Toning adjustment in the Image ⇒ Adjustments menu. This is described on page 436 and provides an alternative approach to applying Shadows/ Highlights type image adjustments.

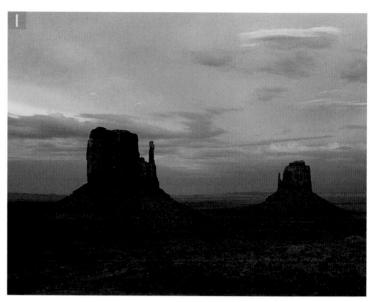

1 In this photograph there were a lot of dark shadows in these rock formations known as 'The Mittens'. Using the Shadows/Highlights adjustment it would be possible to bring out more detail in the shadows, but without degrading the overall contrast.

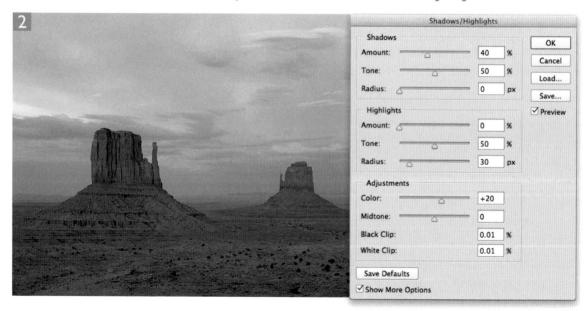

2 I went to the Image menu and chose Adjustments ⇒ Shadows/Highlights. I set the Amount to 40% and raised the Tonal Width to 50%. The Radius adjustment was now crucial because this determined the distribution width of the Shadows/Highlights adjustment. As you can see in this step, if the Radius is set to zero the image looks flat.

3 If you take the Radius setting up really high, this too can diminish the Shadows/ Highlights adjustment effect. It is useful to remember here that the optimum Radius setting is 'area size' related and falls somewhere midway between these two extremes. In the end, I went for a Radius setting of 130 pixels for the shadows. This was because I was correcting large shadow areas and this setting appeared to provide the optimum correction for this particular photo. I also increased the Midtone Contrast to +15. This final tweak compensated for some loss of contrast in the midtone areas.

Color Correction

As you correct the highlights and the shadows, the color saturation may change unexpectedly. This can be a consequence of using Shadows/Highlights to apply extreme adjustments. The Color Correction slider lets you compensate for any undesired color shifts.

Midtone Contrast

The midtone areas may sometimes suffer as a result of a Shadows/Highlights adjustment. Even though you may have paid careful attention to getting all the above settings perfectly optimized so that you successfully target the shadows and highlights, the photograph can end up looking like it is lacking in contrast. The Midtone Contrast slider control lets you restore or add more contrast to the midtone areas.

CMYK Shadows/Highlights adjustments

You can use a Shadows/Highlights adjustment on CMYK as well as RGB images.

Adobe Camera Raw adjustments

Shadows/Highlights adjustments can work great on a lot of images, but now that Camera Raw can be applied as a filter, you may like to explore using the Highlights and Shadows adjustments described on page 156. In many cases Highlights and Shadows adjustments in Camera Raw work better than using the Photoshop Shadows/Highlights adjustment.

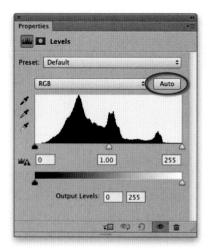

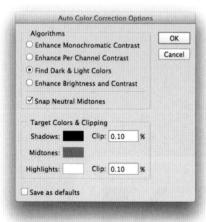

Figure 4.32 The Auto image adjustments can also be accessed when you click on the Options... button in the direct Levels or Curves dialogs, or alt—click the Auto button (circled) in the adjustment layer dialogs. If Snap Neutral Midtones is selected, Auto Color will neutralize these too. You can also customize the Clipping values to determine how much the highlights and shadow tones are clipped by the image adjustment.

Auto image adjustments

The Image menu contains three auto image adjustment options designed to provide automated tone and color corrections: Auto Tone, Auto Contrast and Auto Color (examples of these are shown in Figure 4.33).

The Auto Tone adjustment (# Shift L [Mac], ctrl Shift L [PC]) works by expanding the levels in each of the color channels individually. This per-channel levels contrast expansion method will always result in an image that has fuller tonal contrast, but may also change the color balance. The Auto Tone adjustment can produce improved results, but not always. If you want to improve the tonal contrast, but without affecting the color balance of the photograph, then try using the Auto Contrast adjustment instead (# Shift L [Mac], ctrl all Shift L [PC]). This carries out a similar type of auto image adjustment as Auto Tone, except it optimizes the contrast by applying an identical Levels adjustment to each of the color channels.

Lastly, there is the Auto Color adjustment (**#** Shift **B** [Mac], ctrl Shift **B** [PC]). This applies a combination of Auto Contrast to enhance the tonal contrast, combined with an auto color correction that maps the darkest colors to black and the lightest colors to white and also aims to neutralize the midtones.

If you open the direct Levels or Curves dialogs you will see a button marked 'Options...' just below the Auto button. This opens the Auto Color Correction Options shown in Figure 4.32. If you are applying a Levels or Curves adjustment layer, then you can all-click the Auto button in the Properties panel to open the Auto Color Correction Options dialog. The algorithms listed here match the auto adjustments found in the Image menu. Enhance Per Channel Contrast is the same as Auto Tone. Enhance Monochromatic Contrast is equivalent to Auto Contrast and Find Dark & Light Colors is the same as Auto Color. Notice however there is also a Snap Neutral Midtones option. When this is checked, a gamma adjustment is applied in each of the color channels which aims to correct the neutral midtones as well as the light and dark colors. A clipping value can be set for the highlights and shadows and this determines by what percentage the endpoints are automatically clipped. There is also an Enhance Brightness and Contrast auto adjustment that's only available as an auto option with Brightness/Contrast and Levels and Curves adjustment layer adjustments (see page 372).

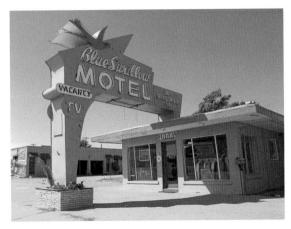

Before

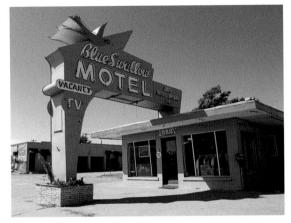

Auto Contrast (Enhance Monochromatic Contrast)

Figure 4.33 This shows the three Image menu auto adjustment methods (with equivalent descriptions for how they are described in the Levels and Curves 'Auto Color Correction Options' dialogs). Auto Tone optimizes the shadow and highlight points in all three color channels. This generally improves the contrast and color balance of the image. Auto Contrast applies an identical tone balancing adjustment across all three channels that improves the contrast, but without altering the color balance. The Auto Color option maps the darkest and lightest colors to a neutral color (if the swatch colors shown in Figure 4.32 have been altered, you may see a different result). Lastly, I have shown an example of an Auto Contrast adjustment followed by a Match Color Neutralize adjustment.

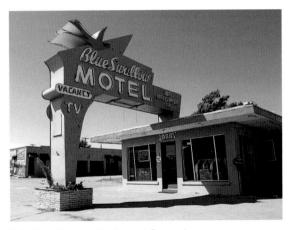

Auto Tone (Enhance Per Channel Contrast)

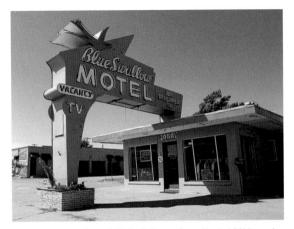

Auto Color (Find Dark & Light Colors + Snap Neutral Midtones)

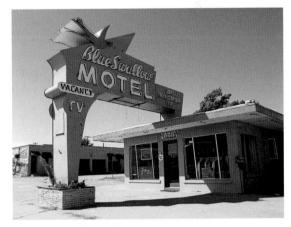

Auto Contrast + Match Color Neutralize

Match Color corrections

The Figure 4.33 example shows a Match Color correction. This is a rather hidden feature, which I reckon only a few people know about. If you go the Image ⇒ Adjustments menu you will see an item called Match Color... In the dialog that's shown in Figure 4.34 you just need to check the Neutralize box to apply a Match Color neutralize adjustment. You'll find it's remarkably good at removing most color casts.

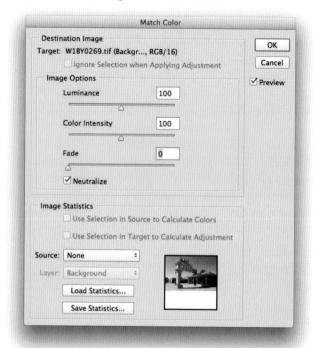

Figure 4.34 The Match Color dialog with the Neutralize box checked.

Enhanced Brightness and Contrast

Photoshop also has an 'Enhance Brightness and Contrast' auto option available in the Levels and Curves adjustment dialogs (see Figure 4.35). This auto correction is a bit more advanced than the other auto options and has now been selected as the default option whenever you click the Auto button in Levels or Curves.

Photoshop makes use here of a hidden database of Levels and Curves adjustments and makes a selection for you when you hit the Auto button (or, all-click the Auto button in the Curves Properties panel and select Enhance Brightness and Contrast from the Algorithms menu). This is done by Photoshop analyzing the histogram and, based on this,

deciding which would be the most appropriate adjustment to select. In the case of Levels (and also Brightness/Contrast), Photoshop aims to clip the black and white points as necessary and applies an appropriate gamma adjustment. In the case of Curves, it selects an appropriate curve shape to apply, based on an analysis of the histogram levels distribution.

This feature is quite effective and can produce some pleasing results. It is not quite such a knock-out feature now as it would have been a few years ago. I think it's more likely that most photographers will want to use Camera Raw to auto process their raw capture images. But the one thing that has to be said when you apply this auto adjustment (as well as any kind of auto adjustment) is you do have the ability to edit the applied Levels or Curves settings before clicking OK to confirm the adjustment. Figure 4.36 shows a before and after example of an Enhance Brightness and Contrast auto Curves adjustment and how it added points to the curve.

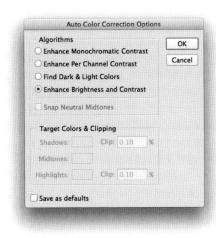

Figure 4.35 This shows the Enhance Brightness and Contrast option selected in the Auto Color Correction Options Curves dialog.

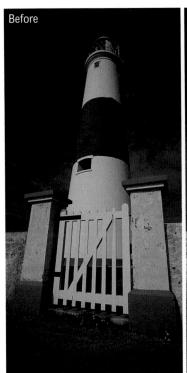

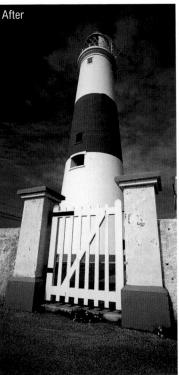

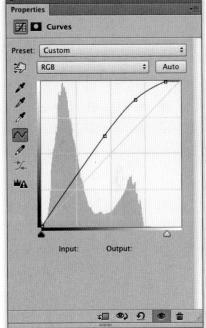

Figure 4.36 This shows a before and after example of an Enhance Brightness and Contrast auto Curves adjustment and the curve shape it applied to this particular image.

Channel selection shortcuts

The channel selection shortcuts are as follows. You now need to use alt 2 to select the composite curve channel, use alt 3 to select the red channel, and so on. Likewise, you can use # alt 2 (Mac), ciri alt 2 (PC) to load the composite (luminosity) channel as a selection, # alt 3 (Mac), ciri alt 3 (PC) to load the red channel as a selection, etc.

Color corrections using Curves

Of all the Photoshop color correction methods described so far, Auto Color probably provides the best automatic one-step tone and color correction method. However, if you prefer to carry out your color corrections manually, I would suggest you explore using Levels or Curves color channel adjustments instead. Earlier I mentioned how you can set the highlight and shadow points in Levels and how to use a gamma adjustment to lighten or darken the image. Let's now take things one stage further and use this technique to optimize the individual color channels in an RGB color image.

On these pages I show how you can use the threshold mode analysis technique to discover where the shadow and highlight endpoints are in each of the three color channels and use this feedback information to set the endpoints. This is a really good way to locate the shadows and highlights and set the endpoints at the same time, because once you have corrected the highlight and shadow color values in each of the color channels independently, the other colors usually fall into place and the photograph won't require much further color correction.

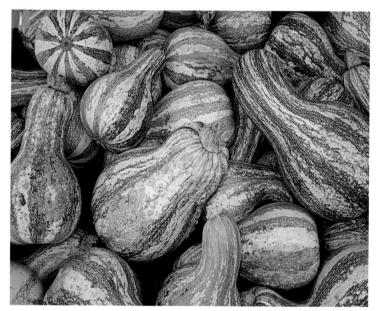

1 This JPEG capture photograph was taken with a basic digital camera and has an overall blue cast. The first step was to go to the Adjustments panel and click on the Curves button (circled) to add a new Curves adjustment layer.

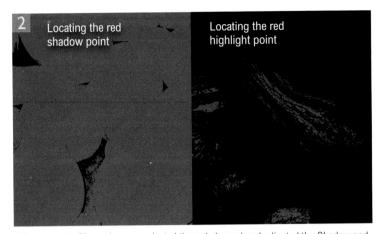

2 I went to the Channel menu, selected the red channel and adjusted the Shadow and Highlight input sliders until the red shadow and red highlight points just started to clip. If you hold down the https://document.org///document.org///document.org/le/ key as you do this you will see the threshold display mode (shown here) which can help you locate the shadow and highlight points more easily. I then repeated these steps with the green and blue channels until I had individually adjusted the shadow and highlight points in all three color channels.

3 Finally, I added a midpoint in the blue channel and dragged it to the right to add more yellow. This technique of adjusting the color channels one by one can help you remove color casts from the shadows and highlights with greater precision. The trick is to use the threshold display mode as a reference tool to indicate where the levels start to clip in each channel and consider backing off slightly so that you leave some headroom in the composite/master channel. This then allows you to make general refinements to the Curves adjustment, ensuring the highlights do not blow out.

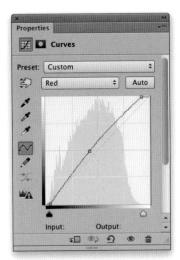

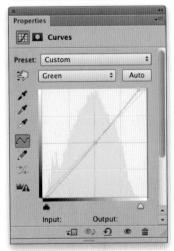

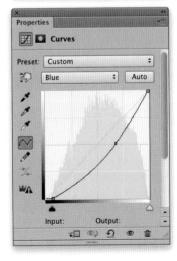

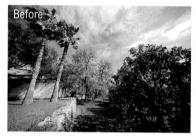

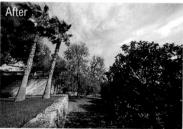

Properties Properties	C
Hue/Saturation	·
Preset: Custom	
Master	•
Hue:	+150
Saturation:	0
Lightness:	0
A A A Colorize	
\$□ © <u>9</u>	● 🛍

Figure 4.37 This shows an extreme example of how a Hue/Saturation adjustment can be used to radically alter the appearance of a photograph. As you move the Hue slider left or right the colors in the image are mapped to new values. You get an indication of this transformation by looking at the two color ramps at the bottom of the dialog. The top one represents the original 'input' color spectrum and the lower ramp represents how those colors are translated as output colors.

Hue/Saturation

The Hue/Saturation dialog controls are based around the HSB (Hue, Saturation, Brightness) color model, which is basically an intuitive form of the Lab Color model. When you select the Hue/Saturation image adjustment you can adjust the image colors globally, or you can selectively apply an adjustment to a narrower range of colors. The two color spectrum ramps at the bottom of the Hue/Saturation dialog box provide a visual clue as to how the colors are being mapped from one color to another. These hue values are based on a 360 degree spectrum, where red is positioned mid-slider at 0 degrees and all the other colors are assigned numeric values in relation to this. So cvan (the complementary color of red) can be found at either -180 or +180 degrees. Adjusting the Hue slider alters the way colors in the image are mapped to new color values and Figure 4.37 shows an extreme example of how the colors in a normal color image would look if they were mapped by a strong Hue adjustment. As the Hue slider is moved you will notice that the lower color ramp position slides left or right, relative to the upper color ramp.

Saturation adjustments are easy enough to understand. A positive value boosts the color saturation, while a negative value reduces the saturation in an image. Apart from the Master edit mode, you can choose from one of six preset color ranges with which to narrow the focus of a Hue/ Saturation adjustment. Once you have selected one of these color range options, you can then sample a new color value from the image window, and this centers the Hue/ Saturation adjustments around the new sampled color. Use a Shift-click in the image area to add to the color selection and an alt-click to subtract colors. There is an 'Auto-Select Targeted Adjustment Tool' Adjustment panel option available from the panel menu (circled in Figure 4.37), which when enabled, automatically selects the target adjustment tool when the adjustment layer is made active. In the case of a Hue/ Saturation adjustment it automatically selects the Saturation slider and targets the appropriate color range.

When the Colorize option is checked, the hue component of the image defaults to red (Hue value 0 degrees), Lightness remains the same at 0% and Saturation at 25%. You could use this to colorize a monochrome image, but I think you will be better off using the Photo Filter adjustment to do this (see page 384).

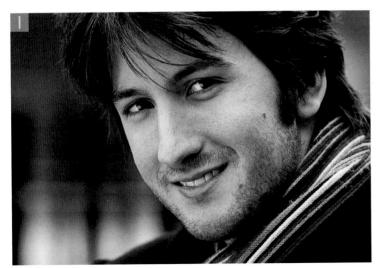

1 This shows a portrait photograph in which I wanted to target the purple background color and make it less intense. One approach would be to go to the target color group menu shown here and select 'Magentas'.

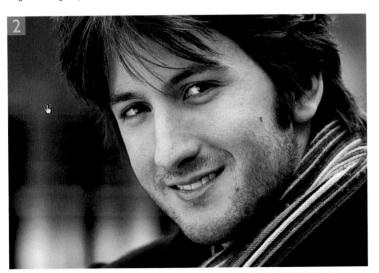

2 Another method was to make the target adjustment tool active (circled) and carry out an on-image adjustment by dragging on the color area I wished to modify (this also selected the target color group from the menu). I was then able to drag left or right to decrease or increase the saturation. You'll notice I also used the Hue and Lightness sliders to further modify this adjustment. The Magentas color group can also be narrowed down. In the color ramp at the bottom, the dark shaded area represented the selected color range and the lighter shaded area (defined by the outer triangular markers) represented the fuzziness drop-off either side of the color selection. I was able to modify the range and fuzziness of the selection by dragging these slider bars.

Color selection shortcuts

The shortcuts for selecting the color groups in Hue/Saturation are as follows.

Use all 2 to select the master group,
all 3 to select the reds, and so on.

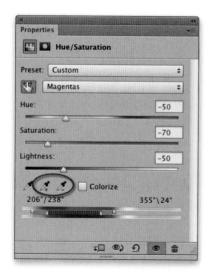

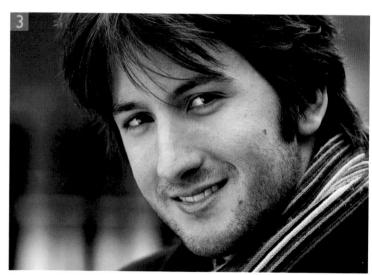

3 As well as manually dragging the sliders, I was also able to use the eyedroppers (circled) to add or subtract from a color range selection. For this step, I selected the plus eyedropper and clicked on the edges of hair to add these colors to the Magentas selection and remove the purple color contamination from the hair. However, you'll also notice that as I widened the color ramp selection, other colors became included in this selection such as the lips and the scarf.

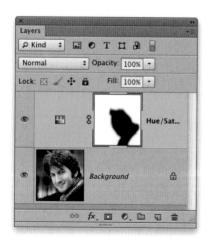

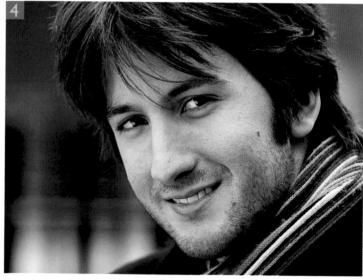

4 This brings us to the final step, in which I painted on the adjustment layer mask with black in order to hide the Hue/Saturation mask and prevented this adjustment from affecting the skin tones and the scarf. Painting with black on the adjustment layer mask restored the colors in these regions to how they were originally.

Photo: © Jeff Schewe

Vibrance

The Vibrance adjustment is available as a direct adjustment and as an Adjustment panel option (Figure 4.38) and allows you to carry out Camera Raw style Vibrance and Saturation adjustments directly in Photoshop. If you refer back to Chapter 2, you will recall that Vibrance applies a non-linear style saturation adjustment in which the less saturated colors receive the biggest saturation boost, while those colors that are already brightly saturated remain relatively protected as you boost the Vibrance. The net result is a saturation control that allows you to make an image look more colorful. but without the attendant risk of clipping those colors that are saturated enough already. As you can see in Figure 4.39 below, Vibrance also prevents skin tones from becoming oversaturated as the amount setting is increased. The Saturation slider you see here is similar to the Saturation slider in the Hue/Saturation adjustment, but applies a slightly gentler adjustment. It matches more closely the behavior of the Saturation slider in Camera Raw.

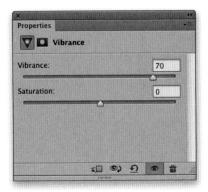

Figure 4.38 The Vibrance Adjustment panel.

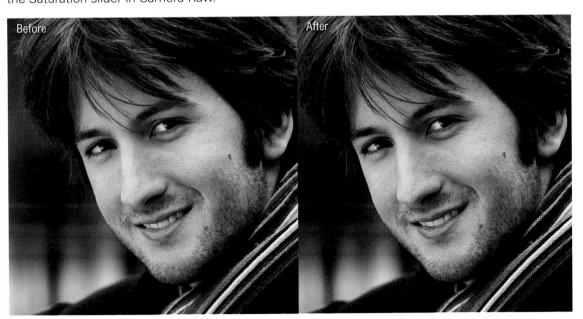

Figure 4.39 This shows a comparison between the before version (left) and the after version (right), in which I boosted the Vibrance by 70%. As you can see, this made the purple colors in the background and on the scarf appear more saturated. You will notices that the Vibrance adjustment also increased the saturation of the skin tones, but the saturation boost here is more modest compared to boosting the saturation with the Saturation slider.

Color Lookup adjustments

The Color Lookup adjustment was first introduced in Photoshop CS6, and provides a new kind of image adjustment that is suited to applying all kinds of varied image adjustment effects. It can use standardized ICC profiles (Abstract and Devicelink), or the less standardized 3DLUT formats (which are widely used in film and video). Basically, Color Lookup adjustments offer a way to package a lot of complicated adjustments into a single profile or LUT (lookup table). Credit should go here to Photoshop engineer Chris Cox, who built most of the 3DLUTs and profiles initially provided in Photoshop. These are not as simple as you might think. A lot of work went into their creation, including writing new code, and as many as eight internal tone and color adjustments are used to create the final effects.

This feature will be of particular interest to video editors because the film industry has for a long time relied on the use of special 3D LUT or Abstract profiles in order to color grade video. You will have seen this all the time in various movies, where the film has been given a certain type of moody color effect. Sometimes this has been done to help unify the color feel of different shots, while some films have incorporated a mixture of special effects. For example, Martin Scorsese's *The Aviator* used a special Technicolor™ colorizing effect, which I reckon the 3strip.look 3D LUT profile aims to simulate. On the page opposite you can see three examples of Color Lookup adjustments (Figures 4.41–4.43) that have been applied to the Figure 4.40 photo.

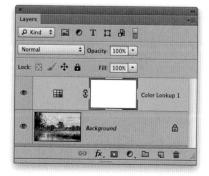

Figure 4.40 This shows the before version of the image to which I applied the Color Lookup adjustments shown on the right.

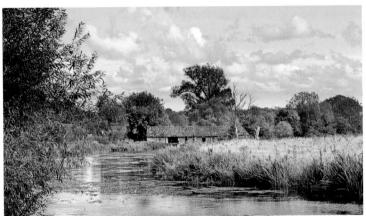

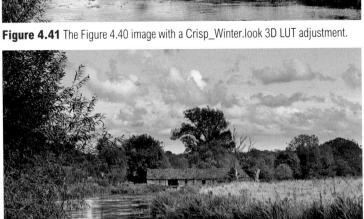

Figure 4.42 The Figure 4.40 image with a Gold-Blue Abstract adjustment.

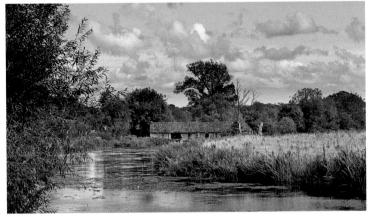

Figure 4.43 The Figure 4.40 image with a Gold-Crimson Abstract adjustment.

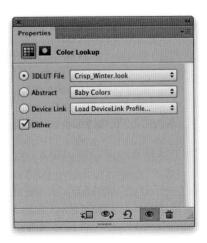

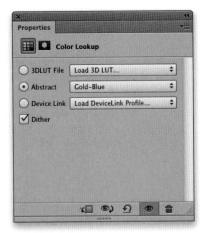

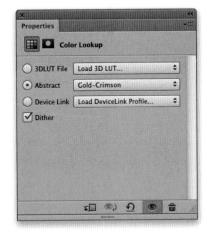

Color Lookup Table Export

You can now generate your own Color Lookup tables via Photoshop for use in Photoshop, After Effects, and other image/video editing applications.

To do this, open an image, add some adjustment layers to give the image the desired look and then go to the File menu and choose Export ⇒ Color Lookup Tables... The dialog will prompt you to give the Lookup table a name plus an optional copyright string: i.e. '(⊚) Copyright' followed by your custom text. Selecting more grid points will result in higher quality tables at the expense of producing bigger files. In the export dialog you can save the look using the 3DL, CUBE, CSP or ICC profile formats (the first three are all 3D LUT formats).

Important things to be aware of here are that to export as a Color Lookup table the image you work must contain a Background layer plus additional layers to modify the colors. This can include the use of color filled pixel layers, gradients and patterns incorporating the use of conditional blending. However, for best results try using adjustment layers only to create the desired coloring effect, as the use of pixel layers may give unexpected results in the final exported Color Lookup table. Also, if you start with a Lab mode file, the export command can save an ICC abstract profile (which is the most general and powerful of the formats). If you start with an RGB document, then only the 3DLUT and RGB device link formats can be saved.

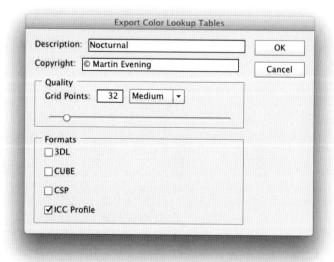

Figure 4.44 The Export Color Lookup Tables dialog.

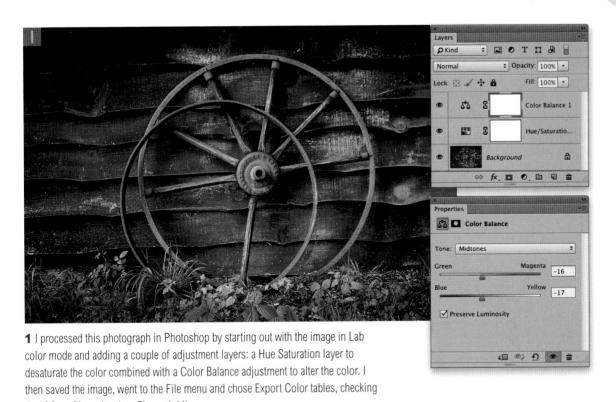

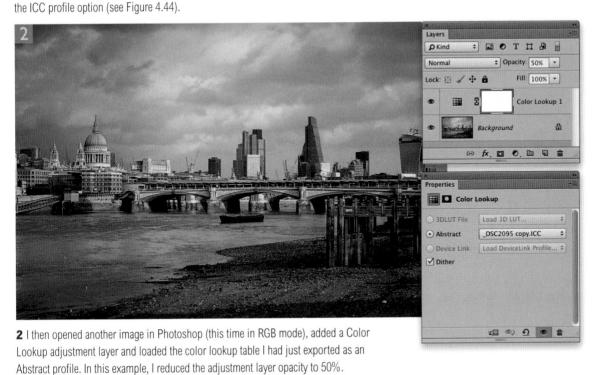

Color temperature and film

In the days of color film there were only two choices of film emulsion: daylight and tungsten. Davlight film was rated at 6,500 K and was used for outdoor and studio flash photography, while tungsten film was rated at 3.400 K and was typically used when taking photographs under artificial tungsten lighting. These absolute values would rarely match exactly the lighting conditions you were shooting with, but would enable you to get roughly close to the appropriate color temperature of daylight/strobe lights or indoor/tungsten lighting. Where the color temperature of the lighting was different, photographers would place color correcting filters over the lens to help balance the colors better. The Photo Filter in Photoshop kind of allows you to do the same thing at the post-production stage.

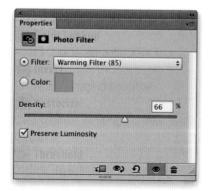

Photo Filter

One of the advantages of shooting digitally is that most digital cameras are able to record a white balance reading at the time of capture and use this information to automatically color correct vour photos as you shoot. This can be done either in-camera (selecting the auto-white balance option) or by using the 'As Shot' white balance setting in Camera Raw when processing a raw capture image. If you didn't manage to set the color balance correctly at the time of capture and were shooting in JPEG mode then you'll be stuck with a fixed white balance in the image. But don't despair, because it is possible to crudely adjust the color balance in Photoshop using the Photo Filter adiustment, which is available from the Image Adjustments menu, or as an image adjustment layer. The Photo Filter effectively applies a solid fill color layer with the blend mode set to 'Color', although you can achieve a variety of different effects by combining a Photo Filter adjustment with different laver blend modes. The Photo Filter offers a few color filter presets, but if you click on the Color button, you can select any color you like (after clicking on the color swatch) and adjust the Density slider to modify the filter's strength. Figure 4.45 shows a typical example where a Photo Filter adjustment might be used.

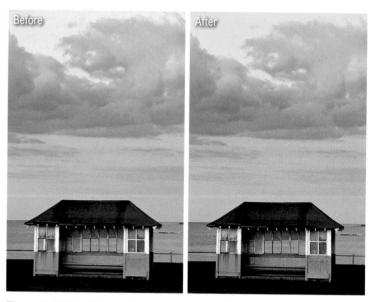

Figure 4.45 The original version (left) had a blue cast. To modify this photograph, I added a Photo Filter adjustment. I selected the Warming (85) filter and raised the Density from 25% to 66%.

Multiple adjustment lavers

Once you start adding multiple adjustment layers you can preview how an image will look using various combinations of adjustment layers, and readjust the settings as many times as you like before applying them permanently to the photo. For example, you might want to use multiple adjustment layers to apply different coloring treatments to a photo. Instead of producing three versions of an image, all you need to do is add three adjustment layers, with each using a different coloring adjustment, and switch the adjustment layer visibility on or off to access each of the color variations (saving Layer Comps can help here, see page 562).

While it is possible to keep adding more adjustment layers to an image, you should try to avoid any unnecessary duplication. It is wrong to assume that when the image is flattened the cumulative adjustments somehow merge to become a single image adjustment. When you merge down a series of adjustment layers, Photoshop applies them sequentially, the same as if you had made a series of normal image adjustments. So the main thing to watch out for is any doubling up of the adjustment layers. If you find you have a Curves adjustment layer above a Levels adjustment layer, it would probably be better to try and combine the Levels adjustment within the Curves adjustment instead. Of course, when you use masked adjustment layers to adjust specific areas of a picture you can easily end up with lots of adjustment layers. One potential drawback of this approach is it may slow down the screen preview times. This slowness is not a RAM memory issue, but to do with the extra calculations that are required to redraw the pixels on the screen. If you think this might be happening then try switching off some of the adjustment layers while you are editing the photograph.

To summarize, the chief advantages of adjustment layers are the ability to defer image adjustment processing and the ability to edit the layers and make selective image adjustments. It is important to stress here that the pixel data in an image can easily become degraded through successive adjustments as the pixel values are rounded off. This is one reason why it is better to use adjustment layers, because you can keep revising these adjustments without damaging the photograph until you finally decide to flatten the image.

Grouped adjustments

If you place your image adjustment layers inside a layer group you can use the layer group visibility to turn multiple image adjustments on or off at once (see Figure 4.46). You can also add a layer mask to a layer group and use this to selectively hide or reveal all the image adjustment layers contained within a layer group.

Figure 4.46 This shows an example of how adjustments can be grouped together and a single mask applied to a combined group of adjustment layers.

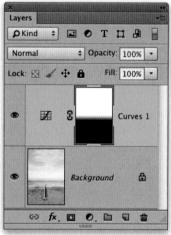

Figure 4.47 This shows an example of a darkening adjustment layer applied to an image, but with a black to white gradient applied to the pixel layer mask to fade out the adjustment from the middle of the photograph downwards.

Adjustment layer masks

As you have seen so far, adjustment layers are always accompanied by a pixel image layer mask. As with ordinary layers, these can be used to mask the adjustment layer contents. Whenever an adjustment layer is active, you can paint or fill the adjustment layer mask using black to selectively hide an adjustment effect and paint or fill with white to reveal again. You can also keep editing an adjustment layer mask (painting with black or white) until you are happy with the way the mask is working (see Figure 4.47).

Having the ability to edit an adjustment layer mask means you can apply such layer adjustments selectively. For example, although Photoshop has dodge and burn tools and these were improved in Photoshop CS4, they are still not really suited for dodging and burning broad areas of a photograph. They also have to be applied to a pixel layer directly, forcing you to create a copy layer if you wish to keep your edits non-destructive. If you want to dodge or burn a photo in order to darken a sky or lighten someone's face, the best way to do this is by adding an adjustment layer, fill the mask with black and paint with white to selectively reveal the adjustment laver effect. Working with adjustment layers is by far the best way to shade or lighten portions of a photograph. You have the freedom to re-edit the adjustment layer, to make the adjustment lighter or darker, and you can edit the layer mask to precisely control which areas of the image are affected by the adjustment.

Properties panel mask controls

The Properties panel in 'Masks mode' (Figure 4.49) can be used to refine the mask or masks associated with a layer (such as an additional vector mask). Layer masking is a topic I'll be discussing more fully in Chapter 8, but because it is relevant to masking adjustment layers, I thought it best to briefly introduce the Properties panel masking features here first.

Adjustment layers are added to the layer stack with a pixel layer mask, so the default mode for the Properties panel Masks mode shows the Pixel Mask mode options. If you click on the Vector Mask mode button next to it, you can add and/or edit a vector layer mask (see Step 4 on page 389). You can tell which mode is active because it will say Pixel Mask or Vector Mask at the top of the panel and the relevant mode button will have a stroked border.

The Feather slider can be used to soften the mask edges up to a 250 pixel radius. Beneath this though is the Mask Edge... button which opens the Refine Mask dialog (Figure 4.48). Here you'll find you have even greater control over the mask edges and softness (these are described more fully in Chapter 8).

The Color Range button takes you to the Color Range dialog, which allows you to make selections based on color. This means that you can select colors to add to or subtract from a Color Range selection and see the results applied directly as a mask. Beneath this is the Invert button for reversing a masking effect. At the bottom of the panel are buttons that allow you to: convert a mask to a selection, delete the mask and apply it to the layer, enable/disable the mask and a delete button to remove a mask.

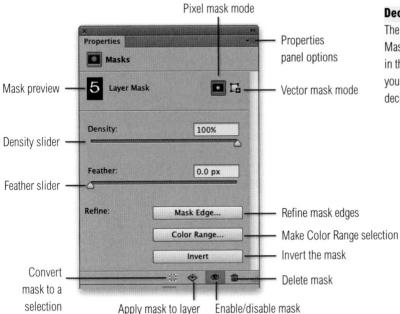

Figure 4.49 The Properties panel Masks mode controls.

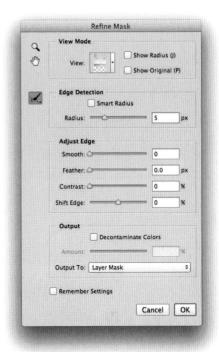

Figure 4.48 This shows the Refine Mask dialog.

Decimal place accuracy

The Feather slider in the Properties panel Masks mode (as well as elsewhere, such as in the Options bar for various tools) allows you to apply a Feather setting with up to 2 decimal places accuracy.

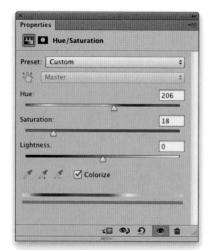

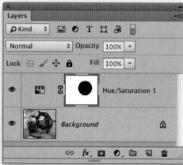

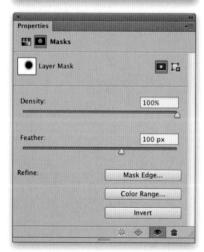

Editing a mask using the masks controls

1 Here, I applied a Hue/Saturation adjustment that applied a blue colorize effect. I then made an elliptical selection, selected the pixel layer mask and filled with black to reveal the original colors in the photograph.

2 I then went to the Properties panel in Masks mode and increased the Feather amount to 100 pixels to make the hard mask edge softer.

3 Let's say I wanted to soften the transition between the masked and unmasked areas. By decreasing the Density I could make the black areas of the mask lighter and thereby reveal more of the adjustment effect in the masked area of the image.

4 This technique is not just limited to pixel masks. In this step I started with a subtractive elliptical pen path shape, applied this as a Vector Mask and used the same Properties panel settings as in Step 2 to soften the vector mask edge.

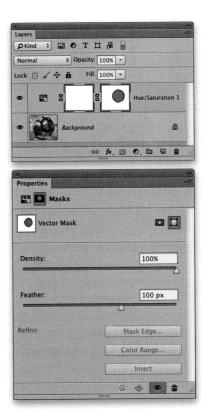

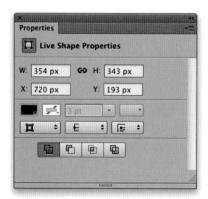

Figure 4.50 This shows the Live Shapes Properties panel for the Ellipse shape tool.

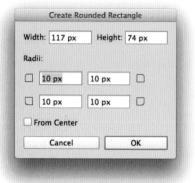

Figure 4.51 The Create Rounded Rectangle dialog.

Live shape properties

This is a new addition to Photoshop CC. When you add an ellipse shape you will see the Live Shape Properties shown in Figure 4.50. When you add a rectangle or rounded rectangle shape you'll see the Live Shape Properties shown in Figure 4.52. Here, it is possible to edit the corners of the rectangle shape. Note that the Properties panel only shows these options where an ellipse, rectangle or rounded rectangle path or shape layer is selected. If you click in the image with the rounded rectangle tool, this pops the dialog shown in Figure 4.51, where you can also set the corner radii.

This feature will mainly benefit graphic designer users, although the following steps show how it might also prove useful when editing photographs.

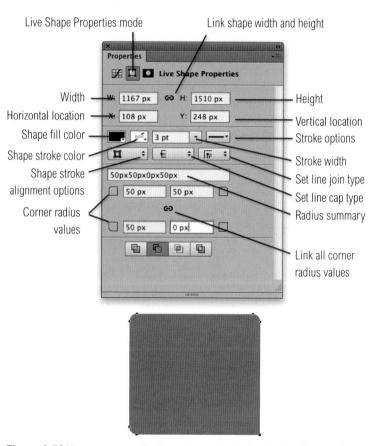

Figure 4.52 Here you can see the Properties panel showing the Live Shape options, where it is possible to edit the individual corner settings for a rectangle, rounded rectangle shape or path outline. Below the Properties panel is the shape outcome for a rectangle shape with these applied settings.

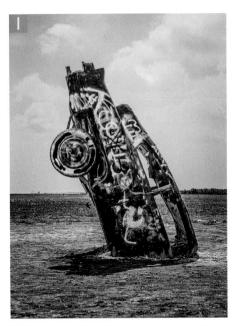

1 I began here with a photograph taken at Cadillac Ranch, just outside Amarillo, Texas. In the following steps I wanted to show how you can use the Properties panel to edit the corners of a vector mask.

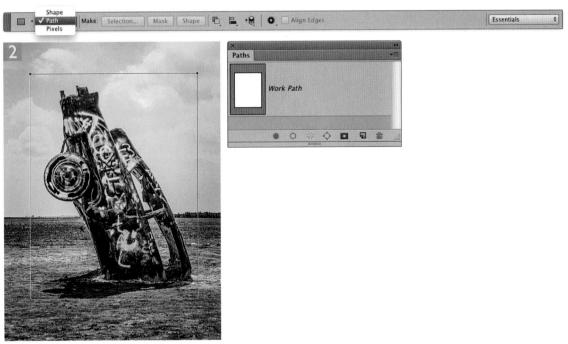

2 I first selected the regular rectangle tool in Path mode and defined a rectangle path outline. This added a new Work Path in the Paths panel.

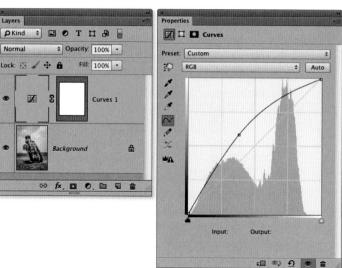

3 With the work path active, I added a new Curves adjustment layer, which added a curves adjustment layer and applied the active path as a vector mask. I then edited the Curve to apply a lightening adjustment.

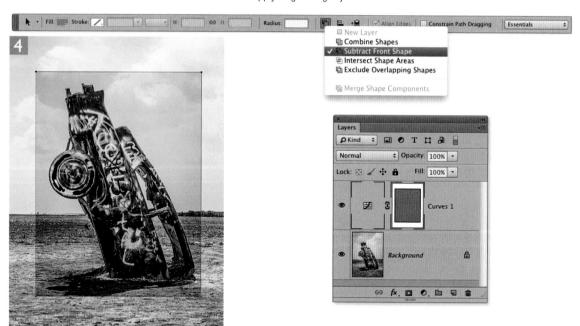

4 For this image I wanted the effect to be reversed, so I selected the path select tool, clicked to activate the path and selected Subtract From Shape from the menu shown here to invert the vector mask.

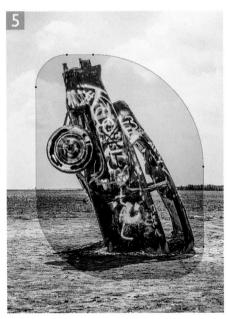

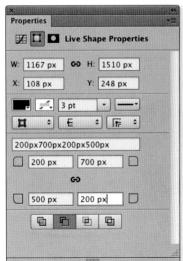

In the Properties panel I clicked on the Live Shape Properties button (between the Adjustment settings and Masks buttons) and proceeded to edit the corner settings. By doing so, I was able to control the shape for the original rectangular outline.

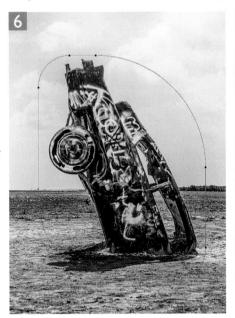

Lastly, I clicked on the Masks button to switch to the Masks mode for the Properties panel and adjusted the Feather setting to soften the modified mask edge.

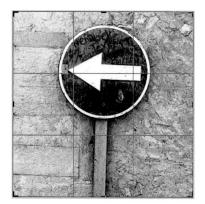

Figure 4.53 This shows an image with the crop tool active, but no crop applied yet.

Figure 4.54 This shows the image being cropped, before confirming the crop.

Cropping

To crop an image, select the crop tool from the Tools panel. Note that when the crop tool is selected, the crop bounding box overlays the entire image (Figure 4.53). You can then drag any of the corner or side handles to adjust the crop. Or, you can click anywhere in the image area and drag to define the area to be cropped. As you crop an image the outer crop appears shielded (Figure 4.54). If you prefer, you can uncheck the Show Cropped Area option in the crop tool settings (Figure 4.57). Then, as you apply a crop (and switch to the crop mode) the Layers panel temporarily shows a crop preview layer. Don't worry. It doesn't mean any layers have been deleted - this is just a temporary preview (see Figure 4.55). As you drag a crop handle you'll notice how the underlying image moves as you adjust the crop and when a crop is active you can click and drag inside the crop area to reposition the image (and use the keyboard arrows to nudge the image). Both these behaviors make the Photoshop crop tool more like the one that's in Lightroom and (in my view) makes it easier to work with. Note there is also a single undo available when working in a modal crop and while the crop tool is in use you can click with the Shift key to then define a new crop area.

Entering measurement units

You can constrain a crop to specific dimensions by using the $W \times H \times Resolution$ option and enter the desired numeric units in the crop ratio field boxes plus the following abbreviations: Pixels (px), Inches (in), Centimeters (cm), Millimeters (mm), Points (pt) or Picas (pica).

Figure 4.55 The Layers panel view on the left shows an image in mid-crop where Delete Cropped Pixels is enabled and displays a Crop Preview layer. In this instance, an image that starts out with a Background layer will retain the Background layer after being cropped. However, if the Delete Cropped Pixels option is unchecked, a Background layer will afterwards become a Layer 0 layer.

Delete cropped pixels

If the Delete Cropped Pixels option is checked in the crop tool Options bar, the image will be cropped permanently and the Background layer preserved. But if the Delete Cropped Pixels option is unchecked it merely 'trims' the image, preserving the original image contents, including all the layers information, and a previous Background layer will be promoted to a normal layer. For example, Figure 4.55 shows how the Background layer becomes a Layer 0 layer.

Crop ratio modes

You can mouse-down on the crop aspect ratio menu to select which crop ratio mode you want to use (see Figure 4.56). In Photoshop CC the 'Unconstrained' option has been removed and there is now a clearer indication between the 'Ratio' and 'W x H x Resolution' modes (you can click the 'Clear' button to clear all the current fields to quickly get the 'unconstrained' behavior). Also, when the W x H x Resolution mode is selected, a Resolution field box appears in the Options bar (see Figure 4.57) and the last used settings are always remembered when exiting the crop tool. The Original Ratio option is still available though, but this has now been placed among the ratio presets list (see Figure 4.56).

Figure 4.56 This view of the crop tool Options bar shows the Crop aspect ratio menu. You can select 'Ratio', 'W x H x Resolution', or one of the aspect ratio presets shown here. If you select the New Crop Preset... menu option this saves the settings as a new crop tool preset that will be added to the Tool Presets panel. Or, if you apply a crop and then click on the Add new preset button at the bottom of the Tool Presets panel (circled), this adds a new preset based on the current image size settings. Note that with CC, ratio presets use ':' as a separator and W x H x Resolution presets continue to use x as a separator.

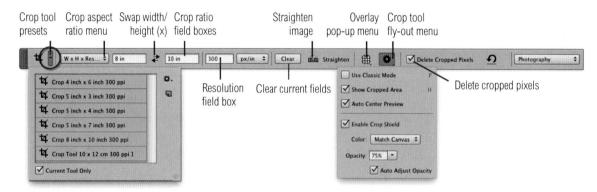

Figure 4.57 Here are the primary options for the crop tool. If you mouse down on the triangle button next to the crop tool you will see listed any preloaded crop tool presets.

Landscape and portrait mode crops

You will notice in Photoshop CC that the Rotate Crop Box button has disappeared. Instead, there is a swap width and height double arrow button in the crop tool Options bar. This used to be there in earlier versions of Photoshop. but got removed as part of the CS6 reorganization for the crop tool. What happens now is that when working in the W x H x Resolution mode, the value entered in the first entry field always corresponds to the width and the second value corresponds to the height. You then have the option to click on the double arrow button to swap these values around as necessary. So, you can click on the Swap width/height button to swap between a landscape or portrait mode crop and while a crop is active you can click on it to flip the crop between horizontal and vertical (or use the M key). When resizing a restricted aspect ratio crop box, you can also switch between the portrait and landscape orientations by dragging the bounding box from the corner.

Crop tool presets

Figure 4.57 shows the crop tool Options bar in normal mode before applying a crop. Here you can see the crop tool presets menu, which contains the same preset options that appear in the Tool Presets panel. This allows you to select a pre-saved crop preset setting that applies a crop with the required aspect ratio to crop an image and resize it to specific image dimensions and a specific pixel resolution setting. This is useful if you want to crop and resize an image to the desired pixel resolution in one go. As you drag on a corner or side

handle the crop can be scaled up or down, preserving the crop aspect ratio. When a fixed crop aspect ratio is in force the crop proportions will remain locked.

If no crop tool presets are visible in the Crop tool presets list, try going to the Tool Presets panel and load the *Crop and Marquee.tpl* preset.

You will notice that new factory presets have been added for the 'W x H x Resolution' mode. When saving a new crop tool preset the name of the tool (either crop tool or perspective crop tool) will be added as a prefix. (see Figure 4.58).

Figure 4.58 This shows the Tool Preset dialog for the crop tool (left) and perspective crop tool (right).

Crop overlay display

Once you are in a modal crop state you'll have a choice of crop guide overlay options (Figure 4.59). The default 'Rule of Thirds' option is shown in use in Figures 4.53 and 4.54. This applies a 3×3 grid overlay, which can be useful when composing an image.

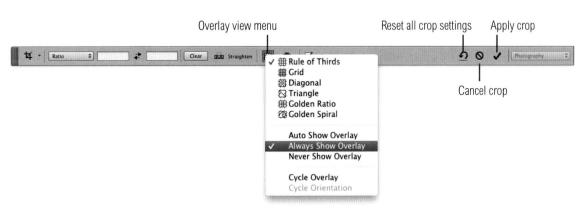

Figure 4.59 After you have dragged with the crop tool and before you commit to the crop, the tool Options bar will change (as shown here) to the crop modal state. To apply a crop, you can click on the Apply Crop button, double-click inside the crop area or hit the *Enter* or *Return* keys. To cancel a crop, click on the Cancel Crop button or hit the *esc* key.

Figure 4.60 The Crop options fly-out menu.

There are other overlay options you can choose. The 'Grid' option can be helpful when aligning a crop to straight lines in an image and there are also further options such as Diagonal, Triangle, Golden Ratio and Golden Spiral overlay options. You can cycle between these overlay options using the key and cycle between different crop overlay orientations using the shift keyboard shortcut.

Crop tool options

The crop tool options (Figure 4.60) can be accessed from the crop tool Options bar (Figure 4.57). The 'Use Classic Mode' option (P) allows you to toggle between the default behavior where the image moves relative to the crop, or the old behavior where the crop bounding box only is moved. Note that some new functionality will be lost if you choose to revert to the classic mode. The Auto Center Preview option allows you to toggle the 'image moving while resizing' behavior that keeps the crop box centered. The default settings have the crop shield enabled, applying a color that matches the canvas color at 75% opacity. But you can set this to any color you like, such as black at 100% opacity. The opacity can also be made to auto adjust when adjusting the crop position to reduce the opacity outside the bounding box area.

Front Image cropping

Selecting 'Front Image' (1) from the crop aspect ratio menu (se Figure 4.56) loads the current document full image size dimensions and resolution settings (there is also a Front Image button in the perspective crop tool Options bar).

Disable edge snapping

The edge snapping behavior can be distracting when you are working with the crop tool. This can easily be disabled in the View \Rightarrow Snap To submenu (or by using the \Re Snift; [Mac], ctrl Snift; [PC] shortcut).

1 In the following steps the Show Cropped Area option was enabled in the crop tool options (see Figure 4.57). I selected the crop tool and dragged across the image to define the crop area. The cursor could then be placed over any of the eight handles in the bounding rectangle to readjust the crop.

3 I could then mouse down outside the crop area and drag to rotate the crop around the center point, which can even be positioned outside the crop area. You normally do this to realign an image that is at an angle.

2 Dragging the cursor inside the crop area allowed me to move the crop. I could also drag the crop bounding box center point to establish a new central axis of rotation.

4 Here, I deselected the Show Cropped Area option from the crop tool Options bar (you can also use the **H** key shortcut to hide the outer shaded area).

Selection-based cropping

To make a crop based on a selection, all you need to do is select the crop tool () and the crop will automatically fit to the selected area. For example, you might want to () (Mac) (PC)-click a layer to make a selection based on a single layer and then execute a crop (as described below in Figure 4.61). You can also make a crop based on an active selection by choosing Image \Rightarrow Crop. When you do this the crop tool automatically matches the bounds of any selection. Where a selection has an irregular shape, the crop is made to the outer limits of the selection and the selection retained.

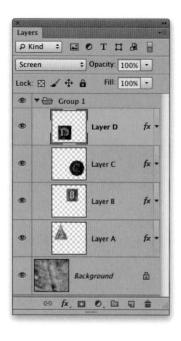

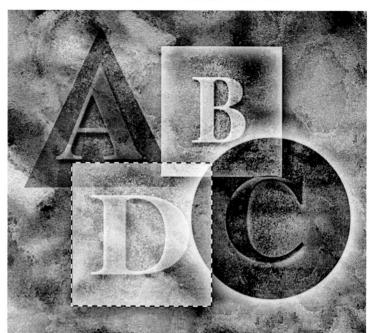

Figure 4.61 Sometimes it is quicker to make a crop from a selection rather than try to precisely position the crop tool. In the example shown here, if I wanted to make a crop of the box containing the letter D, the quickest solution would be to ∰ (Mac), (PC)-click on the relevant layer in the Layers panel and select the crop tool (C), or choose Image ⇒ Crop.

Canvas size

The Image ⇒ Canvas size menu item allows you to enlarge the image canvas area, extending it in any direction. This lets you extend the image dimensions in order to place new elements. If you check the Relative box you can enter the unit dimensions you want to see added to the current image size. The added pixels are then filled using the current background color, but you can also choose other fill options (see Figure 4.62). It is also possible to add to the canvas area without using Canvas Size (see Figure 4.63 below).

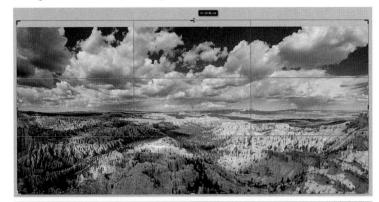

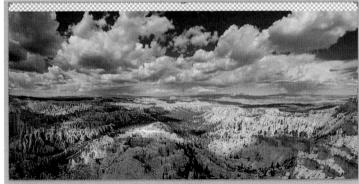

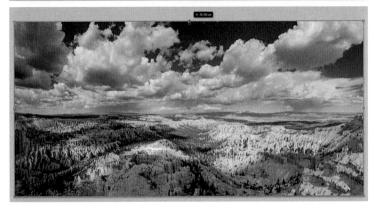

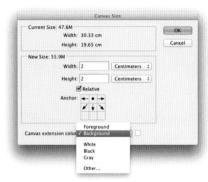

Figure 4.62 Canvas Size can be used to add pixels beyond the canvas bounds. In the example shown here, the image is anchored so that pixels are added equally left and right and to the bottom of the image only. When the Relative box is checked this allows you to enter the number of units of measurement you wish to add 'relative' to the current image size.

Figure 4.63 You can also use the crop tool as a canvas size tool. Make a full frame crop. release the mouse and then drag any one of the bounding box handles outside the image and into the canvas area. Double-click inside the bounding box area or hit Enter to add to the canvas size. If the starting point image has a Background layer, this step fills the added canvas with the current background color. In this example, the starting point is a non-Background layer, so adds transparency as more canvas is added. In the bottom image I used the content-aware scaling feature (discussed on page 404) to expand the image to fill the top and bottom of the new canvas area.

Big data

The Photoshop PSD, PDF and TIFF formats all support 'big data'. This means that if any of the layered image data extends beyond the confines of the canvas boundary, it is still saved as part of the image when you save it, even though it is no longer visible. If you have layers in your image that extend outside the bounds of the canvas, you can expand the canvas to reveal all of the big data by choosing Image ⇒ Reveal All (see Figure 4.64). Remember though, the big data can only be preserved providing you have saved the image using the PSD, PDF or TIFF formats. Also, when you crop an image that contains a normal, non-flattened Background layer and the 'Delete Cropped Pixels' box is unchecked, Photoshop automatically converts the background layer to a Layer 0 layer (and preserves all the big data).

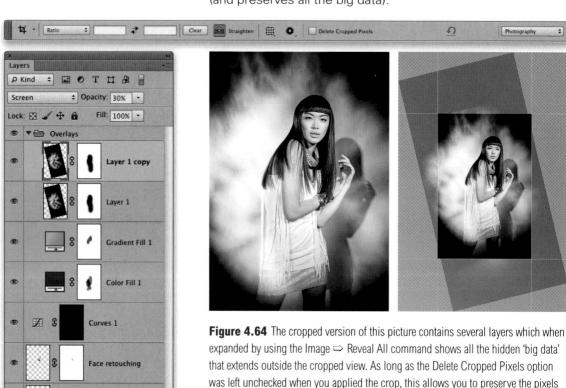

Client: Gallagher Horner. Model: Kelly @ Zone.

that fall outside the selected crop area instead of deleting them.

69 fx. 10 0. 13 1 1

Retouching

Perspective crop tool

The perspective crop tool can be used to crop and correct the converging verticals or horizontal lines in a picture with a single crop action. In Figure 4.65 I wanted to correct the perspective distortion seen in this photograph. Using the perspective crop tool I was able to accurately reposition the corner handles on the image to match the perspective of the shop front. You can either marquee drag with the tool as usual, or click to define the four corners of the perspective crop, after which you can drag on the corner and/or side handles to adjust the crop shape. Having done this you can click to confirm and apply the crop and, at the same time, correct the perspective. The perspective crop should work well in most cases, but you may sometimes need to apply a further transform adjustment to compensate for any undesired stretching of the image.

Modifying a perspective crop

When the perspective crop bounding box is active you can modify the crop shape by dragging the corner or side handles. If you hold down the Shift key as you drag a handle this constrains the movement to vertical or horizontal plane movement only. If you hold down the All key as you drag a corner handle this allows you to resize the crop in both planes at once. If you hold down the All key as you drag a side handle this allows you to expand the crop equally both sides at once.

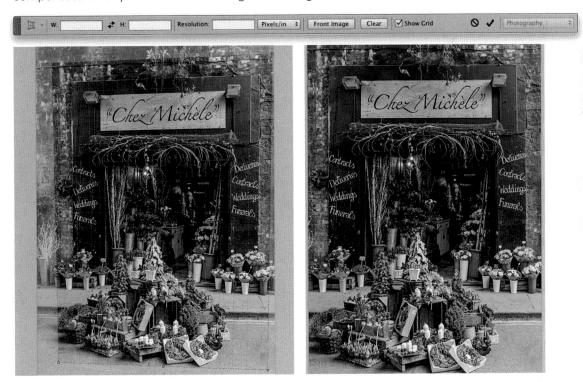

Figure 4.65 The perspective crop tool is great for correcting perspective. You will mostly find it easier to zoom in to gauge the alignment of the crop edges against the converging verticals. Here, it was also useful to check the 'Show Grid' option to help gauge the alignment correctly. Note also the 'Front Image' button. Clicking this loads the current document full image size dimensions and resolution settings, so that when you apply the crop the cropped image retains the same size (but may well appear stretched of course).

Edge detection success rate

The content-aware scale feature is very clever at detecting which edges you would like to keep and those you would like to stretch or squash, but it won't work perfectly on every image. You can't expect miracles, but if you follow the suggestions on these pages, you will pick up some of the basic tips for successful use. What I have noticed though is it does appear to do a very good job of recognizing circular objects and can preserve these without distorting them. Russell Brown has done some very cool demos on working with this feature. You check them out on his site: www. russellbrown.com/tips tech.html.

Content-aware scaling

The content-aware scale feature first appeared in Photoshop CS4. It was quite controversial since it invited Photoshop users to tamper with photographs in ways that were likely to raise the hackles of photography purists. Would this spell the 'death of real photography' (DORP)? That I don't know, but over the next few pages I have outlined some of the ways you can work with this tool and suggested some practical uses. Advertising and design photographers may certainly appreciate the benefits of being able to adapt a single image to multiple layout designs.

To use this feature, you will need an image that's on a normal layer (not a Background layer). Next, you need to go to the Edit menu and choose Content-Aware Scale (or use the Balt Shift C [Mac], ctrl alt Shift C [PC] shortcut). You can then drag the handles that appear on the bounding box for the selected layer to scale the image, making it narrower/wider, or shorter/taller. The preview then updates to show you the outcome of the scale adjustment and you can use the Options bar to access some of the extra features discussed here such as the Protect menu options.

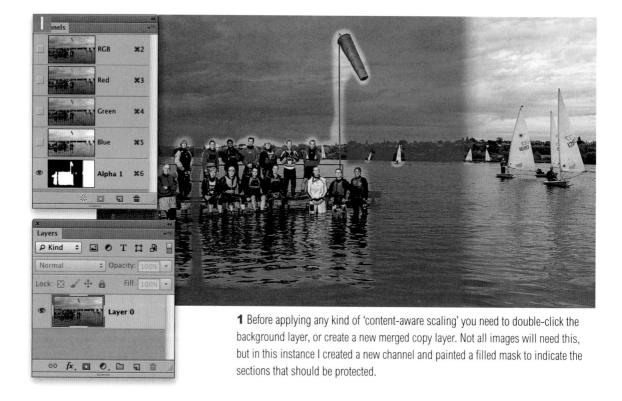

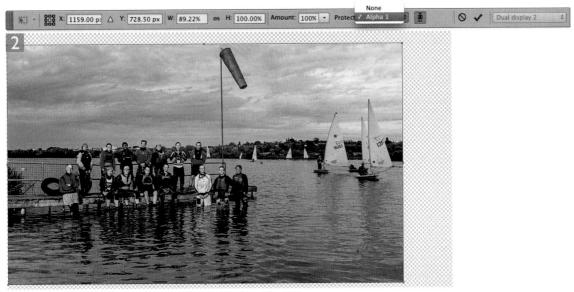

2 This shows what the photograph looked like after I had used the Edit

Content-Aware Scale command to compress the image on the side as well as top
and bottom. Note that the Alpha 1 channel mask created in Step 1 was selected in the
Protect menu.

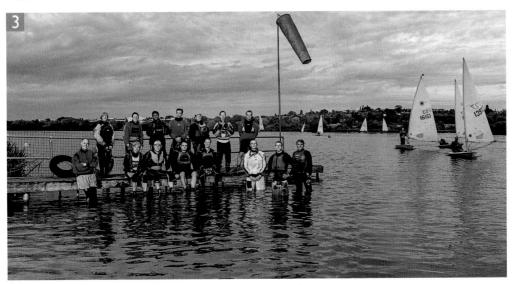

3 Here is the final result, in which there was now less gap between the jetty and the boats on the right. The people in the group now appear relatively bigger in the scene. Whenever you scale an image using this method, you have to watch carefully for the point where important parts of the picture start to show jagged edges. When this happens, you'll need to ease off and consider scaling the image in stages instead. For example, with this image I applied a second pass content-aware scale to reduce the height of the wind sock mast.

Layers P Kind Opacity: 100% Lock: A A B Fill: 100% Layer 0

How to protect skin tones

1 In this example I wanted to show how you can help protect people's faces from being squashed or stretched as you scale an image.

Amount slider

After you have applied a content-aware scale adjustment to a photograph (and before you click OK to apply it), you can use the Amount slider to determine the amount of content-aware scaling that is applied to the layer. If you set this to zero, no special scaling is applied and the image will be stretched as if you had applied a normal transform. You will note that I left the Amount slider setting at 100% in all the examples shown here, in order to demonstrate the full effect of the content-aware scaling.

2 In general, you will find that the content-aware scale feature does a pretty good job of distinguishing and preserving the important areas of a photograph and tends to scale the less busy areas of a photograph first, such as a sky, or in this case the mottled backdrop. However, if you click on the Protect Skin tones button (circled), this usually ensures that faces in a photograph remain protected by the scaling adjustments. As you can see here, I was able to stretch this picture horizontally so that the couple in this photograph were moved across to the right. I was able to stretch the image quite a bit, but without distorting the faces.

Photograph: © Jeff Schewe

How to remove objects from a scene

1 The content-aware scale feature can also be used as a tool to selectively remove objects from a scene. The results won't always be completely flawless, but it can still work pretty well where you wish to squash an image tighter and remove certain elements as you do so. To begin with it is important that the layer you are working on is a non-Background layer. You will need to either duplicate the Background layer or double-click to convert it to a normal layer. I hit the key to switch to Quick Mask mode (see Chapter 9) and painted on the image to outline the bits that I wished to remove. With the Quick Mask, white protects and black (which appears on the image as a red overlay) indicates the areas to remove.

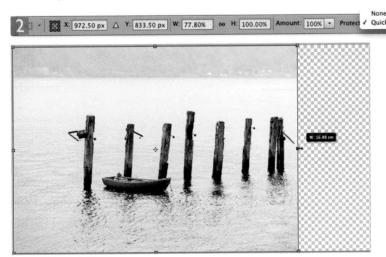

2 Next, I reselected the RGB composite channel in the Channels panel and selected the Edit ⇒ Content-Aware Scale command. From the Protect menu in the Options bar, I selected the Quick Mask I had just created, and as I scaled the image, the masked posts started to disappear. As before, it is important to watch carefully for jagged edges and not compact the image too much.

Dual display 2

Straighten tool shortcut

When the crop tool is selected you can use the # (Mac) ctrl (PC) key to temporarily access the straighten tool. Or, if you are in the straighten tool mode, you can use the # (Mac) ctrl (PC) key to switch back to the crop box editing mode.

Image rotation

If an image needs to be rotated you can use the Image Rotate menu to orientate a photo the correct way up, turn it 180°, flip it horizontally, or vertically even. To apply a precise image rotation, you can click to select the straighten tool from the crop tool Options bar (circled) and drag across the image as shown in Figure 4.66. Alternatively, if you wish to rotate an individual layer, make the layer active, select the ruler tool and drag to define the edge you wish to appear straight. Then click the Straighten Layer button in the ruler tool Options bar (Figure 4.67) to straighten.

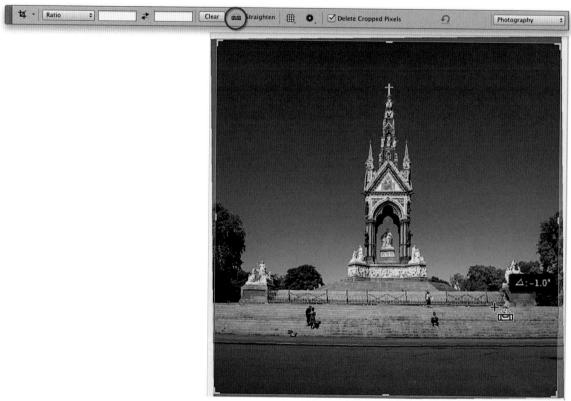

Figure 4.66 If an image doesn't appear to be perfectly aligned, click on the Straighten button in the crop tool Options bar and drag along what should be a vertical or horizontal edge in the photo. This will rotate the image so that it appears to be perfectly straight.

Figure 4.67 To straighten a layer, select the ruler tool and again, drag to define the edge that should be straight. Then in the ruler tool Options bar click on the Straighten Layer button to straighten the selected layer.

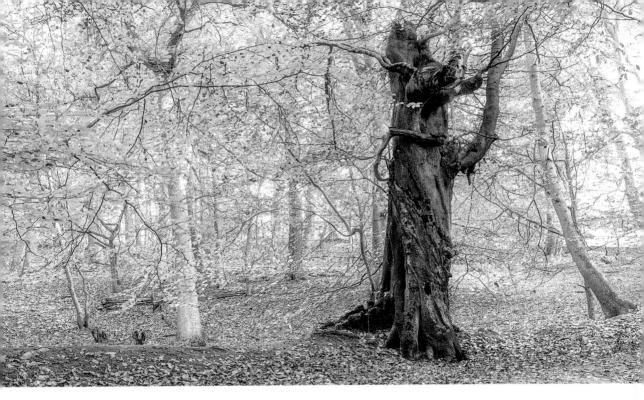

Chapter 5

Black and white

I was eleven years old when I first got into photography. My first darkroom was kept under the stairs of our house and, like most other budding amateurs, my early experiments were all done in black and white. Back then, very few amateur photographers were competent enough to know how to process color, so black and white was all that most of us could manage to work with. For me, there has always been something rather special about black and white photography and digital imaging has done nothing to diminish this. If anything, I would say that the quality of capture from the latest digital cameras coupled with the processing expertise of Photoshop and improvements in inkjet printing have now made black and white photography an even more exciting avenue to explore.

Black and white film conversions

Traditional black and white film emulsions all differ slightly in the way they respond to different portions of the visual spectrum (as well as the colors we can't see). This is partly what gives emulsion films their 'signature' qualities. So in a way, you could say that film also uses standard formulas for converting color to black and white, and that these too are like rigid grayscale conversions. You may also be familiar with the concept of using strong colored filters over the lens when shooting with black and white film and how this technique can be used to emphasize the contrast between certain colors, such as the use of yellow, orange or red filters to add more contrast to a sky. Well, the same principles apply to the way you can use the Black & White adjustment to mix the channels to produce different kinds of black and white conversions.

Figure 5.1 If you convert a color image to grayscale mode, Photoshop pops the dialog shown here which is basically advising you there are better ways to convert to black and white.

Converting color to black and white

The most important tip here is to always shoot in color. Wherever possible you are far better off capturing a scene in full color and using Camera Raw or Photoshop to carry out the color to mono conversion. Having said that, you do need to use the most appropriate conversion method to get the best black and white photographs from your color files.

Dumb black and white conversions

When you change a color image from RGB to Grayscale mode in Photoshop, the tonal values of the three RGB channels are averaged out to produce a smooth continuous tone grayscale. The formula for this conversion consists of blending 60% of the green channel with 30% of the red and 10% of the blue. The rigidity of this color to mono conversion limits the scope for obtaining the best grayscale conversion from a scanned color original (see Figure 5.1). The same thing is true if you make a Lab mode conversion, delete the *a* and *b* channels and convert the image to grayscale mode, or if you were to simply desaturate the image. There is nothing necessarily wrong with any of these methods, but none allow you to make full use of the information that's contained in a color image.

Smarter black and white conversions

If you capture in color, the RGB master image contains three different grayscale versions of the original scene and these can be blended together in different ways. One of the best ways to do this is to use the Black & White image adjustment in Photoshop, which while not perfect, can still do a good job in providing you with most of the controls you need to make full use of the RGB channel data when applying a conversion. The Black & White slider adjustments will, for the most part, manage to preserve the image luminance range without clipping the shadows or highlights. These adjustments can be applied to color images directly, or by using the Adjustments panel method to add an adjustment layer. The advantage of using an adjustment layer to apply a black and white conversion is that you can quickly convert an image to black and white and have the option to play with the blending modes to refine the appearance of the black and white outcome. Let's start though by looking at the typical steps used when working with the Black & White adjustment controls.

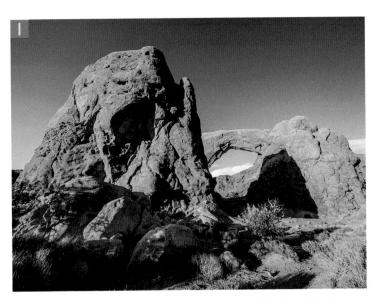

1 The following steps show a basic method for converting a full color original photograph to black and white. The Black & White image adjustment can be applied directly by going to the Image ⇒ Image Adjustments menu, or you can go to the Adjustments panel and click on the Black & White button (circled in red) to add a new adjustment layer.

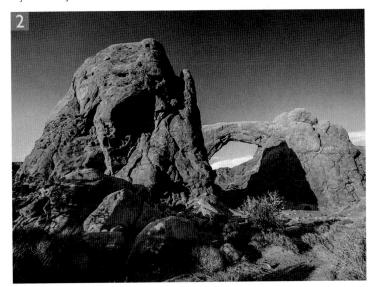

2 To begin with I clicked on the Auto button (circled in blue). This applied an auto slider setting based on an analysis of the image color content. The auto setting usually offers a good starting point for most color to black and white conversions and won't do anything too dramatic to the image, but is immediately a lot better than choosing Image

Mode
Grayscale.

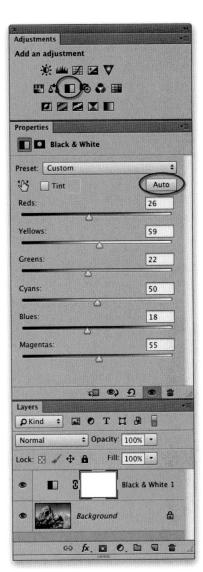

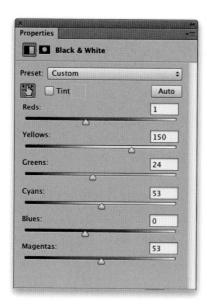

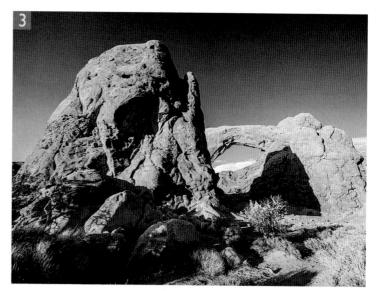

If you don't like the auto setting result, you can adjust the sliders manually to achieve a better conversion. In this example, I lightened the Yellows and darkened the reds slightly.

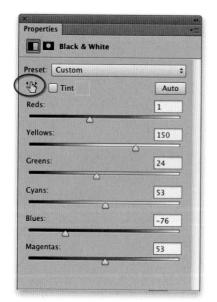

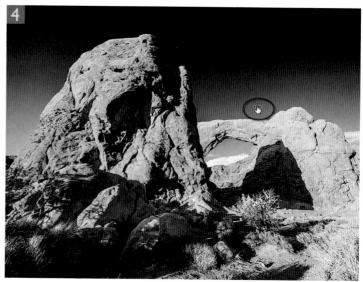

Lastly, I clicked on the target adjustment mode button (circled) for the Black & White adjustment. This allowed me to move the cursor over particular areas of interest (such as the sky) and drag directly on the image to modify the Black & White adjustment. This step selected the nearest color slider in the Black & White adjustment panel. Dragging to the left made the tones beneath the target adjustment tool cursor go darker and dragging to the right, lighter. In the example you see here I managed to increase the contrast in the sky.

Black & White adjustment presets

As with other image adjustments, the Black & White adjustment has a Presets menu at the top from where you can select a number of shipped preset settings. Figure 5.3 shows examples of the different outcomes that can be achieved through selecting some of the different presets from this list.

Once you have created a Black & White adjustment setting that you would like to use again you can choose Save Preset... from the Properties panel options menu (Figure 5.2). For example, I was able to save the slider settings shown here as a custom preset called 'Red Contrast'.

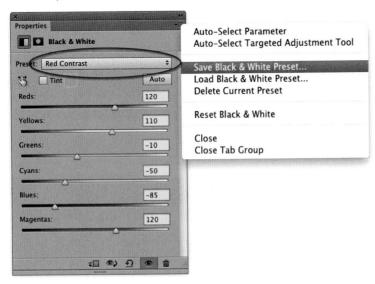

Figure 5.2 The slider settings shown here were saved as a 'Red Contrast' preset. Saved presets can be accessed by mousing down on the Presets menu at the top of the Black & White adjustment Properties panel (circled).

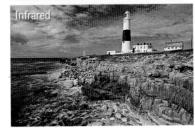

Figure 5.3 This shows some examples of different Black & White adjustment presets applied to a color image.

Split color toning using Color Balance

Although the Black & White adjustment contains a Tint option for coloring images, this only applies a single color overlay adjustment and I have never really found it to be that useful. It is nice though to have the ability to apply a split tone coloring to a photograph and one of the best ways to do this is by using the Color Balance image adjustment. This is ideal for coloring RGB images that have been converted to monochrome using the Black & White adjustment method, mainly because the Color Balance controls are really quite intuitive and simple to use. If you want to colorize the shadows, click on the Shadows radio button and adjust the color settings, then go to the Midtones, make them a different color, and so on. Note that it is best to apply coloring effects with the adjustment layer set to the Color blend mode. The advantage of using the Color blend mode is that you will be able to alter the color component of an image without affecting the luminosity. This is important if you wish to preserve as much of the tone levels information as possible.

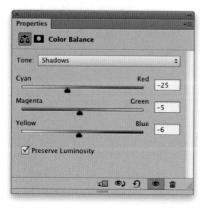

1 I started here with an RGB color image and converted it to monochrome using the Black & White image adjustment. I then added a Color Balance adjustment layer to colorize the RGB/monochrome image. To do this, I went to the Adjustment panel and selected the Color Balance adjustment. In the Properties panel I selected the Shadows option from the Tone menu and adjusted the three color sliders to apply a color cast to the shadows.

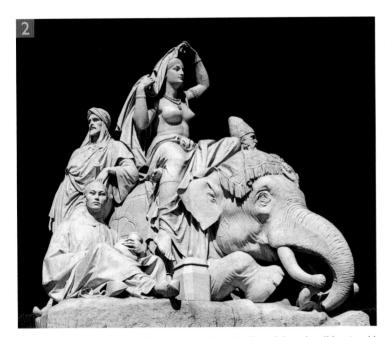

2 I then selected the Midtones Tone menu option and adjusted the color sliders to add a warm color balance to the midtones. You will notice that I had Preserve Luminosity checked. This helped prevent the image tones from becoming clipped.

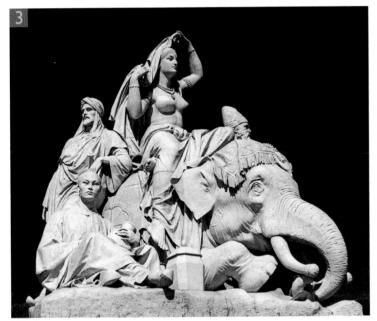

3 Finally I selected the Highlights option from the Tone menu and added a red/yellow cast to the highlights. I also set the adjustment layer blending mode to Color, which helped preserve all the image luminance information.

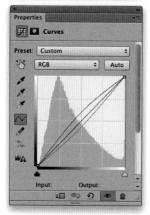

Split color toning using Curves adjustments

The Color Balance method is reasonably versatile, but you can also colorize a photograph by using two Curves adjustment layers and taking advantage of the Layer Style blending options to create a more adaptable split tone coloring effect.

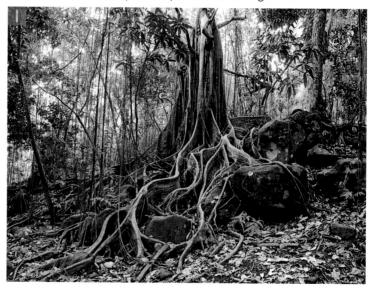

1 To tone this image, I first added a Curves adjustment layer above a Black & White adjustment layer and adjusted the channel curves to apply a blue/cyan color adjustment.

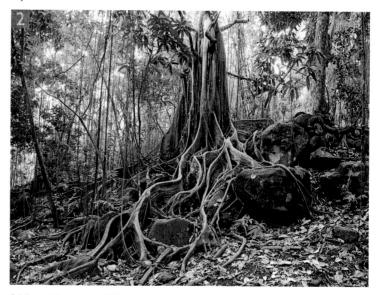

2 I then added a second Curves adjustment above the previous one and this time adjusted the channel curves to apply a sepia colored adjustment.

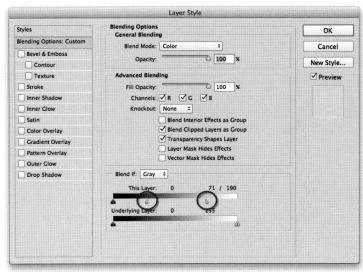

Double-click in this area of the layer to open the Layer Style dialog.

3 I made the first Curves layer active and double-clicked to open the Layer Style dialog shown here. I then all-clicked on the highlight divider triangle in the 'This Layer' 'Blend If' layer options. This enabled me to separate the divider, splitting it into two halves (circled). This allowed me to control where the split between these two points occurred.

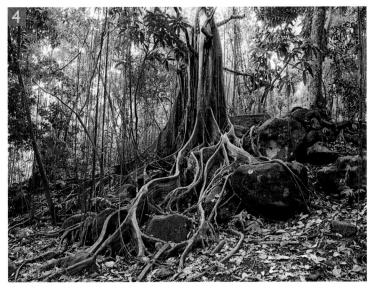

4 The advantage of this method is that you can adjust the layer opacity and Layer Style blending modes of each individual layer and this offers more flexibility when it comes to deciding how best to color the shadows and highlights.

Photographic toning presets

If you click on the Presets menu, circled red in Step 2, or click on the gradient ramp options, circled blue in Step 2 (and then click on the presets options icon), you can add new sets of gradient map presets. Among these is a set titled 'Photographic Toning' (see Figure 5.4). This set of gradient maps has been specifically designed for creating split toning effects.

Figure 5.4 This shows the gradient map presets in the new Photographic Toning set.

Split color toning using a Gradient Map

The coloring techniques shown so far allow you to apply split tone type coloring effects. Of these the Color Balance method is perhaps the easiest to use. However, there is another method you can apply in Photoshop and that is to use the Gradient Map adjustment that's shown here. When applied using the Normal blend mode the Gradient Map uses a gradient to map the tones in the image to new values. This in itself can produce some interesting effects when combined with standard Photoshop gradients. But if you set the Gradient Map adjustment layer blend mode to Color you can restrict the adjustment so that it can be used just to colorize the image. As you can see in Step 2, the gradient doesn't have to go from dark to light, what counts are the color hue and saturation values that are applied at each stage of the gradient. To edit the colors you just need to click on the gradient ramp to add a new color swatch and double-click a swatch color to open the Photoshop Color Picker and select a new color.

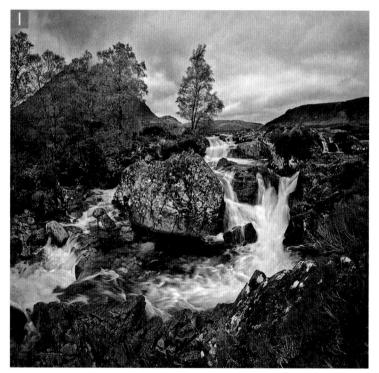

1 Here is a photograph that I wished to apply a duotone type effect to, but at the same time I wanted to keep this image in RGB mode.

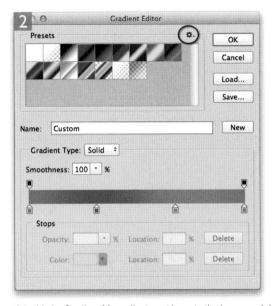

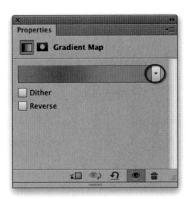

2 I added a Gradient Map adjustment layer to the image and double-clicked the gradient in the Gradient Map adjustment Properties panel to create a new gradient setting.

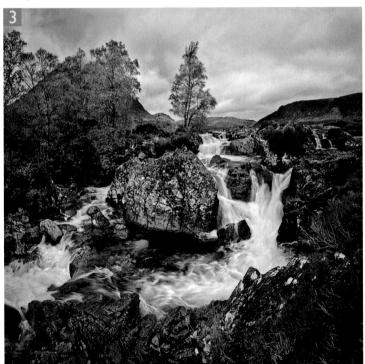

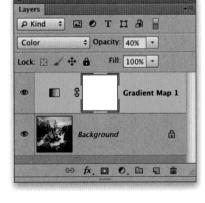

 $\bf 3$ I set the Gradient Map layer blend mode to Color and in this instance reduced the layer opacity to 40% to produce the coloring effect seen here.

The extra color sliders

Camera Raw provides you with more sliders to play with than the Black & White adjustment. These allow you to adjust the in-between color ranges such as Oranges, Aquas and Purples. The Oranges slider is useful for targeting skin tones and the Aquas is useful for adjusting things like the sea. Having these extra sliders provides you with extra levels of tone control.

Camera Raw black and white conversions

You may already have noticed that you can use Camera Raw to convert images to black and white. This can be done at the raw processing stage to a raw, JPEG, or TIFF image (providing the TIFF is flattened). Or, you can do so using the Camera Raw filter from the Filter menu.

If you go to the HSL/Gravscale panel and check the Convert to Grayscale box, Camera Raw creates a black and white version of the image, which is produced by blending the color channel data to produce a monochrome rendering of the original. Clicking 'Auto' applies a custom setting that is based on the white balance setting applied in the Basic panel and clicking 'Default' resets all the sliders to zero. You can manually drag the sliders to make certain colors in the color original lighter or darker, or select the target adjustment tool (circled in Step 2) to click and drag on the image to make certain colors convert to a darker or lighter tone. The overall tone brightness and contrast should not fluctuate much as you adjust the settings here and this makes it easy to experiment with different slider combinations. For example, if you want to make a sky go darker you can copy what I did in Step 2. Here, I selected the target adjustment tool, clicked on the sky and dragged to the left. This caused the Aquas and Blues sliders to shift to the left, darkening these tones. I would also suggest sometimes switching over to the Basic and Tone Curve panels. to make continued adjustments to the white balance and tone controls as these can also strongly influence the outcome of a black and white conversion

Pros and cons of the Camera Raw approach

In my view, Camera Raw black and white conversions have the edge over using the Black & White adjustment in Photoshop. This is because the slider controls are better thought out and the addition of the in-between color sliders (see sidebar) makes it possible to target certain colors more precisely. The target adjustment mode correction tool in Camera Raw also performs better than the one found in Photoshop's Black & White adjustment.

An important question to raise here is 'when is the best time to convert a photo to black and white?' If you do this at the early Camera Raw stage it limits what you can do to a photo should you then want to retouch the image in Photoshop. I find it is usually better to carry out the black

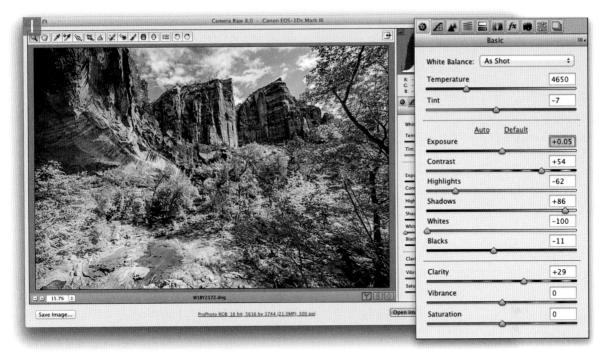

1 This shows a color image opened in Camera Raw.

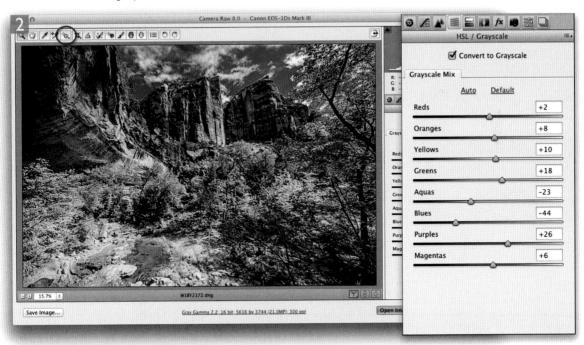

2 In the HSL/Grayscale panel I clicked on the Convert to Grayscale button and with the help of the target adjustment tool (circled), clicked and dragged directly on the image to make adjustments that would increase the contrast in the clouds.

and white conversion at the end of the editing process and have the adjustment be reversible. This is not a problem in Photoshop, because if you add a Black & White adjustment laver, it is easy enough to toggle the adjustment on or off. If vou want to use Camera Raw to make the black and white conversion, you need to somehow take the Photoshop-edited image back through Camera Raw again, Before Photoshop CC this meant saving a JPEG or flattened TIFF version and re-editing a derivative version of the master image via Camera Raw. But as I mentioned earlier, now that Camera Raw is available as a filter from the Filter menu, it is now much easier to apply a Camera Raw adjustment directly in Photoshop. I would recommend you convert the image layer or layers you wish to edit into a smart object first though, so the Camera Raw black and white edits remain non-destructive. Another option is to use Lightroom. Here, it is possible to re-import your Photoshop-edited images back into Lightroom and use the Develop module in Lightroom to carry out a black and white conversion. The advantage of this approach is that both PSD and TIFF formats can be read and they don't have to be flattened - Lightroom doesn't have a problem processing layered PSD or TIFF format images.

HSL grayscale conversions

If you set all the Saturation sliders in the HSL panel to -100, you can then use the Luminance sliders in the HSL panel to make almost the same type of adjustments as in the Grayscale mode. One of the chief advantages of this method is you can use the Saturation and Vibrance controls in the Basic panel to fine-tune the grayscale conversion effect, which you can't do when using just the ordinary Grayscale conversion mode.

Camera Calibration panel tweaks

Another thing I discovered is you can also use the Camera Calibration panel sliders to affect the outcome of a Camera Raw black and white conversion.

Camera Raw Split Toning panel

After you have used the HSL/Grayscale panel to convert a photograph to black and white you can use the Split Toning panel to colorize the image. These controls allow you to apply one color to the highlights, another color to the shadows and use the Saturation sliders to adjust the intensity of the colors. This is how you create a basic split tone color effect. There is also the Balance slider, which lets you adjust the midpoint for the split tone effect. In Figure 5.5 I applied a warm tone to both the highlights and shadows and adjusted the Balance slider so that the split toning was biased more towards the highlights. The HSL/Grayscale and Split Toning controls are incredibly versatile. Bear in mind these can work equally well with non-raw images.

Saturation shortcut

When dragging the Hue sliders in the Split Toning panel you can hold down the ** key to temporarily apply a boosted saturation to the split tone adjustment and thereby see more clearly the hue value you are applying. This works even when the Saturation sliders are set to zero.

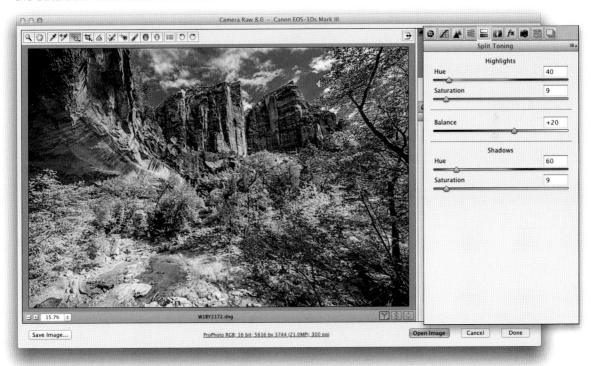

Figure 5.5 This shows an example of a Split Toning adjustment in Camera Raw.

Camera Raw color image split toning

Although the Split Toning panel is designed to be used with black and white images, these controls can be just as useful when editing color photos. While it is possible to apply split toning effects in Photoshop, the Split Toning controls in Camera Raw can produce similar results, but with less hassle.

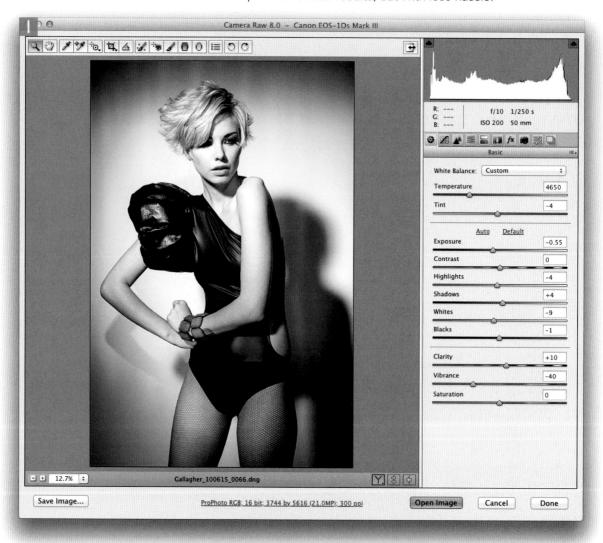

1 Here you can see a photo before I had applied a split toning effect. This started out as a full-color image, although I did apply a -40 Vibrance adjustment to desaturate the colors slightly.

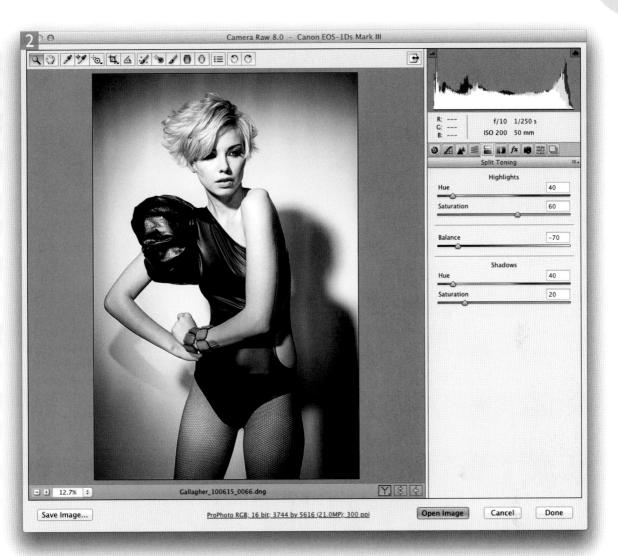

2 I then went to the Split Toning panel and adjusted the Hue and Saturation sliders to create the split toning effect shown here. Essentially, the Hue sliders allow you to independently set the hue color for the highlights and the shadows and the Saturation sliders let you adjust the saturation. As I mentioned on page 423, if you hold down the all key as you drag on a Hue slider you'll see a temporary, saturated preview. This allows you to set the Hue slider for the desired color, without needing to adjust the Saturation slider first. The Balance slider can be used to adjust the balance between the highlight and shadow colors. This lets you offset the midpoint between the two. What is interesting to note here is that although the Hue values were the same for both the highlights and shadows, the Balance slider can still have a subtle effect on the outcome of any Split Tone adjustment.

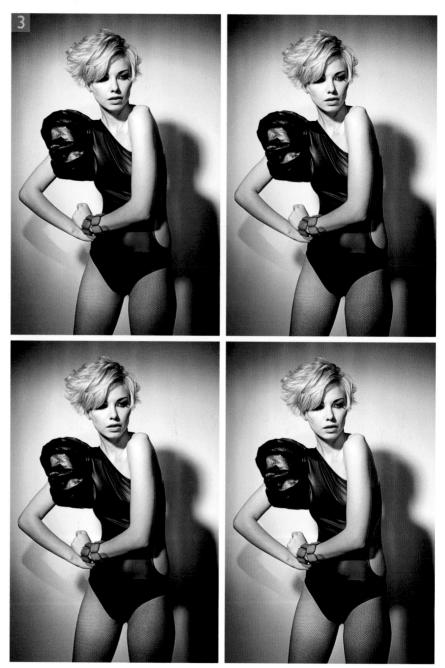

To demonstrate the versatility of the Split Toning panel, these four additional looks were created by further tweaking the Split Toning panel settings.

Black and white output

Black and white printing should be easy, but if you are printing from RGB files you'll meet exactly the same issues that affect normal color printing. Your ability to match the print output to the display will, as always, be dependent on the accuracy of the computer display calibration, the type of paper you are printing with and the effectiveness of the printer profile you are using. Mind you, with black and white printing there is perhaps more latitude for the color to be off and still produce pleasing results. But if you are aiming for a perfectly neutral black and white print, then the profile used must be accurate. In theory, if the measured Info panel gray values are all neutral, the print output should be neutral too.

Advanced B&W Photo tips

If you are using one of the more advanced Epson printers you may be interested to know that you can access the Advanced B&W Photo settings shown in Figure 5.6, where you can apply coloring effects via the Epson driver system Print dialog. There are a few things you need to do in order to access and make the most of the Advanced B&W feature for Epson printers. Firstly, this is only available with certain printer models, such as the Epson 4800 and later models. You can make a print from either RGB or Grayscale images, but the printer driver assumes the image to be in neutral RGB (and ignores any colors), or to be in Grayscale mode. Normally you would convert to Grayscale first, in which case the gamma of the Grayscale space you convert to should match the gamma of your RGB workspace (see the Color Management PDF that is on the book website). In the Photoshop Print dialog you will want to select Photoshop Manages Colors and select an appropriate printer profile and rendering intent (again, see the Color Management PDF). When you click Print, this will take you to the Epson print dialog, where in the Print Settings section you will need to select an appropriate media type, such as Photo Paper ⇒ Premium Glossy Photo Paper, in order to match the profile selected in the Photoshop Print dialog (note also that not all paper media settings support Advanced B&W). Next, select 'Advanced B&W Photo' from the Color section of the Print dialog (see page 692). Having done that, click on the Advanced Color Settings, to access the Print dialog options shown in Figure 5.6, where the key thing is to leave most of

K.

these sliders as they are, apart from choosing a color toning method. You can choose a preset color from this menu, click on the color wheel below, or adjust the Horizontal and Vertical values. You will notice that the Tone setting says 'Darker'. This is actually the default setting, but you can modify this if you wish.

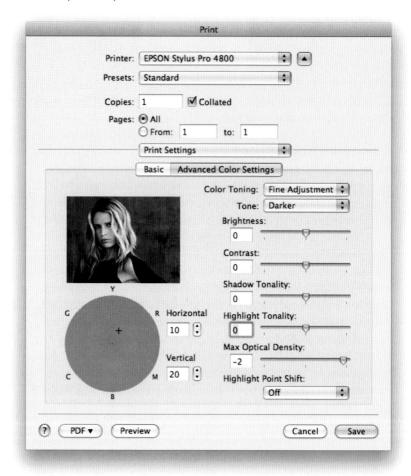

Figure 5.6 This shows the Advanced Color Settings for the Epson 4800 printer when the 'Advanced B&W Photo' option is selected in the main Print Settings section of the System print interface. This allows you to apply different black and white output toning options.

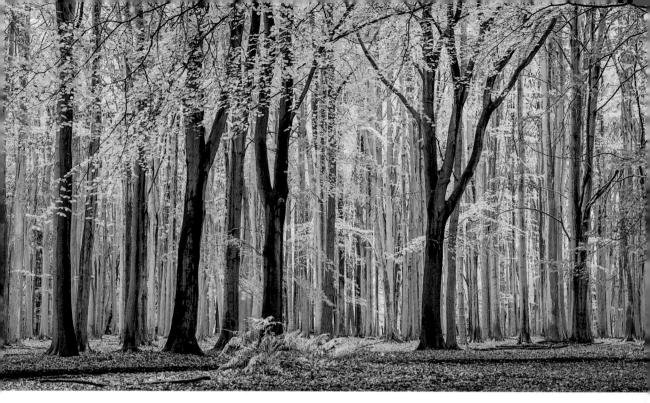

Chapter 6

Extending the dynamic range

For some time now, everyone has become preoccupied with counting the numbers of pixels in a digital capture as if this is the one benchmark of image quality that matters above all else. Size isn't everything though and it is really the quality of the pixel capture we should be concerned with most. The one thing people haven't focused on so much is the dynamic range of a camera sensor. Dynamic range refers to the ability of a sensor to capture the greatest range of tones from the minimum recordable shadow point to the brightest highlights and this is what we are going to focus on here in this chapter.

Other HDR applications

32-bit image editing is also used extensively to make the realistic CGI effects you see in many movies and television programs. These are created using a 32-bit color space to render the computer-generated characters. It is necessary to do this in order to make them interact convincingly with the real world film footage. What usually happens is a light probe image is taken of the scene in which the main filming takes place. This is an omnidirectional HDR image that can consist of a sequence of six or seven overlapping exposures shot of a mirrored sphere. The resulting light probe image contains all the information needed to render the shading and textures on a computer-generated object with realistic-looking lighting. Paul Debevec is a leading expert in HDR imaging and his website www.debevec.org contains a lot of interesting information on HDR imaging and its various applications.

High dynamic range imaging

It is interesting to see how camera sensor technology has evolved over the last few years and speculate what might be in store in the years to come. In time we may see camera sensors become available that are able to capture high dynamic range scenes in a single exposure. However, HDR cameras are not that common yet, so currently it is all about capturing bracketed sequences of images and blending these together to create single high dynamic range images that can contain the entire scenic tonal range.

Right now there are a lot of photographers interested in exploring what can be done using high dynamic range image editing. For example, using the Merge to HDR Pro feature in Photoshop you can combine two or more images that have been captured with a normal digital camera, but shot at different exposures and blend these together to produce a 32-bit floating point, high dynamic range image. You can then convert this 32-bit HDR file into a 16-bit per channel or 8-bit per channel low dynamic range version, which can then be further edited in Photoshop. In Figure 6.1 I show some examples of what high dynamic range processed images can look like. You are probably familiar with the typical 'HDR look' where there are obvious halos in the picture. While there are some photographers who like this kind of effect there has been a backlash against the illustrated feel of such images. A couple of years ago I was asked to help judge the UK's Landscape Photographer of the Year competition. I thought it was interesting to note that of all the obvious HDReffect photographs, not one of these got short-listed into the final selection. That said, there may have been some HDR processed images that did make it through, because HDR editing does not have to be about creating an artificial look.

Basically, high dynamic range image editing requires a whole new approach to the way image editing programs like Photoshop process the high dynamic range image data. Because of this the Photoshop team had to rewrite a lot of the Photoshop code so that some of the regular Photoshop tools could be made to work in a 32-bit floating point image editing environment. Photoshop therefore now offers a limited range of editing controls such as layers and painting in 32-bit mode. The Merge to HDR Pro feature has been further improved in Photoshop, but as you will read later in this chapter, Process 2012 for Camera Raw can also cope very effectively with raw image captures of high dynamic range subjects.

HDR essentials

Camera sensors record the light that hits the individual photosites and the signal is processed and converted into a digital file. I won't complicate things with a discussion of the different sensor designs used, but essentially the goal of late has been to design sensors in which the photosites are made as small as possible and crammed ever-closer together to provide an increased number of megapixels. Camera sensors have also been made more efficient so they can capture photographs over a wide range of ISO settings without generating too much electronic noise in the shadow areas or at high ISO settings. The problem all sensors face though is that at the low exposure extreme there comes a point where the photosites are unable to record any usable levels information over and above the random noise that's generated in the background. At the other extreme, when too much light hits a photosite it becomes oversaturated and is unable to record the light levels beyond a certain amount. Despite these physical problems we are now seeing improvements in sensor design, as well as the Camera Raw software, which means it is now possible to capture wide dynamic range scenes more successfully in a single exposure and process them in Camera Raw (using Process 2012).

DxO Mark sensor evaluation

If you go to the DxO Mark by DxO Labs website (www.dxomark.com, or more specifically: tinyurl.com/7nwftam) you will find technical reports on most of the leading digital cameras. These evaluate the performance of sensors, indicating their optimum effective performance for ISO speed, color depth and dynamic range. For example, the latest Nikon D800 scores an impressive dynamic range of 14.3 EV, which is better than most medium format digital backs.

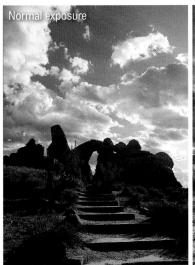

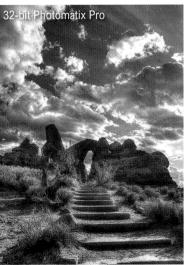

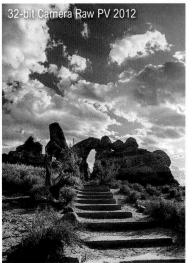

Figure 6.1 This shows a comparison of how a scene can be captured and processed in different ways. On the left is a normal exposure image of a wide dynamic range scene. In the middle is a merged, bracketed 32-bit image that was processed using Photomatix Pro. On the right is the same 32-bit image processed using the Process 2012 controls in Camera Raw.

Exposure slider

It is impossible to represent an HDR image on a standard computer display, which is why the Exposure slider is available for 32-bit images as a slider in the status box section of the document window (Figure 6.3). This allows you to inspect an HDR image at different brightness levels. Since the display you are using is most likely limited to a bit depth of 8 or 10 bits, this is the only way one can actually 'see' what is contained in a high dynamic range 32-bit image.

Alternative approaches

Other high dynamic range sensor technologies are in the pipeline. One method relies on the ability of a sensor to quickly record a sequence of images in the time it takes to shoot a single exposure. By varying the exposure time value for each of these exposures the camera software can extract a single high dynamic range capture. The advantage of this approach is that it might be feasible to capture a high dynamic range image using a fast shutter speed, although maybe not with a high speed strobe flash unit. So far we have seen a number of consumer digital cameras adopt this approach (as well as the iPhone), but so far with limited success.

Bracketed exposures

Until we have true HDR cameras, we will have to rely on using bracketed exposures (see Figure 6.2). The aim here is to capture a series of exposures that are far enough apart in exposure value so that we can extend the combined range of exposures to encompass the entire scenic tonal range as well as extend beyond the limits of the scenic tonal range. The advantage of doing this is that by overexposing for the shadows we can capture more levels information and this can result in cleaner, noise-free shadow detail. Exposing beyond the upper range of the highlights can also be useful when trying to recover information in certain tricky highlight areas. Shooting bracketed exposures is the only way most of us can realistically go about capturing all of the light levels in any given scene and merge the resulting images into a single HDR file. When this is done right you have the means to create a low dynamic rendered version from the HDR master that allows you to reproduce most if not all of the original scenic tonal range detail.

Photomatix Pro

Photoshop's tone mapping methods are designed to help you create natural-looking conversions from an HDR to an LDR image. Photomatix Pro has proved extremely popular with photographers because it offers excellent photo merging, ghosting control, is better at merging hand held shots and above all, offers more extensive tone mapping options. Tone mapping with Photomatix Pro is much easier and also allows you to create those illustration-like effects that are often associated with a high dynamic range image look (which we should really call 'HDR to LDR converted images'). One

explanation for the difference between the Photoshop HDR conversion method and Photomatix Pro may be because Photoshop uses a bilateral filter for the tone mapping, while Photomatix Pro uses a Gaussian filter, which can produce more noticeable-looking halos. I quite like using Photomatix Pro because it is quick to work with and the tone controls are easy to master. However, I now mostly prefer to edit my 32-bit HDR images in Camera Raw because I find it is best for preserving the colors and producing more natural-looking results.

Displaying deep-bit color

It is hard to appreciate the difference between 8-bit per channel and 16-bit per channel images, let alone 32-bit images when all you have to view your work with is an 8-bit or 10-bit per channel display. However, display technology is rapidly improving and in the future we may see the introduction of displays that use a combination of LEDs and LCDs to display images at greater bit depths and over a higher dynamic range. Dolby already supply such specialist high dynamic range displays and the difference is remarkable. In the future, such displays may allow us to preview our images in greater tonal detail over a much wider dynamic range.

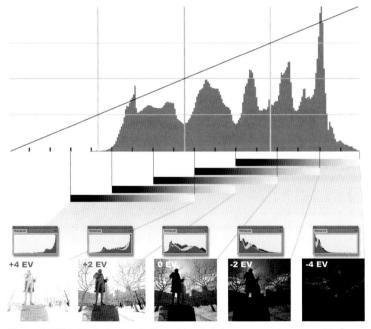

Figure 6.2 This illustrates how individual bracketed exposures when merged to form a single high dynamic range image can extend the histogram scale to encompass the entire luminance of the subject scenic range.

Figure 6.3 This shows a 32-bit image with the Exposure slider shown in the status box.

Capturing a complete scenic tonal range

The light contrast ratio from the darkest point in a scene to the brightest will vary from subject to subject, but in nearly every case it will certainly exceed the dynamic range of even the best digital cameras. Our human vision is able to differentiate between light and dark over a very wide range. It is hard to say precisely how good our eyesight is, but it has been argued that human vision under some circumstances might be equivalent to as much as 1,000,000:1, or 20 EV. Meanwhile, most digital cameras capture a tonal range that's far less than that. For the most part we have to choose our exposures carefully and decide in advance whether we wish to expose for the shadows, for the highlights, or somewhere in between. We also know from experience that we don't always need to record every single tone in a scene in order to produce a goodlooking photograph. It is OK after all to deliberately allow some highlights to burn out, or let the shadows go black. However, if we wish to capture every level of tonal information in a scene. the only practical solution right now is to shoot a succession of bracketed exposures (see Figure 6.2), From this we can create a single image that is capable of capturing the entire scenic tonal range (see Figure 6.3).

Therefore, when capturing a high dynamic range image the objective is to make sure you capture the entire contrast range in a scene from dark to light. You can do this by taking spot meter readings and manually work out the best exposure bracketing sequence to use, and how many brackets are required. An alternative (and simpler) approach is to use a standard method of shooting in which you first measure the best average exposure (as you would for a single exposure) and bracket either side of that using either 3, 5 or 7 bracketed exposures at 2 EV apart. This may not be so precise a method, but a 5-bracketed sequence should at the very least double the dynamic range of your camera.

There are several benefits to capturing a high dynamic range. First of all you can potentially capture all the light information that was in the original scene and edit the recorded information any way you like. Secondly, a merged HDR image should contain smoother tonal information in the shadow regions. This is because more levels are captured at the bright end of the levels histogram (see 'Digital exposure' on page 164). Because of this the overexposed brackets will have more levels with which to record the shadow detail. When you successfully capture and create an HDR image, there should

be little or no noise in the shadows and you should have a lot more headroom to edit the shadow tones without the risk of banding or lack of fine detail that is often a problem with normally exposed digital photos.

HDR shooting tips

The first thing you want to do is to set up your camera so it can shoot auto bracketed exposures. Some cameras only allow you to shoot three bracketed exposures, others more. With the Canon EOS range you should find that by tethering your camera to the computer you can use the Canon camera utilities software to set the default to five or more exposure brackets. The bracketing should be done based on varying the exposure time. This is because the aperture must always remain fixed so you don't vary the depth of field or the parallax between captures. Next, you want the camera to be kept still between exposures. It is possible to achieve this by shooting the pictures with a hand held camera and keeping as still as possible, but for best results you should use a sturdy tripod with a cable release. Even then you may have the problem of mirror shake to deal with (this is where the flipping up of the mirror on an SLR camera can set off a tiny vibration, which can cause a small amount of image movement during the exposure). However, this is mostly only noticeable if using a long focal length lens. It's really when shooting on a tripod this can be a problem - if you shoot hand held, the vibration will be dampened by you holding the camera. So apart from using a cable release, do enable the mirror up settings on your camera if you can.

The ideal exposure bracket range will vary, but an exposure bracket of five exposures of 2 EV apart should be enough to successfully capture most scenes. If you shoot just three exposures 2 EV apart you should get good results, but you won't be recording as wide a dynamic range. As you shoot a bracketed sequence watch out for any movement between exposures such as people or cars moving through the frame, or where the wind may cause movement. Sometimes it can be hard to prevent everything in the scene from moving. Merge to HDR Pro is capable of removing some ghosting effects, but it's best to avoid this if you can.

If you shoot three or five exposures and separate these by 2 exposure values (EV), this should allow you to capture a wide scenic capture range efficiently and quickly. You can consider narrowing down the exposure gap to just 1 EV between each

Really still, still life

The Merge to HDR Pro dialog can automatically align the images for you. but it is essential that everything else remains static. You might just get away shooting the HDR merge images with a hand held camera using an auto bracket setting, but if so much as just two of the pictures fail to register you won't be able to create a successful HDR merge. If you do resort to hand holding the camera, use a fast motor drive setting, raise the ISO setting at least two stops higher than you would use normally for hand held shooting and try to keep the camera as steady as possible (hand holding the camera should also absorb some of the mirror shake movement).

Figure 6.4 This shows the TIFF options when saving a 32-bit file as a TIFF.

exposure and shoot more exposures. This can make a marginal improvement to the edge detail in a merged HDR image, but also increases the risk of error if there is movement between any of the individual exposures.

HDR File formats

True high dynamic range images can only originate from a high dynamic range capture device, or be manufactured from a composite of camera exposures using a method such as the Merge to HDR pro option (which is described later in this chapter). Photoshop's 32-bit mode uses floating point math calculations (as opposed to regular whole integer numbers) to describe the brightness values, which can range from the deepest shadow to the brightness of the sun. It is therefore using a completely different method to describe the luminance values in an image.

If you want to save a 32-bit HDR image in Photoshop you are offered a choice of formats. You can use the Photoshop PSD, Large Document format (PSB), or TIFF format (see Figure 6.4). These file formats can store Photoshop layers or adjustment layers, but the downside is the file sizes will be at least four times that of an ordinary 8-bit per channel image. However, there are ways to make 32-bit HDR files more compact. You can use the OpenEXR or Radiance formats to save your HDR files more efficiently with compression and the OpenEXR format will very often be only slightly bigger than an ordinary 8-bit version of an image. The downside is you can't save Photoshop layers using OpenEXR, but this could still be considered a suitable format choice for archiving flattened HDR images, despite the fact it compresses the data compared to a full 32-bit per channel format such as PSB or TIFF.

How to fool Merge to HDR

Some people have asked if it is possible to take a standard single shot image, create versions of varying darkness and merge these together as an HDR image. The thing is, you can't fool Merge to HDR Pro since it responds to the camera time exposure EXIF metadata information in the file rather than the 'look' of the image. However, you can use the HDR Toning adjustment (Image \Rightarrow Adjustments \Rightarrow HDR Toning) to create a fake HDR look from a normal dynamic range image. The way it does this is to convert an 8-bit, or ideally a 16-bit per channel image to 32-bits per channel mode and then pops the HDR

Toning dialog shown in Figure 6.5, which allows you to apply HDR toning adjustments as if it were a true 32-bit HDR original. Note, this only works if you are editing an image that is in RGB or Grayscale mode and has been flattened first. This isn't true HDR to LDR photography, but it does provide a means by which you can create an 'HDR look' from photographs that weren't captured as part of a bracketed exposure sequence.

16-bit single exposure

OpenEXR files and ICC profiles

Currently there is no accepted color management standard for the OpenEXR format. Therefore, when you open such images in Photoshop you need to have an idea about what would be the best profile to apply here, and assign this via the Missing Profile box that pops up when you open the image. In most cases it will be safe to assume this should be your regular RGB workspace (particularly if it was you who saved the OpenEXR file in the first place). While the document profile choices will say Adobe RGB or ProPhoto RGB etc. the selected profile will use the color primaries of the selected workspace, but in a linear RGB space (which is the same for all 32-bit images opened in Photoshop).

HDR Toning

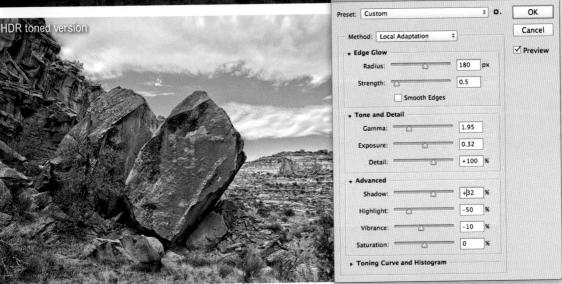

Figure 6.5 This shows an example of HDR Toning being applied to a normal 16-bit per channel image (top) to produce the fake high dynamic range effect shown here.

Camera Raw Smart Objects

A Smart Object stores the raw pixel data within a saved PSD or TIFF image (you'll learn more about Smart Objects in Chapter 8). This means you have the freedom to re-edit the raw data at any time. Although it is possible to apply the technique shown here to JPEG images, this won't bring you any real benefit compared with processing a raw image original. The important thing to stress here is that this technique really applies to editing raw files only.

1 When shooting this landscape photo it was not possible to capture the entire scene using a single exposure. It needed one exposure made for the sky and another exposure made for the ground, with a difference of around 2 stops between the two. The photos you see here were captured in raw mode and only the default Camera Raw adjustments had been applied to each shot.

Basic tonal compression techniques

Blending multiple exposures

A simple way to extend the dynamic range of your capture images is to blend two or more exposures together using a simple mask. The approach described here in the following steps also brings you the benefit of being able to edit the individual Camera Raw Smart Object layers.

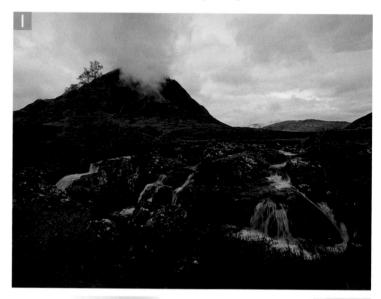

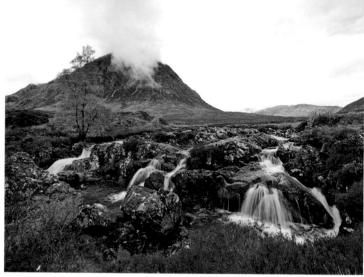

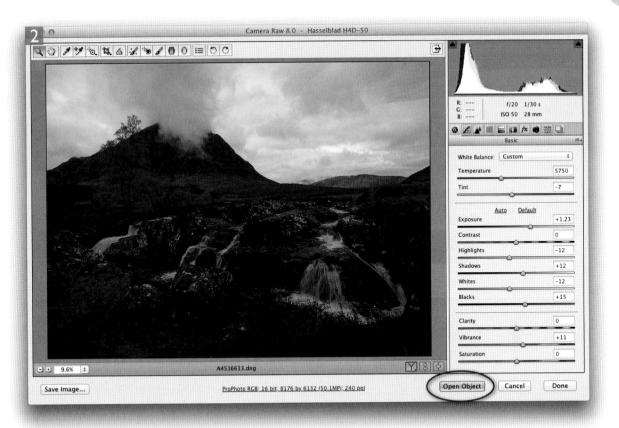

2 I began by opening these two raw images as Smart Objects. To do this. I opened each image via Camera Raw, held down the *Shift* key and clicked the 'Open Object' button (circled) to open as a Smart Object in Photoshop. Note, this button usually says 'Open Image' and switches to say 'Open Object' when the *Shift* key is held down.

3 After opening both raw images as Smart Objects I used the move tool to drag the darker exposure image to the lighter exposure image window, placing it as a layer (with the *Shift* key held down to keep in register). At this stage I could double-click the thumbnails to reopen the images in Camera Raw and re-edit the original settings.

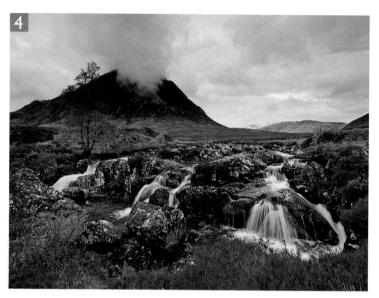

With the darker Smart Object layer selected I clicked on the Add Layer Mask at the bottom of the Layers panel (circled) to add an empty new layer mask. I then selected the gradient tool and added a white to black gradient. This faded the visibility of the top layer.

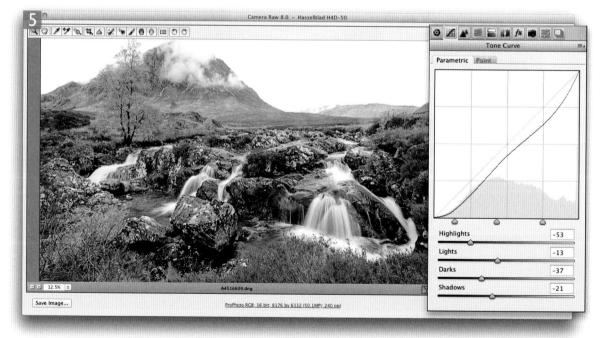

I then selected the bottom layer, double-clicked the thumbnail to open it in Camera Raw and made some further tweaks to the Tone Curve panel to add more tonal contrast. Once I was done I clicked OK to close the Camera Raw dialog.

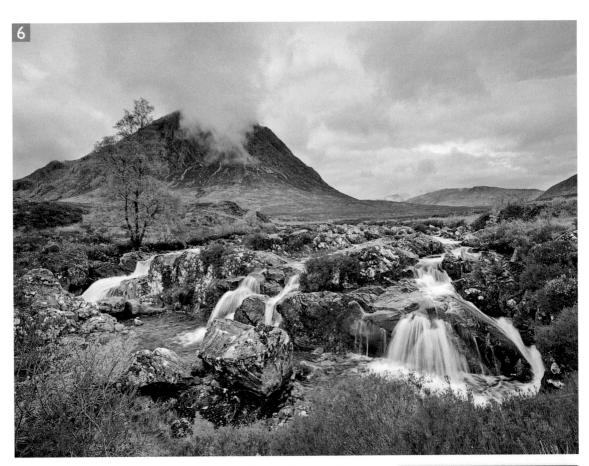

6 Whenever you update the Camera Raw settings it usually takes a few seconds after closing the Camera Raw dialog to see the changes updated in the Photoshop document window. To produce the final image shown here, I did a couple more things. I reopened the dark Smart Object layer and adjusted the white balance to make the image slightly cooler. I then also used the brush tool and painted with white and black on the associated layer mask to fine-tune the mask border edge. In some instances you might find it desirable to apply a mask that precisely follows the outline of the horizon. However, a lot of the time a soft edge mask will work fine. The effect I was trying to achieve here was somewhat similar to placing a graduated filter in front of the lens. Except when you do this in Photoshop you have the means to edit the mask edge as much as you like.

Camera Raw adjustments using Process 2012

You won't always be able to set up the camera on a tripod to shoot a series of bracketed exposures. However, the latest Process 2012 for Camera Raw does now provide you with the ability to effectively edit a raw image and compress the scenic tonal range without needing to rely on multiple exposures. Since using Process 2012 I have found less need to rely on Merge to HDR techniques. Quite often, all I need is one properly exposed raw image.

1 Here is a raw image that was processed using the Auto Tone setting. Now, with this photo the camera was able to capture a full range of tones from the shadows to the highlights, but as you can see, with the auto tone setting applied here, it was missing contrast in the highlights, and the shadows were rather dark and lacked detail.

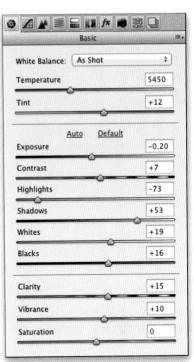

2 In the Camera Raw dialog I made sure I had updated to Process 2012 and adjusted the Basic panel sliders (shown here on the right) to achieve the best detail in the tower and the clouds. You will notice here that I mainly used a negative Highlights adjustment to darken the highlights and a positive Shadows adjustment to bring out more detail in the shadow areas. Having applied these major adjustments to compress the scenic tonal range, all I needed to do was fine-tune the Whites and Blacks sliders to set the highlight and shadow clipping.

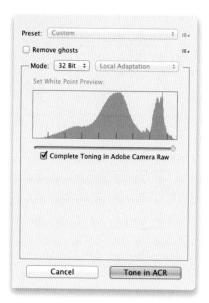

Figure 6.6 This shows a close-up view of the 32-bit mode panel in the Merge to HDR Pro dialog after merging a bracketed sequence of photos. When 'Complete Toning in Adobe Camera Raw' is checked, you'll see the 'Tone in ACR' button at the bottom.

Processing HDR files in Camera Raw

Camera Raw now has the ability to edit TIFF 32-bit HDR files just as you would a regular TIFF or raw image. What this means is you can now use the Basic panel controls in Camera Raw, or Lightroom to edit 32-bit HDR files (providing they have been saved as flattened TIFFs). If you have got accustomed to working with the latest Process 2012 tone controls, your editing experience working on HDR images will not be that much different from when working with regular raw, TIFF or JPEG images, except the dynamic range you'll have to work with will potentially be that much greater. In my view, working with the Camera Raw tone adjustments makes it easier to achieve the desired tone balance in an image. The other benefit from using Camera Raw as an HDR editor is you don't end up with the noticeable 'HDR look' you tend to get when processing HDR files to render low dynamic range versions. i.e. you can avoid getting the rather obvious halos (although some photographers do seem to like this kind of effect).

The Camera Raw options

One way to process an HDR image using Camera Raw is to create an HDR 32-bit file, or take an existing 32-bit image and force open it via Camera Raw. To do this the image must be flattened and saved using the TIFF file format. This is a good way to handle existing HDR 32-bit files. Alternatively, you can go to the file Handling preferences and check the 'Use Adobe Camera Raw to convert 32-bit files to 16/8 bit' option. Once this is done, when you open a 32-bit image in Photoshop and change the bit depth from 32-bit to 16-bit or 8-bit, this automatically pops Camera Raw in place of the HDR Toning dialog. In effect, it opens Camera Raw as a filter.

Lastly, you can convert to Camera Raw when you use Merge to HDR Pro to merge bracketed exposures to create a single HDR master. When the Merge to HDR Pro dialog opens and you are in the default 32-bit mode (see Figure 6.6), there is an option to 'Complete Toning in Adobe Camera Raw'. When this is checked, the OK button will say 'Tone in ACR'. Click this and you will be taken to the Camera Raw dialog in Camera Raw filter mode. Once you have finished editing the Camera Raw settings and clicked OK, the processed image will be a 32-bit image as a smart object layer, where you'll have the ability to open and re-edit the Camera Raw settings.

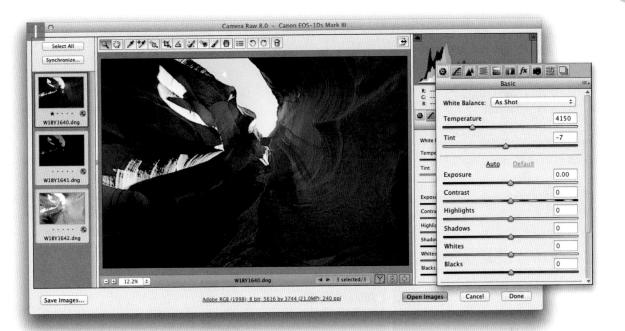

1 To begin with I opened three photos that were shot around two stops apart, where the camera was set to aperture priority mode and the shutter speed only was adjusted with each bracket. This ensured the aperture and depth of field would be consistent for each exposure. To get even better results, you may want to shoot a 5-bracket sequence.

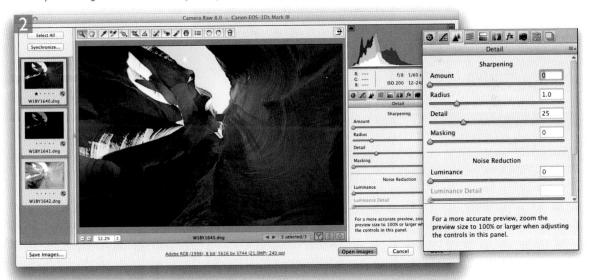

2 Before creating a merged HDR image I find it helps to disable sharpening of the raw master files. To do this, I went to the Detail panel and set the sharpening Amount slider to zero. Having done this, I selected all three of the photos I was going to merge and synchronized the Detail panel settings.

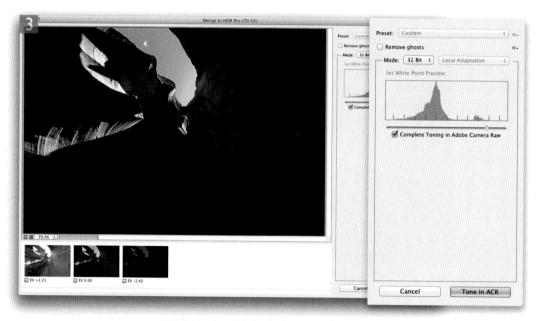

3 In Bridge I went to the Tools menu and chose Photoshop ⇒ Merge to HDR Pro... This opened all three images, blended them together and presented the Photoshop Merge to HDR Pro dialog shown here. You can use this dialog to tone map and convert the 32-bit data to 16-bit or 8-bit within Merge to HDR Pro. Instead I selected the 32-bit option, checked the 'Complete Toning in Adobe Camera Raw option' and clicked 'Tone in ACR' at the bottom.

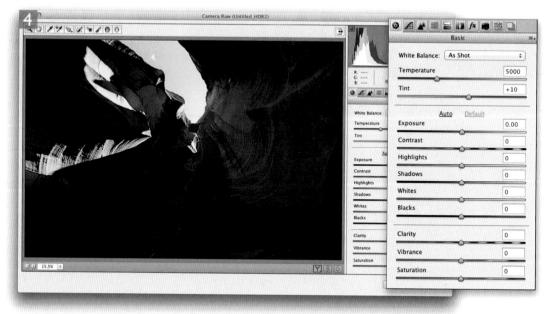

4 Here is how the saved image looked when previewed in Camera Raw with zero settings applied by default.

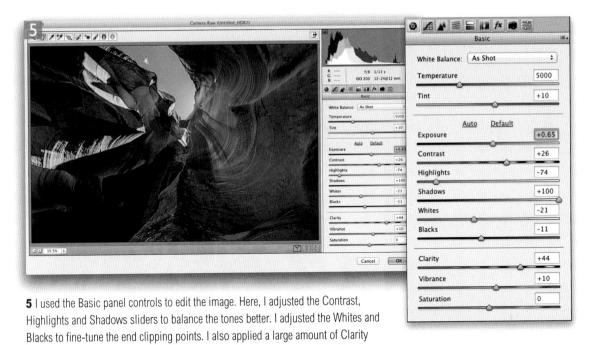

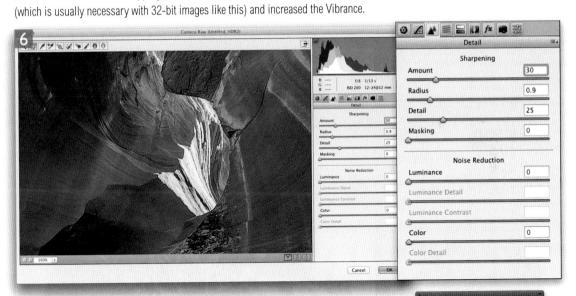

6 In this final version I went to the Detail panel and edited the Sharpening sliders to apply the desired capture sharpening (remember, I had disabled the sharpening prior to creating the original HDR master file). When I clicked OK you can see that this method created a smart object image in Photoshop, which meant the Camera Raw adjustments would remain editable.

Merge to HDR Pro

The Merge to HDR Pro command can be accessed via the File

⇒ Automate menu in Photoshop or via the Tools ⇒ Photoshop menu in Bridge. I usually find it best to open via Bridge, since the image alignment is applied automatically.

Response curve

Each time you load a set of bracketed images, Merge to HDR Pro automatically calculates a camera response curve based on the tonal range of images you are merging. As you merge more images from the same sensor, Merge to HDR Pro updates the response curve to improve its accuracy. If consistency is important when using Merge to HDR Pro to process files over a period of time, you might find it useful to save a custom response curve (see Step 3) and reuse the saved curve when merging images in the future.

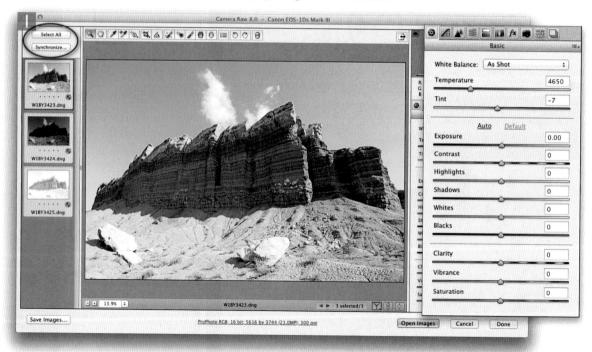

1 The original pictures were bracketed using different time exposures at two exposure values (EV) apart. I began by opening a selection of three raw digital capture images via Camera Raw. It was important that all auto adjustments were switched off. In this example, I made sure the Camera Raw Defaults were applied to the first image and synchronized these settings across all the other selected images.

- 2 With the images selected in Bridge I went to the Tools menu and chose Photoshop

 Merge to HDR Pro.
- 3 This shows the Merge to HDR Pro dialog in 16-bit mode. When the 8-bit or 16-bit mode are selected you will see the HDR toning options shown here. These allow you to apply an HDR to LDR conversion in one step (the HDR toning controls are described more fully on pages 450–451). If you prefer at this stage to simply save the image as a 32-bit master HDR file, you should select 32-bit from the Mode menu, where the only option available is to adjust the exposure value for the image preview. There is also a fly-out menu in the Merge to HDR Pro dialog (circled below) where you can save or load a custom response curve.

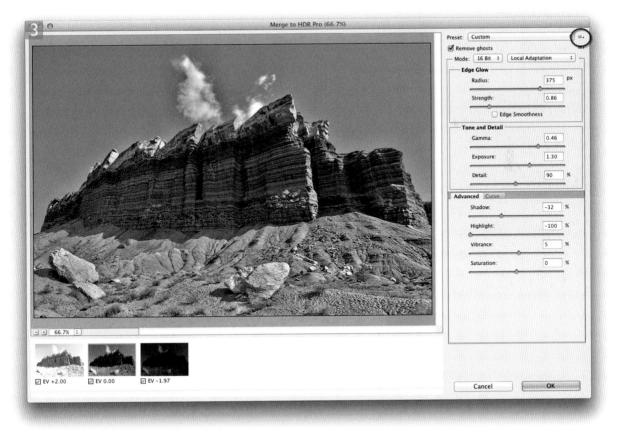

Merge to HDR Pro script

There is a 'Merge to HDR' script you can load from the Presets/Scripts folder that allows you to open files or folders of images to process via Merge to HDR Pro. It does not allow you to process layered files, although there are hooks present that could allow this to be scripted.

Exposure and Gamma

You can use the Exposure slider to compensate for the overall exposure brightness and the Gamma slider to (effectively) reduce or increase the contrast. The controls are rather basic, but they do allow you to create a usable conversion from the HDR image data.

Highlight Compression

The Highlight Compression simply compresses the highlights, preserving all the highlight detail. It can render good midtones and highlights at the expense of losing some detail in the shadows.

Equalize Histogram

The Equalize Histogram option attempts to map the extreme highlight and shadow points to the normal contrast range of a low dynamic range Photoshop image, but it's a rather blunt instrument to use when converting a high dynamic range image.

Tone mapping HDR images

After you have created a merged 32-bit per channel HDR image. vou can save the HDR master using the PSD, PSB or TIFF formats to preserve maximum image detail plus any layers. Or, you can use the OpenEXR format, which as I explained earlier is a more efficient, space saving file format for storing 32-bit images. You can if you like skip saving the merged HDR image and iump straight into the tone mapping stage by selecting the 16-bit per channel or 8-bit per channel option in the Merge to HDR dialoa. I think you will find though there are some definite advantages to preserving a master image as an HDR file. There is a real art to tone mapping an image from a high dynamic range to a normal, low dynamic range state and you won't always get the best results at your first attempt. It is a bit like the need to preserve your raw masters as raws and therefore makes sense to save an HDR file as a 32-bit master image first and then use Image ⇒ Mode menu to convert from 32-bits to 16-bits or 8-bits per channel. If the 'Use Adobe Camera Raw to convert 32-bit files to 16/8 bit' option is unchecked in the File. Handling preferences, this pops the HDR Toning dialog (Figure 6.8), which offers four methods of converting an HDR image to a low dynamic range version (see the sidebars on the left and the section below). With each the aim is the same: to squeeze all of the tonal information contained in the high dynamic range master into a low dynamic range version of the image. Here I am just going to concentrate on the Local Adaptation method.

Local Adaptation

The Local Adaptation method is designed to simulate the way our human eyes compensate for varying levels of brightness when viewing a scene. For example, when we are outdoors our eyes naturally compensate for the difference between the brightness of the sky and the brightness of the ground. The difference in relative brightness between these two areas accounts for the 'global contrast' in the scene. As our eyes concentrate on one particular area, the contrast we observe in, say, the clouds in the sky or the grass on the ground is contrast that is perceived at a localized level. The optimum settings to use in an HDR conversion will therefore depend on the image content. Figure 6.7 shows a photograph of a scene with a high dynamic range. The global contrast would be the contrast between the palm tree silhouetted against the brightly lit buildings in the background, while the localized contrast would be the detail contrast within both the bright and dark regions of the picture (magnified here).

The Radius slider in the Local Adaptation HDR Toning dialog Edge Glow section (Figure 6.8) is said to control the size of the glow effect, but I prefer to think of this as a 'global contrast' control. Basically, the tone mapping process lightens the shadows relative to the highlights and the tone mapping is filtered via a soft edge mask. Increasing the Radius amount widens the halos. At a low setting you'll see an image in which there may be a full tonal range from the shadows to the highlights, but the image looks rather flat. As you increase the Radius this widens the halos, which softens the underlying mask and this is what creates the impression of a normal global contrast image. You can then use the Strength slider to determine how strong you want the effect to be. At a zero Strength setting the picture will again look rather flat. As you increase the Strength amount, you'll see more contrast in the halos that are generated around the high contrast edges in the image. The Edge Glow Strength slider can therefore be used to soften or strengthen the Radius effect, but you do need to watch for ugly halos around the high contrast edges.

When the Gamma slider is dragged all the way to the left, there is no tone compression between the shadows and highlights. As you drag the other way to the right, this compresses the shadows and highlights together. The Exposure slider can then be used to compensate for the overall exposure brightness. This slider adjustment can also have a strong effect as it is applied after the tone mapping stage rather than before.

The Detail slider works a bit like the Clarity slider found in Camera Raw and you can use this to enhance the localized contrast by adding more Detail. The Shadow and Highlight sliders are fine-tuning adjustments. These can be used to independently adjust the brightness in the shadows or highlight areas. For example, the Shadow slider can be used to lighten the shadow detail in the darkest areas only. HDR Local Adaptation conversions typically mute the colors so you can use the Vibrance and Saturation sliders to control the color saturation.

Finally, we come to the Toning Curve and Histogram. You can use this to apply a tone enhancing contrast curve as a last step in the HDR conversion. The histogram displayed here represents that of a 32-bit image, but you'll find the Histogram panel in Photoshop more useful when gauging the outcome of a conversion. When you are done you can click on the OK button for Photoshop to render a low dynamic range version from the HDR master.

Figure 6.7 Here is an example of a subject that has a wide dynamic range and strong global contrast.

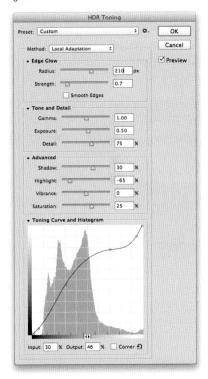

Figure 6.8 The Local Adaptation tone mapping method (also showing the Tone Curve and Histogram options).

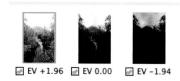

Figure 6.9 When removing ghosts you can select the image to base the anti-ghosting on.

Capture sharpening and HDR

As you apply HDR toning to a high dynamic range image edge artifacts can start to appear. The things that cause this are heavy use of the Detail slider and edges where there is a sharp amount of contrast. Over the page you can see an example of how turning on the Edge Smoothing can help mitigate some of these effects. Beyond that, try not to go too crazy with the Detail slider, but there is also one more thing you should try and that is to turn off the capture sharpening for the raw files before you generate a Merge to HDR Pro image. In Figure 6.11 you can see how doing this can make it easier for you to process certain types of images. If you do this you just need to remember to apply the required capture sharpening after you have created the HDR toned version.

Removing ghosts

It is important to minimize any movement when shooting bracketed exposures, which is why it is best to shoot using a sturdy tripod and cable release. Even so there remains the problem of things that might move between exposures such as tree branches blowing in the wind. To help address this the Merge to HDR Pro process in Photoshop utilizes a ghost removal algorithm which automatically tries to pick the best base image to work with and discards the data from the other images in areas where some movement is detected. When the 'Remove Ghosts' option is checked in the Merge to HDR Pro dialog you'll see a green border around whichever thumbnail has been selected as the base image (Figure 6.9). You can override this by clicking to select an alternative thumbnail and make this the new base image. For example, if the moving objects are in a dark portion of the photograph then in these circumstances it will be best to select a lighter exposure as the base image. In practice I have found the ghost removal to be effective on most types of subjects, although moving clouds can still present a problem. Skies are also tricky to render because the glow settings can produce a noticeable halo around the sky/horizon edge. This problem can usually be resolved by placing the medium exposure image as a separate layer masked with a layer mask based on the outline of the sky.

How to avoid the 'HDR' look

It has to be said that HDR to LDR converted images can sometimes look quite freaky because of the temptation to squeeze everything into a low dynamic range. Just because you can preserve a complete tonal range doesn't mean you should. It really is OK to let the highlights burn out sometimes or let the shadows go black. The Photomatix Pro program has proved incredibly popular with HDR enthusiasts, and in the process spawned the classic 'HDR' look, which personally I think has been done to death now. Besides, Photomatix Pro can actually be used to produce nice, subtle tone mapped results, but I suppose people don't notice these types of HDR photos quite so much. The Photoshop approach also lets you produce what can be regarded as natural-looking conversions and I think you'll agree that the Figure 6.10 example shows how the HDR to LDR image process can result in a photo that looks fairly similar to a normal processed image, but with much improved image detail in the shadow regions.

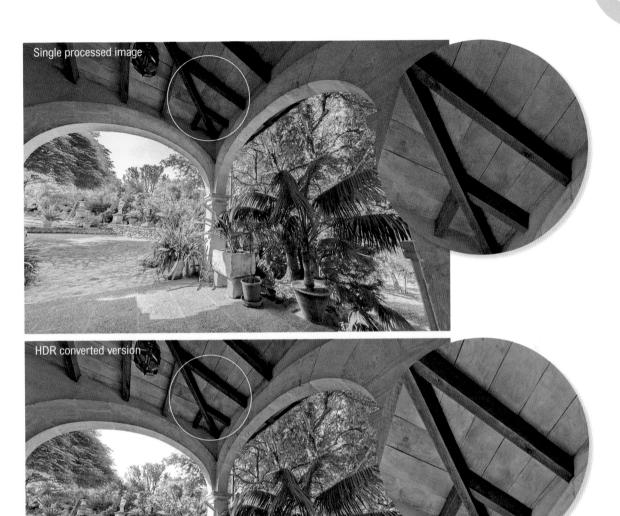

Figure 6.10 The top photo here is a single edited image, shot using an optimum exposure processed via Camera Raw and output as a 16-bit file. Below you can see an HDR edited version that was converted to a 16-bit low dynamic range image. I tried to get the two images to match as closely as possible, but you should notice better tone and detail contrast in the roof rafters in the HDR converted version. The difference was more noticeable though when I examined the shadow areas. In the enlarged close-up views you can see there is much more image detail and virtually no shadow noise in the bottom image.

Figure 6.11 This shows an example of Smooth Edges off (top) and on (middle) and Smooth Edges on with capture sharpening off (bottom). Note that edge smoothing can dilute the contrast. To restore this, try boosting the Detail slider.

Smooth Edges option

When using the Local Adaptation method, there is a Smooth Edges option. When this is checked it can improve the image quality when toning HDR merged photos. Figure 6.11 shows before and after examples and how it can improve the appearance of the edges in a photo. I would say this is a problem you are more likely to notice when using a high Detail slider setting, where you can often end up seeing unwanted halos around high contrast edges. Applying edge smoothing won't help get rid of all types of artifacts and it can also influence the effect of the other HDR toning slider adjustments. So you may sometimes need to revisit these after applying the Smooth Edges option.

HDR toning examples

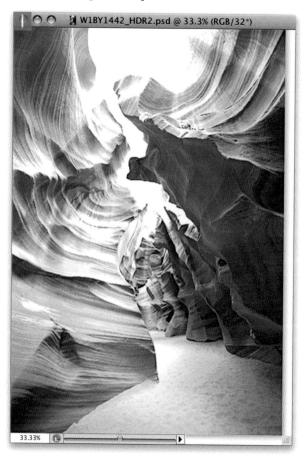

1 I began here with an HDR image that was produced by merging together a bracketed sequence of three photographs shot at 2 EV apart.

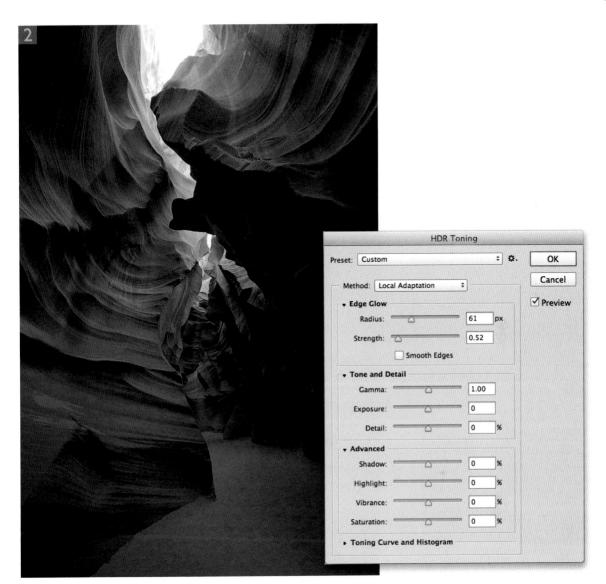

2 To convert a high dynamic range image into a low dynamic range version I went to the Image

Mode submenu and switched the bit depth from 32-bits to 16-bits per Channel. Providing the 'Use Adobe Camera Raw to convert 32-bit files to 16/8 bit' option was unchecked in the File Handling preferences, this opened the HDR Toning dialog shown here. Of the four tone mapping options available in this dialog, I find that the Local Adaptation method usually works the best. In this screen shot I left all the sliders at their default positions. Although the image doesn't look that great just yet, it is certainly quite an improvement upon how the default HDR converted image preview looked in earlier versions.

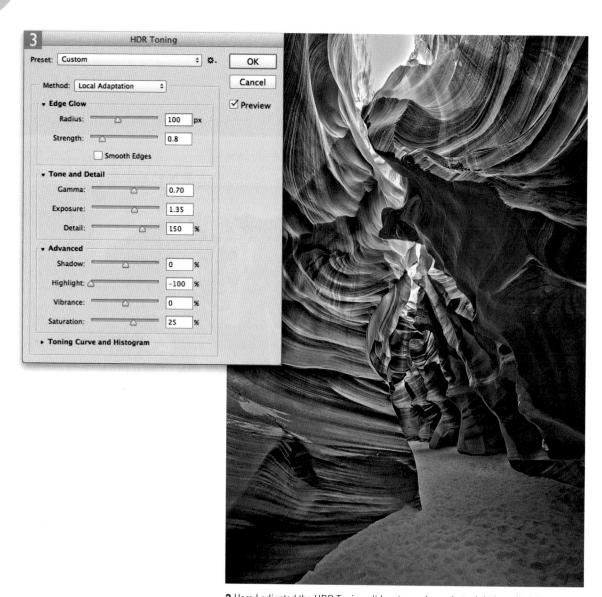

3 Here I adjusted the HDR Toning sliders to produce what might be called the 'illustration look' favored by many HDR photography enthusiasts. If this is the type of effect you are after I don't think the Photoshop HDR Toning adjustment is really as capable as, say, Photomatix Pro and nor is it as simple to configure. Having said that, Photoshop can still be made to produce the rather obvious 'HDR toned effect'. Looking at the settings shown here, I set the Radius slider to 100 pixels and raised the Strength to 0.80. I took the Gamma slider to 0.7, set the Exposure slider to +1.35 and the Detail slider to 150%. I then reduced the Highlight slider to -100% and increased the Saturation slightly, setting it to 25%.

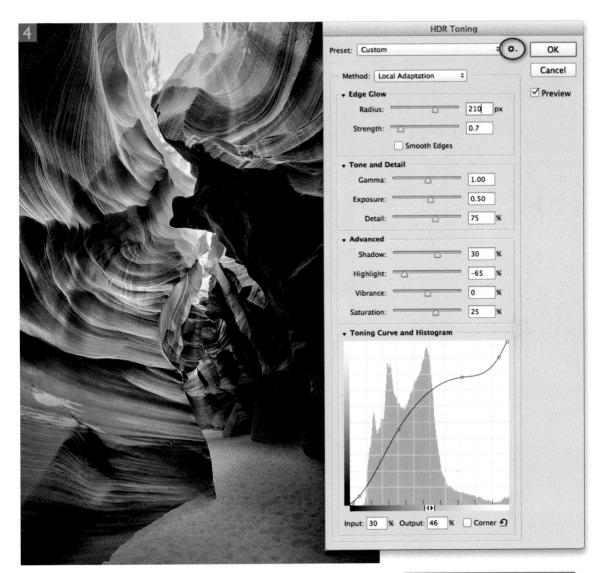

4 In this step I aimed to produce a more natural-looking result. To start with I set the Radius slider to 210 pixels. This was done to create much wider halo edges. I set the Strength slider to 0.7 and the Gamma slider to the default 1.00 setting. Exposure was reduced to 0.5. I also reduced the Detail slider to 75% and made some further tweaks to the Advanced slider settings below. I then adjusted the Toning Curve to fine-tune the final tone mapping (I find it helps to also refer to the Histogram panel in Photoshop as you do this). Lastly, I clicked on the HDR Toning options button (circled), selected Save Preset... and saved the Local Adaptation settings as a new preset, which might serve as a useful starting point for other HDR conversions of photos shot at the same location.

How to smooth HDR toned images

The following tutorial shows some additional things you can do in Photoshop to retouch an HDR tone mapped image and cure some of the problems created by the tone mapping process.

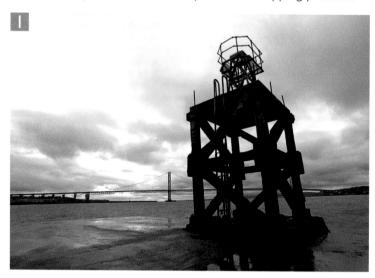

1 Here is an HDR, 32-bit image that was created from a bracket sequence shot 2 EV apart.

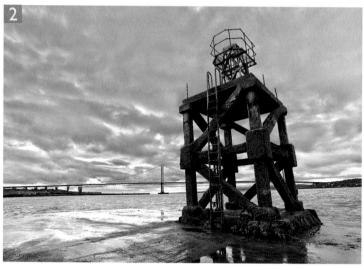

2 I chose Image
→ Mode 16-bits to open the HDR Toning dialog (with 'Use Adobe Camera Raw to convert 32-bit files to 16/8 bit' option was unchecked in the File Handling preferences), where I applied the settings shown here. In particular, I made one of the curve points in the Toning Curve a corner point. When tone mapping HDR images it can be helpful to add a midpoint to the curve and make this a corner point. This then makes it easier to manipulate the tone curve shape, adjusting two or more portions of the tone curve separately.

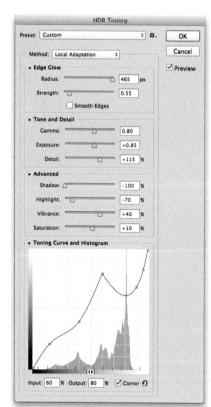

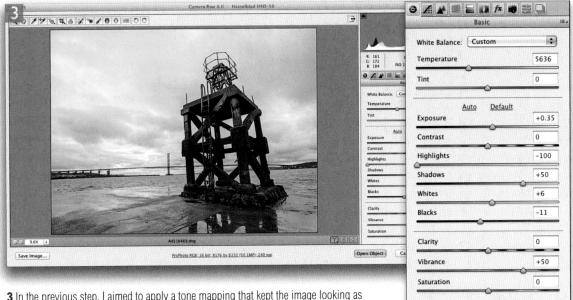

In the previous step, I aimed to apply a tone mapping that kept the image looking as realistic as possible. For example, I kept the Edge Glow Radius wide and the Strength low. HDR processing does tend to distort the colors though, so what I did here was to open the midtone exposure image in Camera Raw and adjust the settings to try and match as closely as possible the HDR processed version.

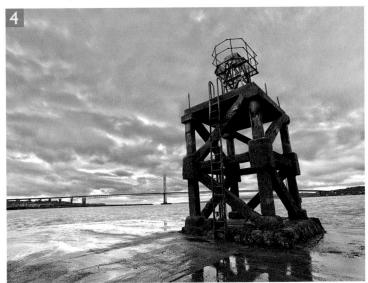

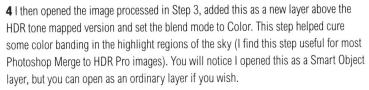

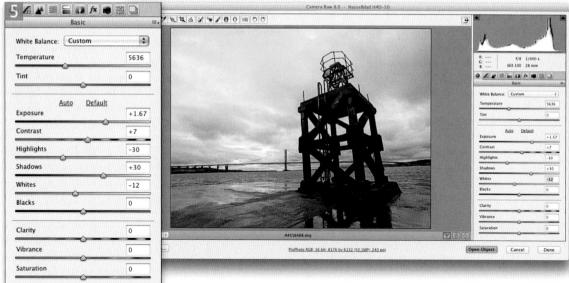

5 I was now happy with everything except the look of the sky. In the previous Step there were noticeable wide-edge halos. I now opened the darkest exposure image and lightened it to get the sky to look roughly as bright as the tone mapped version.

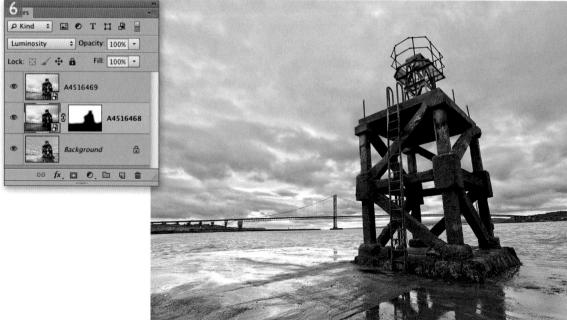

6 I then added this as a Smart Object layer, sandwiched below the Color mode layer and set to the Luminosity blend mode. I added a layer mask filled with black and painted with white to reveal the layer contents in the sky areas only. The final version shown here has all the benefits of HDR editing, but without the photograph looking as if it had been HDR processed.

Chapter 7

Image retouching

Photoshop has become so successful that its very name is synonymous with digital image retouching. Photoshop retouching tools such as the humble clone stamp have been around since the very early versions of the program and have been used and abused in equal measure. The new retouching tools that have been added since then mean that you can now transform images almost any way you want. As my colleague Jeff Schewe likes to say: 'You know why Photoshop is so successful? Because reality sucks!' Well, that's Jeff's viewpoint, but then he does come from a background in advertising photography where heavy retouching is par for the course. The techniques described in this chapter will teach you some of the basic procedures, such as how to remove dust spots and repair sections of an image. We'll then go on to explore some of the more advanced techniques that can be used to clean up and enhance your photographs.

Figure 7.1 If you are carrying out any type of retouching work which relies on the use of the paint tools, a pressure sensitive graphics tablet and pen, such as the Wacom™ device shown here, is absolutely invaluable.

All Layers option

The Current & Below and All Layers options are useful if you want to work with the clone stamp or healing brush and store your retouching on a separate layer. If you select the Current & Below option, Photoshop only samples from the visible layers that are below the current layer and ignores any layers that are above it. If the All Layers option is selected, Photoshop samples from all visible layers, including those above the active layer (see page 468).

Basic cloning methods

At the beginning of any retouching session the clone stamp tool and healing brush are the most useful tools to work with. You can use these to carry out most basic retouching tasks before you proceed to carry out the more advanced retouching steps.

Clone stamp tool

To work with the clone stamp tool, hold down the all key and click to select a source point to clone from. Release the all key and move the cursor over to the point that you wish to clone to, and click or drag with the mouse. If you have the tool set to aligned mode, this establishes a fixed relationship between the source and destination points. If the clone stamp is set to the non-aligned mode, the source point starts from the same location after each time you lift the pen or mouse until you all-click again to establish a new source point. When working with the clone stamp or healing brush I do find it helps to use a graphics tablet (like the Wacom™ device shown in Figure 7.1), as this can help you work more quickly and efficiently.

Clone stamp brush settings

As with all the other painting tools, you can change the brush size, shape and opacity to suit your needs. When working with the clone stamp I mostly leave the opacity set to 100%, since cloning at less than full opacity can lead to tell-tale evidence of clone stamp retouching. However, when smoothing out skin tone shadows or blemishes, you might find it helpful to switch to an opacity of 50% or less. You can also use lower opacities when retouching areas of soft texture. Otherwise I suggest you stick to using 100% opacity. For similar reasons, you don't want the clone stamp to have too soft an edge. For general retouching work, the clone stamp brush shape should have a slightly harder edge than you might use normally with the paint brush tools. When retouching detailed subjects such as fine textures, you might want to use an even harder edge so as to avoid creating halos. Also, if film grain is visible in a photograph, anything other than a harder edge setting will lead to soft halos, which can make the retouched area look slightly blurred or misregistered. If you need extra subtle control, lower the Flow rate; this allows you to build an effect more slowly, without the drawbacks of lowering the opacity.

1 The best way to disguise clone stamp retouching is to use a full opacity brush with a medium hard edge at 100% opacity. It is also a good idea to add a new empty layer above the Background layer, which you can do by clicking on the Add New Layer button (circled in blue). This lets you keep all the clone retouching on a separate layer, and it was for this reason I chose to have the 'All Layers' Sample option selected in the Options bar (circled in red) so that all visible pixels were copied to this new layer.

2 The Aligned box is normally checked by default in the Options bar. Here, I used the all key to set the sample point on an undamaged part of the wall and was then able

3 I then dragged to paint with the clone stamp. Photoshop retains the clone source/ destination relationship for all subsequent brush strokes until a new source and destination are established. In situations like this you may find the Clone Source panel 'Show Overlay' option proves useful (see page 466).

Pressure sensitivity

If you are using a pressure sensitive tablet such as a Wacom[™] tablet, the default brush dynamics will be size sensitive, so you can use light pressure to paint with a small brush, and heavier pressure to apply a full-sized brush.

Healing brush

The healing brush can be used in more or less the same way as the clone stamp tool to retouch small blemishes, although it is important to stress here that the healing brush is more than just a magic clone stamp and has its own unique characteristics. These differences need to be taken into account so that you can learn when it is best to use the healing brush and when it is more appropriate to use the clone stamp.

To use the healing brush, you again need to establish a sample point by alt-clicking on the portion of the image you wish to sample from. You then release the all key and move the cursor over to the point where you want to clone to and click or drag with the mouse to carry out the healing brush retouching. The healing brush works by sampling the texture from the source point and blends the sampled texture with the color and luminosity of the pixels that surround the destination point. The healing brush reads the pixels within a feathered radius that is up to 10% outside the perimeter of the healing brush cursor area. By reading the pixels that are outside the cursor area at the destination point, the healing brush is (in most cases) able to calculate a smooth transition of color and luminosity within the area that is being painted (always referencing the pixels within a feathered radius that is up to 10% outside the perimeter of the healing brush cursor area). It is for these reasons that there is no need to use a soft edged brush and you will always obtain more controlled results through using the healing brush with a 100% hard edge.

Once you understand the fundamental principles that lie behind the workings of the healing brush, you will come to understand why the healing brush may sometimes fail to work as expected. You see, if the healing brush is applied too close to an edge where there is a sudden shift in tonal lightness, it will attempt to create a blend with the pixels immediately outside the healing brush area. So when you retouch with the healing brush you need to be mindful of this intentional behavior. However, there are things you can do to address this. For example, you can create a selection that defines the area you are about to start retouching (maybe with some minimal feathering) and constrain the healing brush work so that it is carried out inside the selection area only.

1 I selected the healing brush from the Tools panel and selected a hard edged brush from the Options bar. The brush blending mode was set to Normal, the Source button set to 'Sampled' and the Aligned box left unchecked.

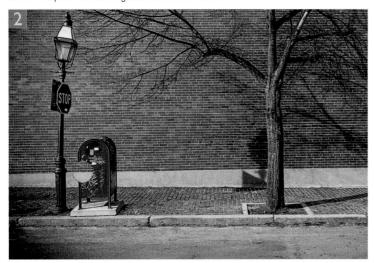

2 Before using the healing brush, I again added a new empty layer and made sure the Sample options were set to 'All Layers' or 'Current & Below'. I all -clicked to define the source point, which in this example was an area just to the right of the trash bin. I then released the all key, moved the cursor over to where the bin was and clicked to remove it using the healing brush. Here is an example where having the Clone Source Show Overlay visible (see page 486) ensured the bricks were carefully aligned.

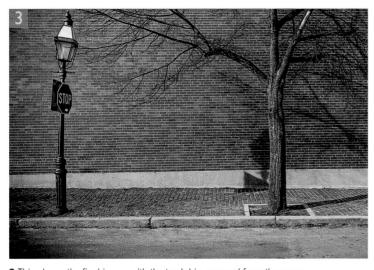

3 This shows the final image with the trash bin removed from the scene.

Figure 7.2 This shows how the clone stamp (or healing brush) cursor looks when using the Clone Source panel options shown in Figure 7.3, with the 'Show Overlay' and 'Clipped' options checked.

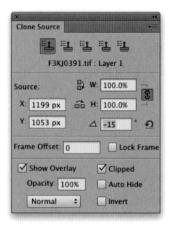

Figure 7.3 The Clone Source panel, shown here with the Show Overlay and Clipped options checked.

Choosing an appropriate alignment mode

You can use the clone stamp and healing tools in aligned, or non-aligned mode (see Figure 7.4). I tend to find it is more convenient to use the clone stamp tool in aligned mode and the healing brush in non-aligned mode. This is because when you use the clone stamp you can preserve the relationship between the source and destination points, apply a few clones, then sample a new source point as you continue cloning over other parts of the photograph. You can even clone data from a separate document (as shown in Figure 7.5).

If you try to use the clone stamp over an area where there is a gentle change in tonal gradation, it will be almost impossible to disguise the retouching work, unless the point you are sampling from and destination point match exactly in tone and color. It is in these situations that you are usually better off using the healing brush. For most healing brush work I suggest you use the non-aligned mode (which happens to be the default setting for this tool). This allows you to choose a source point that contains the optimum texture information with which to repair a particular section of a photograph. You can then keep referencing the same source point as you work with the healing brush.

Clone Source panel and clone overlays

The Clone Source panel was mainly implemented with video editors in mind. This is because it can sometimes be desirable to store multiple clone sources when cloning in exact registration from one frame to another across several frame images in a sequence. The current version offers an improved overlay cursor view where if the 'Show Overlay' and 'Clipped' options are both checked, a preview of the clone source can be seen inside the cursor area. Earlier, on page 463, I made a reference to the Clone Source panel, saying this was just the kind of retouching task that would benefit from having an overlay inside the cursor to help guide where to click when setting the destination point for the clone stamp. Figure 7.2 shows a detail view of the clone stamp being applied using the settings shown in Figure 7.3, where the 'Show Overlay' and 'Clipped' options were both enabled. You could choose to have the 'Show Overlay' option switched on all of the time, but there is usually a slight time delay while the cursor updates its new position and this can at times become distracting. I therefore suggest you only enable it when you really need to.

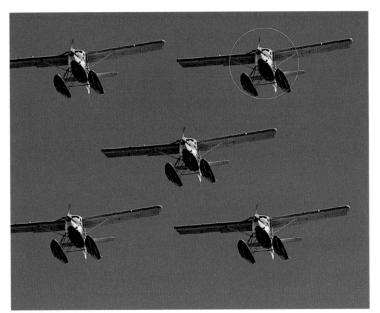

Figure 7.4 When you have the clone stamp tool selected and the Aligned box in the tool Options bar is unchecked, the source point remains static and each application of the clone stamp makes a copy of the image data from the same original source point.

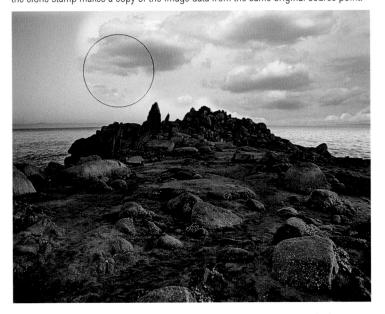

Figure 7.5 In this example you can see how I was able to sample the sky image data from one image window and copy it to another separate image using the clone stamp. I just all-clicked with the clone stamp in the source (sky) image, then selected the other image window and clicked to establish a cloning relationship between the source and destination image windows.

Aligned or non-aligned cloning?

When the source area is unrestricted I suggest you choose the aligned mode for the clone stamp tool. However, when the source area is restricted and you don't want to pick up from other surrounding areas, choose non-aligned.

Ignore adjustment layers

When 'Ignore Adjustment Layers' is switched on, Photoshop ignores the effect any adjustment layers might have when cloning the visible pixels. Therefore, when the 'All Layers' sample option is selected this prevents adjustment layers above the layer you are working on from affecting the retouching carried out on the layers below.

Clone and healing sample options

The layer sample options (Figure 7.6) allow you to choose how the pixels are sampled when you use the clone stamp or healing brush tools. 'Current Layer' samples the contents of the current layer only and ignores all other layers. The 'Current & Below' option samples the current layer and visible layers below (ignoring the layers above it), while the 'All Layers' option samples all visible layers in the layer stack, including those above the current layer. If the Ignore Adjustment Layers button (circled) is turned on, Photoshop ignores the effect any adjustment layers above the selected layer are having on the image (see sidebar). Meanwhile, the spot healing brush only has the 'Sample All Layers' option in the tool Options bar to check or uncheck.

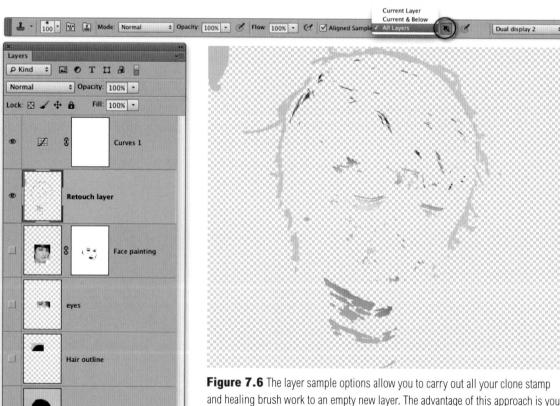

and healing brush work to an empty new layer. The advantage of this approach is you can keep all your retouching work separate and leave the original Background layer untouched. In this example the All Layers option allowed me to sample from layers above and below and carry out the retouching to a separate layer (which for the sake of clarity is shown here in isolation). Because the Ignore Adjustment Layers option was checked (circled above), Photoshop ignored the effect the Curves adjustment layer would have on the sampled pixels.

fx. 🖂 Ø. 🗅 🖫 📾

Laver 0

Better healing edges

Since the healing brush blends the cloned source data with the edges that surround the destination point, you can improve the efficiency of the healing brush by increasing the outer circumference size for the healing brush cursor. The following technique came via Russell Brown, who was shown how to do this by an attendee at one of his seminars.

If you change the healing brush to an elliptical shape, you will tend to produce a more broken-up edge to your healing work and this can sometimes produce an improved healing blend (Figure 7.7). There are two explanations for why this works. Firstly, a narrow elliptical brush cursor has a longer perimeter. This means that more pixels are likely to be sampled when calculating the healing blend. The second thing you will notice is that when the healing brush is more elliptical, a randomness is introduced into the angle of the brush. Try changing the shape of the brush in the way I describe below and as you paint, you will see what I mean.

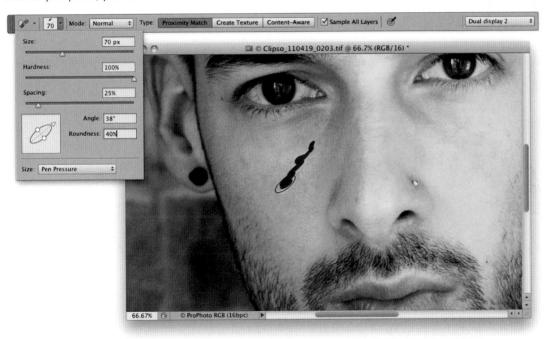

Figure 7.7 To adjust the shape and hardness of the healing brush or spot healing brush, select the healing/spot healing brush tool and mouse down on the brush options in the tool Options bar. Set the hardness to 100% and drag the elliptical handles to make the brush shape more elliptical. Notice also that if you are using a Wacom™ tablet or other pressure sensitive input device, the brush size is linked by default to the amount of pen pressure applied.

Figure 7.8 The spot healing brush warning dialog. You'll see this if you accidentally try to sample a source point using the **alt** key.

Spot healing brush

As you will have noticed, the default healing tool in Photoshop is the spot healing brush. To use the spot healing brush you just click on the marks or blemishes you wish to remove. It then automatically samples the replacement pixel data from around the area you are trying to heal. If the spot healing brush is selected in the Tools panel and you try to use the all key to establish a source point to sample from (thinking you have just selected the ordinary healing brush), you will be shown a warning dialog explaining there is no need to create a sample source when using this tool (Figure 7.8).

The spot healing brush tool has three basic modes of operation: Proximity Match, Create Texture and Content-Aware. These modes can be selected via the spot healing brush Options bar (Figure 7.9). In 'Proximity Match' mode it analyzes the data around the area where you are painting to identify the best area to sample the pixel information from. It then uses the pixel data that has been sampled in this way to replace the pixels beneath where you are painting. With the Proximity Match mode selected you can use the spot healing brush to click away and zap small blemishes. When you are repairing larger areas in a picture you will usually obtain better results if the brush size is slightly smaller than the area you are trying to retouch and you then click and drag to define the area you wish to repair. As you work with the spot healing brush you'll notice how it is mostly quite smart at estimating which are the best pixels to sample from. Sometimes though, the spot healing brush will choose badly, so it pays to be vigilant and understand how to correct for this. If you are removing marks close to an edge, it is usually best to apply brush strokes that drag inwards from the side where the best source data exists (see Figure 7.10). This is because in Proximity Match mode the spot healing brush intelligently looks around for the most suitable pixel data to sample from, but if you drag with the brush it looks first in the direction from where you dragged.

If the Proximity Match mode fails to work you may in some instances want to try using the Create Texture mode. Rather than sampling an area of pixels from outside the cursor it generates a texture pattern within the cursor area based on the surrounding area. It may just occasionally offer a better result than the Proximity Match mode, but you'll find that the Content-Aware mode does the same kind of thing only more successfully.

Healing blend modes

You'll notice in Figure 7.9 that there are a number of different blend modes available for when working with the spot healing brush (as well as the main healing brush). Most of the time you will find that the Normal blend mode works fine and you will get good results, but when retouching some areas you'll find the Replace blend mode may work more successfully, especially when using the Content-Aware mode (which is discussed next). The edge hardness can also be a factor here, but I find that by adjusting the softness of the brush when using the Replace blend you can get improved results. The Replace blend preserves more of the texture in the boundary edges and the difference is therefore more pronounced as you soften the edge hardness. When using the Content-Aware mode this can make a difference when painting up close to sharp edges. In the Normal blend mode you may still see some edge bleeding, whereas in Replace mode the edges are less likely to bleed. I generally find that for detailed areas such as when retouching out the wires that covered the rocks in the Figure 7.12 example, the Replace mode worked more effectively. The other blend modes include items such as Darken, Lighten, and Color. Now, if you refer to the later section on beauty retouching you can see how these might be useful where you wish to apply healing to an image so that, say, only the darker pixels or lighter pixels get replaced. This can be useful where you wish to minimize the amount of change that takes place in an image. For example, the Lighten blend mode would be an appropriate choice for getting rid of dark marks against a light color. By selecting the Lighten mode you should be able to target the retouching more effectively in removing the dark marks. Similarly, you could use the Darken mode to remove light marks against a dark background.

Figure 7.10 In Proximity Match mode, the spot healing brush works by searching automatically to find the best pixels to sample from to carry out a repair, but if you drag with the spot healing brush it uses the direction of the drag as the source for the most suitable texture to sample from. By dragging with the tool you can give the spot healing brush a better clue as to where to sample from. In this instance I could prompt it to sample from the area of clear skin that didn't have loose hairs.

Stroking a path

A really useful tip is to use the stroke path option in conjunction with the spot healing brush to apply a precisely targeted spot heal brush stroke. For example, to retouch the cables seen in the Figure 7.12 photo. vou could try the alternative approach described below. Select the pen tool and use it to create an open path that follows the line of one of the cables. With the path still active, you can then go to the Paths panel options and choose 'Stroke Path' This will open the Stroke Path dialog shown in Figure 7.11, where you can select the desired tool from the menu. If you were to select the Spot healing brush here and click OK, this will apply a spot healing brush stoke that follows the direction of the path.

Figure 7.11 This shows the Stroke Path dialog, which can be accessed via the Paths panel when a pen path is active.

Spot healing in Content-Aware mode

When working with the spot healing brush in the default Proximity Match mode you have to be careful not to work too close alongside sharply contrasting areas in case this causes the edges to bleed. The Content-Aware mode was added to the spot healing brush options in Photoshop CS5 and it intelligently works out how best to fill the areas you retouch when you use the spot healing brush. Note that the content-aware healing does make use of the image cache levels set in the Photoshop performance preferences to help speed up the healing computations. If you have the Cache limit set to 4 or fewer levels, this can compromise the performance of the spot healing brush in Content-Aware mode when carrying out big heals. It is therefore recommended that you raise the cache limit to 6 or higher.

Let's now look at what the spot healing brush is capable of when used in Content-Aware mode. In the Figure 7.12 example there were a number of cables and wires in this photograph that spoiled the view. By using the spot healing brush in Content-Aware mode I was able to carefully remove all of these to produce the finished photo shown below. Although the end result showed this tool could work quite well I should point out that you do still have to apply a certain amount of skill in your brush work and choice of settings in order to use this tool effectively. To start with I found that the Normal blend mode worked best for retouching the cables that overlapped the sky, since this blend mode uses diffuse edges to blend seamlessly with the surroundings. I also mostly used long, continuous brush strokes to remove these from the photograph and achieve a smooth blended result with the rest of the sky. When retouching the rocks I gradually removed the cables bit by bit by applying much shorter brush strokes and using the Replace blend mode. I find that you need to be quite patient and note carefully the result of each brush stroke before applying the next. You'll discover that dragging the brush from different directions can also influence the outcome of the heal blend retouching and you may sometimes need to carry out an undo and reapply the brush stroke differently and keep doing this until you get the best result. I also find that you can disguise the retouching better by adding extra, thin light strokes 90° to the angle of the first, main brush stroke and this too can help disguise your retouching work with the spot healing brush used in this mode.

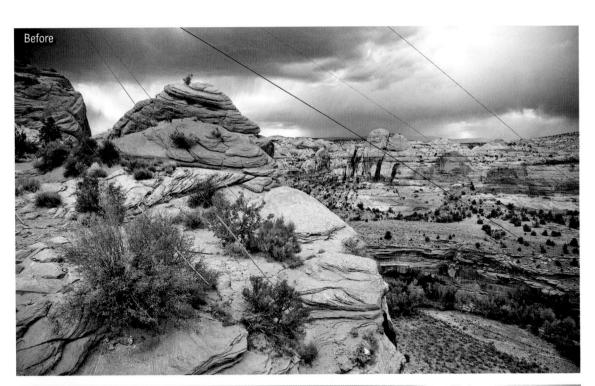

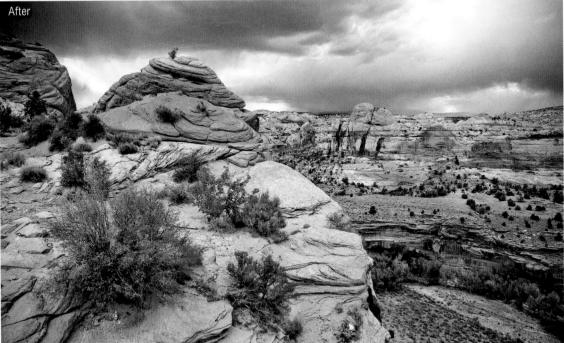

Figure 7.12 This shows a before version (top) and after version (bottom), where I had used the spot healing brush in Content-Aware mode to retouch the image.

Source and Destination modes

In Source mode you drag the patch tool selection area to a new destination point to replace the pixels in the original source selection area with those sampled from the new destination area. In Destination mode you drag the patch tool selection area to a new destination point to copy the pixels from the original source selection area and clone them to the new destination area.

Use Pattern option

The Use Pattern button in the Options bar lets you fill a selected area with a pattern preset using a healing type blend.

Patch tool

The patch tool uses the same algorithm as the healing brush to carry out its blend calculations, except the patch tool uses selection-defined areas instead of a brush. When the patch tool is selected, it initially operates in a lasso selection mode. For example, you can hold down the all key to temporarily convert the tool to become a polygonal lasso tool with which to draw straight line selection edges. The selection can be used to define the area to 'patch from' or 'patch to'. It so happens you don't actually need the patch tool to define the selection; any selection tool or selection method can be used when preparing a patch selection. Once you have made the selection, select the patch tool to proceed to the next stage. Unlike the healing brushes, the patch tool has to work with either the Background laver or a copied pixel laver. What is useful though is the patch tool provides an image preview inside the destination selection area as you drag to define the patch selection.

tool method you like to define the selection as you prepare an image for patching.

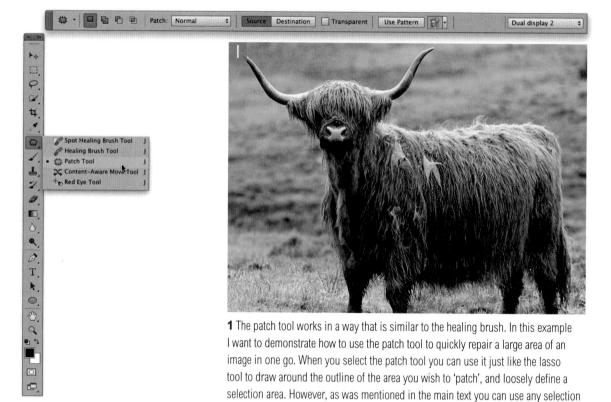

2 Having defined the area I wanted to patch, I made sure that the patch tool was selected (and was in Source mode). I then dragged inside the selection to locate an area of the image that could be used to 'patch over' the original area (i.e. remove the matted hair). As I dragged the patch selection this created a second selection area which I could use to define the area to clone from. Meanwhile, I was able to see a live preview in the original patch selection, indicating which pixels would be cloned to this selection area.

3 As I released the mouse, Photoshop began calculating a healing blend, analyzing the pixels from the source area (that I had just defined) and used these to merge them seamlessly with the pixels in the original selection area. The patch tool repair will usually work effectively first time. If it doesn't look quite right, I suggest deselecting the selection and use either of the healing brushes (or the clone stamp) to fine-tune the result. In this final version I repeated using the patch tool to remove more of the matted clumps of hair.

Transparent mode

In Transparent mode you can use the patch tool in the Source or Destination mode to blend selected areas transparently. In Figure 7.13 below you can see a before and after example where the patch tool was applied using the patch tool in Destination mode with the Transparent option checked.

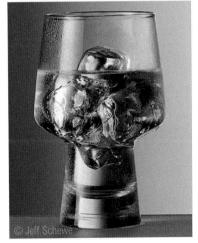

Figure 7.13 This shows an example of the patch tool applied in Transparent mode to copy an ice cube in a glass and have it blend transparently.

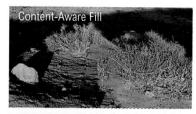

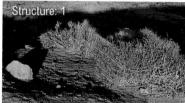

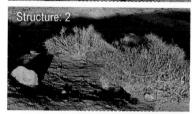

Figure 7.14 Examples of content-aware fill outcomes using different adaptation methods.

The patch tool and content-aware filling

Content-aware filling can be done by making a selection, choose Edit \Rightarrow Fill and fill using the Content-Aware fill mode (as shown below). There is also a Content-Aware mode when working with the patch tool. The following steps show a comparison between the use of the Edit \Rightarrow Fill command and the patch tool in Content-Aware mode. Note that when the Sample All layers option is checked, you can apply a patch tool content-aware fill to an empty new layer.

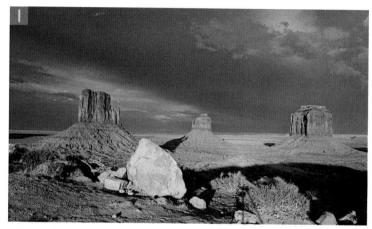

1 This photograph was taken at sunset and you can see the shadow of the tripod and camera. To remove this from the photo, I first made a rough lasso selection to define the outline of the shadow.

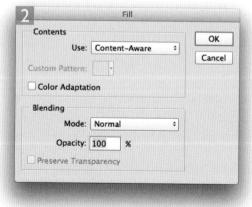

2 I then went to the Edit menu and chose Fill... (or, you may find it easier to use the **Shift F5** shortcut). This opened the Fill dialog shown here where in the Contents section I selected 'Content-Aware' from the pop-up menu. When I clicked OK, this filled the selected area. You can see the result of this fill at the top in Figure 7.14.

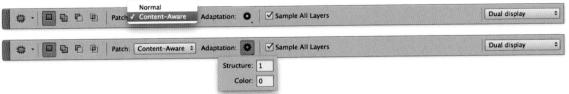

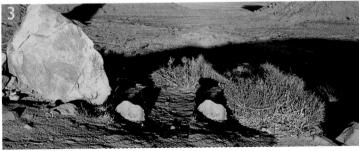

3 I undid the content-aware fill, selected the patch tool and in the patch tool Options bar chose the Content-Aware option. I added an empty new layer and with the 'Sample All Layers' option checked, dragged the selection to the left and released the mouse. With the selection still active, I was able to go through all the Structure options from the Adaptation menu, finally settling on a Structure setting of 1. You can see the results of all the different adaptation methods in Figure 7.14 on the left.

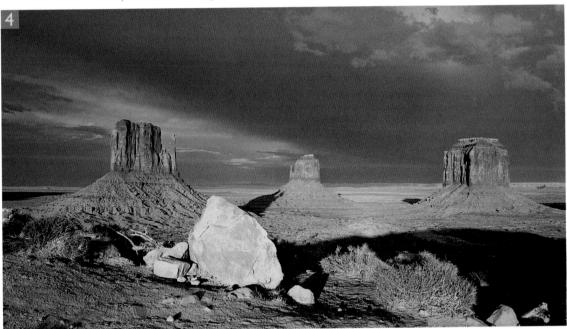

4 Here is the final version with the shadow successfully removed.

Constraining the content-aware fill

To improve the effectiveness of a content-aware fill you can use a layer mask to hide areas of an image that you would rather the content-aware fill ignored when filling a selection. For example, if you start with a Background layer, double-click to convert this to a regular layer and add an empty layer mask to that layer. Then with black as the foreground color, paint with black to hide the bits you don't want the content-aware fill to pick up. Now make a regular selection and apply the content-aware fill. When you are done you can delete the layer mask to reveal the entire layer again.

Delete options

If you make a selection on a background layer, or a flattened image and hit Delete, you'll see the Fill dialog box. This allows you to choose how you wish to fill the selected areas and will have Content-Aware Fill selected by default. If you want to bypass this and apply the previous default behavior, you can use # Delete (Mac), Ctrl Delete (PC) to fill using the background color.

Improved Content-aware fill

Content-aware processing has been improved in the current release of Photoshop CC. There has been an overall improvement in terms of quality and speed. For example, content-aware is now around 10 times faster when working on really large repair areas and around 4 times faster when editing smaller images.

When you use the Content-Aware Fill feature you have no control over the adaptation Structure mode used. Even so, the Content-Aware Fill feature will work well in most cases. All you have to do is to make a rough selection around the outline of whatever it is that you wish to remove from a scene and let the content-aware fill do the rest. Photoshop can usually work out how best to fill in the gaps in the selection and construct a convincing fill by sampling pixel information from the surrounding area. If you don't get a satisfactory result straight off, there are a couple of things you can try doing to make it work better. For example, it is recommended you expand the selection slightly before applying a content-aware fill. You can do this by using the Refine Edge command or go to the sometimes if you apply a content-aware fill more than once. As you apply subsequent fills you may see the filled area improve in appearance each time you do this. You might also like to try the layer mask trick described in the sidebar.

Adaptation Structure control

If you choose the patch tool method you have more control over the content-aware fill calculations. The main advantage you have here is that when you drag a patch selection you manually define which areas you would wish the content-aware fill to sample from. This can make a big difference to the final outcome.

The other thing you have control over is the adaptation Structure method that you would prefer to use. In Step 3 on the previous page I dragged the patch tool selection to the left to indicate the area I would like the tool to sample from. After letting go with the mouse, Photoshop carried out a content-aware fill. I was then able to select different adaptation Structure methods to see which worked best here. Note that while you can set the adaptation method first before you use the patch tool, you can also edit this after dragging the patch tool selection and review the effect this has on a contentaware fill. When Structure is set to 5, Photoshop uses a rigid sampling from the surrounding area and when it is set to 1, it tends to jumble things up more. The default setting is 3, which is probably a good starting-point to work with. In the previous example though, I found that the 1 setting happened to produce the best-looking result.

Content-aware move tool

The content-aware move tool works in a similar way to the patch tool in Destination mode, except it allows you to either extend a selected area or move it and fill the initial selected area (see the Options bar in Figure 7.15). In doing this it offers you the same adaptation methods as provided for the patch tool in the content-aware fill mode. You can cleverly adjust selected areas to make objects appear taller, shorter, wider, or thinner or to move selected items. Basically, the content-aware move tool allows you (in the right circumstances) to manually resculpt a photograph. We'll begin by looking at a move example using the content-aware move tool.

Editing portraits

Note that the content-aware move tool uses face detection to help get improved results when editing photos where people are featured in the shots.

Figure 7.15 The content-aware move tool Options bar.

1 In this example I selected the contentaware move tool and drew a rough outline around the outside of the leaf. Note that the 'Sample All Layers' option was selected and that I had created a new empty layer to carry out the content-aware move tool editing.

2 With the content-aware move tool in 'Move' mode I clicked inside the selection area and dragged a copy of the leaf to the right.

2

3 When I released the mouse this caused the original selection area to fill using a content-aware type fill and left a copy of the leaf just to the right of the original.

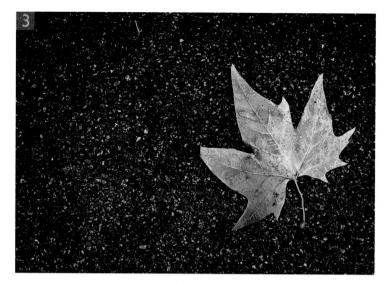

4 As with the patch tool, the content-aware move tool provides options for controlling the adaptation method. You can access these from the Adaptation menu shown above. To achieve the result shown in Step 3, the adaptation Structure was set to 5, but on the right I have shown the outcomes had I selected one of the other four options instead. As you can see, the 'Very Strict' adaptation method was the only suitable choice in this instance. All the other methods would have resulted in the leaf appearing broken up.

Border textures

The content-aware move tool tends to produce better-looking results when the surrounding area has a lot of texture detail to work with. The example shown here works nicely because of the surrounding asphalt texture. To produce a good blend you should have at least 10% space around the surrounding edges for the content-aware move tool to work with.

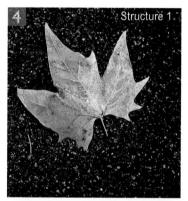

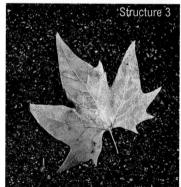

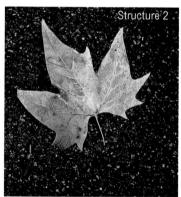

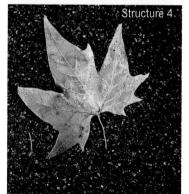

Content-aware move tool in Extend mode

When the content-aware move tool is used in the Extend mode you can use it to move selected areas and have these blend with the original image, rather than fill the original selected area. For example, you can use this to make buildings taller or stretch someone's neck. The content-aware move tool also performs a content-aware type fill with its surroundings as you create a new blend. However, be aware that whenever you use this tool to make things more compact you usually need to ensure the selected area on the side opposite to the direction you intend dragging is big enough to create a suitable overlap. This is because as you move the selection you need to be able to cover up whatever it is you are shortening. In the example shown below I used the content-aware move tool to extend the clouds in the sky.

Figure 7.16 This shows the cloud photo used in the steps below before applying the extend edit using the content-aware move tool.

1 Here, I used the content-aware move tool in Extend mode to select the outline of the clouds and then clicked inside the selection and dragged to the left.

Mode: Extend + Adaptation: Sample All Layers

2 As I released the mouse this dropped the copy selected area and blended it with the clouds below. In this instance I set the adaptation Structure to 1.

Dual display 2

Enhanced content-aware color adaptation

In the Fill dialog there is now a Color Adaptation checkbox. Shown here is an example of a basic content-aware fill combined with a color adaptation.

In the Options bar Adaptation menu for the patch tool and content-aware move tool there is also a Color setting. A zero setting means no color tolerance occurs (just as before). As you increase this value more color blending occurs up to a maximum blend setting of 10 (an example of this is shown over the page). The Content-aware algorithm generally has a preference for smoothness over texture. Increasing the color tolerance further improves the smoothness and this method of filling and repairing is mainly useful when working on smooth graduated areas. A Color Tolerance setting of 10 will tend to over compensate, so the best setting options are within the 3–7 range.

1 In this example I wanted to show a simple way to remove the clouds from this photograph. I began by making a simple rectangular marquee selection of the clouds.

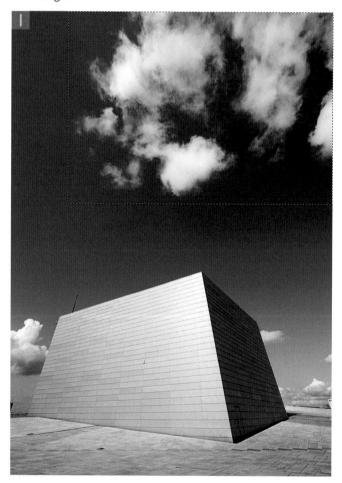

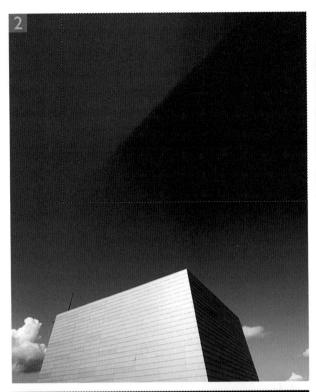

2 I then went to the Edit menu and chose Fill. In the Fill dialog shown here I selected the Content-Aware option. This filled the selection, removing the clouds, but left noticeable banding in the sky.

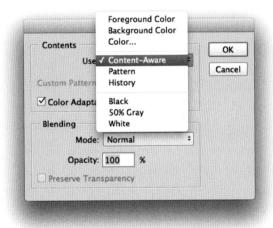

3 I undid the last step and repeated, except this time I checked the Color Adaptation option in the Fill dialog. This did a better job of filling the sky compared to without. It's not completely perfect, but shows the dramatic difference that can be achieved when this new option is enabled.

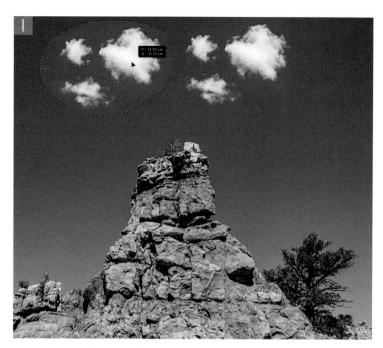

1 To demonstrate the power of the new Color Tolerance controls, I used the contentaware move tool to move the cloud selection in this photograph.

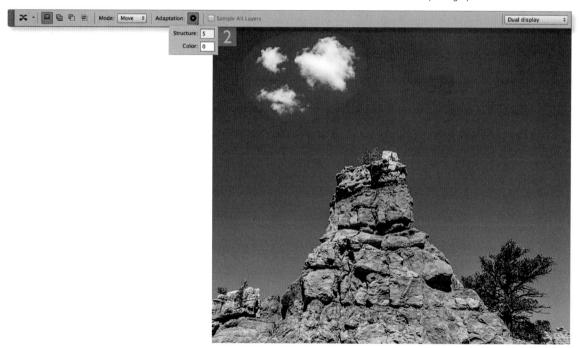

2 In this example the Adaptation Structure was set to the default 5 setting with zero Color tolerance. This matches the legacy setting for this tool. Notice how the moved selection shows poor blending around the selection edges.

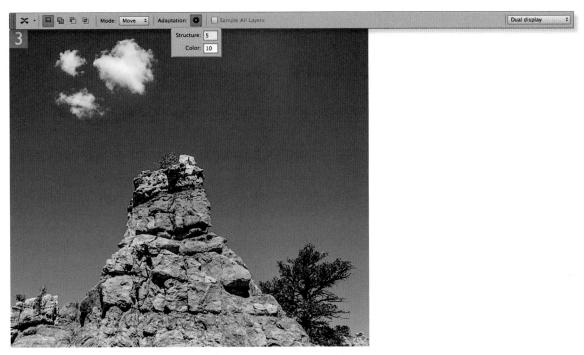

3 I then redid the last step, but this time set the Color setting to 10. However, this over compensated with the cloud selection blending.

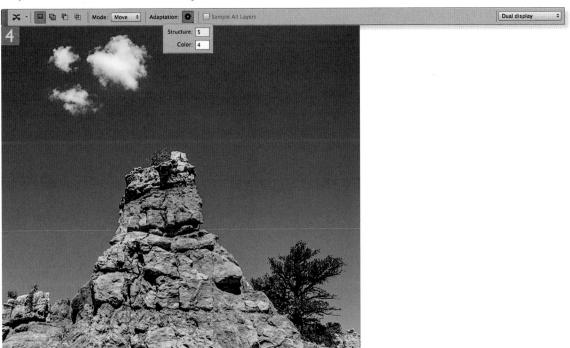

4 Here, I used the content-aware move with a Color setting of 4 to produce a much smoother-looking result.

Working with the Clone Source panel

1 Here I wanted to show how you can work with the healing brush or clone stamp tools to clone at an angle. I added a new layer and sampled a side of the bowl with the healing brush.

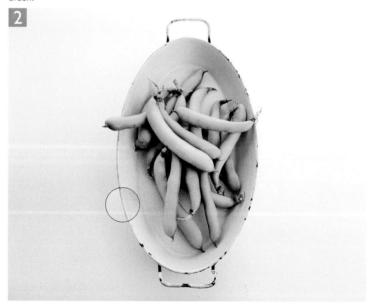

2 I then went to the Clone Source panel and adjusted the angle. The best way to do this is double-click to highlight the angle field, place the cursor over the area to be cloned and use the keyboard arrow keys to adjust the angle value up or down. Also, hold down the **Shift** key to magnify the arrow key adjustment.

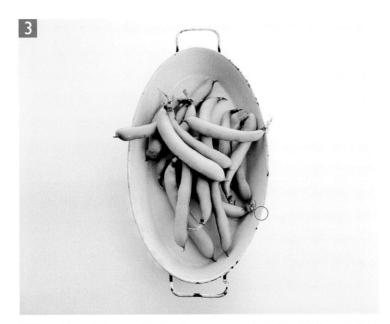

After making a first successful clone it was necessary to double-click the angle field again to make it active, position the cursor and once more adjust the angle.

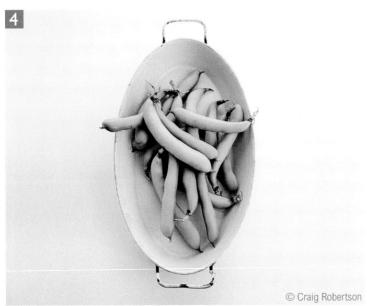

Perspective retouching

The Vanishing Point filter can be accessed from the Filter menu and allows you to retouch photographs while matching the perspective. I have provided here a quick example of how one might use the Vanishing Point filter to retouch out some road markings. For more details about working with this filter, there is a PDF you can download from the book website.

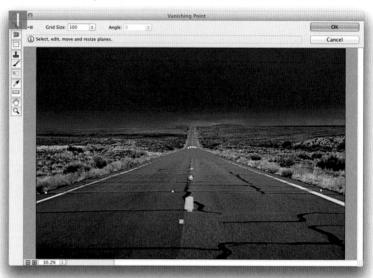

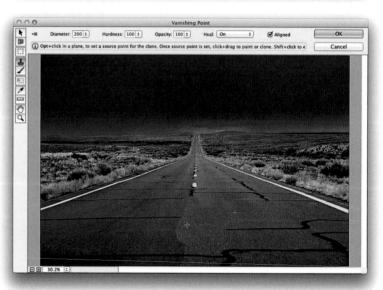

1 To begin with I selected a Background copy layer and chose Filter ⇒ Vanishing point and used the create plane tool (ⓒ) to define the road perspective. I selected the stamp tool (⑤), and with the Heal mode switched on, removed the unwanted road markings.

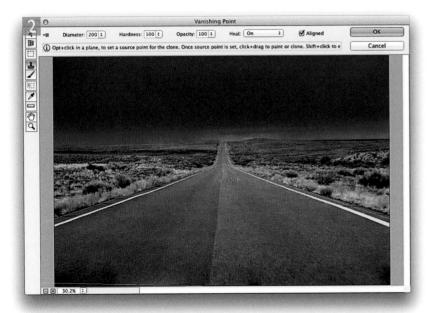

2 This shows how the road looked after retouching it using the Vanishing Point filter.

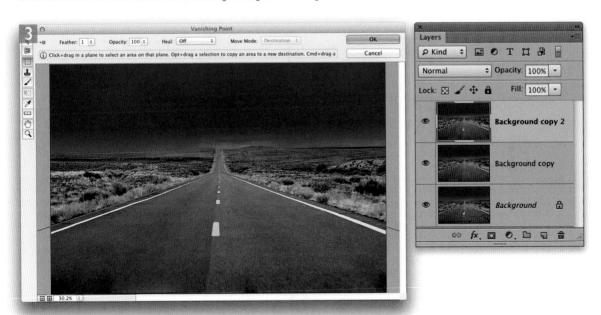

3 I applied the filter at the Step 2 stage and copied the Background Copy layer to make a new copy layer. To this I added a single yellow dash line in the middle of the road (which I had sampled from the original Background layer). I then opened the Vanishing Point filter a second time (note that the previously created perspective plane was still saved) and used the stamp tool in Heal mode again to clone the yellow dash down the middle of the road.

Replacing film grain

If the photographic original contains noticeable film grain, you may encounter a problem here since even with a selective application of the Dust & Scratches filter, you may end up softening the image as you retouch it. To counteract this it may help to apply a small amount of noise after you have applied the Dust & Scratches filter. Add just enough noise to match the grain of the original (usually around 2–3%). This will enable you to better disquise the history brush retouching.

Lighten/Darken blend mode

The Lighten blend mode was used to remove the dark marks in the image. Similarly, you can use the Darken blend mode to remove any light blemish marks. For example, if you were to retouch a scanned color negative, the dust spots would all show up as white marks and you would want to spot with the history brush set to the Darken blend mode.

Alternative history brush spotting technique

This spotting method has evolved from a technique that was first described by Russell Brown, Senior Creative Director of the Adobe Photoshop team. It revolves around using the Remove Dust & Scratches filter, which can be found in the Filter

Noise submenu. If you apply this filter globally to the entire image, you end up with a very soft-looking result. So ideally this filter should be applied selectively to the damaged portions of the image only. The technique shown here has the advantage of applying the filtered step via the history brush so that only the pixels which are considered too dark or too light are painted out. This modified approach to working with the Dust & Scratches filter avoids doing any more harm to the image than is absolutely necessary. As you can see, the technique works well when you have a picture that is very badly damaged and where using the clone stamp would be a very tedious process. What is really clever is the way that the Lighten (and Darken) blend modes can be used to precisely target which pixels are repaired from the stored Dust & Scratches history state.

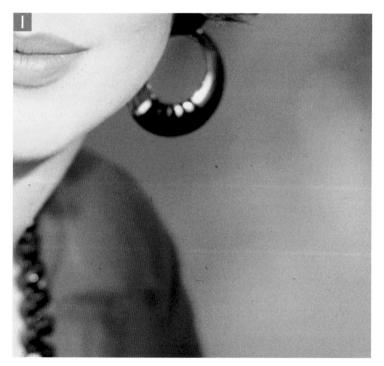

1 This scanned photograph is as a good example with which to demonstrate the history brush spotting technique, as a lot of dust marks are clearly visible.

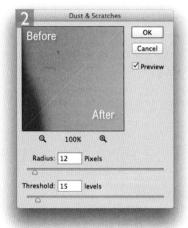

Threshold adjustment

One way to reduce the destructiveness of this filter is to raise the Threshold value in the Dust & Scratches Filter dialog.

2 I went to the Filter menu and chose Noise ⇒ Dust & Scratches. I adjusted the Radius and Threshold settings so that most of the dust marks would be removed and clicked OK to apply this filter to the image.

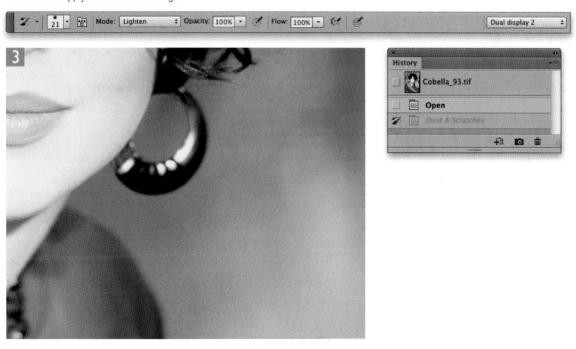

3 I then went to the History panel and clicked on the previous unfiltered image history state, but set the Dust & Scratches filtered version as the history source to paint from. I then selected the history brush and in the tool Options bar changed the history brush blend mode to Lighten. As I painted over the dark spots, the history brush lightened only those pixels that were darker than the sampled history state. All the other pixels remained unchanged. I continued using the history brush in this way until I had removed all the dust spots in the photograph.

Portrait retouching

Here is an example of a restrained approach to retouching, where only a minimal amount of Photoshop editing was used. Of course you can retouch portraits as if they were fashion shots and some publications may demand this, but I thought I would start off by showing a more subtle approach to portrait retouching.

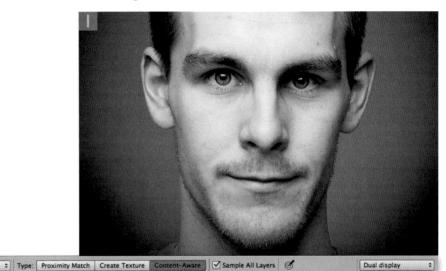

fx. 00 0. 00 00 00

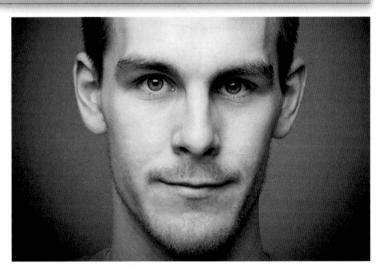

1 The top photograph shows the unretouched 'before' version and below this you can see the results of the initial retouching in which I mainly used the healing brush to remove some of the skin blemishes. The key thing was not to overdo the retouching. What I did here was more like 'tidying and grooming' rather than 'digital surgery'.

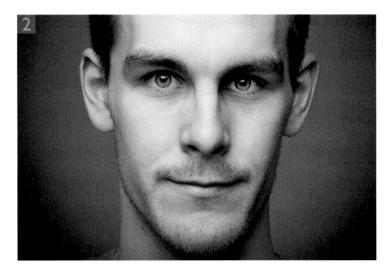

2 For this next step I wanted to lighten the eyes. To do this, I used the lasso tool to define the outline of the eyes. In the Adjustments panel I clicked to add a Curves adjustment and in the Properties panel adjusted the curve shape to lighten the selected area. I then selected the whites of the eyes only and applied a separate Curves adjustment. The aim here was to add more contrast and make the eyes slightly lighter.

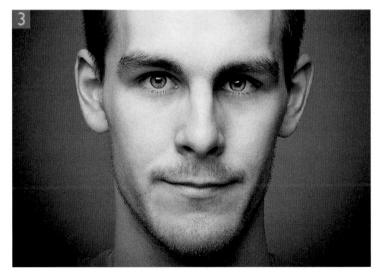

3 You don't want the eyes to be too light, so in this step I reduced the eye adjustment layer opacity slightly. Lastly, I wanted to adjust the shapes of the eyes. To do this, I used the **Shift** (Mac), ciri all Shift** (PC) command to create a merged copy layer at the top of the layer stack. I made a marquee selection to include the eyes, inverted the selection and hit *Doloto** (this was done to keep the file size down). I then went to the Filter menu, and chose Liquify (described later in this chapter), where I made the left eye smaller, opened up the eye on the right and raised the eyebrow slightly. I then clicked OK to complete the retouching shown here.

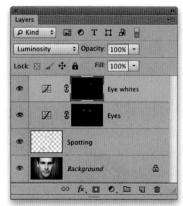

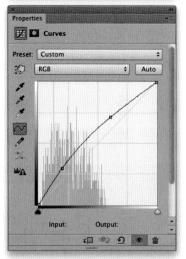

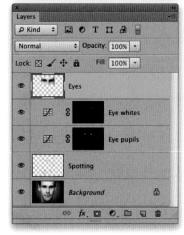

Getting the balance right

The main thing I show on these pages is how to use the paint brush to smooth the skin tones. I happen to prefer using the manual painting approach (rather than simply blur the skin texture). This is because the painting method offers more control over the retouching. An important issue here is "how much should you retouch?" This is mostly down to personal taste. My own view is that it is better to fade any painting work that's done and let the natural skin texture show through. It is possible to retouch to produce a clean-looking image, while still keeping the model looking vaguely human.

Beauty retouching

Beauty photographs usually require more intense retouching, where the objective is to produce an image in which the model's features and skin appear flawless. This can be done through a combination of spotting and paint brush work.

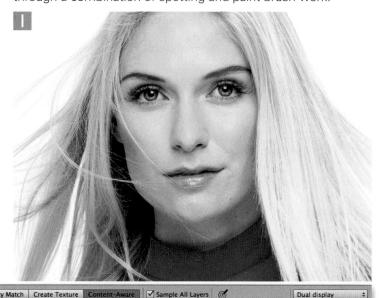

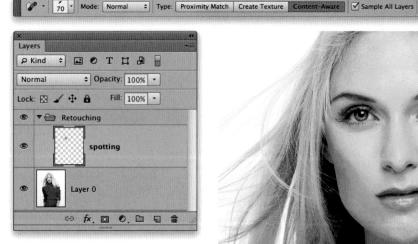

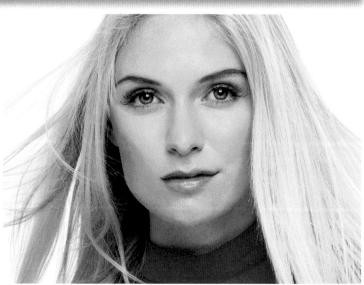

1 The top photograph here shows the before version and below that, how the same image looked after I had added a new empty layer and carried out some basic spotting work with the healing brush, where I cleaned up the spots and got rid of unwanted stray hairs.

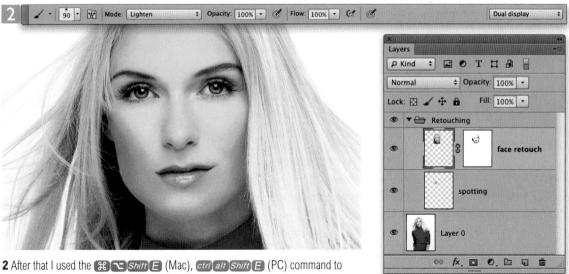

2 After that I used the According (Mac), cut all Shift (PC) command to create a merged copy layer at the top of the layer stack (based on a marquee selection) and worked with the paint brush on the merged layer. The trick here was to hold down the all key to sample a skin tone color and gently paint using low opacity brush strokes with the blend mode set to 'Lighten'. This meant the paint strokes only affected those colors that were darker than the sample color. Similarly, I switched to 'Darken' mode when I wished to darken only those pixels lighter than the paint sample color. This selective method of painting can produce more controlled results compared with using the Normal blend mode.

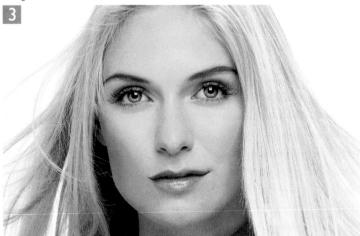

3 This shows the finished retouched version in which I faded the opacity of the painted layer to 40% and added a layer mask so that I could carefully mask the areas where the paint retouching had spilled over. Lastly, I made a lasso selection of the eyes and clicked on the Add Adjustment Layer button in the Layers panel to add a Curves adjustment based on the eyes selection. I then applied a lightening adjustment to lighten the eyes slightly.

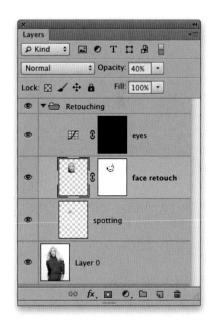

Liquify tools

Forward warp tool (W)

Provides a basic warp distortion with which you can stretch the pixels in any direction you wish.

Reconstruct tool (R)

Can be used to reverse a distortion and make a selective undo.

Smooth tool (E)

Can be used to smooth out ripples in the mesh caused by multiple, small warp tool applications.

Twirl clockwise tool (C)

Twist the pixels in a clockwise direction (hold down the All key to switch tool to twirl in a counterclockwise direction).

Pucker tool (S)

Shrink the pixels and produce an effect similar to the 'Pinch' filter.

Bloat tool (B)

Magnify the pixels and produce an effect similar to the 'Bloat' filter.

Push left tool (0)

Shift the pixels at 90° to the left of the direction in which you are dragging.

Freeze mask tool (F)

Protect areas of the image. Frozen portions are indicated by a quick mask type overlay. These areas are protected from any further liquify distortions.

Thaw mask tool (D)

Selectively or wholly erase the freeze tool area.

🖱 Hand tool (H)

For scrolling the preview image.

□ Zoom tool (Z)

Used for zooming in or zooming out (with the at key held down).

Liquify

The Liquify filter is designed to let you carry out freeform pixel distortions. When you choose Filter \(\simes\) Liquify (or use the \(\mathbb{H}\) Snift \(\mathbb{X}\) [Mac], \(\mathbb{CIT}\) Shift \(\mathbb{X}\) [PC] keyboard shortcut), you are presented with what is known as a modal dialog, which basically means you are working in a self-contained dialog with its own set of tools and keyboard shortcuts, etc. The Liquify filter therefore operates like a separate program within Photoshop. To use Liquify efficiently, I suggest you first make a marquee selection of the area you wish to manipulate before you select the filter, and once the dialog has opened use the \(\mathbb{H}\) O (Mac), \(\mathbb{CIT}\) O (PC) keyboard shortcut to enlarge the Liquify filter dialog to fit the screen.

Basically, you can use the Liquify tools to manipulate the image and when you are happy with your liquify work, click the OK button or hit *Enter* or *Return*. Photoshop then calculates and applies the liquify adjustment to the selected image area. The Liquify tools are all explained in the column on the left and Figure 7.17 provides a visual guide to what they can do. One of the main things to point out here is that Liquify is optimized to make use of the GPU (Graphics Processing Unit) and provide good overall responsiveness. As a consequence of this the turbulence and mirror tools were removed when Photoshop CS6 came out. This is because they couldn't be enabled to work with the GPU, but it's not such a great loss as people weren't using these particular tools a lot anyway.

The Liquify filter opens in a basic mode of operation (Figure 7.18), where initially only the forward warp, reconstruct, pucker, bloat, push left, hand and zoom tools appear in the tools section. You also have just a simplified set of tool options and you'll need to check the Advanced mode box if you want to access the full list of tools and other Liquify options (Figure 7.19).

The easiest tool to get to grips with is the forward warp tool, which allows you to simply click and drag to push the pixels in the direction you want them to go in. However, I also like working with the push left tool, because it lets you carry out some quite bold warp adjustments. Note that when you drag with the push left tool it shifts the pixels 90° to the left of the direction you are dragging in and when you aft drag with the tool, it shifts the pixels 90° to the right. The key to working successfully with the Liquify filter is to use gradual brush movements and build up the distortion in stages.

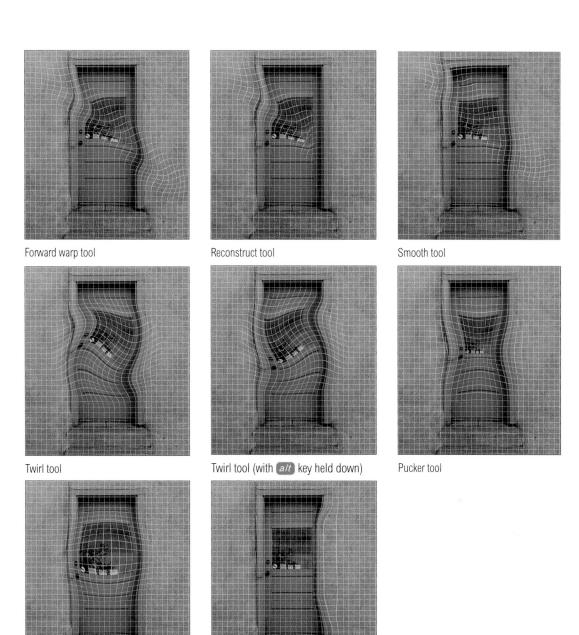

Figure 7.17 These illustrations give you an idea of the range of distortion effects that can be achieved using the Liquify tools listed on page 496.

Push left tool (pushed up)

Bloat tool

Figure 7.18 The basic Liquify settings.

Figure 7.19 The advanced Liquify dialog options. There is a new Pin Edges option. When checked, this prevents the image edges from warping inwards.

Advanced Liquify tool controls

Once you have selected a tool to work with you will want to check out the associated tool options that are shown in the Advanced mode dialog in Figure 7.19. These tool options are applied universally to all the tools and include: Brush Size, Brush Density, Brush Pressure and Brush Rate. All tools (apart from the hand and zoom tool) are displayed as a circular cursor with a crosshair in the middle. You can use the square bracket keys In to alter the tool cursor size and the rate of increase/decrease can be accelerated by holding down the Shift key. You can also right mouse drag with the all key in the Preview area, or use the scrubby sliders to adjust the cursor size. The maximum brush size is 15,000 pixels. I highly recommend here that you use a pressure sensitive pen and pad such as the Wacom™ system and if you do so, make sure that the Stylus Pressure option is checked and that the Brush Pressure setting is reduced to around 10-20%.

Reconstructions

Next we have the Reconstruct Options. If you apply a Liquify distortion and click on the Reconstruct button, this opens the Revert Reconstruction dialog shown in Figure 7.20. By setting the Amount to anything less than 100, you can decide by how much to reduce the current overall image liquify distortion—the reconstruction is applied evenly to the whole image and allows you to unwarp by however much you like. Note that as you do this the distortion will be preserved for any areas that have been frozen using the freeze tool. If you click on the 'Restore All' button the entire image is restored in one step (ignoring any frozen areas). There is also a reconstruct tool ((R)), which can be used to selectively paint over any areas where you wish to selectively undo a warp, and a new smooth tool ((E)) that can be used to smooth out ripples in the mesh caused by multiple, small warp tool applications.

Don't forget that while inside the Liquify dialog, you also have multiple undos at your disposal. Use # Z (Mac), ctrl Z (PC) to undo or redo the last step, # Z (Mac), ctrl alt Z (PC) to go back in history and # Shift Z (Mac), ctrl Shift Z (PC) to go forward in history.

Mask options

The mask options can utilize an existing selection, layer transparency or a layer mask as the basis of a mask to freeze and constrain the effects of any Liquify adjustments (Figure 7.21). The first option is 'Replace Selection' (.). This replaces any existing freeze selection that has been made. The other four options allow you to modify an existing freeze selection by 'adding to' (.), 'subtracting from' (.), 'intersecting' (.) or creating an 'inverted' selection (.). You can then click on the buttons below. Clicking on 'None' clears all freeze selections, clicking 'Mask All' freezes the entire area, and clicking 'Invert All' inverts the current frozen selection.

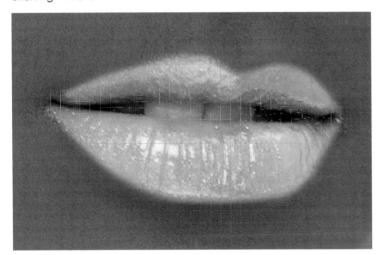

Figure 7.22 Freeze masks can be used to protect areas of a picture before you begin doing any liquify work. In the example shown here a freeze mask was loaded from a layer mask (see Figure 7.21). When you freeze an area in this way it is protected from subsequent distortions so you can concentrate on applying the Liquify tools to just those areas you wish to distort. Frozen mask areas can be unfrozen by using the thaw mask tool.

View options

The View options can be seen in Figure 7.23. The 'Show Mesh' option lets you see a mesh overlay revealing the underlying liquify distortion and the mesh grid can be displayed at different sizes using different colors. This can readily help you pinpoint the areas where a distortion has been applied. You can use the check boxes in this section to view the mesh on its own or have it displayed overlaying the Liquify preview image (as shown in the Figure 7.17 examples).

Figure 7.20 The Revert Reconstruction dialog.

Figure 7.21 If you mouse down on the arrow next to the mask options you can also load a mask from the pop-up menu. This can include saved alpha channels and this was how, for example, I was able to load the precision mask shown in Figure 7.22.

Figure 7.23 The Liquify View options.

The freeze mask overlay can be made visible or hidden by using the 'Show Mask' checkbox in the View options and this section also allows you to choose a mask color.

The Show Backdrop option is normally left unchecked. If the Liquify image contents are contained on a layer, then it is possible to check the Show Backdrop option and preview the liquified layer against the Background layer, all layers, or specific layers in the image. Here is how this option might be used. Let's imagine for example that you wished to apply a liquify distortion to a portion of an image and you started out with just a flattened image. You then make a selection of the area you wish to work on and make a copy layer via the selection contents using \(\mathbb{H} \) (Mac), \(\cappatril \) (PC). Once you have done this, as you apply the Liquify filter you can check the Show Backdrop checkbox and set the mode to Behind. At 100% opacity the Liquify layer covers the Background layer completely, but as you reduce the opacity you can preview the effect of a Liquify distortion at different opacity percentages. This technique can prove useful if you wish to compare the effect of a distortion against the original image or a target distortion guide (as in the step-by-step example at the end of this chapter).

Saving the mesh

The Liquify dialog includes 'Save Mesh...' and 'Load Mesh...' buttons. These allow you to save your Liquify work as a mesh setting and reload this later. And there is also a 'Load Last Mesh' button.

When you save a mesh you have the option to work on the image again at a later date and reload the previous mesh settings. So, for example, if you have a saved mesh, this gives you the option to copy the original layer contents again, reapply the previously used mesh and re-edit the image contents in Liquify. Another thing you can do is to edit a low resolution version first, save the mesh and then reload and apply this mesh to the full resolution version later.

To reapply a Liquify filter using the last applied settings, go to the Filter menu and choose 'Last Filter', or use the **# F** (Mac), **CIT F** (PC) shortcut.

Photoshop CC Liquify performance

A number of improvements have been made to the user interface in Photoshop CC as well as steps made to improve performance. Liquify now runs faster, maybe as much as 16 times faster, when working on large documents. Also, zooming in on large documents is much faster now and aliasing has been removed when zooming levels at in-between full magnification views (i.e. at 33% and 66%).

Also, each tool in Liquify now remembers its own settings for size, density, pressure and rate. When you switch tools, the new tool will always remember its last-used settings.

Smart Object support for Liquify

Photoshop CC notably provides Smart Object support for the Liquify filter. The reason why Liquify was not supported previously as a Smart Object was because this filter relied on the creation of a mesh, which would be automatically deleted once you clicked OK to apply a mesh edit. Now, when a document or layer is converted to a Smart Object, Liquify saves a compressed mesh within the document. This means that when you choose to re-edit a (smart object) Liquify filter setting the mesh can be reloaded. Note that while the mesh saved is compressed, this will still cause an image document to increase in size.

On-screen cursor adjustments

Providing you have the OpenGL option enabled in the Photoshop Performance preferences, you can now apply onscreen cursor adjustments in the Liquify dialog preview. This means that if you hold down the crift keys (Mac), or the all key and right-click (PC), dragging to the left makes the brush cursor size smaller and dragging to the right, larger (and keeps the cursor position centered as you do so). If you drag upwards with these same keys held down you can decrease the brush pressure settings and dragging downwards will increase the brush pressure (see Figure 7.24).

If you hold down the key the Cancel button changes to 'Reset'. But in addition now, if you hold down the (Mac), (PC) key, the Cancel button changes to 'Default', which returns the controls to the 'factory original settings'.

Figure 7.24 In the Liquify dialog, if you hold down the crin keys (Mac), or the last key and right-click (PC), this reveals the onscreen cursor display. Drag left/right to make the cursor smaller or larger and drag up/down to decrease or increase the brush pressure setting.

Targeted distortions using Liquify

With the recent introduction of the Puppet warp tool you may be wondering if we still need to use Liquify? After all, Puppet Warp does allow you to work on an image layer directly rather than via a modal dialog. Although I am a fan of the Puppet Warp feature, I do still see a clear distinction between the types of jobs where it is most appropriate to use Puppet Warp and those where it is better to use Liquify. In the example shown here, the Liquify filter was still the best tool to use because you can use the paint-like controls to carefully manipulate the mesh that controls the distortion. Plus you can also use the freeze tool (which is unique to Liquify) to control those parts of the image that you don't want to see become distorted. Every job is different and you'll need to decide for yourself which is the most appropriate distortion tool to use and which can best help you achieve the result you are after.

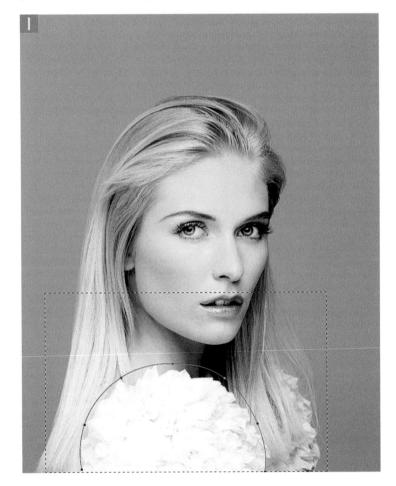

1 The objective here was to enlarge the rosette on the shoulder using the Liquify filter. This first step was to create a guide for subsequent Liquify work. I created an empty new layer (Layer 1) and used the pen tool to draw a path outline and stroked this path using the brush tool (see page 472). I then made a selection of the area of interest and used (Mac), (Mac), (Mac), (PC) to copy the Layer 0 selected area. I then (Mac), (PC)-clicked the copied layer to reactivate the selection. This is important as having a selection active forces Liquify to load the selected area only.

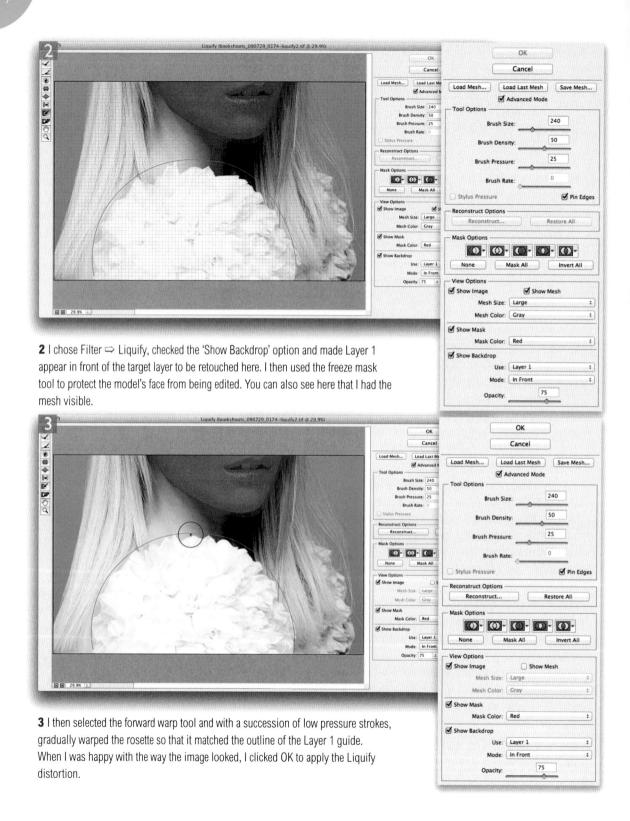

Chapter 8

Layers, Selections and Masking

For a lot of photographers the real fun starts when you can use Photoshop to create composite photographs and combine different image elements into a single photo. This chapter explains the different tools that can be used for creating composite photographs as well as the intricacies of working with layers, channels, mask channels and pen paths. To begin with, let us focus on some of the basic principles such as how to make a selection and the interrelationship between selections, alpha channels, masks and the Quick Mask mode.

Figure 8.1 A selection is represented in Photoshop using marching ants.

Selections and channels

Whenever you read about masks, mask channels, image layer mask channels, alpha channels, quick masks or saved selections, we are basically talking about the same thing: an active, semipermanent or permanently saved selection.

Selections

There are many ways you can create a selection in Photoshop. You can use any of the main selection tools such as the lasso tool or the Select

Color Range command, or convert a channel or path to a selection. Whenever you create a selection, you will notice that it is defined by a border of marching ants (Figure 8.1). It is important to remember that selections are only temporary—if you make a selection and accidentally click outside the selected area with the selection tool, the selection will be lost, although you can always restore a selection by using the Edit ⇒ Undo command (第2 [Mac], ctrl Z [PC]). As you work on a photo in Photoshop, you will typically use selections to define specific areas of an image where you wish to edit the image or maybe copy the pixels to a new layer and when you are done, you'll deselect the selection. If you end up spending any length of time preparing a selection, you'll maybe want to save such selections by storing them as alpha channels (also referred to as 'mask channels'). To do this, go to the Select menu and choose Save Selection... The Save Selection dialog box then asks if you want to save the selection as a new channel (Figure 8.2). If you select a pre-existing channel from the Channel menu you will have the option to replace, add,

Figure 8.2 To save a selection as a new alpha channel you can choose Select ⇒ Save Selection and select the New Channel button option.

subtract or intersect with the selected channel. You can also create new alpha channels by clicking on the 'Save selection as a channel' button at the bottom of the Channels panel, which will convert a selection to a new channel. If you look at the Channels panel shown in Figure 8.3, you will notice how a saved selection has been added as a new alpha channel (this will be channel #6 in RGB mode, or #7 if in CMYK mode). You can also click on the 'Create new channel' button, then fill the empty new channel with a gradient or use the brush tool to paint in the alpha channel using the default black or white colors. Once you create a new channel it is preserved when you save the image.

To load a saved channel as a selection, choose 'Load Selection...' from the Select menu and select the appropriate channel number from the submenu. Alternatively, you can (Mac), (PC)-click a channel in the Channels panel, or highlight a channel and click on the 'Load channel as a selection' button.

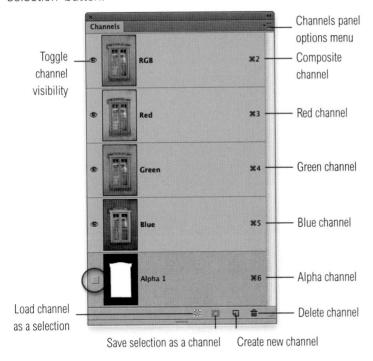

Figure 8.3 When you save a selection it is added as a new alpha channel in the Channels panel. Channels can be viewed independently by clicking on the channel name. However, if you keep the composite channels selected and click on the empty space next to the channel (circled), you can preview a channel as a quick mask overlay.

Recalling the last used selection

Omitting channels in a save

As was pointed out in the main text, channels are automatically saved when you save an image. However, if you choose Save As... you do have the option to exclude saving alpha channels with an image should you wish to do so.

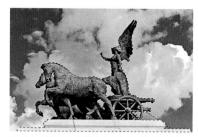

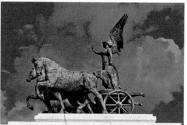

Figure 8.4 The top image shows an active selection and the bottom image shows the same selection displayed as a Quick Mask.

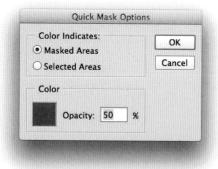

Figure 8.5 The Quick Mask Options.

The marching ants indicate the extent of an active selection and any image modifications you carry out are applied within the selected area only. Remember though, all selections are only temporary and can be deselected by clicking outside the selection area with a selection tool or by choosing Select Deselect (HD [Mac], CIND [PC]). If you find the marching ants to be distracting you can temporarily hide them by going to the View menu and deselecting 'Extras'. Or, you can use the H (Mac), CINH (PC) keyboard shortcut to toggle hiding/showing the marching ants (though this is dependent on how you have configured the HH (Mac), CINH (PC) behavior [see page 32]).

Quick Mask mode

You can also preview and edit a selection in Quick Mask mode, where the selection will be represented as a transparent colored mask overlay (Figure 8.4). If a selection has a feathered edge, the marching ants boundary will only represent the selected areas that have more than 50% opacity. Therefore, whenever you are working on a selection that has a soft edge you can use the Quick Mask mode to view the selection more accurately. To switch to Quick Mask mode from a selection, click the quick mask icon in the Tools panel (Figure 8.6) or use the (a) keyboard shortcut to toggle back and forth between the selection and Quick Mask modes. Whether you are working directly on an alpha channel or in Quick Mask mode, you can use any combination of Photoshop paint tools, or image adjustments to modify the alpha channel or Quick Mask content. If you double-click the quick mask icon, this opens the Quick Mask Options shown in Figure 8.5, where you can alter the masking behavior and choose a different color from the Color Picker (this might be useful if the Quick Mask color is too similar to the colors in the image you are editing).

Figure 8.6 The Quick Mask mode button is in the Tools panel just below the foreground/background swatch colors. Shown here are the two modes: Selection mode (left) and Quick Mask mode (right). You can toggle between these by clicking on this button. Double-click to open the Quick Mask Options shown in Figure 8.5.

Creating an image selection

1

1 In this example I selected the elliptical marquee tool and dragged with the tool to define the shape of the cup and saucer. Note how you get to see a heads up display of the selection dimensions.

2

2 Now that I had created this selection I could use it to modify the image. With the selection still active, I added a new Curves adjustment layer (using the settings shown here in the Properties panel) to cool the cup and saucer. When you add an adjustment layer and a selection is active, the selection automatically generates a layer mask and the mask also appears in the Channels panel as 'Curves 1 Mask'.

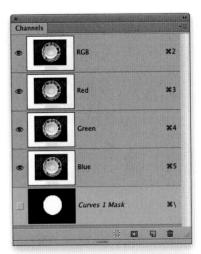

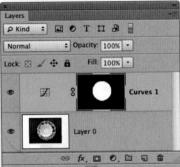

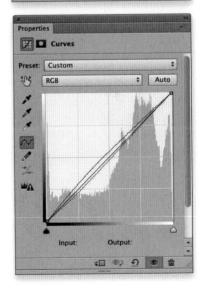

Reloading selection shortcuts

To reload a selection from a saved mask channel, choose Select ⇒ Load Selection... You can also ∰ (Mac), ctrl (PC) + click a channel to load it as a selection. To select a specific channel and load it as a selection, use ∰ ► + channel # (Mac), ctrl alt + channel # (PC) (where # equals the channel number).

To select the composite channel, use ∰ ② (Mac), ctrl ② (PC) and use

2 (Mac), ctrl 2 (PC) and use # 3 (Mac) ctrl 3 (PC) to select the red channel, # 4 (Mac), ctrl 4 (PC) to select the green channel, # 5 (Mac), ctrl 5 (PC) to select the blue channel and subsequent numbers to select any additional mask/alpha channels that are stored in an image.

Modifying selections

You can modify the content of a selection using the Shift and all modifier keys. If you hold down the Shift key you can add to a selection. If you hold down the all key you can subtract from a selection and if you hold down the Shift (Mac), all Shift (PC) keys you can intersect a selection as you drag with a selection tool. The magic wand is a selection tool too, but here all you have to do is to click (not drag) with the magic wand, holding down the appropriate keys to add or subtract from a selection. Note that if you select either the lasso or one of the marquee tools, placing the cursor inside the selection and dragging moves the selection boundary position, but not the selection contents.

Alpha channels

An alpha channel is effectively the same thing as a mask channel and when you choose Select ⇒ Save Selection..., you are saving the selection as a new alpha channel. These are saved and added in numerical sequence immediately below the main color channels. Just like normal color channels, an alpha channel can contain up to 256 shades of gray in 8-bits per channel mode or up to 32,000 shades of gray in 16-bits per channel mode. You can select a channel by going to the Channels panel and clicking on the desired channel. Once selected, it can be viewed on its own as a grayscale mask and manipulated any way you like using any of the tools in Photoshop. An alpha channel can also effectively be viewed in a 'quick mask' type mode. To do this, select an alpha channel and then click on the eyeball icon next to the composite channel, which is the one at the top of the Channels panel list (see Figure 8.3). You will then be able to edit the alpha channel mask with the image visible through the mask overlay. There are several ways to convert an alpha channel back into a selection. You can go to the Select menu, choose Load Selection... and then select the name of the channel. A much simpler method is to drag the channel down to the 'Make Selection' button at the bottom of the Channels panel, or 🔀 (Mac), ctrl (PC)-click the channel in the Channels panel.

Modifying an image selection

2

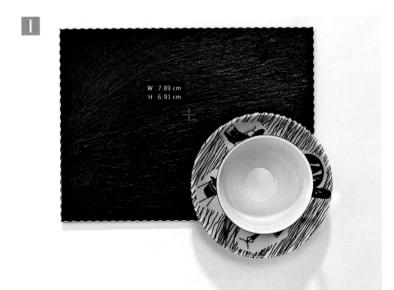

1 Here, I started off with a rectangular marquee selection. I then selected the elliptical marquee tool and dragged across the image with the **a**tt key held down. This allowed me to subtract from the original rectangular marquee selection.

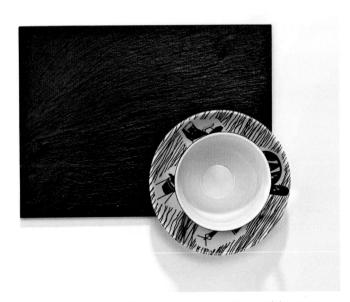

2 As with the previous example I added a Curves adjustment that used the current active selection to create the masked adjustment layer seen here. I then adjusted the Curves to make the place mat cooler.

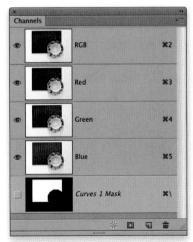

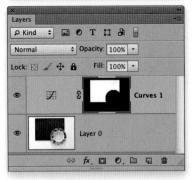

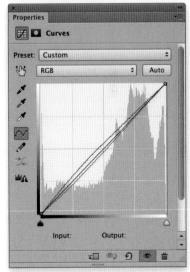

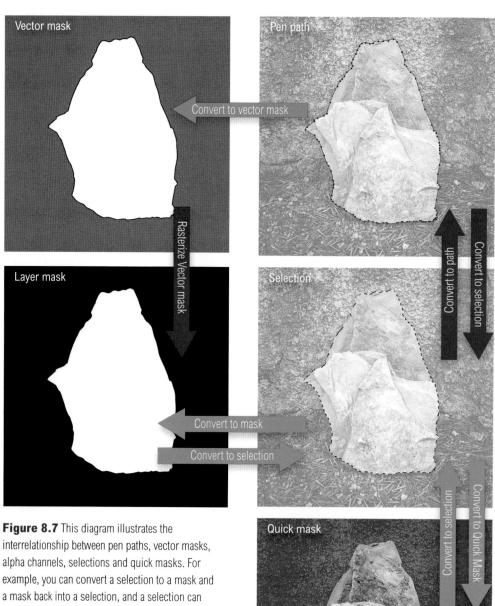

temporarily be displayed and edited in Quick Mask mode and switched back to selection mode again. The red arrows indicate that some data loss is incurred during the conversion from one state to the other.

Selections, alpha channels and masks

As was pointed out at the beginning of this chapter, there is an interrelationship between selections, quick masks and alpha channel masks. This also extends to the use of vector paths and vector masks (vector paths are discussed towards the end of this chapter). The accompanying Figure 8.7 diagram highlights these relationships in more detail.

Starting at the top right corner, we have a path outline that has been created using the pen tool in Photoshop. A pen path outline can be saved as a path and an active path can be used to create a vector mask, which is a layer masked by a pen path mask (see pages 605–614). A vector mask can also be rasterized to make a layer mask (a layer that is masked by an alpha channel). Meanwhile, a pen path can be converted to a selection and a selection can be converted back into a work path. If we start with an active selection, you can view and edit a selection as a quick mask and a selection can also be converted into an alpha channel and back into a selection again.

When preparing a mask in Photoshop, most people will start by making a selection to define the area they want to work on and save that selection as an alpha channel mask. This allows you to convert the saved alpha channel back into a selection again at any time in the future. The other way to prepare a mask is to use the pen tool to define the outline and then convert the pen path to a selection. If you think you will need to reuse the pen path again, such as to convert it to a selection again at a later date, then it is worth remembering to save the work path with a meaningful name, rather than the default 'Path 1' etc., in the Paths panel.

As I say, the business of using vector masks and layer masks is covered in more detail later on, but, basically, a layer mask is an alpha channel applied to a layer that defines what is shown and hidden on the associated layer. And a vector mask is a pen path converted to a vector mask that defines what is shown and hidden on the layer. There are good reasons for having these different ways of working and I provide a few practical examples in this chapter that show when it is most appropriate to use either of these two main methods to mask an image.

Converting vectors to pixels

In Figure 8.7 I mention that some of the conversion processes will incur a loss of data. This is because when you convert vector data to become a pixel-based selection, what you end up with is not truly reversible. However, drawing a pen path and converting the path to a selection is a very convenient way to make an accurate selection. But, if you attempt to convert a selection back into a pen path again, you won't end up with an identical path to the one that you started with. Basically, converting vectors to pixels is a one-way process. Converting a vector path into a pixel-based selection is a good thing to do. but you should be aware that converting a pixel-based selection into a vector path will potentially incur some loss of data. More specifically, a selection or mask can contain shades of gray, whereas a pen path merely describes a sharp outline where everything is either selected or not.

Figure 8.8 The above illustration shows a graphic where the left half is rendered without anti-aliasing and the right half uses anti-aliasing to produce smoother edges.

Figure 8.9 The Feather Selection dialog can be used to feather the radius of a selection.

Anti-aliasing

Bitmapped images are made up of a grid of pixels, where without anti-aliasing, non-straight lines would be represented by a jagged sawtooth of pixels. Photoshop gets round this problem by anti-aliasing the edges, which means filling the gaps with in-between tonal values, so that non-vertical/horizontal sharp edges are rendered smoother by the anti-aliasing process (Figure 8.8). Wherever you encounter anti-aliasing options, these are normally switched on by default and there are only a few occasions where you might find it useful to turn these off.

If you have an alpha channel where the edges are too sharp and you wish to smooth them, the best way to do this is to apply a Gaussian Blur filter using a Radius of 1 pixel. Or, you can paint using the blur tool to gently soften the edges in the mask that need the most softening.

Feathering

Whenever you do any type of photographic retouching it is important to always keep your selections soft. If the edges of a picture element are defined too sharply it will be more obvious to the viewer that a photograph has been retouched. The secret to good compositing is to avoid creating hard lines and keep the edges of the picture elements soft so that they blend together more smoothly.

There are two ways to soften the edges of a selection. You can go to the Select menu and choose Modify ⇒ Feather (Shift F6) and adjust the Feather Radius setting (Figure 8.9). Or, if you have applied a selection as a layer mask, you can use the Feather slider in the Masks mode of the Properties panel to feather the mask 'in situ'. A low Feather Radius of between 1 or 2 pixels should be enough to gently soften the edge of a selection outline, but there are times when it is useful to select a much higher Radius amount. For example, earlier on page 388, I used the elliptical marquee tool to define an elliptical selection, applied this as a Levels adjustment layer mask and feathered the selection by 100 pixels in the Properties panel Masks mode. This allowed me to create a smooth vignette that darkened the outer edges of the photograph. The maximum feather radius allowed is 1000 pixels and Photoshop supports feather values up to two decimal places.

Layers

Layers play an essential role in all aspects of Photoshop work. Whether you are designing a Web page layout or editing a photograph, working with layers lets you keep the various elements in a design separate. Layers also give you the opportunity to assemble an image using separate, discrete entities and have the flexibility to make any edit changes you want at a later stage. You can also add as many new layers as you like to a document up to a maximum limit of 8000. The Photoshop layers feature has evolved in stages over the years, including new ways for selecting multiple layers and linking them together. First let's look at managing layers and the different types you can have in a Photoshop document.

Layer basics

Layers can be copied between open documents by using the move tool to drag and drop a layer (or a selection of layers) from one image to another. This step can also be assisted by the use of the Shift key to ensure layers are positioned centered in the destination image. To duplicate a layer, drag the layer icon to the New Layer button and to rename a layer in Photoshop, simply double-click the layer name. To remove a layer, drag the layer icon to the Delete button in the Layers panel and to delete multiple layers, use a Shift-click, or # (Mac), (PC)-click to select the layers or layer groups you want to remove and then press the Delete button at the bottom of the Layers panel. There is a 'Delete Hidden Layers' command in both the Layers panel submenu and the Layer ⇒ Delete submenu. In addition there is also a File ⇒ Scripts menu item that can be used to delete all empty layers (see Figure 8.10).

Image layers

The most common type of layer is a pixel image layer, which is used to contain pixel information. New documents have a default *Background* layer and you can now convert a background layer to a regular layer by simply clicking on the Background layer lock icon. New empty image layers can be created by clicking on the Create new layer button in the Layers panel (Figure 8.14). They can also be created by copying the contents of a selection to create a new layer within the same document. To do this, choose Layer \Rightarrow New \Rightarrow Layer via Copy, or use the \Rightarrow (Mac), *ctn* (PC) keyboard shortcut.

Image Processor...

Delete All Empty Layers

Flatten All Layer Effects
Flatten All Masks

Layer Comps to Files...
Layer Comps to PDF...
Layer Comps to WPG...

Export Layers to Files...

Script Events Manager...

Load Files into Stack...
Load Multiple DICOM Files...
Statistics...

Browse...

Figure 8.10 This shows the File ⇒ Scripts menu, where there is also an item called 'Delete All Empty layers'.

Renaming layers

To rename a layer, double-click the layer name in the layers panel to highlight the text. Use Tab to go to the next layer down and rename. Use Shift Tab to go to the next layer up.

Making Properties panel visible

There is a new option in the Properties panel fly-out menu that forces Photoshop to open the Properties panel whenever you add a new vector shape layer.

Figure 8.11 The pen tool and shape tools include a Shape layer mode button for creating shape layer objects defined by a vector path.

Figure 8.12 Text layers are created whenever you add type to an image. Text layers can be re-edited at any time.

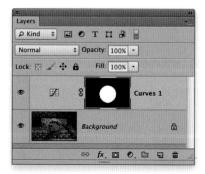

Figure 8.13 Adjustment layers are image adjustments that can be applied to individual or multiple layers within an image. Like other layers, you can mask the contents and adjust the blending mode and layer opacity.

This copies the selection contents, so that they become a new layer. You can use this shortcut to copy multiple layers or layer groups. Also, you can cut and copy the contents from a layer by choosing Layer \Rightarrow New \Rightarrow Layer via Cut or use the \Re Shift \Im (Mac), cir Shift \Im (PC) keyboard shortcut.

Vector layers

Vector layers is a catch-all term used to describe non-pixel layers where the layer is filled with a solid color and the outline is defined using a vector layer mask. A vector layer is created whenever you add an object to an image using one of the shape tools, or draw a path using the Shape layer mode, or when you add a solid fill layer from the adjustment layer menu. Figure 8.11 shows an example of a vector layer, which is basically a solid fill layer masked by a vector mask.

Text layers

Typefaces are made up of vector data, which means that Text layers are essentially vector-based shape layers. When you select the type tool in Photoshop and click or drag with the tool and begin to enter text, a new text layer is added to the Layers panel. Text layers are symbolized with a capital 'T', and when you hit *Return* to confirm a text entry, the layer name displays the initial text for that layer, making it easy for you to identify (see Figure 8.12). Note that you can double-click the text layer 'T' icon to highlight the text and make the type tool active.

Adjustment layers

Adjustment layers are image adjustments applied as layers. With adjustment layers you have the opportunity to edit the adjustments as often as you like, plus you can toggle an adjustment on or off by clicking the layer eyeball icon (Figure 8.13). The chief advantages of working with adjustment layers are that you can re-edit the adjustment settings at any time and, use the paint, fill or gradient tools in the accompanying mask, to selectively apply those adjustments to the image.

Layers panel controls

Figure 8.14 shows an overview of the Layers panel controls for the layered image shown in Figure 8.15. The filter options are new and I'll be discussing these on page 574. The blending mode options determine how a selected layer will blend with the layers below, while the Opacity controls the transparency of the layer contents and the Fill opacity controls the opacity of the layer contents independent of any layer style (such as a drop shadow) which might have been applied to the layer. Next to this are the various layer locking options. At the bottom of the panel are the layer content controls for layer linking, adding layer styles, layer masks, adjustment layers, new groups and new layers as well as a Delete layer button. Most of the other essential layer operation commands are conveniently located in the Layers panel fly-out menu options.

Layer visibility

You can selectively choose which layers are to be viewed by selecting and deselecting the eye icons. If you go to the History panel options and check 'Make Layer Visibility Changes Undoable', you can even make switching the Layer visibility on and off an undoable action. Note also that the Blend mode and layer opacity remain visible even if the layer visibility is switched off.

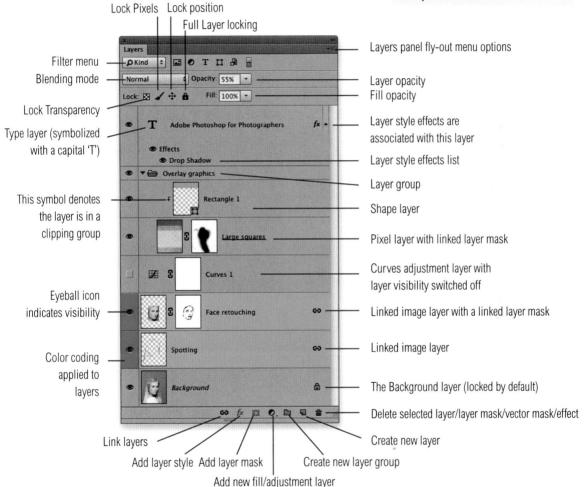

Figure 8.14 This shows an overview of the Photoshop Layers panel.

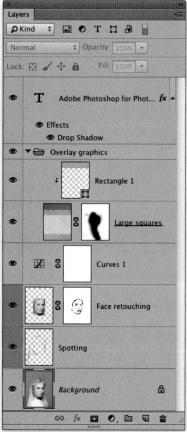

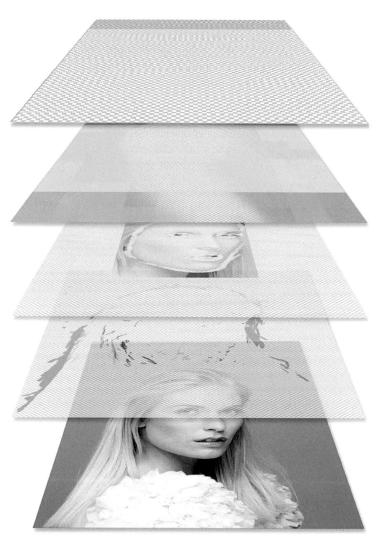

Figure 8.15 Here is an expanded diagram of how the layers in a book cover image file were arranged inside Photoshop. The checkerboard pattern represents transparency and the layers are represented here in the order they appear in the Layers panel.

Layer styles

You can use the layer style menu at the bottom of the Layers panel (see Figure 8.14) to apply different types of layer styles to an image, shape or text layer. This feature is really of more interest to graphic designers rather than photographers, but you'll find descriptions of the various layer styles in the online Help Guide.

Adding layer masks

You can hide the contents of a layer either wholly or partially by adding a layer mask, a vector mask or both. Masks can be applied to any type of layer: image layers, adjustment layers, type layers or shape layers. Image layer masks are defined using a pixel-based mask, while vector masks are defined using path outlines. Click once on the Add Layer Mask button to add a layer mask and click a second time to add a vector mask (in the case of shape layers a vector mask is created first and clicking the Add Layer Mask button adds a layer mask). You will also notice that when you add an adjustment layer or fill adjustment layer a layer mask is added by default. The layer mask icon always appears next to the layer icon and a dashed stroke surrounding the icon tells you which is active (see Figures 8.16 and 8.17).

The most important thing to remember about masking in Photoshop is that whenever you apply a mask you are not deleting anything; you are only hiding the contents. By using a mask to hide rather than to erase unwanted image areas you can go back and edit the mask at a later date. If you make a mistake when editing a layer mask, it is easy enough to correct such mistakes since you are not limited to a single level of undo. To show or hide the layer contents, first make sure the layer mask is active. Select the paintbrush tool and paint with black to hide the layer contents and paint with white to reveal. To add a layer mask based on a selection, select a layer to make it active, make a selection and click on the Add Layer Mask button at the bottom of the Layers panel, or choose Layer

⇒ Layer Mask

⇒ Reveal Selection. To add a layer mask to a layer with the area within the selection hidden, alt-click the Layer Mask button in the Layers panel, or choose Layer ⇒ Laver Mask ⇒ Hide Selection.

Lastly, the mask linking buttons referred to in Figures 8.16 and 8.17 allow you to lock or unlock a mask so that you can move the mask or layer contents independently of each other.

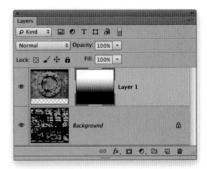

Figure 8.16 This Layers panel view contains two layers, and the selected layer is the one that's highlighted here. The dashed border line around the layer mask icon indicates the layer mask is active and any editing operations will be carried out on the layer mask only. There is no link icon between the image layer and the layer mask. This means the image layer or layer mask can be moved independently of each other.

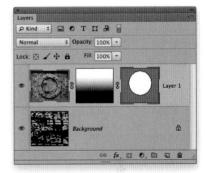

Figure 8.17 In this Layers panel screen shot, the border surrounding the vector mask indicates the vector mask is active and any editing operations will be carried out on the vector mask only. In this example, the image layer, layer mask and vector mask are all linked. This means if the image layer is targeted and you use the move tool to move it, the image layer and layer masks will move in unison.

Copying a layer mask

You can use the **alt** key to drag/copy a layer mask across to another layer in the same document.

Figure 8.18 The remove layer mask options.

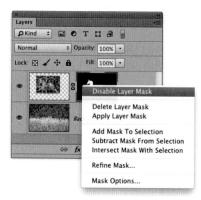

Figure 8.19 The layer mask contextual menu options.

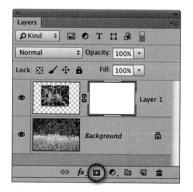

Figure 8.20 Click the Add Layer Mask button (circled) to add a layer mask where the contents remain visible. [a]] -click to add a layer mask filled with black, where the contents are hidden.

Viewing in Mask or Rubylith mode

The layer mask icon preview provides you with a rough indication of how the mask looks, but if you alt-click the layer mask icon the image window view switches to display a full image view of the mask (see Step 1 opposite). If you shift (Mac), all shift (PC)-click the layer mask icon, the layer mask is displayed as a quick mask type transparent overlay (see Step 2 opposite). Both these steps can be toggled.

Removing a layer mask

To remove a layer mask, select the mask in the Layers panel and click on the Layers panel Delete button (or drag the layer mask to the Delete button). A dialog box then appears asking if you want to 'Apply mask to layer before removing?' (Figure 8.18). There are several options here: if you simply want to delete the layer mask, then select 'Delete'. If you wish to remove the layer mask and at the same time apply the mask to the layer, choose 'Apply'. Or click 'Cancel' to cancel the whole operation.

To temporarily disable a layer mask, choose Layer ⇒ Layer Mask ⇒ Disable, and to reverse this, choose Layer ⇒ Layer Mask ⇒ Enable. You can also Shift-click a mask icon to temporarily disable the layer mask (when a layer mask is disabled it will appear overlaid with a red cross). A simple click then restores the layer mask again (but to restore a vector mask you will have to Shift-click again). Or alternatively, (Mac) or right mouse-click the mask icon to open the full list of contextual menu options to disable, delete or apply a layer mask (see Figure 8.19).

Adding an empty layer mask

To add a layer mask to a layer so that the layer contents remain visible, just click the Layer Mask button in the Layers panel (Figure 8.20). Or, choose Layer ➡ Add Layer Mask ➡ Reveal All. To add a layer mask to a layer that hides the layer contents, all-click the Add Layer Mask button in the Layers panel. Or, choose Layer ➡ Add Layer Mask ➡ Hide All. This adds a layer mask filled with black.

Thumbnail preview clipping

If you use a right mouse-click on a layer thumbnail, this opens the contextual menu shown in Figure 8.21 where you can choose to clip thumbnails to the layer or document bounds.

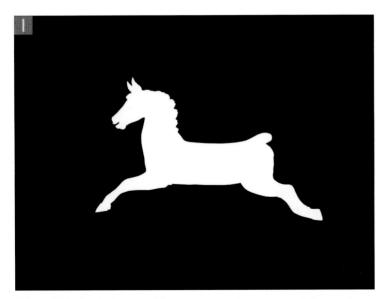

1 If you *alt* -click the layer mask icon, you can preview a layer mask in normal mask mode.

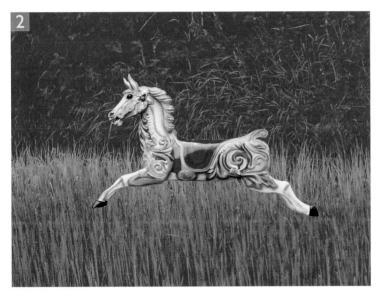

2 If instead you Shift (Mac), alt Shift (PC)-click the layer mask icon, you can preview a layer mask in Quick Mask mode. The mask can be edited more easily in either of these preview modes. The backslash key (1) can be used to toggle showing the layer mask as a quick mask and return to normal view mode again.

Figure 8.21 There is a layer thumbnail contextual menu that allows you to determine whether the thumbnail preview clips to the document bounds (top) or to the layer bounds (below). This option affects the layer contents visibility in the Layers panel (but does not affect the associated pixel/vector layer masks). Once selected this option remains persistent for all document Layers panel views.

Density and mask contrast

The Density slider answers requests to have some kind of control over the mask contrast. A lot of layer masks will originate as black and white masks where the image adjustments or pixel layer contents are either at full opacity or hidden (the same is true of vector masks, of course). The Density slider allows you to preserve the mask outline, but fade the contrast of the mask in a way that is completely re-editable.

Properties panel mask options

Figure 8.22 shows the Properties panel Masks mode options menu, where you can use the menu options shown here to add, subtract or intersect the current mask with an active selection. Imagine you want to add something to a selection you are working on. You simply choose the 'Add Mask to Selection' menu option to add it to the current selection.

Figure 8.22 The Properties panel Masks mode panel controls are accessible from the menu circled in Figure 8.23.

Properties Panel in Masks mode

I have already shown a few examples of how the Properties panel in Masks mode can be used to modify pixel or vector layer masks and the Properties panel Masks mode controls are all identified in Figure 8.23 below. The pixel mask/vector mask selection buttons are at the top of the panel and can also be used to add a mask (providing a pixel or vector mask is already present). Below that are the Density and Feather sliders for modifying the mask contrast and softness. Next are the Refine buttons, which are only active if a pixel mask is selected. The Mask Edge... button opens the Refine Edge dialog, where, as you can see in Figure 8.24, you can further modify the edges of a mask. The Color Range... button opens the Color Range dialog, where you can use a Color Range selection to edit a mask. The Invert button inverts a pixel mask, but if you want to do the same thing with a vector mask you can do so by selecting a vector path outline and switching the path mode (see page 612). At the bottom of the panel there are buttons for loading a selection from the mask, applying a mask (which deletes the mask and applies it to the pixels) plus a Delete Mask button.

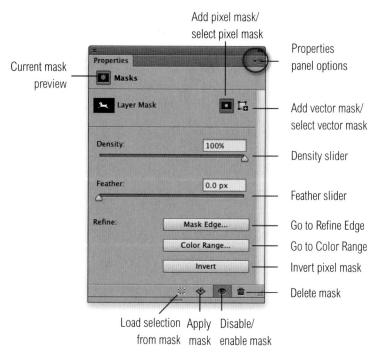

Figure 8.23 The Properties panel Masks mode controls.

Refine Edge command

The Refine Edge command is available foremost as a Select menu item (Mac), ctrivation [PC]) for modifying selections, which uses a Truer Edge™ algorithm to enable complex outline masking. The dialog says 'Refine Edge' when editing a selection, but if you are preparing a selection in order to create a mask, it makes more sense to use the Refine Edge command when you are working on an active layer mask. You can do this by clicking on the Mask Edge... button in the Properties panel Masks mode, or by using the above keyboard shortcut. Whichever method you choose the controls are exactly the same, except the dialog is called 'Refine Mask' when editing a layer mask. The Refine Edge controls offer everything you need to modify a selection or layer mask edge. At the bottom are the Output mask refinement controls for removing color contamination from a masked layer.

Refine Edge is a one-way process

Unlike the Properties panel Masks mode controls, once a Refine Edge adjustment has been applied it is non-editable after you click OK. Therefore, you may want to take the precaution of preserving important mask outlines as saved channels before using Refine Edge to modify a selection or mask. In any case, the Output options shown in Figure 8.24 below allow you to output a modified selection/mask in different ways, such as a new layer with a laver mask, or a new document even. With this in mind, you may also want to use the Properties panel Masks mode Feather slider (which can be re-edited) as a primary means for feathering a mask outline.

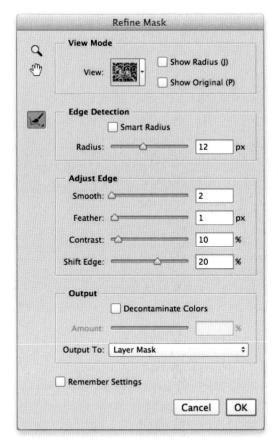

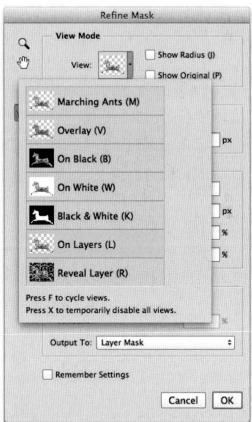

Figure 8.24 The Refine Edge dialog.

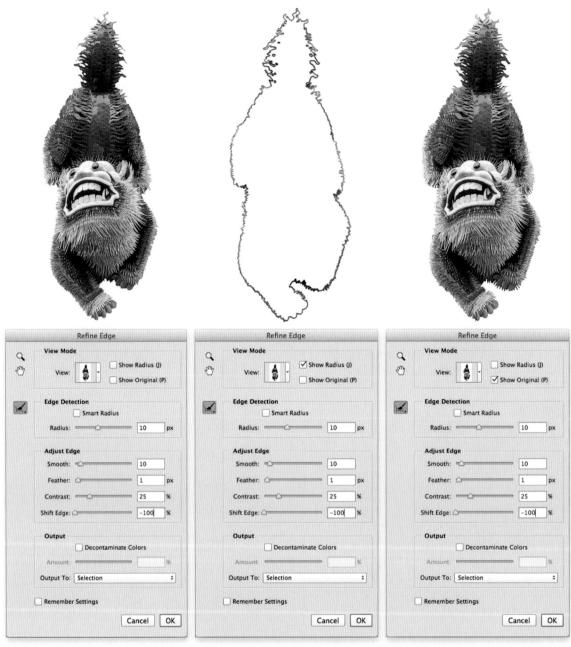

Figure 8.25 This shows examples of how the Radius and original image view modes might be used. Here you can see an image masked using the On White mask view mode. On the left you can see how the masked image looks using the current Refine Edge settings. In the middle is the preview with the Show Radius () option checked. This displays the refine edge boundary only. On the right is the preview with the Show Original () option checked. This allows you to view the masked image and compare the original version against the refine edge masked version (left).

View modes

When you first select Refine Edge, the initial view mode shows the layer masked against a white background, which isn't so helpful when editing a layer mask, but you can easily switch to the On Layers view by pressing (and once you have done this I suggest you click on the Remember Settings button at the bottom of the Refine Edge dialog to keep this as the new default setting. Without adjusting anything, click OK to close the dialog. You'll then see the On Layers appear by default the next time you open Refine Edge. In the subsequent tutorial (on pages 530-535) I suggest you do all your main Refine Edge adjustments using the 'On Layers' preview mode since this allows you to preview the adjustments you make in relation to the rest of the image. This and the other modes can be accessed from the pop-up menu shown in Figure 8.24 and you'll notice the keyboard shortcuts are also listed here that allow you to quickly switch between view modes. Next to the View menu in the View Mode section, the Show Radius option () displays the selection border only for where the edge refinement occurs, while Show Original (Pa) allows you to guickly display the image without a selection preview (see Figure 8.25 for more details).

Edge detection

The Edge Detection section gives you some control over how the Truer Edge™ algorithm processing is used to refine the edge boundaries. This essentially analyzes the border edges in the image and calculates the most appropriate mask opacities to use, primarily according to the Radius setting you have applied. What you want to do here is to adjust the Radius setting to what is most appropriate for the type of image you are masking. If the edges to be masked are mostly fine, sharp edges, then a low Radius setting will work best. For example, a Radius of 1 pixel would be suitable for a selection that contained a lot of fine edges such as a wire fence. If the edges you wish to mask are soft and fuzzy, then a wider Radius setting will be most appropriate and it is suggested that you should aim to set the Radius here as wide as you can get away with.

Since a photographic image is most likely going to contain a mixture of sharp and soft edges, this is where the refine radius tool (🗹) comes in. This can be used to extend the areas of the edge to be refined. So if you have chosen a narrow

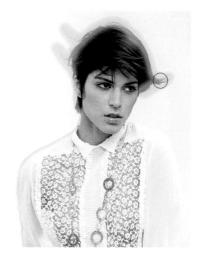

Figure 8.26 You need a narrow thickness edge to refine sharp mask edges and a wider thickness to refine soft, wide mask edges. Here you can see the refine radius tool used at different thicknesses to manually edit a mask. You can set a narrow or wide Radius in the Refine Edge dialog and use the refine radius brush to modify that edge. Note that the edit brush work shows up as a green overlay in the Reveal Layer view mode.

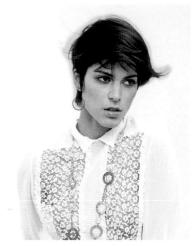

Figure 8.27 This shows the erase refinements tool in use, which shows up as a red overlay when applied in the Reveal Layer view mode.

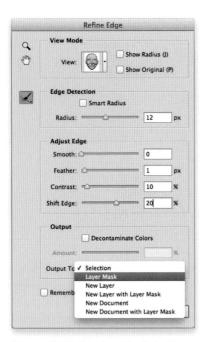

Figure 8.28 This shows the Output To menu options for the Refine Edge dialog.

Radius setting, which would be appropriate for refining narrow edges, you can paint with the above tool using a wider brush diameter to paint over the softer edges and thereby apply the most suitable edge refinement algorithm along those sections of the border edge. In use, you select the brush and adjust the cursor size, using the square bracket keys (to determine what size brush you need to work with. Once you have done this you can click and drag to paint along the edges to be refined (see Figure 8.26). Bear in mind here that after each brush stroke, Photoshop needs to recalculate a new edge outline using the new algorithm and this may take a few seconds to complete, during which time you won't be able to edit the edge any further. It may seem a little off-putting at first, but I assure you that the time delay you may experience here is nothing compared to the amount of time you are able to save through the use of this automated masking process. Holding down the all key switches from the refine radius tool to the erase refinements tool (). Or, you can select this tool from the same tool menu as the refine radius tool, or use the Shift E key to toggle between the two tool modes. The erase refinements tool can be used to remove areas of the edge to be refined and basically undoes the refined radius mask editing. When working in the Reveal Layers mode, the refine radius painting shows as a green overlay and the erase refinement tool painting shows up as a red overlay (see Figures 8.26 and 8.27).

Smart Radius

The Smart Radius option can often help improve the mask edge appearance, as it automatically adjusts the radius for the hard and soft edges found in the border transition area. With hair selections in particular, you should find it helps if you aim to set the Radius slider as high as you can and check the Smart Radius option. I have found that this combination usually produces the best hair mask.

Adjust Edge section

In the Adjust Edge section there are four sliders. The Smooth slider is designed to smooth out jagged selection edges but without rounding off the corners. The Feather slider uniformly softens the edges of the selection and produces a soft edged transition between the selection area and the surrounding pixels, while the Contrast slider can be used to

make soft edges crisper and remove artifacts along the edges of a selection, which are typically caused when using a high Radius setting. When compositing photographic elements you usually want the edges of a mask to maintain a certain degree of softness, so you don't necessarily want to apply too much contrast to a mask here. Some images may need a high contrast, but you are usually better off relying on the Smart Radius option combined with the refine radius and erase refinements tools to refine such a selection/mask edge.

If you want to achieve a more aggressive smoothing you can combine adjusting the Feather and Contrast sliders. Simply increase the Feather slider to blur the mask and then increase the Contrast to get back to the desired edge sharpness.

The Shift Edge slider is like a choke control. It works on the mask a bit like the Maximum and Minimum filters in Photoshop. You can use this slider to adjust the size of the mask in both directions, making it shrink or expand till the mask fits correctly around the object you are masking. I usually find the Shift Edge slider is the most useful for adjusting the selection/mask shape, followed by the Feather and Contrast sliders when I wish to refine the mask further.

Refine Edge output

Lastly, we have the Output section (Figure 8.28), which determines how the masked image layer blends with the image layers below it. This is a crucial component to successful masking, which can so often fail when the pixels around the outer edges of a mask (picked up from the original background) don't match those of the new background. Whenever you need to successfully blend a masked image layer with the other layers in a new image you can check the Decontaminate Colors option. You can then adjust the Amount slider in order to remove any of the last remaining background colors that were present in the original photo (see Figure 8.29). The best advice here is to only dial in as much decontamination as is necessary in order to achieve the most detailed and smoothest-looking blend.

The 'Output To' section allows you to output the refined selection in a variety of ways, either as a modified selection, as a layer mask, as a new layer with transparent pixels, as a new layer with a layer mask, or as a new document: either with transparent pixels or with a layer mask.

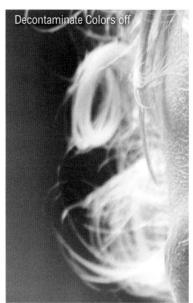

Figure 8.29 Here you can see a close-up comparison between a Refine Edge edited masked layer (top) and below that, one where the Decontaminate Colors option was switched on to help improve the blend between the masked layer and the pixels in the layer below.

Quick selection brush settings

The quick selection brush settings are the same as for the other paint tools, except adjusting the brush hardness and spacing won't really have any impact on the way the quick selection tool works. If you are using a pressure sensitive tablet it is worth checking that the Pen Pressure option is selected in the Size menu, as this allows you to use pen pressure to adjust the size of the quick selection tool brush (see Figure 8.30 below).

Figure 8.30 This shows the quick selection tool brush settings where the Pen Pressure option has been selected from the Size menu. This links the quick selection tool cursor size to the amount of pen pressure applied.

Working with the quick selection tool

The guick selection tool is grouped with the magic wand in the Tools panel. It is a more sophisticated kind of selection tool compared with the magic wand and has some interesting smart processing capabilities. Basically, you use the guick selection tool to make a selection based on tone and color by clicking or dragging with the tool to define the portion of the image that you wish to select. You can then keep clicking or dragging to add to a selection without needing to hold down the Shift key as you do so. You can then subtract from a guick selection by holding down the all key as you drag. What is clever about the quick selection tool is that it remembers all the successive strokes that you make and this provides stability to the selection as you add more strokes. So, as you toggle between adding and subtracting, the guick selection temporarily stores these stroke instructions to help determine which pixels are to be selected and which are not. The Auto-Enhance option in the Options bar can help reduce any roughness in the selection boundary, as it automatically applies the same kind of edge refinement as you can achieve manually in the Refine Edge dialog using the Radius, Smooth and Contrast sliders.

Sometimes you may find it helps if you make an initial selection and then apply a succession of subtractive strokes to define the areas you don't want to be included. You won't see anything happen as you apply these blocking strokes, but when you go on to select the rest of the object with the quick selection tool, you should find that as you add to the selection, the blocking strokes you applied previously will help prevent leakage outside the area you wish to select. In fact, you might find it useful to start by adding the blocking strokes first, before you add to the selection. This aspect of guick selection behavior can help you select objects more successfully than was ever possible before with the magic wand. However, as you make successive additive strokes to add to a selection and then erase these areas from the selection, you'll have to work a lot harder going back and forth between adding and subtracting with the guick selection tool. In these situations it can be a good idea to clear the quick selection memory by using the 'double Q trick'. If you press the (1) key twice, this takes you from the selection mode to the Quick Mask mode and back to selection mode again. The stroke constraints will be gone and you can then add to or subtract from the selection more easily since you have now cleared the quick selection memory.

Dual display 2

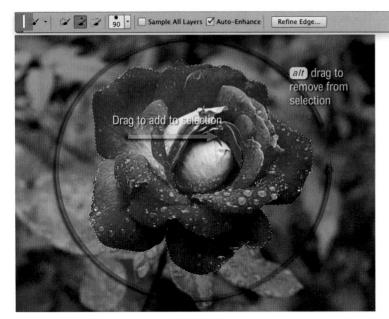

1 In this example, I selected the quick selection tool, checked the Auto-Enhance edge option and dragged to make an initial selection of the flower. Then, with the held down, I dragged around the outer perimeter of the flower to define the areas that were to be excluded from the selection. I then continued clicking and dragging to select more of the flower petals to fine-tune the selection edge.

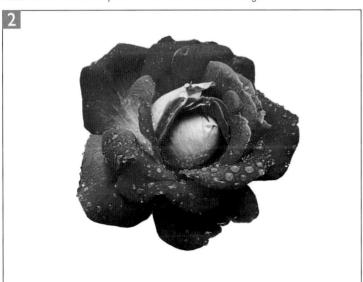

2 I clicked on the Refine Edge... button and selected the 'On White' mask option, which displayed the cut-out selection against a white background color. In the Edge Detection section I applied a 3 pixel Radius with the Smart Radius option checked. I also expanded the edge slightly, applying a +20% Shift Edge amount.

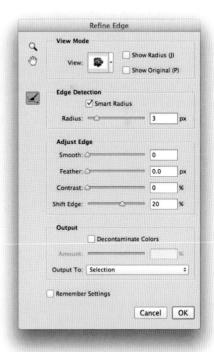

Combining a quick selection with Refine Edge

1 Here I wanted to demonstrate the capabilities of the Refine Edge/Refine Mask feature and show how, when used in conjunction with the quick mask tool, you can use it to mask tricky outlines such as fine hair. To demonstrate how this works. I have selected here a photograph that I took of my daughter, Angelica. This was a good example to work with since her blonde hair was strongly backlit by the sun. There was a reasonable amount of tone and color separation between her and the background scenery and it certainly helped that the background was slightly out of focus. Overall, the conditions were pretty favorable for making a cut-out mask. Having said that, there were a number of areas where the tones and colors between the subject and the background matched guite closely and these would present more of a challenge.

To start with, I selected the quick selection tool from the Tools panel and applied a succession of brush strokes to select her outline. As is often the case, every now and then I had to hold down the well-key to switch to subtract mode in order to fine-tune the quick selection. There was no need for me to be too precise here, but it is usually helpful if you try to achieve the best quick selection you can. I then double-clicked the Background layer to convert it to a normal layer and was ready for the next step.

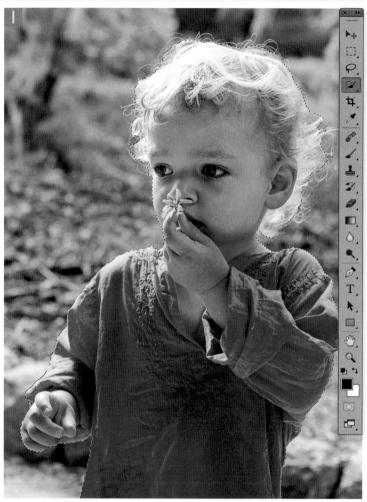

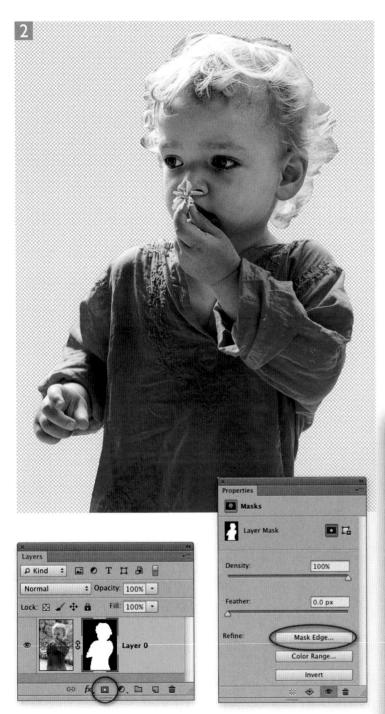

2 With the initial selection prepared, I clicked on the Add Layer Mask button in the Layers panel (circled) to add a layer mask based on the current selection. I then went to the Properties panel and clicked on the Mask Edge... button (or you could just go to the Select menu and choose Refine Edge...). This opened the Refine Mask dialog shown here, where to start with, I selected the 'On Layers' () preview option and started adjusting the sliders to achieve a better mask edge. With the Smart Radius option checked, I set the Radius to 20 pixels and Contrast to 25% to improve the mask border edge. I kept the Smooth value low and increased the Feathering to 1.3 pixels to keep the mask outline edges reasonably soft.

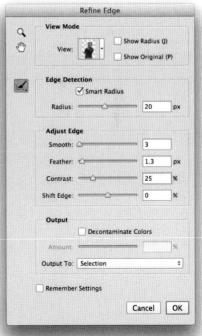

3 I could tell from the current state of the layer mask that while the body outline looked good, the biggest problem was (as always) how to most effectively mask the hair. In this screen shot the Refine Mask dialog was set to the Reveal Layer (1811) preview mode. I selected the refine radius tool (circled) and started brushing over the outline of the hair. There are a couple of things to point out here. By working in the Reveal Layer preview mode, you can see more accurately where you are brushing, as the green overlay allows you to see which areas have been selected. You won't actually see the results of this masking refinement yet, but it helps using this preview mode in the initial stages. The second point is that the Refine Mask recalculates the mask edge after each single brush stroke, so you can't expect to apply a quick succession of brush strokes to define the mask, instead you do so by applying one brush stroke at a time. You'll also notice how Photoshop pauses for a few seconds while it carries out these calculations before it allows you to continue.

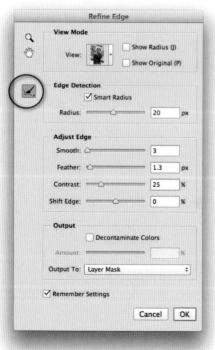

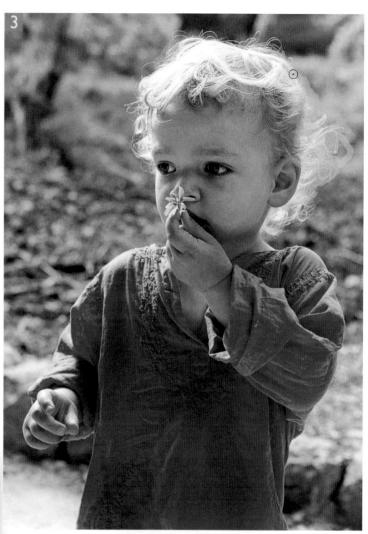

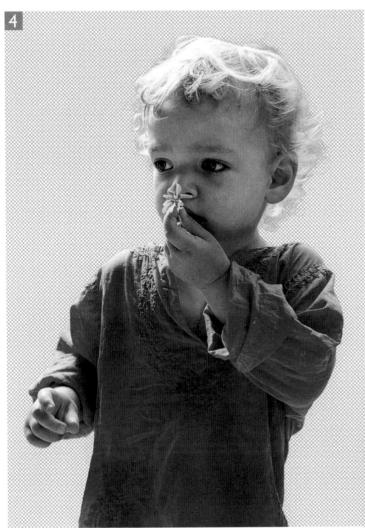

4 To refine the mask further, it was now best to revert to the 'On Lavers' () preview option, as this allowed me to preview the mask edges against a transparent backdrop. At this stage I continued to work with the refine radius tool to perfect the edges of the hair outline. One can use the all key to select the erase refinements tool () and remove parts of the mask, but in this instance I found that the refine radius tool was the only one that was needed here. As in the previous step, you have to apply a brush stroke and then wait a few seconds. for Photoshop to recalculate before applying any further brush strokes. I then adjusted the Shift Edge slider to contract the mask edge slightly and make it shrink more to Angelica's outline.

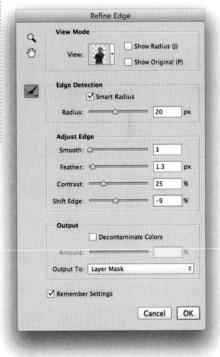

5 It was all very well, looking at the masked image against a transparent background, but the real challenge was how the image previewed against backdrops of different color and lightness. To test this particular masked image, I selected the 'On White' (W) preview. By previewing the image against white I was able to get a better indication of how effective the mask was at separating the subject from the original background. As expected, I needed to check the Decontaminate Colors box in the Output section (circled) if the subject edges were to blend more convincingly with the white backdrop. As you can see, the mask was working quite well by this stage. However, I didn't want to decontaminate the layer just yet, so I unchecked this option for now.

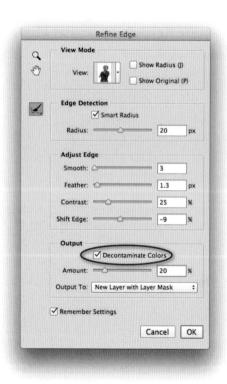

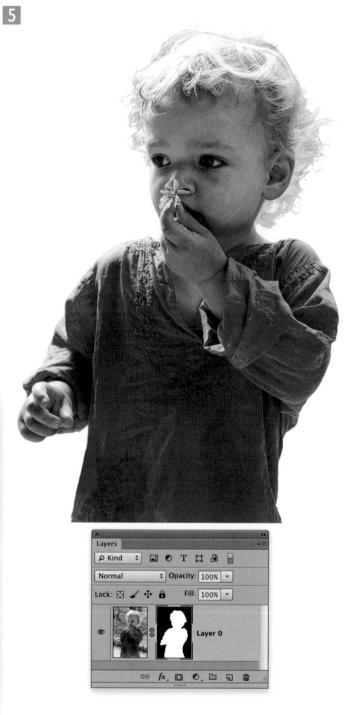

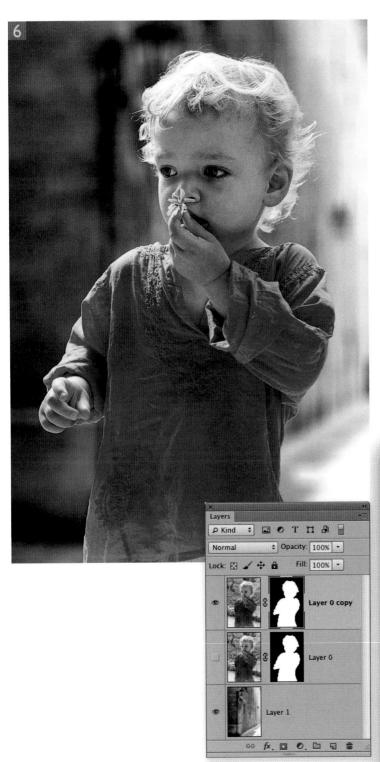

6 The real test though was how the masked layer would look when placed against a different background image. In this final step I took an out-of-focus backdrop image and dragged it across to the main image, placing this as a new layer below the current layer. I then reselected the masked layer of Angelica, and making sure the layer mask was active I opened the Refine Mask once more. Now, since the mask edges had already been modified I did not want to refine them any further, so I therefore set all the settings to zero. I did though want to now check the Decontaminate Colors option in the Output section at the bottom. I was now able to preview the masked layer against the final backdrop and could tell how much to adjust the Amount slider. When I was happy with the way things were looking, I clicked OK to apply this final modification to the mask with the 'New Layer with Layer Mask' option selected in the Output To menu at the bottom of the dialog.

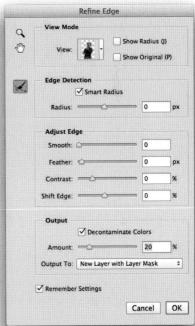

Tips when working with Focus Area

If the selection needs improvement it is best to override the Auto option and adjust the In-Focus Range slider. If the In-Focus Range selection happens to include a lot of the out-of-focus background area this could be because the Focus Area selection is picking up noise. If this happens expand the Advanced options, deselect the auto option and gradually increase the Noise slider to see if this clears up the selection area. Basically, with higher ISO images you will need to increase the slider setting. However, sometimes when the Noise slider is set high, everything will be selected. So it is best to make small careful adjustments and if it's not looking right check the Auto option to reset to auto mode again.

Focus area

The Focus Area feature is a selection tool that can be used to make selections based on focus. It can be used to make selections based on sharpness and is useful for cutting out objects shot against an out-of-focus background.

When creating a selection you have the option of overriding the Auto option and manually adjusting the In-Focus Range slider. This can help refine the selection. You can also click on the add and subtract tools to add to or remove from a focus area selection (just like you would when working with the quick select tool). The Focus Area selection will always have a hard edge, but this can be improved by checking the Soften Edge box. You can also modify by clicking the Refine Edge... button to open the Refine Edge dialog where you can fine-tune the selection edges as desired.

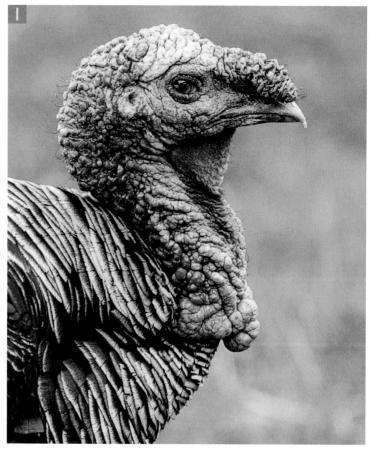

1 Here is a photograph of a turkey photographed using a long focus lens, where the background was out of focus.

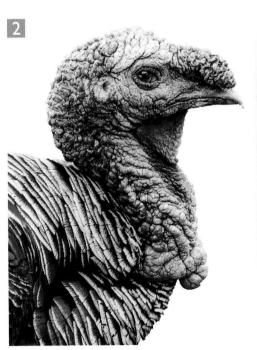

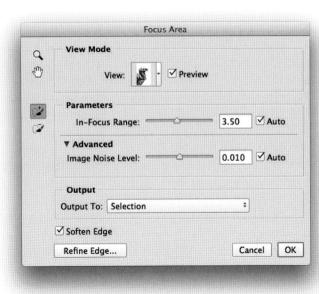

2 In Photoshop I chose Select ⇒ Focus Area... to open the dialog shown here with the default In-Focus Range Auto settings and the Soften Edge option checked.

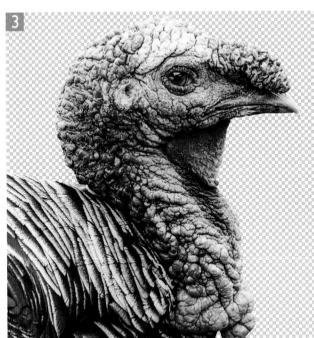

3 Finally, I clicked on the Refine Edge... button to go to the Refine Edge dialog where I was able to make further fine-tuning adjustments to the selection outline.

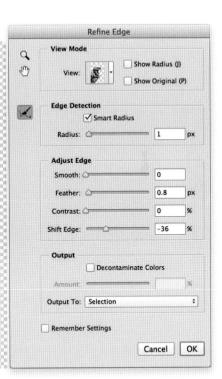

Ragged borders with the Refine Edge adjustment

The Refine Edge command is primarily designed as a tool for improving edge masks. However, Adobe engineer Gregg Wilensky, who worked on the Refine Edge feature, discovered how it can also be used to create interesting ragged-edge borders that look similar to those produced in the darkroom.

The main point to bear in mind here is you primarily use the Radius slider to create the main effect and a wide Radius will usually work best with the Smart Radius option disabled. Basically, the rough edges you see are actually based on the content of the image itself so it is the image content that determines the outcome of the Refine Edge adjustment. The Feather, Contrast and Shift Edge adjustments can then be used to modify the main effect. In addition to this you can also select the refine radius tool and carefully paint along sections of the edge to further modify the border and generally roughen it up a little more. Above all you have to be patient as you do this and apply small brush strokes a little at a time, but the results you get can be pretty interesting.

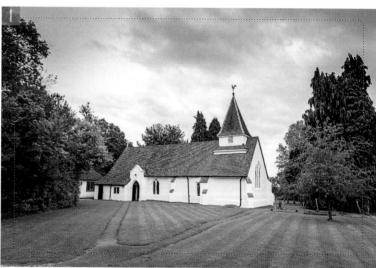

1 The first step was to make a copy of the background layer and fill the original background layer with a solid color, such as white. I then made a rectangular marquee selection, went to the Select menu and chose Modify ⇒ Smooth and applied an appropriate Sample Radius (in this case 50 pixels).

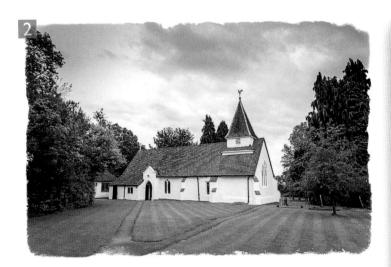

2 I then went to the Select menu and chose Refine Edge... (# R [Mac], ctr) all R [PC]). The main controls I adjusted here were the Radius, to produce a wide border effect. The Contrast slider was used to 'crispen' the edges, Feather was used to smooth them slightly and a positive Shift Edge adjustment was used to expand the border edge. I also used the refine radius tool (circled) to manipulate some sections of the border to create a rougher border. In the Output To section I selected 'Layer Mask'. This would automatically generate a pixel layer mask for the layer based on the current selection.

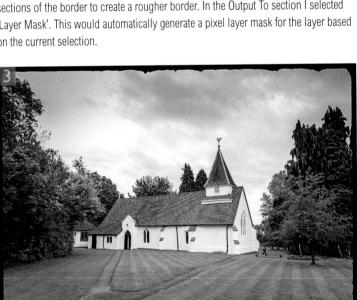

3 Here you can see an alternative border effect in which I started with a rounded marquee selection that was closer to the edges of the photo. This time I filled the Background color with black and used a 33 pixel Radius, a higher Contrast and a softer Feather adjustment to create a tighter border edge. As in Step 2, I also applied a few refine radius tool brush strokes to roughen the edge slightly.

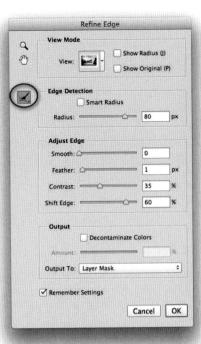

Q (2)	View Mod View:	Show Radius (I)		
	Edge Dete	ection Smart Radius		
	Radius:		33	рх
	Adjust Ed	ge		
	Smooth:		23	
	Feather:		4	рх
	Contrast:		85	%
	Shift Edge:		50	%
	Output			
		Decontaminate Co	olors	
	Amaunt:			96
	Output To:	Layer Mask		\$
	✓ Remembe		incel	Ok

1 This shows a photograph taken of a sailing ship mast against a deep blue sky. Obviously, it would be potentially quite tricky to create a cut-out mask of the complex rigging in this photo. One approach would be to analyze the individual RGB color channels and see if there was a way to blend these together using Calculations and create a new mask channel that could be used as a cut-out layer mask. A much easier way is to use the Color Range command. So to start with, I went to the Select menu and chose 'Color Range...'

Color Range masking

So far I have shown how to replace the background using the quick selection tool combined with Refine Edge/Refine Mask command. Let's now look at how to create a cut-out mask of a more tricky subject where the quick selection tool would not be of much use. Advanced users might be tempted to use channel calculations to mask a picture like this. That could work, but, you know, there is a much simpler way. Color Range can also be considered an effective tool for creating mask selections that can be used when compositing images. In fact, I would say that the quick selection and Color Range adjustment are powerful tools that offer relatively speedy (and sophisticated) methods of masking.

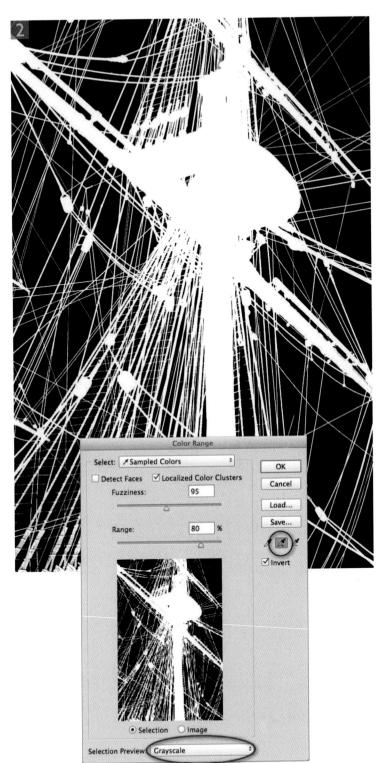

2 This opened the dialog shown below. With the standard evedropper selected to begin with. I was able to simply click with the evedropper anywhere in the image window to sample a color to mask with. In this instance I clicked in the blue sky areas to select the sky and checked the Invert box so that I was able to produce the inverted selection shown here. To create a more accurate selection. I checked the 'Localized Color Clusters' box and used the plus evedropper (circled in blue) to add to the Color Range selection. You can click or drag inside the image to add more colors to the selection and also use the minus eyedropper (or hold down the all key) to subtract from a selection. The Fuzziness slider increases or decreases the number of pixels that are selected based on how similar the pixels are in color to the already sampled pixels, while the Range slider determines which pixels are included based on how far in the distance they are from the already selected pixels. The Color Range preview is rather tiny, so you may find it helps to do what I did here, which was to select the Grayscale Selection Preview (circled in red) so that I could view the edited mask selection in the full-size image window.

3 Having completed the selection I clicked on the 'Add layer mask' button in the Layers panel to convert the active selection to a layer mask, which masked the Ship mast layer. I then wanted to blend the masked image with a photograph of a cloudy sky. This could be done by dragging the masked ship mast layer to the sky image, or as I did here, drag the sky image to the ship mast image and place it as a layer at the bottom of the layer stack. Shown here is the cloudy sky layer on its own with the layer visibility for the masked Ship mast layer switched off.

4 This shows a 100% close-up view of the masked layer overlaying the sky layer with the Ship mast layer visibility switched back on and the Ship mast layer mask targeted. In the Properties panel there was no need to feather the mask. Instead, I clicked on the Mask Edge... button to open the Refine Mask... dialog.

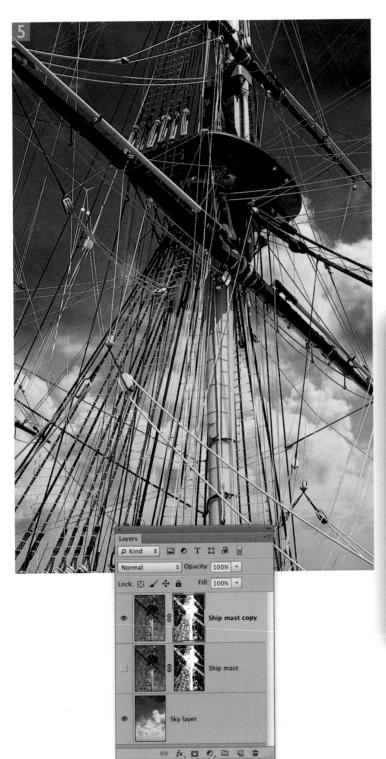

5 This shows the finished composite image, in which I used the Refine Mask controls to fine-tune the mask edges. As in the previous example, I selected the 'On Layers' view mode. I was then able to preview the Refine Mask adjustments on a layer mask that actively masked the Ship mast layer. I didn't have to do too much here. I disabled the edge detection by setting the Radius to 0 pixels, applied a Feather of 0.5 pixels and contracted the mask by -15%. I checked the Decontaminate Colors option and set the Amount slider to 20%. This combination of sliders appeared to produce the best result using the Refine Edge/Refine Mask dialog.

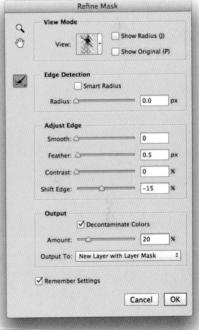

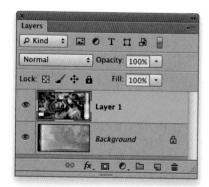

Layer blending modes

The layer blending modes allow you to control how the contents of a layer will blend with the layer or layers immediately below it. These same blend modes can also be used to control how the paint and fill tools interact with an image (you can also alter the blend mode for multiple selected layers). Here is a summary of all the blend modes currently found in Photoshop when blending together the two images shown in Figure 8.31.

Figure 8.31 The following pages illustrate all the different blending modes in Photoshop. In these examples, the photograph of the flowers was added as a new layer above a gray textured Background layer and the layer settings recorded in the accompanying panel header screen shots.

Normal

This is the default mode. Changing the opacity simply fades the intensity of overlaying pixels by averaging the color pixels of the blend layer with the values of the composite pixels below (the opacity was set here to 80%).

Dissolve

This combines the blend layer with the base using a randomized pattern of pixels. No change occurs when the Dissolve blend mode is applied at 100% opacity, but as the opacity is reduced, the diffusion becomes more apparent (the opacity was set here to 80%). The dissolve pattern is random, which is reset each time the application launches. There is actually a good example of the Dissolve blend mode in use on page 645.

Darken

The Darken mode looks at the base and blending pixel values and pixels are only applied if the blend pixel color is darker than the base pixel color value.

Multiply

Multiply multiplies the base by the blend pixel values, always producing a darker color, except where the blend color is white. The effect is similar to viewing two transparency slides sandwiched together on a lightbox.

Color Burn

This darkens the image using the blend color. The darker the color, the more pronounced the effect. Blending with white has no effect.

Linear Burn

The Linear Burn mode produces an even more pronounced darkening effect than Multiply or Color Burn. Note that the Linear Burn blending mode clips the darker pixel values and blending with white has no effect.

Darker Color

Darker Color is similar to the Darken mode, except it works on all the channels instead of on a per-channel basis. When you blend two layers together only the darker pixels on the blend layer remain visible.

Lighten

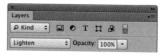

This mode looks at the base and blending colors and color is only applied if the blend color is lighter than the base color.

Screen

Multiplies the inverse of the blend and base pixel values together to always make a lighter color, except where the blend color is black. The effect is similar to printing with two negatives sandwiched together in the enlarger.

Color Dodge

Color Dodge brightens the image using the blend color. The brighter the color, the more pronounced the result. Blending with black has no effect (the opacity was set here to 80%).

Linear Dodge (Add)

This blending mode does the opposite of the Linear Burn tool. It produces a stronger lightening effect than Screen or Lighten, but clips the lighter pixel values. Blending with black has no effect.

Lighter Color

Lighter Color is similar to the Lighten mode, except it works on all the channels instead of on a per-channel basis. When you blend two layers together only the lighter pixels on the blend layer will remain visible.

Overlay

The Overlay blending mode superimposes the blend image on the base (multiplying or screening the colors depending on the base color) while preserving the highlights and shadows of the base color. Blending with 50% gray has no effect.

Soft Light

This darkens or lightens the colors depending on the base color. Soft Light produces a more gentle effect than the Overlay mode. Blending with 50% gray has no effect.

Hard Light

Hard Light multiplies or screens the colors depending on the base color. Hard Light produces a more pronounced effect than the Overlay mode. Blending with 50% gray has no effect.

Vivid Light

This applies a Color Dodge or Color Burn blending mode, depending on the base color. Vivid Light produces a stronger effect than Hard Light mode. Blending with 50% gray has no effect.

Linear Light

Linear Light applies a Linear Dodge or Linear Burn blending mode, depending on the base color. Linear Light produces a slightly stronger effect than the Vivid Light mode. Blending with 50% gray has no effect.

Pin Light

This applies a Lighten blend mode to the lighter colors and a Darken blend mode to the darker colors. Pin Light produces a stronger effect than Soft Light mode. Blending with 50% gray has no effect.

Hard Mix

Hard Mix produces a posterized image consisting of up to eight colors: red, green, blue, cyan, magenta, yellow, black and white. The blend color is a product of the base color and the luminosity of the blend layer.

Difference

This subtracts either the base color from the blending color or the blending color from the base, depending on whichever has the highest brightness value. In visual terms, a 100% white blend value inverts the base layer completely (i.e. turns to a negative). A black value has no effect and values in between partially invert the base layer. Duplicating a Background layer and applying Difference at 100% produces a black image. Difference is often used to detect differences between two near-identical layers in exact register.

Exclusion

The Exclusion mode is a slightly muted variant of Difference. Blending with white inverts the base image.

Subtract

This simply subtracts the pixel values of the target layer from the base layer. Where the result ends up being a negative value it is displayed as black.

Divide

This example doesn't really show you anything useful, but the Divide blend mode does have useful applications such as when carrying out a flat field calibration (see the website for more on how this blend mode can be used).

Hue

This preserves the luminance and saturation of the base image, replacing the hue color with the hue of the blending pixels.

Saturation

Saturation preserves the luminance and hue values of the base image, replacing the saturation values with the saturation of the blending pixels.

Color

Color preserves the luminance values of the base image, replacing the hue and saturation values of the blending pixels. Color mode is particularly suited for hand-coloring photographs.

Luminosity

This mode preserves the hue and saturation of the base image while applying the luminance of the blending pixels.

Photomerge layout options

Auto

In most cases I suggest you use the Auto option first to see what it does before considering the alternative layout options. Very often, Auto produces the best results.

Perspective

The Perspective layout can produce good results when the processed photos are shot using a moderate wide angle lens or longer, but otherwise produces rather distorted, exaggerated composites.

Cylindrical

The Cylindrical layout ensures photos are aligned correctly to the horizontal axis. This is useful for keeping the horizon line straight when processing a series of photos that make up an elongated panorama.

Spherical

This can transform and warp the individual photos in both horizontal and vertical directions. This layout option is more adaptable when it comes to aligning tricky panoramic image sequences.

Collage

This positions the photos in a Photomerge layout without transforming the individual layers, but does rotate them to achieve the best fit.

Reposition

The Reposition layout simply repositions the photos in the Photomerge layout, without rotating them.

Camera Raw lens corrections

When preparing images for stitching with Photomerge, it does not necessarily matter whether lens profile corrections have been applied in Camera Raw or not. However, Photomerge may do a better job if a good profile lens correction has been applied beforehand in Camera Raw.

Creating panoramas with Photomerge

The Photomerge feature allows you to stitch individual photos together to build a panorama image. There are two ways you can do this. You can go to the File ⇒ Automate menu in Photoshop and choose Photomerge... This opens the dialog shown in Step 2, where you can click on the Browse... button to select individual files to process. If you have images already open in Photoshop, then click on the 'Add Open Files' button to add these as the source files. Alternatively, you can use Bridge to navigate to the photos you wish to process and open Photomerge via the Tools ⇒ Photoshop submenu.

To get the best Photomerge results, you need to work from photographs where there is a significant overlap between each exposure. You should typically aim for at least a 25% overlap between each image and overlap even more if you are using a wide angle lens. For example, Photomerge is even optimized to work with fisheye lenses, providing Photoshop can access the lens profile data (see page 652), but with wide angle/fisheye lenses you should aim for maybe as much as a 70% overlap between each image. In the majority of cases the Auto layout option is all you will need to get good-looking panoramas, although the Cylindrical layout option is best to use for panoramic landscapes such as the example shown over the next few pages.

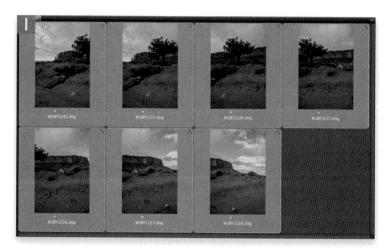

1 To create a Photomerge image, I started by selecting the seven photographs shown here in Bridge. I then went to the Tools menu in Bridge and chose Photoshop ⇒ Photomerge...

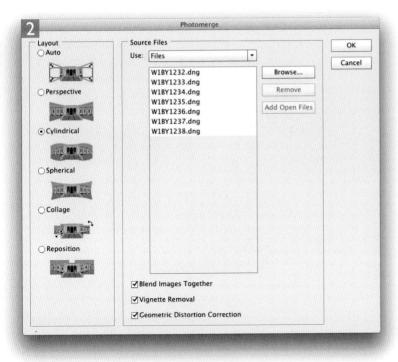

2 This opened the Photomerge dialog, where you'll note that the selected images were automatically added as source files. Instead of using Auto, I selected the 'Cylindrical' layout option; I checked the three options at the bottom and clicked OK to proceed.

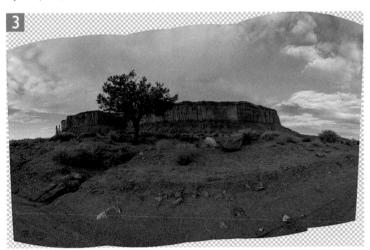

3 As you can see here, this aligned the photos automatically and included a blend step to blend the tones and colors between the layers, followed by an auto layer mask step in which the individual layers ended up being masked so that each part of the Photomerge image consisted of no more than one visible layer.

Blending options

The 'Blend Images Together' option completes the Photomerae processina because it adds laver masks to each of the Photomerged layers (see the Layers panel view in step 3). You can always choose not to run this option and select the Edit Auto-Blend Lavers option later to achieve the same end result (see page 555), 'Vignette Removal' and 'Geometric Distortion Correction' are optional and can help improve the result of the final image blending, especially if you are merging photos that were shot using a wide angle lens. When the Geometric Distortion Correction checkbox is enabled, Photomerge aims to create a better stitch result by directly estimating the lens distortion in the individual image layers. Photomerge does not need to read the lens profile information except when it comes to handling fisheye lens photos.

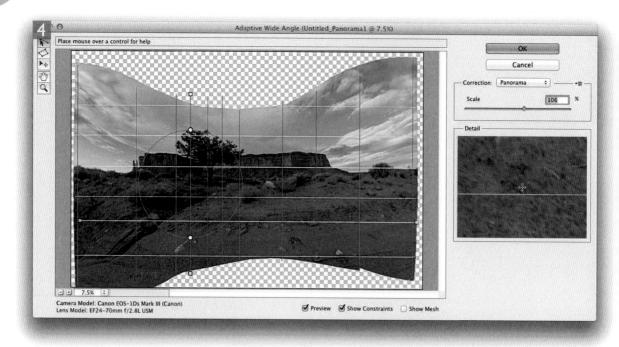

4 I merged all the layers in Step 3 and chose to apply the Adaptive Wide Angle filter. While some have thought of this filter as being specially designed for architectural photography, it also happens to be very useful when used on panorama landscape images. Sometimes the constrain area tool may be all you need. With this image I found it best to apply multiple constraint lines. For more about working with this filter see page 654.

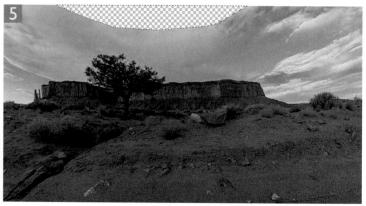

5 Typically you'll find that Photomerge panoramas will have missing gaps around the edges. It is quite easy to fill these in by using the Content-Aware Fill feature. I made a magic wand selection of the outer, transparent pixels. I then went to the Select menu, chose Modify ⇒ Expand and entered an amount of 5 pixels. I then went to the Edit menu and chose the Fill command, using the Content-Aware mode. This should successfully fill the selected area by sampling detail from the main image.

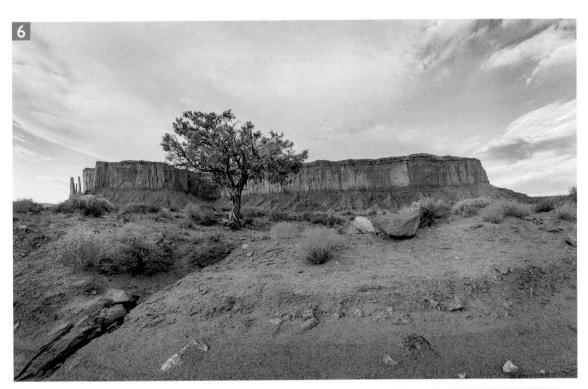

6 I was fairly pleased with the Step 5 result. But there are always small details that need some improvement. To achieve the finished step shown here I did a number of extra things.

One thing you will have noticed is that the composite image looked rather dark in the preceding steps. This was deliberate. You see, when using the Photomerge command, it does end up recalculating the brightness levels across the whole of the composite panorama area. In doing so this can cause the end points to become clipped. Even though the end points may not have appeared clipped in the original source layers, the Photomerge process can sometimes cause clipping to occur. To address this it is a good idea to soften the tone range in Camera Raw for all the images you are about to process so that you will have a safe margin of clipping, especially in the highlights. To create the final version shown above, I added a number of Curves adjustment layers. One was a masked layer that lightened the tree only, another applied a global contrast boost and lightening. Above that, I added a gradient masked layer to darken the sky and, finally, a vignette masked Curves layer to darken the edges.

The other thing I should mention here is that the images used to create this composite were all captured using an 22 megapixel digital SLR. The final composite seen here was approximately $8,370 \times 4,490$ pixels in size. This was equivalent to a single 38 megapixel capture.

Depth of field blending

The Edit Auto-Blend Layers command also allows you to blend objects that were shot using different points of focus and blend them to produce a single image with optimal focus.

1 I began by going to Bridge and selected a group of photographs that had been shot at different points of focus. These were photographed at a fixed aperture and with the camera mounted on a tripod. I then went to the Tools menu and chose Photoshop ⇒ Load Files Into Photoshop Layers.

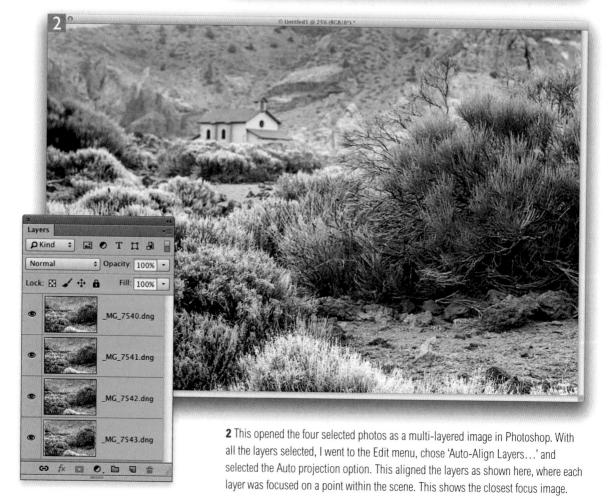

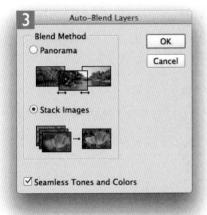

The next step was to merge the layered photos together, which I did by going to the Edit menu again and this time I selected 'Auto-Blend layers...' Here, I selected 'Stack Images' and made sure the 'Seamless Tones and Colors' option was checked.

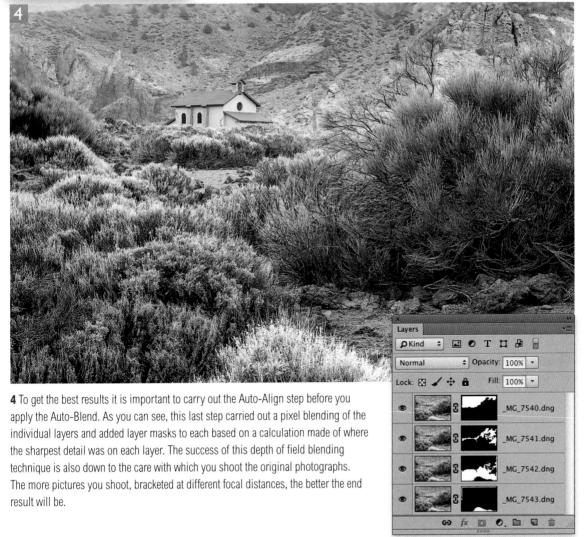

Figure 8.32 To color code a layer or layer selection, use a right mouse-click on a layer to access the contextual menu shown here and select a color from the bottom of the menu (the contextual menu varies depending on whether you click the layer thumbnail or just the layer).

Working with multiple layers

Layers have become an essential feature in Photoshop because they enable you to do all kinds of complex montage work, but as the layers features have evolved there has been an increasing need to manage them more efficiently.

Color coding layers

One way to manage your layers better is to color code them, which can be done by selecting a layer and use the contextual menu shown in Figure 8.32 to pick the desired color label to color code the layer. You can also add and edit color labels on multiple layers at once.

Layer group management

Multi-layered images can be unwieldy to navigate, especially when you have lots of layers placed one above the other. They can therefore be organized more efficiently if you place them into layer groups. Layer groups have a folder icon and the general idea is that you can place related layers together inside a layer group and the layer group can then be collapsed or expanded (the layer group icon reflects this). Therefore, if you have lots of layers in an image, layer groups can make it easier to organize the layers and layer navigation is made simpler.

If you click on the 'Create a new group' button in the Layers panel, this adds a new layer group above the current target layer, while ** (Mac), ** (PC)-clicking on the same button adds a layer group below the target layer and ** alt-clicking opens the New Group from Layers dialog (see Figure 8.33). You can use Layer ** Group Layers. Or, simply select the layers in the Layers panel and use ** G (Mac), ** (PC) to place them into a layer group.

The Layer group visibility can be toggled by clicking on the layer group eye icon. It is also possible to adjust the opacity and blending mode of a layer group as if it were a single layer, while the subset of layers within the layer group itself can have individually set opacities and use different blending modes. You can also add a layer mask or vector mask to a layer group and use this to mask the layer group visibility, as you would with individual layers. To reposition a layer in a Layer group, click on the layer and drag it up or down within the layer stack. To move a layer into a layer group, drag it to the layer group icon or drag to an expanded layer group. To remove a layer from a layer group, just drag the layer above or below the group in the stack (see page 558). You can also lock all layers inside a layer group via the Layers panel fly-out submenu.

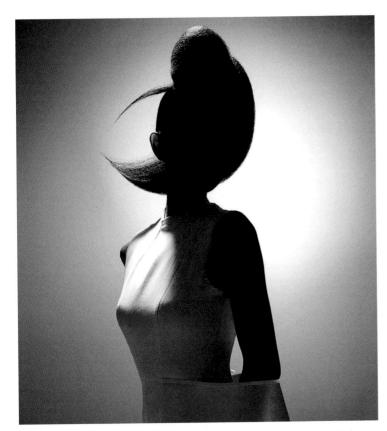

Figure 8.33 When a Photoshop document ends up with this many layers, the layer stack can become difficult to manage, but it is possible to organize layers within layer groups. In this example, I used a **Shift**-click to select the three retouching layers near the bottom of the layer stack. I then went to the Layers panel fly-out menu and chose 'New Group from Layers...' I name the new group 'Retouching work' and selected a red color to color code the layers within this group. Once I had done this, the visibility of all layers within this group could be switched on or off via the layer group eyeball icon and the opacity of the group could be adjusted as if all the layers in the group were a single merged layer.

Nested group layer compatibility

With Photoshop CS5 or later you can have a layer group (or groups) nested within a layer group up to ten nested layer groups deep. As a consequence of this, if a CS5 (or later) image with more than five nested layer groups is opened in an earlier version of Photoshop, a warning dialog will be shown. In the case of Photoshop CS3 or CS4, you'll see a 'this document contains unknown data...' warning where you can choose one of the two options mentioned in the side panel in order to open the image.

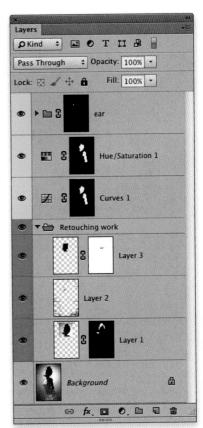

Client: Andrew Collinge Hair & Beauty. Hair by Andrew Collinge artistic team. Make-up: Liz Collinge.

Nested layer group warnings

'Flatten' preserves the appearance of the document by reading the flattened composite data (provided Maximum Compatibility was switched on). The 'Keep Layers' option attempts to preserve all the layers but this may produce different-looking results.

Managing layers in a group

The following steps help illustrate the workings of the layer group management discussed on the preceding pages.

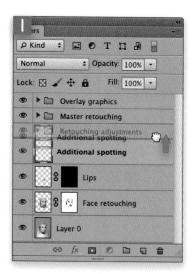

1 Layers can be moved into a layer group by mousing down on a layer and dragging the layer into the desired layer group.

2 The same method can be used when you want to move a layer group to within another layer group. Mouse down and drag the group to another layer group.

3 You can move multiple layers at once. Make a *Shift* select, or **(PC)** layer selection of the layers you want to move and then drag them to the layer group.

4 To remove a layer or layer group from a group, just drag it out of the layer group until you see a bold line appear on the divider above or below the layer group.

5 Here is a view of the Layers panel with the 'Retouching adjustments' group now outside and above the 'Master retouching' layer group.

Clipping masks

Clipping masks can be used to mask the contents of a layer based on the transparency and opacity of the layer or layer group beneath it. So, if you have two or more layers that need to be masked identically, one way to do this is to apply a layer mask to the first layer and then use this to create a clipping mask for the layer or layers above. Once a clipping mask has been applied, the upper layer or layers will appear indented in the Layers panel (Figure 8.34). You can alter the blend mode and opacity of the individual layers in a clipping group, but it is the transparency and opacity of the lower (masked) layer that determines the transparency and opacity of all the layers that are in the clipping mask group.

The main advantage of using clipping masks is that whenever you have a number of layers that are required to share the same mask, you only need to apply a mask to the bottom-most layer. Then when you create a clipping mask, the layer (or layers) in the clipping mask group will all be linked to this same mask. So for example, if you edit the master mask, the edit changes you make are simultaneously applied to the layer (or layers) above it.

Ways to create a clipping mask

To create a clipping mask, select a single layer or make a shift selection of the layers you want to group together and choose Layer \Rightarrow Clipping Mask \Rightarrow Create. Alternatively, alt-click the border line between the layers. This action toggles creating and releasing the layers from a clipping mask group. Plus you can use the $\Re G$ (Mac), ciril alt G (PC) keyboard shortcut to make the selected layer or layers form a clipping mask with the layer below.

Whenever you add an adjustment layer you can create a clipping mask with the layer below by clicking on the Clipping Mask button in the Properties panel. This allows you to toggle quickly between a clipping mask and non-clipping state (see Figure 8.35).

You can also create clipping masks at the same time as you add a new layer. In the example that's shown on the next few pages, you can see how I all-clicked the 'Add New Adjustment Layer' button, which opened the New Layer dialog. This allowed me to check the 'Use Previous Layer to Create Clipping Mask' option (the same thing applies when you alt-click the 'Add New Layer' button).

Figure 8.34 This shows an example of a clipping mask, where the Gradient Fill layer forms a clipping mask with the masked image layer beneath it. Note how the Gradient Fill layer in the clipping mask group appears indented in the layer stack.

Figure 8.35 This shows the Clipping Mask button in the Properties panel that allows you to toggle between enabling and disabling a clipping mask with the layer beneath the adjustment layer.

Masking layers within a group

I use clipping masks quite a lot, but there is also another way that you can achieve the same kind of result and that is to make a selection of two or more layers and place them into a masked layer group (choose Layer \Rightarrow Group Layers). With the layer group selected, click on the Add Layer Mask button in the Layers panel to add a layer mask to the group. If you now edit the layer mask for the layer group, you can simultaneously mask all the layer group contents.

Clipping layers and adjustment layers

The following steps show how clipping masks can be used to group a fill layer with an image layer and how you can group two adjustment layers together so that they form a clipping mask.

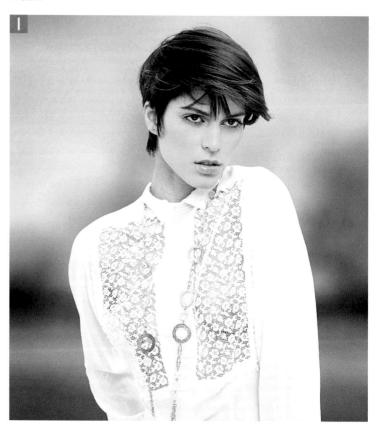

1 This shows a composite image in which I had carried out most of the retouching on the face and added a layer containing a new backdrop image. In this instance, the mask allowed the model image layer and retouching layers to show through from below.

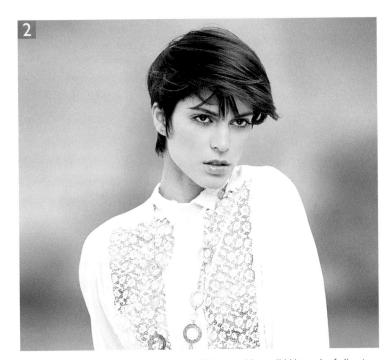

2 In this next step I added a linear Gradient Fill layer with a solid blue color fading to transparency. As you can see, when adding this new fill layer I created a clipping mask with the backdrop image layer. One way to do this was to hold down the all key as I clicked on the 'Add New Adjustment Layer' button (circled). This opened the New Layer dialog shown here, where I checked 'Use Previous Layer to Create Clipping Mask'.

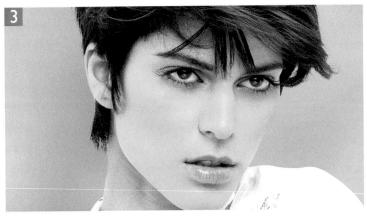

3 Lastly, I made a lasso selection of the model's eyes and added a new Curves adjustment to lighten them. I then did the same thing as in Step 2. I held down the all key as I clicked on the 'Add New Adjustment Layer' button and chose a Hue/ Saturation adjustment. Again, I checked the 'Use Previous Layer to Create Clipping Mask' option. When I boosted the saturation in the Hue/Saturation layer, this adjustment was clipped to the same mask as the one used for the Curves adjustment.

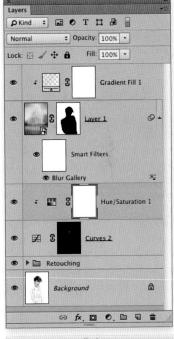

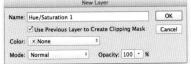

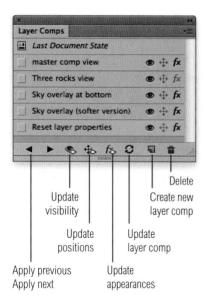

Figure 8.36 The Layer Comps panel.

Layer comp scripts

If you go to the File ⇒ Scripts menu you will find a number of script options. Layer Comps to Files... can be used to generate separate files from layer comps and Layer Comps to PDF... allows you to generate a PDF document based on the layer comps.

Layer Comps panel

As you work on a layered file you may find yourself in a situation where you are not sure which combination of layer settings looks best, or you may wish to incorporate different treatments within the one image document. The Laver Comps panel (Figure 8.36) can prove useful, because among other things, you can use it to store saved layer settings that can be contained within the document. This means that you can experiment using different combinations of laver options and save these as individual layer comps. It is a bit like having the ability to save snapshots, except unlike history snapshots. layer comps are saved permanently with the file. You can save the current layer settings using the following criteria: you can choose whether to include the current laver visibility, the current position of the layer contents and, lastly, the current Layer Style settings, such as the blend mode, opacity or other blending options.

To save a layer comp setting, click on the 'Create new layer comp' button in the Layer Comps panel. This will open the dialog shown below in Figure 8.37. Here, you can give the new layer comp setting a name and select which attributes you wish to include. Once you have done this the new layer comp will be added to the Layer Comps panel list.

The Layer Comps panel uses icons to signify which attributes (visibility, position and appearance) have been saved for each layer comp. The buttons at the bottom allow you to update these attributes independently (for visibility, position and appearance), or update everything. There is also now a warning indicator icon if, for example, a smart object status invalidates other existing layer comps.

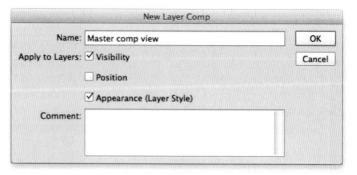

Figure 8.37 This shows the Layer Comps Options dialog. Here, you can see that I had just the Visibility and Appearance (Layer Style) options checked.

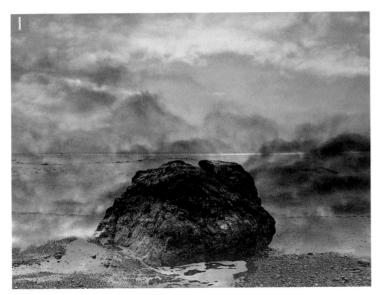

1 This shows a master layered file for a multi-layered image. As you can see, to produce the composite seen here, this image contains a variety of pixel and adjustment layers, which in turn used a number of different blending modes.

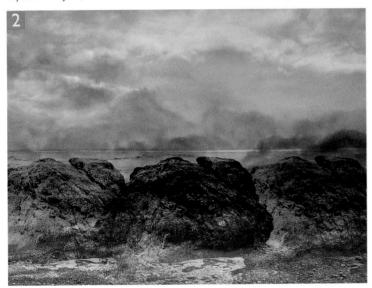

2 As I experimented with different versions of this composite, I saved each as a separate layer comp state. So in the example shown here, I created a layer comp in which all the layers were made visible and with a Hard Light blend mode set for the uppermost layer.

Multiple layer opacity adjustments

If you make a selection of layers, you can use the Opacity or Fill adjustment to adjust the values for all the layers in a layer selection. However, you need to be aware that a multiple layer selection opacity adjustment will override any adjustments that have already been made to individual layers. There are a few restrictions though. In the case of Layer groups you'll only be allowed to make opacity changes and locked layers won't allow changes for either Opacity or Fill. Where these restrictions apply in a layer selection, the most restrictive layer will determine which fields are available to edit. So if you try this out and it doesn't appear to work, it may be because you may have a locked layer selected.

Layer linking

When working with two or more layers you can link them together by creating links via the Layers panel. Start by Shirt-clicking to select contiguous layers, or H (Mac), (Mac), (PC)-clicking to select discontiguous layers. At this point you can move the selected layers, apply a transform, or make the layers form a new layer group. However, if you need to make the layer selection linking more permanent, the layers can be formally linked together by clicking on the Link Layers button at the bottom of the Layers panel (circled in Figure 8.38). When two or more layers are linked by layer selection or formal linking, any moves or transform operations are applied to the layers as if they were one. However, they still remain as separate layers, retaining their individual opacity and blending modes. To unlink, select the layer (or layers) and click on the Link button to turn the linking off.

Selecting all layers

You can use the **X A** (Mac), *ctrl alt* **A** (PC) shortcut to select all layers (except a Background layer) and make them active.

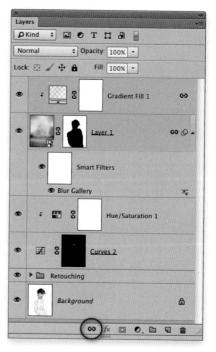

Figure 8.38 To link two or more selected layers, click on the Link button at the bottom of the Layers panel (circled).

Layer selection using the move tool

When the move tool is selected and the Auto-Select option is checked in the move tool options, you can auto-select layers (or layer groups) by clicking or dragging in the image (Figure 8.39), plus you can use the contextual menu to auto-select specific layers (Figure 8.40). You can also use **(Mac), **ctrl* alt* + right mouse (PC)-click to auto-select layers when the move, marquee, lasso or crop tools are selected.

Auto-Select shortcut

If Auto-Select Layer is unchecked, you can toggle the behavior by holding down the (Mac), (PC) key as you click or drag using the move tool.

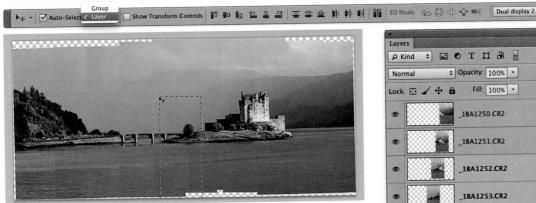

Figure 8.39 When Auto-Select Layer is checked, you can marquee drag with the move tool from outside the document bounds to make a layer selection of all the layers within the marqueed area, but the move tool marquee must start from outside the document bounds, i.e. you must start from the canvas area and drag inwards. In the example shown here, the Auto-Select and Layer options were selected and only the layers that came within the marquee selection were selected by this action.

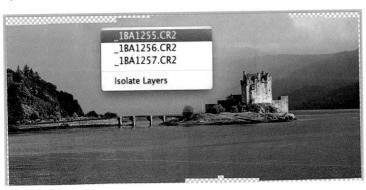

Figure 8.40 When the move tool is selected, you can use the contextual menu to select individual layers. Mouse down on the image using *Mac*, or a right mouse-click to access the contextual menu shown here and click to select a named layer. The contextual menu will list all of the layer groups in the document that are immediately below the mouse cursor. If there are any layer groups, the layers within the layer group will appear indented in the list.

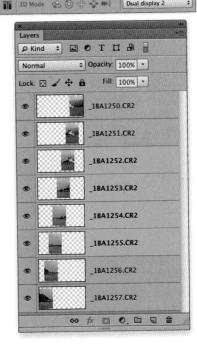

Layer selection with the path selection tools

There is a new option in the Option bar for the path selection and direct selection tools that allows you to select All Layers/ Active Layers (see Figure 8.41). The All Layers mode retains the original Photoshop CC behavior. However, when Active Layers is chosen, the path selection tools will only be able to affect the layers that are currently active in the Layers panel. The steps shown on the following page help explain this more clearly.

Figure 8.41 This shows the Options bar for the path selection tool and the new pop-up menu offering a choice of All Layers/Active Layers.

Previously in Photoshop CC, when using the path selection or direct selection tools you could double-click on a vector path as a shortcut to switch to an isolation mode filter view of just that layer in the Layers panel. You could then double-click again on the path to toggle and revert to a full layer view again. This can still be done when you are in All Layers mode, but not, if you have Active Layers selected. Flipping between these two modes can also be assigned a keyboard shortcut in the Tools section at the bottom of the list (see Figure 8.42).

Figure 8.42 If you go to the Edit menu in Photoshop and choose Keyboard Shortcuts... this opens the dialog shown here. If you select Shortcuts For: Tools and scroll to the bottom of the list you can assign a shortcut to toggle the new All Layers/ Active Layers mode behavior.

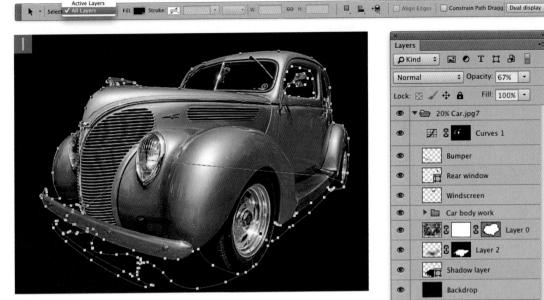

1 In this example the All Layers option was selected in the path selection tool Options bar. When I marquee dragged across the whole image with the path selection tool all the vector path layers became selected and with it the layers in the Layers panel associated with these paths. This was regardless of whatever layer selection might have been in place.

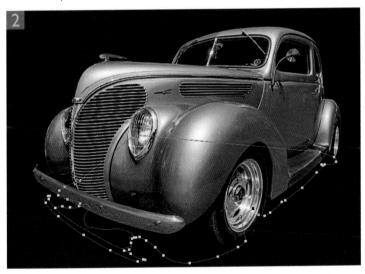

2 In this next example, just the three layers at the bottom were made active in the Layers panel. I set the path selection tool Options bar to Active Layers mode and marquee dragged across the whole image again. This time only the vector paths associated with the active layers in the selection made in the Layers panel became selected and the Layers panel selection remained unchanged.

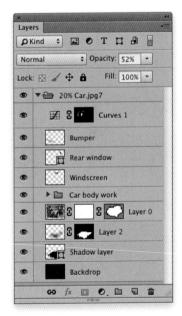

Layer mask linking

Layer masks and vector masks are linked by default to the layer content and if you move a masked layer or transform the layer content, the mask is adjusted along with it (as long as no selection is active). When the Link button (3) is visible, you know the layer and layer mask are linked. It can sometimes be desirable to disable the link between the layer mask/vector mask and the layer it is masking. When you do this, movements or transforms can be applied to the layer or layer/vector mask separately. You can tell if the layer, layer mask or vector mask are selected, as a thin black dashed border surrounds the layer, layer mask or vector mask icon.

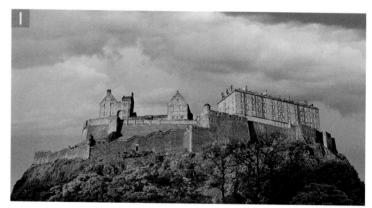

1 This photograph contained a clouds layer masked by the outline of the castle. The layer and layer mask are normally linked and here you can see a dashed border surrounding the layer mask, which means that the layer mask is currently active.

2 I then clicked on the link icon between the layer and the layer mask, which disabled the link between the mask and the layer. Now, when the layer was selected (note the dashed border around the layer thumbnail) I could move the sky layer independently of the layer mask.

Layer locking

The layer locking options can be found at the top of the Layers panel just below the blending mode options. Photoshop layers can be locked in a number of ways. To apply one of the locking criteria listed below, you need to first select a layer and then click on one of the Lock buttons. These have a toggle action, so to remove the locking, just click on the button again. This mechanism can also be used to lock/unlock multiple layers.

Lock Transparent Pixels

When Lock Transparent Pixels is enabled (Figure 8.43), any painting or editing you do is applied to the opaque portions of the layer only. Where the layer is transparent or semitransparent, the level of layer transparency will be preserved.

Lock Image Pixels

The Lock Image Pixels option (Figure 8.44) locks the pixels to prevent them from being edited (with, say, the brush tool or clone stamp). If you attempt to paint or edit a layer that has been locked in this way, you will see a prohibit warning sign. This lock mode does still allow you to move the layer contents though.

Lock Layer Position

The Lock Layer Position option (Figure 8.45) locks the layer position only. This means that while you can edit the layer contents, you won't be able to accidentally knock the layer position with the move tool or apply a Transform command.

Lock All

You can select combinations of Lock Transparent Pixels, Lock Image Pixels, and Lock Layer Position, plus you can also check the Lock All option (Figure 8.46). When this option is selected, the layer position is locked, the contents cannot be edited and the opacity or blend modes cannot be altered. However, the layer can still be moved up or down the layer stack.

The above options mainly refer to image layers. With non-pixel layers you can only choose to lock the layer position or lock all.

Figure 8.43 This shows the Layers panel with an image layer selected. The Lock Transparent Pixels option prevents you painting in the layer's transparent areas.

Figure 8.44 Lock Image Pixels prevents you accidentally painting on any part of the layer.

Figure 8.45 Lock Layer Position prevents the layer from being moved when you edit it.

Figure 8.46 The Lock All box locks absolutely everything on the layer.

Generator overhead

Enabling Generator does imply some additional overhead. However, since Generate Assets must be selected on a document basis it seems that this only applies when it's active on an open document.

Generator: generate assets from layers

This feature uses a customizable JavaScript-based platform and can be used to automatically create derivative files from the master image you are working on. To get set up you'll first need to go to the Photoshop Plug-ins preferences and check the Enable Generator box. This launches Generator so it is always running in the background. Following that you'll need to enable Generator for each image document you are working on. To do this, select File ⇒ Generate ⇒ Image Assets. This initiates Generator for the selected document and the setting remains sticky the next time you reopen the image. Once you have followed these steps you can follow specific layer naming conventions to determine how derivative files will be created. You see, Generator uses the layer or layer aroup naming to determine what derivative files are created and, more specifically, their attributes: such as the file format used, the quality setting and image size. Basically, you define the desired file output by the way you name the layers. For example, adding a file format suffix, such as .jpg, .png, or .gif, lets you indicate the file format you want the derivatives to be saved in. You can specify more precisely how the file is to be saved. If you add .png to a layer name, it will (by default) create a PNG 32 file. But if you wish, you can specify other PNG formats such as: .png8, or .png24. With JPEG you can specify the desired image quality setting (from 1 to 10) by adding a number. The default JPEG quality setting is 9, so adding .jpg6 creates a JPEG file saved using a 6 quality setting. To specify the JPEG quality more precisely you can add a percentage value. So you can type .ipg55% to save a JPEG that uses a 55% quality setting. With the .gif tag this saves a basic alpha transparency GIF and there are no other options that can be specified using Generator.

Extended tagging

Other tags can be used to specify size by adding one of the following tags at the beginning of the layer name. To adjust the size by percentage you can type in a percentage scale value, such as 25% or 33% at the beginning of the layer name. To adjust the size to fit within specific dimensions, enter the units like this: 600×400 can be used to specify creating a file that fits within a 600×400 pixel size (Generator uses pixel values unless otherwise specified). So, you would need to add in (for inches), cm (for centimeters) and mm (for millimeters). Tags can be separated by commas when naming a layer to

indicate that more than one type of file should be generated (but each tag must be properly formatted with a valid file extension). For example, naming a layer 20% garden.png, 10in x 8in garden.jpg8 will create a 20% scaled PNG, plus a 10 inch x 8 inch JPEG file saved using a quality 8 setting. The file naming in Photoshop now accommodates names up to 255 characters long.

Summary of how Generator works

Let me summarize what happens in the background when using Generator. Whenever you work on a brand new image and File \Rightarrow Generate \Rightarrow Image Assets has been activated, assets are initially saved to a generic assets folder on the desktop, most likely named: Untitled-1-Assets. Whatever assets have been generated will be present in this folder. Once a master file has been saved though, an assets folder is created alongside the parent file inside whatever folder directory you chose to save the file to. This assets folder will use the same name as the file it relates to. The original desktop assets folder (which was temporary) then disappears. All subsequent edits made to the open image will continue to generate updated assets, regardless of whether the master file has been saved and the parent file updated.

Generator uses

Generator is a feature that should be of interest to a lot of different types of Photoshop users. The following example shows a simple use of generator in which a low res JPEG version of the composite image was created. This would continuously get updated as the file was worked on. A practical use for this type of workflow would be the ability to have instant access to a low res, composite version of the image you are working on, ready to email to a client.

I would say this feature was devised mainly with multimedia designers in mind. By using Photoshop CC in conjunction with the Edge Reflow CC program, designers can use Generator to work on a master file in Photoshop and generate Web asset files that are automatically updated in real time. For example, designers at The Engine Co, have used Generator to write a plug-in for their Loom gaming engine. This allows them to update the user interface for a game in Photoshop while it is being played. The system is pretty flexible too and allows designers to generate Retina resolution assets to accompany regular resolution versions. All in real time.

Adobe Edge Reflow CC

Adobe Edge Reflow CC is a new Web tool that can be used to create responsive Web designs that adapt content to different screen sizes. Using Edge Inspect CC, it is possible to extract the CSS code from an Edge Reflow project to work on in other code editors, such as Dreamweaver.

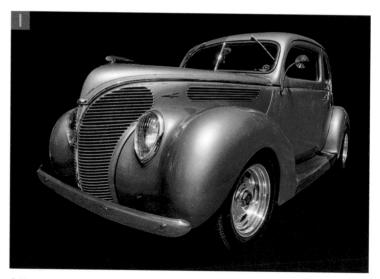

1 Here is an open image document where in the Plug-ins preferences I had checked Enable Generator. With the document open, I went to the File menu and chose Generate ⇒ Image Assets. I arranged all the layers into a single layer group and named this '20% Car.jpg7'. This naming specified creating a JPEG file resized to 20% the original image's file size using a JPEG quality setting of 7.

2 Because Generator was enabled, this automatically created an assets folder identified using the file name of the original image. Inside this you can see it generated a reduced size JPEG version of the master image.

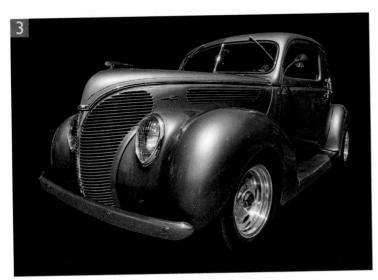

3 I then selected the masked Hue/Saturation layer below and clicked on the eyeball in the Layers panel to enable the adjustment. This changed the color of the car from green to mauve. There was no need for me to save the image as the change automatically updated the JPEG image stored in the accompanying assets folder.

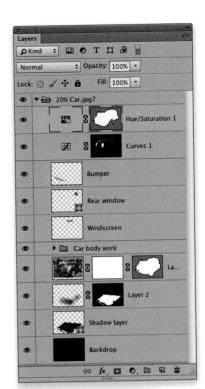

4 To check this was the case, I once again visited the file's assets folder and saw the JPEG version had been updated to show the car with the new, changed color.

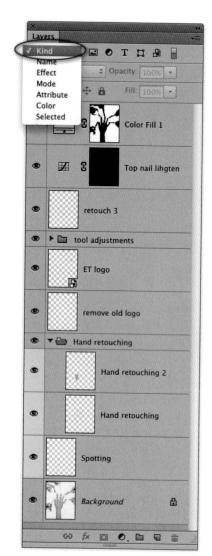

Figure 8.47 This shows the Layers panel for a multi-layered image and the filter layer options that are available.

Smarter naming when merging layers

When you merge a selection of layers together in Photoshop, the usual convention has been for the merged layer to take on the name of the uppermost layer in that layer selection. Now, Photoshop is a little smarter in that it ignores any of the default layer names such as 'Layer 1' or 'Curves' and uses the top-most, manually renamed layer to name the merged layer. It is a subtle change in behavior that makes some sense. However, a downside of this change (which was introduced to Photoshop CS6.1) is that some Photoshop actions can fail to work correctly as a result of this. Something I found out to my cost when updating to CS6.1!

Layer filtering

Layer filtering can be used to determine what gets displayed within the Layers panel depending on the selected criteria. To filter the layers in an open document, select one of the filter options from the menu circled in Figure 8.47. Here, you can choose to filter the layers by Kind, Name, Effect, Mode, Attribute, Color or Selected. You'll notice there is also a switch in the top right of the Layers panel. This is colored red when a filter of any kind is active and you can click on the switch to toggle the layer filtering on or off. Note that none of the following filtering options are recordable as actions.

When the default Kind option is selected you can filter using the following criteria: pixel layers, adjustment layers, type layers, Vector layers, Movie layers or Smart Objects (see the examples shown in Figure 8.48). If you filter by 'Name' you can search for any layers that match whatever you type into the text box. So for instance, in the bottom right example in Figure 8.48 I typed in 'retouching', which revealed all the layers with the word 'retouching' in their layer names. It so happens you can also use the Select \Rightarrow Find Layers menu command (**Shift**F** [Mac], all Shift**F** [PC]) to carry out a layer filter search by 'Name'. If you select the Name filter and don't enter any text, no red light will show because nothing has been filtered yet.

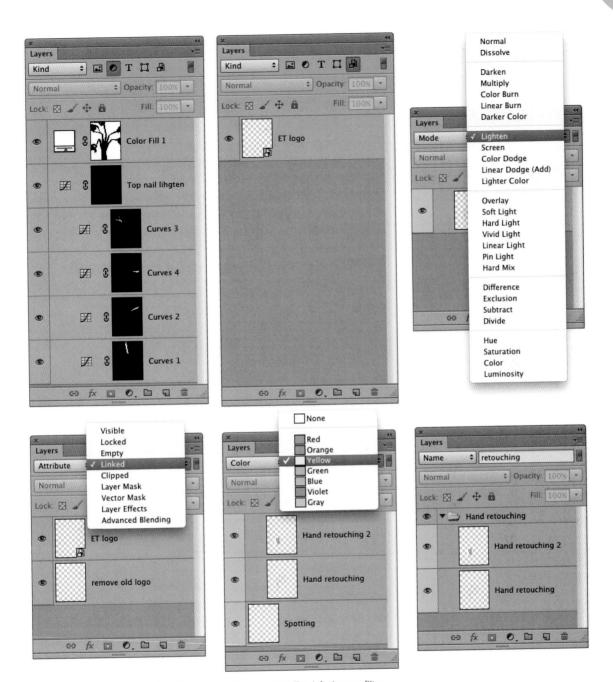

Figure 8.48 Here are examples of some layer filter searches. Top left shows a filter search by 'Kind', searching for adjustment layers only. Top middle, a search by 'Kind' for Smart Objects only. Top right shows a search by 'Mode' to filter by the Lighten blending mode. Bottom left shows an 'Attribute' search for layers that are linked. Bottom middle shows a 'Color' search for layers that are colored yellow. Bottom right shows a 'Name' search for layers that include the word 'retouching'.

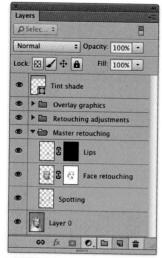

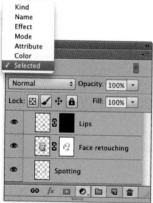

Figure 8.49 Invoking isolation mode.

Figure 8.50 The path selection/direct selection contextual menu.

Isolation mode layer filtering

Isolation mode is an additional layer filtering option that allows you to filter the active selected layers in a document. This means you can specify a subset of layers within a document and isolate them so that only these layers are visible in the Layers panel (although all other layers will remain visible in the document). Tool use then becomes restricted to just the selected layers, but you can add, duplicate, reorder or delete any of the visible layers while they are in the filtered state. You can modify an isolated layer selection by targeting a layer and choose 'De-isolate Layer' from the Select menu or contextual menu (use crif [Mac], or a right mouse-click to access).

To invoke the isolation mode, make a selection of layers active and enable the 'Isolate Layers' option via the Select menu, or select the Selected filter mode. To undo, select 'Isolate Layers' again, or click on the filter switch to disable the filtering. You can also invoke 'Isolate Layers' via the contextual menu for the move tool. In Figure 8.49 three pixel layers were active. When layer filtering was enabled using the 'Selected' mode only these three layers remained visible within the Layers panel.

When either the path selection or direct selection tools are active you can use (Mac), or a right mouse-click to access the contextual menu and choose 'isolate Layers' to enable/ disable the isolation mode layer filtering (see Figure 8.50). Also, double-clicking on an active shape layer path using either of these tools, automatically isolates the targeted layer. Double-click again to de-isolate the layer again (providing you are in All Layers mode [see page 566]).

Although tool usage is restricted to the selected layers only, when the move tool is selected and in auto-select layer mode, you can click with the move tool on the image to auto-add additional layers to an isolation mode filtered selection.

Whenever a layer filter is active most normal layer functions will remain active. This means that you can still edit layers, reorder or delete them. Layer filter settings aren't saved when you close a document, but the layer filtering settings do remain sticky for as long as a document remains open in Photoshop and any layer filters you apply will also be persistent for each individual document. Only one filter type can be active at a time, so it is currently not possible to apply multiple search criteria to the layers in an image. And, when filtering a new document, you will always encounter the normal default layer filtering state when filtering for the first time.

Transform commands

There are a range of options in the Image

Image Rotation submenu (Figure 8.51). These allow you to rotate or flip an image. For example, you can rotate an image 180° where a photo has been scanned upside down.

The Transform commands are all contained in the Edit

Transform menu (Figure 8.52) and these allow you to apply transformations to individual or linked groups of layers. There are three main ways you can apply a transform. You can select a layer or make a pixel selection that you wish to transform and choose either Edit

Transform, or Edit

Free Transform. Also, whenever a layer plus one of the selection tools is selected, the Free Transform command is available via the contextual menu (just

Mac], or right mouse-click on a layer and select 'Free Transform'). The other option is to check the Show Transform Controls box in the move tool Options bar (Figure 8.53).

The main Transform commands include: Scale, Rotate, Skew, Distort and Perspective, and these can be applied singly or combined in a sequence before clicking *Enter*, or double-clicking within the Transform bounding box to OK a transformation. The interpolation method used when calculating a transform can be selected from the Interpolation menu in the modal Transform Options bar (see over the page).

You can apply any number of tweaking adjustments before applying the actual transform and you can use the undo command (#2 [Mac], [Mac], [PC]) to revert to the last defined transform preview setting. You can also adjust the transparency of a layer mid-transform. This means you can modify the opacity of the layer as you transform it (this can help you align a transformed layer to the other layers in an image).

Of all the transform options, the Free Transform is the more versatile and the one you'll want to use most of the time. Choose Edit \Rightarrow Free Transform or use the R (Mac), Ctr (PC) keyboard shortcut and modify the transformation using the keyboard controls as indicated on the following pages. When you are in transform mode, the Options bar offers you precision controls as well as other options.

Figure 8.51 The Image ⇒ Image Rotation submenu can be used to rotate or flip the entire image.

Figure 8.52 The Edit ⇒ Transform submenu can be used to transform or rotate individual layers or linked groups of layers.

Figure 8.53 The move tool Options bar also allows you to make the transform bounding box visible.

1 You can rotate, skew or distort an image in one go using the $\mbox{Edit} \Rightarrow \mbox{Free Transform command. The following steps show you}$ some of the modifier key commands that can be used to constrain a free transform adjustment.

2

2 You can place the cursor outside the bounding border and drag in any direction to rotate the image. If you hold down the Shift key as you drag, this constrains the rotation to 15° increments. You can also move the center axis point to change the center of the rotation.

3 If you hold down the (#) (Mac), otri (PC) key as you click any of the handles of the bounding border, this will allow you to carry out a free distortion.

4 If you want to constrain the distortion symmetrically around the center point of the bounding box, hold down the att key as you drag any handle.

5 To skew an image, hold down the **\$\mathbb{R}** \tag{Mac}, **\$\left(Mac)\$**, **\$\left(dotr) \right(alt)\$**(PC) keys and drag any one of the corner handles.

6 To carry out a perspective distortion, hold down the Schift (Mac), ctrl alt Shift (PC) keys in unison and drag on one of the corner handles. When you are happy with any of the new transform shapes described here, press Enter or Return or double-click within the transform envelope to apply the transform. Press esc if you wish to cancel.

Repeat Transforms

After you have applied a transform to an image layer or image selection, you can get Photoshop to repeat the transform by going to the Edit menu and choosing: Transform Again (the shortcut here is **Shift**T** [Mac], **ctrl**Shift**T** [PC]). This can be done to transform the same layer again, or you can use this command to identically transform the contents of a separate layer. I generally find the Transform Again command is most useful when I need to repeat a precise transform on two different layers, a similar object within the image, or on a separate image.

Interpolation options

The Interpolation menu allows you to select one of the following options: Nearest Neighbor, Bilinear, Bicubic, Bicubic Sharper, Bicubic Smoother, or Bicubic Automatic (but not 'Preserve Details'). These are exactly the same as the General preferences options and the options bar interpolation setting remains sticky while you are working in Photoshop.

Manually setting the transform axis

In addition to the simplified Options bar icon for determining the transform axis, you can place the transform bounding box center axis point anywhere you like by simply dragging it.

Numeric Transforms

When you select any of the Transform commands from the Edit menu, or check 'Show Transform Controls' in the move tool options, the Options bar displays the Numeric Transform commands shown below in Figure 8.54. The Numeric Transform options allow you to accurately define any transformation as well as choose where to position the centering reference point position. For example, the Numeric Transform can commonly be used to change the percentage scale of a layer. You just enter the scale percentages in the Width and Height boxes. If the Constrain Proportions link icon is switched off you can set the width and height independently. You can also change the central axis for the transformation by repositioning the white dot (circled) from its default center position. For example, if you click in the top left corner you can have all transforms (including numeric transforms) default to rotating around the top left corner.

Figure 8.54 This shows the move tool Options bar in Transform mode. The same Options bar controls are seen when a selection is active and you choose Select ⇒ Transform Selection

Expand/Contract selections

The Select ⇒ Modify menu contains
Expand... and Contract... menu options.
These allow you to expand or contract a selection. One of the downsides of using this approach is that when you enlarge a rectangular selection in this way, you'll end up with rounded corners. If instead you use the Transform selection method, you will be able to preserve the sharp corners of a rectangular selection.

Transforming paths and selections

You can also apply transforms to Photoshop selections and vector paths. For example, whenever you have a pen path active, the Edit menu switches to Transform Path mode. You can then use the Transform Path commands to manipulate a completed path or a group of selected path points (the path does not have to be closed). You just have to remember you can't execute a regular transform on an image layer (or layers) until *after* you have deselected any active paths.

To transform a selection, choose Select ⇒ Transform Selection (note, if you choose Edit ⇒ Transform, this transforms the selection contents). Transform Selection works just like the Edit ⇒ Free Transform command. You can use the exact same modifier key combinations to scale, rotate and distort the selection outline. Or, you can use [CIT] (Mac), or right mouse-click to call up the contextual menu of transform options.

Transforms and alignment

When you have more than one layer in an image, the layer order can be changed via the Layer ⇒ Arrange submenu (Figure 8.55), which can be used to bring a layer forward or send it further back in the layer stacking order. You can also use the following keyboard shortcuts. Use 🕱 1 (Mac), ctrl 1 (PC) to bring a layer forward and 🕱 1 (Mac), ctrl 1 (PC) to send a layer backward. Use 🛣 Shift 1 (Mac), ctrl Shift 1 (PC) to bring a layer to the front and 🕱 Shift 1 (Mac), ctrl Shift 1 (PC) to send a layer to the back.

If two or more layers are linked, these can be aligned in various ways via the Layer ⇒ Align menu (Figure 8.56). To use this feature, first make sure the layers you want to align are selected, or are linked together, or in a layer group. The Align commands can then be used to align the linked layers using the different rules shown in the submenu list, i.e. you can align to the Top Edges, Vertical Centers, Bottom Edges, Left Edges, Horizontal Centers or Right Edges, and the alignment will be based on whichever is the top-most or left-most layer, etc. There is also a Distribute submenu, which contains an identical list of options to the Align menu, but is only accessible if you have three or more layers selected, linked, or in a layer group. The Distribute commands allow you to distribute layer elements evenly based on either the Top, Vertical Centers, Bottom, Left, Horizontal Centers or Right edges. So for example, if you had three or more linked layer elements and you wanted them to be evenly spread apart horizontally and you also wanted the distance between the midpoints of each layer element to be equidistant, you would select all the layers and choose Layer ⇒ Distribute ⇒ Horizontal Centers.

Rather than use the Layer menu options you can click on the Align and Distribute buttons in the move tool Options bar (Figure 8.57). Generally, I would say the Align and Distribute features are perhaps more useful for graphic designers, where they might need to precisely align image or text layer objects in a Photoshop layout.

Arrange, Align and Distribute shortcuts

Note here that all the Layer menu and Layers panel shortcuts are listed in a separate appendix which is available from the book website as a PDF document.

Figure 8.55 The Layer ⇒ Arrange submenu.

Figure 8.56 The Layer ⇒ Align submenu.

Figure 8.57 This shows the move tool Options bar in alignment/distribution mode. Note that the alignment options (shaded blue) will only become available when two or more layers are selected and the distribution options (shaded green) are only available when three or more layers are selected. Shaded in red is the Auto-Align Layers button. Clicking this is the same as choosing: Edit ⇒ Auto-Align Layers when two or more layers are selected.

Warp transforms

Bend: 50.0 % H: 0.0

% V: 0.0 %

When the Warp transform first appeared in Photoshop it provided a perfect solution for all those Photoshop users who had longed for a means to carry out direct, on-canvas image warping. The Warp transform is therefore more like an extension of the Free Transform. All you have to do is to select the Free Transform option from the Edit menu and then click on the Transform/Warp mode button (circled in Figure 8.58) to toggle between the Free Transform and Warp modes. The beauty of this is that you can combine a free transform and warp distortion in a single pixel transformation. It has to be said that the magic of the Warp transform has been somewhat superseded by the Puppet Warp adjustment, but it is still nonetheless a very useful tool.

When the Warp option is selected you can control the shape of the warp bounding box using the bezier handles at each corner. The box itself contains a 3×3 mesh and you can click in any of the nine warp sectors, and drag with the mouse to fine-tune the warp shape. What is also great about the Warp transform is the way that you can make a warp overlap on itself (as shown on the page opposite).

You can only apply Warp transforms to a single layer at a time, but if you combine layers into a Smart Object, you can apply non-destructive distortions to multiple layers at once. For more about working with Smart Objects see pages 597–600.

Warp transforms are better suited for editing large areas of a picture where the Liquify filter is less able to match the fluid distortion controls of the Warp transform. However, as I just mentioned, the new Puppet Warp (see pages 589–594) is also worth considering as an ideal tool for this type of image manipulation work.

Dual display 2

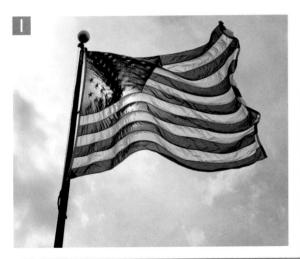

1 In this example I took a photograph of a US flag, separated out the flag from the flag pole on a separate layer and placed both these elements as individual layers above a separate sky backdrop and converted the Flag layer to a Smart Object.

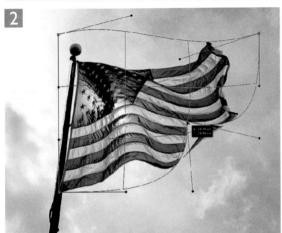

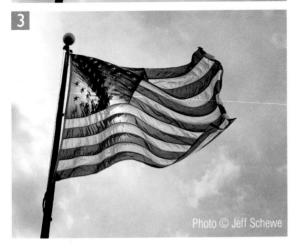

- 2 I then went to the Edit menu and selected Edit ⇒ Transform ⇒ Warp. The default option is the 'Custom' mode, where I had access to the bezier control handles at the four corners of the warp bounding box. These could be adjusted in the same way as you would manipulate a pen path to control the outer shape of the warp. Here, I was able to drag the corner handles and click inside any of the nine sectors and drag with the mouse to manipulate the flag layer, just as if I were stretching the image on a rubber canvas. You'll note how I was even able to adjust the warp so that the flag twisted in on itself to reveal the reverse side of the flag
- **3** In Step 2 the warp preview in the bottom right corner had some sky area included with the warp. This is just how the preview is rendered when warping an image. You can see here how once the warp had been applied, the warped image appears as expected. Because the Flag layer remained as a Smart Object I could still continue to edit the Flag layer non-destructively.

Enable Graphics Processor

For the Perspective Warp feature to work, make sure you have the Graphics Processor enabled in the Photoshop Performance preferences. 'Use Graphics Processor to Accelerate Computation' should be selected In the Advanced Settings.

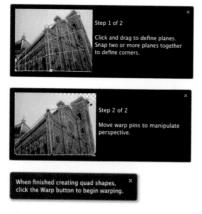

Figure 8.59 When you first select the Perspective Warp you will see these helpful animated help dialogs. They go away after the first time you use Perspective Warp.

Perspective Warp

Perspective Warp provides a new way to warp photos in order to correct or manipulate perspective. It allows you to manipulate the perspective in parts of your image, while maintaining the original perspective in other areas. You can find Perspective Warp under the Edit menu: Edit ⇒ Perspective Warp and it is particularly well suited to images of architectural subjects. For example, one way to use this tool is to correct the perspective of buildings in a photograph, where you wish to make a building's perspective look more correct, but without distorting everything else in the image. The thing is, this only works if the building in question is fairly rectangular in shape. Anything with a pitched roof isn't going to work, though the animated Perspective Warp help screens shown in Figure 8.59 demonstrate how this tool can be applied to some architectural photographs where the building shape is slightly irregular. You can also use the Perspective Warp feature to manipulate a layered object as I have shown over the following pages.

When you apply a Perspective Warp you will initially be working in the Layout mode () where the idea is to define the warp planes. You do this by clicking and marquee dragging to define the first warp plane and then clicking on the corner handles to adjust the shape. Subsequent warp planes can be added to define other object planes and these will automatically snap-align to the edges of other existing planes. Once you have done this you can click on the Warp button in the Options bar to access the Warp controls shown in Figure 8.60 below.

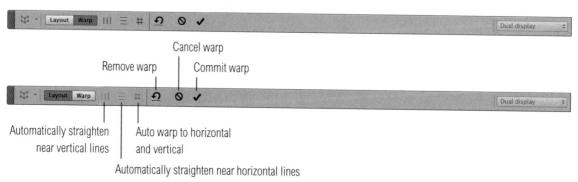

Figure 8.60 This shows the Perspective warp Options bar in Layout mode ((L)), at the top and Warp mode ((V)) at the bottom.

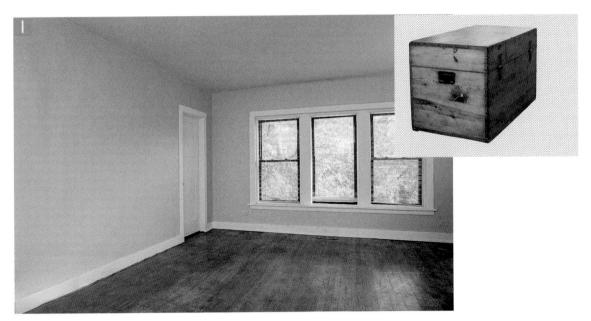

1 To illustrate working with the Perspective Warp feature, I used the two photographs seen here. One is an empty room interior and the other, a photograph of a wooden box cabinet, which I had cut out using a pen path.

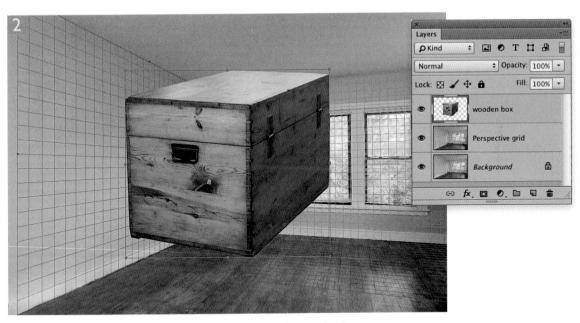

2 I placed the box as a layer in the Empty Room image document. As an optional step, I created a layer containing perspective grid guide lines, which I added here as a temporary layer and would use later to help guide the positioning of the box in the image.

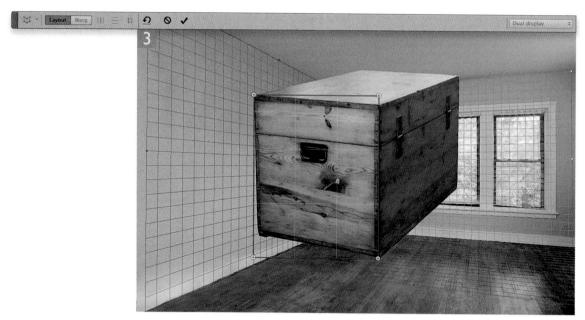

3 I went to the Edit menu and chose Perspective Warp. I began by marquee dragging over the box image layer to add the first quad plane.

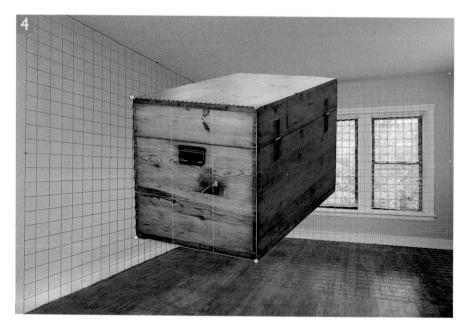

4 I then clicked on the quad plane corner pins to fine-tune their placement and align with the first plane of the wooden box. You can also use the keyboard arrow keys to nudge a selected quad pin.

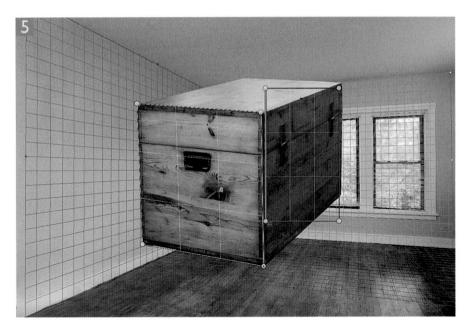

5 I then clicked and dragged to add a second quad plane. You will note as you do this how when the second plane edge meets the first the two edges are highlighted blue and the second plane snaps to the edge of the first. After doing this I fine-tune adjusted the corner pin positions of the second quad plane. You can hold down the (Mac) (PC) key while drawing quads to place them close but without joining.

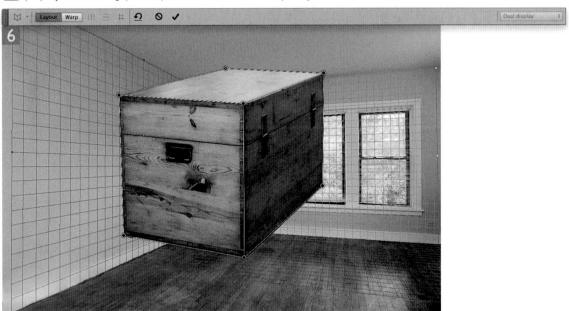

6 I added a third quad plane to define the top of the box. I then clicked on the Warp button (W) in the Options bar to prepare the layer for warping. You can also use the key to hide the grids when working in the Warp mode.

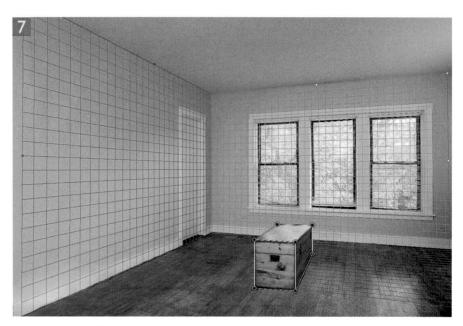

7 I clicked on the quad plane corner pins to move them and create a new perspective for the layer object. You will notice how if you hold down the **Shift** key as you click on a segment between two pins the segment turns yellow and will automatically snap to the horizontal, vertical, or a 45° angle (**Shift** click again to disable).

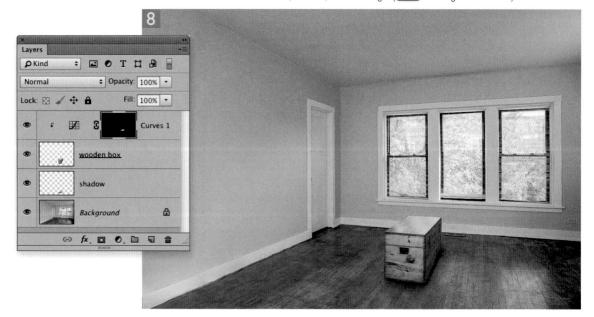

8 Lastly, I clicked Enter to OK the Perspective Warp adjustment. I then removed the perspective guides layer and carried out some further retouching to change the color of the top of the box and added some shading beneath it.

Puppet Warp

Whenever you are editing a normal, non-background layer the Puppet Warp feature will be available from the Edit menu. This is a truly outstanding feature for anyone who uses Photoshop for retouching work. While the Liquify filter and Warp transform are great, the main benefits of working with the Puppet Warp tool are that the warp response feels that much more intuitive and responsive. As you edit the pins, the other elements of the photograph appear to warp in a way that can help the warping effect look more natural. The other advantage is you can edit the layers directly in Photoshop without having to do so via a modal dialog. Or rather it seems to be non-modal whereas in fact the Puppet tool is really still modal – it's just that you are able to work on a layer directly rather than via a dialog interface (as is the case with Liquify).

The only way to truly appreciate Puppet Warp is to watch a movie demo, such as the one on the book's website, or better still, try it out for yourself. The Puppet Warp tool Options bar (Figure 8.61) offers three modes of operation. The Normal mode applies a standard amount of flexibility to the warp movement between the individual pins, while the Rigid mode is stiffer and good for bending things like hands. The Distort mode provides a highly elastic warp mode which can be good for warping wide angle photographs. The Puppet Warp function is based on an underlying triangular mesh. The default Density setting is set to Normal, which is the best one to choose in most instances. The More points density option provides more precise warping control but at the expense of speed since the processing calculations are more intense. The Fewer Points setting allows you to work faster, but you may get unpredictable or unusual warp results. There is also a Show Mesh option that allows you to show or hide the mesh visibility.

The next thing to do is to add some pins to the mesh. These can be applied anywhere, but it is important you add at least three pins before you start manipulating the layer, since

Including soft edges

The Puppet Warp mesh is mostly applied to all of the selected layer contents, including the semi-transparent edges, even if only as little as 20% of the edge boundary is selected. And if this fails to include all the desired edge content you can always adjust the Expansion setting to include more of the layer edges.

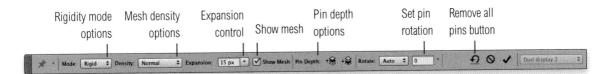

Figure 8.61 The Puppet Warp Options bar.

Multiple objects

If you have multiple objects on a layer, the Puppet Warp mesh is applied to everything on that layer. However, while the mode operation is global you can apply separate distortions to each of the layer elements.

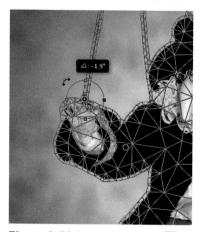

Figure 8.62 If you hold down the *alt* key and hover the mouse over an already selected pin, this shows a pin rotation circle that you can adjust to twist the rotation of the selected pin.

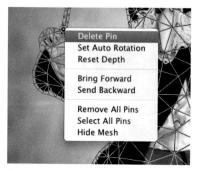

Figure 8.63 This shows the pin contextual menu, which offers quick access to a list of useful options for modifying pins that have been added using Puppet Warp. (ctr)-click or use a right mouse-click to reveal the contextual menu shown here). Set Auto Rotation can be used to reset the pin rotation.

the more pins you add, the more control you'll have over the Puppet Warp editing. The thing to bear in mind here is that as you move a pin, other parts of the layer will move accordingly, and perhaps do so in ways that you hadn't expected. This is the result of the Puppet Warp tool intelligently working out how best to distort the layer. As you add more pins to different parts of the layer you will find that you gain more control over the Puppet Warp distortions. The keyboard arrow keys can also be used to nudge the selected pin location, but if you make a mistake with the addition or placement of a pin you can always use the undo command () [Mac], ctrl Z [PC]), or hold down the all key to reveal the scissors cursor icon and click on a pin to delete it. Or, you can simply select a pin and hit the Delete key. In order to further tame the Puppet Warp behavior, you can use the Expansion setting to modify the area covered by the mesh, since this can have the effect of dampening down the Puppet Warp responsiveness. This can be considered essential if you want to achieve manageable distortions with the Puppet Warp. The default setting of 2 pixels allows for precise control over the warp distort movements, but this won't help with every image. In the Puppet Warp example shown over the next few pages I found it necessary to use a more expanded mesh, since without this the Puppet Warp distortions became rather unwieldy. This was especially noticeable when I tried setting the Expansion setting to 1 pixel or less. If you find that your Puppet Warp editing feels uncontrolled, try increasing the Expansion amount.

Pin rotation

The Rotate menu normally defaults to 'Auto'. This rotates the mesh automatically around the pins based on the selected mode option. However, when a pin is selected you can hold down the all key and hover the cursor over a pin, which reveals the rotation circle that also allows you to set the pin rotation manually (see Figure 8.62). Be careful though, because if you happen to all-click a pin, this will delete it. As you rotate a pin, the rotation value shows in the tool Options bar. This extra level of control allows you to twist sections of an image around a (movable) pin point as well as alter the degree of twist between this and the other surrounding pins. In the case of the puppet image example shown here, this gave me better control over the angle of the strings. See also Figure 8.63, which shows the pin contextual menu options.

Pin depth

The pin stacking order can be changed by clicking on the buttons in the tool Options bar. Where a Puppet Warp distortion results in elements overlapping each other, you can decide which section should go on top and which should go behind. You can either click on the move up or move down buttons shown in Figure 8.64, or use the key to bring a pin forward and use the key to send a pin backward (or use the pin contextual menu shown in Figure 8.63). Basically, this is a mechanism that allows you to determine whether warped elements should go in front of or behind other elements in a Puppet Warp selection.

Multiple pin selection

You can select multiple pins by *Shift*-clicking the individual pins. Once these are selected, you can drag them as a group using the mouse, or use the arrow keys to nudge their positions. You can *Shift*-click again to deselect an already selected pin from a selection. However, operations which affect a single selected pin, such as rotation and pin depth, are disabled when multiple pins are selected.

While in Puppet Warp mode, you can also use **\$A** (Mac), *ctrl* **A** (PC) (or the contextual menu) to select all the current pins and you can use the **\$B D** (Mac), *ctrl* **D** (PC) shortcut to deselect all pins. Also, if you hold down the **H** key, you can temporarily hide the pins, but leave the mesh in view.

Smart Objects

If you convert a layer to a Smart Object before you carry out a Puppet Warp transform this will allow you to re-edit the Puppet Warp settings. You can also use the Puppet Warp feature to edit vector or type layers. However, if you apply the Puppet Warp command to a type or vector layer directly, the Puppet Warp process automatically rasterizes the type or vector layer to a pixel layer. Therefore, in order to get around this I suggest you select the layer and choose Filter \Rightarrow Convert to Smart Filters first, before you select the Puppet Warp command.

Now for a quick run through of the Puppet Warp in action, for which I chose to use an image of what else, but a puppet!

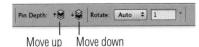

Figure 8.64 The pin depth controls allow you to move the selected pin positions on a Puppet Warp selection up or down. This allows you to control whether certain image areas slide in front or behind other areas of the image. The preview you see in the Puppet Warp edit mode will include the Extension area, but this won't be seen in the final render.

1 The first step was to have the puppet image as a separate layer. One can use the Puppet Warp tool on a complete layer, but it's really designed to function at its best when editing a cut-out layered object such as a type layer, vector layer or as a separate pixel image layer. Before doing anything else though, I converted the targeted layer to a Smart Object.

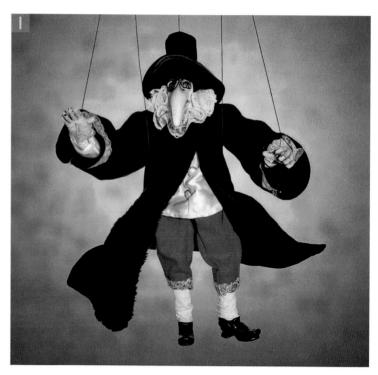

2 I made sure the puppet layer was selected. then went to the Edit menu and chose Puppet Warp. This step added a triangular mesh to the layer contents and the tool Options bar revealed the options for the Puppet tool. Here, I chose the 'Rigid' Mode and Normal Density option for the mesh. I also set the Expansion option to 15 pixels, as this would give me better control over the warp adjustments (at the default 2 pixel setting, the strings would bend all over the place). I should also point out the Expansion setting is dependent on the image pixel size, so although 15 pixels was correct for the full resolution version I edited here, you would need to use a lesser setting when editing the lower resolution test image that's on the website. I was then ready to start adding some pins. As I mentioned in the main text, the more pins you add, the more control you have over the warping effect.

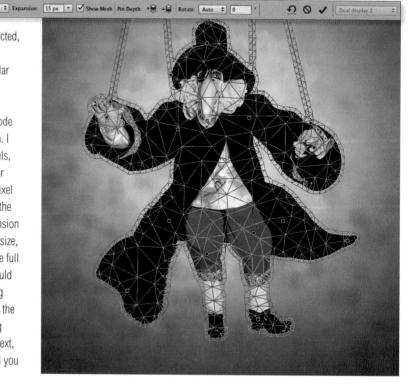

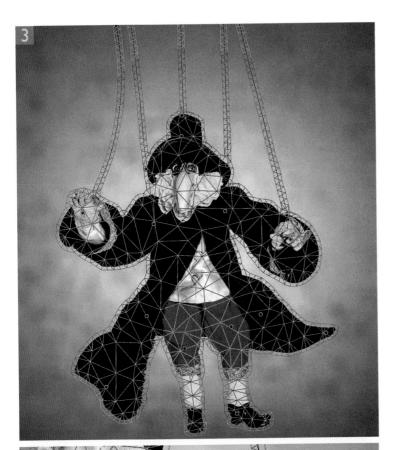

3 I was now ready to start warping the layer. All I had to do was to click to select a pin and drag to reshape the image. The interesting thing to note here is that as you move one part of the layer, other parts adjust to suit.

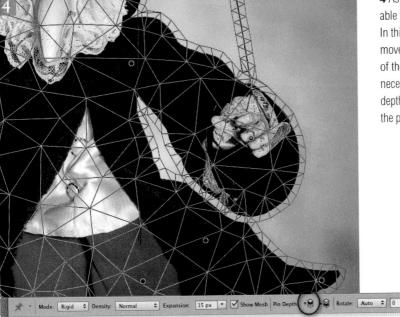

4 As I clicked and moved the pins I was able to create the desired distortion effect. In this close-up view you can see I had moved an arm so that it intersected one of the coat tails. In this instance it was necessary to click on the move upward pin depth button (circled) to bring the sleeve of the puppet's left arm in front of the coat tail.

What is particularly interesting with this image (and you'll notice this better if you work with the demo image that's on the book website) is how, as I moved different parts of the puppet's body, the puppet strings moved accordingly. In order to counter this, I clicked on the pins that were at the bottom and top of the strings and rotated them to remove the curvature and make the strings straighter.

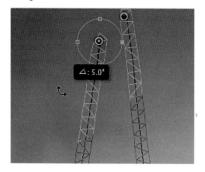

When I was done, all I had to do was to hit the *Enter* key. Now, because I had prepared this layer as a Smart Object you'll notice how the Puppet Warp adjustment was added as a Smart Filter in the Layers panel. This meant that if I wanted to re-edit the Puppet Warp settings, I could do so by double-clicking the Puppet Warp Smart Filter and carry on editing.

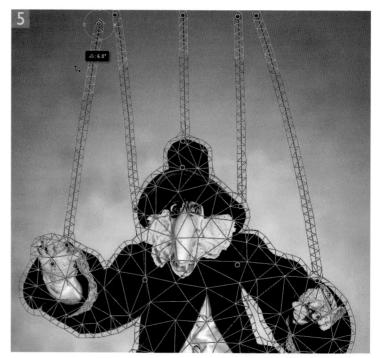

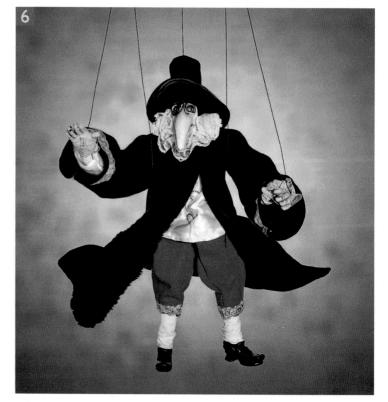

Drag and drop a document to a layer

It is possible to drag and drop a file onto an open Photoshop document to place as a new layer. This applies to all types of image documents and the main thing to bear in mind here is the image file you wish to place in this way must be of a compatible file format. In other words, you can only place files such as TIFFs, JPEGs, Adobe PDFs, Adobe Illustrator Al files, or DNGs. Whenever you place a layer in this way it will be placed as an embedded Smart Object (therefore remaining editable) and named using the original image document name (incidentally, you can also place any image as a layer by choosing the File \Rightarrow Place... command). You can if you like, choose Layer \Rightarrow Smart Objects \Rightarrow Replace Contents... and update a Smart Object choosing a different, external image to update the embedded Smart Object you have just created.

1 In Photoshop it is possible to drag a document to an image document window that's open in Photoshop and place the dragged document as a new Smart Object layer. You can drag and drop a document via Bridge or, as shown here, directly via the Finder/Explorer.

2 In this example I dragged and dropped a DNG file to add it as a layer in the targeted document. When you place a layer in this manner you will be placing it as an embedded Smart Object. First of all you will see the Camera Raw dialog (which I have not included here as a step). This allows you to edit the image file's raw settings before the final placement (you can click Cancel to dismiss the Camera Raw dialog for now). Next, you will see the Place Image bounding box shown here. This allows you to scale the image before committing to the placement, but, of course, since this is going to be a Smart Object layer, you will be able to rescale this layer at any time without degrading the image.

3 Here is a final version of the image in which you can see that I placed the layer centrally, set the layer blend mode to Multiply and reduce the Opacity to 66%. Because the newly added layer was placed as a Camera Raw Smart Object, I could double-click this layer at any time to reopen the Camera Raw dialog and re-edit the layer contents.

Smart Objects

One of the main problems you face when editing pixel images is that every time you scale an image or the contents of an image layer, pixel information is lost. And, if you make cumulative transform adjustments, the image quality can degrade quite rapidly. However, if you convert a layer or a group of layers to a Smart Object (Figure 8.65), this stores the layer (or layers) data as a separate image document within the master image. The Smart Object data is therefore 'referenced' by the parent image and edits that are applied to the Smart Object layer (such as a transform adjustment) are applied to the proxy only instead of to the pixels that actually make up the layer.

With Smart Object layers you can use any of the transform adjustments described so far plus you can also apply filters to a Smart Object layer (known as Smart Filtering). What you can't do is edit a Smart Object layer directly using, say, the clone stamp tool or paint brush, but you can double-click a Smart Object layer to open it as a separate image document. Once opened you can then apply all the usual edit adjustments before closing it, after which the edit changes are updated in the parent document.

Figure 8.65 You can promote any layer or group of layers to become a Smart Object. A Smart Object becomes a fully editable, separate document stored within the same Photoshop document. The principal advantage is you can repeatedly scale, transform or warp a Smart Object in the parent image without affecting the integrity of the pixels in the original.

Smart Filters

If you go to the Filter menu, there is an option there called 'Convert for Smart Filters'. What this does is to convert a selected layer to a Smart Object and this is no different from choosing 'Convert to Smart Object' from the Layers panel fly-out menu. With Smart Objects you can apply most Photoshop filters, but not all (including some third-party filters). However, you can enable all filters to work with Smart Objects by loading the 'EnableAllPluginsforSmartFilters.jsx' script. I explain how this is done later on page 620.

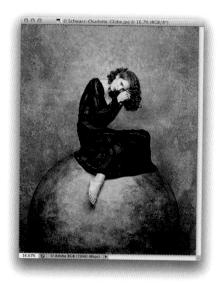

1 We'll now examine in more detail how you would use a Smart Object in Photoshop. Here is a photograph of a book that shows a couple of my promotional photographs, where let's say I wanted to place the photograph shown on the right so that it matched the scale, rotation and warp shape of the photograph on the right-hand page.

Quick tip

In these situations it is useful to remember that you can use the (Mac), (Mac), (PC) keyboard shortcut to quickly zoom out just far enough to reveal the transform bounding box handles.

2 I used the move tool to drag the photograph across to add it as a new layer and then went to the Layers panel options and chose 'Convert to Smart Object'. This action preserved all the image data on this layer in its original form. I then went to the Edit menu and chose Transform ⇒ Free Transform. Because the layer boundary exceeded the size of the Background layer, I had to zoom out in order to access the corner handles of the Transform box.

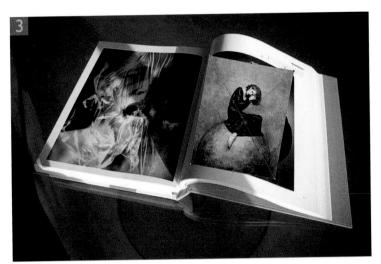

Dual display 2

3 I then scaled the Smart Object layer down in size so that it more closely matched the size of the photograph on the page. I also dragged the cursor outside the transform bounding box, in order to rotate the photograph roughly into position.

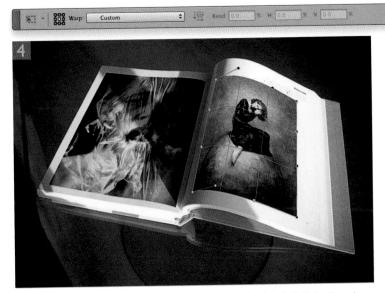

4 After that, I clicked on the Warp button in the Options bar (circled). This allowed me to fine-tune the position of the Smart Object layer, by using the corner curve adjustment handles to modify the outer envelope shape. I then moused down inside some of the inner sections and dragged them so that the inner shape also matched the curvature of the page.

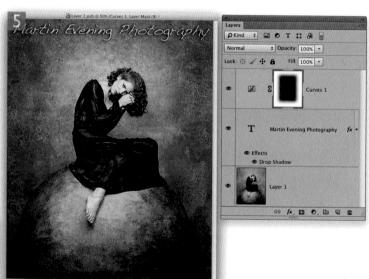

Save changes to the Adobe Photoshop document "Layer 1.psb" before closing?

Don't Save Cancel Save

5 I was then able to edit the Smart Object layer any way I liked. To do this, I went to the Layers panel fly-out menu and selected 'Edit Contents'. (An alternative option was to simply double-click on the Smart Objects layer in the Layers panel). In the example shown here, I added a text layer plus a Curves adjustment layer to darken the corners of the photo. I then closed the window, and as I did so this popped the prompt dialog shown here, reminding me to click 'Save' in order to save and update the master Smart Object layer.

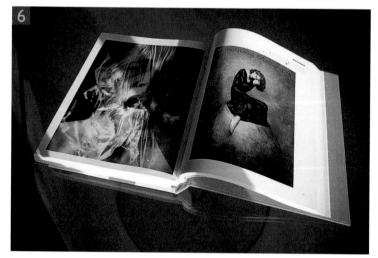

6 Here is the final image in which I added a Curves adjustment layer in a clipping group with the Smart Object layer so that the shading matched that of the original photograph on the page.

Linked Smart Objects

Smart Objects were first introduced to Photoshop with version CS2. This latest update allows you to link to an external file that can be edited independently and updated in Photoshop and will work with all the usual supported file formats, including raw files (with linked smart objects there is support for XMP sidecar files when linking to ACR files). You can now have smart objects that are either embedded (as before), or linked (this is new to this latest version of Photoshop CC). However, images that use linked Smart Objects must be saved using the PSD format. The Layers panel now displays these two kinds of Smart Objects using different icons, which are explained in Figure 8.66 below.

Creating linked Smart Objects

To create a linked Smart Object, you can all-drag an image document from the Finder/Explorer, or from Bridge to an open image document in Photoshop. This places the dragged

Figure 8.66 This shows a Layers panel view of a layered image that uses Smart Objects. Here you can see that the Background layer was converted to an embedded Smart Object so that I was able to apply a Blur Gallery filter effect as a Smart Filter. The selected layer and the layer below it are linked Smart Object layers, which means the layer contents are linked to an external file. The Layers panel view on the left shows the normal 'updated' state. The one on the right shows the Smart Object file it links to is missing.

Figure 8.67 The images used to create the image below with linked Smart Objects.

document as a layer, where you will see a placed image bounding box. Click *Enter* to confirm and create a linked Smart Object. You will then see the Smart Object layer appear in the Layers panel as a linked Smart Object (see Figure 8.66). This particular image was constructed from the selected image shown at the top of the Bridge Content view in Figure 8.67 and the linked layers were created by *alt*-dragging the two other images shown below to place these as linked Smart Objects.

If you go to the Status bar at the bottom of the application screen, or bottom of the image document window (Figure 8.68), there is a new option 'Smart Objects', which allows you to see the latest status for any smart objects in the current image. This indicates how many Smart Objects in an opened document are either missing or need to be updated. This is also available as a selectable option in the Info panel.

Once you have created a linked Smart Object, if you move or rename the parent image the relative linking within it will be retained. When you click on a Smart Object layer, the Properties panel (Figure 8.69) provides information about the current Smart Object layer status, allowing you to click on the Edit Contents button to edit the original Smart Object layer/

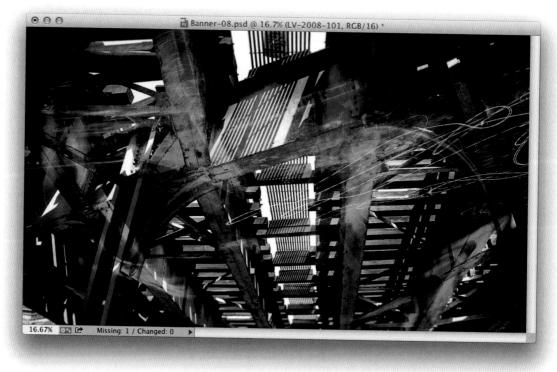

Figure 8.68 The status bar now has a Smart Objects option that shows the current status for linked Smart Objects.

image, or click on the Embed button to convert a linked Smart Object to a regular embedded Smart Object. You can change a Linked Smart Object to an Embedded Smart Object by choosing Layers

Smart Objects

Embed Linked, or Embed All Linked. If you wish to reverse this process you can now also convert an embedded smart object to a linked package file. To do this, go to the Layers menu and choose Smart Objects

Convert to Linked...

Packaging linked embedded assets

To help users share files that contain Linked Smart Objects and make them portable, there is now a Package... command available from the File menu. When you have an image open that contains Linked Smart Objects, this allows you to save a copy of the master to a packaged folder containing the master image plus a folder that contains the linked Smart Object files. The Package command currently packages image asset files only and does not yet include other assets such as fonts.

Resolving bad links

If a link is missing on opening you will see the dialog shown in Figure 8.70. This alerts you to any missing links Photoshop can't find. Maybe the linked Smart Object has been deleted? To update a bad link, click on the red question mark icon in the Properties panel and choose 'Resolve broken link...' from the menu. Alternatively, use a right mouse-click on the Smart Object layer in the Layers panel to open the contextual menu and select 'Resolve broken link...' from this menu. If you open a child Smart Object image directly, edit it and choose save,

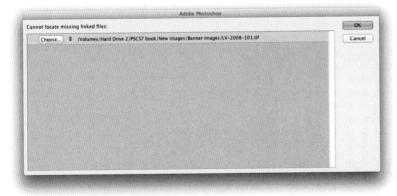

Figure 8.70 This shows the missing assets dialog that will appear when opening a parent image and the linked Smart Objects can't be found.

Multiple instances of Smart Objects

To avoid redundancy, where there are multiple instances of Linked Smart Objects pointing to the same source file the Package operation only creates one copy of the Linked Smart Object source image.

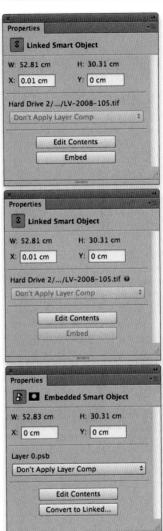

Figure 8.69 This shows Properties panel views for the status of Smart Objects. Top shows a linked Smart Object where you have the option to embed. Middle shows a linked Smart Object with a broken link and bottom shows an embedded Smart Object.

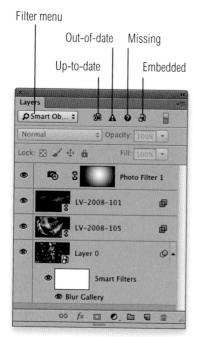

Figure 8.72 This shows the Layers panel view and new Smart Object filter options. The buttons highlighted above show the following filter options: Up-to-date linked Smart Objects, Out-of-date linked Smart Objects, Missing linked Smart Objects and Embedded Smart Objects. The Layers panel view at the bottom shows an example of a Layers panel filter search where I filtered for embedded Smart Objects only.

Figure 8.71 This shows the layers panel contextual menu for a selected layer with options for updating or replacing a linked Smart Object.

the parent image won't update until you force it to do so (which you can do for example, by going to the Properties panel). If you open a child Smart Object image by double-clicking the Smart Object layer, the parent image will update automatically.

You can also create Smart Object layers via the File menu. Choosing File ⇒ Place Linked will allow you to select an external file and link it to a file saved using the PSD file format. Choosing File ⇒ Place Embedded will embed the file in the parent image. i.e the same behavior as used currently in Photoshop.

You can use the contextual menu (shown in Figure 8.71) to resolve broken links and update them. The update process only modifies the currently selected Smart Object (or duplicate thereof), rather than all linked Smart Objects. Choosing 'Update All Modified Content' updates all Linked Smart Objects in the document. You can use 'Replace Contents...' to change the source file used as a Linked Smart Object.

Layers panel Smart Object searches

The search feature in the Layers panel can be used to find both Linked and Embedded Smart Objects. Figure 8.72 shows the Smart Object filter options for the Layers panel. Basically, a search can be carried out to find up-to-date, out-of-date or missing Smart Objects, as well as Embedded Smart Objects.

Photoshop paths

If you need to define a complex outline you will usually find it quicker to draw a path and convert this to a selection rather than rely on selection tools like the magic wand or lasso, or painting on a mask.

The Paths panel is shown in Figure 8.73. The Fill path button fills the current path using the current foreground color. The Stroke path button strokes a path using a currently selected painting tool. The Load path as a selection button can be used to convert a path to a selection. If a path is selected, clicking the Add mask button adds a vector mask based on that path. Clicking the Create new path button creates a new empty path and you can remove a path by clicking the Delete path button.

Figure 8.74 summarizes how a pen path can be converted to a selection or a vector mask to isolate an object. An active selection can be converted to a path by clicking on the 'Make work path from selection' button. Alternatively, you can choose the Make work path option from the Paths panel fly-out menu.

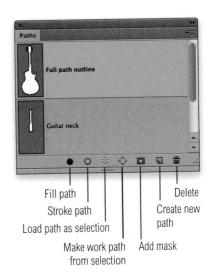

Figure 8.73 The Paths panel.

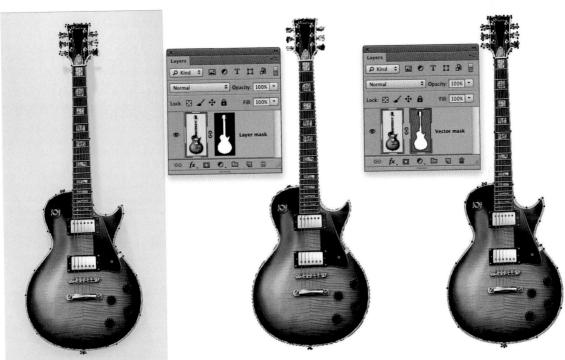

Figure 8.74 Make a path active and hit 第 Return (Mac), ctrl Return (PC) to convert a path to a selection. You can then click on the Add Layer Mask button in the Layers panel to add as a layer mask. To load a path as a vector mask, go to the Layer menu and choose Vector Mask 中 Current Path (or click twice on the Add Layer Mask button in the Layers panel).

Figure 8.75 In the past the Shape layers mode has been the default setting in the pen tool options. The Path mode is now the new default in Photoshop.

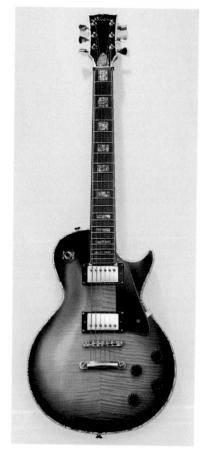

Figure 8.76 This is the path tutorial file, which can be found on the book website. In the first pen path drawing exercise all you need to do is to click with the pen tool to create a series of straight line segments that define the outline of the fretboard.

Pen path modes

The pen tool has three modes, of which there are only two you will really be interested in using. If the pen tool is in 'Shape layers' mode (Figure 8.75), when you draw with the pen tool this creates a vector mask path outline that masks a solid fill layer filled with the current foreground color. If you select the Path mode option this allows you to create a regular pen path without adding a fill layer to the document. You can of course use any path outline to generate a vector mask, so I usually suggest you keep the pen tool in the default 'Path' mode and leave it set like this. Note there are also Selection..., Mask and Shape buttons in the Options bar for converting a regular pen path.

Drawing paths with the pen tool

Unless you have worked previously with a vector-based drawing program (such as Adobe Illustrator), drawing with the pen tool will probably be an unfamiliar concept. It is difficult to get the hang of it at first, but I promise you this is a skill that's well worth mastering. It's a bit like learning to ride a bicycle: once you have acquired the basic techniques, everything else should soon fall into place. Paths can be useful in a number of ways. The main reason why you might want to use a pen path would be to define a complex shape outline, which in turn can be applied as a vector mask to mask a layer, or be converted into a selection. You can also create clipping paths for use as a cut-out outline in a page layout, or you can use a path to apply a stroke using one of the paint tools.

Pen path drawing example

To help you understand how to create pen paths let's start with the task of following the simple contours of the guitar that's illustrated in Figure 8.76 (you will find a copy of this image as a layered Photoshop file on the book website). This image contains a saved path outline of the guitar at a 200% view. The underlying image is therefore at 200% its normal size, so if you open this at a 100% view, you are effectively able to work on this demo image at a 200% magnification. The Background layer contains the Figure 8.66 image and above it there is another layer of the same image but with the pen path outlines and all the points and handles showing. I suggest you make this layer visible and fade the opacity as necessary. This will then help you to follow the handle positions when trying to match the path outlines. Let's begin by making an outline of the

guitar fretboard (as shown in Figure 8.76). Click on the corner points one after another until you reach the point where you started. As you approach this point you will notice a small circle appears next to the cursor. This indicates you can now click on it to close the path. If you have learnt how to draw with the polygon lasso tool, you will have no problem drawing this path outline. Actually, this is easier than drawing with the polygon lasso because you can zoom in if required and precisely adjust each and every point. To reposition, hold down the (Mac), (PC) key to temporarily switch the pen tool to the direct selection tool and drag a point to realign it precisely. After closing the path, hit (Mac), (tr) Enter (PC) to convert the path to a selection, or click Enter on its own to deselect the path.

Now try to follow the guitar body shape (Figure 8.77). This will allow you to concentrate on the art of drawing curved segments. Note that the beginning of any curved segment starts by you dragging the handle outward in the direction of the intended curve (to understand the reasoning behind this, imagine you are trying to define a circle by following the imagined edges of a square box containing the circle). To continue a curved segment, click and hold the mouse down while you drag to complete the shape of the end of the previous curve segment (and predict the initial curve angle of the next segment). This last sentence is written assumina that the next curve will be a smooth continuation of the last. If there happens to be a sharp change in direction for the outline you are trying to follow you will need to add a corner point. You can convert a curved anchor point to a corner point by holding down the [att] key and clicking on it. Click to place another point and this will now create a straight line segment between these two points. Now, if you hold down the 🎛 (Mac), oth (PC) key you can again temporarily access the direct selection tool and reposition the points. When you click on a point or a segment with this tool the handles are displayed and you can use the direct selection tool to adjust these and refine the curve shape.

If you want to try defining the entire guitar, including the headstock, you can practice making further curved segments and adding corner points (such as around the tuning pegs). These should be placed whenever you intend the next segment to break with the angle of the previous segment – hold down the all key and drag to define the predictor handle for the next curve segment.

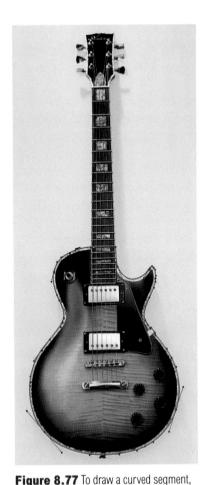

instead of clicking, mouse down and drag as you add each point. The direction and length of the handles define the shape of the curve between each path point. When you create a curved segment the next handle will continue to predict a curve, continuing from the last curved segment. To create a break in the direction of a path, you'll need to modify the curve point by converting it to a corner point. To do this, hold down the all key, click on the path point and drag to create a new predictor handle going off in a new direction.

Figure 8.78 Shown here are the main tools you need to edit any pen path. However, with the pen tool selected (left). you can access all of these tools without actually having to switch tools in the Tools panel. To add new continuing anchor points to an existing path just click with the pen tool. Instead of selecting the convert point tool (second along) you can use the all shortcut and instead of selecting the direct select tool (third along), you can use the (Mac), ctrl (PC) key. To add an anchor point to an existing path, rather than selecting the add anchor point tool (fourth along) you can simply click on a path segment. To delete an anchor point, rather than select the delete anchor point tool (fifth along), you can click on an existing anchor point using the pen tool.

Pen tool shortcuts summary

To edit a pen path, you can use the <code>#</code> (Mac), <code>ath</code> (PC) key to temporarily convert the pen tool to the direct selection tool, which you can use to click on or marquee anchor points and reposition them. You can use the <code>alt</code> key to convert a curve anchor point to a corner anchor point (and vice versa). If you want to convert a corner point to a curve, you can <code>alt</code> + mouse down and drag. To change the direction of one handle only, you can <code>alt</code> drag on a handle. To add a new anchor point to an active path, you simply click on a path segment with the pen tool, and to remove an anchor point, you click on it again (these shortcuts are outlined also in Figure 8.78).

You can edit a straight line or curved segment by selecting the direct selection tool, clicking on the segment and dragging. With a straight segment the anchor points at either end will move in unison. With a curved segment, the anchor points remain fixed and you can manipulate the shape of the curve as you drag with the direct selection tool.

Rubber Band mode

There are a number of occasions where I find it necessary to use the pen tool to define an outline and then convert the pen path to a selection. In the end, the pen tool really is the easiest way to define many outlines and create a selection from the path. One way to make the learning process somewhat easier is to switch on the Rubber Band option, which is hidden away in the Pen Options on the pen tool Options bar (Figure 8.79). In Rubber Band mode, you will see the segments you are drawing take shape as you move the mouse cursor and not just when you mouse down again to define the next path point. As I say, this mode of operation can make path drawing easier to learn, but for some people it can become rather distracting once you have got the basic hang of how to follow a complex outline using the various pen tools.

Figure 8.79 The easiest way to get accustomed to working with the pen tool is to go to the pen tool Options bar, mouse down on the cogwheel icon and check the Rubber Band box (circled).

Multi-selection path options

In the Paths panel, it is now possible to select multiple paths, more or less in the same way as you can select multiple layers via the Layers panel (see Figure 8.80). For example, you can use the *Shift* key to select a range of paths from the paths panel to make them active, or you can use the (Mac), *ctrl* (PC) key to make a discontiguous path selection. This latter change does mean that you can no longer load a selection from a path by (Mac), *ctrl* (PC) + clicking on it. To do that you will need to select the target path, or paths and click on the Load path as selection button in the Paths panel.

Multiple selected paths can be deleted, duplicated or moved. You can duplicate a path or multiple path selection by dragging it to the new path button in the Paths panel, or you can simply all drag a selected path (or paths) in the Paths panel to create duplicates.

The path selection tool and the direct selection tool are now multi-path savvy. Select the paths you wish to target via the Paths panel and subsequent to that, use the path selection and/or direct selection tools to select the targeted paths only as you drag on canvas. Let's say you have two paths selected in the Paths panel. With the new behavior you can use the path selection tool or direct selection tool to target either or both selected paths via on-canvas dragging (see Figure 8.81).

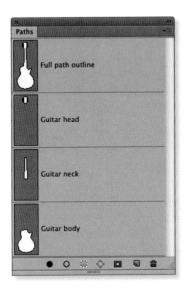

Figure 8.80 More than one path can be selected at a time in the Paths panel.

Nudging with the arrow keys

When an anchor point is selected and you need to position it accurately it can be nudged using the arrow keys on the keyboard. Use the **Shift** key to magnify the nudge movement.

Spacebar tip

In Photoshop CC there is now the ability to move a point during path creation with the pen tool by holding down the spacebar. Add a point, keep the mouse held down, press the spacebar and you can reposition that point.

Figure 8.81 This shows an example of how the multiple path selection feature can be used. In the example shown here, three paths were first selected via the Paths panel: the guitar head, neck and main body. With these paths 'activated' via the Paths panel, I selected the path selection tool (A) and dragged on the image to select one or more of the activated paths. In the left-hand example I dragged to select the Guitar Body path only and make that selected. In the middle example I dragged to select the head and neck only. In the right-hand example, I dragged to select the head first, then held down the **Shift** key to select the body as well, making both paths selected. To help make the above points clearer, I have shaded the selected paths in green.

The main thing to remember here is that clicking on a path or multiple paths in the Paths panel 'activates' them. To then 'select' a path or paths, click on a path outline in the image, or marquee-drag with the path selection or direct selection tool.

Selecting path anchor points

Refinements have been made to anchor point selection when working with the direct selection tool. As can be seen below in Figure 8.82, if you have a path selected with multiple anchor points activated, a mouse-click on an anchor point with the direct selection tool will make that single anchor selected and all the other points deselected. Previously, when you clicked with the direct selection tool the anchor point selection would be preserved. You can still retain this behavior. Let's say you make a selection of a few anchor points and wish to move them. What you do is click and hold with the mouse and drag. The anchor point selection will then be preserved. It is just when you single-click on an anchor point that it deselects all the anchor points.

Figure 8.82 If you have a path with multiple anchor points active and the direct selection tool is selected, if you click on a single anchor point this will be selected and all the other points deselected.

Hiding/showing layer/vector masks

You can temporarily hide/show a layer mask by Shift-clicking on the layer mask icon. Also, clicking a vector mask's icon in the Layers panel hides the path itself. Once hidden, hover over it with the cursor and it will temporarily become visible. Click it again to restore the visibility.

Vector masks

A vector mask is just like an image layer mask, except the mask is described using a vector path (Figure 8.83). A big advantage of using a vector mask is it can be further edited using the pen path or shape tools. To add a vector mask from an existing path, go to the Paths panel, select a path to make it active, and choose Layer \Rightarrow Add Vector Mask \Rightarrow Current Path. Alternatively, go to the Properties panel in Masks mode and click on the 'Add Vector Mask' button (see Figure 8.23 on page 522).

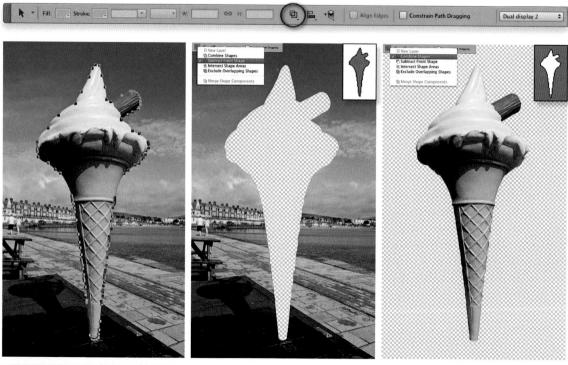

Figure 8.83 A vector mask can be created from a currently active path such as the one displayed here in the image on the left. The path mode influences what is hidden and what is revealed when the path is converted into a vector mask, and if a path has been created in the 'Subtract Front Shape' mode (as in the middle example), the area inside the path outline is hidden. If the path is created in the 'Combine Shapes' mode (as in the right-hand example) the gray fill in the path icon represents the hidden areas, where everything outside the path outline is hidden. However, it is very easy to alter the path mode. Select the path selection tool and click on the path to make all the path points active. You can then click on the path mode menu (circled in the Options bar) to switch between the different path modes.

Isolating an object from the background

Let's now look at a practical example of where you might want to use a vector path to mask an object in preference to using a pixel layer mask. Remember, one of the benefits of using a vector mask is that you can use the direct path selection tool to manipulate the path points and fine-tune the outline of a mask.

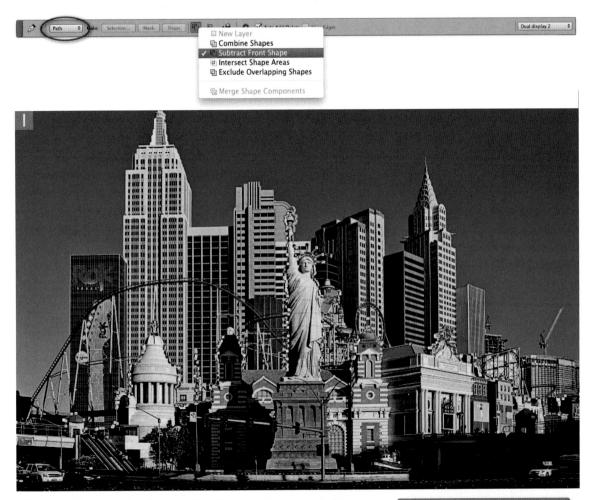

1 Here, I used the pen tool to define the outline of just everything that was in the foreground. Note that the pen tool was in the Path mode (circled in the Options bar). Also, because I wanted to create a path that selected everything outside the enclosed path, I checked the Subtract Front Shape option before I began drawing the path. When the path was complete, I went to the Paths panel, double-clicked the "Work Path' name and clicked OK to rename it as 'Path 1' in the Save Path dialog. This saved the work path as a new permanent path. It is important to remember here that a work path is only temporary and will be overwritten as soon as you deselect it and create a new work path.

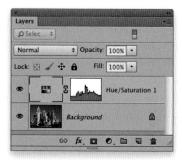

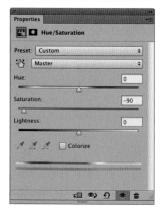

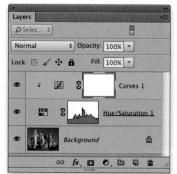

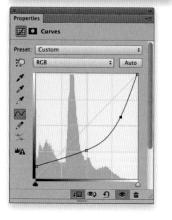

2 With the Path 1 active, I clicked on the 'Add New Adjustment Layer' button in the Layers panel and selected Hue/Saturation. I then set the Saturation to –90. As you can see, this applied a desaturating adjustment to the buildings in the background.

3 In this final step I added a Curves adjustment layer in a clipping group with the vector masked Hue/Saturation layer. With the Curves adjustment I applied a darkening effect, but which also lightened the shadows. With the Hue/Saturation adjustment layer I set the Saturation to –100 to remove all the color from the background.

Chapter 9

Blur, optical and lighting effects filters

One of the key factors behind Photoshop's success has been the program's support for plug-in filters. A huge industry of third-party companies has grown in response to the needs of users wanting extra features within Photoshop. Instead of covering all the hundred or more filters that are supplied in Photoshop, I have just concentrated here on those filters that I believe are useful for photographic work. In particular, I have concentrated on those filters that relate to blurring, optical and perspective corrections, and creating lighting effects. I also show you ways you can use the Smart Filters feature to extend your filtering options.

Figure 9.1 The Average Blur can be used to merge the pixels within a selection to create a solid color which can then be used to take an accurate sample color measurement of the average color within that selection area.

Figure 9.2 The Noise

Add Noise filter can be used to add artificial noise to an image. It is particularly useful whenever you wish to disguise banding that may have been caused through excessive use of the Gaussian Blur filter.

Filter essentials

Most Photoshop filters provide a preview dialog with slider settings that you can adjust, while some of the more sophisticated plug-ins (such as the Lens Correction filter) are like mini applications operating within Photoshop. These have a modal dialog interface, which means that whenever the filter dialog is open, Photoshop is pushed into the background and this can usefully free up already-assigned keyboard shortcuts. With so many effects filters to choose from in Photoshop, there are plenty enough to experiment with. The danger is that you can all too easily get lost endlessly searching through all the different filter settings. Here, we shall look at a few of the ways filters can enhance an image, highlighting those that are most useful. Photoshop supports a limited number of filters in 16-bit. However, most of the essential filters, such as those used to carry out standard production image processing routines are all able to run in 16-bit mode.

Blur filters

There are now 16 different kinds of blur filters you can apply in Photoshop and each allows you to blur an image differently. You don't really need to bother with the basic Blur and Blur More filters, but what follows are some brief descriptions of the blur filters I do think you will find useful.

Average Blur

The Average Blur simply averages the colors in an image or a selection. At first glance it doesn't do a lot, but it is still a useful filter to have at your disposal. Let's say you want to analyze the color of some fabric to create a color swatch for a catalog. The Average filter merges all the pixels in a selection to create a solid color and you can then use this to sample with the eyedropper tool to create a new Swatch sample color (see Figure 9.1).

Gaussian Blur

The Gaussian Blur is a good general purpose blur filter and can be used for many purposes from blurring areas of an image to softening the edges of a mask. The Gaussian Blur can sometimes cause banding to appear in an image, which is where it may be useful to use the Noise ⇒ Add Noise filter afterwards (Figure 9.2).

Adding a Radial Blur to a photo

The Radial Blur can do a good job of creating blurred zoom effects. For example, the Zoom blur mode, shown in Figure 9.3, can be used to simulate a zooming camera lens. For legacy reasons the Radial Blur filter offers a choice of render settings. This is because the filter was devised before the age of GPU processing. For top quality results, select the Best mode, but if you just want to see a quick preview of the whole image area you can always select the Draft mode option. Now that Photoshop features a new Blur Gallery Spin Blur filter effect, the Spin mode is less relevant.

New 32-bit filters

There are now 24 more filters that work in 32-bit mode. Blur: Blur, Blur More; Distort: Displace, Pinch, Polar Coordinates, Ripple, Shear, Spherize, Twirl, Wave, Zig-Zag; Pixelate: Color Halftone, Crystalize, Facet, Fragment, Mezzotint, Mosaic, Pointilize; Render: Fibers, Lens Flare; Sharpen: Sharpen, Sharpen More; Stylize: Diffuse, Trace Contour; Other: Custom. Note when using the Diffuse filter in 32-bit mode, the Anisotropic option is grayed out.

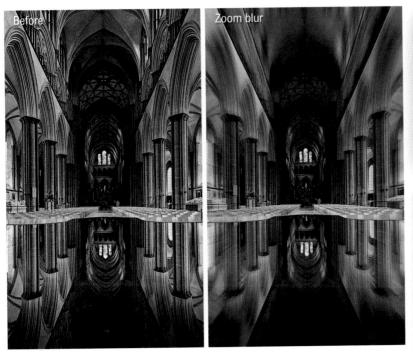

Figure 9.3 When using the Radial Blur filter in Zoom mode, you can create fast zoom lens effects such as in the example shown here on the right. You can also drag the center point in the filter preview dialog to approximately match the center of interest in the image you are about to filter. Note that I added a radial gradient to the Smart Filters mask to hide the blur effect in the center.

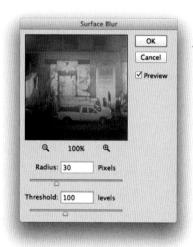

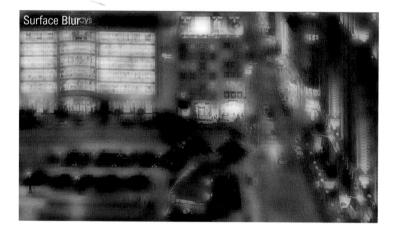

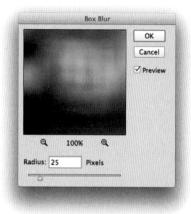

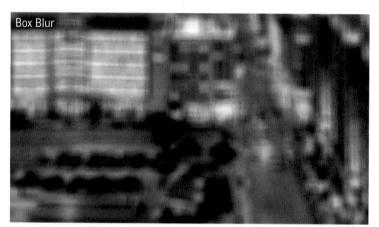

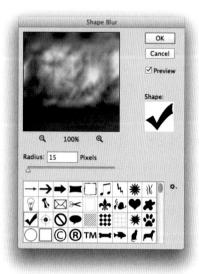

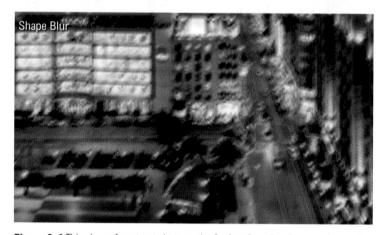

Figure 9.4 This shows from top to bottom, the Surface Blur, Box Blur and Shape Blur filters applied to the same image.

Surface Blur

This might be considered to be an edge preserving blur filter. The Radius adjustment is identical to that used in the Gaussian Blur filter, so the higher the Radius, the more it blurs the image. Meanwhile, the Threshold slider determines the weighting given to the neighboring pixels and whether these become blurred or not. Basically, as you increase the Threshold this extends the range of pixels (relative to each other) that become blurred. So as you increase the Threshold, the flatter areas of tone are the first to become blurred and the high contrast edges remain less blurred (until you increase the Threshold more).

Box Blur

The Box Blur uses a simple algorithm to produce a square shape blur. It is a fairly fast filter and is useful for creating quick 'lens blur' type effects and certain other types of special effects. The Box Blur is no match for the power of the Lens Blur filter, but it is nonetheless a versatile and creative tool.

Shape Blur

The Shape Blur filter lets you specify any shape you like as a kernel with which to create a blur effect and you can then adjust the blur radius accordingly. In Figure 9.4 (bottom image) I selected a tick pattern shape.

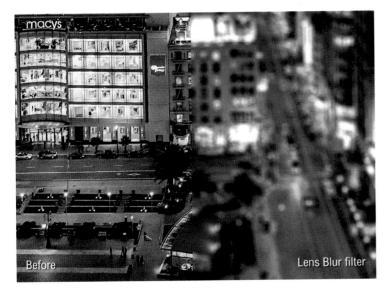

Fade command

Filter effects can be further refined by fading them after you have applied the filter. The Fade command is referred to at various places in the book (you can also fade image adjustments and brush strokes, etc.). Choose Edit ⇒ Fade Filter and experiment with different blending modes. The Fade command is almost like an adjustment layer feature, but without the versatility and ability to undo later. It makes use of the fact that the previous undo version of the image is stored in the undo buffer and allows you to apply different blend modes, but without the timeconsuming expense of having to duplicate the layer first. Having said all that, the History feature offers an alternative approach whereby if you filter an image once or more than once, you can return to the original state and paint in the future (filtered) state using the history brush or make a fill using the filtered history state (provided Non-linear History has been enabled in the History panel options).

Figure 9.5 In this night-time scene there are lots of small points of light; you can use this image example to get a clear idea of how the Lens Blur filter Specular Highlights and Iris controls work, and observe how they affect the appearance of the blur in the photograph. Note that this image is also available from the book website for you to experiment with.

Enabling Lens Blur as a Smart Filter

Smart Filters are mainly intended for use with value-based filters only, such as the Add Noise or Unsharp Mask filter. They are not intended for use with filters such as Lens Blur because the Lens Blur filter can sometimes make calls to an external alpha channel, and if the selected alpha channel were to be deleted at some point, this would prevent the Smart Filter from working. However, so long as you are aware of this limitation, it is still possible to enable Smart Filters to work with filters. like Lens Blur. You first need to go to the Adobe website and search for the following script: EnableAllPluginsforSmartFilters.isx. This then needs to be placed in a suitable folder location such as Adobe Photoshop CC/Presets/Scripts folder. Then, go to the File ⇒ Scripts menu in Photoshop and choose Browse... This opens a system navigation window. From there you'll want to locate the above script. Once you have done this, you can click Load or doubleclick to run it, which will pop the Script Alert dialog shown in Figure 9.6. If you wish to proceed, click 'Yes'. The Lens Blur, as well as all other filters will now be accessible for use as Smart Filters. If you want to turn off this behavior, run through the same above steps and click 'No' when the Script Alert dialog shows.

Figure 9.6 The Script Alert dialog.

Lens Blur

If you want to make a photograph appear realistically out of focus, it is not just a matter of making the detail in the image more blurred. Consider for a moment how a camera lens focuses a viewed object to form an image that is made up of circular points on the film/sensor surface. When the radius of these points is very small, the image is considered sharp and when the radius is large, the image appears to be out of focus. It is also particularly noticeable the way bright highlights tend to blow out and how you can see the shape of the camera lens iris in the blurred highlight points. The Lens Blur filter has the potential to mimic the way a camera lens forms an optical image and the best way to understand how it works is to look at the shape of the bright lights in the night-time scene in Figure 9.5 which shows the image before and after I had applied the Lens Blur filter.

The main controls to concentrate on are the Radius slider, which controls the amount of blur that is applied to the image, and the Specular Highlights slider, which controls how much the highlights blow out. To add more lens flare, increase the Brightness slightly and carefully lower the Threshold amount by one or two levels and check to see how this looks in the preview area. The Iris shape controls (Blade Curvature and Rotation) should be regarded as fine-tuning sliders that govern the shape of the out-of-focus points in the picture. You can select from a menu list of different iris shapes and then use these sliders to tweak the iris shape. The results of these adjustments will be most noticeable in the blown-out highlight areas, and if you want to predict more precisely what the Lens Blur effect will look like it is better to have the 'More Accurate' button checked.

Depth of field effects

With the Lens Blur filter you can also use a mask channel to define the areas where you wish to selectively apply the Lens Blur. This allows you to create shallow depth of field effects, such as in the example shown on the right. Basically, you can use a simple gradient (or a more complex mask) to define the areas that you wish to remain sharp and those that you want to have appear out of focus. You can then load the channel mask as a Depth Map in the Lens Blur dialog and use the 'Blur Focal Distance' slider to determine which areas remain sharpest.

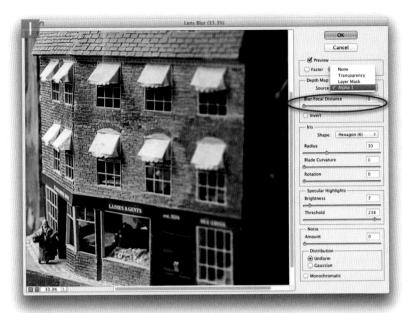

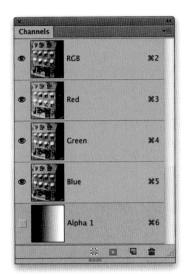

1 In this example, I created a linear gradient mask channel called Alpha 1, where the gradient went from white to black. I then loaded the Alpha 1 channel in the Lens Blur filter dialog to use as a depth map. With the Alpha 1 channel selected, I could now adjust the Blur Focal Distance slider (circled) to determine where I wanted the image to remain sharp.

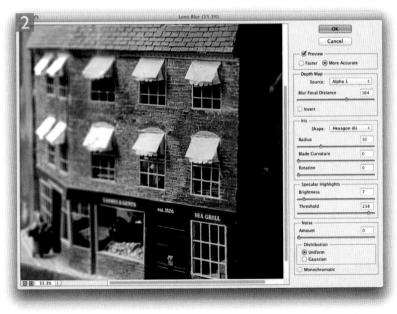

2 Another way to use a depth map is to click in the preview area to set the point where the image should be sharpest. Basically, the degree of Lens Blur is linked to the gray values in the Depth Map source channel.

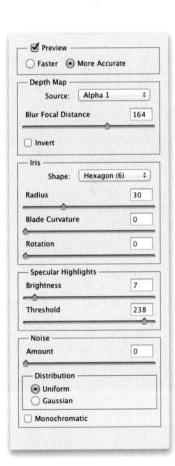

Blur Tools limitations

The Blur Tools offer quite a lot of options for being creative, but there are some restrictions you need to be aware of. You can only apply this filter to RGB or CMYK images and it won't work on grayscale images, alpha channels or layer masks.

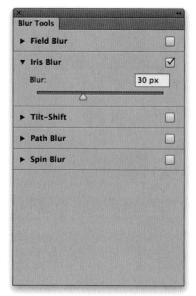

Figure 9.7 The Blur Tools controls. This and the panel below only appear when one of the new Blur Tools filters is selected

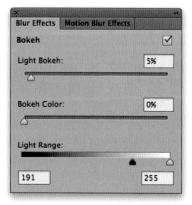

Figure 9.8 The Blur Effects controls.

Blur Gallery filters

The Lens Blur filter has enough slider controls to let you create a fairly realistic-looking Lens Blur effect, but it does suffer from certain limitations. Firstly, it can be guite slow to work with and therefore a painstaking experience to tweak the sliders in search of an optimum blur setting. The sheer number of sliders can be considered quite intimidating, which may put some people off using this filter. While it is possible to create blur maps that can be used in conjunction with the Lens Blur filter, it is this aspect of its design that limits it from being accessible as a Smart Filter (though as I point out on page 620 it is possible to override this). The Blur Gallery filters offer a more simplified interface for applying Lens Blur effects. Overall these are a lot quicker to work with than the Lens Blur filter and have fewer controls to worry about and the blur effects can easily be edited. These are all available from the Filter ⇒ Blur Gallery menu and you'll note that when one Blur Gallery filter is active, the other four Blur Gallery filter modes will be available too from the Blur Tools panel.

Iris Blur

Let me start first with the Iris Blur filter (Figure 9.7). The Blur slider controls the strength of the blur effect and allows you to apply much stronger blurs than you can with Lens Blur. In the Blur Effects panel below (Figure 9.8) are the Blur Effects controls. The term 'bokeh' refers to the appearance of out-offocus areas in a picture when photographing a subject using a shallow focus (see Figure 9.9). What happens when you do this is that out-of-focus objects in a scene are focused as large, overlapping circles at the plane of focus. Objects that are in focus are also focused as overlapping circles, but an image is perceived to be sharp when those circles are small enough that they create the illusion of sharpness. The circles of confusion aren't actually circles. They are determined by the shape of the lens iris, which is usually pentagonal or hexagonal in shape. So, to create a bokeh-type effect in Photoshop. the Iris Blur filter applies a hexagonal iris shape blur to the image. The Light Bokeh slider lets you control the intensity of the bokeh effect by working in conjunction with the Light Range sliders to 'blow out' selected tonal areas and create bright, out-of-focus highlights. With the Lens Blur filter you have a Brightness and a single Threshold slider that control the appearance of the specular highlights. The Light Range control in the Blur Effects panel is a little more sophisticated.

There are two sliders: one for the highlights and one for the shadows. What happens here is the filter uses an inverse high dynamic range tone mapping to create a pseudo high dynamic range between the two slider points. By adjusting the shadow and highlight sliders, Photoshop can intensify the tonal range between these two points. This simulates a real-life subject brightness range and then applies the blur effect to the data. This is an important difference and is what helps make the Blur Gallery effects look more realistic compared with other blur methods. Basically, this gives you the flexibility to apply the bokeh effect to any tone area in the image you like and not just the highlights. For example, you can have a bokeh effect applied to the midtones or the shadows. The Bokeh Color slider allows you to specifically intensify the color saturation of the bokeh effect. The default setting of zero will be best in most cases, but some shots may benefit from increasing the Bokeh Color slider

Radius field controls

When using the Iris Blur filter you will see the radius field control shown below in Figure 9.10. This always appears centered in the image. You can click on any of the four outer ellipse handles to adjust the shape and angle of the radius field. There is also a radius roundness knob that you can drag to make the radius field rounder or squarer. If you click on the

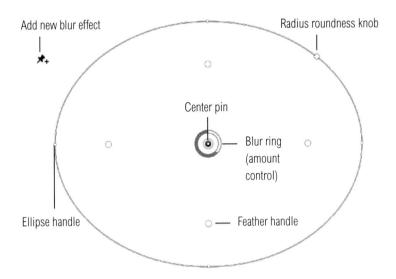

Figure 9.10 The Iris Blur ellipse field controls. Note you can hold down (H) to hide the on-image display.

Figure 9.9 This shows what a typical lens bokeh effect looks like.

OpenCL benefits

Blur Gallery filters make use of what is known as 'Mercury Graphics' processing in Photoshop. If Open CL is enabled in the advanced graphics processor settings this can help speed up the time it takes to render the Blur Gallery previews in mouseup mode as well as when processing the final render. Depending on the card this can make a big difference to final render times. Note that Open CL is only available using compatible graphics cards and operating systems. In Photoshop CC you should also notice a more accurate preview while making blur adjustments or when moving a pin. However, this preview enhancement will only be noticed if using a graphics card that supports 1GB of VRAM or higher. For example, Intel HD 4000 and AMD Trinity APU cards will support improved mouse-down previews.

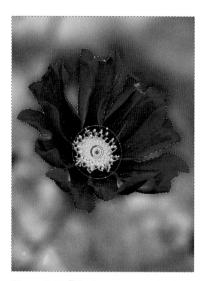

Figure 9.11 This shows an example of where the Selection Bleed amount was increased to allow the unselected area (the flower) to bleed into the selection area.

center pin you can drag to reposition the entire field radius. In between the center and the outer radius are the feather handles. You can drag on any of these to adjust the overall hardness/softness of the blur effect edge relative to the center or outer ellipse edge and if you hold down the all key you can click and drag any of these four pins independently. Just outside the pin in the center is a blur ring. This indicates the blur amount applied to the effect. Click on the ring and drag clockwise to strengthen the blur effect and drag anticlockwise to reduce the blur amount. As you move the mouse around the image you'll see an 'add new pin' icon. If you click, this adds a new blur effect providing radius ellipse controls to edit the settings for a new blur effect.

Blur Tools options

The Blur Gallery Options bar (Figure 9.12) provides additional controls. The Selection Bleed slider controls the extent to which areas outside the selection can bleed into the area that's selected (there must be an active selection for this to be enabled). In Figure 9.11 I selected everything but the flower and as I blurred the selected area, I set the Selection Bleed in the Options bar to 50%. This deliberately allowed the areas outside the selection to blend into the blurred area. To help make the edges look more convincing, only a small amount of bleed should be applied, but you can also use this as a way to produce creative edge bleed effects by applying a heavy blur with a high Selection Bleed value. The Focus slider lets you to control how much the focus in the center is preserved. At 100%, everything is kept sharp. As you reduce the amount the center becomes more out of focus. But when multiple Pins are placed this does allow you to preserve the non-blurred area for each specific pin (this is a per-pin setting). The 'Save Mask To Channels' checkbox lets you save an alpha channel that contains a blur mask based on the feathered area. This could be useful if you felt you needed to add noise later to a blur effect based on the same degree of feathering. Lastly, checking the High Quality checkbox will result in more accurate bokeh highlights.

Figure 9.12 The Blur Gallery Options bar. You can use the drop-down menu on the right to reset the Blur Gallery panel positions and settings.

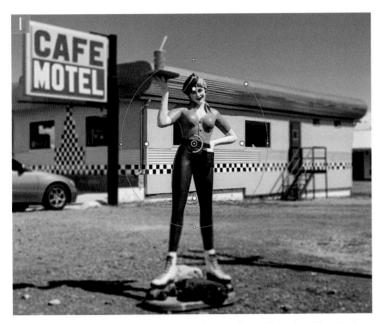

When applying the Blur Gallery filter in Iris Blur mode, you'll see the ellipse field controls shown, where you can edit the controls and adjust the Blur Tools settings.

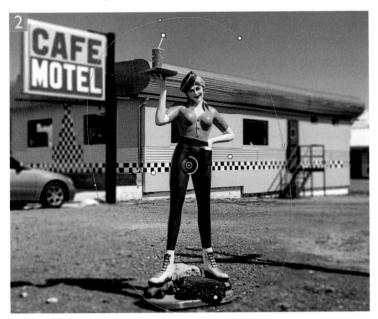

I dragged the outer ellipse handles to rotate and increase the size of the radius field, and dragged the Radius roundness knob to make the radius slightly squarer. I then held down the **all** key to drag the inner feather handles to independently adjust the hardness/softness of the blur edge for all four corners. Lastly, I adjusted the Blur Effects panel sliders as shown here to create the bokeh effect seen in this screen shot.

► Field Blur	
▼ Iris Blur	
Blur:	25 px
► Tilt-Shift	
► Path Blur	
► Spin Blur	
Blur Effects Motion B	lur Effects
Blur Effects Motion B Bokeh	
BAUTSALOARISHES	AND DESCRIPTION OF THE PROPERTY OF THE PROPERT
Bokeh Light Bokeh:	
Bokeh Light Bokeh: Bokeh Color:	0%

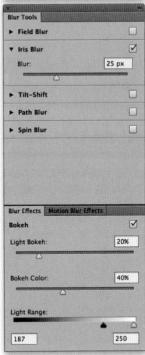

Figure 9.13 This shows an example of how tilt-shift distortion should be expected to work when a lens is tilted. In one direction the circles of confusion become more elliptical, stretching outwards from the center and becoming more elongated towards the corners. This can be simulated using positive Distortion with the Tilt-Shift blur filter. On the opposite axis the distortion does not have the same effect. Here, the distortion is circumferential. This can be simulated using negative Distortion with a Tilt-Shift blur filter effect.

Multiple blur effects

Note that with both the Tilt-Shift and Iris blur effects the pins within each effect will interact with each other using what is essentially a Multiply blend mode. When multiple effects are combined the resulting blur radius fields from each effect are added together. Also at the same time, the areas of clarity are added together so that where there is an overlap the clarity is always preserved. This means you can easily combine different kinds of Blur Gallery effects to produce a 'merged' blur effect.

Tilt-Shift blur

The Tilt-Shift blur filter allows you to mimic both the blur and distortion effect you would get when shooting with a view camera that allows you to tilt the film plane and also the kind of effect you can get when shooting with a Lens Baby™ lens. You can also combine multiple Tilt-Shift blur effects with one or more other Blur Tools effects to achieve any kind of blur effect you want.

When you apply a Tilt-Shift blur you'll first see a pin in the center with two solid focus lines either side of the pin (Figure 9.14). These indicate the no-blur zone in which the image will remain in focus. Beyond this are the dotted feather lines. Between the focus and feather lines lies the transition zone where the image will fade from being in focus to out of focus, as set by the Blur slider in the Blur Tools panel. You can adjust the width of these lines by dragging anywhere on these lines. To adjust the Tilt-Shift blur angle, click and hold anywhere outside the central no blur zone and drag with the mouse (you'll see a double-headed arrow cursor). To relocate a blur effect, click and drag inside the no blur zone. To remove a blur effect, just hit the Delete key. New effects can be added by clicking anywhere in the image.

The Distortion slider can apply a distortion effect that radiates outwards from the center pin. So, if you apply a distortion and move the center pin from side to side you'll notice how the radial distortion effect adjusts as you do this, centering around wherever the center pin is placed (see Figure 9.13 for more details).

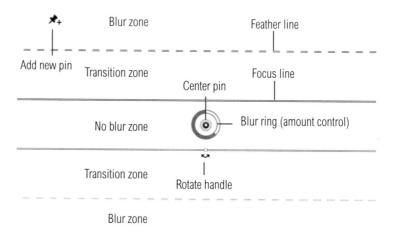

Figure 9.14 The Tilt-Shift blur controls. Note you can use H to hide these.

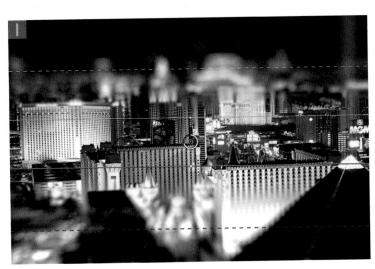

1 In this example I had placed a Tilt-Shift pin in the middle of the image. I increased the blur effect to 80 pixels and applied a maximum +100% Distortion. Both sides of the pin appear blurred, but by default the Distortion setting affected the bottom section only. As you can see, the positive distortion created radially facing ellipses towards the bottom of the picture. Also, if I were to reposition the central pin, the ellipses would reface to the new pin position.

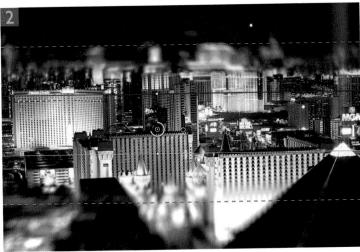

2 To distort the top half of the picture, I added a new pin next to the first. Here, I clicked and held the cursor just below the no blur/transition zone line and dragged to rotate the Blur effect 180°. By default the same blur settings were applied to this second pin. All I did here was set the Distortion to -100% to create a circumferentially oriented distortion in the top half of the picture and adjusted the settings slightly. Alternatively, you can check the 'Symmetric Distortion' box to apply a mirrored distortion without needing to add a second pin. But note that a symmetric distortion always shares the same Distortion slider setting.

Blur Tools	
Field Blur	
► Iris Blur	0
▼ Tilt-Shift	☑
Blur:	80 px
Distortion:	100%
Symmetric Disto	rtion
► Path Blur	
► Spin Blur	
Blur Effects Motion 81	ur Fffects
Bokeh	✓
Light Bokeh:	30%
<u> </u>	***************************************
Bokeh Color:	0%
4	
Light Range:	
	MANAGEMENT OF THE PARTY OF THE

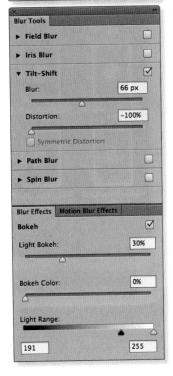

Figure 9.15 A blur amount display appears as you interactively click and drag on the outer blur ring.

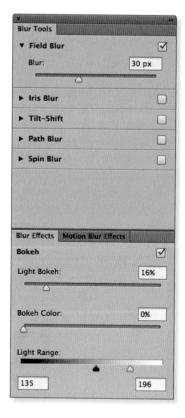

Blur ring adjustments

The Blur ring has a central pin and, when activated, an outer ring, which indicates the blur amount applied to that pin. As you adjust the Blur slider you'll notice that the outer ring provides a visual indication of the blur amount that's been applied. It is also possible to click and drag on this ring to adjust the blur amount (see Figure 9.15).

Field Blur

The Field Blur effect can be used to apply a global blur effect. As with the Iris and Tilt-Shift blurs, you have a Blur slider in the Blur Tools panel and the usual set of Bokeh sliders in the Blur Effects panel below. You can use this filter to apply an overall lens blur type of effect, but as you can see in the accompanying example, by adding further pins it is quite easy to create different kinds of custom gradient blur effects.

1 Here, you can see the Field Blur filter effect in action. When you first apply this filter you'll have a pin in the middle of the frame set to a default 15 pixel wide blur. What I did here was to increase this to 30 pixels to apply an all-over blur effect to the image.

In this next step I moved the first pin to the top left of the picture and added a second pin in the center and set the blur amount to zero pixels. This created an area of clarity that counteracted the effect of the first pin. Essentially, when you have two pins placed like this, you can create a simple blur gradient.

You can keep on adding extra Field Blur pins to create more complex blur gradients. In this step I added an extra no blur pin and two extra 30 pixel blur effect pins and dragged the pins to achieve the combined blur effect shown here.

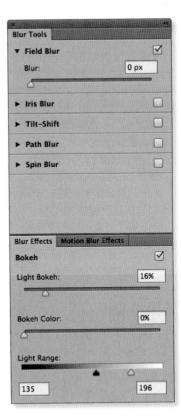

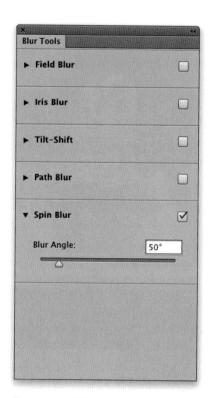

Figure 9.16 The Spin Blur controls in the Blur Tools panel.

Spin blur

When the Spin Blur effect is selected you can apply a spin blur in varying intensity. This filter effect you can produce is similar to the Radial Blur filter in Spin mode, except when applied here as a Blur Gallery filter you have a lot more interactive control over the final effect. For example, you can apply an elliptical shaped blur, recenter the blur effect and adjust the Blur angle (see Figure 9.16) while being able to see a live preview.

You can adjust the Spin blur by dragging the Blur Angle slider to increase or decrease the strength of the effect (or click and drag clockwise or anti-clockwise on the blur ring). You can then drag the handles to change the Spin blur size and shape, plus drag the feather handles to adjust the feathering. You can reposition by click dragging anywhere inside the ellipse area and further spin blurs can be added by clicking anywhere else in the image area and you can also have them overlap.

The rotation center point can be adjusted by all dragging the blur ring. This allows you to create spin blurs on objects that are viewed from an angle. To copy a Spin Blur, click inside a Blur ring, hold down the key (Mac) ctrl key (PC) and then the all key and with both keys held down drag to copy to a new location within the image. To hide the blur ring go to the View menu and deselect 'Extras', or use the H (Mac) ctrl H (PC) shortcut.

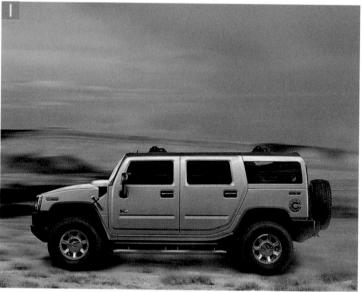

1 I created this image by taking a photograph of a 4x4 vehicle that was shot in a town, cut it out and placed as a layer above a photograph shot in a deserted landscape.

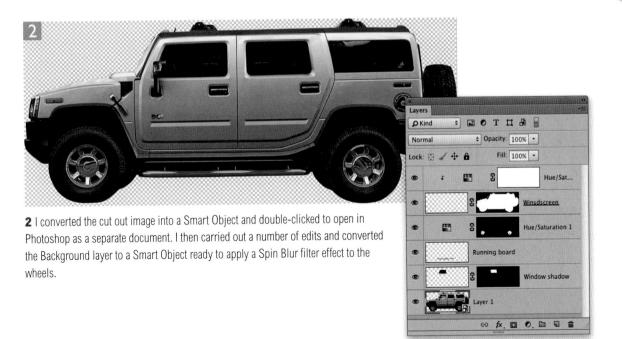

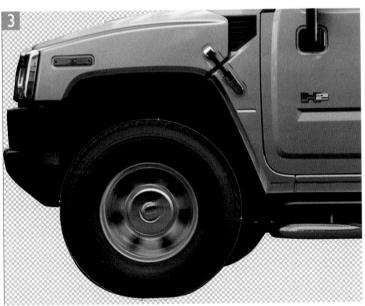

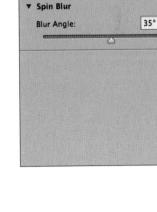

► Field Blur

► Tilt-Shift

► Path Blur

3 I then went to the Filter menu and chose Blur Gallery \Rightarrow Spin Blur... I dragged the Spin Blur ellipse over to the front wheel and manipulated the shape so that the Spin Blur ellipse matched the shape of the tire. I then applied a 35° Blur Angle via the Blur Tools panel Spin Blur section.

V

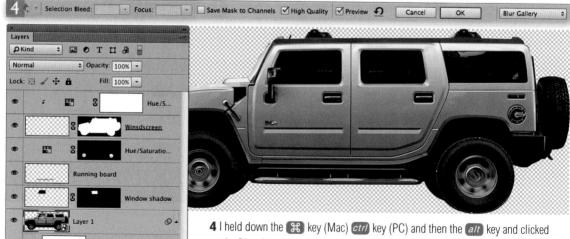

4 I held down the #\$ key (Mac) ctrl key (PC) and then the att key and clicked on the Blur ring center and dragged to create a duplicate of the first Spin Blur effect. I dragged to locate this second Spin Blur effect over the rear wheel. Once done, I checked the High Quality option in the Options bar and clicked the OK button. This applied the Spin Blur effect as an editable Smart Filter to the 4x4 layer.

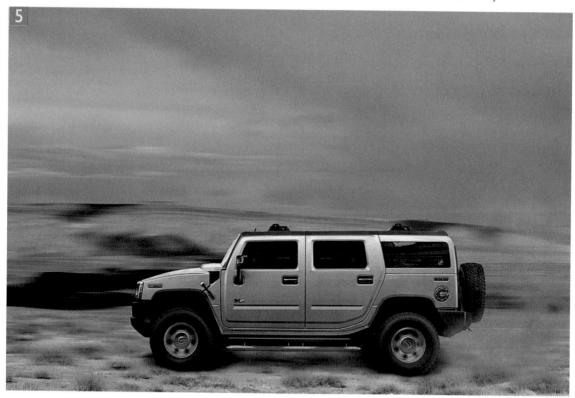

5 Lastly, I chose File Save to save the edited Smart Object layer and closed the Smart Object document window. The original image with the 4x4 plus landscape was now updated to show the vehicle with wheels that appeared to be in motion.

Smart Filters

fx. 🗖

Blur Gallery

Path blur

The Path Blur tool can be used to create a motion blur effect along a user-drawn path. Basically, by adjusting the path shape you can manipulate the shape and direction of the motion blur to create an effect similar to camera shake, such as when photographing a moving subject and the camera shutter is left open for a long exposure time. You can manipulate the curve shape to control the length and curvature of the Path Blur, click on the path to add more control points and click on existing curve points and drag to further modify the shape. [all] -click on a Path Blur control point to convert it to a corner point, or convert a corner point back to a smooth point.

The path blur shape will have red blur direction arrows at either end point. You can click on a path blur shape end point, or a blur direction arrow and click and drag to determine the blur direction (the End Point Speed) and adjust the angle. The blur directional arrows also have a midpoint control you can click on and drag to further alter the shape of the blur direction. To disable an end point blur direction arrow, hold down the key (Mac) we (PC) and hover over a path blur end point, you'll see a filled circle appear next to the cursor. Click on the end point to disable. Hold down the key [Mac] we [PC] and click again to enable. If you hold down the shift key you can click and drag a blur direction arrow at one end and simultaneously move the arrow at the other end as well.

It helps to understand here that the defined blur shapes at the two ends of a path are interpolated between the two end points. Also, as you add more path blur shapes to an image these will influence each other and it is this aspect of the Path Blur filter that provides lots of opportunities to produce creative blurring effects. To add a new path blur keep clicking to add more control points and press **Enter** or **esc** to end the path blur shape, or just click on the last control point. To reposition a path blur, hold down the **E** key (Mac) **etr** key (PC) and click on the blue path or a control point and drag to relocate. To remove a control point, select a path blur control point and hit the **Delete** key. To duplicate a Path blur, hold down **E** all** (Mac) **etr** all** (PC) as you drag a blue path or one of the control points.

The overall blur strength can be controlled by adjusting the Speed slider in the Path Blur section of the Blur Tools panel (Figure 9.17). There are two starting point modes here: Basic Blur and Rear Sync Flash (examples of which are shown over the page). The Taper slider can be used to dampen the path

Figure 9.17 The Path Blur controls in the Blur Tools panel.

Extent of slider controls

The Speed and Taper sliders affect all path blur shapes equally. The End Point Speed slider is set for each blur direction arrow independently. blur effect and adjust the edge fading from either end. The Centered Blur checkbox governs the way the blur shapes are calculated. This box is checked by default to ensure the blur shape for any pixel is centered on that pixel. This produces a more controlled behavior when editing path blur shapes. When it's unchecked it will sample from one side of any pixel only and the path blur will flow around a lot more as you edit the path blur shapes. As I just mentioned, the End Point Speed slider is linked to the length of the blur direction arrows, and the Edit Blur Shapes box allows you to view/hide the blur direction arrows. In the Options bar is a High Quality checkbox (Figure 9.18). Check this to produce high quality rendering to prevent any jaggedness appearing in a path blur effect.

Figure 9.18 The Blur Tools Options bar.

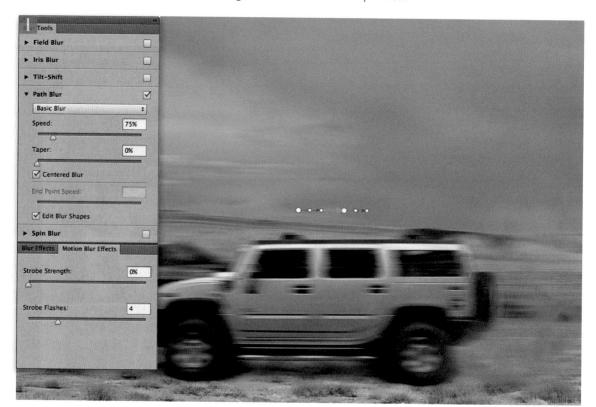

1 To show how the Path Blur can be used I continued editing a copy of the car layer Smart Object. In this step I applied a simple, linear Path Blur filter using a Speed setting of 75% and the Basic Blur mode.

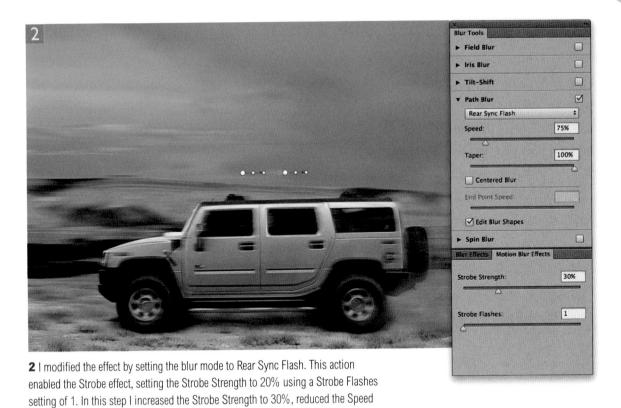

Motion Blur Effects panel

slider setting to 75% and increased the Taper amount to 100%.

The Motion Blur Effects panel (Figure 9.19) gives you the ability to create a multiple strobe/flash effect. You can adjust this to determine how much blur will show between flash exposures. In Basic Blur mode the Strobe Strength Slider is set to 0%, where there will be no strobe effect. As you increase the slider you create a more noticeable strobe effect with very little blur between exposures. This slider allows you to control the balance of the strobe light effect. Below that is the Strobe Flashes slider, which can be used to set the number of strobe flash exposures (from 1 up to 100).

Figure 9.19 The Motion Blur Effects panel.

1 In this example, I began by making a cutout of the dancer featured in this photograph to isolate him on a separate layer and converted this layer to a Smart Object.

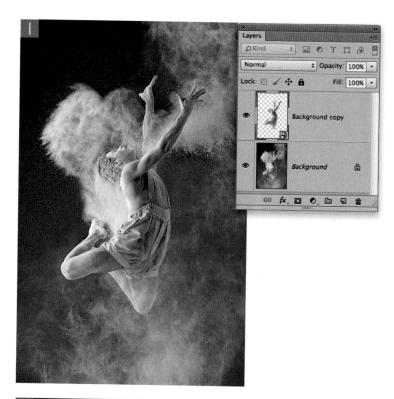

2 I then went to the Filter menu and chose Blur Gallery ⇒ Path Blur...This step shows the Path Blur filter applied using the default settings, with the Basic Blur mode selected and the Speed set to 50%.

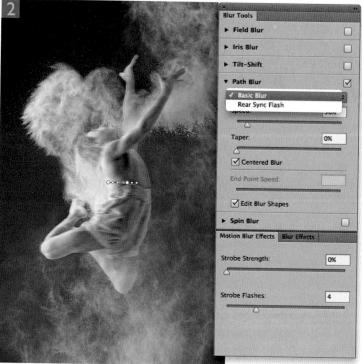

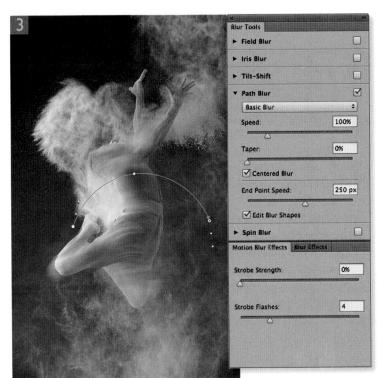

3 In this step I manipulated the path blur handles to create the arc shape seen here. I also edited the path blur end points and clicked and dragged the red handles to define the beginning and end blur directions. You will notice as you do this how the length of each of these red handles is also linked to the End Point Speed slider. I also increased the Speed amount, applying a 100% setting.

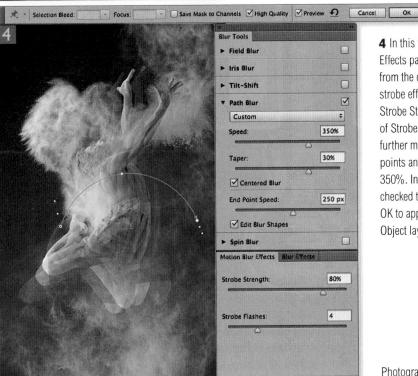

4 In this final step I went to the Motion Blur Effects panel and raised the Strobe Strength from the default zero setting to apply a strobe effect. In this instance I applied a Strobe Strength of 80% and set the number of Strobe Flashes to 4. In addition to this I further manipulated the two path blur end points and increased the Speed amount to 350%. In the Path Blur Options bar I also checked the High Quality box and clicked OK to apply the filter effect to the Smart Object layer.

Blur Gallery

Photograph: © Eric Richmond.

Smart Object support

Photoshop CC now also provides Smart Object support for the Blur Gallery filters. Having the ability to apply the Blur Gallery filters to Smart Objects opens up a number of interesting opportunities. Primarily, it means that you can now apply Blur Gallery filters non-destructively and you can easily toggle the smart filter visibility on or off like any other smart filter effect. You can combine Blur Gallery filters with other filter effects and create different results by placing other filter effects above or below a Blur Gallery smart filter.

Blur Gallery filters on video layers

Above all, you can apply Blur Gallery filters to a video layer. This means that you can easily apply effects such as a Tilt-Shift Blur filter to a video clip to produce the classic miniaturization effect (see opposite). Note, if you apply a Blur Gallery filter effect to a video layer as a smart object and check the 'Save Mask to Channels' option this will cause an alpha channel for each video frame to be saved to the Channels panel. Now, remember here, Photoshop only stores up to 99 channels and can therefore soon max out. So be sure to keep the 'Save Mask to Channels' option unchecked to avoid this happening.

Smart objects and selections

If you apply a Blur Gallery filter to a Smart Object layer with a selection that's active, the filter effect is applied to the whole layer and the active selection is used to create a smart filter mask (see page 640). However, it also means that the Selection Bleed is fixed at 100%—the Selection bleed setting appears grayed out in the options bar (see Step 2) and you won't be able to edit the Selection Bleed setting. To be honest, I am not sure why this should be the case as it does seem to limit the effectiveness of converting a layer to a smart object and using a Blur Gallery filter in conjunction with a mask. In the example shown over the page this suggests that it is not always a good idea to convert a layer to a smart filter when using the Blur Gallery filters.

Applying a Blur Gallery filter to a video clip

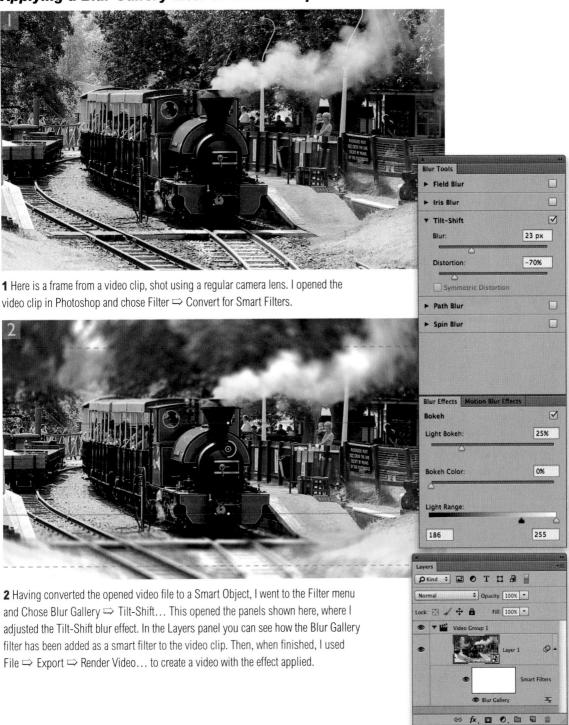

Blur Gallery filter with a smart object plus mask

1 In this example I converted a layer to a Smart Object (Smart Filter) and loaded a selection that selected everything but the statue.

Blur Gallery

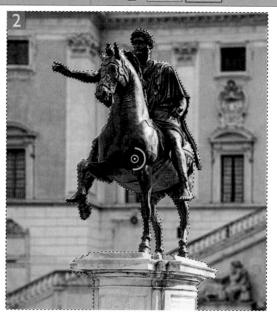

2 I went to the Filter menu, selected Blur Gallery ⇒ Field Blur... and applied the settings shown here. You will notice in the Options bar the Selection Bleed option (circled) was grayed out.

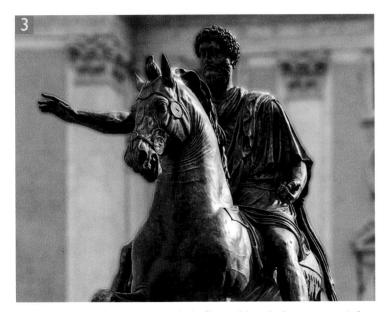

3 I clicked OK in the Options bar to apply the filter and the selection was converted into a mask that masked the Smart Filter layer. This did result in some selection bleed around the edges of the statue, but I was at least able to re-edit the filter settings.

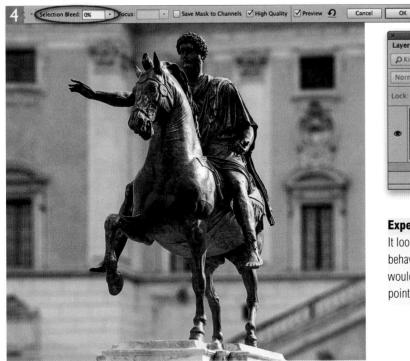

4 An alternative was to not process the image as a smart object. Here, I loaded the same selection as in Step 1 and applied the same filter settings to a Background layer with Selection Bleed set to 0% (circled). This method didn't result in any edge bleed.

Expected behavior

It looks to me like the current Smart Object behavior is probably a bug. Therefore, I would expect this to be corrected at some point, most likely in a future dot release.

Third-party plug-ins

With third-party plug-ins, you will find that those plug-ins that have been recently updated for Photoshop will have the embedded 'Smart Filter' marker that automatically makes them compatible with Smart Filters in Photoshop. If that isn't the case, then enabling all filters as Smart Filters (as described on page 620) will help your get around such restrictions, but with the proviso that any filter you apply as a Smart Filter must be a 'value-based' filter if it is to fit in successfully with a Smart Filter workflow. Some Photoshop filters, as well as advanced third-party filters, require the use of things like external channels or texture maps in order to work correctly. Since this information can't be stored safely within the Smart Object itself, this can prevent a Smart Filter from working reliably.

New Laver · morna Duplicate Lavers... Delete Hidden Layers Fill: 100% -New Group. New Group from Layers.. Lock Lavers... Convert to Smart Object Blending Options. Edit Adjustment Create Clipping Mask Link Lavers lect Linked Layers Merge Lavers ₩E Merge Visible Ω#E 0.0 G 8 Flatten Image **Animation Options** Panel Options... Close Close Tab Group

Smart Filters

For many years Photoshop users had requested having the ability to apply live filters in the same way as you can apply image adjustments as adjustment layers. Smart Filters was the solution the Photoshop team came up with and this feature can be particularly useful when working with some of the blur filters discussed in this chapter, as you may very often need the ability to re-edit the blur amount. I have already shown a couple of examples earlier of Smart Filters in use, such as when applying the Spin blur and Motion Blur filters.

When you go to the Filter menu and choose Convert for Smart Filters, you are basically doing the same thing as when you create a Smart Object. So, if a layer or group of layers have already been converted to a Smart Object, there is no need to choose 'Convert for Smart Filters'.

You can switch Smart Filters on or off, combine two or more filter effects, mask the overall Smart Filter combination as well as adjust the Smart Filter blending options. These allow you to control the opacity and blend modes for individual filters. As I have shown below in Figure 9.20, you can also group one or more layers into a Smart Object and filter the combined layers as a single Smart Object layer.

Double-click to edit a Smart Object

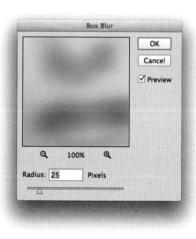

Figure 9.20 You can make a selection of more than one layer in a document and convert these into a Smart Object. From there you can add filter effects that are applied as Smart Filters to a composite version of all the selected layers. The multi-layered image can still be accessed and edited by double-clicking the Smart Object thumbnail.

Applying Smart Filters to pixel layers

Smart Filters are essentially filter effects applied to a Smart Object. The process begins with you converting a layer or group of layers to a Smart Object, or selecting a layer and choosing Filter Department for Smart Filters. Smart Filters allow you to apply most types of filter adjustments non-destructively and the following steps provide a brief introduction to working with the Adaptive Wide Angle filter as a Smart Filter.

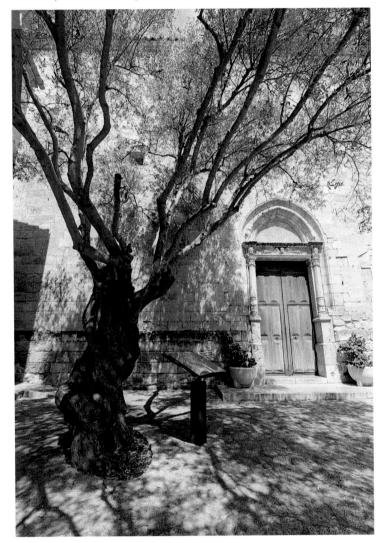

1 To apply the Adaptive Wide Angle filter as a non-destructive Smart Filter, the Background layer first had to be converted to a Smart Object. To do this I went to the Filter menu and chose 'Convert for Smart Filters'. This converted the Background layer into the Smart Object layer shown here in the Layers panel.

Pros and cons of Smart Filters

The appeal of Smart Filters is that you can apply any filter non-destructively to an image in Photoshop, but this flexibility comes at the cost of larger file sizes (making the file size 4 to 5 times bigger), plus a slower workflow switching between the Smart Object and parent documents, not to mention longer save times. This at least has been my experience when working with a fast computer and lots of RAM memory. This is not the first time we have come across speed problems like this. We have in the past seen other new Photoshop features that were a little ahead of their time and have had to wait for the computer hardware to catch up before we could use them comfortably. While Smart Filtering does offer true non-destructive filtering, it is a feature you probably want to use sparingly.

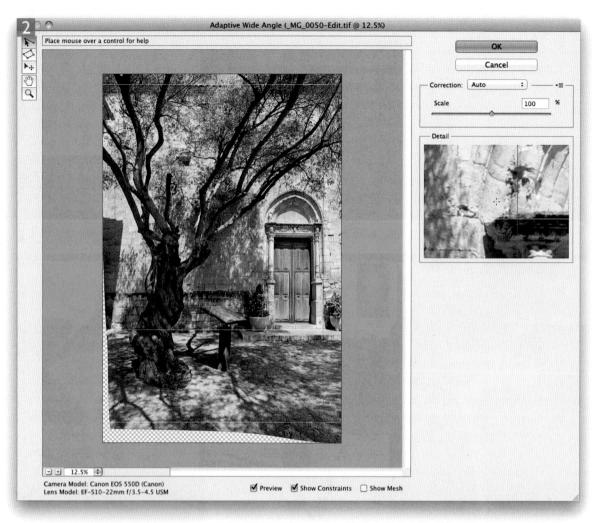

I then went to the Filter menu, selected the Adaptive Wide Angle filter and applied the adjustments shown here, where I used the Adaptive Wide Angle filter to correct the perspective in the original photograph. If you check the Layers panel you will notice that after I had applied the Adaptive Wide Angle filter, this added a Smart Filter layer to the layer stack. I could now click the filter name eye icon (circled) to switch this adjustment on or off.

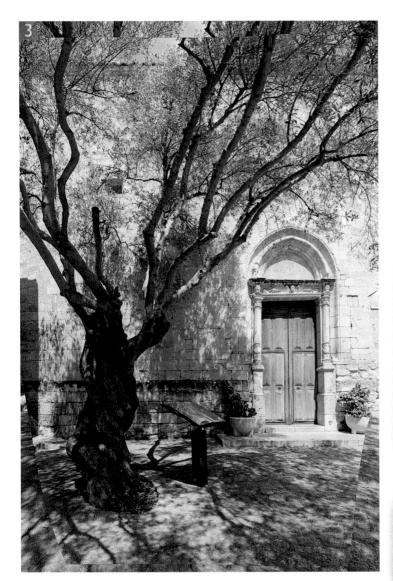

3 I then double-clicked on the Smart Filter blend options button (circled in blue). Here, I found it useful to select the Dissolve blend mode as this blend mode helped reveal the uncorrected version of the image behind the perspective-corrected version. I then double-clicked the Smart Object layer itself (circled in red). This popped the warning dialog shown on the right. This indicated that any subsequent changes I might make to the Smart Object image would need to be saved before closing the document window. It also reminded me that one should always save to the same location (in practice this should never be an issue if you always use the File ⇒ Save command rather than File ⇒ Save As…).

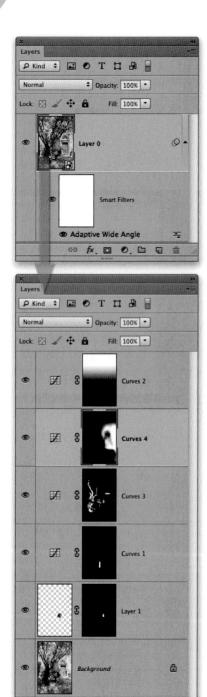

4 Here you can see the original Smart Object image document, but without the Adaptive Wide Angle filter. I could now edit this document as one would do normally. I added a number of layers which were used to selectively lighten or darken various parts of the photograph. When I closed the document window a dialog box prompted me to choose 'Save'. As I pointed out in Step 3, this must be done in order to save the Smart Object back to the parent document.

fx. 回 0. □ 司 曲

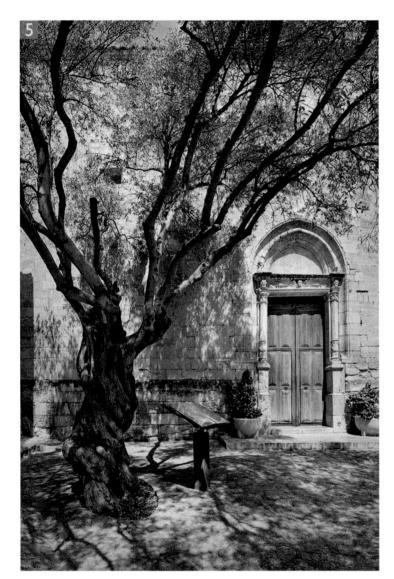

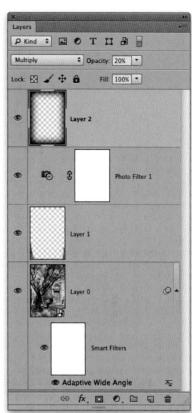

5 Here is the final version in which you can now see the result of the image adjustments applied to the Smart Object image combined with the Adaptive Wide Angle filter I had applied as a Smart Filter (filtering the entire image). In addition to this, I added a few layers including a retouch layer to neatly fill in the edges at the bottom, a Photo Filter layer to adjust the color slightly and a darken edges layer to vignette the image. The key lesson here is that nearly all of the adjustments I had just applied to this photograph, including the Adaptive Wide Angle filter settings, remained fully editable.

Scanned image limitations

The chromatic aberration and vignetting adjustments are always applied relative to the center of the image circle. In the case of digital capture images the auto correction adjustments will work precisely so long as the source image has not been cropped. In the case of scanned images things get a little trickier since the auto corrections will only work correctly if the source image has been precisely cropped to the exact boundaries of the frame.

Video clip Lens Corrections

You can apply the Lens Correction filter to video clips by opening a video file in Photoshop and applying the Lens Correction filter as a Smart Object. This is quite a powerful feature and can greatly improve the appearance of your video footage. Providing that is, you have a lens profile for the camera and lens used, such as video recorded using a digital SLR camera.

Lens Corrections

The Photoshop Lens Correction filter appears at the top of the main Filter menu and has its own shortcut (**E) Shift **R* [Mac] **ett Shift **R* [PC]*). You will notice there are two tabs in the panel and that the Auto Correction tab is shown by default (Figure 9.21). Here you'll find various options that are intended to fix common lens problems, starting with the Correction section. The Geometric Distortion option can be used to correct for basic barrel/pincushion distortion. Next we have the Chromatic Aberration option, which can be used to counter the tendency some lenses have to produce color fringed edges. Below that is the Vignette option, which can be used to correct for darkening towards the edges of the frame, which is a problem most common with wide angle lenses. Lastly, if you check the Auto Scale Image option this ensures the original scale is preserved as much as possible in the picture.

Basically, if you are about to apply an auto lens correction to an image that contains EXIF camera and lens metadata, the EXIF metadata information is used to automatically select an appropriate lens profile in the Lens Profiles section below. If the image you are editing is missing the EXIF metadata (i.e. it is a scanned photo) and you happen to know which camera and lens combination was used, you can use the Search Criteria section to help pinpoint the correct combination. It is important to appreciate here that the camera body selection is also important. This is because some camera systems capture a full-frame image (therefore making full use of the usable lens coverage area), while compact SLR cameras mostly have sensors that capture a smaller area. The lens correction requirements will therefore vary according to which camera body type is selected. Once you have selected the correct lens profile you can use the Preview button at the bottom of the dialog to toggle and compare a before and after view of the auto lens correction.

Custom lens corrections

In the Custom tab (Figure 9.22), the Geometric Distortion section contains a Remove Distortion slider that can correct for pincushion/barrel lens distortion. Alternatively, you can click to select the remove distortion tool and drag toward or away from the center of the image to adjust the amount of distortion in either direction. Overall, I find the Remove Distortion slider offers more precise control.

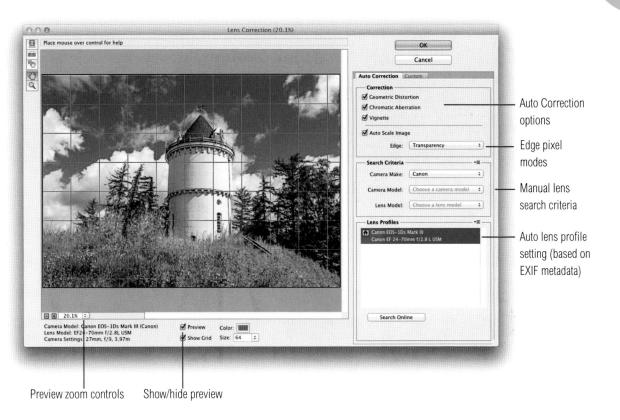

Figure 9.21 The Lens Correction filter dialog in the default Auto Correction mode.

The Chromatic Aberration section contains three color fringe fixing sliders for fixing the red/cyan, green/magenta and blue/yellow fringing.

The Vignette section contains Amount and Midpoint sliders, which are also identical to those found in the Camera Raw Lens Corrections panel and these can be used to manually correct for any dark vignetting that occurs at the corners of the frame.

The Transform section controls let you correct the vertical and horizontal perspective view of a photograph such as the vertical keystone effect you get when pointing a camera upwards to photograph a tall building, or to correct the horizontal perspective where a subject hasn't been photographed straight on.

You can adjust the rotation of an image in a number of ways. You can click and drag directly inside the Angle dial, but I mostly recommend clicking in the Angle field (circled in Figure 9.22) and using the up and down keyboard arrow keys

Edge pixels

As you apply Lens Correction Transform adjustments, the shape of the image may change. This leaves the problem of how to render the outer pixels. The default setting uses the Transparency mode, although you can choose to apply a black or white background. Alternatively you can choose the Edge Extension mode to extend the edge pixels. This may be fine with skies or flat color backdrops, but is otherwise quite ugly and distracting, although the extended pixels may make it easier to use the healing brush to fill these areas.

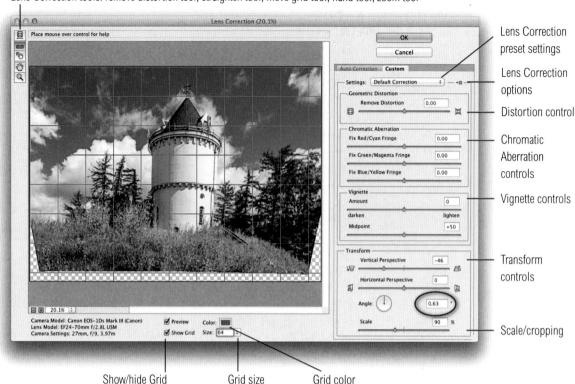

Lens Correction tools: remove distortion tool; straighten tool; move grid tool; hand tool; zoom tool

Figure 9.22 The Lens Correction filter dialog in Custom mode.

to nudge the rotation in either direction by small increments. The other option is to select the straighten tool and drag to define what should be a correct horizontal or vertical line. The image will then rotate to align correctly.

The Scale slider can be used to crop a picture as you apply a correction. On the other hand you may wish to reduce the scale in order to preserve more of the original image (as shown in Step 2 on the page opposite). The grid overlay can prove useful for helping you judge the alignment of the image and you can use the move grid tool to shift the placement of the grid. The grid controls at the bottom of the Lens Correction filter dialog also enable you to change the grid color and adjust the grid spacing, plus toggle showing or hiding the grid. Note that if you select the move grid tool this allows you to adjust the grid position by dragging in the preview window.

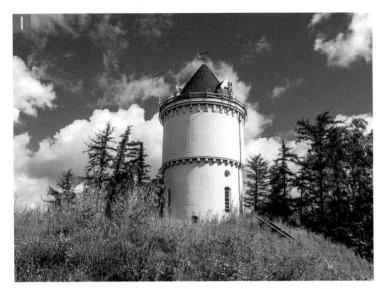

1 In this example I checked all the Auto Correction options to apply an auto lens correction to this photograph, which in this case was based on the EXIF metadata contained in the original photo (there is a layered version of this image on the website for you to compare).

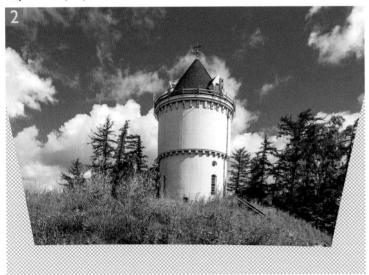

2 I then switched to the Custom mode and applied a custom lens correction to further correct for the perspective angle this photograph was shot from. Basically, I adjusted the Vertical Perspective slider and made a minor adjustment to the angle of rotation. You'll also note that I adjusted the Scale slider to reduce the scale size and preserve more of the image.

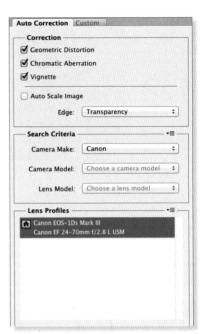

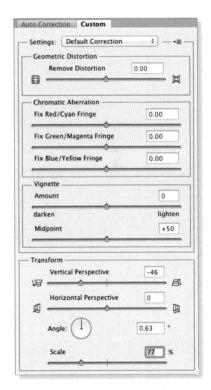

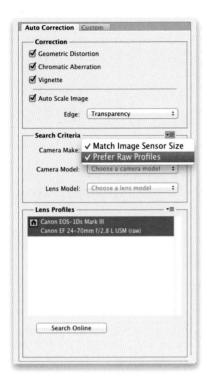

Figure 9.23 You can choose to prefer raw profiles via the Search Criteria section fly-out menu options in the Lens Correction filter dialog.

Selecting the most appropriate profiles

If the camera/lens combination you are using matches one of the Adobe lens correction profiles that was installed with Photoshop, then that is the only option you'll see appear in Lens Profiles (Figure 9.23). If no lens correction profile is available (because the necessary lens EXIF metadata is missing), you'll see a 'No matching lens profiles found' message. The Search Criteria Camera Make, Camera Model and Lens Model menus will then allow you to manually search for a compatible camera/lens profile combination. If you wish to explore alternative lens profile options, then click on the 'Search Online' button. This carries out an online search for lens correction profiles that have been created by other users where the lens profile EXIF data matches and is publicly available to share. You can initially preview these profiles to see what the results look like before deciding whether to use them and save them locally to your computer. When looking through the list of alternative online lens profiles you'll see some of these have been given ratings by other users. Similarly, if you create your own custom profiles using the Adobe Lens Profile Creator program (see website for details), and wish to share these with other users you can do so by going to the program's File menu and choose Send Profiles to Adobe... (Figure 9.24). If you can't find any matching lens profiles then you can always select the nearest equivalent via the Search Criteria menus, and fine-tune the result using the Custom panel controls in the Lens Correction filter dialog.

The Lens Correction filter can make use of profiles created from raw files or from rendered TIFF or JPEG capture images. This means that two types of lens profiles can be generated: raw and non-raw lens profiles. In terms of the geometric distortion and chromatic aberration lens correction, you are unlikely to see much difference between these two types. With regards to the vignette adjustment, here it does matter more which type of source files were used. In the case of raw files, the vignette estimation and removal is measured directly from the raw linear sensor data. Now, if the Lens Correction filter were able to process raw files directly this would result in more accurate lens vignette correction results. Since the Lens Correction filter is used to process rendered image files such as JPEGs and TIFFs, it is therefore better to use the nonraw file generated lens profiles, where available. It is for this reason that the Lens Correction filter dialog displays the nonraw lens correction profile by default and only shows a raw

profile version if there is no non-raw profile version available on the system. The raw profile versions are therefore only available as a backup. However, if you go to the Search Criteria section and mouse down on the fly-out menu you can select the 'Prefer Raw profiles' option (see Figure 9.23). When this is checked the Lens Correction filter automatically selects the raw profiles first in preference to the non-raw versions. Overall I recommend you stick to using non-raw profiles as the default option for Photoshop lens corrections.

Adobe Lens Profile Creator

You can use the Adobe Lens Profile Creator 1.04 program to help characterize optical aberrations such as geometric distortion, lateral chromatic aberration and vignetting and build your own custom lens profiles. It is available as a free download. Go to the Lens Profiles fly-out menu and choose 'Browse Adobe® Lens Profile Creator Online...' This leads you to a page from where you can download the program. Basically you need to print out one of the supplied charts onto matte paper and then photograph it as described in the Creating lens profiles PDF on the website.

Interpolating between lens profiles

The zoom lens characteristics will typically vary at different focal length settings. Therefore to get the best lens profiles for such lenses you may need to capture a sequence of lens profile shots at multiple focal length settings such as at the widest, narrowest and mid focal length settings. The Adobe Lens Profile Creator program can then use the multiple lens capture images to build a more comprehensive profile for a zoom lens. You can also build lens profiles based on bracketed focusing distances. For example, this might be considered a useful thing to do with macro lenses, where you are likely to be working with the lens over a wide range of focusing distances.

Lens Correction profiles and Auto-Align

The Auto-Align feature shares the same lens correction profiles as those used by the Lens Correction filter dialog. This is why you should mostly see much improved performance in the way the Auto-Align feature is able to stitch photos together. Adobe have also added caching support so that the Lens Correction and Auto-Align Layers dialogs open more speedily on subsequent launches after the first time you open either dialog.

Non-raw profile variance

When it comes to applying lens corrections, you are much better off doing so at the raw processing stage, where raw lens profiles are the default. Raw profiles used at this stage are more consistent since they all start from a known baseline. Non-raw generated profiles are subject to a number of unknown factors. Non-raw profiles are still the best choice for use with the Lens Correction filter, but consider Camera Raw and raw profiles as a better starting point.

Figure 9.24 When using the Adobe Lens
Profile Creator program you can use the File
menu to choose 'Send Profiles to Adobe'
(# 5 [Mac] ctr) all S [PC]).
This allows you to share lens profiles you
have created with other users.

Fisheve lens corrections

You will also see improved auto-alignment for fisheye photos that have been shot in portrait mode. However, for this to work properly it is necessary that all the source images are shot using the same camera, lens, image resolution and focal length. If these above criteria are not met, then you will most likely see a warning message.

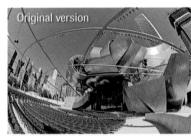

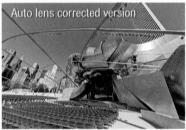

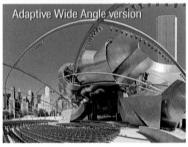

Figure 9.25 Here you can see three variations of the same image. The top version shows the original fisheye lens photo with no lens corrections applied to it. The middle version shows the same image with an auto lens profile correction. The bottom version shows how the image looked after using the Adaptive Wide Angle filter with custom constraint adjustments.

Adaptive Wide Angle filter

So, if Camera Raw and Photoshop provide the ability to make automatic lens profile corrections, why do we also need an Adaptive Wide Angle filter? It does seem like an odd addition until, that is, you understand the logic behind this feature and why it can be so useful.

Essentially, the problem is this: how do you take a wide angle, spherical field of view and represent it within a rectangular frame? One approach is to preserve the spherical field of view without distorting the image. This is what fisheve lenses do. The other approach is to apply a perspective type projection, which will attempt to straighten the image so that straight edges in the scene appear straight. While some rectilinear lenses can be very good, the problem with perspective projections is that objects will appear more stretched towards the edges of the frame. Round objects become egg-shaped and everything tends to look more stretched. I suppose in this instance you could sum up the problem as 'how do you squeeze a round peg into a square hole?' Artists over the centuries have overcome this problem by not observing true, camera lens-like perspective projections, where objects would appear distorted at the edges. They have sometimes combined multiple perspective projections in a single image, or adapted the perspective of some objects to avoid the effects of perspective distortion. They have effectively deviated from painting in true perspective.

In the world of photography we have so far been limited to what perspective projection lenses have been able to do at the point of capture and what programs like Photoshop can do in the post-processing. What's been missing until now has been the means to manipulate the field of view and determine precisely which lines should remain straight - something no camera lens can achieve. The Adaptive Wide Angle filter is the result of research which came out of Berkeley University California (Robert Carroll, Maneesh Agrawala and Aseem Agarwala) into 'Image Warps for Artistic Perspective Manipulation'. The clue here is in the title: this is an artistic tool that can be used to manipulate the appearance of a wide angle view such that you can take extreme wide angle photographs and apply constraint lines to create more natural-looking images, where the entire mapping is as shape-preserving as possible. This filter has a number of uses. It can be used to uniquely change the perspective composition of a scene

to produce an end result where the perspective looks more natural. It can be used to explore different artistic perspective interpretations, or it can be used to match the visual perspective in another scene. This could be particularly useful if you are required to blend two images together where it is necessary to get the perspective in one image to match more closely the perspective in the other – something that has been impossible till now.

If you want to test this filter out you should ideally do so using ultra wide angle images, such as those shot with a fisheye lens (see Figure 9.25) or an ultra wide perspective correcting lens, such as a lens with an effective focal length of 24 mm lens on a full-frame 35 mm SLR system or wider. You could try using this filter to edit other types of images, but is really intended as a correction tool for extreme wide angle photographs.

The Adaptive Wide Angle filter combines the technology utilized in the Lens Correction filter with Puppet Warp distortions. When using this filter it will not be necessary to apply a lens correction first via Camera Raw or Photoshop, and in fact, will work better if you don't. After all, since this filter can be used to make user-indicated distortion corrections, it is better to begin with an image that has had no distortion corrections so far applied to it, especially in the case of fisheye lenses, where it would be trickier to use corrected fisheve images as your starting point. This is because the Adaptive Wide Angle filter makes use of the Adobe Lens profiles to refine the lens distortion. As a consequence of this if you correct the lens distortion in Camera Raw first (or use the Lens Correction filter)this may potentially confuse the Adaptive Wide Angle filter. Generally speaking, the Adaptive Wide Angle filter is robust enough to cope with minor corrections, but if you choose to correct a fisheye image first using a Camera Raw lens profile correction, the Adaptive Wide Angle filter will have trouble processing the image correctly.

With photos that have been shot using a tilt-shift lens the user will have the opportunity to adjust the center of the optical axis and apply a certain amount of perspective correction at the time of capture. Such photos may still benefit from being processed using the Adaptive Wide Angle filter. However, it is absolutely paramount you have access to an accurate lens profile and the Auto mode selected in the Correction options.

Optically corrected JPEGs

Some cameras may apply automatic lens corrections when you shoot in JPEG mode. It is therefore better to shoot in raw mode if you intend processing photos using the Adaptive Wide Angle filter.

Figure 9.26 This shows the Adaptive Wide Angle filter tools and their associated shortcuts.

Basically, the filter allows you to indicate which lines in a scene should be straight or horizontal/vertical. As these constraints are applied, the filter smoothly applies a Puppet Warp type adaptive warp projection to the image between the constraint lines and image boundary. In other words, you get to define which are the salient lines in the image that should appear straight and the image data is progressively warped to match the constraints you have applied and will continue to update as you add more constraints.

When correcting a fisheye lens image such as the one shown in Figure 9.25, it should not be necessary to apply many more constraint lines than one horizontal and two vertical constraints. Three constraint lines was all that was needed in this example to achieve the main distortion effect you see here. As it happens, I did end up adding a few extra constraints to fine-tune this particular image, but once the main key constraint lines had been added the adaptive wide angle adjustment was mostly complete.

How the Adaptive Wide Angle filter works

When you first open an image in the Adaptive Wide Angle filter it will search the lens profiles database to see if there is lens profile data that matches the image's lens EXIF metadata. If a lens profile is present the Correction section of the filter dialog will show 'Auto'. If not, you may want to see if one is available online. Go first to the Lens Correction filter and apply it to the same image. Click on the Search Online button. This will show a list of other user-created lens profiles that may possibly match. You can then select one of these and go to the Lens Profiles fly-out menu and choose 'Save Online Profile Locally'. This will then save the profile to the lens profile database on your computer and automatically be available the next time you open the Adaptive Wide Angle filter.

What the Adaptive Wide Angle filter does is it reads in the EXIF lens metadata, locates an appropriate lens profile and, based on this, assesses which is the best projection method to use. When the Preview box is checked, the preview shows an initial distortion correction that you can then refine further using the constraint controls. This initial preview will show what is known as a 'shape conformal' projection, as opposed to a perspective-accurate projection. With this type of projection the emphasis is on preserving shapes proportional to the distance from the viewer. As you add constraint lines you are essentially

overriding this projection and telling it to add more perspective. Essentially, the filter lets you selectively apply a perspective projection to the image.

As you apply constraints to the preview some parts of the image will be more squashed together and other parts will become stretched apart. The Scale slider can therefore be used to adjust the scale of the image relative to the dimensions of the original document.

Applying constraints

It helps to understand here that because the Adaptive Wide Angle filter is able to use the Lens profile information for the lens the photo was taken with (based on your file's EXIF metadata) it therefore knows how to calculate all edges as being straight. As I explained earlier, instead of applying a distortion correcting perspective projection the Adaptive Wide Angle filter applies a 'shape conformal' projection which helps avoid the effects of wide angle, perspective projection distortion. As you apply constraint lines to the image you are selectively overriding the shape conformal projection and telling the filter you want to apply a perspective type projection to this particular section of the image.

In use, you drag with the constraint tool () along an edge to define it as a straight line. As you do this the constraint line will appear to magically know exactly how much to bend. Well, it's not magic really, as the filter already knows how much to bend based on the Lens Profile data. In the case of the Lens Correction filter the Lens Profile data is used to precisely remove the geometric distortion. With the Adaptive Wide Angle filter it doesn't straighten the lines unless you ask it to do so and it knows how much to bend the constraint based on the Lens Profile data. So, as you add constraints you'll see the lines in your image straighten. If you hold down the Shift key as you do so, you can both straighten an edge and make it a vertical or horizontal line. Where possible, the trick here is to use a minimum of two vertical constraints to apply vertical corrections left and right, plus a single horizontal constraint to match the horizon line. It is best to first align these constraints to known edges in the image preview and once you have done this it is easy enough to edit the constraint lines by clicking on the end points and dragging them to the edge of the frame. This is often crucial, because by doing so you are able to apply an even smoother correction across the entire width

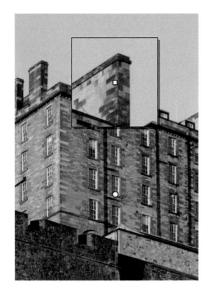

Figure 9.27 As you select a constraint handle to edit it, you will see a magnified loupe, as shown here. This is also available by holding down the key.

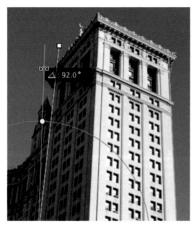

Figure 9.28 This shows a close-up section of a building where I had applied two vertical constraints to straighten the converging verticals. To keep the perspective looking natural, I edited the orientation of the constraints, setting the one on the left to 92° and the one on the right to 88°.

and height of the image area. You can hold down the key to switch to a magnified view (to 200% from a 100% view and 100% from smaller magnifications). Also, at views less than 100%, clicking and dragging a handle will show a 100% loupe view (see Figure 9.27) This can make precise placement easier. Once you have got these first three constraint lines to extend edge to edge, you should end up with a fairly satisfactory distortion where you'll only need to add further constraint lines where these are absolutely necessary. As you edit the constraints you'll probably notice how they may follow an odd kink here and there (this can be because the underlying mesh has so far been unevenly warped and the lens profile information guides the constraint line accordingly).

Rotating a constraint

If you click to select a constraint, you'll see two handles appear on the constraint line. If you click on one of these and drag you will see an overlaying circle and you can drag to apply an arbitrary rotation to the constraint. A green line appears as you do this and the edited constraint will afterwards be colored green (see Figure 9.28). This can be particularly useful when editing architectural photos where you wish to correct the converging verticals and remove a keystone effect. While it is possible to make the converging vertical lines go perfectly vertical. It may not always be best to force them to do so, but allow them to converge just slightly. Therefore, then applying vertical constraints, you can adjust the orientation angle for each constraint line.

Saving constraints

Working with the Adaptive Wide Angle filter usually involves making a fair number of intricate adjustments. To keep the work you do in this filter editable you can save the constraints as a settings file. To do this, go to the Corrections menu shown in Figure 9.29 and select 'Save Constraints...' The constraint settings file is named the same as the image, which can make it easier to locate the correct constraint setting. When you need to load these same constraint settings you can then go to the same menu and choose 'Load Constraints...' But note that while a settings file can be shared with other images, it will only do so providing the embedded EXIF lens metadata matches exactly. The other thing you can do is to convert an

image to a Smart Filter before you apply the Adaptive Wide Angle Filter. If you do this, you can create and save a number of different correction settings for a particular photo. To help you avoid losing any work, if you exit the Adaptive Wide Angle filter by pressing the see key, you will see a warning dialog that reminds you to apply or save the constraint settings first.

Constraint line colors

The constraint colors are colored as follows. Unfixed constraints are colored cyan, horizontals colored yellow, verticals magenta, fixed orientation constraints green and invalid constraints are colored red, indicating that the constraint you are trying to apply can't be calculated. When you go to the fly-out menu shown in Figure 9.29 you can open the Preferences shown in Figure 9.30. This allows you to edit the color swatches and choose new colors for the different constraint guide modes.

Polygon constraints

The polygon constraints tool (Y) can be used to define specific areas of a picture where you wish to apply a perspective correction. Just make a succession of clicks to define an area that you wish to see corrected. For example, if you were to click in all four corners of the preview area, the effect would be similar to applying a lens correction to the entire image. The polygon constraint tool is therefore useful for correcting areas of an image where there are no straight lines available to reference, or where you need to correct, say, a building facade or a large expanse of tiled flooring. You can also add horizontal/vertical oriented constraints to just outside the edges of a polygon constraint as a way to help control the overall polygon distortion.

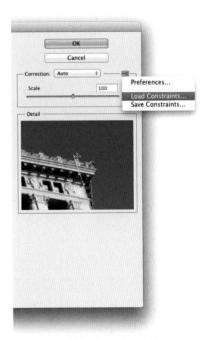

Figure 9.29 This shows the Adaptive Wide Angle filter Correction menu options that includes the Preferences, Load Constraints... and Save Constraints... options.

Figure 9.30 This shows the Adaptive Wide Angle preferences dialog, including a preference to set the size of the floating loupe (see Figure 9.27).

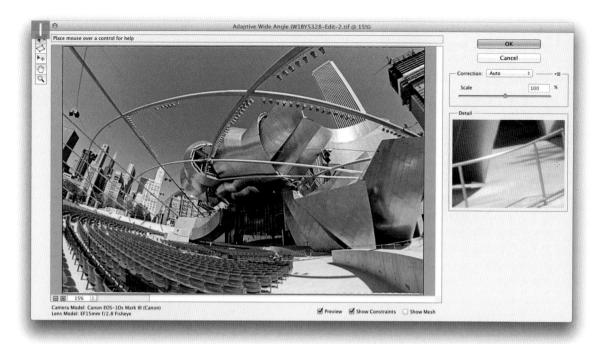

1 In this screen shot you can see a photograph that was shot with a 15 mm fisheye lens, opened in the Adaptive Wide Angle filter prior to making any corrections.

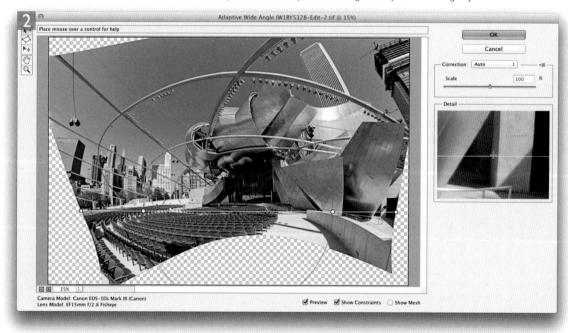

2 To start with, I selected the constraint tool and with the *Snift* key held down dragged across the horizon to correct the horizontal distortion at this point in the photograph.

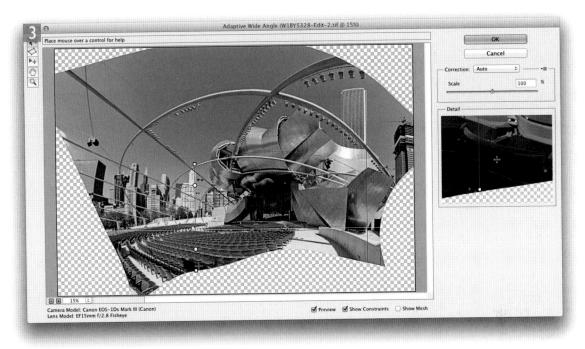

3 I again held down the *Shift* key and this time added a succession of vertical constraints to selectively correct for the vertical distortion (plus I also added a further horizontal constraint near to the bottom of the image). When I was done I clicked OK.

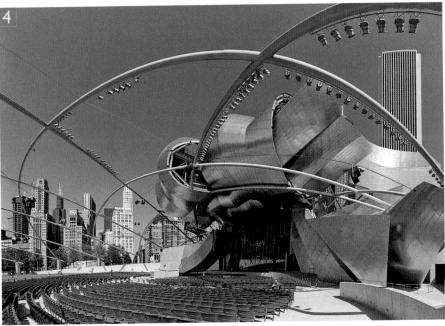

4 Here you can see the final, corrected version. If you refer back to Figure 9.25 you can also compare this with the original and a standard 'lens corrected' version.

Calibrating with the Adaptive Wide Angle filter

If you are dealing with images that have no EXIF lens data then the Adaptive Wide Angle filter will have nothing to work from. In these situations it is possible to calibrate the filter so that it is able to determine the curvature of the lens. As is shown in Figure 9.31, this is really a method that can only be applied to fisheye lenses. If you select the constraint tool and no EXIF lens data is detected, after you click to add a constraint this will produce a straight constraint line with a midpoint handle. What you have to do next is to click on the midpoint handle and drag to make the constraint line match a known vertical or horizontal line in the image (you can see this taking place in the Figure 9.31 example). After you have carried out the initial calibration you should find it quite easy to add further constraint lines to constrain the other edges.

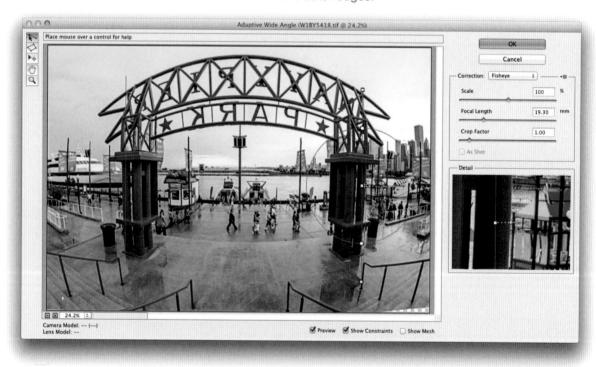

Figure 9.31 Calibrating a photo with no embedded EXIF lens data.

Editing panorama images

It is possible to use the Adaptive Wide Angle filter to correct panoramic images. However, for this to work, the panorama must be generated using Photomerge in Photoshop CS6 or later. This is because the filter relies on lens metadata information being added to the file as the panorama is generated, so it won't be able to process older panoramas in this way. When preparing a Photomerge panorama you need to make sure that you use just the Cylindrical or Spherical projection methods and that the Geometric Distortion Correction option is checked (see page 551). When you open a Photoshop CS6 or later panorama image via the Adaptive Wide Angle filter, you'll see it open in 'Panorama' mode. The Adaptive Wide Angle filter can also be used in the way described here to process 1:2 full-spherical (180 degrees by 360 degrees) Photomerae panoramas. When editing a Photomerge file, the Adaptive Wide Angle filter needs to be able to read metadata information such as the focus length and where the center of the panorama is. This is all figured out as the images are stitched together in Photomerge. Note that checking the Geometric Distortion Correction checkbox box in Photomerge should not affect the Adaptive Wide Angle filter.

The following steps show how I managed to correct the distortion in such an image, where I had, rather ambitiously, shot the seven images that made up this panorama using an extreme wide angle lens. Up until now it would not have been possible to do much to correct the major distortion that can be seen in this stitched panorama.

Since first experimenting with the Adaptive Wide Angle filter I have come to the conclusion that it is useful for editing not just architectural photographs, but almost any Photomerge panorama that has been created in Photoshop. More recently, I have been shooting panorama stitch images using a 14 mm, rectilinear fisheye lens and post-editing the Photomerge panoramas using the Adaptive Wide Angle filter to tame the perspective (see Figure 9.32). The benefit of this approach is that one can capture a highly-detailed panorama that holds an extremely wide view yet not have it look like a typical, ultra wide angle photograph. The perspective view that you can achieve reminds me of the work of classical landscape painters, who, as I mentioned earlier, played fast and loose with perspective to create idealized landscape views.

Figure 9.32 This ultra wide angle panorama image was created from six photographs, all shot using a 14 mm lens.

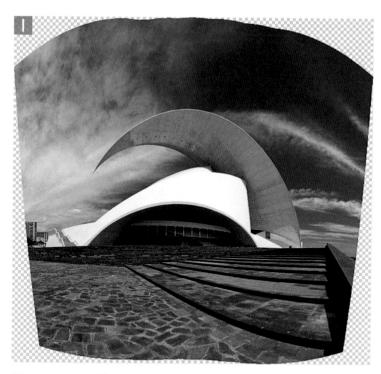

1 Here you can see a Photomerge image created in Photoshop using the Cylindrical layout/projection mode and with the Geometric Distortion Correction checked.

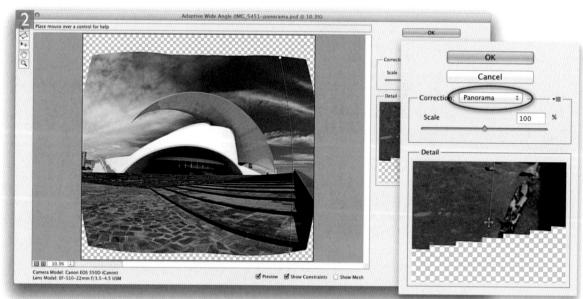

2 When I applied the Adaptive Wide Angle Filter to the image in Step 1, it opened using the Panorama correction method (circled). To begin with, I held down the *Shift* key to add a vertical constraint to the image.

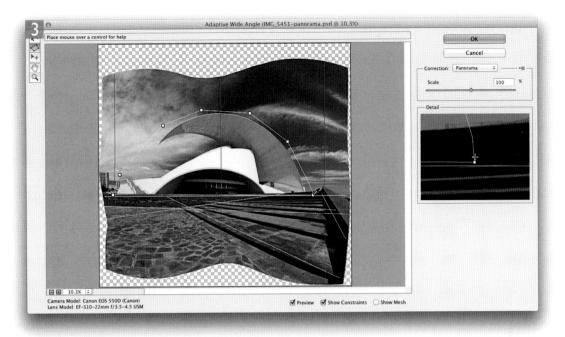

3 Following on from this, I added further vertical, horizontal and regular constraint lines to correct the distortion in the image. Since there weren't any straight lines to align to on the opera house, I used the polygon constraint tool to define the shape of the building. I hit *Enter* to close the polygon, which corrected the distortion inside the defined area.

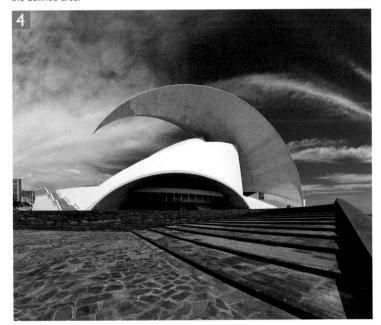

4 This shows the final, corrected version.

Creating a texture map

As mentioned here and in the tutorial over the page, you can use any of the RGB channels or an alpha channel as a texture map. To create a texture similar to the one shown in the tutorial steps, try using the Fibers filter, which is also contained in the Filter Render submenu.

Lighting Effects filter

For many years Photoshop had a Lighting Effects filter which was temporarily removed when Photoshop made the transition from being 32-bit to 64-bit processing enabled. A lot of engineering resources were devoted to making everything in Photoshop 64-bit. Some components didn't make the cut and the Lighting Effects filter was one of those things that got quietly dropped. In part it was because the filter interface was rather dated and only offered you a tiny preview. The intention all along was to update this filter properly at some point. The Lighting Effects filter was returned in Photoshop CS6 and can now be found in the Filter ⇒ Render menu. The Lighting Effects filter is driven by Photoshop's 3D engine, allowing you to edit what is known as a '3D postcard'. The lighting controls are the same as those available for full 3D rendering in Photoshop, but are applied to a flat plane image surface. If you are familiar with the old-style Lighting Effects filter you'll notice that some of the original presets have been updated in this new version. When used properly, this filter is an occasionally useful Photoshop tool for applying creative effects.

To see the filter in use check out the step-by-step tutorial on pages 668–669. You will notice that Lighting Effects opens the image in a Full Screen mode. At the top are the Options bar settings shown in Figure 9.33, where you can click on one of the three Lights buttons to add a Spot, Point or Infinite light source. In the case of the Spot and Point lights you'll see a circle where you can drag any of the four handles to control the positioning and width of the light source. In the case of the Infinite light you'll see the light control shown in Figure 9.34. These can be used to adjust the light angle and coverage as well as the effect intensity.

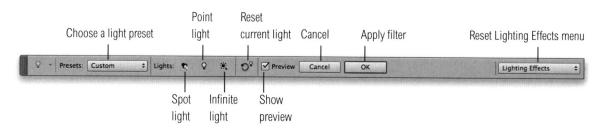

Figure 9.33 The Lighting Effects Options bar.

To add more lights, you can either click on the Light buttons in the Options bar, or drag on an existing light to make a copy of the light. As you add more lights you'll see these appear listed in the Lights panel shown in Figure 9.35.

If you create a lighting effect and would possibly like to reuse it, then go to the Presets menu (Figure 9.33) and save the current lights setting as a new lighting effect preset. To select a saved preset, go to the same Presets menu and select it from the list.

Properties panel adjustments

In the Properties panel (Figure 9.36) you can click on the menu at the top to switch between the three types of light sources: Spot, Point or Infinite. If you click on the Color box you can choose a color other than white for the light source. Below this is the Intensity slider, which controls how bright the light will be. For all the following settings you can click and drag in the settings box or on the field name with the (Mac), ctrl (PC) key held down to access the scrubby sliders (hold down the Shift key as well to amplify a scrubby slider adjustment). Although the lighting controls are primarily designed for editing 3D objects, these will still be effective when working on a 3D postcard, 2D image. If a Spot light is selected, the Hotspot slider allows you to control the width of the hotspot. Gloss and Metallic interact with each other. In the context of lighting a 3D postcard, a low Metallic setting applies a slightly foggy lighting effect. Unless this is something you specifically wish to create, I suggest you leave this at the default +100 setting. The Gloss slider can then be used to add contrast to the lighting effect. The default -79 setting is a good starting point and if you take this down to -100, you'll get a more natural, matte surface effect. As you increase the Gloss amount you'll be adding more contrast to the lighting. Ambience controls the amount of background fill. With a low Ambience a lighting effect will cast dark shadows, while a high setting will produce more filled in, lighter shadows. The Ambience slider is also linked to the color selected in the Colorize swatch. Depending on the color selected here, a positive Ambience value applies an increasingly saturated fill color based on the Colorize swatch color. A negative Ambience applies the inverse of the Colorize swatch color. The Texture menu allows you to select a channel or alpha channel to use as a texture map and below that there is a Height box to determine the texture height (a higher amount will produce a more pronounced texture).

Figure 9.34 The Infinite light control.

Figure 9.35 The Lights control panel.

Figure 9.36 The Properties panel.

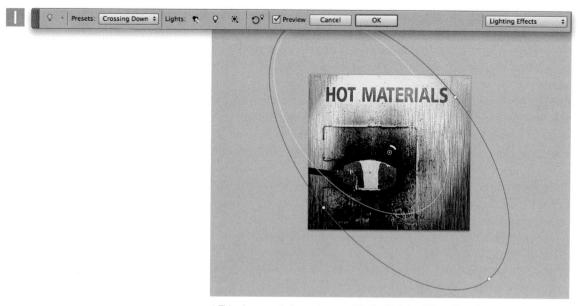

Lights

Spot Light 1

Spot Light 2

Properties

Lighting Effects

Spot

Color: Intensity: 28

Hotspot: 51

Colorize: Exposure: 0

Ciloss: -79

Metallic: 100

Ambience: 11

Texture: None +

1 This shows a photograph opened in the Lighting Effects filter. To start with I went to the Presets menu in the Options bar and selected the 'Crossing Down' preset lighting effect.

2 This added two Spot light sources. I clicked on the light control shown above in Step 1 and dragged the handles to make the light coverage area smaller and more focused on the area seen here and edited the light source settings, reducing the Spot light Intensity.

3 I then went to the Lights panel and selected the other light source. Here, I selected a pre-saved Alpha 1 channel as a texture source. With the Height set to 3, this added a fibrous texture to the photograph, which responded to the angle and other light source settings.

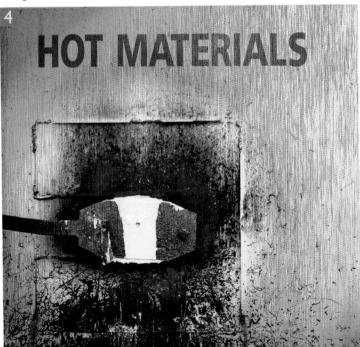

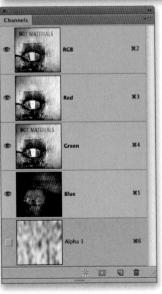

Full filter access

You'll notice that when the 'Show all Filter Gallery Groups and Names' option is deselected in the Photoshop Plug-ins preferences (the default setting) this limits the number of filters listed in the main Filter menu submenus. The Filter Gallery gives you access to the remaining 47 'artistic' filter effects, which are otherwise hidden.

Filter Gallery

To use the Filter Gallery, select an image, choose Filter Gallery from the Filter menu and click on the various filter effect icons revealed in the expanded filter folders. The filter icons provide a visual clue as to the outcome of the filter, and as you click on these the filter effect can be previewed in the preview panel area. This gives you a nice, large preview for many of the creative Photoshop filters. As you can see in Figure 9.37, you can combine more than one filter at a time and preview how these will look when applied together. To add a new filter, click on the New Effect Layer button at the bottom. As you click on the effect layers you can edit the individual filter settings. To remove a filter effect layer, click on the Delete button.

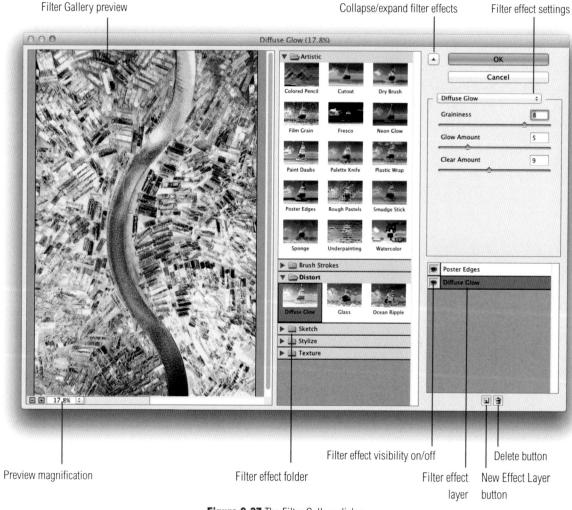

Figure 9.37 The Filter Gallery dialog.

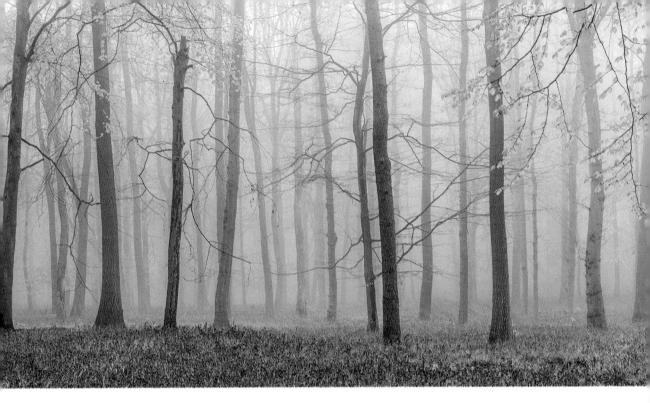

Chapter 10

Print output

This chapter deals with the print output process. Photographers reading this book will probably own at least one color desktop printer and the print quality that you can get from the latest inkjet devices has improved enormously over the last 15 years or so. To obtain the best quality print output, it is important to have a good understanding of the Photoshop Print and system print dialog interfaces and how to configure the settings. There are also other issues to address in this chapter, such as how to use soft proofing, and how you ensure the colors you see on the display will be reproduced accurately in the final print.

Rather than go into all the details about different print processes, the different ink sets and papers that you can choose from, I have pared this chapter down so that it concentrates on just the essentials of inkjet printing. If you want to know more about Photoshop printing, there is a book I co-wrote with Jeff Schewe titled Adobe Photoshop CS5 for Photographers: The Ultimate Workshop. I can recommend Mastering Digital Printing, Second Edition (Digital Process and Print) by Harald Johnson, which provides an extensive overview of desktop printing and also a new title from Jeff Schewe: The Digital Print – Preparing Images in Lightroom and Photoshop for Printing.

Print sharpening

One of the most important things you need to do before making a print is to sharpen the image before you send it to the printer. So we are going to start by looking at print output sharpening.

Earlier in Chapter 3, I outlined how you can use the Detail panel sharpening sliders in Camera Raw to capture sharpen different types of images. This pre-sharpening step is something that all images require. The goal in each case is to prepare an image according to its image content so that it ends up in what can be considered an optimized sharpened state and the aim is to essentially sharpen each photograph just enough to compensate for the loss of sharpness that is a natural consequence of the capture process.

Output sharpening is a completely different matter. Any time you output a photograph and prepare it for print—either in a magazine, on a bill board, or when you send it to an inkjet printer—it will always require some additional sharpening beforehand. Some output processes may incorporate automatic output sharpening, but most don't, so it is therefore essential to always include an output sharpening step just before you make a print output. The question next is how much should you sharpen? While the capture sharpening step is tailored to the individual characteristics of each image, the output sharpening approach is slightly different. It is a standard process and one that is dictated by the following factors, namely: the output process (i.e. whether it is being printed on an inkjet printer or going through a halftone printing process), the paper type used (whether glossy or matte) and finally, the output resolution.

Judge the print, not the display

It is difficult, if not impossible to judge just how much to sharpen for print output by looking at the image on a display. Even if you reduce the viewing size to 50% or 25%, what you see on the screen bears little or no resemblance to how the final print will look. The ideal print output sharpening can be calculated on the basis that at a normal viewing distance, the human eye resolves detail to around 1/100th of an inch. So if the image you are editing is going to be printed from a file that has a resolution of 300 pixels per inch, the edges in the image will need a 3 pixel Radius if they are to register as being sharp in print. When an image is viewed on a computer display at 100%, this kind of sharpening will look far too sharp, if not downright ugly (partly because you are viewing the image much closer up than it will actually be seen in print), but the actual physical print should appear correctly sharpened once it has been printed from the 'output sharpened' version of the image. So, based on the above formula, images printed at lower resolutions require a smaller pixel radius sharpening and those printed at higher resolutions require a higher pixel radius sharpening. Now, different print processes and media types also require slight modifications to the above rule, but essentially, output sharpening can be distilled down to a set formula for each print process/resolution/media type. This was the basis for the research carried out by the late Bruce Fraser and Jeff Schewe when they devised the sharpening routines used for PhotoKit Sharpener (see sidebar). These are elaborated upon in Real World Image Sharpening with Adobe Photoshop, Camera Raw, and Lightroom (2nd Edition), also by Bruce Fraser and Jeff Schewe (ISBN: 978-0321637550).

High Pass filter edge sharpening technique

The technique that's described on pages 674–675 shows an example of just one of the formulas used in PhotoKit Sharpener for output sharpening. In this case I have shown Bruce Fraser's formula for sharpening a typical 300 pixel per inch glossy inkjet print output. You will notice that it mainly uses the High Pass filter combined with the Unsharp Mask filter to apply the sharpening effect. If you wish to implement this sharpening method, do make sure you have resized the image beforehand to the exact print output dimensions and at a resolution of 300 pixels per inch.

PhotoKit Sharpener

PhotoKit Sharpener is available from www. pixelgenius.com, from where you can obtain trial versions of this and other Pixel Genius products. There is also a special discount coupon at the back of the book as well as from the book website, which entitles you to a 10% discount. PhotoKit Sharpener provides Photoshop sharpening routines for capture sharpening, creative sharpening and output sharpening (inkjet, continuous tone, halftone and multimedia/ Web). The Camera Raw sharpening sliders are based on the PhotoKit Sharpener methods of capture sharpening, so if you have the latest version of Photoshop or Lightroom, you won't need PhotoKit Sharpener for the capture sharpening. If you have Lightroom 2 or later, you will find that the output sharpening for inkjet printing is actually built-in to the Lightroom Print module. Therefore, if you don't have Lightroom 2 or later, you'll definitely find the PhotoKit Sharpener output sharpening routines useful for applying the exact amount of output sharpening that is necessary for different types of print outputs and at different pixel resolutions.

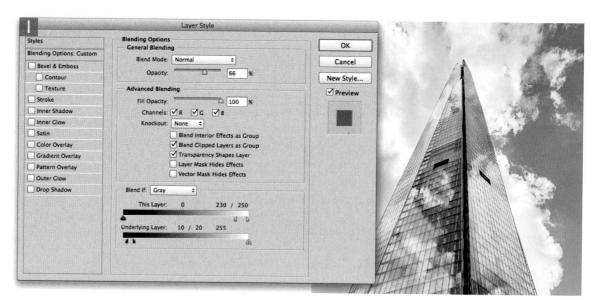

The sharpening method described here is designed for sharpening an inkjet print on glossy paper at 300 ppi. To begin with, I made a duplicate copy of the Background layer and set the layer opacity to 66%. I then double-clicked on this duplicate layer to open the Layer Style options and got the Blend If sliders to match the settings shown here.

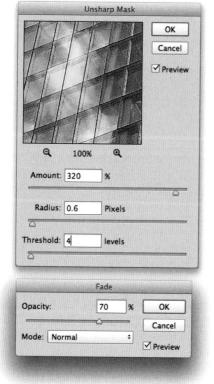

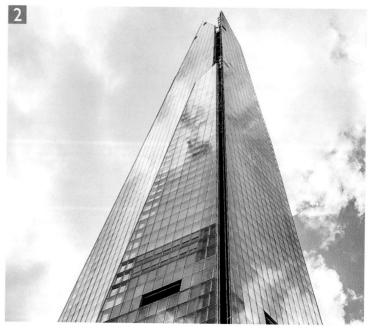

Next, I applied the Unsharp Mask filter to the layer using an Amount of 320, Radius of 0.6 and Threshold of 4. I then chose Edit ⇒ Fade, changed the blend mode to Luminosity and reduced the opacity to 70%.

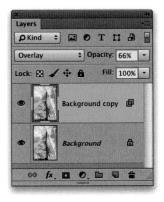

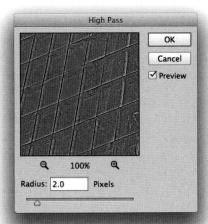

3 I changed the Layer blend mode from Normal to Overlay and went to the Filter menu, chose Other ⇒ High Pass filter and applied a Radius of 2 pixels. Here is a 1:1 close-up view of the sharpened image. Remember, you can't judge the sharpening by looking at the display, but you should be able to judge the effectiveness of the technique by how sharp the photograph appears here in print. Note that the sharpening layer here can be increased or decreased in opacity or easily removed and that the underlying Background layer remained unaffected by the preceding sharpening steps.

Overlay blend mode

When the sharpening layer was set to the Overlay blend mode this resulted in an isolation of the High Pass filter sharpening effect. This is because, when a layer is set to the Overlay blend mode, a neutral gray color will have no effect on the image, only those colors that are lighter or darker than neutral gray will have an effect.

Gamut warning

The View menu contains a Gamut Warning option that can be used to highlight colors that are out of gamut. The thing is, you never know if a highlighted color is just a little or a lot out of gamut. Gamut Warning is therefore a fairly blunt instrument to work with, which is why I suggest you use the soft proofing method described here.

Print from the proof settings

The Customize Proof condition is also important because when it is active and applied to an image, the Photoshop Print dialog can reference the soft proofed view as the source space. This means you can use the Customize Proof Condition to select a CMYK output space and the Photoshop Print dialog can allow you to make a simulated print using this proof space.

Soft proof before printing

Color management can do a fairly good job of translating the colors from one space to another, but for all the precision of measured targets and profile conversions, it is still essentially a dumb process. When it comes to printing, color management can usually get you fairly close, but it won't be able to interpret every single color or make aesthetic judgments about which colors are important and which are not. Plus some colors you see on the computer display simply can't be reproduced in print. This is where soft proofing can help. If you use the Custom Proof Condition dialog as described here, you can simulate on the display pretty accurately how the print will look when printed. Soft proofing shows you which colors are going to be clipped and also allows you to see in advance the difference between selecting a Perceptual or Relative Colorimetric rendering intent. All you have to do is to select the correct profile for the printer/paper combination that you are about to use, choose a suitable rendering intent and make sure Black Point Compensation and the Simulate Paper Color (and by default simulate black ink) are checked.

1 To begin with, I opened the image shown here, went to the Image menu and chose Duplicate... This created a duplicate copy image, which is shown here on the left next to the original on the right. In this screen shot you may already see a slight difference in tone contrast and color between the two. This is because I had applied the Customize Proof Condition shown in Step 2 to the original master image (seen here on the right).

2 To soft proof the master image I went to the View menu and chose Proof Setup

Custom... Here I selected a profile of the printer/paper combination that I wished to
simulate, using (in this case) the Relative Colorimetric rendering intent and with the
Simulate Paper Color option checked in the On-Screen Display Options.

Simulate paper color

Simulate Paper Color may often make the whites appear very blueish, which is most likely associated with optical brightener detection in the ICC profile. It is optional that you check this when carrying out a soft proof.

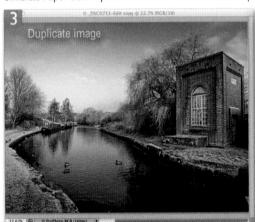

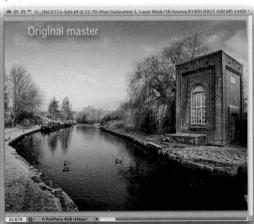

3 I now had a soft proof prediction of how the master file would print that could be viewed alongside a duplicate of the original image. The goal now was to add a Curves adjustment layer to tweak the tones (using the Luminosity blend mode) and a Hue/ Saturation adjustment to tweak the colors (using the Color blend mode). A few minor adjustments were enough to get the soft proofed master to match more closely to the original (which I was comparing here to the Duplicate image on the left).

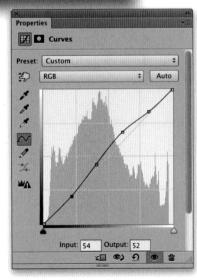

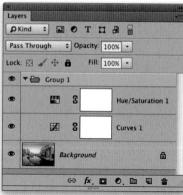

4 Here is the final version, which shows the corrected, soft proofed master image. When this corrected version was sent to the printer, one would expect the print output to match very closely to what was seen on the computer display. I recommend the correction adjustment layers be preserved by grouping them into a layer group. You will then be able to turn the visibility off before saving and only need to switch the layers back on again when you want to make further prints.

Managing print expectations

When you use soft proofing to simulate a print output your initial response can be 'eek, what happened to the contrast?' This can be especially true when you also include Simulate Paper Color in a soft proof setup. If we assume you are using a decent display and that it has been properly calibrated, the soft proof view should still represent an accurate prediction of the contrast range of an actual print compared to the high contrast range you have become accustomed to seeing on an LCD display (it's also a good idea to not have the luminance of the display set too high relative to the viewing environment, which may also lead to false expectations). One solution is to look away as you apply the soft proof preview so that you don't notice the sudden shift in the on-display appearance so much.

Making a print

There are just two Photoshop Print options File \Rightarrow Print...

(## P [Mac] ctrl P [PC]), which takes you directly to the Photoshop Print dialog and the File \Rightarrow Print One Copy command (# Shift P [Mac] ctrl all Shift P [PC]). You can use 'Print One Copy' should you wish to make a print using the current configuration for a particular image, but wish to bypass the Photoshop Print dialog.

The Photoshop print workflow is designed to make the print process more consistent between operating systems, as well as more repeatable. The operating system Page Setup option was removed from the File menu and is now accessed solely within the Photoshop Print dialog via the Print Settings button, from where you can manage all the remaining operating system print driver settings. The net result is that by incorporating both the Mac and PC operating system print drivers into the Photoshop Print dialog, the process of scripting and creating print actions is now more reliable. Previously, the vagaries of the operating system Print dialogs meant that it was not always possible to create print output actions that could work reliably on another system. Since the introduction of these improvements to the Photoshop Print workflow, the Photoshop print process can now be made more consistent.

Photoshop Print dialog

When you choose Print... from the File menu, this takes you to the Photoshop Print dialog shown in Figure 10.1. A number of improvements have been made to the Print dialog since Photoshop CS6. You can resize the dialog as big as you like to see an enlarged print preview and because of this you can now get a much clearer preview of what the print output will look like, especially when using the soft proof preview options. Also, when the Print dialog is enlarged you can easily access all the print controls at once from the panel list on the right. Plus you can now click on a button to open the selected printer Print Utility dialog. To begin with let's take a look at the Printer Setup options.

Printer selection

If you have just the one printer connected to your computer network, this should show up in the Printer list by default (circled in Figure 10.1). If you have more than one printer connected you can use this menu to select the printer you

Remembering the print settings

The settings you apply in the Photoshop Print dialog are included with the document after you click Print or Done and then save the file. So, if you open a document that you have printed before, you'll get to see the last settings that were used to print that document. If you open a document which hasn't been printed before, you get the last used print settings. If you hold the spacebar as you select File ⇒ Print, Photoshop ignores the Print Settings that may previously have been saved to that document. This allows you to specify the print settings from a fresh starting point. However, if your print settings are for a printer that is no longer available, everything gets reset to the default settings.

Solo panel opening

If you alt-click on a panel header this expands the selected panel contents and keeps all the others closed.

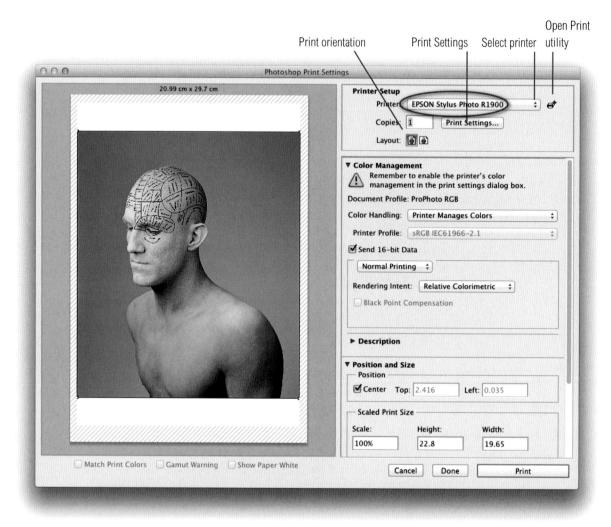

Figure 10.1 The Photoshop Print dialog, with the focus on the Printer Setup options.

Preview background color

The outer background color matches the canvas color set in the Photoshop Interface preferences (see pages 6–7). However, you can right-click on the outer background area to view the contextual menu and select a different background color if you like.

wish to print with. Below that are the Print Settings and print orientation buttons. Here, you need to click on the Print Settings button to open the operating system print driver dialog for Mac or PC and configure the desired print settings, specifying the paper size you intend to print with as well as the media type. In Figure 10.2, you'll see screen shots of the Mac OS Print dialog showing how to select the correct printer model and an appropriate paper size. Figure 10.3 shows the Windows 8 dialog, where in the Advanced panel section you can go to the paper size menu (circled) and do the same thing. Once you are done, you can click on the Save or OK button to return to the Photoshop Print dialog.

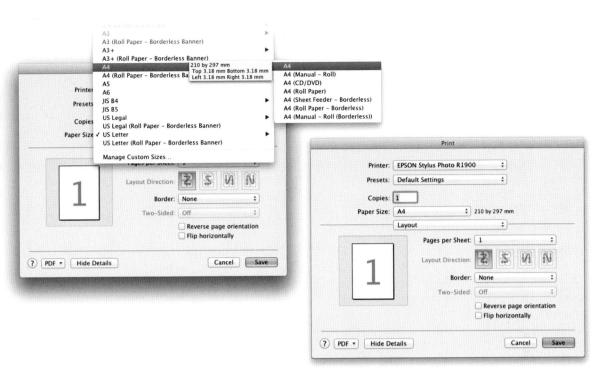

Figure 10.2 The Mac OS X Printer Settings, showing the paper size selection menu.

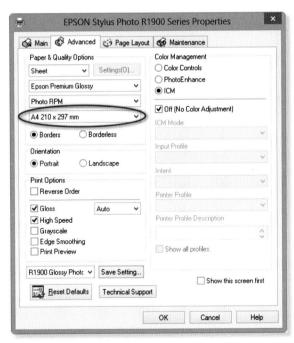

Figure 10.3 This shows the Windows 8 Printer Settings, with the Paper Size section circled.

No Color Management missing

The Color Management Color Handling options no longer include an option for printing with 'No Color Management'. This is due to the fact that updating the Mac code to Cocoa 64-bit made it problematic to retain the 'No Color Management' print route. This option was required for producing neutral target prints intended for reading and generating ICC profiles. However, you can download an Adobe Color Printer Utility from the Adobe website. This now allows you to print your print target files without applying color management. Here is the link to download: tinyurl.com/25onde3. Once you have used this to create custom profiles, these will need to be used with the 'Photoshop Manages Colors' option.

Color Management

Now let's look at the Color Management settings, which are shown in Figure 10.5, as well as close-up in Figure 10.4 below. In the Color Handling section you have the option to choose Printer Manages Colors or Photoshop Manages Colors. The former can be used if you want to let the printer driver manage the color output. If this option is selected the Printer Profile menu appears grayed out, as will the Black Point Compensation box, but it will be possible to select a desired rendering intent: either Perceptual or Relative Colorimetric (although not all printers will be able to honor this setting). It is also possible to select the 'Hard Proofing' option from the menu circled below when letting the printer manage the colors, but if this is your aim you should really choose the 'Photoshop Manages Colors' option to do this. Note, if you change printers in the Print dialog, the color management always switches to select 'Printer Manages Colors'. This default setting is most suitable for casual users of the Print dialog, but it's easy enough to change to 'Photoshop Manages Colors'.

When the 'Photoshop Manages Colors' option is selected the Photoshop Print dialog can be used to handle the print output color management. You will then need to mouse down on the Printer Profile menu. Here you need to select the printer profile that matches the printer/paper you are about to print with. It used to be the case that canned profiles were frowned upon as being inferior, but with the latest printer devices these

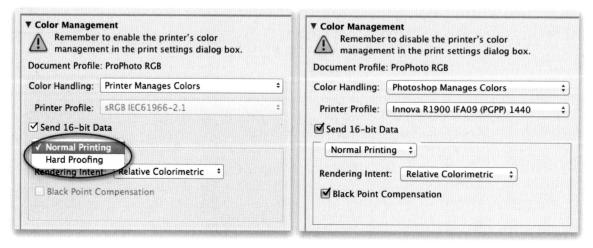

Figure 10.4 This shows the two Color Handling options: Printer Manages Colors or Photoshop Manages Colors.

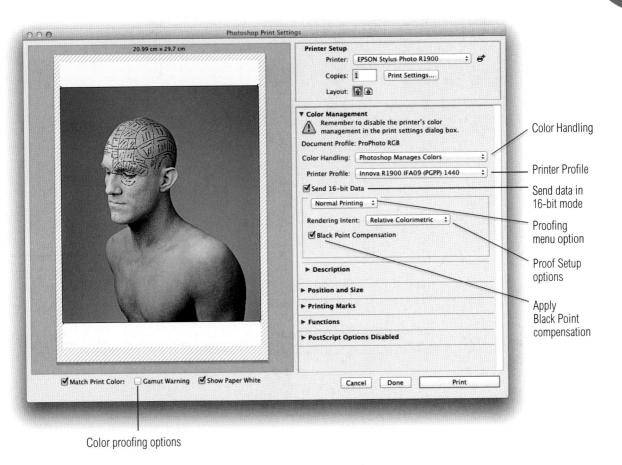

Figure 10.5 The Photoshop Print dialog, showing the Color Management options.

are now very consistent in print output and canned profiles should work pretty well, so you will usually be advised to use the manufacturer's own brand profiles for the papers that their printers support.

When you select the printer model in the Print Settings this also filters the ICC profiles that are associated with the printer, so these will appear at the top of the profile list (see Figure 10.6). A set of canned printer profiles should be installed in your System profiles folder at the same time as you install the print driver for your printer. If you can't find these, try doing a reinstall, or do a search on the manufacturer's website. Also, the printer selection and profiles are sticky per document, so once you have selected a printer and configured the associated print settings, these will be saved along with everything else in the document. So it is important to remember to always save after printing.

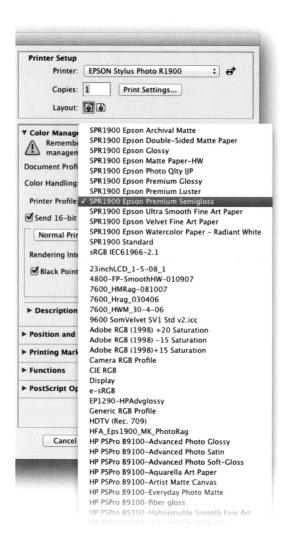

Figure 10.6 This shows the printer profile list, with the printer manufacturer profiles for the currently chosen printer placed at the top of the list.

Rendering intent selection

The rendering intent in 'Normal Printing' mode can be set to Perceptual, Saturation, Relative Colorimetric or Absolute Colorimetric. However, for normal RGB printing the choice boils down to a choice of just two settings. Relative Colorimetric is the best setting to use for general printing as this will preserve most of the original colors. Perceptual is a good option to choose when printing an image where it is important to preserve the detail in saturated color areas, or when printing a

photo that has a lot of deep shadows, or when you are printing to a smaller gamut output space, such as a fine-art matte paper. Whichever option you choose, I advise you to leave Black Point Compensation switched on, because this maps the darkest colors from the source space to the destination print space. Black Point Compensation preserves the darkest black colors and maximizes the full tonal range of the print output.

The Photoshop Print dialog preview can be color managed by checking the 'Match Print Colors' option (see Figure 10.5). You will notice that as you pick a printer profile or adjust the rendering intents you can preview on-screen what the printed colors will look like. When proofing an RGB output in this way you can also check the 'Show Paper White' option to see an even more accurate simulation, one that takes into account the paper color of the print media. There is even a Gamut Warning option, but as I pointed out on page 676, this isn't as useful as using the soft proofing method described earlier to gauge how your print output will look.

Hard Proofing

Earlier, in the Soft proof before printing section (pages 676–678), I described using the soft proof setup to predict how an RGB photograph might actually print via an inkjet or when printed in CMYK or any other print output space for which you have a profile. If the Hard Proofing option is selected in the Color management settings (circled), you'll see the options shown below in Figure 10.7.

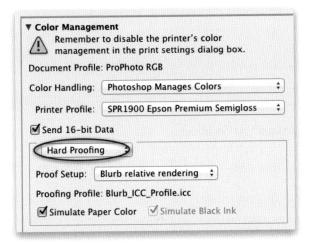

Figure 10.7 This shows the Color Management Hard Proofing options. In this example I used a custom proof setup created for Blurb book printing.

16-bit output

Image data is normally sent to the printer in 8-bit, but a number of inkjet printers now have print drivers that are enabled for 16-bit printing (providing you are using the correct driver and the 16-Bit Data box is checked in the Color Management section). There are certain types of images that may theoretically benefit from 16-bit printing and where using 16-bit printing may avoid the possibility of banding appearing in print, but I have yet to see this demonstrated. Let's just say, if your printer is enabled for 16-bit printing, Photoshop now allows you to send the data in 16-bit form (but only if the file you are attempting to print is in 16-bit, of course).

Overcoming dull whites

If you use the Hard Proofing option to produce a Hard Proof print output and you have the 'Simulate Paper Color' option selected, the whites may appear duller than expected when the print is made. This does not mean the proof is wrong, rather it is the presence of a brighter white border that leads to the viewer regarding the result as looking inferior. To get around this try adding a white border to the outside image you are about to print. You will need to do this in Photoshop by adding some extra white canvas. After making your print, trim away the outer 'paper white' border so that the eye does not get a chance to compare the dull whites of the print with the brighter white of the printing paper used.

Proof print or aim print?

If you are in a situation where someone asks you to produce RGB inkjet prints that simulate the CMYK print process, you can use the 'Hard Proofing' option to create what is sometimes referred to as a 'cross-rendered aim print'. This is not quite the same thing as an official 'contract proof' print, but a commercial printer will be a lot happier to receive a print made in this way, as a guide to how you anticipate the final print image should look when printed on a commercial press, rather than one made direct from an RGB image using the full color gamut of your inkjet printer.

When the Hard Proofing option is selected you'll need to select a proof setup setting from the Proof Setup menu. This is how you configure a printer to simulate a specific CMYK output when making a print. You may already have configured a custom proof setup via the Custom Proof Condition dialog (see Figure 10.8). If not you can go to the View menu, choose Proof Setup ⇒ Custom... and configure a custom setting. However, if a proof condition is already active for a document window (such as a standard CMYK preview or a custom proof setting) and you select the Hard Proofing option, this proof condition will be selected automatically. In the Photoshop Print dialog Color Management section (see Figure 10.8), the Simulate Black Ink is always checked by default, but you can also choose to check Simulate Paper Color when creating a hard proofing output. If you do this it is a good idea to ensure you include a white border when making a print (see sidebar).

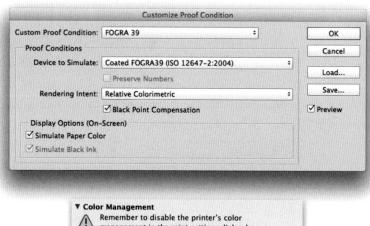

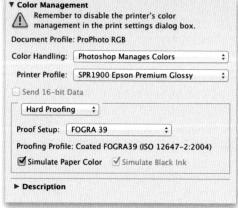

Figure 10.8 The View ⇒ Proof Setup ⇒ Custom Proof Condition dialog for screen viewing (top) and how these Custom Proof settings are interpreted in the Photoshop Print dialog Color Management section for print output (below).

Position and Size

You'll notice that the print preview is contained within a bounding box (Figure 10.9). You can position the image anywhere you like, by dragging inside the box, or scale it by dragging any of the bounding box handles. In the Position and Size section you can choose to center the photo, or precisely position it by entering measurements for the Top and Left margins. In the Scaled Print Size section, if the image overflows the currently selected page size, you can choose 'Scale to Fit Media'. This automatically resizes the pixel resolution to fit the page and the Print Resolution PPI adjusts accordingly. You can also enter a specific Scale percentage, or Height and Width for the image, but I don't advise you to do this unless you absolutely must. It is usually much better to resize the image in Photoshop first and print using a 100% scale size.

Heads up display in the Print dialog

As you drag the print preview you'll see a heads up display showing the precise position on the print page (see the move tool in use in Figure 10.10). Also, when dragging the preview corner handles the heads up display indicates the print dimensions.

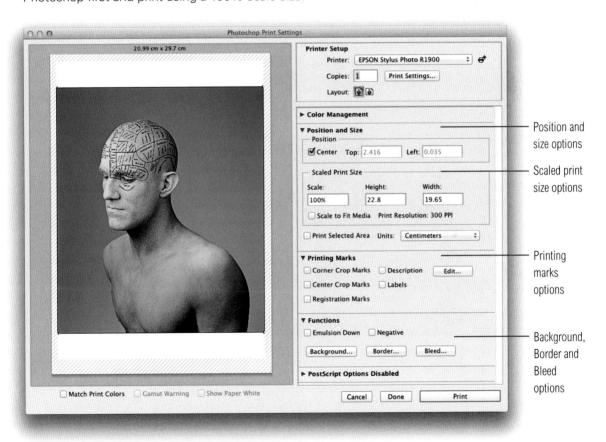

Figure 10.9 The Photoshop Print Dialog focusing on the remaining panel options.

Adjusting the print margins

If you hold down the aft key while dragging a margin for the print selected area, the opposite margin will move accordingly. So, if you aft drag the left margin, the right margin will move also. Hold down the ** (Mac), atri (PC) key to have all four margins move to match the drag made on one margin.

Printable area

Cropped

Print selected area

With most printers the printable area is restricted in the margins and the trailing edge at the bottom that is usually wider than the side and top margin edges. You can see this in Figure 10.10, where the printable area margin is indented more at the bottom than it is at the top and sides. You can't adjust these of course, but if the Print Selected Area option is checked (circled below) you can adjust the cropped print margin sliders to apply a crop via the Print dialog within the printable area. Or, if you have applied a selection in the image first, this automatically adjusts the margin sliders to crop the image accordingly. The thing to make clear here is that you are determining the area within the page that can be printed, rather than cropping the actual image itself (even though the end result appears to be the same thing). You can also mouse down on the print preview and click and drag the image relative to the crop using the move tool shown here.

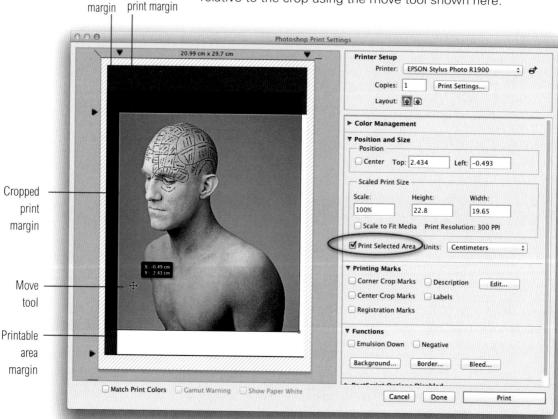

Figure 10.10 The Photoshop Print Dialog focusing on the Print Selected Area option.

Ensuring your prints are centered (Mac)

We would all love Photoshop printing to be simpler, but unfortunately there are no easy solutions and this is not necessarily Photoshop's fault. The problem is that there are a multitude of different printer devices out there and in addition to this, there are different operating systems, each of which has its own protocols as to how the system print dialogs should be organized.

Making sure a print is centered is just one of several problems that require a little user intervention. If you center a print in the Photoshop Print dialog, but it doesn't print centered, this is probably due to the default margin settings being uneven. The reason for this is that some printers require a trailing edge margin that is wider than all the other margins (see previous page). However, as I have shown in Figure 10.11 below, you can overcome this on the Macintosh system by creating your own custom paper size and margin settings.

Figure 10.11 In Mac OS X, click on the Print Settings... button in the Photoshop Print dialog and choose Manage Custom Sizes... from the Paper Size menu. In the Custom Page Sizes dialog check the margin width for the bottom trailing edge margin for the selected printer. If you want your prints to always be centered, all you have to do is to adjust the Top margin width so that it matches this Bottom measurement. Set a Width and Height for the new paper size and save this as a new paper size setting and add 'centered' so you can easily locate it when configuring the Page Setup or Paper Size settings.

Figure 10.12 The Border option allows you to add a black border and set the border size.

Figure 10.13 The Bleed option works in conjunction with the Corner Crop Marks option and determines how far to position them from the edge of the printed image.

Printing Marks

In this section you can select any extra items that you wish to see printed outside the image area. The Corner and Center Crop Marks indicate where to trim the image, while adding Registration Marks can help a printer align the separate plates. Checking the Description box will print any text that has been entered in the File \Rightarrow File Info box Description field, though you can also click on the Edit... button next to this and enter description text directly via the Photoshop Print dialog. Lastly, check the Labels box if you want to have the file name printed below the picture.

Functions

Click on the Background... button if you want to select a background color other than white. For example, when sending the output to a film writer, you would choose black as the background color. You can click on the Border... button to set the width for a black border (Figure 10.12), but just be aware that the border width can be unpredictable. If you set too narrow a width, the border may print unevenly on one or more sides of the image. The Bleed... button determines how much the crop marks are indented (Figure 10.13).

Figure 10.14 To save the PC system print settings as a preset, click on the Save Settings button in the Printer Properties dialog (see Figure 10.3) and click 'Save'.

Saving operating system print presets

Once you have established the operating system print dialog settings (as shown in Figures 10.2 and 10.3) for a particular printing setup, it makes sense to save these settings as a system print preset that can easily be accessed every time you want to make a print using the same printer and paper combination. To do this, apply the required print settings and save the settings via the Printer Properties/Print dialog and give the setting an appropriate name (see Figures 10.14 and 10.15).

Print output scripting

Since Photoshop CS5 the system print settings are applied *after* the Photoshop Print dialog. This means it is now possible to record a Photoshop action in which you select the printer model, the media size, type and orientation plus the system Print settings, followed by the Photoshop Print dialog settings. Once recorded, you can use this action to make print outputs with the click of a button (Figure 10.17). So while it is a shame that there is no current mechanism in Photoshop to create and save custom print settings, the ability to record the print output step as an action does at least provide one reliable method for saving the Photoshop print settings for future reuse. You can also convert such actions into Droplets (as shown below in Figure 10.16), where you can simply drag and drop a file to a droplet to make a print (I'll be discussing actions and droplets in Chapter 11).

Figure 10.16 You can automate the print process further. If you convert an action like the one shown in Figure 10.17 into a droplet, you can make it possible to simply drag and drop files to the droplet to initiate the desired print output. This allows you to bundle the printer model selection, the page setup, the media type and Photoshop print settings all into the one droplet/action.

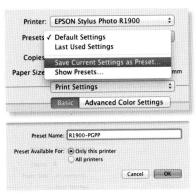

Figure 10.15 To save print settings on a Mac, choose 'Save Current Settings as Preset ...' via the system Print dialog Presets menu.

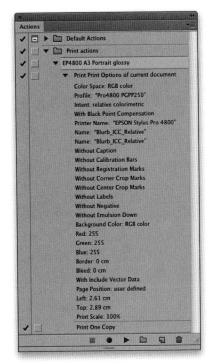

Figure 10.17 Photoshop actions can be used to record the complete print process. Once you have done this you can make further prints by simply replaying the action.

Print quality settings

In the Print settings, a higher print resolution will produce marginally better-looking prints, but take longer to print. The High Speed option enables the print head to print in both directions. Some people prefer to disable this option when making fine quality prints, but with the latest inkjet printers, the high speed option shouldn't necessarily give you inferior results.

Figure 10.18 This shows the Mac Print Settings for the Epson R1900 printer. In the Print Settings you will need to select a media type that matches the paper you are going to print with. Go to the Media Type menu and choose the correct paper. Next, you will want to select a print quality setting that might say 'Super-duper Photo' or 'Max Quality'. You may also need to locate an Off switch for the printer color management. This is because you do not need to make any further color adjustments. Note that with this particular driver it knows when you are choosing to print with the printer color management switched off and the 'Off (No Color Adjustment)' option is selected automatically. All you have to do now is click on the Save button at the bottom of the dialog to return to the Photoshop Print dialog from where you can click on the Print button to make a print.

Configuring the Print Settings (Mac and PC)

The following dialogs show the Mac and PC Print Settings dialogs for the Epson R1900 inkjet printer (Figures 10.18 and 10.19). In both the examples shown here, I wished to produce a landscape oriented print on a Super A3 sized sheet of Epson glossy photo paper using the best quality print settings and with Photoshop handling the color management.

The system print settings dialog options will vary a lot from printer to printer. As well as having Mac and PC variations, you might have a lot of other options available to choose from and the printer driver for your printer may look quite different. However, if you are using Photoshop to manage the colors, there are just two key things to watch out for. You need to make sure you select the correct media setting in the print settings and that you have the printer color management turned off. This may mean selecting 'No Color Adjustment' in the Print Settings or Color Management sections and you should ignore any of the other options you might see such as: 'EPSON Vivid' or 'Charts and Graphs'.

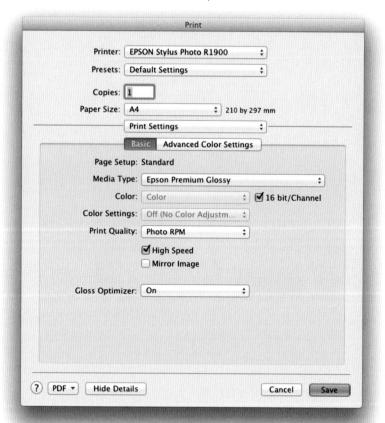

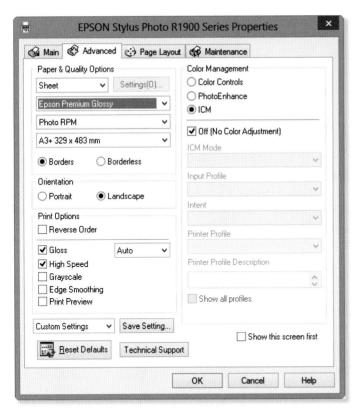

Figure 10.19 This shows the Windows 8 Print Settings for the Epson R1900 printer. Again, you will need to use the Media Type menu to select the correct paper to print with. For the Print Quality, select a high quality setting, such as the Photo RPM Quality setting selected here. In the Color management section I checked the ICM button and checked the Off (No Color Adjustment) box below to disable the printermanaged color management. Lastly, I clicked the OK button to return to the Photoshop Print dialog from where I could click on the Print button to make a print.

Photoshop managed color on Windows

When using 'Photoshop Manages Colors' on a PC system, the Photoshop Print dialog reads the JobOptimalDestinationColorProfile tag when selecting a default color profile. However, so far very few print drivers have got around to implementing this functionality. As and when such drivers do eventually ship, the printer will be able to better communicate with Photoshop as to which is the best profile, based on the media type you have selected.

Figure 10.20 Here is an example of an X-Rite color target that can be used to build an ICC color profile. The target file must be opened without any color conversion and sent directly to the printer without any color management and the print dimensions must remain exact. If it is necessary to resize the PPI resolution, make sure that the Nearest Neighbor interpolation mode is selected.

Replacing canned profiles

I don't have room to go into too much detail here, but on the Mac system at least, if you are familiar with using the ColorSync Utility, you can go to the Devices section, select a canned profile, click on the Current Profile name, choose Other... and select a custom profile to replace it with. This will allow you to promote a custom profile to appear in the filtered profile list for that printer.

Custom print profiles

As I have mentioned already, the profiles that are shipped with the latest inkjet printers can be considered reliable enough for professional print quality work (providing you are using the manufacturer's branded papers). If you want to extend the range of papers you can print with, then you will either have to rely on the profiles supplied by these paper companies or consider having a custom printer profile built for each paper type.

One option is to purchase a complete calibration kit package such as the X-Rite i1 Photo Pro 2 with i1Profiler software. The other alternative is to get an independent color management expert to build a profile for you. There are quite a few individuals who are able to offer these services, such as Andrew Rodney, who is based in the US (www.digitaldog.net). At the back of the book and also on the book website, you'll see that a company called colourmanagement.net are also offering a special coupon to readers that entitles you to a discount on their remote printer profiling services.

Remote profiling is a simple process. All you have to do is to follow the link to the provider's website, download a test target similar to the one shown in Figure 10.20 and follow the instructions closely when preparing a target print for output. The system print dialog settings used to produce the target print should also be saved so that exactly the same print settings can be used again when you then follow the steps outlined on pages 682–683.

You will then need to send the printed target to the supplied address, where the patch readings will be used to build an ICC profile that represents the characteristics of a particular paper type on your individual printer. You'll usually receive back an ICC profile via email.

The important points to bear in mind are that you must not color manage the target image when printing. The idea is to produce a print in which the pixel values are sent directly to the printer without any color management being applied. With previous versions of Photoshop you could do all this directly within the Photoshop Print dialog. However, since the CS5 version, Photoshop no longer has a 'No Color Management' print option. As I mentioned earlier on page 682, you should look out for the new *Adobe Color Printer Utility* from the Adobe website. You can use this to print out non-color managed print targets for custom profiling.

Chapter 11

Automating Photoshop

Getting to know the basics of Photoshop takes a few months, although it will take a little longer than that to become a fluent Photoshop user. One way you can speed up your Photoshop work is by learning how to use many of the various keyboard shortcuts. There are a lot of these in Photoshop, so it is best to learn a few at a time, rather than try to absorb everything at once. Throughout this book I have indicated the Mac and PC key combinations for the various shortcuts that are in Photoshop. While I have probably covered nearly all those one might use on a regular basis, there are even more shortcuts you can use. Most of these are listed in the Shortcuts table PDF, which is available from the book website. Or, you can go to the Keyboard Shortcuts dialog in the Photoshop Edit menu to see what's available.

Sourcing ready-made actions

When you first install Photoshop you will find some actions are already loaded in the Default Actions Set and you can load more by going to the Actions panel fly-out menu and clicking on one of the action sets in the list (see Figure 11.1). There are also many more Photoshop actions that are freely available on the Internet. A useful starting point is the Adobe Add-ons site: creative.adobe.com/addons. This provides access to lots of extras for Photoshop, including Photoshop actions.

Figure 11.1 Here is the Actions panel showing the panel fly-out menu options. You can easily add more action sets to the Actions panel via this list.

Working with Actions

You can record a great many operations in Photoshop using actions. Photoshop actions are application scripts you can use to record a sequence of events that have been carried out in Photoshop and any actions recorded this way can then be replayed on other images. If there are certain image processing routines you regularly need to carry out when working in Photoshop, recording an action can save you the bother of having to laboriously repeat the same steps over and over again on subsequent images. Not only that, but you can also use actions to batch process multiple images.

A new action must always be saved within an action set in the Actions panel. Such action sets can then be saved and shared with other Photoshop users so that they too can replay the same recorded sequence of Photoshop steps on their computers.

Playing an action

The Actions panel already contains a set of prerecorded actions called *Default Actions.atn*. If you go to the Actions panel flyout menu you can load other sets from the menu list such as: 'Frames', or 'Image Effects' (Figure 11.1). To test these out, open an image, select an action from the menu and press the Play button. Photoshop then applies the recorded sequence of commands to the selected image. However, if the number of steps in a complex action exceeds the number of available histories there will be no way to completely undo all the commands once an action has completed. As a precaution, I suggest you either take a Snapshot via the History panel or save the document before executing an action. If you are not happy with the result of an action, you can always go back to the saved snapshot in History or revert to the last saved version.

The golden rule when replaying an action is 'never do anything that might interrupt the progress of the action playback in Photoshop'. If you launch an action in Photoshop you must leave the computer alone and let Photoshop do its thing. If you click on the finder while an action is in playback mode this can sometimes cause an action to fail.

Photoshop Actions are always appended with the .atn file extension and saved by default to the Photoshop Actions folder inside the Photoshop Application Presets folder, but you can store them anywhere you like. If you want to install an action

that you have downloaded or someone has sent to you, all you have to do is double-click it and Photoshop will automatically load the action into the Actions panel (and launch Photoshop in the process if the program is not already running at the time).

Recording actions

To record an action, you'll first need to open a test image to work with and you must then create a brand new action set to contain the action (or use an existing set, other than the Default Actions set). Next, click on the Create new action button at the bottom of the Actions panel (Figure 11.2), which adds a new action to the action set. Give the action a name before pressing the Record button. At this stage you can also assign a custom keystroke using the Function keys (F1—F5) combined with the Shift and/or (Mac), CIII (PC) keys. You will then be able to use the assigned key combination to initiate running a particular action. Now carry out the Photoshop steps you wish to record and when you have finished click the Stop recording button.

When recording a Photoshop action, I suggest you avoid recording commands that rely on the use of named layers or channels that may be present in your test file, as these will not be recognized when the action is applied to a new image. Also try to make sure that your actions are not always conditional on starting in a specific color mode, being of a certain size, or being a flattened image. If the action you intend recording is going to be guite complex, the best approach is to carefully plan in advance the sequence of Photoshop steps you intend to record. A Stop can always be inserted in an action, which will then open a message dialog at a certain point during playback (see page 701 and Figure 11.5). This can be used to include a memo to yourself (or another user replaying the action), reminding what needs to be done next at a certain stage in the action playback process. Or, if the action is to be used as a training aid, a Stop message could be used to include a teaching tip or comment.

As I mentioned already, if you want to save an action, it must be saved within an action set. So if you want to separate out an action and have it saved on its own, click on the Create new set button in the Actions panel to create a new set, drag the action to the set, name it and choose Save Actions... from the Actions panel fly-out menu (the action set must be highlighted, not the action). The following steps show how to record a basic action.

A: This Action Set contains inactive actions.

B: Indicates one or more action steps are inactive and contains a Pause.

C: An active step.

D: An active step with a Pause which will open a dialog box.

E: An active step with a Stop which will open a message dialog.

F: An inactive step.

Figure 11.2 The Actions panel column showing the different action state icons.

Descriptions of all actions

If you hold down the # (Mac),

ctrl alt (PC) keys as you choose Save

Actions... this saves the text descriptions of
the action steps for every Photoshop action
currently in the Actions panel.

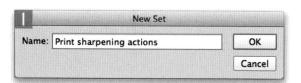

Here, I wanted to show a practical example of how to create an action, by showing how the print sharpening steps starting on page 674 could be recorded as an action. The first step was to create a new action set. To do this, I clicked on the Create new set button (see Figure 11.2), named this 'Print sharpening actions' and clicked OK.

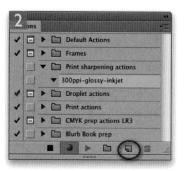

I then clicked on the Create new action button (circled) in the Actions panel, named this action '300ppi-glossy-inkjet' and clicked the 'Record' button.

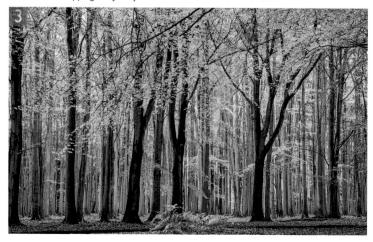

I then used a sample image to apply all the steps described on pages 674–675.

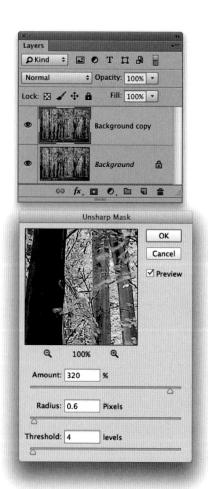

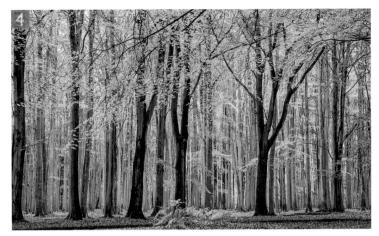

4 When I had finished recording all the steps, I clicked the Stop button to end the recording. In the Actions panel view shown on the right you can see a fully expanded list of all the steps, including the settings used. This action could then be applied to other images by clicking on the Play button, or could be applied as a batch action process. You can also switch the Actions panel to Button mode (Figure 11.3), which makes the actions playback selection even simpler.

Troubleshooting actions

If an action doesn't seem to be working, first check that the image to be processed is in the correct color mode. Many actions are written to operate in RGB color mode only, so if the starting image is in CMYK, the color adjustment commands won't work properly. Quite often, assumptions may be made about the image data being flattened to a single layer. One way to prevent this from happening is to start each action by using the all shortcut (to select the top-most visible layer), followed by the Merge Visible to new layer shortcut (**Shift**E* [Mac], cirl all Shift**E* [PC]). These two steps will add a new, flattened merged copy layer at the top of the visible layer stack. Some pre-written actions require that the start image fits certain criteria. For example, the Photoshop-supplied 'Text Effects' actions require that you begin with an image that contains layered text and with a text layer selected.

If you have just recorded an action and are having trouble getting it to work, you can inspect it command by command. Open a test image, expand the action to display all the items, select the first step in the action, hold down the (Mac), (PC) key and click on the Play button. This allows you to play the action one step at a time. You need to have the (Mac), (PC) key held down and keep clicking the

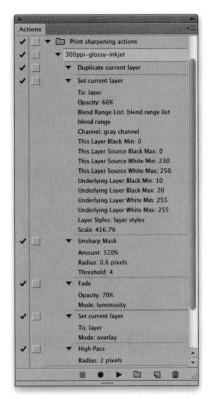

Figure 11.3 This shows the Actions panel in Button mode, where all you have to do is click on a button to initiate a recorded action (like the 300ppi-glossy-inkjet action circled above).

Recording ruler units

For actions that involve recording the placement of objects or drawing of marquee selections, it is a good idea to record setting the ruler units as part of the action. If you go to the Photoshop preferences and choose 'Units & Rulers', you can set the rulers to 'Percentage'. By recording this as part of an action, any subsequent placement of Photoshop guides, placement of the type tool or use of the marquee tools can be recorded relative to the proportions of the document. When you then replay an action, the action should work effectively no matter what the size or proportions of the image.

Volatile actions

One thing you have to be aware of is that although actions will remain stored in the Actions panel after you guit Photoshop, a newly installed or created action can easily become lost should you suffer a computer or program crash before you quit. Photoshop Actions can also become lost if you trash the Photoshop preferences or uninstall Photoshop. It is therefore always a good idea to take the precaution of saving any newly created or newly edited action sets so you don't lose them. These can be saved anywhere you like, but they ideally need to be stored in the Username/ Library/Application Support/Adobe/Adobe Photoshop CC/Presets/Actions folder (Mac), or Username\AppData\Roaming\ Adobe\ Adobe Photoshop CC\Presets\ Actions folder (PC), if they are to be seen listed at the bottom of the Actions panel fly-out menu (see Figure 11.1).

Play button to run through the remaining steps. If there is a problem with one of the action steps then double-click the relevant action step in the list to rerecord it. You will then need to make sure that action step is selected, keep the (Mac), (PC) key held down again and click on the Play button to continue.

Limitations when recording actions

Most Photoshop operations can be recorded as an action, such as image adjustments, History panel steps, filters, and most Photoshop tool operations, although you should be aware that tools such as the marquee and gradient fills are recorded based on the current set ruler unit coordinates (see sidebar on recording ruler units). If you go to the Actions panel menu and check the 'Allow Tool Recording' item, this does allow things like brush strokes to be recorded as part of an action now.

Actions only record changed settings

One of the problems you commonly face when preparing and recording an action is what to do if certain settings are already as you want them to be. Actions only record a setting as part of an action if it actually changes something. For example, let's say you are recording an image size adjustment where you want the image resolution to end up at 300 pixels per inch, but the image is already defined in the Image Size dialog as being 300 pixels per inch. In these situations, Photoshop won't record anything. To resolve a problem like this you must deliberately make the image resolution something different before you record a 'set image resolution' step. Then, when you change the pixel resolution, this will get recorded. For example, while recording, you could go to the Image Size dialog and temporarily make the image, say, 200 pixels per inch (without resampling the image), then record setting the resolution to 300 pixels per inch. When you are finished recording, delete the 200 pixels per inch step from the completed action.

Background layers and bit depth

The lack of a Background layer can also stop some actions from playing. There is not always much you can do about this, other than to convert the current base layer to a Background layer by choosing Layer \Rightarrow New \Rightarrow Background from Layer before playing the action. This isn't always advisable since you wouldn't want to accidentally flatten all the layers in an important image. Alternatively, you could make a flattened

duplicate of the current image and then run the action. You may also want to check the bit depth of the image you are applying the action to. If the bit depth is 16-bit, not all Photoshop filters will work and you will need to convert the photo to 8-bits per channel mode first.

Layer naming

Action recordings should be as unambiguous as possible. For example, if you record a step in which a named layer is brought forward in the layer stack, in playback mode the action will look for a layer with exactly the same name. Therefore, when adding a layer include the naming of the layer as part of the action (but don't use Layer 1, Layer 2, etc., as this may only cause confusion with Photoshop's default layer naming). Also, use the main Layer menu or Layer key command shortcuts to reorder the layer positioning. Doing this will make your action more universally recognizable.

Inserting menu items

There are some things which can be added as part of a Photoshop action that can only be included by forcing the insertion of a menu item. For example, Photoshop doesn't record zoom tool or View menu zoom instructions. However, if you select 'Insert Menu Item' from the Actions panel fly-out menu, as you record an action, you will see the dialog shown in Figure 11.4. The Menu Item dialog will initially say None Selected, but you can now choose, say, a zoom command from the View menu and the zoom instruction will be recorded as part of the action, although frustratingly the image won't actually zoom in or out until you replay the action! I often use the Insert Menu Item as a way to record actions that open certain Photoshop dialogs that I regularly need to access, such as the various Automated plug-ins. This saves me having to navigate the Photoshop menus to access them.

Figure 11.4 The Insert Menu Item dialog will initially say None Selected. You can then select a menu item such as Window ⇒ Arrange ⇒ Tile All Vertically, and click OK. When the Action is replayed the inserted menu item will be included in the playback list.

Tutorial Builder

Over on the labs.adobe website is an interesting tool called Tutorial Builder: labs.adobe.com/technologies/tutorialbuilder/. Currently at version 3, this allows you to record steps carried out in Photoshop and compile these as ready made, step-by-step Photoshop tutorials. Also included is the code required to replay each step using the Touch SDK to replay the steps in Photoshop via a mobile device.

Stops and Pauses

When editing an action, you can insert what is known as a Stop. This allows you to halt the action process to display an alert message. This could be a useful warning like the one shown in Figure 11.5, which could be displayed at a key point during the action playback. If you click in the Stop/Pause column space to the left of the action step, next to a step where a dialog can be shown, you can instruct Photoshop to open the dialog at this point (see the red icons in the Stop/Pause column in Figure 11.2). This allows you to custom edit the dialog box settings when playing back an action.

Figure 11.5 The Record Stop dialog.

'Override Action "Open" Commands'

If there is a recorded 'Open' item, such as an ACR processing step in an action, checking 'Override Action "Open" Commands' overrides popping the ACR dialog for each image and simply applies the ACR processing. However, if you check this and there is no open step recorded in the action, this will prevent the action from running.

Batch processing actions

One of the great advantages of actions is having the ability to batch process images. The Batch dialog (Figure 11.6) can be accessed via the File ⇒ Automate menu, plus it can also be accessed via the Tools ⇒ Photoshop menu in Bridge. You first need to select an action set and action from the Play section and then you'll need to set the Source and Destination. The Source can be all currently open images, the selected images in the Bridge window, an Import source, or a specific folder, in which case, you'll need to click on the Choose... button below and select a folder of images. The following items in the Source section will only show if the Folder or Bridge options are selected. These allow you to decide how to handle files that have to be opened first in Photoshop before applying an action. The 'Override Action "Open" Commands' is a tricky one to understand (see sidebar), but basically, most of the time you'll want to leave this unchecked. Only check the 'Include All Subfolders' option if you want to process all the subfolders within the selected folder. If you are processing a bunch of

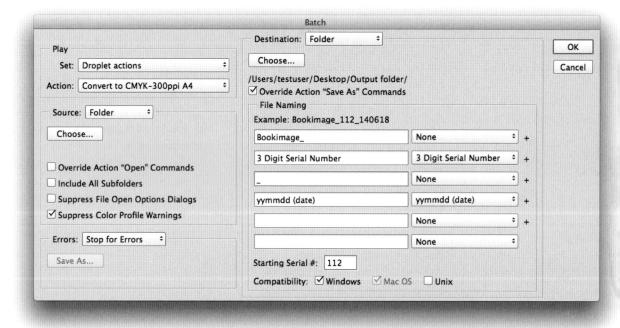

Figure 11.6 This shows an example of the Batch Action dialog set to apply a prerecorded action. The 'Windows' box has been checked here to ensure file naming compatibility with PC systems.

raw files and wish to override seeing the ACR dialog then do check the 'Suppress File Open Options Dialogs' option. Lastly, if you want to prevent the Missing Profile and Profile Mismatch dialogs appearing when you batch process images, check the 'Suppress Color Profile Warnings' option. As a consequence of doing this, if there is a profile mismatch, Photoshop checks what you did previously. If you previously chose to keep the image in its own profile space, then this is how the images will be batch processed. If there is no profile present, Photoshop checks to see if your previous preference was set to: Ignore, Assign a profile, or Assign and convert to the working space, and acts accordingly. If 'Stop For Errors' is selected, this halts the batch processing in Photoshop any time an action trips up over a file for some reason. You can prevent this by selecting the 'Log Errors to File' option instead. This allows the batch processing to complete, but creates a log report of any files that failed to process.

In the Destination section you have three options. If you choose 'None', Photoshop processes the selected files and leaves them open. If you choose 'Save and Close', Photoshop does just that and overwrites the originals, and if you choose 'Folder', you'll need to click on the Choose... button to select a destination folder.

Now it might so happen that the action you have selected to run the batch process with may contain a Save or Save As command that uses a specific file format and format settings, and this action step will contain a recorded Save destination. It might be the case that the Save destination is an important part of the action, but if the destination folder no longer exists, the action will fail to work (besides, you can specify a destination folder within the Batch dialog itself). So in the majority of instances, where the action contains a Save instruction, I recommend you check the 'Override Action: "Save As" Commands' checkbox. If the action does not contain a Save or Save As command, then leave this option unchecked.

If a folder is selected as the destination, you can use the file renaming fields below to apply a renaming scheme to the processed files. You can use any combination you like here, but if you select a custom file extension option this must always go at the end. The file naming options also let you define the precise numbering of the batch processed files. As you edit the fields, you will see an example of how the naming will work in the 'Example:' section above (Figure 11.7 shows the complete list of naming and numbering options).

Customized file naming

It is easy to customize the File Naming with your own fields. In Figure 11.6, I created a batch process where the images were renamed 'Bookimage_' followed by a three digit serial number, followed by an underscore '_' and with the date expressed as: year; month; and day. Note that the numbering was set to start at '112'. So in this example the file name structure would be as follows: Bookimage 112 140618.

√ Document Name document name DOCUMENT NAME 1 Digit Serial Number 2 Digit Serial Number 3 Digit Serial Number 4 Digit Serial Number Serial Letter (a, b, c...) Serial Letter (A, B, C...) mmddyy (date) mmdd (date) yyyymmdd (date) yymmdd (date) yyddmm (date) ddmmyy (date) ddmm (date) extension **EXTENSION** None

Figure 11.7 The Batch interface naming and numbering options.

Migrating presets

The initial preset migration has been refined in Photoshop CC. To start with the preset migration no longer requires you to restart the computer and only migrates presets from the last installed version of Photoshop (instead of all previous installed versions). The preset migration now migrates settings from both the user library Presets folder as well as the Photoshop application Presets folder. It now also migrates all active presets as well as any non-loaded presets that are around.

Exporting and importing presets

When you initially installed Photoshop, you may have noticed a dialog asking 'Would you like to migrate presets from the following versions?' In that dialog the most recent previous version of Photoshop appeared listed (see page 2). This allowed you to automatically import the preset settings that were contained in your old version of Photoshop. If you ignored this dialog and clicked 'No', you can go to the Edit Presets... This opens the dialog shown below in Figure 11.8. In Import Presets mode, select the Presets folder from your old version of Photoshop and click on an arrow to add selected presets to the list on the right (or click 'Add All'), then click 'Import Presets'. In Export Presets mode, select presets from the list on the left and click on an arrow to add these to the list on the right (or click 'Add All'), then click 'Export Presets'. This will allow you to create an 'Exported Presets' folder that contains a subset of presets folders, mirroring what was in the original Presets folder.

Figure 11.8 This shows the Export/Import Presets dialog.

Creating a droplet

Photoshop actions can also be converted into self-contained, batch processing applications, known as droplets, which can play a useful role in any production workflow. When you drag a document or a folder on top of a droplet icon this launches Photoshop (if the program is not already running) and initiates the action sequence contained within the droplet. The beauty of droplets is you only need to configure the batch processing settings once and they'll then be locked into the droplet. Droplets can be stored anywhere you like, although it makes sense to have them readily accessible such as in an easy-to-locate system folder (see Figure 11.9). Droplets can perform Save and Close operations (overwriting the original), or can be configured to save the processed images to an accompanying folder as a new version of the master image.

To make a droplet, go to the File ⇒ Automate menu and choose Create Droplet... Figure 11.10 shows the Create Droplet interface and you will notice that the Create Droplet options are identical to those found in the aforementioned Batch Actions dialog. Choose a location to save the droplet to and, if required, you can also choose a destination folder for the droplet processed files to be saved to. When you are done, click OK.

Cross platform droplets

You can name a droplet anything you like, but if a droplet is created on a Mac you'll need to add a .exe extension for it to be PC compatible. If you are a Mac user and someone sends you a droplet that was created using a PC, it can be made Mac compatible by dragging it on top of the Photoshop application icon first to convert it.

Figure 11.9 Photoshop Droplets (shown here with output folders).

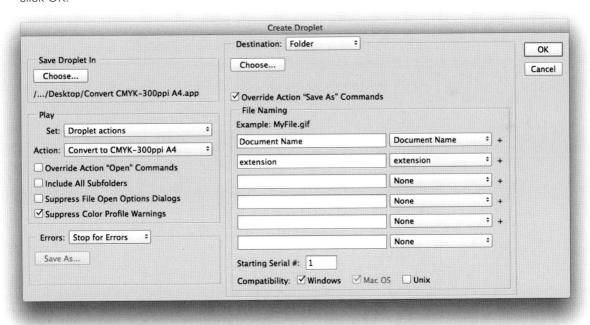

Figure 11.10 This shows the Create Droplet dialog.

Conditional Actions

The CS6.1 update introduced conditional actions, which can be inserted into regular actions.

Essentially what you can do is create a new action and choose 'Insert Conditional...' via the Actions panel fly-out menu. From there, you can choose a condition from the menu shown in Figure 11.12 to determine which action will be played if this condition is met. If not, you can choose an action from the Else menu to play instead. Only actions that are included within the current action set will be displayed in the 'Then' and 'Else' pop-ups. Note that if both menus are left set to 'None', no conditional action will be created because the resulting action would do nothing.

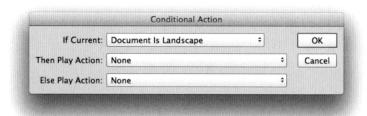

Figure 11.11 The new Conditional Actions dialog.

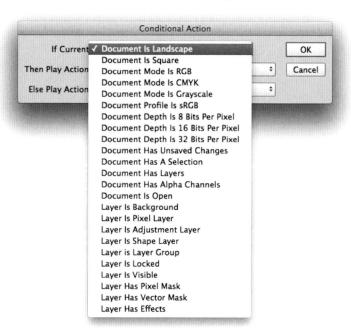

Figure 11.12 The new Conditional Actions dialog showing all the available conditional action options.

Conditional action droplets

A conditional action can be included in batch or droplet operations. The following steps show how.

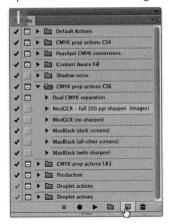

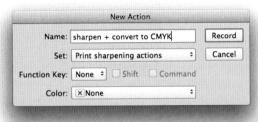

1 I went to the Actions panel, expanded an existing Action set and clicked on the Create New Action button to create a new action, called 'sharpen + convert CMYK'.

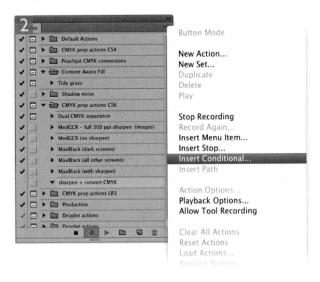

2 I then went to the Actions panel fly-out menu and selected 'Insert Conditional...'

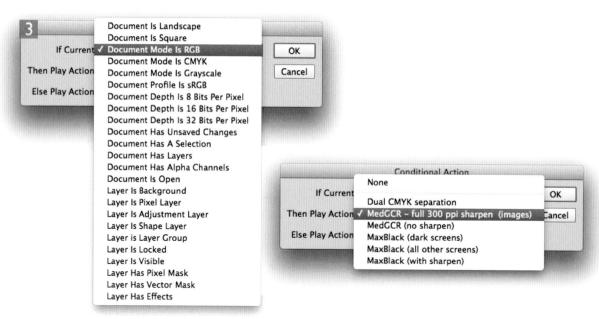

3 My aim here was to create a conditional action that was able to filter out the RGB images only to apply a 'convert from RGB to CMYK' action that also included an output sharpening step. In the 'If Current' menu I selected 'Document Mode is RGB'. Then, from the 'Then Play Action' menu I selected the appropriate action from the same parent Actions folder. I left the 'Else Play Action' menu set to 'None'.

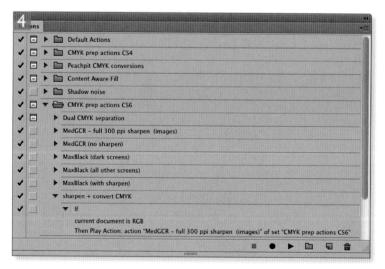

4 Here you can see an expanded view of the Actions panel after creating the above conditional action. The action that's being called here is one that was designed to process RGB images only, which would otherwise fail to run if applied to an image already in CMYK mode. So, using this inserted conditional item it would only process files that were in RGB mode and leave the CMYK files untouched.

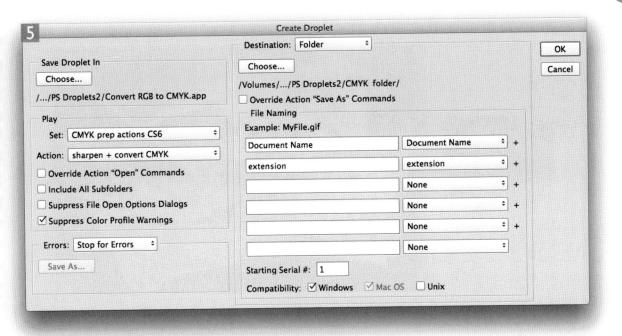

5 I was now ready to put the conditional action to use. I went to the File menu in Photoshop and chose Automate ⇒ Create Droplet... This opened the dialog shown here which I configured so that a new droplet was added to a special folder I keep all my droplets in and saved the processed files to a destination folder called 'CMYK'.

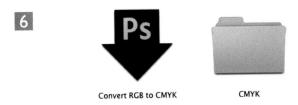

6 I clicked OK in the Create Droplet dialog to create the droplet and folder shown here. I was now able to test the new droplet. I made a selection of files that were a mixture of RGB and CMYK images. I dragged these across to the droplet and Photoshop knew to process all the RGB files and ignore the CMYKs. Without a conditional action a droplet like this would trip up on the CMYK files and display an alert message asking me if I wanted to stop or continue. With conditional actions you can avoid distracting dialog messages that would otherwise halt an automated batch process.

Preparing JPEGs for the Web

When you are preparing images that are destined to be shared by email or published via the Web, the Image Processor is a handy tool to use because you can not only resize the images as part of the image processor to convert the image from its current profile space to sRGB, which is the ideal RGB space for general purpose Web viewing.

Figure 11.13 This shows the Image Processor (formerly known as Dr. Russell Brown's Image Processor). This Scripting dialog can be configured to process single or multiple images, apply Photoshop actions, add copyright info and save the files to a designated folder location in one or more of the following file formats: JPEG, PSD or TIFF. The destination folder will contain the processed images and these will be separated into folders named according to the file formats selected. Once configured, you can click on the Save... button to save these settings and load them again at a future date.

Image Processor

The Image Processor (Figure 11.13) is located in the File \Rightarrow Scripts menu in Photoshop and can also be accessed via the Tools \Rightarrow Photoshop menu in Bridge. The Image Processor is a fine example of what Scripts can do when they are presented via an easy-to-use interface. The Image Processor basically allows you to select a folder of images (or select all open images) to process and select a location to save the processed files to. The Image Processor can then be configured to run a Photoshop action (if required) and save the processed files using either the JPEG, PSD or TIFF file formats. However, it also allows you to simultaneously process and save files in multiple file formats. This can be very handy if you wish to produce, say, both a TIFF version at high resolution and a JPEG version ready to place in a web page layout.

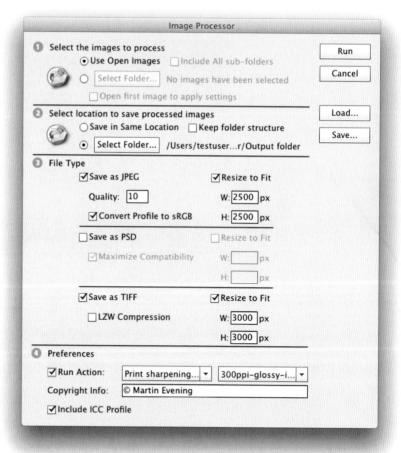

Scripting

One of the most neglected aspects of Photoshop has been the ability to write scripts that automate the program. For most of us, the prospect of writing scripts is quite scary and I freely confess I am one of those who has looked at the scripting manuals and simply shuddered at the prospect of having to learn computer code. Steps have been taken though to make scripting more accessible to the general user. You can start by referring to the Photoshop Scripting Guide and other PDF documents about scripting that can all be found at: www. adobe.com/devnet/photoshop/scripting.html. You can also download pre-made scripts from the Adobe Add-ons website: creative.adobe.com/addons.

To start with, go to the Scripts menu in the Photoshop File menu (Figure 11.14). There you will see a few sample Scripts that are readily available to experiment with. Among these is a script called 'Export Layers to Files' (Figure 11.15). This can be used to generate separate file documents from a multi-layered image. Other scripts I like to use include the Load Files into Stack..., which I find useful when preparing images for stacks image processing or before choosing Edit

Auto-Align layers.

Script Events Manager

The Script Events Manager can be configured to trigger a Javascript, or an action in Photoshop whenever a particular operation is performed. Figure 11.16 shows a simple example of what can be done using the Script Events Manager.

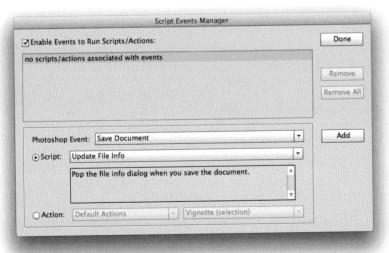

Figure 11.14 The Photoshop Scripts menu.

Figure 11.15 An example of the Export Layers to Files... script dialog.

Figure 11.16 The Script Events Manager is located in the File ⇒ Scripts menu. The dialog shown here has been configured to trigger popping the File Info dialog whenever a document is saved.

Figure 11.17 The Crop and Straighten Photos plug-in can be used to extract scanned photos that need to be rotated and cropped.

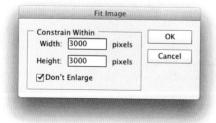

Figure 11.18 The Fit Image dialog.

Automated plug-ins

The Automation features described on this page are examples of Automated plug-ins. What distinguishes these from normal plug-ins is they enable Photoshop to perform a complex set of procedures based on simple user input. Adobe has also made Automated plug-ins 'open source', which means it is possible for third-party developers to build their own Automated plug-ins for Photoshop. I believe that Pixel Genius (of which I am a co-founder) is so far the only company who has made use of this feature in Photoshop to produce the PhotoKit, PhotoKit Sharpener and PhotoKit Color Automated plug-ins.

Crop and Straighten Photos

This Automated plug-in is very straightforward to use, if you have scanned images that need to be rotated and cropped. You can gang up several images at once on your scanner, scan the pictures in as one image and choose Crop and Straighten Photos from the Automate submenu (note, this option is not available in Bridge). Photoshop then creates a rotated and cropped copy version of each picture (Figure 11.17). It kind of works, but only if the background has a reasonably solid color. Crop and Straighten therefore works best if the border is a clear white or black. If Crop and Straighten fails to work on all images at once, it sometimes helps if you make a selection around the individual images first and process them one by one.

Fit Image

Fit Image... is a very simple Automated plug-in that allows you to bypass the Image \Rightarrow Image Size menu item (Figure 11.18). It is well suited for the preparation of images for screen-based design work. You enter the pixel dimensions you want the image to fit to, by specifying the maximum pixel width or height. Note that if you enter the same pixel dimensions for the width and height, Fit Image can be used to simultaneously batch process landscape and portrait format images. Note here that scripts can be made to call other scripts and it is often useful to include Fit Image within a more complex script, or as part of a recorded action sequence.

Index

3D engine 666 3DL 382 3DLUT profiles 380, 382 3D postcard 666

16-bit 345 color space selection 346 32-bit 430, 436

Exposure 15 32-bit filters 617

Symbols

32-bit filters of

ACR compatible cameras 216 Acrobat format (PDF) 80 Actions 691, 696–703 actions panel 64 allow tool recording 64 actions sets 696–697 and background layers 700

> and bit depth 700 batch actions 64, 702–703 customized file naming 703

destination options 703 file naming options 703 handling save commands 703

override open commands 702 override save as 703

selecting the source 702

suppress color profile warnings 703 suppress file open dialogs 703

button mode 699

conditional actions 706–709

conditional action droplets 707–709 create new action 697–698 creating droplets 705

default actions 696 editing actions 700

history panel steps 700 including text 699

inserting a pause 697, 701 inserting a stop 697, 700–701

inserting menu items 701 inspecting actions 699

interrupting playback 696

layer naming 701

limitations of actions 700 log errors to file 703 override open commands 702 playing an action 696, 699

ready-made actions 696

recording actions 697–700

recording changed settings 700 recording ruler units 700

safeguarding actions 700

saving actions 697

save actions descriptions 697

sourcing actions 696 stop and pause 701

stop for errors 703 stop recording 699

troubleshooting actions 699

volatile actions 700 Activating Photoshop 2

Adaptive Wide Angle filter

See Filter menu

ADC 90

Add anchor point tool 52

Adjustment layers

See Image adjustments
Adjustments panel 351, 410–411, 493
auto-select targeted adjustment 358

reset adjustment 353 Adobe Add-ons 696–697

Adobe Color Printer Utility 682, 694

Adobe DNG Converter 220

Adobe Drive 15

Adobe Edge Reflow 571

Adobe ID 2

Adobe Lens Profile Creator 653-655

and Auto-Align 653

browse Adobe Lens Profile Creator online 653

interpolating lens profiles 653

Adobe Lens Profiles 188

Adobe Online 21

Adobe PDF 80

Adobe Reader 80

Adobe RGB 348–349

Adobe Transient Witticisms Agarwala, Aseem 654

Agrawala, Maneesh 654

Aim prints 686

Align layers 56

Alpha channels 506, 510, 512-513

Alternative Raw processors 94

Andreas, Peter XXII

Anti-aliasing 514

Aperture 94, 99

Application frame mode 3-4, 10

Art history brush 66, 69

Auto adjustments 370

Automated plug-ins 702, 712

Automating Photoshop 64, 695–708

Automator workflow 108

Auto-save 74

Auto-select layer 55

В

Background eraser tool 53

Background saving 74

Barroso, Clicio 174

Barstow, Neil XXII

Batch processing 702

Berkley University 654

Bibble 94, 105–106

Bibble Pro 5 105

Bicubic interpolation 337

bicubic automatic 337 bicubic sharper 337

bicubic snarper 337

Big data 402

Bilinear interpolation 337

Bird's eye view 10, 58

Bit depth 344

32-bit floating point 430, 436 raw images 345

raw images 345

Black and white

black and white adjustments adjustment presets 413

black and white output 427

converting color to B&W 410-421

Lab mode conversions 410

Black Point Compensation 682 Blending modes 63, 544–548

Color 42, 362, 459, 549, 677

Color Burn 545

Color Dodge 546	opening files from Bridge 85	color mode 251
Darken 490-491, 545	slideshow view 85-86	color swatch 252
Darker Color 545	tethered shoot imports 105	defringe slider 198-200
Difference 548	Tools menu	density 241
Dissolve 544, 645	automation 702	edit brush 245
Divide 549	Photoshop 448	erase 245
Exclusion 548	Brown, Russell XXII, 404, 469, 490, 710	extending the sharpening limits 299
Hard Light 547, 563	Bruno, Andrea XXII	feather 241
Hard Mix 548	Brushes	flow 241
Hue 549	bristle shape brushes 41, 48	hand-coloring 249
Lighten 490-491, 546	bristle preview panel 48	how to apply localized sharpening 300
Lighter Color 546	brush attributes 44	moiré reduction 316–317
Linear Burn 545	brush picker 42	negative sharpening 299, 302
Linear Dodge (Add) 546	brush preset menu 42	noise reduction 314–315
Linear Light 547	brush size limits 47-48	pin markers 242
Luminosity 362-363, 460, 549, 677	dual brush control 45	resetting the sliders 253
Multiply 545	jitter control 45	sharpening 299, 301
Normal 544	on-the-fly brush changes 42	show mask option 245
Overlay 328-329, 547, 675	pressure sensitive control 45	size 241
Pin Light 548	shape dynamics 45	speed limitations 251
Saturation 549	texture dynamics 45	undoing brush strokes 245
Screen 546	Brush panel 43-44	altering background color 135
Soft Light 547	bristle qualities options 48	alternative raw processors 94
Subtract 548	brushes panel options 45	as a JPEG editor 94
Vivid Light 547	brush pose 45	auto corrections 141
Blending multiple exposures 438	color dynamics 45	apply auto grayscale 141
Blur filters	flow jitter 45	apply auto tone 141
See Filter menu	scattering controls 45	Basic panel 95–96, 146–147
Blur tool 41	Brush preset picker 41	auto tone corrections 169, 442
Bokeh 622-623	hardness slider 41	basic adjustment procedure 166
Box blur filter	size slider 41	blacks 157, 168, 443
See Filter menu	Brush tool 41	auto-calculated blacks range 157
Bracketed exposures for HDR 432	brush tool presets 46	clarity 172, 313
Bridge 72, 81–85, 99	Bunting, Fred 356	clipping points 158
Bridge interface 83–87	Burn tool 41, 48, 386	contrast 155, 167, 182
Bridge preferences	Byte order 78	exposure 154, 158, 182
file type associations 72	•	extreme highlights/shadows 156
compact mode	C	extreme whites/blacks 157
content panel 85	Cadman, Rob XXII	hiding shadow noise 161
custom work spaces 84	Camera exposure 93, 341	highlights 156, 167, 182, 443
favorites panel 83	Camera histograms 137, 165	negative vibrance 176
File menu	Camera JPEG previews 92	saturation 176-177, 251
get photos from camera 100	Camera Raw 86–88, 112–152, 340	shadows 156, 167, 250, 443
open in Camera Raw 116	ACR preferences 114	suggested order 157
filter panel 81	adjusting hue and saturation 186	vibrance 176–177
folders panel 83	adjustment brush 240	white balance 146-151
installing Bridge 81	add new brush effect 242	whites 157, 168, 443
Make Bridge CS6 work with CS7 83	auto mask 247, 252, 317	bit depth 114
opening camera raw 112-115	brush settings 241	
	-	

histogram and RGB space 137 radius slider 284, 288, 296 black and white conversions how Camera Raw calculates 165 save sharpen settings 297 410. 420-421 HSL/Gravscale panel 184, 421 sharpening cache size 141 auto gravscale 420 micro detail 215 Camera Calibration panel color sliders 420 sharpening a landscape 295 152, 154, 222-223 convert to grayscale 169, 420-421 sharpening a portrait 294 black and white conversions 422 gravscale conversions 420, 422 sharpening defaults 286 Camera Raw profiles 216-218 HSL color controls 184 sharpening effect sliders 286 process versions 153 saturation 186 sharpening examples 294 camera profile calibrations 218 image browsing via Camera Raw 138 sharpening fine detail 296 Camera Raw advantages 90 installing updates 112 Smart Object sharpening layers 299 Camera Raw database 266 Lens Corrections panel 188-189 suppression controls 289 Camera Raw defaults 267 chromatic aberrations 191 develop settings 223 Camera Raw filter 224-227, 422, 444 Color tab 191 DNG Camera Raw/Photoshop workflow 95 custom lens profiles 190 DNG file handling 141 Camera Raw presets 268 defringe sliders 193-198 undate embedded JPEG previews 266 Camera Raw profiles 216, 216-218 enable lens profile corrections 188 does the order matter? 91 camera look profiles 217 enable profile corrections 189 Effects panel 208 Camera Raw settings 258 lens calibration charts 190 grain slider 214-215, 312-313 folder location 298 lens settings 186 post crop vignetting 208 Camera Raw support 91, 98 lens vianettina 206 amount slider 209 Camera Raw tools 114 Manual tab 200-205 color priority 211, 213 Camera Raw workflow 90 highlight priority 212-213 profile tab camera specific default settings 171 distortion 188 highlights slider 212 capture sharpening 673 remove chromatic aberration 191 midpoint slider 208 CMYK proofing 123-127 paint overlay 210 vignetting 188 color sampler tool 114 remove chromatic aberration 192 roundness slider 209 copying settings 269-270 transform controls 206-207 style options 210 correcting high contrast 182 upright corrections 200-205 emulating Hue/Saturation 186 cropping 114, 143-144 load settings 266 export settings to XMP 266 custom crop ratio 145 localized adjustments 240 file format compatibility 274 deleting images 138 adjustment strength 242 forward compatibility 98 demosaic processing 282-284 defringe slider 198 full screen mode 116, 138 Detail panel 285-315 maintaining ACR compatibility 278 graduated filter 253 amount 287, 313 MakerNote data 275 angled gradient 253 color detail slider 307, 309 matching JPEG rendering 216 modifying graduated filter masks color slider 307, 308 multiple file opening 116-117 261-262 color smoothness slider 310-311 navigation controls 138 negative sharpening 299 default sharpening settings 297 open as a Smart Object 128 pin markers 253 detail slider 289-290, 296 opening multiple files 116-117 selective sharpening 299 grayscale preview 291 opening photos from Bridge 86 sharpness interpreting the grayscale previews 291 opening TIFFs 142 negative sharpness 303 luminance contrast slider 309 open object 129 hand tool 114 luminance detail slider 306 output proofing 124 HDR processing 444-447 luminance slider 306, 309 pasting settings 270 hiding shadow noise 161 masking slider 292-293, 296 PNG support 91 high dynamic range adjustments 442 noise reduction 304-307 Preferences 140-141 process versions and noise reduction highlight recovery 158 automatically open JPEGs/TIFFs 142 histogram 114, 137 304 default image settings 141 clipping indicator 157 radius preview 291

disable JPEG/TIFF support 142	Visualize spots 232–233	Clipping the shadows 161
general preferences 140	star rating edits 138	Clone Source panel 466-467, 486-487
ignore sidecar "xmp" files 141	straighten tool 114, 143, 144	angled cloning 486
sharpening 140	suggested workflows 90	show overlay 463, 466
preserve cropped pixels 132	synchronized spotting 230	Clone stamp tool 53, 462-463, 466-
preserving highlight detail 158	synchronized view 138	468, 467
Presets panel 223, 267-268	synchronize settings 116-117, 269	aligned cloning 467
presets	synchronizing process versions 270	alignment mode 466
legacy presets 270	target adjustment tool 114, 179, 187	ignore adjustment layers 468-469, 472
preview controls 118–121	thumbnails filmstrip 116	layer selection options 462
checkpoints 119	Tone Curve panel 178-183, 183	non-aligned cloning 467
preview preferences 119	linear contrast curve 178	sample all layers 468
process versions 152-157, 216	parametric curve 179	sample current & below 462, 468
process 2012 443	point curve editor mode 180-181	tool settings 462
process version mismatch 271	RGB Curves 180	Cloning 462–464
synchronizing settings 270	transparency support 86	CMOS sensors 90, 307
radial filter 114, 258-262	update DNG previews 266	CMYK
fill to document bounds 261	upright corrections 200-205	CMYK conversions 158
modifying radial filter masks 261-262	white balance	Color blend mode 549
recovering out-of-gamut colors 185	auto white balance 150-151	Color Burn blend mode 545
red eye removal 114, 238-239	white balance tool 114, 147-151	ColorChecker chart 221
pet eye removal 239	workflow options 114-115, 122-126	Color Dodge blend mode 546
rendering times 153	resolution 114	Color gamut
rotate	workflow presets 122	choice of RGB space 348
rotate clockwise 114	Zoom tool 114	Colorize
rotate counterclockwise 114	Canon	hue/saturation 376
save dialog 134	Canon DPP 275	Color management
save new Camera Raw defaults 171	EOS utility 106-108	See PDF on book website
save options 132	Canvas	black point compensation 685
saving 143	canvas color 6	print color management 676, 682
resolving naming conflicts 133	canvas size 401	printing
save options 132	relative canvas size 401	no color management 682, 694
save settings 143, 266	Caplin, Steve XXII	setting the endpoints 162
saving a JPEG as DNG 133	Capture One 94, 105, 109	Color picker
saving presets 267	Capture sharpening 672	Hex field 50
selecting rated images only 138	Carroll, Robert 654	Color Range
sidecar files 140	Casio 274	See Select menu
single file opening 114	Causa, Ettore 174	Color replacement tool 53
smart objects 438	CCD sensors 90, 307	Color sampler tool 59
Snapshots panel 272	CGI effects 430	ColorSync
snapshots 272–273	Chan, Eric XXII, 217, 284	profiles
Lightroom snapshots 272	Channel Mixer 614	3DLUT 380
softening skin tones 174	Channels 506-508	abstract 380
Split Toning panel 423–426	omitting channels in a save 507	devicelink 380
spot removal tool 114, 228-229	Chien, Jeff XXII	ColorSync Utility 694
brush spots 234-237	Chromatic aberration 191	Color temperature 147, 384
circle spots 229–230	Clipping masks 559–561	Color toning 414
deleting spots 235	clipping adjustment layers 560-561	Colourmanagement.net 694
synchronized spotting 230	Clipping the highlights 160	Conditional Actions 706–709

OFigureton 2	CSP 382	drag and drop as a layer 595-596
Configurator 3	CUBE 382	Dreamweaver, Adobe 76
Configuring Photoshop	Current Tool status 15	Droplets 691, 705, 707–709
See book website	Curves	cross platform droplets 705
Connor, Kevin XXII	See Image adjustments	Duplicate an image state 70
Content-aware filling	Custom keyboard shortcuts 23–24	Dutton, Harry XXII
See Edit menu Content-aware move tool 479, 484–485	Custom shape tool 51	DxO Labs
adaptation menu 480–481	Oustoni shupo toor or	DxO Mark sensor evaluation 431
color tolerance 484–485	D	DxO Optics Pro 94, 263
extend mode 481	D. I I	Dynamic range 164, 429
face detection 479	Darken blend mode 545	
move mode 479	Darker Color blend mode 545	E
sample all layers 479	Dead pixels 305	Easter eggs 88
Content-aware scaling 404–407	Debevec, Paul 430	Editing JPEGs & TIFFs in Camera Raw 93
amount slider 406	Delete anchor point tool 52	Edit menu
protect skin tones 406	Delete options 478	Auto-Align layers 554, 653
Contextual menus 39	Deleting camera card files 104, 107	Auto-Aligh layers 554–555
Convert for Smart Filters 318	Depth of field blending 554–555	seamless tones and colors 555
Converting vectors to pixels 513	Depth of field brush 328 Depth of field effects 620	Color Settings 348
Convert point tool 52	1	content-aware fill
Convert to Smart Object 598	Detect faces 34	color adaptation 482–483
Corrupt files 72	Difference blend mode 548	Convert to Profile 163
Count tool 61	Digital dog 694	Fill 476
Cox, Chris XXII, 380	Digital exposure 164 Direct selection tool 52, 566–567, 607–	content-aware fill 476–477, 552–553
Crack, Richard XXII	608, 609–610	keyboard shortcuts 566–567
Creating a Droplet 704–705	layer selection 566–567	menu options 22–23
Creating a new document 5	Displays	paste special
Creating a texture map 666	calibration 678	paste in place 32
Cropping 394	dual display setup 26–27	perspective warp 584–588
crop and straighten photos 712	Dissolve blend mode 544	layout mode 584
crop tool 394	Distribute layers 56	warp mode 584, 587
crop guide overlay 397	Distribute layers 581	presets
crop preview 394	DNG Converter 278	export/import presets 704
crop ratio modes 395	DNG Profile Editor 220–223	Puppet Warp
crop tool options 398	create color table 221	adding pins 589
crop tool presets 396	edit menu	distort mode 589
delete cropped pixels 395	export 222	expansion setting 590
disable edge snapping 398	file menu	multiple pin selection 591
front image cropping 398	open DNG Image 221	normal mode 589
measurement units 394	Document profile 15	pin depth 591, 593
options bar 396	Documents layout options 3	pin rotation 590, 594
straighten tool 408	Document windows 14	rigid mode 589, 592
selection-based cropping 400	exposure slider 432	show mesh 589
swap aspect ratio 396	floating windows 11–14	using Smart Objects 591
perspective cropping 402	switching between windows 12–15	Transform 577-586
perspective crop tool 403	Dodge tool 41, 48, 386	aligning layers 581
Crop tool 30, 53	Dolby 433	distribute layers 581
options bar	Dots per inch 334	free transform 577-578, 580, 598
delete cropped pixels 402	Drag and drop documents	interpolation options 579
	3	

manually set transform axis 580	Filmstrip 79	Import
numeric transforms 579-580	JPEG 79	import images from device 110
perspective 579	image processor 710	new document 5
rotate 578	JPEG compression 79	pixel aspect ratio 5
show transform controls 580	JPEG saving 73	Open in Camera Raw 112
skew 579	saving 16-bit as 8-bit 79	Place 595–596
transforming paths 580	OpenEXR 436-437	Print One Copy 679
transform menu 577	ICC profiles 437	Save 73
warp transforms 599-600	PDF 74, 80-83	Save As 75
Efficiency 15	placing PDF files 81	Scripts 515, 620, 711
Eismann, Katrin XVIII, XXII	Photoshop PSD 73, 76	layer comps to PDF 562
Electronic publishing 80	maximize compatibility 76	Files that won't open 72
Elliptical marquee tool 33-34, 509	smart PSD files 76	Film grain retouching 462
Elliptical shape tool 51	PICT 79	Filter Gallery 670
EnableAllPluginsforSmartFilters 597, 620	PNG 80, 91, 324	Filter menu
Epson	PSB 74, 436	32-bit filters 617
Epson printers	PSDX 77	Adaptive Wide Angle 552, 643–
advanced B&W photo 427	Radiance 436	647, 654–663
Epson 4800 dialog 692	TIFF 74, 77, 436	applying constraints 657
Eraser tool 53	compression options 79	calibrating 659
Exclusion blend mode 548	flattened TIFFs 79	constraints 661
EXIF metadata 436	pixel order 78	constraint tool 657
Export/Import Presets 704	save image pyramid 79	editing panorama images 663–665
Eyedropper tool 59	File header information 72	loupe view 658
eyedropper wheel display 59	File menu	missing lens profiles
options bar	Automate 448, 702	search online 656
all layers no adjustments 59	Merge to HDR Pro 430, 452	panorama correction 664
current & below 59	complete toning in ACR 444	panorama mode 663
current & below no adjustments 59	detail slider 451	polygon constraint tool 665
Eylure XXII	exposure slider 451	preferences 659
_	gamma slider 451	rotating a constraint 658
F	HDR toning 449, 454	saving constraints 658
Fade command 619	highlight slider 451	Blur 616–619
File Browser 99	radius slider 451	Average blur 616
File compression	removing ghosts 452	Box blur 619
LZW compression 79	response curve 448–449	Field blur 628
File formats 76–82	saturation slider 451	Gaussian blur 616
BIGTIFF 78	script 450, 452	Iris blur 622
DNG 141, 266, 274–276	shadow slider 451	radius field controls 623
compatibility 98	smooth edges 454	radius roundness 623, 625
convert to DNG 103	smoothing HDR images 458	Lens blur 620–623
DNG adoption 274	strength slider 451	depth of field effect 620
DNG compatibility 98, 275	tone in ACR 444, 446	Radial blur 617
DNG Converter 278	toning curve and histogram 451	zoom mode 617
DNG file handling 141	vibrance slider 451	distortion slider 626–627
embed custom profiles 218	Photomerge 550	no-blur zone 626
lossy DNG 276–277	Close	transition zone 626
MakerNote data 275	close all 74	Blur Gallery 622–641
use lossy compression 276–277	Generate	blur effects panel 622
200 1000y compression 210-211	image assets 570-573	Side Silvers puller OLL

intensity slider 667 vianette section 649 blur gallery options 624 metallic slider 667 vignette removal 648 blur ring 623, 626, 628 texture menu 667 Liquify 493, 496-504, 582 bokeh color 623 Sharpen bloat tool 496-497 light bokeh 622 Shake Reduction 322-327 forward warp tool 496-497, 504 light range controls 622 smart object support 324 freeze mask tool 496-497, 499, 504 multiple blur effects 626, 641 Smart Sharpen 318-321 GPU improved performance 496 Path blur 633-637 advanced mode 318 hand tool 496 blur direction arrows 633 lens blur mode 319 Liquify tool controls 498 centered blur 634 motion blur 321 Liquify tools 496 end point speed 637 save settings 320 mask options 499 motion blur effects 635 Unsharp mask 282, 330, 673-674 mesh arid 499 rear sync flash 633, 635 Smart filters 615, 628 on-screen cursor adjustments 502 Speed slider 633 convert for smart filters 643 pin edges 498 strobe flashes 637 enable all plugins 620 pucker tool 496-497 strobe strength 635, 637 Vanishing Point 488 push left tool 496-497 taper slider 634 create plane tool 488 reconstruct tool 496-498 save mask to channels 624 stamp tool 488 restore all 498 selection bleed slider 624 Filters revert reconstruction 498 smart object support 638-640 third-party plug-ins 622, 642 saving the mesh 500-502 Shape blur 619 FireWire 105 show backdrop 500, 504 Spin blur 630-632 Fisheve lens 189, 550, 654 smart object support 501 Tilt-Shift blur 626-627 fisheve lens corrections 653 smooth tool 496, 498 symmetric distortion 627 Fit image 712 thaw mask tool 496-497 video layers 639-640 Fit to screen view 13 twirl clockwise tool 496-497 Camera Raw Filter 224-227 Flick panning 59 view options 503-504 convert to smart filters 591 Flip a layer 577 zoom tool 496 Fade filter 619 Focus area Noise Filter Gallery 670 See Select menu Add Noise 616 new effect layer 670 Fraser, Bruce XIX, XXII, 143, 328, 673 Dust & Scratches 490-491 Lens Correction 648-653 Freeform lasso tool 32 threshold 491 Adobe Lens Profile Creator Freeform pen tool 52 Reduce Noise filter See Adobe Lens Profile Creator See PDF on book website Fuii and EXIF metadata 648, 652 Fuji SuperCCD 282 Other auto correction 649, 651 High Pass 330, 672-673, 675 auto-scale Images 648-649 G Render chromatic aberration 648-649, 652 Fibers 666 Garner, Claire XXII custom lens corrections 648 Lighting Effects 666-669 geometric distortion 648-649, 652 Gaussian Blur filter adding lights 667 See Filter menu: Blur grid overlay 650 intensity 666 lens profiles 648, 652-653 Generator 570-573 infinite light control 667 extended tagging 570 move grid tool 650 lights non-raw profile variance 653 Gorman, Greg XXII spot light 668 Gradient tool 51, 440 remove distortion 648 options bar settings 666 Graphic Converter 73 rotation 649 presets menu 667 Grayscale mode scanned image limitations 648 properties panel 667 grayscale conversions 410 search criteria 648, 652 ambience slider 667 Grid 17-18 selecting appropriate profiles 652 colorize swatch 667 send profiles to Adobe 652 Guides gloss slider 667 transform section 649 adding new guides 17 hotspot slider 667

н	history panel 491, 66, 487, 696	channel selection 356
Hamburg, Mark XXII, 70	create new snapshot 70	channel selection shortcuts 374
Hamilton, Soo XXII	new snapshot dialog 70	color corrections 374
Hand tool 58	non-linear history 66, 71	curves histogram 357
Hard Light blend mode 547	history settings and memory usage 67	draw curve mode 358
Hard Mix blend mode 548	history versus undo 69	dual contrast curve 365
Hasselblad 274	make layer visibility changes undoable 67	locking down curve points 364
HDR	purge history 68	negative number support 356
bracketed exposures 432, 435	Holbert, Mac XIX	on-image editing 358
capturing HDR 434	Holm, Thomas XXII	point curve editor mode 357
displaying deep-bit color 433	Horwich, Ed XXII	removing curve points 358
exposure bracket range 435	Howe, David XXII	target adjustment tool 358-359
HDR essentials 431	HSB color model 376	using Curves in place of Levels 360
HDR file formats 436	HTML	data loss 342
Large Document format (PSB) 436	HTML color support 49	direct image adjustments 350
OpenEXR 436	HUD color picker 43	Exposure 352
Radiance 436	Hue blend mode 549	Gradient fill 561
TIFF 436	Hue/Saturation 376–377	Gradient Map 352
HDR shooting tips 435	Hughes, Bryan O'Neil XXII	black and white toning 418-419
HDR Toning 450	1	photographic toning presets 418
limits of human vision 434	_	HDR Toning 367, 436–437
Photomatix program 432	lannotti, Kate XXII	detail slider 456–457
tone mapping HDR images 450	IEEE 1394 105	edge glow radius 459
equalize histogram 450	Illustrator, Adobe 332	edge glow strength 459
exposure and gamma 450	Image adjustments	exposure slider 456
highlight compression 450	adjustment layers 350-353, 385-	gamma slider 456-457
local adaptation 450	386, 516	highlight 456
Healing brush 53, 462-466	adjustment layer masks 386	local adaptation 455
alignment mode 466	cumulative adjustments 385	radius slider 456
better healing edges 469	Auto	save preset 457
elliptical brush setting 469	Auto Color 370–371	strength slider 457
replace blend mode 471	Auto Contrast 370–371	toning curve 457-458
sample options 468	Auto Levels 354, 370	Hue/Saturation 33, 352, 376–377, 677
Help menu 22	Auto Tone 370–371	saturation 376
Hex field 50	enhance brightness and contrast	Invert 352
Hide Extras 32	370, 372	Levels 162, 352
Hide Photoshop 32	Black & White 97, 352, 410-413, 416	basic Levels editing 343
High dynamic range imaging	adjustment presets 413	gamma slider 342
See HDR	auto 411	output levels 360
Highlight detail	Brightness/Contrast 352	Match Color 372
how to preserve 158	Channel Mixer 352	multiple adjustment layers 385
High Pass sharpening 673-675	Color Balance 352, 414	Photo Filter 352, 384, 647
Hince, Peter XXII	preserve luminosity 415	Posterize 352
Histogram 340-341	Color Lookup 352, 380-381	save preset 413
Histogram panel 163, 342-345, 354	color lookup table export 382–383	Selective Color 352
History 55, 66–70, 74	Curves 352	Shadows/Highlights 345, 366-369
history brush 66, 490	adjustment layers 356-359	amount 366
history options 67	auto 356	CMYK mode 369
	black and white toning 416	color correction 369

midtone contrast 369	K	lock all 569
radius 366, 369		lock image pixels 569
tonal width 366, 368	Keyboard shortcuts 22–23	lock layer position 569
Threshold 352	Knoll, Thomas XXII, 216	lock transparent pixels 569
Vibrance 352, 379	Kost, Julieanne XXII	layer masks 513, 519-520
Image editing tools 53-54	Krogh, Peter XXII	adding a layer mask 519
ImageIngester 110-111	L	copying a layer mask 520
Image ingestion 99–112	-	density and mask contrast 522-523
Image interpolation 336–339	labs.adobe.com 190	linking layer masks 568
bicubic 337	Lasso tool 32, 493, 495, 510	layer selection 56
bicubic automatic 337	Laye, Mike XXII	layers panel controls 516-517
bicubic sharper 337	Layer Comps	layer visibility 517
bicubic smoother 337	Layer Comps panel 562-563	managing layers 515
bilinear 337	Layers , 63, 515-537	merged copy layer 495
nearest neighbor 336	adding a layer mask 519	merge visible 699
Image menu	adding an empty layer mask 520	merging layers
Canvas size 401	add vector mask	layer naming 574
Duplicate 676	current path 605, 612	move tool alignment 580
image rotate menu 577	adjustment layers 516	multiple layer opacity adjustments 564
Image Size 700	align linked layers 581	multiple layers 556
reveal all 133	align shortcuts	new layer 515
ImagePrint 77	See Shortcuts PDF on book	removing a layer mask 520
Image Processor 710	website	renaming layers 515
Image rotation 408	arrange layer menu 581	selecting all layers 564
Imagesetters 333	arrange shortcuts	select top most layer 699
Image size 335–339	See Shortcuts PDF on book	straightening layers 408
altering image size 335	website	text layers 516
Import Images from Device 110	auto-select shortcut 565, 570, 571	thumbnail contextual menu 521
InDesign, Adobe 76–77	clipping group 600	clip to document bounds 521
Info panel 16	clipping mask 561	thumbnail preview clipping 520
Information tools 57	color coding layers 556	vector masks 389, 512-513, 519, 612-
Ingestamatic 109	copy layer 515	614
Installing Photoshop 2	distribute linked layers 581	combine shapes 612
Interface	drag and drop layers 63	isolating an object 613
customizing the interface 4	flattening layers 699	subtract front shape 612-613
interface preferences 10	image layers 515	Layer Styles/Effects 517, 519
settings 6	layer basics 515	See also book website
Interpolation 336	layer filtering 574–576	layer style dialog
preserve details 335, 338–339	isolation mode filtering 576	blend if layer options 417
iPhone 432	layer groups 556–558	blend if sliders 329
ISO settings 93	group linked 559	layer style options 329, 416-417
•	layer group management 556	layer style options 674
J	lock all layers 556	Leica 98, 274
Johnson, Carol XXII	managing layer groups 558	Lens Baby blur effect 626
Johnson, Harald 672	masking group layers 560	Lens profiles 188, 656
Jones, Lisa XXII	moving layers in a group 556	Levels 354-364
JPEG capture 93	nested layer groups 557	Lighten blend mode 546
or Ed dupture do	layer linking 564–567	Lighter Color blend mode 546
	layer locking 569	

Lighting Effects filter	Moiré removal 316	Paint bucket tool 51
See Filter menu	Motion blur	Painting tools 41–45
Lightroom 94, 99, 109, 673	how to remove 321	Panasonic
black and white conversion 422	Motion blur filter	Panasonic G1 camera 282
Linear Burn blend mode 545	See Filter menu: Blur	Panels 19-20
Linear Dodge blend mode 546	Move tool 53, 55–56	closing panels 21
Linear Light blend mode 547	align/distribute layers 56	collapsing panels 19-20
Lines per inch 333	auto-select layers 565	compact panels 4, 20-21
Line tool 51	layer selection 55, 565	docked layout 19-21
Liquify filter 496–504	options bar 581	organizing panels 19–20
See also Filter menu	auto-select 56	panel arrangements and docking 20–21
Live shape properties 390-393	show transform controls 55	panel positions in workspaces 21
Load Files Into Photoshop Layers 554	Multiple undos 66	revealing hidden panels 20–21
Lock image pixels 569	Multiply blend mode 545	Panoramas (with Photomerge) 550–551
Lossy DNG 276–277		Parser plug-in 81
Lucky Seven beta 88	N	Patch tool 53, 474–477
Luminosity blend mode 549	Neels John VVII	adaptation menu 477–478
Luxon, Tai XXII	Nack, John XXII	structure control 478
Lyons, lan XXII	Nearest Neighbor interpolation 336	content-aware mode 477
LZW compression 79	Nikon	sample all layers 477
	D800E camera 316	source and destination modes 474–475
M	Nikon Capture NX2 105	transparent mode 475
Magic arross tool 52	Noise reduction	use pattern option 474
Magic eraser tool 53	See PDF on book website	Paths 513, 605–608
Magic wand tool 32, 510	ideal noise reduction 284	
Magnetic lasso tool 32	Non-linear history 70	convert path to a selection 607
Marchant, Bob XXII	Normal blend mode 544	curved segments 607
Marquee selection tool 32, 510	Notes panel 61	make path 605
Masks 513	Notes tool 61	multi-selection options 609–610
clipping masks 559–561	Numeric transform 55, 579	nudging with arrow keys 609
mask channels 507	N-up window options 12–13	rubber band mode 608
Maximize backward compatibility 76	0	shape layers mode 606
Measurement scale 15–18	J	vector masks 612–614
Menus	Online help guide instructions XX	Path selection tool 52, 566–567, 609–610
customizing menu options 22	On-screen brush adjustments 43	layer selection 566–567
Mercury Graphics processing 623	Onyx	Paths panel 605
Merge to HDR Pro	PosterShop 77	add mask 605
See also File menu: Automate	OpenCL 623	create new path 605
Migrate settings 2	Open command 72	fill path button 605
Migrate Settings 2	Open Documents as Tabs 10	load path as a selection 605
Migrating presets 704	OpenGL 10–13, 18–19, 43, 59–60	Stroking a path 472
Mini Bridge	Options bar 4, 30–31	Pattern stamp tool 53
Mirror shake 435	Outlying pixels 305	Pawliger, Marc XXII
Mixer brush tool 29, 41, 46-47	Output sharpening 672–675	Paynter, Herb XXII
clean brush 47	Overlay blend mode 547	PDF file format 80–83
flow rate 47	Overlay biend mode 547	Pencil tool 41
mix ratio 47	P	Pen paths 512
paint wetness 47		Pentax 274
Mobile & Devices presets 5	Page Setup	Pen tool 52, 503, 606, 608, 613
Modifier keys 39–40	manage custom sizes 689	corner points 607

open documents as tabs 10 scale to fit media 687 curved segment 607 show tool tips 28, 30, 351 show paper white 685 paths mode 606 simulate black Ink 686 UI text options pen tool shortcuts 608 UI font size 9 soft proofing 685 shape layers mode 606 Performance 584 solo panel opening 679 Perspective crop tool 53, 403 Pin Light blend mode 548 front image 403 Plua-ins show all filter gallery groups 670 Pixel aspect ratio 5 show grid 403 Photoshop print dialog 679-684 Pixel Genius 712 Perspective retouching 488 background color 690 Pixel grid view 18-19 Perspective Warp 584-588 Pixels per inch 333 Phase One 94 bleed option 690 border 681-683, 690 Pixl XXII Photo Downloader 99-104, 100 centering prints 689 Polygon lasso tool 32 advanced dialog mode 102 Polygon shape tool 51 check all photos 102 color management 682 PostScript 16-bit output 685 advanced options PostScript RIP 334 black point compensation 682, 685open Adobe Bridge 102 Preferences backing up data 101 See Photoshop preferences color management off 692, 694 convert to DNG 103 Preserve Details interpolation 335, 338-Photoshop managed color (PC) 693 deleting camera card files 104 339 Photoshop manages colors 682 get photos 103 Preset manager 62-63 printer manages colors 682 preserve current filename in XMP 102 saving presets as sets 65 rename files 100, 102 profiles Presets folder 696 canned profiles 682 Photo Filter 379 custom print profiles 694 Printing PhotoKit Sharpener 673 See also Photoshop print dialog Photomatix Pro 432, 452, 456 description box 690 making a print 679-688 Photomerge 550-553, 663 functions 690 managing print expectations 678 gamut warning 685 auto 550 printing resolution 334, 673 heads up display 687 blending options 551 print quality settings 692 match print colors 685 Camera Raw lens corrections 550 position and size 687 print sharpening 672-675 collage 550 saving print presets 691 preview background color 680 cylindrical 550-551 sharpening actions 698 printer manages colors 682 geometric distortion correction 551 viewing distance 336 printer profile menu 682 perspective 550 Print output scripting 691 printer selection 679 reposition 550 Print settings printer setup 679 spherical 550 Mac 692-693 print from proof setup 676 vignette removal 551 PC 692-693 printing marks 690 Photoshop activation 2 Print (system) dialogs print margins Photoshop license 2 color management 692 adjusting 688 Photoshop Online 88 media type 692 Photoshop preferences 700 print orientation 680 print resolution 692 See also book website print output scripting print settings 691 Cursors 43 actions 691 Process versions 152-157, 282-285, 308 print preview 687 brush preview overlay color 43 Process 2003/2010 File Handling print selected area 688 See PDF on website print settings 679-680 background saving 74 Process 2012 152 filtered ICC profiles 683 Camera Raw to convert 32-bit 444 synchronizing settings 270 proof settings 685 General tone controls 154 registration marks 690 history log 74 process version mismatch 271 Interface 7, 11-14 rendering Intents 684 enable text drop shadows 9 scaled print size 687

Profiling	feather 526-527, 538-539	RGB
remote profiling 694	radius 531	RGB color space selection 346
Prohibit sign 28	shift edge 527, 533, 538-539	Richmond, Eric XXII
Proof printing 686, 687	smooth 526	Ricoh 274
Properties panel 351, 353	auto-enhance 528	Rochkind, Marc 109
adjustment controls 356, 493	contrast slider 528, 539	Rodney, Andrew XIX, XXII, 694
live shape properties 390-393	decontaminate colors 527-528, 534-	Roff, Addy XXII
masks controls 351, 386-391, 522	535	Rotate a layer 577
color range 387	edge detection 525	Rotate image 408
density 387, 389	radius 525	Rotate view tool 60
feather 387-388, 514	smart radius 526, 531, 538-539	Rounded rectangle shape tool 51
invert 522	erase refinements tool 526	Rubylith mode 520
mask edge 522	feather slider 531, 539, 543	Rulers 17
masks mode options 522	output 527	Ruler tool 59
masks panel editing 388	radius 528, 539	straighten layer 408
refine mask edge 387	ragged border effect 538-539	6
ProPhoto RGB 346–349	refine radius tool 525, 532–533,	S
Puppet Warp 589	539	Samsung 274
See Edit menu	shift edge slider 539	Saturation
density setting 589	show original 524-525	and curve adjustments 362
multiple objects 590	show radius 524–525	Saturation blend mode 549
semi-transparent edges 589	smart radius 527, 529	Save Progress
Q	smooth slider 528, 531	status bar indicator 15
_	truer edge algorithm 523, 525	Saving 73
QuarkXPress 78	view modes 525	background saving 74
Quick mask 508-510, 512, 521, 528	on layers 525, 531, 533	Save As 75
Quick selection tool 32, 528-530	on white 534	Schewe, Becky XXII
add to a selection 528	reveal layer 532	Schewe, Jeff XIX, XXII, 70, 461, 672-
auto-enhance edge 529	show original 525	673
blocking strokes 528	show radius 525	Scorsese, Martin 380
brush settings 528	Refine Mask	Scratch disks
double Q trick 528	See Refine Edge	scratch disk sizes 15
subtract from a selection 528	Reloading selections 510	Screen blend mode 546
R	Remote shooting controls 107	Script Event Manager 711
•	Removing objects 407	Scripting 711
Radial blur filter	Rendering intents	Scripts 711–712
See Filter menu: Blur	absolute colorimetric 684	export layers to files 711
Raw capture 92	perceptual 676, 684 relative colorimetric 676–677, 684	image processor 710
forward compatibility 98		Selections 506–513
Raw processing comparisons 216	saturation (graphics) 684 Replacing film grain 490	adding to a selection 511
Rectangular marquee tool 33–34, 511	Resnick, Seth XIX, XXII	anti-aliasing 514
Rectangular shape tool 51	Resolution	creating a selection 509
Red eye tool 53	terminology 333	feathering 514
Reducing noise	Resolution and viewing distance 336	load selections 507
through HDR merging 432	Retouching beauty shots 494	marching ants mode 508
Refine Edge 387, 478, 523–536, 536–	Retouching portraits 492	modifying 510
537, 543	Reveal All 402	recalling last used selection 507
adjust edge section 526	Reveal in Finder 10	reloading selections 510
contrast 526-527, 531, 538-539		save selections 506

selection shortcuts 510	protect detail 318	Swatches panel 49
Selection tools 31–34, 32	Show all menu items 22	load from HTML 49
elliptical selection tool 32	Single column marquee tool 32	load swatches 49
magnetic lasso tool 32	Smart filters 597–604, 642–647	replace swatches 49
marquee selection tool 32	See also Smart Objects	Synchronized scroll and zoom 13-16
quick selection tool 32	enable all plug-ins 620	_
single column selection tool 32	enabling the Lens Blur filter 620	т
single row selection tool 32	Smart guides 17–18	Tabbed document windows 10
Select menu	Smart Objects 319, 438–439, 597–	move to a new window 10
Color Range 34–35, 540	604, 129–131	
-	blending options 319	Task-based workspaces 24
adjustable tone ranges 36–38 detect faces 34	convert for Smart Filters 318	Technicolor effects 380
	edit contents 600	Tethered shooting 105–108
fuzziness slider 34	enable all plug-ins 597	file transfer protocols 105
localized color clusters 34, 541	Layers panel searches 604	Third-party plug-ins 622, 642
out-of-gamut selections 34	linked smart objects 601–604	Threshold mode preview 360
preview options 541		Timing 15
range slider 34, 541	multiple instances 603	Title bar proxy icons 14
skin tones selection 34	packaging linked smart objects 603	Tonal compression techniques 438
deselect 508	resolving bad links 603	Tool preset picker 46
focus area 536–537	Smart Object sharpening layers 299	Tool presets panel 30
modify	status bar 602	current tool only 31
contract 580	transform adjustments 597	Tools panel 28–29
expand 478, 552–553	Smudge tool 41	Tool switching behavior 28
smooth 538	Snapshots 69–70, 696	Tool tips 30
reselect 507	Snap to behavior 18	Tool tips info 28
transforming selections 580	Snap to edge 398	Trackpad gestures 57
Shadows/Highlights 366–369	Soft Light blend mode 547	Transform command
Shake Reduction filter 322–327	Soft proofing 676–678	See Edit menu
See also Filter menu: Sharpen	Camera Raw 127	Tutorial Builder 701
Shape conformal projection 657	via Photoshop print dialog 685	TWAIN 110
Shape tools 51	Sony	U
Sharpening	RX-100 camera 263	J
and JPEG captures 281	Sponge tool 41	Unsharp mask filter
and raw mode capture 281	Spot healing brush 53, 470–471	See PDF on book website
capture sharpening 280	content-aware mode 472–473	USB devices
depth of field brushes 328	normal blend mode 472	USB 2 105
edge sharpening technique 673	replace blend mode 472	User interface
for scanned images 281	create texture mode 471	settings 6
high pass edge sharpening 672	proximity match mode 470	
Lab mode sharpening 281	replace blend 471	V
localized sharpening 280	stroking a path 472	Vanishing Point filter 488
PhotoKit Sharpener 281	sRGB 349	Vector masks
print sharpening 280, 672-675	Status information box 15	
Real World Image sharpening 280	Straighten tool 408	See Layers
sample image 285	Subtract blend mode 548	Vector programs 333
Smart Sharpen filter	Superstition beta	Vectors
See Filter menu: Sharpen	Surface Blur filter	converting vectors to pixels 513
When to sharpen 280	See Filter menu: Blur	vector to pixels 513
Sharpen tool 41, 318		

View menu gamut warning 676 grid 17 guides 17 proof setup custom proof condition 676-677 snap to 18, 398 view extras 17 Vianettina 206 Vivid Light blend mode 547

W

Wacom 42, 46, 462, 464, 498 WebDAV 14 Weisberg, Gwyn XXII Weston, Stuart What Digital Camera XXII WhiBal cards 147 Wilensky, Gregg 538 Williams, Russell XXII Window documents 12 floating windows 12

Window menu arrange 3, 13 match location 13 match zoom 13 cascade windows 12 extensions tile windows 12 workspace new workspace 24 panel locations 25 photography workspace 26 reset workspace 25 workspace options 3 workspace settings 20, 24-25 workspace shortcuts 23 Windows 7 multi-touch support 59 Wireless tethered shooting 105 Woolfitt, Adam XXII, 274 Work Group Server 14

image tiling info 15

N-up windows 12

Workspace See Window menu Wynne-Powell, Rod XIX, XXII WYSIWYG image editing 340 X

XMP metadata 141 XMP sidecar files 140 X-Rite XXII, 218 ColorChecker chart 147, 218, 220, 221 i1 Pro 2 694 i1 Profiler software 694

Z

ZIP compression 79 Zoom blur filter 617 Zooming scrubby zoom 14 zoom percentage info 14 zoom shortcuts 12 Zoom tool 57 zoom tool shortcuts 57

Remote profiling for RGB printers

You have just been reading one of the best digital imaging books in the marketplace. Now you'll probably want to be sure your colour is as good as it can be, without too much back and forth when printing. Lots of print testing to achieve expected colour really does use up the ink and paper, but, more importantly it uses up the creative spirit. We'd like to offer you a deal on a printer profile. Just download the profiling kit from: www.colourmanagement.net/profiling_inkjets.html.

Our kit contains a detailed manual and colour charts. You post printed charts to us. We will measure using a professional auto scanning spectrophotometer. This result is then used within high-end profiling software to produce a 'printer characterisation' or ICC profile which you will use when printing. Comprehensive instructions for use are included.

You can read a few comments from some of our clients at: www.colourmanagement.net/about.html.

Remote RGB profiles cost £95 plus VAT. For readers of 'Adobe Photoshop CC for Photographers', we are offering a special price of £50 plus VAT. If our price has changed when you visit the site, then we will give you 30 percent off.

We also resell the colour management gear that you need: profiling equipment, LCD displays, print viewers, RIPs, printers and consumables etc. http://www.colourmanagement.net/profilegear.html.

Is your colour right? do you need to be sure? Have a read about our Verification Kit http://www.colourmanagement.net/prover.html. Normally £80 + VAT with UK postage, offer 50% discount. Overseas delivery by arrangement.

We also resell the colour management gear that you need: profiling equipment, LCD displays, print viewers, RIPs, printers and consumables etc. http://www.colourmanagement.net/profilegear.html.

Consultancy services

Neil Barstow, colour management and imaging specialist, of www.colourmanagement. net, offers readers of this fine book a discount of 15% on a whole or half day booking for consultancy (subject to availability and normal conditions).

Coupon code: MEPSCS7-10

Please note that the above coupons will expire upon next revision of Adobe Photoshop for Photographers. E&OE.

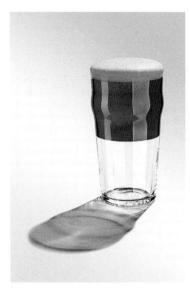

Photograph and retouching: Rod Wynne-Powell

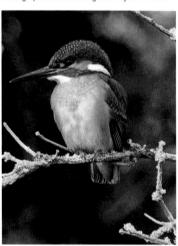

Rod Wynne-Powell

Rod, a fellow Adobe Prerelease tester continues to provide technical help and suggestions when tech-editing for this series of books. When he is not helping me, he finds time to train other photographers in Lightroom and Photoshop workflow, and recently one of his 'students' was asked by her colleagues what was it he had, to which the reply was "Gravitas and Patience" — seemingly they thought he had an App called "Gravitas"!

He keeps abreast of the technologies that affect photography, the Mac and Photoshop, which can prove invaluable, and he somehow manages to keep his hand in taking a wide range of photographs.

Photographer and moving image maker, Ben Rice refers to him as 'Doctor', and Rod's adoption of his firm's trading name stems from the most frequent of requests for help which began with "Rod, I have a problem..." — the only obvious response was to adopt the name of 'SOLUTIONS photographic'.

SOLUTIONS Photographic

Now enters its twenty-sixth year, and provides Consultancy and Training, Retouching to Graphic Designers, Progress Photography to Construction companies, help with specifying Mac hardware and software to photographers, and diagnostics and remedial help when photographers face problems with their digital setups. He also can offer online help and Training on an ad hoc basis.

Much of his training is tailored for one-to-one involvement as this has generally proved to be the most effective way to learn. Several photographers have availed themselves of his time for extended periods up to six days as far afield as Tuscany, Provence, Paris and Aberdeen, with follow-up sessions remotely using programs such as iChat, and Skype. Contact details are below:

Email: rod@solphoto.co.uk

Blog: http://rod-wynne-powell.blogspot.com

Skype: rodders63 iChat: rodboffin

T: +44(0)1582-725065 M: +44(0)7836-248126

Pixel Genius PhotoKit plug-in www.pixelgenius.com

PhotoKit Analog Effects for Photoshop

This Photoshop compatible plug-in is designed to provide photographers with accurate digital replications of common analog photographic effects. PhotoKit is quick and simple and allows for a greatly enhanced workflow. Priced at \$49.95.

PHOTOKITTM

PhotoKit SHARPENER

A complete Sharpening Workflow for Photoshop

Other products may provide useful sharpening tools, but only PhotoKit SHARPENER provides a complete image 'Sharpening Workflow'. From capture to output, PhotoKit SHARPENER intelligently produces the optimum sharpness on any image, from any source, reproduced on any output device. But PhotoKit SHARPENER also provides the creative controls to address the requirements of individual images and the individual tastes of users. PhotoKit SHARPENER is priced at \$99.99.

PhotoKit Color

Creative color effects for Photoshop

PhotoKit Color applies precise color corrections, automatic color balancing and creative coloring effects. This plug-in also provides a comprehensive suite of effects that lets you recreate creative effects like black and white split toning and cross processing. PhotoKit Color is priced at \$99.95.

Pixel Genius is offering a 10% discount on any whole order, which must be placed from the Pixel Genius store at: www.pixelgenius.com. This is a one-time discount per email address for any order made from Pixel Genius. This coupon will not work on affiliate sites. Also it cannot be combined with other discounts or programs except for certain cross-sell items. Please note that this coupon will expire upon next revision of *Adobe Photoshop for Photographers*.

Coupon ID: PSFPCS7ME